THE GREAT PARK
&
WINDSOR FOREST

THE GREAT PARK
&
WINDSOR FOREST

Clifford Smith

THE GREAT PARK & WINDSOR FOREST

First published 2004

ISBN 1-904408-01-X

Designed and typeset in England by Starfish1
www.starfish1.co.uk

Printed and bound in England by JRDigital Print Services

This book is
dedicated to my ancestors

Published by
BANK HOUSE BOOKS
PO Box 3
NEW ROMNEY
TN29 9WJ

www.bankhousebooks.com

CONTENTS

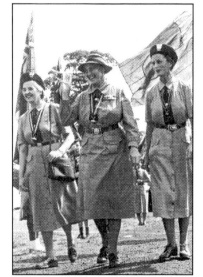

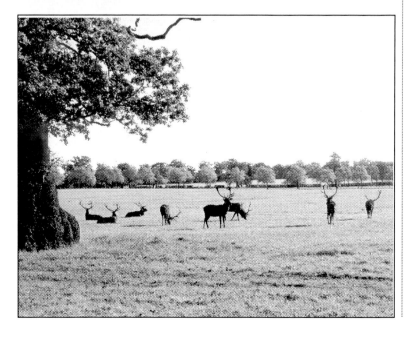

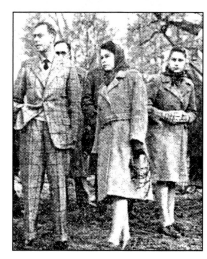

The origins of the Royal Estate attached to Windsor Castle are hidden in the mists of time. It certainly pre-dates William of Normandy's castle and for all its known history there is a rich vein of myths and legends. Harrison Ainsworth's 'Herne the Hunter' is a gripping tale about this legendary gamekeeper in the time of Henry VIII. A great oak tree is flourishing on the traditional site of Herne's Oak in the Home Park.

Many Kings have left their mark on the Estate. Charles I planted trees and avenues and Charles II recovered the Park from Cromwell's soldiers, who had been given small-holdings in the Great Park after the Civil War. George II's son, the Duke of Cumberland, of Culloden fame, was responsible for much of the landscaping of the southern part of the Park. George III was an enthusiastic and knowledgeable farmer, who established Norfolk and Flemish farms. George IV had a great liking for the Great Park and lived at Royal Lodge while the Castle was being 'modernised' and made habitable by his architect, Wyatville. He kept a menagerie of exotic animals at Sandpit Gate. George VI created the gardens at Royal Lodge, built the Village and, together with Sir Eric Savill, established the Valley and Savill Gardens. Today, the majority of the Great Park is open to the public.

Ever since George III handed over the properties of the Crown to the Government in 1760, in exchange for a Parliamentary annuity known as the Civil List, the management of the estate has been in the hands of the Crown Estate Commissioners. In 2002 the estate earned £163M for the government, but the net cost of the management of the three sections of the rural part of the Windsor estate, the Home Park, the Great Park and Windsor Forest amounted to £1.2M. The Home Park was split into Public and Private in 1848 when the road from Windsor to Datchet across the Victoria Bridge cut off the northern section of the Park bordered by the Thames. This section was handed over to the Borough of Windsor for public recreation and became the Home Park Public.

Clifford Smith has taken infinite pains to collect a mass of facts and figures about the whole estate and the result is a comprehensive record by someone, whose family has been intimately involved with its development for 180 years.

Philip

Introduction

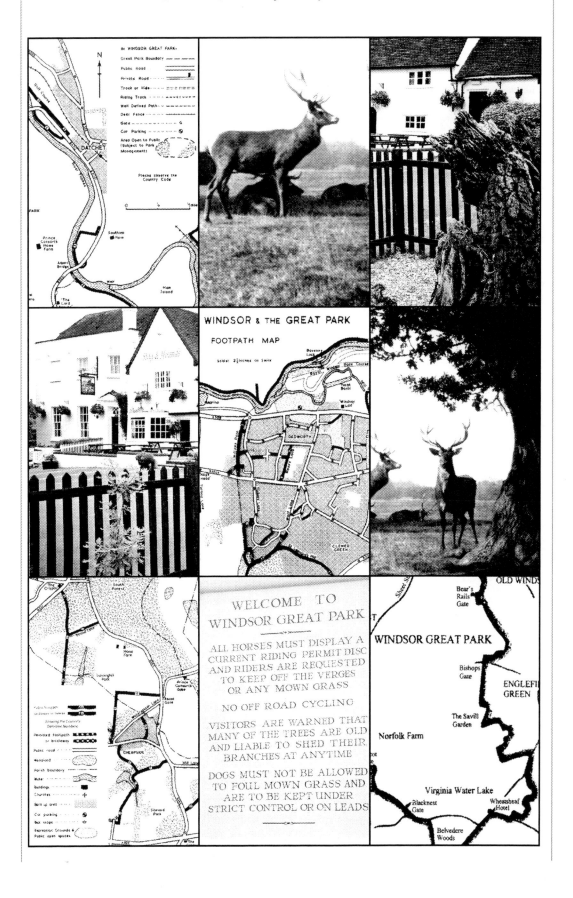

Introduction

The Great Park and Windsor Forest are the major areas of the Windsor Crown Estate. The estate stretches from the Home Park, a private northern area of parkland at the eastern side of Windsor Castle, to Bagshot Park 18 kilometres (11.2 miles) distance at the extreme south. The estate, which also includes Sunninghill Park and Ascot Heath, is irregular in shape with the western and eastern boundaries coming close together at the public road roundabout junction at the western end of Ascot Heath. It then broadens out again towards Swinley Forest at the southern end of the estate.

The estate currently covers a total area of 6,070 hectares (15,000 acres), having a dominance of deciduous trees such as oak and sweet chestnut in The Great Park, whereas, there is a progressive increase of evergreens, mainly pine, towards the south of the estate. Although the estate has retained most of its character over the years, it is now a far cry from what it was only a century or so ago. Large areas of the Windsor Forest have been sold, the only exception being Sunninghill Park which has been purchased by the Crown, was then sold and, many years later, re-purchased. The Great Park and Windsor Forest became an extremely popular hunting ground by William the Conqueror after his conquest of England in 1066 and barely one hundred years later, Windsor Forest had a circumference of 193 kilometres (120 miles). It covered most of the counties of Surrey, the eastern side of Berkshire as far as Hungerford and parts of Buckinghamshire and Middlesex. The junction of Forest Road and Church Lane at Binfield, near Bracknell is recognised as being the old central position. It should be pointed out that the term 'forest' in this instance is very misleading, because much of Windsor Forest was in fact heathland. Over the years numerous grants and encroachments have progressively reduced the area and, by 1600, it had been reduced by about a third. In 1813, the Windsor Forest Enclosure Act became law. However, it was not until the ensuing Enclosure Awards of 1817, that the effects of law came into full operation. It was at this time that we saw a major change to the size and shape of the forest. In almost every inn in the area auctions were held to sell allotted areas of land to the highest bidders. This 'land grabbing' period made the rich richer. After the 'dust had settled', the Crown Land became more clearly defined and better managed. After a long period of stability, a further reduction in the size of the Windsor Crown Estate took place in March 1952 when 760 hectares (1,878 acres) of the southern area of the estate was sold to the War Office for use by the nearby Royal Military Academy, Sandhurst.

The very nature and history of The Great Park, with its proximity to Windsor Castle, its thousand year old oak trees and herds of red deer conjures up a classic picture of medieval England. The trees often shrouded in mist, the tales of Herne the Hunter and the ghost stories add to this image. As a boy, the eeriness of the park in the winter, particularly when I came across a group of gigantic red deer stags in the gloom, would petrify me and I could not get home quickly enough. Much of this presence disappeared at the time of the Second World War when the deer were rounded up and the fields were ploughed and fenced. It also brought an end to centuries of hunting in the park and forest, making many of the kennels redundant.

The natural 'monuments' of the past are the old and hollow pollard oak trees, the like of which are found nowhere else in Europe. A few are over a thousand years old and the William the Conqueror Oak near Cranbourne Tower was already an established tree when William's army won the historical Battle of Hastings in 1066.

There are many magnificent avenues of trees in the park. The most notable is The Long Walk which stretches from Windsor Castle in a straight line to Snow Hill at the south. It was created between 1682 and 1685 during the reign of King Charles II and although it has often been stated that it is three miles long, it is in fact considerably shorter, being 2 miles 660 yards (3.822 kilometres). The original elm trees became unsafe and were replaced with horse chestnut and plane trees during an interrupted period between 1920 and 1945. An even longer avenue is Queen Anne's Ride which stretches from Queen Anne's Gate in a straight line to Prince Consort's Gate at the south, a distance of 2.9 miles (4.67 kilometres). It was created over the period 1708 to 1720 using elm and lime trees. Unfortunately, the Dutch elm disease that ravaged the country's elms during the 1960s affected the elms in the ride and they were replaced with oak.

WELCOME TO
WINDSOR GREAT PARK

ALL HORSES MUST DISPLAY A
CURRENT RIDING PERMIT DISC
AND RIDERS ARE REQUESTED
TO KEEP OFF THE VERGES
OR ANY MOWN GRASS

NO OFF ROAD CYCLING

VISITORS ARE WARNED THAT
MANY OF THE TREES ARE OLD
AND LIABLE TO SHED THEIR
BRANCHES AT ANYTIME

DOGS MUST NOT BE ALLOWED
TO FOUL MOWN GRASS AND
ARE TO BE KEPT UNDER
STRICT CONTROL OR ON LEADS

Both the The Long Walk and Queen Anne's Ride are newcomers when compared to The Oak Avenue that meanders on each side of Sheet Street Road in the park. It was planted c1450 during the reign of King Henry VI. It originally started near Windsor Castle and ended near Forest Lodge to the east of Forest Gate. Although a number of the trees have now gone, the line of the avenue can easily be followed by the pale earth embankment that runs along the line of trees. There are many beautiful and interesting individual groups and plantations of trees on the estate. Many have been planted by members of the Royal Family and dignitaries to commemorate special occasions. The King George VI Coronation Oaks near Cumberland Lodge and the Queen Elizabeth II Coronation Oaks near the park village are of special interest. Most of the commemorative trees have a metal plaque in front of them describing the occasion. Many of the plantations simply have an iron post giving the date of planting. The most common posts read, 'Planted about 1820'. These are very dear to the author's family, as the plantations were planted by my great great grandfather Joseph Smith, who was in charge of the planting and care of the trees in the park between 1820 and 1860. As a kind of 'signature' he would often mix oak and sweet chestnut trees in the same plantation. For the person who loves pine trees, Swinley Forest in the southern half of the estate is the place to be. From 'The Look Out' facilities at the southern side of Bracknell, there is a large expanse of pine forest where the beauty and smell of the pines are unforgettable.

Most of the lakes and ponds on the estate have been created by damming an existing stream. The beautiful Virginia Water Lake at the southern end of the park, which is the largest expanse of water on the estate, was created this way in the 1700s. Much smaller in size, but nonetheless very interesting, is Great Meadow Pond on Norfolk Farm, the Obelisk Pond near The Savill Garden and the Great Pond in Sunninghill Park. Many of the streams on the estate have the name 'bourne' in the title, a name which derives from 'bourn' meaning a small stream.

There are several farms on the estate which have an interesting background, with Flemish Farm, Norfolk Farm and Shaw Farm being the most notable. It should be pointed out that all of the farms are prohibited to the public in the same manner as the premises and enclosed areas on the estate.

There are many houses, structures and monuments on the estate all with various degrees of history and interest. The following are the most noteworthy –

HOUSES
Bagshot Park Mansion
Cranbourne Tower
Cumberland Lodge
Forest Lodge
Fort Belvedere
Frogmore House
Ranger's Lodge
Royal Lodge
Sunninghill Park Mansion
The Clockcase

MONUMENTS
Caesar's Camp
Cumberland Obelisk
Prince Consort's Statue
The Copper Horse
The Totem Pole
The Jubilee Statue

STRUCTURES
Five Arch Bridge
Stone Bridge (1829)
Stone Bridge (1834)
The Cascade
The Ruins

The estate has been the scene of many historical events. The Royal Reviews that took place on the open space known as the Review Ground at the northern end of the park were phenomenal. They were carried out at regular intervals between 1818 and 1936, a period of 118 years. The largest attracted an estimated 85,000 people in one day. Another historical event was the landing of the United Kingdom's first aerial post in Shaw Farm Meadow on 9th September 1911. The Cavalry Exercise Ground near Queen Anne's Gate was the scene of the country's largest agricultural shows in 1889, 1939 and 1954. In more recent times, The Long Walk saw thousands of people making their way to the top of Snow Hill to celebrate the lighting of the first bonfire for Queen Elizabeth II's Silver Jubilee.

Equestrian events on the estate have always been of the highest level with the Royal Ascot horseracing on Ascot Heath being world renowned. Some of the very first polo matches to be played in England were played in the park. In recent times, many important horse trials and events have been held in the park and on a leisurely basis, horseriding is allowed in parts of the estate strictly by permit only.

Many parts of the estate have been the scene of some major athletic events, marathon, half-marathon, cross-country, road walking and in 1948 it was used to stage the Olympic Cycle Road Race. On a less competitive basis, many charity fund raising events such as sponsored walks are held throughout the year.

The Savill Garden at the eastern boundary of the park and The Valley Gardens on the northern slopes of the Virginia Water Lake, are truly magnificent gardens, particularly during the rhododendron and azalea flowering period. The range of wild life on the estate is enormous. On the land, in the air and in and

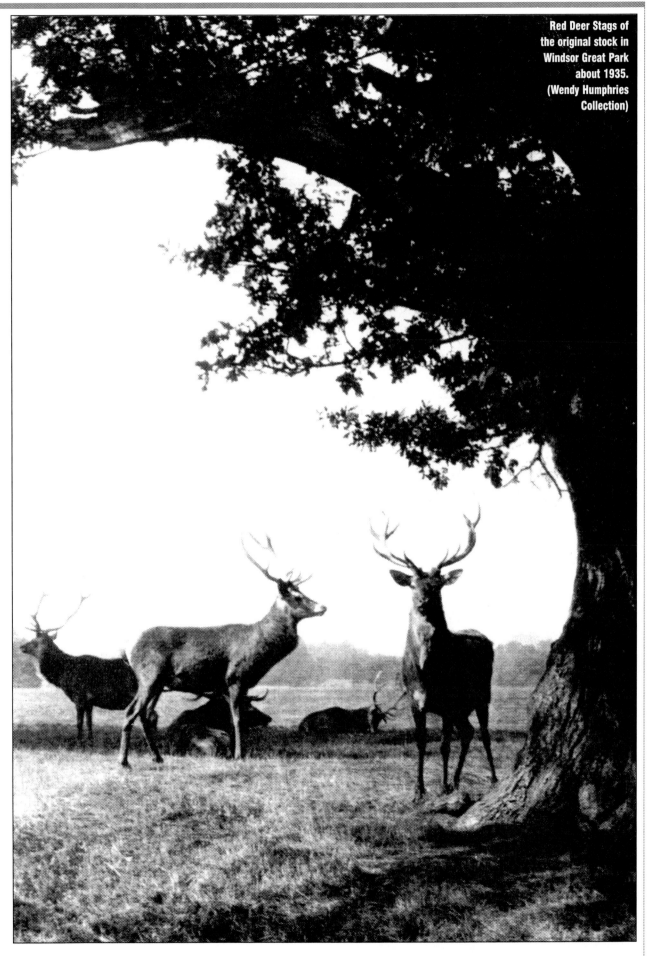

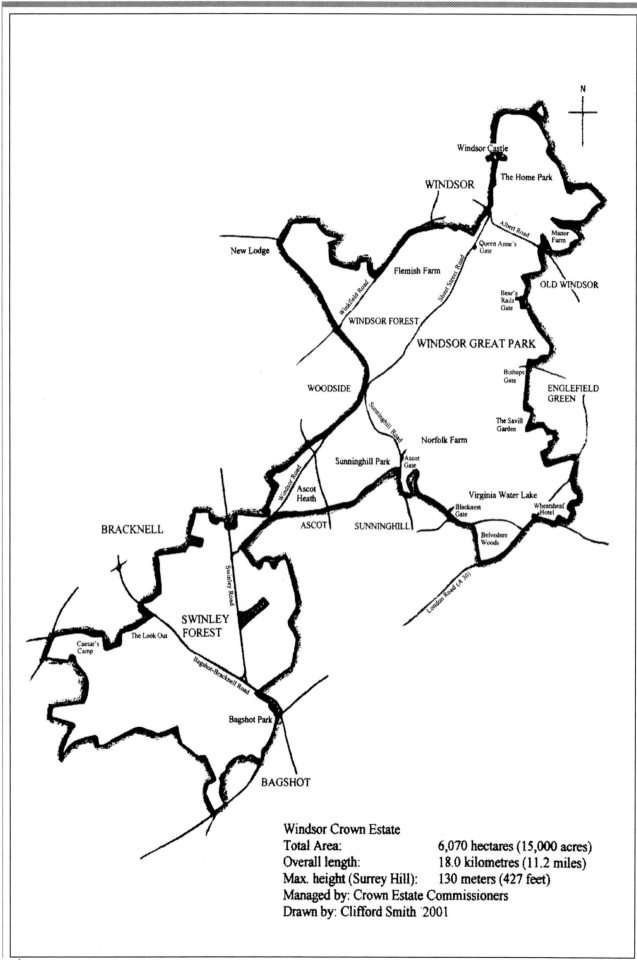

N

Windsor Castle

The Home Park

WINDSOR

Albert Road

Manor Farm

New Lodge

Queen Anne's Gate

OLD WINDSOR

Flemish Farm

Sheet Street Road

Bear's Rails Gate

Winkfield Road

WINDSOR FOREST

WINDSOR GREAT PARK

WOODSIDE

Bishops Gate

ENGLEFIELD GREEN

Sunninghill Road

The Savill Garden

Norfolk Farm

Sunninghill Park

Ascot Gate

Windsor Road

Ascot Heath

Virginia Water Lake

BRACKNELL

ASCOT

SUNNINGHILL

Blacknest Gate

Wheatsheaf Hotel

Belvedere Woods

London Road (A 30)

Swinley Road

SWINLEY FOREST

Caesar's Camp

The Look Out

Bagshot-Bracknell Road

Bagshot Park

BAGSHOT

Windsor Crown Estate
Total Area: 6,070 hectares (15,000 acres)
Overall length: 18.0 kilometres (11.2 miles)
Max. height (Surrey Hill): 130 meters (427 feet)
Managed by: Crown Estate Commissioners
Drawn by: Clifford Smith 2001

14

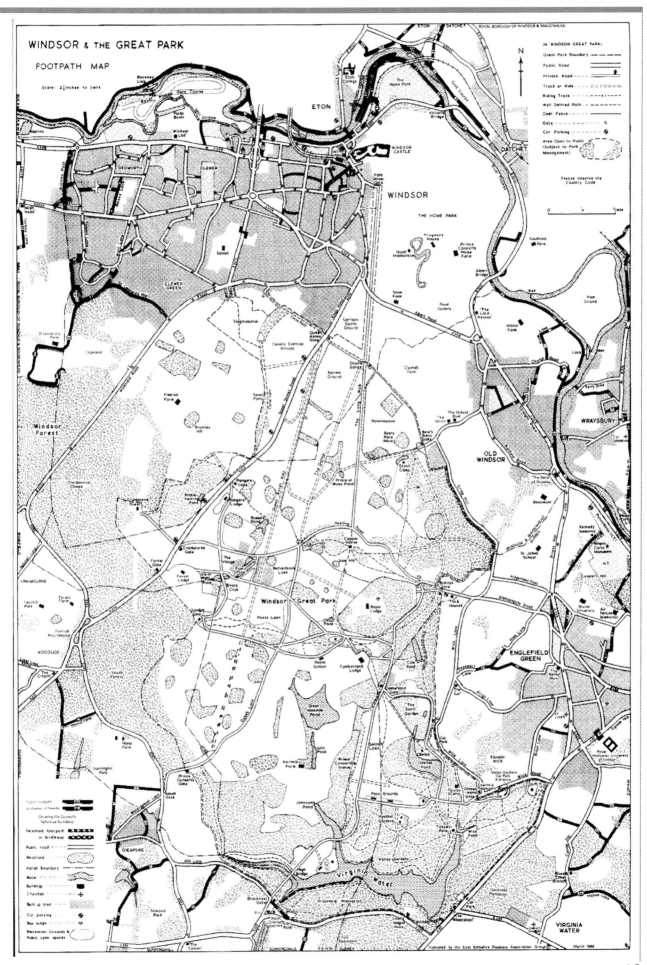

on the water, the range of life is almost infinite. The estate is a nature lover's paradise with every part having its own unique interest.

The estate has been the scene of many happy, sad and unusual occurrences. The last thing that you would expect was that several earthquakes have been felt on the estate during the past two-hundred-and-fifty years. On the 8th of February 1750, a frightening earthquake shook the Thames Valley area and people ran in panic to wherever they thought would be safer. The tremors were widely felt in London barely twenty miles away. On the Thursday morning of the 17th December 1896, another more widespread earthquake was felt on the estate and a large area of southern England. Two more earthquakes were felt on Sunday morning the 15th August 1926 and on Sunday morning the 7th June 1931 . The tremors of this last earthquake were felt over most of England and parts of Scotland.

Nature has often taken its toll of the trees on the estate. In most people's living memory, the destructive violent storm on the night of 16th October 1987 was one of the worst. Many of the old and magnificent trees were brought down or badly damaged during that horrendous night. The tall beech trees with their shallow root bases were particularly badly affected. During the 1960s, much of the country's elm trees were devastated by Dutch Elm Disease and virtually all of the elms on the estate were affected. It is caused by the fungus Ceratocystis Ulmi and spread by bark beetles. Very few trees survive once affected.

On occasions, stringent measures have been taken to prevent Foot and Mouth Disease, a contagious viral disease affecting cloven-hooved animals such as cattle, pigs, sheep, goats and deer. Preventative measures such as covering the entrances to the park with sawdust impregnated with disinfectant was a common practice in the past. Warning notices were also erected at the entrances. Fortunately, the estate escaped the large outbreaks that seriously affected the country in 1967 and 2001. The rabbits and hares on the estate were dramatically reduced in number by the widespread affects of Myxomatosis in the 1950s, being at its height in 1954. It is an horrific viral disease causing swelling of the mucous membranes. Very few rabbits and hares survive once affected. An extremely happy event was the re-introduction of the red deer in the park in 1979. With so many people now visiting the park or driving through it along Sheet Street Road, it was found necessary to erect a fenced Deer Park stretching from Queen Anne's Gate to Bishops Gate and along Snow Hill to Queen Anne's Ride.

Sadly, several people have lost their lives on the estate mainly through car accidents on the public through road, Sheet Street Road. As recently as 9th August 1999, Robert Herbert (founder of the world famous Spice Girls singing group) died as a result of a collision with another car. A passenger in the other car also died. Since that time, a strict 50 MPH speed limit has been placed on the road. On 2nd August 1938, Sir Malcolm Donald Murray, who had retired the year before as Deputy Ranger of the Park, was tragically drowned in a boating accident on Virginia Water Lake.

The community spirit on the estate for the staff and their families has always been very strong; The Crown Estate Office, the Village and the York Club in the centre of the park being the focal point of all activities. The quarterly Windsor Estate News magazine provides some extremely interesting articles and events concerning the estate to all current and retired staff.

In order to provide the reader with the clearest understanding of the geography of the estate, the chapters follow in sequence starting at the north and ending in the south.

The Stag & Hounds Public House at the junction of Forest Road and Church Lane, Binfield. In the foreground is the decaying stump of an old elm tree which marks the central position of Windsor Forest as it was centuries ago. On Thursday 22nd February 2001 an oak sapling was planted as a replacement seen in front of the ninth pale from the left. (photo by the Author - July 2001)

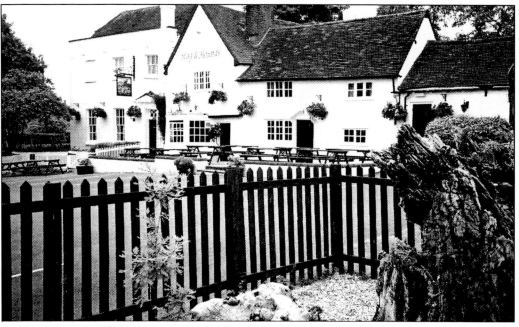

They say an oak tree grows for 300 years, rests for 300 years, then spends some 300 years gracefully expiring

Stag Meadow

1

Stag Meadow

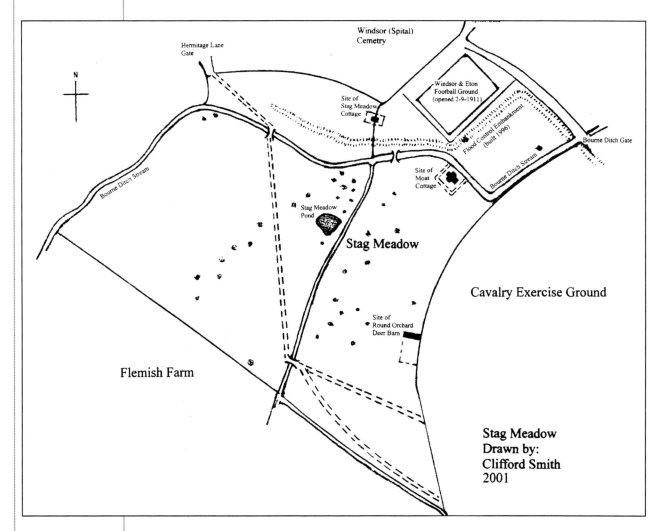

Windsor (Spital) Cemetry

Hermitage Lane Gate

N

Site of Stag Meadow Cottage

Windsor & Eton Football Ground (opened 2-9-1911)

Flood Control Embankment (built 1996)

Bourne Ditch Gate

Bourne Ditch Stream

Site of Moat Cottage

Bourne Ditch Stream

Stag Meadow Pond

Stag Meadow

Cavalry Exercise Ground

Site of Round Orchard Deer Barn

Flemish Farm

**Stag Meadow
Drawn by:
Clifford Smith
2001**

S tag Meadow is an area situated at the far north-western corner of the park covering an area of about 28 hectares (70 acres). It is bordered at the north by the Spital Cemetery and at the south and west by Flemish Farm. At the east is the Cavalry Exercise Ground, which until the 1950s was separated by a six foot high paled fence. The Bourne Ditch Stream and Stag Meadow Pond are the water features of the area. However, parts of Stag Meadow are very low lying and are prone to flood during wet periods.

At the start of the 1800s, the area was part of a country estate known as Moat Park, stretching as far as Sheet Street Road to the east and extending south covering a large part of Flemish Farm. There is no evidence that Stag Meadow has ever been ploughed during its history, either when it was part of the Moat Park or since then as part of the park. However, it is known that livestock was kept there right up until the 1940s, when several horses were often seen grazing in the fields. It will come as no surprise that Stag Meadow gets its name from the deer that once roamed the area. As recently as the 1950s, a disused deer pen, complete with a barn and known as the Round Orchard Pen, stood on the hill rise near the Miniature Rifle Range. In the 1800s the pen was surrounded by a large orchard, hence the name. In the autumn of 1864 two Hoopoes were seen in the area; one was shot as evidence!

For many years, two cottages stood in Stag Meadow. The largest and most imposing of the two was 'Moat Cottage' and, as the name suggests, it was surrounded by a moat. Situated on the southern side of the Bourne Ditch Stream, it was built in 1750 as a single level pleasure pavilion in a cross-shaped plan. It was often visited by the Duke of Cumberland and other members of the Royal Household mainly to have a break during royal and military hunts. Some years later it was used as the residence for the local herdsman, the last one being John Patey. Born at Winkfield in 1803, he lived there with his family until he died in 1895 aged 92 years. The cottage was demolished the following year. The other building was called 'Stag Meadow Cottage'. This was built in 1793 as two semi-detached houses of basic design. It is interesting to note that the 1851 National Census shows that Joseph Cam(m) a park forestry labourer lived here with his family. Joseph was born in Egham in 1801, a member of the Camm family that was to become famous when Sydney Camm designed many excellent aircraft, in particular the Hawker Hurricane Fighter which was the mainstay of the Royal Air Force during the Second World War. It is known that Stag Meadow Cottage was used to house park keepers and Windsor policemen and their families until it was demolished in the 1920s.

The two main entrances to Stag Meadow are Hermitage Lane Gate at the far north-eastern corner, and Spital Gate which directly leads into the Windsor and Eton Football Ground and into the Cavalry Exercise Ground via the Bourne Ditch Bridge. The Spital Gate is certainly the most well used of the two, particularly since the football ground was built

there in 1911. However, for a long time before that, it had been used by the Cavalry to enter the Cavalry Exercise Ground down what was once known as Charity Lane and sometimes called Soldiers Lane. As a boy, I watched many royal and military hunts going down the lane having started out from the Stag & Hounds Public House in St Leonard's Road.

Stag Meadow Pond is situated on the western side of the Bourne Ditch about half way between the Windsor and Eton Football Ground and the Flemish Farm northern boundary fence. It is quite unique in that it was created by digging out an area away from the nearby stream and not by the normal method of damming up the stream. It is almost square in shape and about 23 metres (25 yards) by 23 metres (25 yards) in size. Over the years it has been allowed to silt up until today it is not much more than a reed basin surrounded by trees and bushes. The pond was most probably established as a drinking place for livestock when the area was part of the Moat Park. In my family's memory, this pond has never contained any fish and only on rare occasions has a pair of moorhens nested there.

Spital Gate, looking in towards the park and showing the entrance to the Windsor & Eton Football Ground in the centre – May 1998 (photo by the Author).

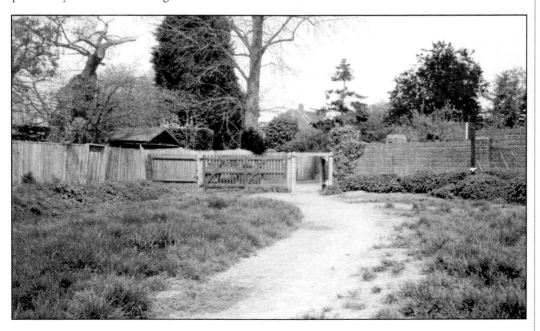

Hermitage Lane Gate, looking out from the park – May 1998 (photo by the Author).

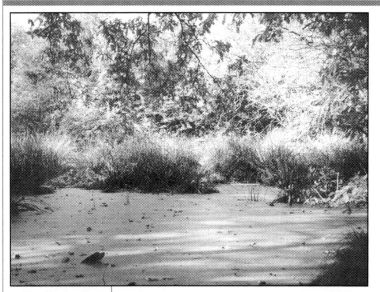

Stag Meadow Pond with the surface of the water covered with duckweed. (photo October 1999 by the Author).

Moat Island looking towards Windsor (Spital) Cemetery Chapel and Windsor and Eton Football Ground. The water in the foreground is part of the old moat that surrounded Moat Cottage. The cottage, demolished in 1896, stood to the left of the oak tree. (photo September 1999 by the Author).

The Bourne Ditch Stream showing the steep embankment on each side of the stream. The grassy slopes, particularly when wet, makes it extremely hazardous to jump over the stream. Many a person has finished up with a bootful of water doing just that. (photo September 1999 by the Author).

In 1911, King George V gave his consent for the Windsor and Eton Football Club to use a corner of Stag Meadow to be sectioned off as their ground. Being crown land, it has always been used on a rent basis only. The very first game was played on Saturday the 2nd September 1911, and the result of that game was not in favour of the local team. Playing against their neighbours Maidenhead in the Great Western Suburban League, they lost 2-3 after being 1-1 at half time. At the time, it was only the second occasion that Windsor and Eton had lost to Maidenhead. Like all sports clubs, the Windsor and Eton team has had its

ups and downs, their most consistent successful spell was during the Second World War when they won the Berks and Bucks Senior Cup five times in six years. It was during those years, that the surrounding oak trees were used as a free grandstand by the local lads.

On occasion, Stag Meadow was used for military camping purposes and it appeared to be a natural follow on, that the area became a popular site for some very large boy scout and girl guide camps. The first of these was the Windsor and District Boy Scouts' Association Jamboree held on Wednesday the 24th and Thursday the 25th August 1921 on the Windsor and Eton Football Ground. Although the camp was restricted in space, it was a great success with many people from Windsor and the surrounding district visiting the camp over the two days. The scouts had laid on many demonstrations and displays such as bridge building, rope knot making, leather making, tent erecting and displays of marching. The scout movement at the time, was still in its early days, and undoubtedly the Jamboree would have attracted many more boys to join the Association.

The next significant camp to be held, was the Girl Guides' World Camp held from 26th July to 8th August 1957. With a total of 4,000 guides attending from sixty-four countries, it had required an enormous amount of organisation and by all accounts it was a tremendous success. On this occasion, the whole of Stag Meadow and the northern half of the Cavalry Exercise Ground was taken up by the Camp. At the time, I was staggered just how quickly the camp was erected; it seemed to appear from nowhere. Little did I know at the time that it had taken eighteen months planning under the control of Molly Walker to stage the event.

The Camp was organised to celebrate the centenary year of the birth of Lord Baden-Powell, founder of the Scout and Guide Movements. It was very fitting that the World Chief Guide, Olave, Lady Baden-Powell, formally opened the Camp on Tuesday 30th July. On Thursday 1st August, the Camp was visited by the Princess Royal (Princess Margaret who was, until her death, the President of the Girl Guide Association) On Sunday 4th August the Camp was visited by Queen Elizabeth II and the Princess Royal. This would have helped to have made it all worthwhile, particularly for the forty-nine Australian girl guides, who had sailed to England in May and did not arrive back home until Mid-November later in the year.

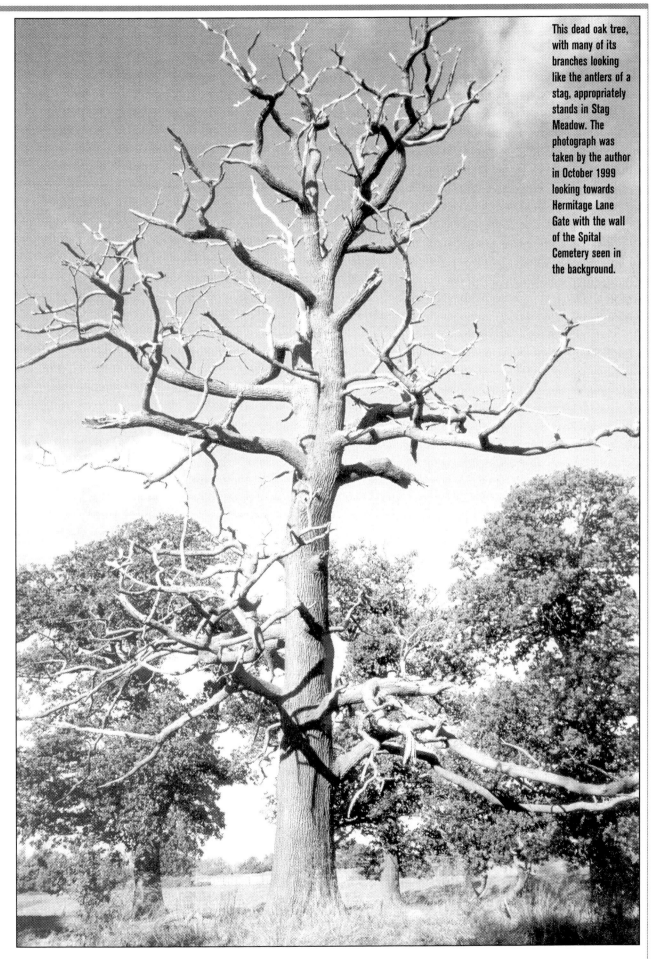

This dead oak tree, with many of its branches looking like the antlers of a stag, appropriately stands in Stag Meadow. The photograph was taken by the author in October 1999 looking towards Hermitage Lane Gate with the wall of the Spital Cemetery seen in the background.

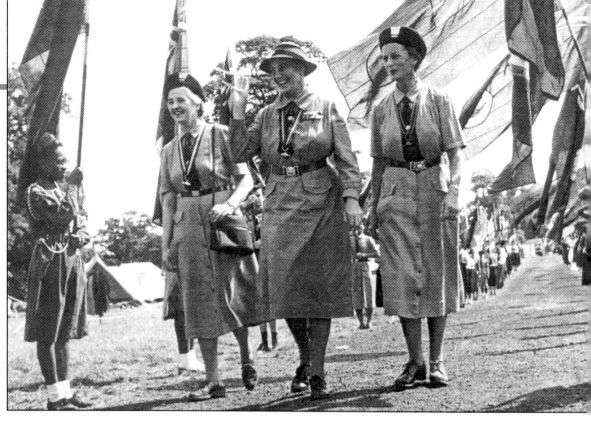

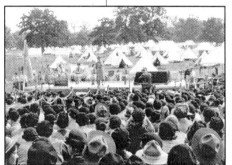

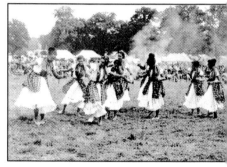

During the week, many excursions were organised for the guides from overseas to places like Blenheim Palace, Hampton Court and London.

On the final day, 21,000 guides from all over Britain visited the Camp, to join in a mass camp fire in the evening. Fortunately, the good weather experienced throughout the Camp continued to the end.

The Camp was divided into ten sections, each consisting of eight groups of approximately fifty campers. The Camps were named after places in all parts of the world linked with the Founder, Lord Baden-Powell of Gilwell. They included Charterhouse (his school), Mafeking, Gilwell Park and Foxlease, the scout and guide training centres, Pax Hill at Bentley, Hants., Arrowe Park (Site of the Scout Coming-of-Age Jamboree in 1929) and Nyeri in Kenya, where Lord Baden-Powell died on Wednesday 8th January 1941 aged 83 years.

The Berkshire International Boy Scout Camp was held in Stag Meadow during 4th to 11th August 1962. A total of 3,000 scouts and cubs from many troops in Britain and abroad attended the Camp. The overseas members came from America, Finland, France, Germany, Holland, Iran, Malaya, New Zealand, Norway and Sweden, providing an international flavour to the Camp. The scout movement was possibly at its strongest at the time, with a total of nine million members throughout the world.

During the first two days of Saturday and Sunday, the weather was fair and appeared to be developing into a heatwave. Unfortunately, it suddenly changed on the Monday Bank Holiday to monsoon weather, followed by more torrential rain on the Tuesday. Anyone who has camped in this type of weather can appreciate just how wretched this can be. However, in spite of this, the overall opinion was that the Camp had been a great success. Certainly it had been for the Chief Scout, Sir Charles Maclean, because the rain had miraculously kept off during the start of his visit on the Monday, and to his credit, he stayed at the site for ten hours, meeting and talking to members of all the troops whilst the rain was progressively saturating the Camp.

The last Camp to be held in Stag Meadow was the Berkshire International Boy Scout Camp. On this occasion the weather kept fine

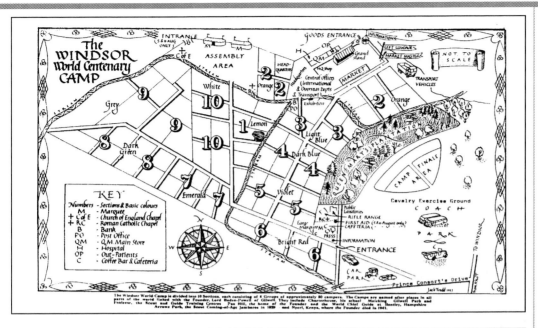

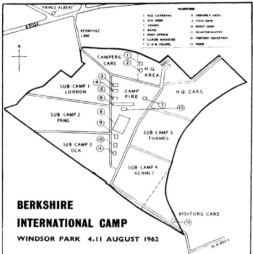

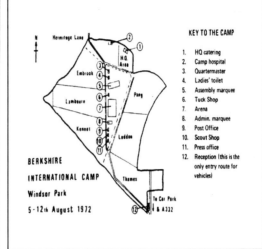

Plans of the 1962 and 1972 the Berkshire International Boy Scout Camps held in Stag Meadow. (Rupert Allison Collection).

The official plan of The World Guide Camp in Stag Meadow, Friday 26th July - Thursday 8th August 1957. (The Guide Association Archives)

The designated areas as shown on the plan, were for the guide groups from the different parts of Britain as follows:-

1 Lemon
Midlands
2 Orange
South West
3 Light Blue
Scotland
4 Dark Blue
Scotland
5 Violet
North West and two Midland groups.
6 Bright Red
South East..
7 Emerald Eastern and two Scottish groups.
8 Dark Green
North East – six groups and South West – two groups.
9 Grey
London, South East one group. Scotland two groups.
10 White
Wales and Ulster.

throughout the eight days of 5th to 12th August 1972. Well over 2,000 scouts including representatives from America, Belgium, Canada, Denmark, France, Germany, Italy, New Zealand, Norway, Sweden and Wales attended.

In the ten years since the previous Camp, the attitudes of society had changed significantly to a period of permissive tolerance. This tolerance showed a downside at this Camp when many cases of theft were reported, and a minibus, which had been loaned by a Windsor School, was set alight near the main marquee. Of course, these could have been the acts of outsiders as the culprits were never caught. For the first time, the Camp also included a strong contingent of Ranger Guides from Berkshire, and human nature being what it is, this created some unplanned 'attractions'.

The Camp was formally opened by the Mayor of Windsor, Councillor Richard Shaw on Saturday 5th at 3 o'clock in the afternoon. The heat was so great that several boys were treated for fainting during the opening ceremony. During the week, many excursions were laid on to visit London, the Houses of Parliament, Hampton Court, Stonehenge and Portsmouth. On Thursday the 10th, the Camp was visited by the pop compere and television personality, Jimmy Savile, much to the delight of the popular music lovers.

The year 1996, saw a major change to the profile of Stag Meadow when a Flood Control Embankment was built from the Hermitage Lane Gate to the Cavalry Exercise Ground. Three years previously, on Tuesday 12th October 1993, torrential rain caused flooding in and around Windsor and Slough. The worse

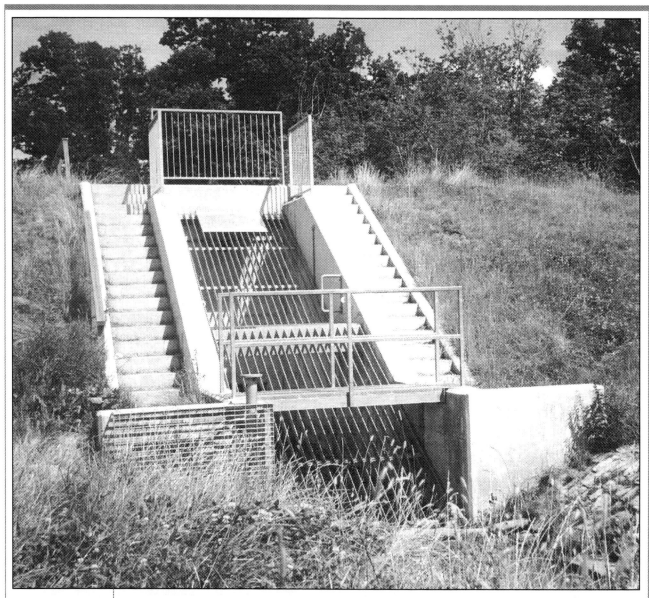

The Bourne Ditch Stream Sluice built into the Flood Control Bund (embankment) that stretches from Hermitage Lane Gate to the Cavalry Exercise Ground. The bund was built in 1996 as a measure to prevent a recurrence of the disastrous floods that affected Windsor in October 1993. (photo August 1998 by the Author).

affected areas were Bourne Avenue, Bolton Road and Victor Road in Windsor. Parts of the Bourne Ditch Culverts that run under the roads and fields between Stag Meadow and the Thames had become blocked and the flooding was a local disaster. About midnight, water was seen rapidly rising in Victor Road and, within two hours, the water in parts of the road had reached a depth of 1.5 metres (5.0 feet). At daylight on Wednesday morning - the 13th of all days - the full extent of the flooding was revealed. The muddy water had gone everywhere, with the interior of the homes being seriously affected, and some of the cars were completely covered with water. Many people were evacuated, eventually returning to a massive mopping and drying up operation. The flooding has gone down in local history as 'Black Wednesday'.

To those of us born and raised in Bourne Avenue, it was always known that the risk of flooding in the area was high. For that reason, a person was paid his 'beer money' for keeping the culverts clear of obstructions in the past. At the

same time the Bourne Ditch was regularly dredged and cleaned. Given another exceptional spell of torrential rain, or the rapid thaw from a heavy snow fall, coinciding with a blockage or collapse within the culvert, I fear that history will repeat itself and the construction of the embankment in Stag Meadow as a bunding area will prove to be of no avail.

Having covered the formal events which have taken place in Stag Meadow, my account of this picturesque and natural part of the park would not be complete if I did not mention the wonderful times I had there as a boy, skating in the moonlight on the frozen flood water, invariably with a handful of hot potato chips wrapped in newspaper. The skating party would always break up, when someone would 'spook' us by saying they had seen something unusual in one of the nearby oak trees. The clothes that we tore clambering, panic stricken, over the park fence left an indelible memory in our mothers' minds.

Cavalry
Exercise Ground

2

Cavalry
Exercise Ground

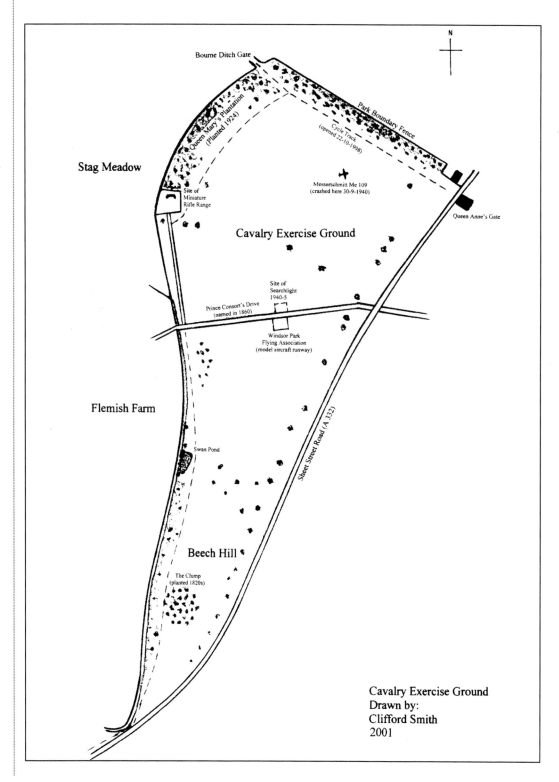

N

Bourne Ditch Gate

Park Boundary Fence

Queen Mary's Plantation
(Planted 1924)

Cycle Track
(opened 22-10-1998)

Stag Meadow

Messerschmitt Me 109
(crashed here 30-9-1940)

Queen Anne's Gate

Site of
Miniature
Rifle Range

Cavalry Exercise Ground

Site of
Searchlight
1940-5

Prince Consort's Drive
(named in 1860)

Windsor Park
Flying Association
(model aircraft runway)

Sheet Street Road (A 332)

Flemish Farm

Swan Pond

Beech Hill

The Clump
(planted 1820s)

Cavalry Exercise Ground
Drawn by:
Clifford Smith
2001

The Cavalry Exercise Ground is situated at the extreme north of the park wedged between Sheet Street Road (A 332) on the east side and Stag Meadow and Flemish Farm on the west side. The widest point is about 628 metres (687 yards) at the northern end and tapers to a point at the southern end. It is approximately 1,571 metres (1718 yards) long. The total area of the ground is about 68 hectares (168 acres) and the ground steadily rises to Beech Hill at the southern end. Sheet Street Road is the only public road to go through the park and it is a direct route between Windsor and Ascot. It was once named Shaw Lane, sometimes spelt Chaw Lane. Now it is more generally known by the local people as 'The Park Road'. This very open area of meadow is the very first part of the park that you will see on the right as you enter from Windsor through Queen Anne's Gate, being on the public road between Windsor and Ascot. How it acquired the name The Cavalry Exercise Ground is self-explanatory. It was ideally suited as a training ground for the nearby Combermere Cavalry Barracks, situated at a distance of just over half a mile via the Spital Gate entrance. At the start of the 1800s, this very same meadow was known as Long Furlong for a reason that totally escapes me, because it is in fact nearly eight furlongs in length. From late Victorian times, the ground became a popular site for staging some very large agricultural shows and for many years afterwards was more generally called the Show Ground.

Queen Anne's Gate has had more different names given to it than any other entrance to the park. During the past two centuries, it has been spelt as, or called, Lister (Lester) (Leicester) Gate, Lachester (Lanchester) Gate, Hudson's Gate (the Gatekeeper's name in 1849), Lakin's Gate (the Gatekeeper's name in 1855), and finally, Queen Anne's Gate, the current and possibly the most appropriate of all. Although the other main entrance to the ground was through Spital Gate, there was an inner gate from Spital that stood just on the eastern side of the Bourne Ditch Bridge. This gate was even more tightly controlled than Spital Gate and was always locked at sunset. The noticeboard bearing the park regulations stood, rather forbiddingly, next to the turn-style gate. This gate came down soon after the Second World War when a healthier level of tolerance was adopted.

Prince Consort's Drive is a gravel track which leads from Sheet Street Road in a westerly direction across the middle of the ground and into Flemish Farm. A gravel track branches off just before the farm gate to the site of a miniature rifle range. The origin of the range goes back to the First World War when the first brick butt was erected. An additional butt was erected during the Second World War. Both butts have since been demolished, the last one as recently as March 2000. (A 'butt' is an embankment or a brick/concrete safety barrier that stands behind the targets).

Behind the site and bordering Stag Meadow is Queen Mary's Plantation. This was planted in 1924 as a sound and visual screen between the nearby Windsor & Eton Football Ground in Stag Meadow and the Cavalry Exercise Ground. The plantation was originally planted with oak, sweet chestnut and fir trees. Right up until the 1950s, the fir trees were so dense and the lower branches so close to the ground that you would come out on the other side 'scratched to pieces' if you ventured through it.

Because the fir trees were so small, it was commonly known as 'The Little Planny'. In spite of the noise from the nearby rifle range, it became a regular nesting place for a pair of sparrowhawks. As the trees matured, the plantation gradually lost its secrecy. Alas, it will never be the same again.

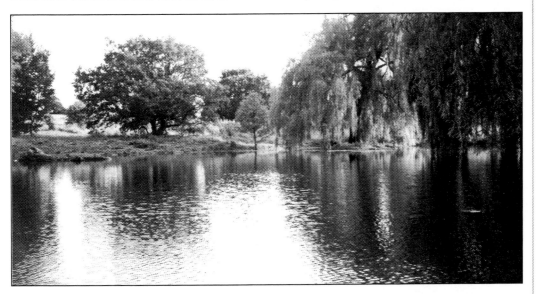

Swan Pond, restored to its former glory during 1997. The photo was taken looking south in June 1998 by the Author.

At the extreme southern end of the ground, proudly standing on Beech Hill there is a mature plantation, mainly of oak with a few sweet chestnut trees. This feature was planted in the 1820s by my great-great-grandfather, Joseph Smith. The plantation is simply known as 'The Clump'. It is one of my daydreams that one day it will be named 'Smith's Clump' in recognition of all the trees that he planted in the park.

Along the Flemish Farm boundary fence runs the Bourne Ditch tributary stream, which starts from Cranbourne Hill at the south and follows the fence northwards through Swan Pond, continuing to just past Prince Consort's Drive before turning left into Stag Meadow.

Swan Pond, more commonly known as just 'Swanee' by the people of Windsor has a rather unusual history in that it was deliberately filled in during the 1970s with lumps of concrete, bricks and soil. I was indeed surprised and highly delighted to see it completely re-dug out and restored in 1997 to something like its former beauty of days gone by. The pond is tucked away on the western edge of the Cavalry Exercise Ground, adjacent to the Flemish Farm boundary fence. Its location can be identified from quite a distance by the nine weeping willow trees (salix babylonica) that stand in all their glory along the length of the pond. It is believed that it acquired its name from the swans that had made it their home and nested there.

The existing Bourne Ditch tributary stream was dammed up to create the pond at least two centuries ago. It is about 35 metres (38 yards) wide at the head and about 60 metres (66 yards) long. It has a history of leaking and it is known that in 1883 the head had major work carried out on it. The sluice stonework bears this date with the name, M K Gray inscribed under it. It has been said that Mr Gray was drowned here when his horse slid into the pond. Unfortunately, I have not been able to substantiate this story. However, it is known that several people had drowned in the pond which was up to 4 metres (13.12 feet) deep in places. Iron railings were erected around the head of the pond in 1883 as a measure to prevent this

happening. During the 1930s, the head of the pond developed a new and very damaging leak and, with the onset of the Second World War, the leak went unchecked, until a large section of the head completely broke away. The pond lost most of its water, and that is how it remained until it was restored as already mentioned.

Right up until the Second World War, the deer would roam freely in this part of the park, sometimes causing chaos as they darted across Sheet Street Road, as happened on Wednesday evening, 25th October 1939. Two Army Cadet Officers were travelling in their car through the park towards Windsor, when they collided with one of the largest stags in the royal herd. Witnesses watched the stag get up on its feet, and proceed to repeatedly charge the car causing much damage and some injuries to the Cadets. The lesson is always to respect stags, especially in the rutting season.

The Windsor Steeplechase Meetings had their origins in the Great Park and Windsor Forest, and were run very much on the basis of wagers between military officers during the 18th-century. The course varied considerably, a popular one being from Old Windsor through the park to a point near the New Lodge at Winkfield. It was not until the 1840s that a permanent racecourse was established on the Bourne Estate at Spital, it being ideally suited for the nearby cavalry barracks. The course was laid out in a circular form and the start and stands were in a position just south of Bolton Road, then known as Bone Lane (sometimes as Bourne Lane because the Bourne Ditch ran through it), and next to St Leonard's Road then known as Spital Street. From the starting point, the course went over Bone Lane up the hill to where the Edward VII Hospital now stands, along the side of Frances Road and down the southern side of Osborne Road, in doing so, using the Bourne Ditch as a natural water jump. It then proceeded along the western side of Kings Road traversing Bone Lane and continuing to a position near Queen Anne's Gate, along the side of the park boundary fence, over the Bourne Ditch and up the slope to St Leonard's Road,

Queen Anne's Gate Lodge (built 1798) showing Sheet Street Road in the foreground going into Windsor. Being such a busy road, the gates became impracticable and were removed many years ago. (photo August 1999 by the Author).

Crown Cottages (built 1850s) standing on the west side of Kings Road near Queen Anne's Gate. Until the 1950s a large oak tree, with a circular seat around it, stood in front of where the park fence butts onto the garden fence. (photo August 1999 by the Author).

then down to the finishing post. Most of the races were of a length that it was necessary to do two laps of the course to make up the distance.

By the 1860s, it had become common to hold two day meetings, attracting large crowds, including a keen following by the nobility. The meetings were further popularised by the unplanned visits by Queen Victoria and other members of the Royal Family. The Queen's favourite spot was at a position near the junction of Kings Road and Bolton Road where she would watch the races from her carriage. Usually the meetings were held on a Monday and Tuesday and, although the meetings had a strong military content, many of the riders being army officers riding their own horses, some civilian riders and owners were starting to compete. The following is an example of a typical race held on the meeting of the 13th and 14th April 1863:

'The Hunters' Stakes, of 25 sovereigns, for horses the property of gentlemen living within 25 miles of Windsor. Race distance 3 miles'.

This particular meeting attracted a large crowd of race followers and with them a large number of pick-pockets. In fact these last had a field day, 'lifting' over fifty pocket

watches during the two day meeting. To add to the misery, many onlookers had their clothes ruined, because someone had treated the boundary fence with a tar-wash the day before. They say that there is one born every minute!

The meetings continued to grow in popularity until Friday 20th March 1874. It was on this day that Lord Rossmore, a very popular officer in the 1st Life Guards, was fatally injured when he was crushed by his horse, 'Crazy Jane', when it fell whilst jumping the hedge next to Bone Lane. Queen Victoria, who was nearby at the time, was so upset by the tragedy that she immediately had the rest of the meeting cancelled. Lord Rossmore survived until the next day in the Combermere Barracks Hospital. No further meetings were held on the course following his death.

Much of the Bourne Estate was developed by Mr T. D. Bolton in the 1890s. Bolton Road, Bolton Avenue and Bolton Crescent are named after him. Bourne Avenue which bears the local name, is where the author was born in 1934.

The Cavalry Exercise Ground has a fascinating history of events that have taken place there - military training, camping and ceremonies, polo matches, agricultural shows, cross-country races and, just over the

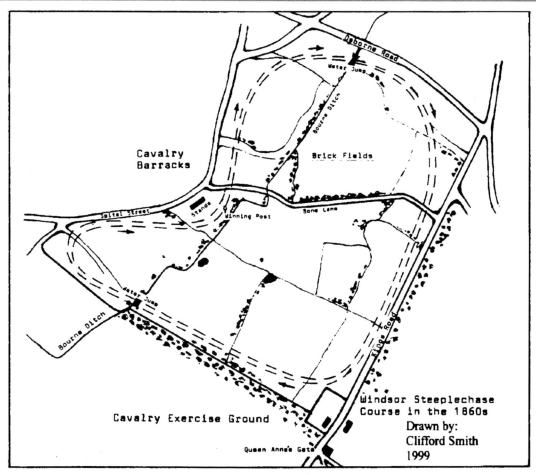

Windsor Steeplechase
Course in the 1860s
Drawn by:
Clifford Smith
1999

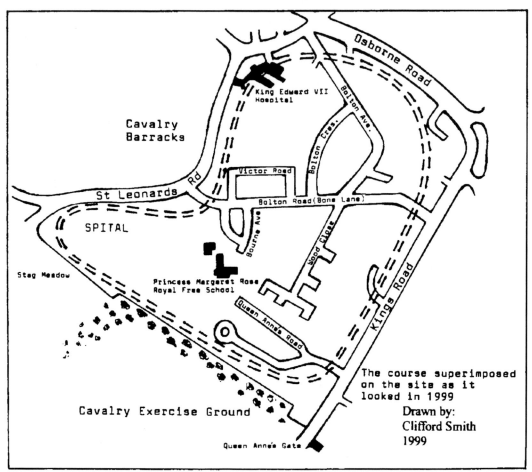

The course superimposed
on the site as it
looked in 1999
Drawn by:
Clifford Smith
1999

northern boundary fence, exciting steeplechase races were held in Victorian times. The details of these occasions are given in chronological order as follows :-

Polo was played here several times in the early years of the game. The first games were casual events until the match held on Tuesday 16th July 1872. It was barely two years after the first game was played in England - a match between the 9th Lancers and the 10th Hussars who had brought the game over from India after a captain in the 10th Hussars had seen it played there. The first games were prone to constant changing of the rules and it was soon decided that, in the best interests of safety, left-handed persons could only play if they used their right hands.

The game in question was played at the northern end of the ground, with the goal-posts lined up in a north to south direction. The game, which was arranged to start at 4 o'clock in the afternoon, was between the Royal Horse Guards and the 9th Lancers, and the spectators were all, but for a few exceptions, members of the Royal Family and the nobility of the country. The following are some of the persons who were there on the day:- The Prince and Princess of Wales, Princess Mary Adelaide, the Duke of Teck, the Earl and Countess Fitzwilliam, the Earl and Countess of Craven, the Earl and Countess of Sandwich, the Duke and Duchess of Manchester, the Countess of Lousdale, Viscountess Folkestone, Earl Spencer, the Earl and Countess of March, the Duchess of Sutherland, Lady Westmoreland, the Marquis of Worcester, the Marquis and Marchioness of Hamilton, the Marquis and Marchioness of Bath, the Marchioness of Hastings, the Marchioness of Westminster and the Duke of Somerset. In addition to the above, there were many titled ladies and gentlemen plus many senior military officers among the several thousand spectators.

A large marquee had been erected towards Queen Anne's Gate for refreshments. From the Marquee there would have been a totally unrestricted view of Stag Meadow because Queen Mary's Plantation and the Windsor and Eton Football Ground did not exist at the time. Closer to the pitch, a large open pavilion with many seats had been provided for the ladies. Each team had six players, the Lancers being recognized by yellow and red caps and the Guards by magenta and blue caps. The game was rather a boisterous affair, marked by the shouting of the players and encouragement from the spectators. The Guards' Band even played some rousing music now and again to encourage their side and to add to the excitement. A small dog ran on to the pitch at one stage to chase the ball, much to the annoyance of the players and horses. A number of polo sticks were broken during the game, and the Marquis of Worcester, who was playing for the Guards, received a deep cut on the head as a result of one of the clashes. The game finished as a 1-1 draw.

For quite a few years after this, polo practice and games continued to be played there, intermixed with pony races which were usually run on a wager basis, twenty pounds appearing to be the normal wager for each rider.

The Royal Agricultural Society of England held an enormous show on the Cavalry Exercise Ground for the first time during eight days from the 22nd to the 29th June 1889. The total number of visitors to the show was 155,671 and, at the time, this was the highest recorded attendance for any agricultural show held in England. The gate takings came to £14,793. The Royal Agricultural Society of England had made this particular show a memorable occasion. It being the 50th year since the foundation of the Society, special visits had been arranged to the Windsor Royal Gardens and a spectacular aquatic show, ending with a firework display, laid on by Eton College on the Thames.

The show proved to be highly successful, both commercially and in the way it was organised. Even the weather remained fine throughout. Just about every conceivable element of agriculture from machinery to livestock was exhibited and demonstrated during the week. In addition, competitions were held on sheep control and shearing, there were prize cattle, country crafts and dairy produce. It is interesting to note that the first prize in the 'shoeing of harness horses' competition was won by Mr Arthur Austin of Windsor. His prize was £10 plus the freedom of the highly respected Farrier's Company.

Queen Victoria and many members of the Royal Family visited the show on most days, with Friday 28th being the largest visit. Aided by the fact that the entrance was one shilling on the day, the lowest of the week, there were 40,000 visitors at the show to make Friday a very special day. The four Royal carriages arrived at the entrance at 11.15 in the morning. In the first carriage were Queen Victoria, The Prince of Wales, Princess Christian of Schleswig-Holstein and Princess Beatrice. In the second carriage, Princess Victoria of Prussia, Prince Henry of Battenburg, the Princess of Leiningen and Princess Victoria of Schleswig-Holstein. The third carriage contained the Dowager Duchess of Roxburghe, the Hon. Harriett Phipps, Lord Henniker and the Hon. A. Yorke. In the fourth carriage were the Royal Household guests. The Royal party was escorted by a detachment of the 1st

Drawing of the main entrance of the Royal Agricultural Society of England Show in 1889. (Royal Agricultural Society of England Collection).

31

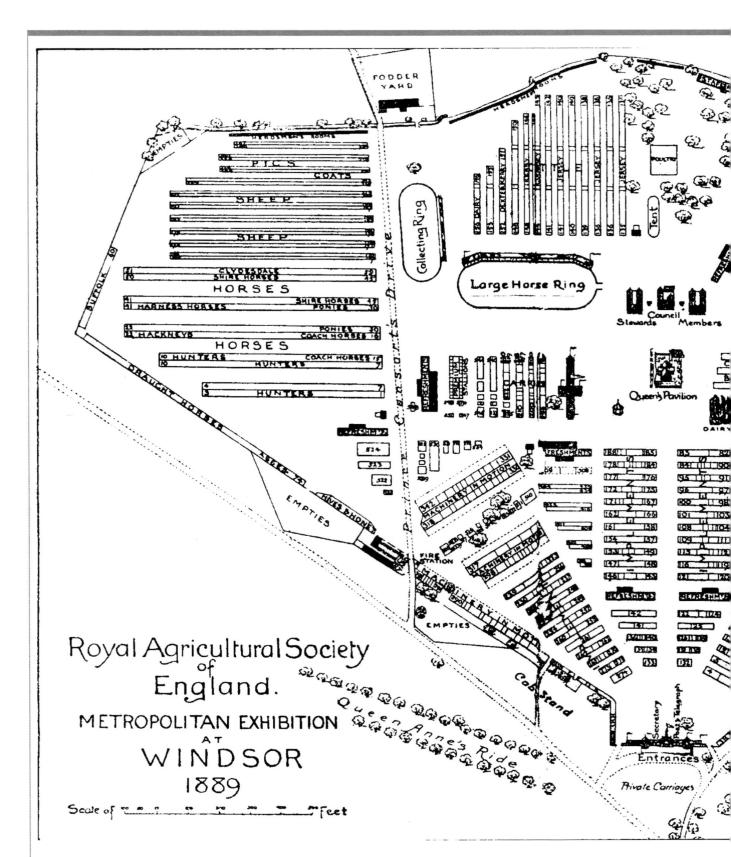

Royal Agricultural Society
of
England.

METROPOLITAN EXHIBITION
AT
WINDSOR
1889

Scale of ⁀⁀⁀⁀⁀⁀⁀⁀⁀⁀⁀⁀⁀⁀Feet

Plan of the Royal Agricultural Society of England Show in 1889. The layout is accurately detailed by Wilson Bennison, Surveyor, when he drew the plan in May 1889. The plan is shown looking west from the entrance near Queen Anne's Gate. Prince Consort's Drive is clearly shown leading into Flemish Farm where a Fodder Yard is situated. You will notice that the show ground went right up to the Bourne Ditch Stream, being thirty-five years before Queen Mary's Plantation was planted. A second Fodder Yard is actually situated in Stag Meadow. (Royal Agricultural Society of England Collection).

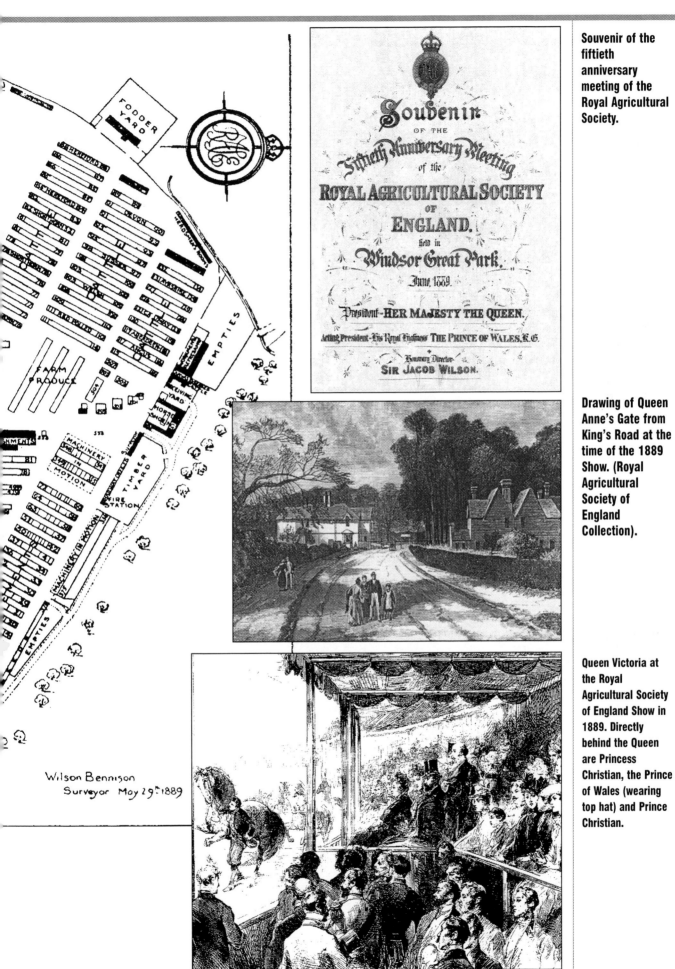

Wilson Bennison
Surveyor May 29th 1889

Souvenir
OF THE
Fiftieth Anniversary Meeting
of the
ROYAL AGRICULTURAL SOCIETY
OF
ENGLAND,
held in
Windsor Great Park.
June, 1889.

President–HER MAJESTY THE QUEEN.

Acting President–His Royal Highness THE PRINCE OF WALES, K.G.

Honorary Director–
SIR JACOB WILSON.

Souvenir of the fiftieth anniversary meeting of the Royal Agricultural Society.

Drawing of Queen Anne's Gate from King's Road at the time of the 1889 Show. (Royal Agricultural Society of England Collection).

Queen Victoria at the Royal Agricultural Society of England Show in 1889. Directly behind the Queen are Princess Christian, the Prince of Wales (wearing top hat) and Prince Christian.

A bird's eye view of the Royal Agricultural Society of England Show in 1889. (Royal Agricultural Society of England Collection).

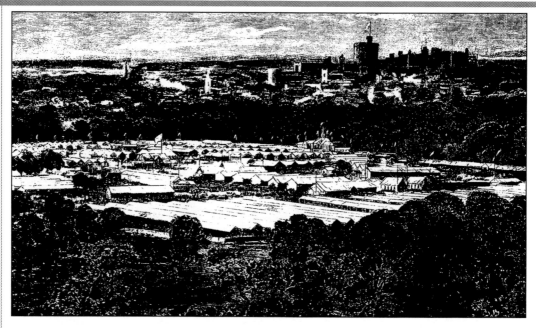

The Queen's Pavilion at the Royal Agricultural Society of England Show in 1889. (Royal Agricultural Society of England Collection).

The Queen's Pavilion after it had been re-erected at Osborne House on the Isle of Wight. The picture shows that chimney stacks had been added to make it a residential cottage known as 'Ladywood Cottage'. Regrettably it was demolished in 1912 to expand the Golf Course. (Osborne House Collection).

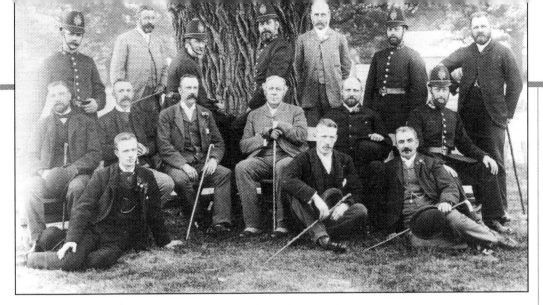

A group of Officials and Policemen at the Royal Agricultural Society of England Show held on the Cavalry Exercise Ground in June 1889. The persons in the photograph are from left to right;
-Back row (standing):- All unknown
Middle row (seated);- Sir J.H. Thorold, Mr Percy Edward Crutchley, Mr Ernest Clarke (Show Secretary), Sir Jacob Wilson (Honourable Director of the Show). Last person and policeman unknown.
Front Row (sitting on the ground):- Mr Alfred Ashworth, last person on the right holding bowler hat. Other two persons unknown.
(Royal Agricultural Society of England collection photograph).

Notes:-
1. Mr Percy Edward Crutchley was a son of the Crutchley family that owned and lived at Sunninghill Park.
2. The oak tree that the group are standing in front of was cut down in the 1960s. The base of the tree can be found about 80 metres (87.5 yards) on the north of, and from the start of the Cycle Track near Queen Anne's Gate. The tree was a favourite nesting place for a pair of tree creepers (Certhia familiaris) before it was cut down.

Life Guards. The Queen, who was wearing her badge as President of the Society, made her way to the Grandstand where she saw the prize cattle being paraded. From there she went on to see the sheep and goat pens, then moving on to the Sutton & Sons of Reading stand, who had a magnificent display of flowers. They then made their way to The Queen's Pavilion, which had been designed and constructed for the Queen's personal use at the show. During the show, the Pavilion was presented to the Queen by the builder, Mr J. Charlton Humphreys from London. After the show it was disassembled and reassembled at the Queen's residence at Osborne on the Isle of Wight. The Royal party left the show at about 1 o'clock in the afternoon to return to Windsor Castle.

The show, being a major agricultural event in England, attracted many orders for the businesses involved. The caterers and local shops also did very well, with one Windsor fishmonger alone supplying over one ton of salmon to one of the caterers at the show.

On the debit side, several pickpockets were caught and promptly sent to gaol. Furthermore, several vehicles broke down and one was in such a bad state, that its bottom fell out and its passengers with it.

Army Camps were set up on numerous occasions on the Cavalry Exercise Ground during the late 1800s and early 1900s. The Camps were the operating bases for military manoeuvres which took place all through the park, including Chobham Common and Swinley Park.

The combination of woods, ponds, hills and open fields was ideally suited for training. The rifle ranges used by the Windsor Great Park Rifle Volunteers at the southern end of Queen Anne's Ride were fully employed for target practice.

During the summer of 1912, over 2,000 men and 1,200 horses from the Household Cavalry, the 2nd Dragoons, Royal Horse Artillery and the Signalling troops were camped on the ground. In addition, the Cyclist Corps stayed for one day before continuing to another camp. It was evident that all of this military activity was in preparation for the day when the storm clouds of war, which were gathering all over Europe, would finally open up, as they did in the summer of 1914, leading to the carnage that would occur during the First World War.

In 1914, military camps were set up in the park at Smith's Lawn, Bear's Rails and on the Cavalry Exercise Ground, the last-mentioned being the largest. By 1916, all of the camps except the ones used by the Canadian Forestry Corps on Smith's Lawn and their satellite camps had gone. Many of the soldiers left the camps never to return to their country.

On Saturday 14th October 1916, the Cavalry Exercise Ground was the scene of a quite extraordinary event. A giant tea party was held as a measure of thanks, and to cheer up 6,600 wounded allied soldiers from all over the world. The soldiers had received invitations to the party whilst they were being treated at hospitals in

Copy of a hand written letter by Queen Victoria on 2nd July 1889 thanking the Council of the Royal Agricultural Society of England for their work in organising the Show. (Royal Agricultural Society of England Collection)

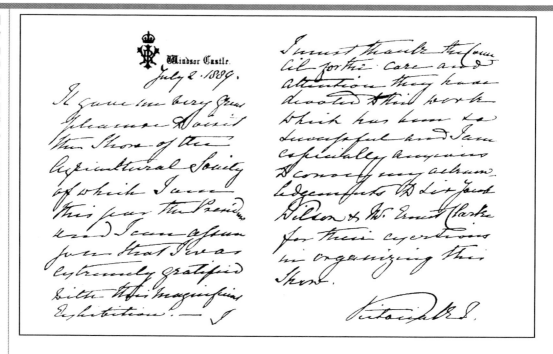

Windsor Castle July 2 1889

It gave me very great pleasure to visit the Show of the Agricultural Society of which I am this year the President and I can assure you that I was extremely gratified with this magnificent Exhibition.

I must thank the Council for the care and attention the have devoted to this work which has been so successful and I am especially anxious to convey my acknowledgements to Sir Jacob Wilson & Mr Ernest Clarke for their exertions in organising this Show.

Victoria Rex.

A copy of an advertisement used at the time of the 1889 Royal Agricultural Society of England which makes full use of the fact that the Royal Farms in Windsor Park are insured with the Company. (Royal Agricultural Society of England Collection).

'ROYAL FARMERS'

AND GENERAL
FIRE, LIFE, & HAIL INSURANCE INSTITUTION.

Empowered by special Act of Parliament.—Capital, £500,000.

OFFICES, STRAND, LONDON.

The Royal Farms in Windsor Park are insured in this Office.

ROYAL AGRICULTURAL SOCIETY OF ENGLAND.—At a Meeting of the Council, held the 6th day of April, 1842, it was, on the motion of the Duke of Richmond, seconded by Colonel Challoner, resolved unanimously :—" That the Society's house and property in Hanover square should be insured in the 'Royal Farmers' Fire and Life Insurance Institution.'"

DIRECTORS.

Chairman—JOSEPH ROGERSON, Esq.
Managing Director—W. SHAW, Esq.

J. BLACKSTONE, Esq.	R. M. JAQUES, Esq.
S. BOYDELL, Esq.	WM SMEDDLE, Esq.
WM. CLUTTON, Esq.	G. P. TUXFORD, Esq.
J. R. COOPER, Esq	J. WORKMAN, Esq.
JOHN HUDSON, Esq.	W. YOUATT, Esq.

Medical Officers—J. BLACKSTONE, Esq. and G. W. BLANCH, Esq.
Standing Counsel—C. W. JOHNSTON, Esq. and W. SHAW, Esq.
Joint Solicitors—JOHN ROGERSON, Esq and C. W. BOYDELL, Esq.
Assistant Manager—W. JENKINSON, Esq.
Secretary—J. HANSON, Esq.
Bankers—The London and Westminster Bank.

The Proprietary of this Company exceeds 1,960 in number, of whom 195 are County Directors.

The share of public favour this Institution has obtained, proves the appreciation of its system by a numerous body of Insurers.

Every kind of **Life** INSURANCE, of Deferred and Immediate Annuities, and of Endowments for Children, may be accomplished on terms as low as is consistent with security.

A Dividend of Four per cent. is now in course of payment to the Shareholders in this office.

In the **Fire** department, INSURANCES effected at the lowest rates.

Hail INSURANCE.—Premium, Sixpence per acre for Wheat, Barley, Turnips, and Peas ; Fourpence per acre for Oats, Beans, and Potatoes. Glass in Hothouses, Greenhouses, or Private Houses, 20s. per cent.

Prospectuses may be obtained at the Office, or will be forwarded, post free, upon application. The usual commission to Solicitors.

Agents are appointed in the principal Towns in the kingdom.

W. SHAW, Managing Director.

London and the home counties. The weather stayed fine throughout the day, although the wind increased causing some concern over the stability of the two huge marquees. Each marquee seated 1,000 soldiers at a time.

Meat: 1,250lbs.
London Chamber of Commerce.
Flour for loaves: 4 tons
London Corn & Flour Association.
Sugar: 6 cwt.
Mr A. Tate.
Cake (currant & plum): 2,000lbs.
Mr Gordon Selfridge.
Tea: 150lbs.
Mr Joseph Lyons.

The smell of the food for the soldiers waiting their turn in the chill wind outside must have been hard to endure. The following is a list of the main food and drink consumed that day which was supplied free by the concerns listed:—

In addition to the food and drink, 18,000 cigarettes were smoked.

During the afternoon, several members of the Royal Household visited the the party, amongst them Princess Christian, the Duchess of Albany, Princess Alexander of Teck and her daughter, Princess May of Teck. The afternoon was further livened up when the band of the 2nd Life Guards played a medley of some well known tunes. Although the tea party had been laid on solely for the benefit of the wounded soldiers, a large number of people had lined the side of the park road to watch the event and to listen to the music.

The Royal Agricultural Society of England held their Centenary Show on the Cavalry Exercise Ground between the 4th and the 8th July 1939. Although the weather was showery throughout the week, the show was a huge success. With an average number of 23,666 visitors each day, attendance far exceeded any previous show.

My most lasting memories of the show, were not of the stands and events to be seen when the show was opened, but of all the banging and sawing that went on during the preceding months while it was being erected. I have often wondered just how much timber and how many nails were used during those months. One benefit my family did have by living on the other side of the park fence, is that we had free access to the ground. We were much more fortunate than the visitors coming by car. The traffic jams on all roads leading to the show were horrendous. Many cars overheated and ground to a halt well before they reached the showground.

The show covered a large area, taking up part of Flemish Farm to accommodate the horses. In the middle was the arena for staging the numerous competitions and displays. Certainly some of the finest specimens of livestock from all over Britain were to be seen there, the

Royal Farms being much in evidence and taking several of the major prizes. Sheep from the Sandringham Royal Estate took first prize, with several second and third placings achieved by livestock from the other Royal Farms. The Royal Family attended the show on most days, starting on Wednesday with King George VI and the Queen, who stayed there for five hours before returning in their open carriage to Windsor Castle. On Thursday it was the turn of Queen Mary and the Duke and Duchess of Gloucester to be amongst the visitors staying for several hours. Friday, saw the return of the King and Queen who arrived in the early afternoon, spending much of their time in the Royal Pavilion as the weather was going through a heavy showery period.

From a trading point of view, many purchases were made during the five days of the show, with the chief interest being in horses and cattle. It is interesting to note that a group of Russian Farmers who had come over for the show, paid £15,000 for 200 head of cattle, mainly Herefords, dairy Shorthorns and beef Shorthorns. This was a considerable amount to pay in those days, so they must have been impressed with what they saw.

At that very early age, I did find it hard to understand why some of the display stands had anything to do with agriculture. Even my older brothers could not give me a logical answer as to why the local schools had stands at the show, the park's Royal School being one of the exhibitors. For me, it was sad to see the excitement of the show come to an end. Barely had the equipment and stands been cleared away, when it was announced that we were at war with Germany. That short-lived wonderment was replaced with bewilderment. The details of how the Cavalry Exercise Ground had its part to play during the Second World War are described in Chapter 18.

The Royal Agricultural Society of England held their 106th show on the Cavalry Exercise Ground on the 6th to the 9th July 1954. This was by far the largest show to date, covering an area of 61 hectares (151 acres). With the car park included, it was 121.4 hectares (300 acres). It covered most of the Cavalry Exercise Ground and extended well into Flemish Farm and Stag Meadow. It attracted visitors from all over the world and, by the time it closed, over 150,000 people had passed through the turnstiles. In addition, there were a further 25,000 ticket holders, stand attendants and assistants at the show.

The cost of preparing this one show was £150,000 which was nothing compared to the total value of the equipment and livestock estimated to run into millions of pounds. There was 4000 head of livestock being exhibited at the show and some of these were worth several thousand pounds each. The actual work on the show had started in September the previous year, and the amount of work was enormous, involving the digging and boring of 22,000 holes in the ground, nine

A drawing of Queen Victoria that appeared in one of the many guides for the Royal Agricultural Society of England Show in 1889. The portrait is an excellent likeness. (Royal Agricultural Society of England Collection).

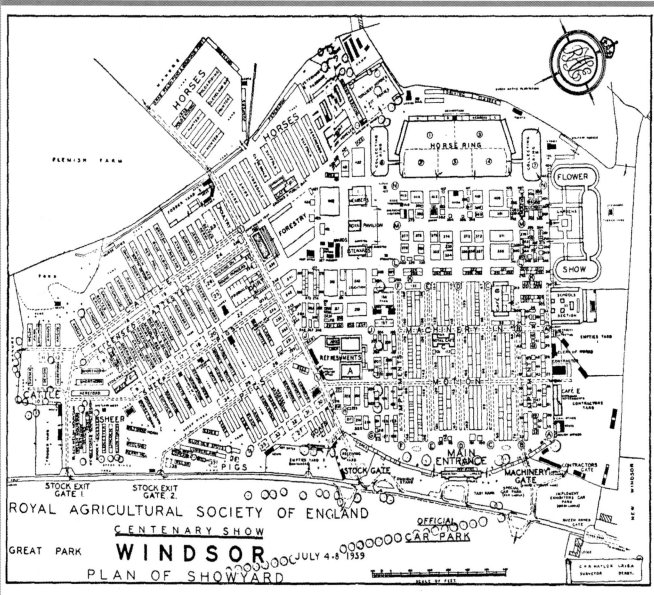

ROYAL AGRICULTURAL SOCIETY OF ENGLAND
CENTENARY SHOW
GREAT PARK **WINDSOR** JULY 4-8 1939
PLAN OF SHOWYARD

Plan of the Royal Agricultural Society of England Show in 1939 (Royal Agricultural Society of England Collection).

King George VI and the Queen (now the Queen Mother) driving round the ring at the Show on Wednesday 5th July 1939. (Author's Collection).

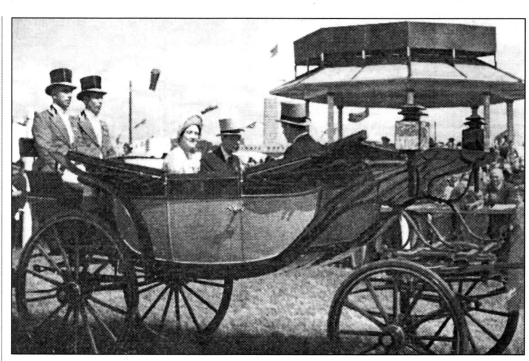

An Aerofilms photograph taken on 26th June 1939 showing the layout of the Royal Agricultural Society of England Show which was held on the Cavalry Exercise Ground from 4th to 8th July 1939. The photograph was taken over Stag Meadow looking in a south-eastern direction. The black curved formation in the foreground is Queen Mary's Plantation and the fir trees were the main feature at the time. Beyond the Show Ground, Sheet Street Road and Queen Anne's Ride are clearly seen. It is interesting to note the extent of the tree replanting work along The Long Walk by 1939. The top left- hand corner of the picture clearly shows that the felling of the old elm trees had reached the southern end of the Review Ground.

miles of water pipes to be connected, eight miles of electric cables and over 100 telephone lines installed. Even as the show was being opened on the Tuesday, last minute panic work was going on. Aside from the enormity of the task of staging such an event, one of the main problems was overnight accommodation. The town of Windsor has never had an abundance of hotels and 'bed and breakfast' houses. However, this was not a problem for Mr. J.W. Riggall, Clerk of Works for the Society, because his bungalow and office moved with him from show to show. He had done this for the previous seventeen years.

The hot weather during the show was good for the people, but not so good for some of the livestock held in confined spaces. The main entrance to the ground was in the usual position near Queen Anne's Gate and the rest of the layout was very much on the lines of previous shows. For the Queen, who was the president of the Society, it must of been a very nostalgic occasion as she had attended the 1939 show when she was only thirteen years old. She was now more directly involved as president of the Society and visited the show on several occasions. Even for people not involved with agriculture, it was a show well worth seeing. There were some of the finest horses, cattle, sheep, goats and pigs on display and being judged for the top prizes. In the Grand Ring, with its covered 5,000 seat stand, some of the best riders in the world could be seen competing in the horse-jumping events. There were also sheepdog demonstrations and parades for the prize-winning livestock. Furthermore. there were demonstrations in modern farming techniques, woodcraft, horse-shoeing and other country crafts. For the garden lover, vegetable grower and beekeeper, there was an enormous marquee staging the various shows. It was also a time to question some of the judges' decisions! . There was one thing I will never forget about this show. It was watching a high

class fashion show, with the models dressed in garments made from wool, being held right next to the sheep pens. The atmosphere of the show was enhanced even further by some excellent playing by the bands of the Grenadier Guards and the Scots Guards.

The cost of staging the shows every year and in different places proved to be prohibitive, and the Royal Agricultural Society of England now has a permanent site at Stoneleigh Park, Warwickshire.

The northern area of the park, in particular, has been the scene of a large number of military and civil cross-country races. The Cavalry Exercise Ground has been the most popular course, for the obvious reasons that it has easy access from Windsor and is ideally suited for cross-country running. Cross-country races and training have been carried out here for several hundred years. Certainly I owe my own athletic achievements to the training that I did on this ground.

The Inter-Counties Cross-Country Championship held on Saturday 23rd March 1968 on the ground was the most important and largest race ever held in the park. It attracted the top athletes and large crowds of spectators from all over England and Wales. The race was the 36th Championship and sponsored by The Daily Telegraph, the national newspaper which had done an enormous amount to promote athletics in Britain. The weather was a typical March day, overcast with a chill wind that would cut across the nostrils of the runners. Most of the course was muddy and very heavy going, requiring extreme physical and mental strength to contend with the seven-and-a-half miles distance of the race.

The changing and parking facilities were organised in the nearby Combermere Barracks and the start and finish of the three lap course was near Queen Anne's Gate. At 2.30 p.m. precisely, the race was started by Alderman J. Deacon, Mayor of Windsor. It was like a

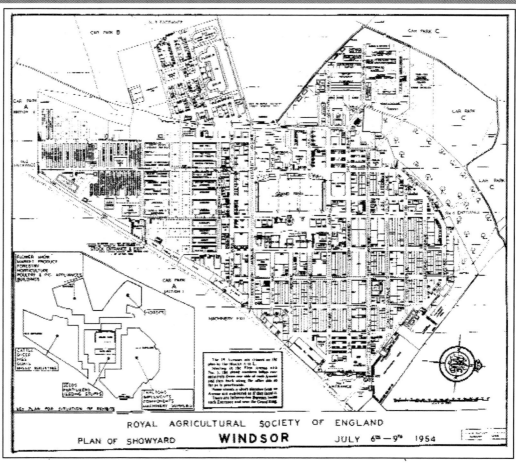

ROYAL AGRICULTURAL SOCIETY OF ENGLAND
PLAN OF SHOWYARD WINDSOR JULY 6ᵗʰ – 9ᵗʰ 1954

Plan of the Royal Agricultural Society of England Show in 1954. The extent of the area covered was larger than any previous show. It was without doubt the largest event, of any kind, to be held in The Great Park and Forest, covering the whole of the Cavalry Exercise Ground, a large area of Flemish Farm and Stag Meadow. The coach and car park covered an enormous area in Flemish Farm, Stag Meadow and the eastern side of Sheet Street Road. The mind boggles when one thinks about the arrangements necessary to stage such a show. Looking across the area today, it is difficult to imagine that the event ever took place. (Royal Agricultural Society of England Collection).

cavalry charge without horses. First and foremost for each competitor was how well they could do as an individual; however this event was more than that, because at the back of everyone's minds was the thought that they must not let their county down. Consequently many of the runners would have pushed themselves to the limit. There were 38 counties competing and, after the first lap, Lancashire were in the lead closely followed by Surrey and Northumberland & Durham. Several of the country's leading athletes were fighting for the first place.

By the time the leaders had started the third lap, the rest of the runners were spread out around the whole course. As the leaders came round the miniature rifle range, Ron Hill (Lancashire) was in the lead followed by Mike Tagg (Norfolk) and Jim Alder (Northumberland & Durham). This is how they stayed, with Ron Hill finishing in 40 mins. 40 secs. Mike Tagg 4 secs. behind and Jim Alder a further 4 secs. behind. The teams were:- Lancashire 1st, Surrey 2nd and Northumberland & Durham 3rd. Berkshire came 13th with their best individual being A.T Ashton who came 24th. What is most extraordinary is that Ron Hill very nearly did not make the race. Arriving late in his train, he had to change in the guard's van and run all the way through Windsor to the park, arriving a few minutes before the start. He had also misplaced his running shoes and ran the whole race in his bare feet, demonstrating unique determination aside from his outstanding prowess as an athlete. Some

lesser mortals would have stayed put in the guard's van.

The awards were made by Mr Harold Fish, publicity director of The Daily Telegraph following a sit down tea in the Combermere Barracks Dining Hall.

The Presentation of a new Guidon (Standard) by Queen Elizabeth II was held on the Cavalry Exercise Ground on Friday afternoon 14th July 1972. This military and very colourful ceremony was carried out just south of Prince Consort's Drive on a beautiful summer's day. The occasion was very memorable for the military personnel because it saw the amalgamation of two famous British Army regiments, the Royal Horse Guards (the Blues) and the 1st Royal Dragoon Guards under the title of The Blues and Royals. The ceremony included the formal introduction of the new Guidon replacing the Standard of the Royal Horse Guards and the Guidon of 1st Royal Dragoon Guards.

Although the event was not well publicised, several thousand spectators had gathered to see the spectacle. The first of the military to arrive was the armoured detachments consisting of Saracen vehicles and Scout cars. The mounted Guards led by their band, made their way down Queen Anne's Ride, across Sheet Street Road coming onto the ground from the south. It was a sight of brilliant military splendour, their scarlet plumed helmets and curaisses glistening in the sun as they took up their positions next to the vehicles.

The royal salute heralded the arrival of the Queen from Windsor Castle. In the car with the Queen was Prince Philip wearing the uniform of Colonel of the

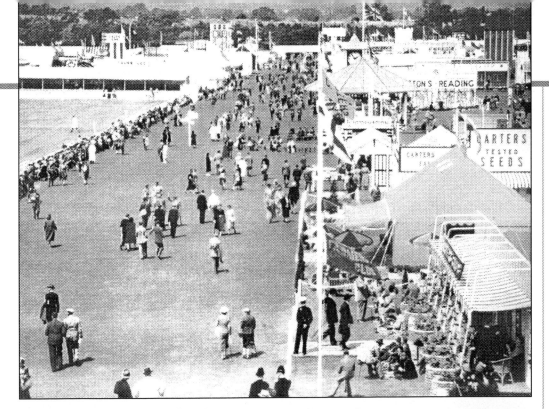

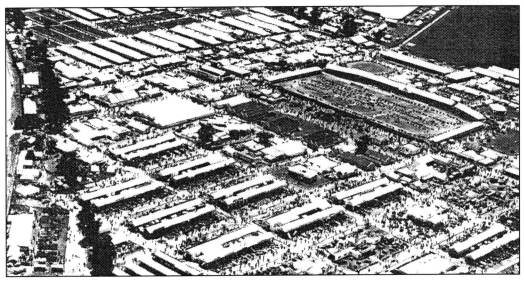

Welsh Guards. At the dais, the Queen and the Prince were received by the Colonel of the Blues and Royals, Field Marshal Sir Gerald Templar. The inspection of the parade was carried out by the Queen in an Ascot landau drawn by Windsor greys. When the inspection was completed, the old Standard and Guidon was impressively trooped before being taken from the parade ground. The new Guidon was ceremoniously placed on piled drums in front of the dais. This was followed by a Service of Consecration performed by four army Chaplains from the Royal Army Chaplains' Department. After the Queen had presented the Guidon, she addressed the parade, referring to the great traditions of both the Blues and Dragoons over 300 years of history and wishing them well as the amalgamated Regiment of the Blues and Royals. Lieutenant-Colonel J.A.C.G. Eyre commanding the parade replied. The Queen then took the salute as first the mounted squadron and then the armoured detachments passed the dais. After the salute, the Queen went across to the old comrades of both regiments and had a word with every man, including a Chelsea pensioner who was an old Dragoon.

The Queen and Prince Philip in the open landau then drove back to Windsor Castle accompanied by the Regiment followed by the armoured cars. The procession went across the park to the Double Gates and along The Long Walk, which was packed with cheering people right up to the castle.

The finale to the day's military spectacle, was the Blues and Royals exercising their right as Freemen of Windsor by parading through the streets of the town with their bands playing and colours flying.

A 'Rent Strike Peoples Festival', or Windsor Free Festival as it became more generally known, first took place on the Cavalry Exercise Ground on Saturday 26th August 1972. The original intention of the organisers was to hold it on Smith's Lawn. However, after an entrenched impasse between the organisers and The Crown Estate Commissioners, it was held on the

Runners lined up at Queen Anne's Gate at the start of the Senior Race of the Inter Counties Cross-Country Championships held on Saturday 23rd March 1968. (photo by the Author).

Plan of the Inter Counties Cross-Country Championships Course 1968. (UK Counties Athletic Union Collection).

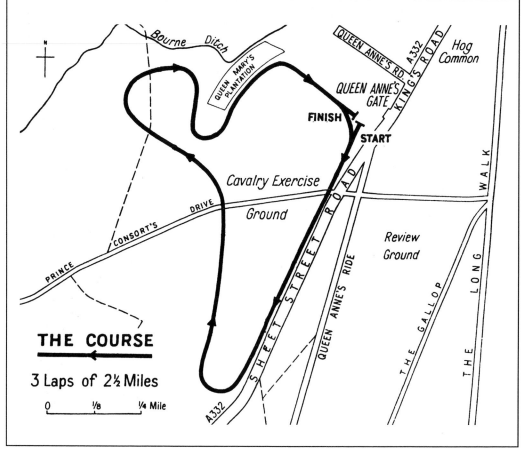

THE COURSE

3 Laps of 2½ Miles

Cavalry Exercise Ground without any permission being given. During this and the next two years, the park and the town of Windsor was to experience some remarkable events never before encountered in the area.

The 1972 Festival started as a relatively quiet affair with just a few thousand attending as opposed to the expected one million projected by the organisers. In reality, the occasion was a non-event with a few guitars being strummed here and there. People came and went with the last persons departing a few weeks later.

The 1973 event was a different matter entirely with people arriving weeks before the planned date. Over the next few weeks the figures progressively increased to almost double the previous year. Many of the attendees did not appear to even have the energy or inclination to pitch their tents. It would be wrong to place everyone in the same category and many took one look before turning round when they

realised that it was not what they had expected.

The unfortunate events that developed during the weeks of the festival, such as theft of milk from people's doorsteps, shoplifting and so on, had their effects on the trade of the shopkeepers and resulted in a hardening of the attitudes of the residents of Windsor to the festival-goers. There was a general sigh of relief when the visitors departed and, as a measure to prevent the festival taking place the following year, a steel single bar barrier was erected along the entire length of the Cavalry Exercise Ground, about 50 metres (55 yards) in from Sheet Street Road.

Come the summer of 1974, it soon became evident that the barrier on its own was not going to be enough to prevent the festival going ahead. The mass of people determined to attend the event virtually forced their way onto the ground. From here on it became a free-for-all for many of the people as park trees and fences were hacked down to

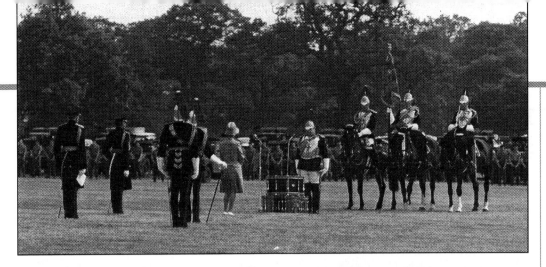

The Presentation of the new Guidon to The Blues and Royals by Queen Elizabeth II on the Cavalry Exercise Ground on Friday 14th July 1972. (Household Cavalry Museum Collection).

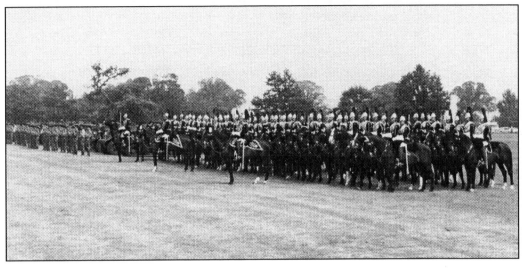

The military parade during the Presentation of the new Guidon by Queen Elizabeth II on the Cavalry Exercise Ground on Friday 14th July 1972. (Household Cavalry Museum Collection).

make fires, some individuals openly urinated in the doorways in King's Road and along the side of Sheet Street Road, sanitation and hygiene on the site being virtually non-existant. For many residents of the park and Windsor the situation had become intolerable. Sleepless nights created by the sound of generators and loud music going on into the early hours of the morning and the worry of what could be going on in their gardens whilst they were trying to sleep resulted in the whole community saying that they could take no more. Many very emotional public meetings were held in the Windsor Guildhall, with the general demand that the festivals had to stop. Local newspapers were inundated with readers letters in protest, and the whole saga had become an issue for the Government.

On Thursday 29th August 1974 at 8.00 in the morning, 600 members of the Police Force moved onto the site, arresting over 300 people and holding them under the Public Order Act. Many of the people quietly left the site when requested to do so, however, a very large number flatly refused and as the morning wore on, pitched battles took place before the site was finally cleared. That was not the end of it, of course. The 'Hippies', as they had generally become known, moved in mass to the streets near the castle, ensuing battles taking place well into the evening. The local hospitals had an extremely busy time attending to the injuries, some of which involved fractured bones. Such was the violence

that over one hundred policemen had their uniforms torn and covered with paint. The bitter taste of these quite unbelievable events was to stay in the mouths of many people for a long time. However, in spite of all of this, the organisers persisted and The Crown Estate Commissioners reluctantly suggested that Manor Farm at Old Windsor could possibly be used for the 1975 festival. The public uproar at the prospect of this, or any other local site being used was enormous and local residents were vehement that there were to be no more festivals. No more were held.

Cycle Route. This safe route for cyclists was constructed during 1998 to remove the risks that cyclists had experienced for many years travelling on the busy Sheet Street Road. The route is part of the National Cycle Network, a Millennium Commission project supported by £43.5 million of National Lottery funds. The Cycle Route starts at Queen Anne's Gate and meets up with a route from Spital Gate at the north-eastern corner of Queen Mary's Plantation. From here the route heads south past Swan Pond to the southern end of the Cavalry Exercise Ground. It then continues along the western side of Sheet Street Road to Ranger's Gate. At this point a traffic controlled crossing takes the route over the road, then along the existing roads before coming out at Bishops Gate.

The Cycle Route was formally opened on Thursday 22nd October 1998 at eleven o'clock in the morning by Mr. Philip Everett, Deputy Ranger.

The site of Swan Pond as it was immediately after the 1974 festival. Due to the fact that no toilet facilities had been laid on by the festival organisers, people simply responded to the call of nature wherever they could. For months after the festival, an indescribable stench hung over the whole area. The photograph also shows how Swan Pond was completely filled in and was devoid of all water. (photo by the Author).

Cavalry Exercise Ground from Queen Anne's Gate showing the new cycle track which was opened on Thursday 22nd October 1998. In the background is Queen Mary's Plantation. (photo by the Author).

Model aircraft enthusiasts on the Windsor Park Flying Association ground in the middle of the Cavalry Exercise Ground – August 1998. (photo by the Author).

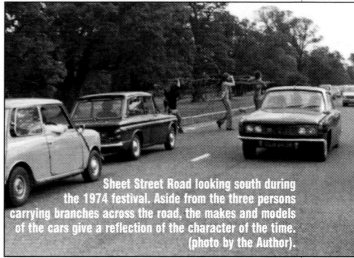

Sheet Street Road looking south during the 1974 festival. Aside from the three persons carrying branches across the road, the makes and models of the cars give a reflection of the character of the time. (photo by the Author).

Review Ground

Review Ground

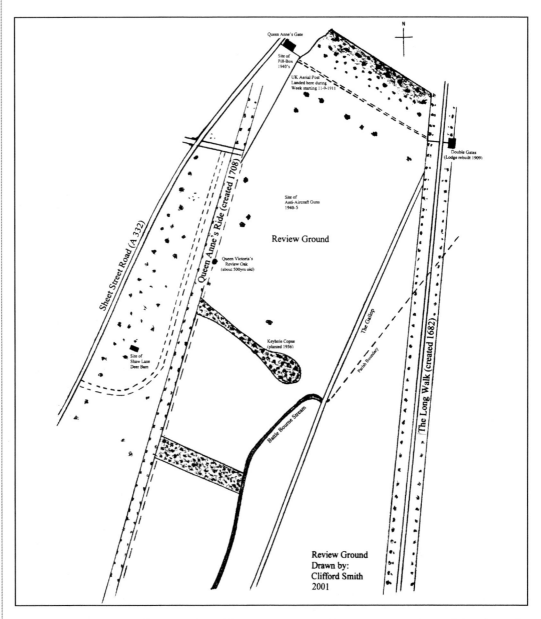

Queen Anne's Gate

Site of
Pill-Box
1940's

UK Aerial Post
Landed here during
Week starting 11-9-1911

N

Double Gates
(Lodge rebuilt 1909)

Site of
Anti-Aircraft Guns
1940-5

Review Ground

Queen Victoria's
Review Oak
(about 500yrs old)

Sheet Street Road (A 332)

Queen Anne's Ride (created 1708)

Keyhole Copse
(planted 1956)

The Gallop

The Long Walk (created 1682)

Parish Boundary

Site of
Shaw Lane
Deer Barn

Battle Bourne Stream

**Review Ground
Drawn by:
Clifford Smith
2001**

The Review Ground is an area of land at the northern boundary of the park, lying between Queen Anne's Ride and The Long Walk. It covers an area of approximately forty hectares (98.94 acres). It has sometimes been described as a level piece of ground, a description which can be very misleading as, in fact, it slopes down quite significantly from Queen Anne's Ride towards The Long Walk. There are also several undulating areas which are more pronounced in extreme wet or dry conditions due to the amount of clay in the area.

This part of the park was known as Fussey Meadow until the Royal Review in honour of the Emperor of Russia was held on it in 1844. Subsequently, it was more generally know as the Russian Field until the review of the Emperor and Empress of France was held there in 1855. From that time on, it was, and still is, known as the Review Ground. Although the meadow has been the scene of many types of event other than reviews, it is the number and size of the reviews that makes this large field a truly remarkable and important part of the history of The Great Park. Today, as you pause for a moment at Queen Victoria's Review Oak,

which stands in the Review Ground close to Queen Anne's Ride, it can be very difficult to imagine that such events ever took place there.

The Review Ground is ideally located for military activities, particularly when you take into account its close proximity to Windsor Castle and the garrison permanently stationed there and in the nearby barracks. It is therefore highly probable that military events took place there well before 1818 which were not formally recorded. The Review which took place on Thursday 2nd July 1818 was to set the scene for later reviews spanning a period of over one hundred years, involving a total number of participants well in excess of 210,000 with hundreds of thousands of spectators. That first Review involved the 1st Battalion of Grenadier Guards and was reviewed by their Commander-in-Chief, the Duke of York, who was then Prince Frederick, the second son of King George III. The number of participants and spectators on that day does not appear to have been recorded.

The second Royal Review was held on Monday 22nd July 1822, starting at 9 o'clock in the morning and ending early in the afternoon. The Duke of York (Prince Frederick) was accompanied by the Duke of Wellington (Arthur Wellesley), and both were riding their favourite chargers. The troops involved were the 1st and 2nd Coldstream Guards who, throughout the morning, performed many exercises with military precision before the final march-past by the Review Oak. After three and a half hours performance, the troops must have surely been relieved when the two Dukes finally rode back to Windsor Castle.

The third Review took place on Monday 27th June 1831, when the 2nd Regiment of Life Guards was reviewed by the Duke of Brunswick in the company of Lord Fitzclarence and Sir Andrew Barnard, together with the Royal Court from Windsor Castle. Glittering in the sun were the magnificent silver kettledrums, which had just been presented to the regiment, and were being used for the first time.

The subsequent reviews grew in size and splendour as the years went by, until the time of the First World War when they underwent a dramatic decline, finally ending with the Review of the Life Guards by King Edward VIII on 7th July 1936. After this date, military reviews and ceremonial occasions were held on the Cavalry Exercise Ground .

The following pages give a detailed account of the Reviews and Military Displays that have taken place on the Review Ground.

Queen Victoria's Review Oak as seen looking from the east. The photograph was taken one hundred years ago in 1900. The large tree on the right, standing in Queen Anne's Ride, no longer exists.

Queen Victoria's Review Oak one hundred years later in March 2000. Very little has changed, with the stub of a broken branch lower down appearing to be the only damage. (Photo by the Author).

*Review of Troops in honour of the Emperor (Tsar Nicholas I)
of Russia by Queen Victoria:*

This took place on Wednesday 5th June 1844 at 11.30 in the morning, involving an assembly of approximately 5,000 troops and an estimated 10,000 spectators.

The military on parade consisted of the 47th regiment, the second battalion of Grenadier Guards, the second battalion of Coldstream Guards, and the second battalion of Scotch Fusilier Guards, which were formed up in a double line. At one end of the line were formed the cavalry consisting of two troops of the Royal Horse Guards, the 1st Regiment of Life Guards, and the 17th Lancers. At the other end of the line were formed the Royal Horse Artillery and a battery of Field Artillery.

In the first carriage from Windsor Castle were Queen Victoria, Prince Albert, the Emperor of Russia, the Duke of Cambridge, and the Duke of Wellington. In the second carriage were the Prince of Wales, Princess Alice and two attendants. The third carriage contained the Countess of Gainsborough, Lady Caroline Cocks, Hon. Miss Devereux, and the Hon. Mrs. Anson. In the fourth, were the baroness Ahlefeldt, the Countess Cowper, the Countess of Rosslyn, and the Earl Delawarr. The fifth carriage brought the countess of Wilton, the Viscountess Canning, the Earl of Aberdeen, and M. de Minckwitz. In the sixth, were the Earl of Cowper, Viscount Canning, Count A. Vitzthum and Dr. Carus. The seventh carried Admiral Sir Robert Otway. All the carriages had a military escort on horseback dressed in full ceremonial splendour. The military escort included the King of Saxony, Count Orloff, General d'Adlerberg, M.d'Adlerberg, Prince Wassiltchikoff, Prince Radzivill, Baron Geradorff, Baron de Reichard, the Earl of Jersey, the Earl of Wilton, the Earl of Hardwicke, Colonel Dyneley, Lord Charles Wellesley, Colonel Arbuthnot, Major General Wemyss, Major General Sir Edward Bowater, Colonel Wilde, and many more dignitaries, including Sir Robert Peel, who was noted for the Establishment of the London Police Force, and who was the Prime Minister at the time of the review.

On arrival at the review oak tree, the carriages were met by General the Viscount Combermere, who was the colonel of the 1st Regiment of Life Guards and overall commander of the parade (The local cavalry barracks at Spital is named after him). The band of the 1st Regiment of Life Guards was playing 'British Grenadiers', which must have provided an extremely proud moment for the General. Viscount Combermere proceeded to inspect the parade, accompanied by the members of the Royal families and military senior officers. On returning to the Review Oak, the military, with the accompaniment of several bands, proceeded to carry out a series of march-pasts. This was followed, at a safe distance from the spectators, by several military actions such as cavalry charges with lances and sabres, and foot riflemen firing as they ran. Finally, demonstrations were given using defensive square formations, front row kneeling and firing, and so on.

The weather throughout the day was very mild and sunny, highlighting the brilliance of the occasion. Many of the younger members of the spectators had climbed the elm trees in Queen Anne's Ride to get a better vantage point. Of the 10,000 spectators, 3,500 had travelled by train from London earlier in the day on the Great Western Railway. What a memorable day it must have been.

*Review of Troops in honour of the Emperor (Napoleon III)
and Empress of The French by Queen Victoria:*

This took place on Tuesday 17th April 1855 at 4.30 in the afternoon, involving an assembly of approximately 5,000 troops watched by an estimated 50,000 spectators.

The military on parade consisted of the 2nd Regiment of Life Guards, the Horse Guards (Blues), the Carabiniers, and two troops and six guns of Horse Artillery, the 94th Regiment of Foot, and a Company of Grenadiers and Coldstream Guards who served as a guard of honour to the Royal families. Without question, this was an occasion far exceeding any previous event to have taken place in The Great Park. From Windsor Castle to the Review Ground, The Long Walk was completely lined with carriages and with spectators on foot. The scene was the same in Sheet Street Road, in the area of the park near Queen Anne's Gate.

The Royal party left the castle in open carriages at four o'clock precisely, led by the Emperor and Prince Albert on horseback. In the carriages were Queen Victoria, the Empress, the Prince of Wales, the Princess Royal, Prince Alfred, Prince Arthur, Princess Alice, Princess Helena, Princess d'Essling, the Duchess of Wellington and numerous ladies in attendance. The Emperor was mounted on his favourite charger, which was named 'Philips' after the gentleman by that name whom he had recently purchased it from at Knightsbridge. Directly the Royal party arrived at the ground, they were received by a Royal salute and the bands playing the national anthem and 'Partant pour la Syrie'.

The party was greeted at the Review Oak by the Duke of Cambridge and Lord Cardigan. The latter had previously been brought to the public's attention through his involvement in the charge at Balaklava.

The parade, under the command of Lord Cardigan, was formed in two lines. A detailed inspection commenced, keenly observed by the Royal families. As soon as the inspection was over, the cavalry, headed by the artillery, marched past, trotted round by squadrons, broke into columns of troops, counter marched and reformed in their original positions. The next events really livened up the afternoon and would have been an occasion never to be forgotten. In the centre of the Review Ground a series of mock battles commenced, with infantry and cavalry charges, supported by the Carabiniers. (The Carabiniers, originated in the 1500s, were light cavalry armed with large pistols know as carabins which had three-foot long barrels) The battles, including the use of the six guns, were realistically enacted, even to the macabre extent of burying the 'dead'.

The Review, which lasted for just over two hours, fortunately in fine weather, had been a magnificent spectacle. However, its size had created some very human problems. Pick-pockets were busy amongst the 50,000 spectators and many of the well-off found themselves departing

the scene minus their watches and other valuables. All hotels and accommodation in the area were full to capacity. In fact, the enormous influx of visitors to the town had taken everyone by surprise. Food and drink was soon in short supply and, in some instances, fights broke out to get that last morsel. The ensuing scramble to catch the homeward-bound trains was another matter.

Review of Volunteers (Citizen-Soldiers) by Queen Victoria:

This took place on Saturday 20th June 1868 at 5.00 in the afternoon, involving an assembly of over 26,000 Volunteers watched by a large number of spectators. (The Volunteers operated on military lines and were made up of civilians from all walks of life with the express purpose of defending the country in the event of an invasion.)

The day was something very special for the town of Windsor for, not only had it prepared a grand welcome for the arrival of thousands of volunteers from all over the country, it was also the 31st anniversary of Queen Victoria's Accession to the Throne. Flags were everywhere and large banners carried the words, "England's Guardians - Welcome to Windsor". however, the welcome was 'dampened' by the outbreak of a thunderstorm early in the morning and the presence of 1,000 policemen who had been drafted in to keep law and order.

In honour of the Queen's Accession to the Throne, the day's events started with a gun salute on Bachelor's Acre, followed by the bells of St George's Chapel and the Parish Church. The Review Ground had been prepared under the watchful eyes of Prince Christian, the Ranger, and of Major General F.H. Seymour, Deputy Ranger of Windsor Park and forest. The Royal Stand, which had been transported from Ascot racecourse, was erected just to the left of the Review Oak facing The Long Walk. A saluting platform was erected in front of the Review Oak.

Many of the Volunteers who had arrived the night before had set up camp in Queen Anne's Mead and in the Cavalry Exercise Ground. During the early afternoon, the Volunteers had started to assemble in the Review Ground, and by 4.30, the parade was assembled in lines stretching to one mile long, parallel to Queen Anne's Ride. The parade was made up from Volunteer Corps from virtually every town and county in England. From a local, and a personal point of interest, the Windsor Great Park (12th Berks) Rifle Volunteers, with which the author's great grandfather, George Smith, was a corporal at the time, were on parade that day as part of the Third Brigade, 6th Battalion Berks Rifle Volunteers.

The Queen arrived in a small open carriage drawn by four white ponies, at her side was the Princess of Wales, and opposite were the Princes Louis of Hess and Christian. On either side of the carriage were the Prince of Wales and Prince Arthur, on horseback. Following the Queen in carriages and on horseback

were Prince Teck, Prince Christian, Prince Louis of Hess, the Crown Prince of Denmark. the Duke of Cambridge, Princess Louise, Princess Mary Adelaide, Princess Victoria of Hess, Prince Leopold, Princess Beatrice, the Duchess of Roxburgh, the Dowager Duchess of Athlone and the Countess of Macclesfield. The Royal party had a military escort which included many high ranking officers.

The Review started with the usual inspection of the Volunteers, followed by a march-past of the review saluting platform. The event, which lasted for almost three hours, included cavalry exercises and numerous simulated battles. Fortunately, there were only a few reported minor injuries incurred during the day.

Review of Guards in honour of Prince Ismail Pasha of Egypt by Queen Victoria:

On Saturday 26th June 1869 at 4.30 in the afternoon 5,000 guards assembled in the Review Ground watched by an enormous crowd of spectators.

The town of Windsor was ablaze with colourful pendants and flowers, which had become the normal practice to welcome the visitors on such occasions. The Guards had started to arrive several days before the review and had camped in the most suitable areas near to the review ground. Hog Common, more generally known as Queen Anne's Mead, was a favourite place for these events.

The Guards on parade that day were made up from the Household Brigade, Royal Horse Guards, and Field Artillery. The contrast of their different coloured uniforms, stood out against the various natural greens of the fields and trees of the park. In what had become normal practice with previous reviews, the Alexandra Stand from the Ascot Racecourse was erected in the Royal Enclosure just in front of the Review Oak. Several other special enclosures with suitable seating arrangements were erected on each side of the main enclosure, to accommodate the Windsor Garrison and the Eton College boys. As the time approached for the actual review, the Guards formed up in straight lines, parallel to Queen Anne's Ride, nearly a mile in length.

The Queen chose a different route from the Castle to the Review Ground for the day. The Royal party travelled along Kings Road and entered the park through Queen Anne's Gate, as opposed to the normal Long Walk route. The Royal party proceeded to the ground in six carriages. The first carriage carried Queen Victoria with the Princess of Wales at her side. Prince Ismail Pasha and Princess Christian sat opposite. In the second carriage were Princess Mary of Cambridge, Princess Louise, Princess Beatrice and Prince Leopold. In the third carriage were Hussein Pasha, Toucan Pasha, Unbar Pasha and the Lord in Waiting. In the fourth carriage were the Lady in Waiting, the Hon. Mrs. Stoner, Lady Caroline Barrington and Lady Susan Melville. The fifth carriage held the Hon. Horatia Stopford, the Hon. Harriet

Phipps, the Hon. Eva Macdonald and Miss Bauer. In the last carriage were Ratib Pasha, Ab-del-Kader Bay, Colonel Cavendish and Sir John Cowell. The carriages, which were drawn by grey ponies, were escorted by Lieutenant- General F.H. Seymour (Deputy Ranger of the Park) and the 5th Dragoon Guards on horseback.

The carriages were met at the saluting stand near the Review Oak by Prince Christian (Ranger of the Park), Prince Edward of Weimar, Prince of Teck and Field-Marshall Duke of Cambridge. Immediately the military bands had finished playing the National Anthem and the 'Egyptian Hymn', the Queen proceeded to inspect the Guards and returned to the saluting base when this had been completed. The march-past which followed must have been quite an occasion, when you consider that it involved 5000 guards, 800 horses and 200 artillery guns. Within the march-past were several military bands. The day's events were concluded with a series of spectacular military mock-battles which were rather quaintly called 'sham fights' at the time.

Review of Troops in honour of the Shah (Nasir-ad-Din) of Persia by Queen Victoria:

This took place on Tuesday 24th June 1873 at 5.15 in the afternoon, involving an assembly of 7,400 troops and 2,174 horses watched by an estimated 150,000 spectators.

In terms of numbers of visitors who came to Windsor to see this review, nothing like this had never been witnessed before. Every train to arrive at the Great Western and South-Western Railway Stations, starting in the early hours of the morning, was packed to capacity. With an estimated 150,000 sightseers on the day, how did so many people get the time off work? It was a Tuesday and it was not a national holiday.

The Town of Windsor, which was festooned with flags and flowers to greet the visitors, had been buzzing with excitement throughout the week as more and more troops set up camps in Hog Common (Queen Anne's Mead), the Cavalry Exercise Ground, Stag Meadow, Cranbourne Hill and on Chobham Common. At the weekend before the review, the camps, which were made up from white canvas round tents, were visited by the Queen in her carriage with her escorts.

The arrangements for the day were on a massive scale, with stands and enclosures being erected in front of the Review Oak to accommodate the Royal party, members of the House of Lords and the House of Commons, the Eton College Boys and children from a few other chosen local schools. Well before the review was due to start, the troops were formed up in lines a mile long parallel to Queen Anne's Ride. On parade were troops from the Royal Horse Artillery, Household Cavalry, Hussars, Dragoons, Scots Guards, Life Guards, Infantry and many more.

The arrival of the Royal party at the Review Ground was signaled by the firing of some of the Artillery guns and, as the smoke drifted over the parade, a roar of excitement was heard from the crowd. In the first carriage were seated Queen Victoria, dressed in her now familiar black clothes. Sitting at her side was the Cesarevna (wife of the heir-apparent to the Russian throne). Opposite them sat the Shah and the Princess of Wales. In the following carriages were seated several members of the Persian and our own Royal Family and many dignitaries. However, many members had taken to horseback that day, including the Prince of Wales, the Cesarewitch (heir-apparent to the Russian throne), the then Duke of Edinburgh, the Duke of Teck, the Duke of Cambridge and several Persian Princes. Incidentally, one of the Persian Princes was slightly injured when he was thrown to the ground when his horse was startled by the artillery fire.

The Royal party took up their positions on the stand, followed by the playing of the National Anthem and a Persian March by military bands. The Queen and the Shah then proceeded in carriages to inspect the lines of troops and, in keeping with our country's normal weather, it decided to drizzle with rain as they set off. On their return to the stand and saluting base, a grand march-past commenced with the bands playing the popular military marches of the day. The mock battles that followed, including cavalry charges and artillery fire, must have been really thrilling for the thousands of spectators.

Review of Troops who had just returned from Ashanti, Gold Coast by Queen Victoria:

This was held on Monday 30th March 1874 at 2.00 in the afternoon involving 2,000 troops watched by several thousand spectators.

At the time of the review, the Ashanti Region was under British occupation. The region is in the southern half of the country now known as Ghana. The Troops had just returned from the Region after successfully bringing some peace in the area in the wake of the 1873-1874 Ashanti War.

From the early part of the morning, flags were being erected in Windsor and, quite surprisingly, 600 Metropolitan Police arrived by train from London. Why that many were drafted in remains a complete mystery. By the standards at the time, this particular review, although very important, was not expected to draw the enormous crowds of spectators that normally attended reviews at the time. The weather on the day, was in sharp contrast to what the troops had become used to in Ashanti. A keen northerly wind swept across the park, sending great clouds of dust into the air, to the discomfort of all.

The troops which were made up from the 23rd Royal Welsh Fusiliers, 2nd Battalion Rifle Brigade, and the 42nd Highlanders were met at Staines Railway Station by the Prince of Wales, Prince Arthur, the Duke of Cambridge, Prince Teck, Prince Edward of Saxe-Weimar, Count Gleichen and Sir Garnet Wolseley. On arrival at Windsor, the Royals mounted their horses and the troops marched past the Castle and then down Sheet Street Road and Kings Road onto the Review Ground. Of particular interest was that the Welsh Fusiliers were led by their

mascot goat, which originated from the Great Park stock.

The Royal line of carriages which had now left the Castle was led by Queen Victoria, accompanied by the Princess of Wales, Princess Helena (Princess Christian of Schleswig-Holstein), and the Duchess of Edinburgh. In the second carriage were Princess Louise (Marchioness of Lorne), Princess Beatrice, Prince Leopold and Lady Churchill. In the third carriage were the Countess of Macclesfield, Lady Caroline Barrington, the Earl of Dunmore and Lord Cardwell. A fourth carriage carried members of the Royal Household. The carriages proceeded down The Long Walk and through the double gates onto the Review Ground. At the saluting base, several military bands played the National Anthem, after which the Queen proceeded to inspect the troops as she passed down the lines in her carriage. On returning to the saluting base, the troops formed up in a hollow square. The Queen then drove into the square and presented Major-General Sir Garnet Wolesley with the insignia of the Order of the Grand Cross of St Michael and St George, and Knight Commander of the Bath. The Victoria Cross was then presented to Lieutenant Lord Gifford. Sergeant S. McGraw, of the 42nd Highlanders, having been wounded and being ill, was unable to be present to receive his Victoria Cross. The presentation ceremony being over, the Queen returned to the saluting base to view a march-past by all of the troops, and on this occasion, there were no subsequent military exercises.

Upon the departure of the Royal Party, the troops were provided with a substantial meal in the two large marquees that had been erected nearby.

Review of Troops of all arms by Queen Victoria:

This was held on Tuesday 10th July 1877 at 5.30 in the afternoon involving 14,771 troops watched by many thousands of spectators.

This particular review was quite different to the previous occasions, in that it was preceded by a review on Chobham Common the day before, and that it had been arranged at very short notice. The review was not in honour of anyone an particular. It was more a morale-boosting and toughening exercise for the troops. Certainly, it had not been laid on as a military spectacle for the general public.

The troops had set up camps on Chobham Common, Ascot Heath and in the park, having marched there from as far away as Aldershot. The different elements of the army were represented at the review by:- 1st Life Guards, Royal Horse Artillery, the Dragoons, The Hussars, the Coldstream Guards, the Grenadier Guards, the Lancers, The Royal Engineers, the Army Service Corps and the Infantry. The Troops marched into the park from every direction, using virtually every entrance. On the Review Ground, the troops formed up in straight lines almost a mile long, parallel to Queen Anne's Ride and in front of the Review Oak where the saluting base and the Royal Standard were erected. An enclosure nearby was filled with distinguished guests, The Compte and The

Comptesse de Paris, the Marquis of Hereford, Lord Chamberlain and many high ranking military officers. The general public was kept well back from the parade area by the military and the police. Tight control was maintained with very few reports of theft.

The Royal procession left the Castle at 5.15 to the sound of a 21 gun salute being fired on the Review Ground. With Queen Victoria in an open carriage drawn by four grey horses was Princess Helena and Princess Beatrice. On this occasion, there were no following carriages, just a majestic military cavalcade to the front, sides and rear. This included Prince Christian wearing the uniform of a Staff Colonel. In glorious warm sunshine, the Queen was received at the saluting base by the military bands playing the National Anthem. At the same time, the Royal Ensign was hoisted. The Queen then proceeded to inspect the troops as she drove down the never-ending lines in her carriage, after which, she returned to the saluting base to watch the march-past. In the front were the Army Corps, who went past in a slow march. They were followed by the Cavalry in a column of squadrons and the Artillery in column of batteries. This was followed by a series of complex formation marching, being most impressive to the onlooker. The final movement was an advance of The whole Army Corps to salute the Queen. This very imposing movement, was a fitting termination to a grand military spectacle which concluded at 7.15. In the evening arrangements had been made for The troops to 'fight' their way back to the barracks at Aldershot. Thank goodness, commonsense prevailed and these arrangements were dropped. Instead, all they had to do was to march back to base !

Review of Troops of all arms by Queen Victoria:

This took place on Wednesday 14th July 1880 at 5.30 in the afternoon involving the assembly of approximately 11,000 troops watched by many thousands of spectators.

The weather in the morning of the review was not exactly encouraging, as from the early hours, heavy showers were threatening to spoil the enjoyment for everyone, who had become accustomed to watching the splendour of these magnificent reviews. Fortunately, the weather gave way to sunshine as the morning moved on. As normal, the preparation of the Review Ground was overseen by Prince Christian (Ranger), assisted by Mr. F Simmons (Deputy Surveyor) and staff from the park. A saluting base was assembled in front of The Review Oak and enclosures were erected each side to accommodate the Royal Household, the Eton College staff and boys. A place was also provided for the press.

On the Monday, the troops, many of whom had set off from Aldershot, one of the main garrison barracks in England, started their march to the park. By Tuesday, the ridges on Chobham Common were covered with tents set up by the troops. Another encampment was erected on Ascot Heath, and some smaller camps were erected in the park itself.

A large number of visitors was expected in Windsor and accordingly 700 policemen from London were drafted in to contain the crowd. Most of the shops had put up their shutters by 4.00 in the afternoon, concerned about the possibility of window damage from the crowds in the High Street.

The Royal carriage's departure from the Castle was indicated by the sound of artillery gun-fire, which also provided a signal to prepare the troops at the Review Ground. In the first carriage was Queen Victoria, accompanied by the Princess of Wales and Princess Christian. In the second carriage were the Duchess of Connaught, Princess Beatrice, Prince Albert Victor and Prince Frederick George. The other carriages carried members of the Royal Household. At the front, sides and rear of the carriages, was a royal and military escort which included the Prince of Wales, the Duke of Connaught, Prince Christian and the Duke of Cambridge. The main body of the escort consisted of riders from the Household Cavalry Brigade and some high ranking German Officers. After a moment's pause at the Royal Standard in front of the Review Oak, the brilliant cavalcade moved off down the lines to inspect the troops and then returned to the saluting base, upon which the march-past began to the rousing marching tunes played by several military bands. The most spectacular sequences of military formation movements were to follow, with the buglers giving the various signals. Large formations of infantry, artillery and cavalry performed simulated battle actions and charges. This was concluded with a mass cavalry charge with sabres in the air and lances in the attack position. It must have been thrilling to watch and left the spectators sad when it was all over.

However, just as it is today, there are some folks who always have a way of spoiling things. During the review, pick-pockets were up to their dirty tricks. At least two of them were caught in the act by the police, which resulted in them having to serve two months' hard labour.

Review of Volunteers (Citizen-Soldiers) by Queen Victoria:
This was held on Saturday 9th July 1881 at 5.00 in The afternoon, involving an assembly of 55,000 volunteers watched by an enormous number of spectators.

The number of participants on parade that day far outnumbered any other event, before or after, held on The Review Ground. The amount of organization required to stage such an event is mind-boggling, and anyone who has been involved in organizing, by comparison, a simple event such as a sports day will appreciate what was involved. Just think, they did not have the instant means of communication that we enjoy today.

During the week, as more and more volunteers arrived at Windsor, mainly by train, the park became a gigantic tented encampment covering the Cavalry Exercise Ground, Stag Meadow, Hog Common, Newmeadow and Bear's Rails. The planned number of volunteers expected was 52,240. However, such was the enthusiasm of the volunteers from all over England and Wales that the final head-count was just over 55,000

with every county being represented. The Windsor Great Park ('N' Berks) Rifle Volunteer Corps had an attendance of 47 riflemen, one of whom was the author's great grandfather, George Smith (sergeant), and another one was a great uncle, Charles Spencer Smith (private). The Windsor ('D' Berks) Rifle Volunteer Corps was represented by 82 riflemen.

Departure of The Royal Party from the Castle was signaled by guns of the Royal Artillery. The carriages proceeded down The Long Walk, which was lined with crowds of spectators, and through the Double Gates where they were met by the Duke of Cambridge, Prince Christian and Prince Edward of Axe-Weimar, and Sir Garnet Wolseley on horseback. In The first carriage was Queen Victoria. In the carriage with her were the Princess of Wales and the Crown Princess of Germany. In the next carriage were the Duchess of Connaught, Princess Christian, Princess Louise and Princess Beatrice. In the third carriage were Prince Leopold, The Duchess of Tech and Prince Waldemar. In the fourth carriage were the two young Princesses of Hesse. Finally, in the fifth carriage were Prince Louis of Hesse and Lord Thurlow. The carriages were accompanied by high ranking British, German and French Officers on horseback.

On their arrival at the saluting base in front of the Review Oak, the National Anthem was played by military bands. This was followed by an inspection of line after line of volunteers. With so many on parade, this took a considerable time to carry out, and the oppressive weather conditions were starting to affect the volunteers, with numerous faintings taking place before the inspection was completed. In reality, it must have been a relief to many of the volunteers when it was all over. However, considering the number of people in the park that day, casualties were very light. The three field hospitals which were stationed nearby treated about 150 people, mainly with minor injuries.

Upon departure of the Queen, the most difficult problem still had to be overcome. That was the return of the volunteers and spectators to where they had come from. Even after calling on every form of transport available at the time, the town of Windsor was still busting at its seams late in the evening. It was not until past midnight that some form of normality returned.

Musical Ride in honour of the Emperor of Germany, William II:
This was held on Tuesday 7th July 1891 at 11.40 in the morning, performed by 40 men of the 2nd Life Guards, and watched by several hundred spectators.

The event was just one of the many royal occasions that took place in Windsor and the park during the week. Many of the festivities were, unfortunately, marred by heavy outbreaks of rain that persisted throughout. The main events were as follows:

Saturday 4th July, arrival of the Emperor and Empress of Germany at the South Western Railway Station at 4.15 in the afternoon. After the formal greetings, no fewer than thirteen horse-drawn carriages

carrying most of the members of the British and German Royal families made their way up Thames Street Hill to the Guildhall. When the leading carriage, carrying the Emperor of Germany, the Prince of Wales, Duke of Edinburgh and the Duke of Connaught, arrived at the Guildhall, they halted to receive the formal welcome address by the Mayor of Windsor, Mr. Thomas Dyson. The carriages then proceeded to the Castle.

Sunday 5th July, a special service was held in the Royal Chapel in the park to mark the Silver Wedding of Prince and Princess Christian who lived at the nearby Cumberland Lodge.

Monday 6th July, the wedding took place in St Georges Chapel, Windsor Castle, between Prince Aribert of Anhalt and Princess Louise of Schleswig Holstein, youngest daughter of Prince and Princess Christian.

Tuesday 7th July, a Musical Ride in honour of the Emperor of Germany was held at 11 .40 in the morning on the Review Ground. The Ride was performed by 40 men of the 2nd Life Guards under the direction of Riding-Master Burt. The Royal party travelled to the ground from Windsor Castle in a line of carriages by way of The Long Walk. The members of the party included the Prince and Princess of Wales, the Emperor and Empress of Germany, Duke and Duchess of Connaught, Duke and Duchess of Edinburgh, Duke and Duchess of Anhalt, Prince and Princess Henry of Battenberg, Princesses Maud and Victoria of Wales and the Duke of Clarence. The Musical Ride was started by the playing of 'Men of Harlech' by the band of the 2nd Life Guards. Twenty of the riders were carrying lances and the other twenty were carrying sabres. They proceeded to give a precision performance of intricate movements, involving line, turn and cross-passes. The display put on by the 2nd Life Guards was highly praised by the members of the Royal party. When the Ride finished, the party split up to return to the Castle or Cumberland Lodge. In the afternoon, some returned to watch a polo match and pony racing in the Cavalry Exercise Ground.

Wednesday 8th July, a party was held at Cumberland Lodge to celebrate the Silver Wedding of Prince and Princess Christian. This included a cricket match played in the morning in front of the lodge between Prince Christian Victor's Team and the Brigade of Guards. Alas, the rain became so heavy that the match had to be stopped before the Guards' turn to bat got underway.

Review of the St. John Ambulance Association by Queen Victoria:

This was held on Saturday 6th May 1893 at 5.15 in the afternoon involving an assembly of 350 members of the St John's Ambulance Association, watched by an estimated 15,000 spectators.

By comparison to previous reviews, this was a small occasion. However, in spite of the small number of participants, it still attracted a very large number of spectators. The members of the Association were

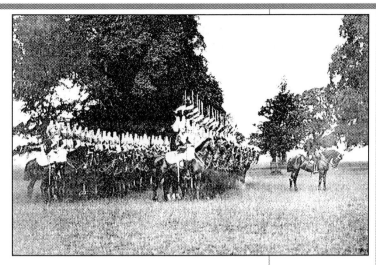

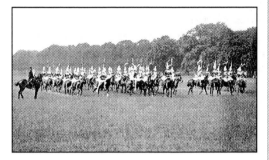

colliery workers from the coal mines, owned by Colonel Seely in Derbyshire and Nottinghamshire. Suffice to say, it was in the best interests for the efficient running of the collieries to have as many of the workers trained in first aid practices as possible, bearing in mind that injuries and illnesses were a daily part of the miner's life. The members travelled to Windsor with their wives and girl friends by train, arriving at about 10.00 in the morning, giving them ample time to do some sight-seeing.

The 2nd Life Guards lined up ready to perform a Musical Ride in honour of the Emperor of Germany, Wilhelm II on the Review Ground on Monday 7th July 1891. (Household Cavalry Museum Collection).

The 2nd Life Guards performing a Musical Ride in honour of the Emperor of Germany, Wilhelm II on the Review Ground on Monday 7th July 1891. (Household Cavalry Museum Collection).

The front cover of the official programme of the Review of the St John Ambulance Brigade by Queen Victoria on the Review Ground on Saturday 6th May 1893. (St John Ambulance Collections).

The arrangements in the park were overseen by Prince Christian (Ranger of the Park), assisted by Captain Walter Campbell (Deputy Ranger) and Mr.F. Simmons (Deputy Surveyor). 400 soldiers of the 1st Battalion Grenadier Guards were available to give assistance as necessary. Large marquees were provided to enable the members to simulate first aid treatment as experienced in coal mines. It was normal for most of the spectators to make their way to the Review Ground along Kings Road and to enter the park through Queen Anne's Gate. As the spectators streamed into the park in the afternoon, the mood changed dramatically when the policemen who were on duty at the gate, stopped any further entries after 10,000 spectators had passed through. From then on, all new arrivals were instructed to walk back down Kings Road, which was notorious for its dust in dry weather, and to enter the park via The Long Walk. Many of them would have already spent many hours walking, and they would have been tired and fed up by the time they reached the Double Gates.

The Royal procession left the Castle a few minutes before 5.00 o'clock with the 1st (King's) Dragoon Guards providing the military escort. In the first carriage with Queen Victoria were Princess Christian and Princess Beatrice. In the second carriage were Prince Henry of Battenberg, Princess Victoria of Schleswig-Holstein and Lord Wolverton. The third carriage brought the Countess of Antrim, the Hon. Harriet Phipps and the Hon. Rosa Hood. In the fourth and fifth carriages were members of the Royal Household. At the double gates, the procession was met by Prince Christian on horseback as it continued to the saluting base in front of the Review Oak. On arrival there, the band of the Association played the National Anthem as Colonel Seely and the rest of the members saluted the Queen. The members then proceeded to perform a series of marching exercises, followed by demonstrations in first aid treatment. Finally, the members gave a smart march-past to the familiar tune of 'Ninety-Five'. The Queen personally thanked Colonel Seely and his wife for playing their part in making the day such a success.

The Queen left the Ground to loud cheers from the crowds as she made her way back to the Castle. The members of the Association were then marched back to the Castle to be shown the State Apartments before they set off for home.

Review of Yeomanry (Berkshire & Middlesex Regiments) by Queen Victoria:

This was held on Friday 18th May 1894 at 5.30 in the afternoon, involving the assembly of 600 men of the Yeomanry and watched by an estimated 10,000 spectators.

The Yeomanry was the original military organisation of what we now know as the Territorial Army. The concept of the Yeomanry was founded in 1761 and was established as a volunteer mounted section of the home defence army of Great Britain. It was formed on a county basis, both in recruitment and in command. The recruits were mainly from farms and estates, and they had to supply their own horses.

During the week of the review, the Yeomanry, who had set up camp on the Cavalry Exercise Ground, were involved in military training and sporting events in the park during the day. In the evenings they attended 'smoking concerts', either at the Cavalry Barracks or in the mess at the camp (a smoking concert was a very popular social function held in Victorian times as an opportunity to have a smoke, usually with a clay pipe, and to have a good drink and hopefully, a good laugh). Horsemanship, coupled with expertise in the use of the lance, sword, rifle and musket was paramount, and military honours were awarded to the winners of the daily competitions. On several occasions, Prince Christian (Ranger of the Park) visited the camp and, on the Tuesday evening, the officers were invited back to Cumberland Lodge as his guests.

On the day of the review, the excellent weather experienced during the week continued. As the day progressed, the crowds of spectators started to arrive by train and by carriage. The carriages entered the park using Sheet Street Road, the only public road through the park. The carriages were lined up and the horses fed in the grass area between Queen Anne's Ride and the road, in keeping with the normal practice.

The Queen left the Castle shortly after five o'clock, and was accompanied in the first carriage by the Duchess of Saxe-Coburg and Gotha, and his Grand Ducal Highness Prince Louis of Battenberg. In the second carriage were the Duke of Saxe-Coburg and Gotha, Prince Henry of Battenberg, Princess Alexanda of Saxe-Coburg and Gotha and Princess Alix of Hesse. The carriages were met at the double gates by his Royal Highness Prince Christian of Schleswig-Holstein, and escorted to the saluting base in front of the Review Oak. There they were received by the Duke of Cambridge. At the same time the standard was hoisted, the guard of honour saluted, and the bands played the National Anthem. The Queen took up her position on the saluting base, whilst the rest of the Royal Family and dignitaries were seated in a place provided opposite her. This group included The Duke of Cambridge, Prince Christian, Prince Henry of Battenberg, Princess Victoria of Schleswig-Holstein, the Baroness von und zu Engloffstein, the Dowager-Duchess of Athlone, General Sir Francis Grenfell and the officers of the staff.

At the review, there was no formal inspection by the Queen in the accustomed way. However, the march-past in columns of cavalry, with the regiment bands in front, was a very impressive sight. The Queen departed the Review Ground to the warm cheering of the crowd.

Review of the South London Volunteer Brigade by Princess Christian:

This was held on Saturday 13th April 1895 at 3.00 in the afternoon involving the assembly of 3,692 volunteers, watched by several thousand spectators.

The whole week leading up to the review day on Saturday, through to the Easter Monday, had seen the towns of Windsor and Eton almost taken over by volunteers, mainly because, on this occasion, they were billeted in the towns, as opposed to being camped outside as as done on previous reviews. Furthermore, the volunteers were actively engaged in all manner of activities throughout the week, such as, military training and public musical performances by their sixteen bands, either by single or massed band playing. On the Good Friday, most of the churches had provided special services for the volunteers, which were well attended.

The day of the review, brilliant sunshine started in the morning and contiued all day. The Review Ground had been been fully prepared under the control of Prince Christian (Ranger of the Park), and assisted by Captain Walter Campbell (Deputy Ranger) and Mr Frederick Simmonds (Deputy Surveyor). In front of the Review Oak, the saluting base complete with the adjacent standard flag pole had been erected. On each side were special enclosures for the Royal Household, the Royal School and the Press. The whole area of the Review Ground had been roped off as a measure to control the crowds. As the time of the review approached, the volunteers were assembled in columns in the following order:- On the extreme right, facing the saluting base, was the Field Battery of the Honourable Artillery Company. Then came numerous columns of infantry regiments, with the whole parade being completed by a column on the extreme left of the Cyclists' Corps. (The cyclist volunteers were very popular and effective at the time, mainly because it was easier and faster than marching. Also the cycles did not have to be fed as was the case with horses). At the rear of the columns were the massed bands of all of the regiments.

Punctually, the two Royal carriages, which had driven down The Long Walk from Cumberland Lodge, arrived at the Review Ground at 3.00 o'clock. In the first carriage were Princess and Prince Christian, accompanied by the Duke and Duchess of Connaught. In the second carriage were the children of the Duke and Duchess of Connaught. Two troopers of the Scots Greys from Aldershot formed the only escort. Then Princess Christian proceeded to inspect the columns before finally arriving at the Review Oak to take the salute, as the march-past commenced. Popular marching tunes of the time, such as, 'The British Grenadiers', 'Highland Laddie' and 'God Bless the Prince of Wales' were played by the volunteer bands. The Cyclists' Corps followed up at the rear riding at a very slow pace, no doubt experiencing a few collisions along the way. The review, which lasted for fifty minutes, came to a satisfactory conclusion.

After the review, many of the volunteers accepted a special invite by Queen Victoria to see the State Apartments, the East Terrace and the Round Tower in the Castle, whilst the Commanding Officers of the volunteers attended a dinner in the evening with Prince and Princess Christian at Cumberland Lodge. In Windsor, the day was concluded by a Grand Tattoo performed by the massed Volunteer bands within the Castle Wall below the guard-room facing Thames Street.

Review of the Public Schools Volunteer Corps by Queen Victoria;

This was held on Tuesday 28th June 1897 at 5.00 in the afternoon, involving an assembly of 3,679 volunteers watched by an enormous crowd of spectators, many of whom were relatives and friends of the volunteers.

The event was unique in that it consisted of representatives from the major public schools in the country. The schools involved were:- Eton, Harrow, Winchester, Cheltenham, Tonbridge, Rossall, Clifton, Bedford, Weymouth, Sherborne, Wellington, Bradfield, Uppingham, Rugby, Warwick, Malvern, Plymouth & Mannamead, Whitgift, Charterhouse, Dulwich, Epsom, Derby, Hurstpierpoint, Forrest, Felstead, Eastbourne, Merchiston, Highgate, St. Paul's, Marlborough, Haileybury, Berkhampstead, and Blair Lodge. The festivity of the occasion was increased by the general mood of the nation which was celebrating Queen Victoria's Diamond Jubilee.

The responsability for preparing the Review Ground was once again in the hands of Prince Christian who was ably assisted by Mr Frederick Simmonds, the Deputy Surveyor of the Park.

The Royal carriages were driven to the Review Ground from the Castle by way of Frogmore and The Long Walk. The Queen's landau was drawn by four greys. The Queen wore a black dress and a bonnet which had several white ostrich feathers fastened to it. She was carrying what had by now become her famous black and white parasol. With her in the carriage were Princess Henry of Battenberg, Prince Maurice and Princess Ena of Battenberg. The second carriage was drawn by four white horses and carried Lady Churchill, the Hon. Miss Phipps and the Hon. Miss Hughes. The escort included Prince Christian, Sir John McNeill and Colonel G. Grant Gordon. Arriving at the saluting base as the Scots Guards band was playing the 'Coburg March', the carriages continued down the parade line and back to take up their positions near the saluting base. Already seated in the Royal enclosure were Princess Victoria of Schleswig-Holstein, and Princess Aribert of Anhalt, the latter proceeded to take photographs with her own hand held camera. The band played 'John Peel' as the march-past began. The Etonians, who wore grey uniforms, had Lee-Metford rifles, as opposed to the other schools who all had Martini-Henry carbines. The march-past having being completed, the complete Brigade formed into quarter column of battalions and advanced in review order to the stirring strains of 'Rule

Britannia'. This was followed by a Royal salute as the band played the National Anthem. When this was completed, the volunteers removed their head-dresses and gave three cheers to the Queen.

As the Queen was returning to the Castle, an incident occurred as her carriage was nearing The Long Walk. One of the Queen's outriders was thrown from his horse and it bolted. A second outrider took pursuit and caught it at Old Windsor. The Queen had stopped her carriage and, having checked that the fallen rider was not seriously injured, continued on her journey to the Castle.

The weather during the day had been quite humid, and this, added to the fatigue of waiting and then marching, took its toll on the volunteers and on some of the spectators. Many people had to be treated for fainting by the Windsor branch of the St. John's Ambulance Brigade.

Review of The Honourable Artillery Company by Queen Victoria:

This was held on Saturday 1st July 1899 at 6.00 in the afternoon, involving an assembly of 600 troops and watched by many thousands of spectators.

The Honourable Artillery Company was a composite force, consisting of Horse Artillery, a Field Battery and an Infantry detachment. It was the armed force in existence at the time of the review, with an unbroken history of over three hundred years, having been started by King Henry VIII in 1537. It was based on the volunteer concept and was stationed in London.

On the morning of the review, four special trains had been laid on to bring them to Windsor. The weather had a foreboding presence, with heavy storm clouds hanging over the Castle from the rain which had fallen earlier on. However, as the day moved on, the clouds dissipated, turning it into a fine day, and the earlier rain had laid the dust in the notoriously dusty Kings Road. As normal, the Review Ground had been well-prepared under the direction of Prince Christian (Ranger of the Park) assisted by Captain Walter Campbell (Deputy Ranger) and Mr. Frederick Simmons (Deputy Surveyor)

On the stroke of six o'clock, the escort of the 1st Life Guards, with their helmets and breastplates gleaming in the sun, were seen turning from The Long Walk having just passed through the Double Gates. These were followed by the Royal landau carrying the Queen and pulled by four greys. She was accompanied by Princess Christian and Princess Louise, Marchioness of Lorne. On horseback, on each side of the carriage, were Prince Christian and the Duke of Connaught. In the second carriage were Princess Henry of Battenberg, the Duchess of Connaught, Princesses Margaret and Patricia of Connaught and Princess Victoria of Schleswig-Holstein. In the third carriage were the Dowager Lady Southampton, Lady Sophia Macnamara and the Hon. Mrs Egerton. In the last carriage were Princess Ena and Prince Maurice and Prince Leopold of

Battenberg. As the carriages moved into the Review Ground, a trumpet rang out and the troops were called to attention. Then came the commands: "Shoulder Arms," and "Present Arms," and the band struck up the National Anthem. The Royal Standard was raised upon arrival at the Review Oak and the Queen was saluted to the playing of 'God Save the Queen'. The Queen, accompanied by the Prince of Wales, drove along the parade lines to inspect the troops and to finish up at the saluting base. The march-past was led by the Horse Artillery Battery. This, with guns being pulled by the horses, must have been a magnificent sight. They were followed by the Field Battery with the infantry marching along at the rear. It is relevant to point out that the Daily Telegraph reported that the marching at the Review was "first-rate despite the slippery uneven state of the ground." After the Queen had departed for the Castle, the Prince of Wales, who was the Captain-General of the Honourable Artillery Company. stayed behind to speak to the men to convey the Queen's pleasure at seeing such an immaculate parade. He went on to explain how proud he was of their performance.

Sadly, this was the last review to be held in the park by Queen Victoria during her sixty-three year reign. She died eighteen months afterwards at Osborne House, Isle of Wight on Tuesday 22nd January 1901, aged 81.

Review of the Officers Training Corps by King George V:

This was held on Monday 3rd July 1911 at 3.00 in the afternoon involving an assembly of 17,987 Officers and Cadets with 470 horses and 14 guns. The Review was watched by a huge crowd of spectators, estimated at 50,000.

The Officers and Officer Cadets were drawn from the leading Universities and Public Schools in all parts of Britain. For much of the Country's history, our greatest military leaders had started their service with our forces in this manner.

What was completely different on this occasion to all previous reviews, was that the leading Royal party was entirely on horseback. The crowds were so enormous, stretching along The Long Walk from the Castle to the Double Gates and beyond, that the party was not seen from the Review Ground until the King had made his way through the Double Gates. It was the playing of the National Anthem by the massed bands that alerted the people of the King's arrival. The King was wearing his Field-Marshal's uniform and he was accompanied by the Duke of Connaught, Prince Christian and Prince Alexander of Teck. The King had almost reached the Review Oak, when the bands once again struck up the National Athem in recognition of the remainder of the Royal party arriving in carriages. In the first carriage was Queen Mary (her maiden name was May of Teck), with her was the Prince of Wales and Princess Mary. In the second carriage were Princess Alexander of Teck, Princess Henry of

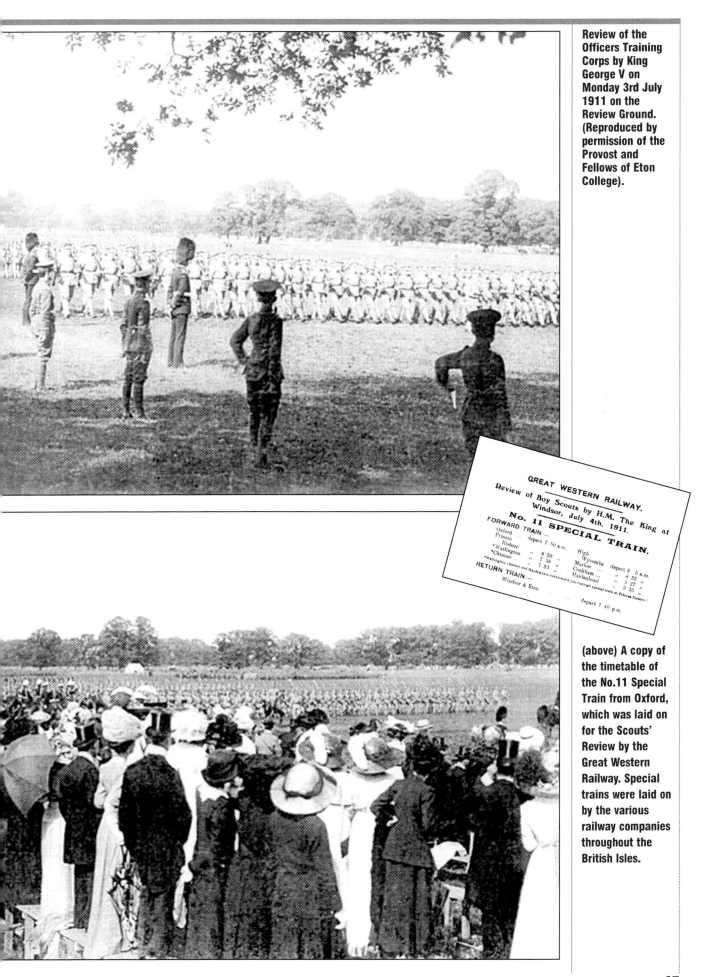

Review of the Officers Training Corps by King George V on Monday 3rd July 1911 on the Review Ground. (Reproduced by permission of the Provost and Fellows of Eton College).

GREAT WESTERN RAILWAY.

Review of Boy Scouts by H.M. The King at Windsor, July 4th, 1911.

No. 11 SPECIAL TRAIN.

FORWARD TRAIN:—

Oxford ... depart 7 50 a.m.
Princes Risboro' ...
*Watlington ... " 8 50 "
*Chinnor ... " 7 38 "
*Watlington, Chinnor and Haddenham continue a join through special train at Princes Risboro'.
" 7 53 "

High Wycombe ...
Marlow ... depart 9 5 a.m.
Cookham ... " 8 32 "
Maidenhead ... " 9 27 "
" 9 35 "

RETURN TRAIN:—

Windsor & Eton ...
depart 7 40 p.m.

(above) A copy of the timetable of the No.11 Special Train from Oxford, which was laid on for the Scouts' Review by the Great Western Railway. Special trains were laid on by the various railway companies throughout the British Isles.

57

Battenberg, Princess Victoria of Schleswig-Holstein and Prince George. Closely behind, in a small pony carriage, was Prince John, who spent most of the review time playing in piles of hay at the side of Queen Anne's Mead.

In the main stand near the Review Oak, in which, aside from the members of the Royal Family, sat some very distinguished persons. Among them was Lieutenant-General Sir Robert Baden-Powell who, on the very next day, was to be riding at the side of the King during the Review of the Boy Scouts. The teachers and pupils of the Royal School were in an enclosure nearby. A detachment of Australian and Canadian Cadets had the honour of being placed on guard-duty each side of the Royal Enclosure. The King, accompanied by senior Officers on horseback, proceeded to inspect the parade, and when completed, return to the saluting base. All of this was carried out whilst the massed bands, who were positioned in the centre of the parade, played appropriate music for the occasion. The King took up his position at the saluting base, still mounted on his charger for the march-past. First came the mounted troops, followed by company after company of the Officers and Cadets in their different coloured uniforms. The Etonians received the loudest cheer from the crowds as they passed the saluting base, this being the natural response to the local College. Two other local colleges were present in the march-past. They were the United Service College, Windsor (63 students, and Beaumont College, Old Windsor, who numbered 83 students). One of the bands played a tune called 'Poacher' as they marched by (not a very wise choice for a Review in The Great Park). With the march-past complete, the infantry formed up in massed columns, marched with their bayonets gleaming and the bands playing towards the King, halted, and gave a Royal Salute with the National Anthem being played. This was followed by placing their caps upon their rifles, with which they waved and cheered the King.

Review of the Boy Scouts by King George V:
This was held on Tuesday 4th July 1911 at 3.00 in the afternoon involving the assembly of 35,200 Boy Scouts watched by an estimated 60,000 spectators.

This event was quite extraordinary, considering that the Boy Scout organization had only been in existence for three years. Started in 1908 by Robert Stephenson Smyth Baden-Powell, who had a distinguished military record. The organization was established very much on military lines, and in it's early years, it was frequently called the 'Scout Army'.

Special trains where laid on from all over the British Isles to bring the Scouts to Windsor. Many of the trains travelled throughout the night and started to arrive at Windsor during the early hours of the morning. As soon as the scouts arrived, weary eyed, they made their way to the park to set up camp, mainly in the Cavalry Exercise Ground. Some of the Scout Troops had already arrived over the weekend, from as far afield as Canada,

Malta and Gibraltar.

The event was superbly organized, and it was the military background of Baden-Powell that played a major part as to the success of the occasion. He had even assigned Railway Officers and Road Officers to ensure that the travelling arrangements went smoothly. The

The front cover of the official programme of the Boy Scouts Review by King George V and Queen Mary on the Review Ground on Tuesday 4th July 1911. The cover also includes a picture of the Prince of Wales, later to become King Edward VIII. (The Scout Association Collection).

camping sites were controlled by a Camp Commandant and the camping arrangements, site facilities, review assembly and parade arrangements were supplied as a printed programme well in advance of the Review.

The preparation on the Review Ground, had by now, become a routine procedure for Prince Christian. Stands had been erected in front of the Review Oak, and long public enclosures had been provided on each side of the stands. Arriving carriages, coaches and motor vehicles were allowed to drive down Queen Anne's Ride. By early afternoon, over 700 motor vehicles were parked in an area next to Shaw Lane Deer Pen, and large areas on each side of Sheet Street Road were taken up by the carriages and coaches. Whilst the thousands of spectators were starting to arrive, the Scout Troops were busy assembling in their allotted areas, some on the eastern side of the Cavalry Exercise Ground, and the rest at the east of The Long Walk in Newmeadow Field. As the time of the Review

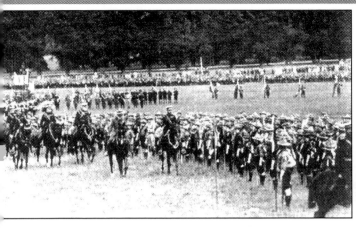

King George V (right) and the Chief Scout Robert Baden-Powell (left) inspecting the King's Scouts on the Review Ground on Tuesday 4th July 1911. The Long Walk is seen in the background.
(The Scout Association Collection).

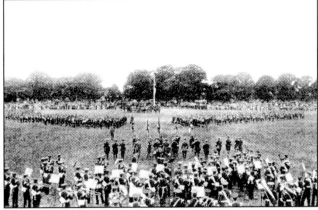

King George V and Queen Mary taking the Salute in front of the Review Oak next to
Queen Anne's Ride at the Review of the Boy Scouts on Tuesday 4th July 1911.
(The Scout Association Collection).

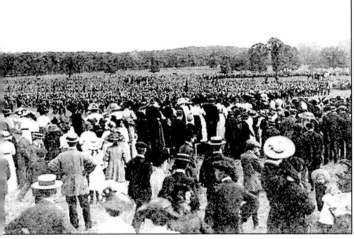

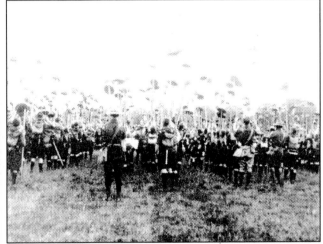

drew near, they marched to their positions on the Review Ground, watched by thousands of spectators who were lined up for almost a mile along Queen Anne's Ride, then in a line from a position near Queen Anne's Gate to the Double Gates at The Long Walk and continuing along The Long Walk elm trees for at least half a mile towards The Copper Horse.

The Royal Party left the Castle about fifteen minutes before 3 o'clock. It was led in the first carriage by Queen Mary accompanied by Princess Christian and the Prince of Wales who was dressed in the uniform of a naval midshipman. In the second carriage was Princess Victoria of Schleswig-Holstein and Princess Alexander of Teck. Some way behind the carriages, the King was on horseback with a mounted escort, which included the Duke of Connaught, Prince Christian, Prince Alexander of Teck, Field-Marshal Earl Roberts and Field-Marshal Lord Grenfell. As they proceeded towards the Review Oak, the Scouts were smartly standing to attention and trying to resist looking at the King as he rode by. When they arrived at the saluting base, they were met by Sir Robert Baden-Powell (Chief Scout). As

soon as the party had taken up their positions in the Royal Enclosure, the King and the Chief Scout, who were still on horseback, proceeded to ride around the many lines of scouts, inspecting them as they went along. On many occasions, the King stopped to talk to the boys. The inspection lasted for nearly an hour. Unfortunately, the sun, heat and lack of sleep was starting to affect the scouts, with several of them fainting before the inspection was completed. The chance to relax came when the King had returned to the saluting base. At the command of the Chief Scout, the whole parade, with staves and flags aloft and shouting their patrol calls, charged forward, coming to a halt just in front of the saluting base, This was followed by a few seconds total silence before the onlookers erupted with spontaneous applause and cheering. The Scouts then sang the 'Een Gonyame Chorus' and 'Boys, be prepared'. This was followed by three cheers for the King and Queen and, finally, the singing of the National Anthem.

Before the parade was dispersed, two Canadian scouts were decorated with good service medals by Sir

The Boy Scouts on parade during the Royal Review on the Review Ground on Tuesday 4th July 1911. The Long Walk is in the background.
(Rupert Allason Collection).

The Boy Scouts cheering the Royal Family by placing their hats on their staves (staffs) at the end of the Royal Review on the Review Ground on Tuesday 4th July 1911. (The Scout Association Collection).

The official plan of the Royal Review of the Boy Scouts by King George V on the Review Ground on Tuesday 4th July 1911. (Rupert Allason Collection)

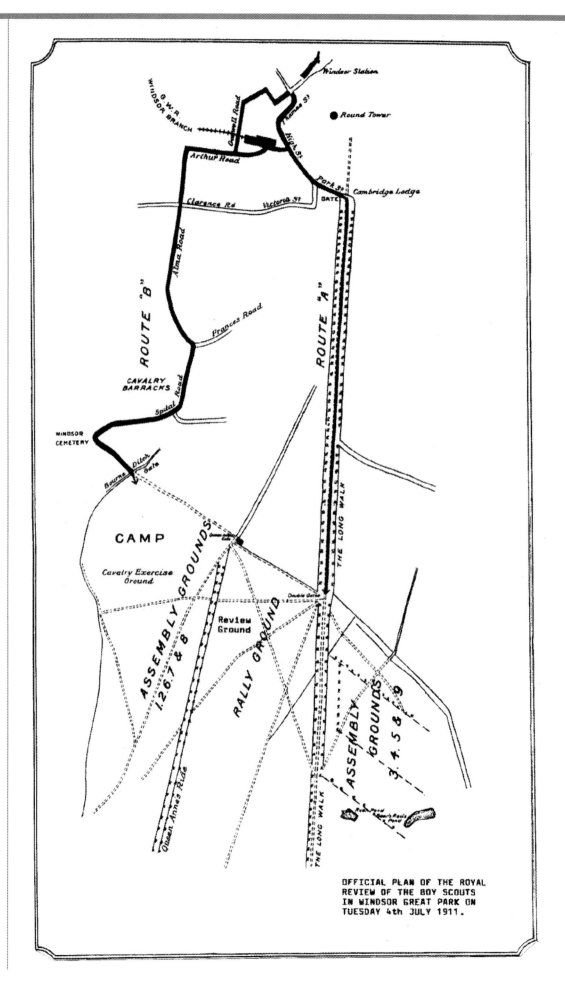

OFFICIAL PLAN OF THE ROYAL
REVIEW OF THE BOY SCOUTS
IN WINDSOR GREAT PARK ON
TUESDAY 4th JULY 1911.

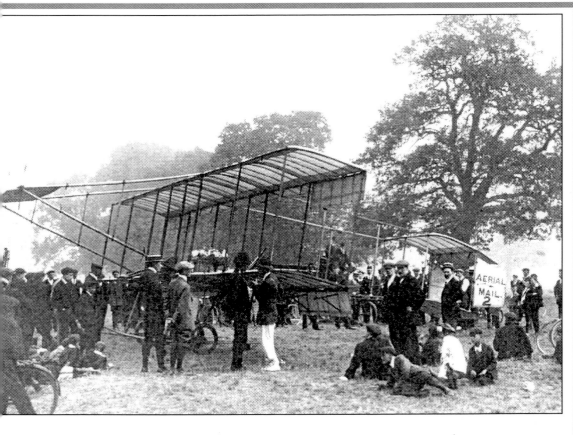

Robert Baden-Powell for tracking down and apprehending, the murderer of a Chief Police Officer in Canada. The memory of the Review for those two scouts, and for the rest of them, must have stayed with them for the rest of their lives. Decades later, many of the Scouts who were on parade on that eventful day recalled the excitement of the occasion. Bearing in mind that for many of them it would have been the first time that they had set foot outside their home-town or village.

From Monday 11th to Tuesday 26th September 1911, the northern end of the Review Ground was the scene of much aerial activity. During that time, sixteen aircraft flights were made between Hendon and Windsor operating the first official airmail service in Great Britain. Although this was the focal point of the service, the very first flight had been on the previous Saturday 9th September 1911, when a single aircraft flown by Gustav Hamel, landed in Shaw Farm Meadow at Frogmore. This flight is described in Chapter 4.

It was arranged that four pilots would carry out the deliveries between Hendon and Windsor. Early on Monday 11th, the first aircraft, flown by Clement Gresswell, successfully departed for Windsor, shortly followed by E F Driver in another aircraft. At 7 in the morning, Gresswell touched down, not on the review ground as originally intended, but on the Cavalry Exercise Ground where a canvas hangar had been erected. Shortly afterwards, Driver landed on the Review Ground and taxied to a point near Queen Anne's Gate. The strip of land just south of the Double Gates on The Long Walk and Queen Anne's Gate used by Driver was to become the main landing strip for the rest of the deliveries. The third aircraft to take off from

Hendon that day was a Farman byplane flown by Charles Hubert. As it turned out, loading the plane with eight mailbags had been too ambitious. He had barely reached a height of 40 feet (12.2 metres) when his plane stalled and 'pancaked' on the ground. Although he survived, he suffered multiple compound fractures to both legs and incurred many other injuries. Hubert and his plane never flew again.

The coming and going of the aircraft attracted large crowds of sightseers and as many as 6,000 people a day would gather on the Review Ground to watch history being

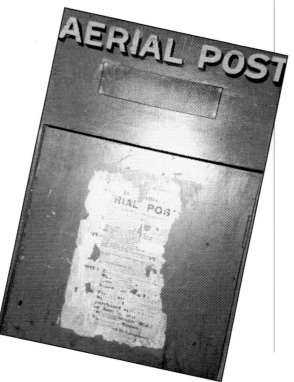

St John Ambulance Brigade nurses making their way across Queen Anne's Ride towards the Review Ground for the Review by King George V on Saturday 22nd June 1912. (St. John Ambulance Collections).

St John Ambulance Brigade nurses making their way across Queen Anne's Ride towards the Review Ground for the Review by King George V on Saturday 22nd June 1912. (St. John Ambulance Collections).

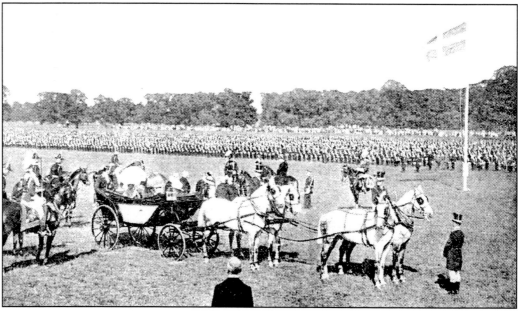

Members of The Order of St. John being presented to King George V at the saluting base on the Review Ground on Saturday 22nd June 1912. (St. John Ambulance Collections).

made before them. The author's father, Tom Smith, would often talk about the excitement the event created, and the fact that the aircraft had to be repaired many times due to souvenir hunters tearing off parts of the canvas.

On a sad note, Gustav Hamel lost his life whilst flying nearly three years later. On 23rd May 1914, he took off in a new Morane-Saulnier monoplane from Villacoublay just south-west of Paris. He was last seen crossing the coast at Calais on his way to London. For several days afterwards, English warships searched the Channel without success.

Fifty years after the very first aerial post delivery by Hamel, the anniversary was celebrated by staging another airmail flight from Hendon to Windsor, on Saurday 9th September 1961. At one minute to noon, a Westland Sikorski British European Airways (BEA) helicopter flown by Captain Jock Cameron landed near Queen Anne's Gate. Its 23 mailbags, weighing a total of 226.8 kgs (500 lbs), were received by the Mayor of Windsor, Alderman Francis Burton, Mr Edward Dolby, airmail manager of BEA, Mr. Morgan Travers, Windsor's postmaster and Mr Harry Hessey. The occasion was particularly memorable

for Mr. Hessey, who, as a 15 year old post office messenger boy, was the first person to greet Gustav Hamel when he landed at Frogmore on 9 September 1911. Unfortunately, the use of a helicopter for the anniversary did little to capture the original atmosphere.

Review of the St. John Ambulance Brigade by King George V:

This was held on Saturday 22nd June 1912 at 3.30 in the afternoon, involving an assembly of 15,000 members watched by many thousands of spectators.

This was the second time that the Brigade had been reviewed on the Review Ground, the first being nineteen years earlier by Queen Victoria and it was extremely likely that some of the members would have been on parade at both Reviews. On this occasion, 2,000 of the members were nursing sisters, dressed in light grey uniforms over which they wore large white aprons. The men wore their well-known military style uniforms. Many of the members had travelled to Windsor during the night in special trains, and had started to arrive, sleepy-eyed, at five o'clock in the

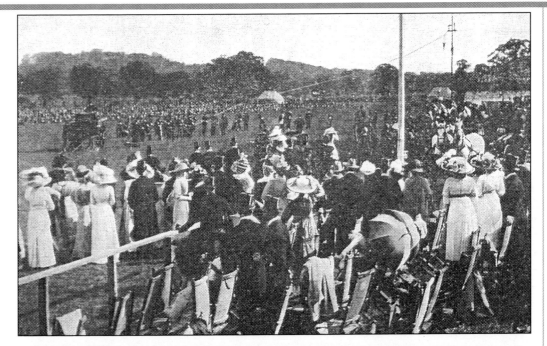

St. John Ambulance Brigade giving a demonstration of life-saving at sea on the Review Ground during the Review by King George V on Saturday 22nd June 1912. (St. John Ambulance Collections).

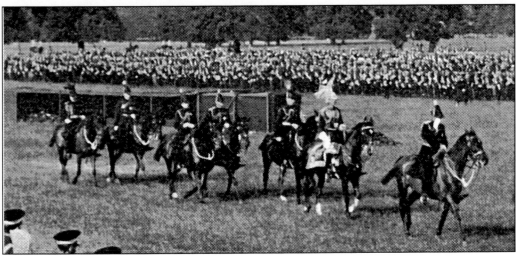

King George V on his favourite charger 'Delhi' being followed by The Duke of Teck and an escort of Life Guards returning to the saluting base after the inspection of the parade on Saturday 22nd June 1912. (St John Ambulance Collections).

morning. As each group arrived, a Boy Scout led them to the Cavalry Exercise Ground, where a tented rest-camp, complete with refreshments, had been prepared for their arrival. In the Overseas Branch of the Brigade, there were representatives from, Australia, New Zealand, Africa, India and Canada.

The Review Ground had been fully prepared, with a Saluting Base in front of the Review Oak. Special enclosures had been erected on each side of the Oak for the Royal Household and for high ranking officials. A place had been put aside for the band of the Grenadier Guards.

The Royal Procession left the Castle at three o'clock, taking a route down The Long Walk to the Double Gates and from there onto the Review Ground. The King, who was in Field-Marshal's uniform, rode his favourite charger, 'Delhi', and was accompanied by the Duke of Teck and escorted by the Life Guards. In the Royal Carriage that followed were Queen Mary, the Prince of Wales, Princess Mary and Princess Christian of Schleswig-Holstein. In contrast to the sombre black dresses associated with Queen Victoria in the past, the Queen wore a bright green costume with pink flowers and a grey hat with pink roses. The Princesses were wearing light coloured dresses. On arrival at the Saluting Base, the Brigade played the National Anthem after which the Principle Officers of the St John Ambulance Brigade were formally introduced to the Royal Family. The King then inspected the parade, accompanied by Colonel Sir James A Clark, the Chief Commissioner. The Queen followed behind in the Royal Carriage. The King, sensing the affects of the heat and tiredness of those on parade (many had hardly slept the night before), suggested that they should sit down on the grass to take a rest. After the inspection, demonstrations were given in lifesaving and first aid practices. Of particular interest was an exercise on life-saving at sea. A tall pole with a platform at the top had been erected to represent the mast of a ship on which three mariners had taken refuge. A group from the Brigade, then enacted a rescue scene with an imaginary

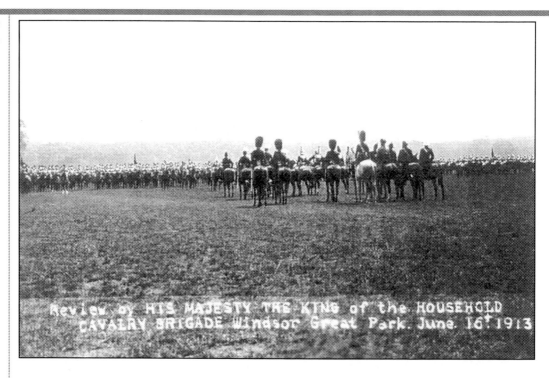

Review by HIS MAJESTY THE KING of the HOUSEHOLD CAVALRY BRIGADE Windsor Great Park. June. 16th 1913

shipwreck, using rocket propelled lines and hawser. One by one the shipwrecked sailors were run 'ashore' in a breeches buoy. This exercise was followed by several others, and one of particular note, was an enactment of a coal mine accident, involving the use of special rescue equipment. The Review was brought to a close after a show of appreciation by the King for the professionalism of the Brigade.

Later in the evening, a group of the Brigade who came from the Titanic conductor's home town of Colne, Lancashire sang hymns on Castle Hill in Windsor in his memory, it being only two months after he had lost his life when the great liner sank.

Review of Household Cavalry by King George V:

This was held on Monday 16th June 1913 at 11.00 in the morning, involving the assembly of 700 men and horses of three regiments of Household Cavalry. It was watched by 6,000 ticket holders, 2,000 schoolchildren from Windsor and Eton and the Park Royal School. In addition, there were many thousands of other spectators clamouring for a view. The estimated total number of spectators was 20,000.

As a military spectacle, this review was compared with the grand Royal Review of the Horse Guards held in 1715 in Hyde Park. The interest was boosted by advertisements for the event displayed in advance at railway stations. At Paddington Station the crowds had packed the platforms and, by 8.30 in the morning, trains were leaving for Windsor every few minutes. On the ground, large stands had been erected each side of the Review Oak. The brilliant sunshine was shining right into the stands, which was a drawback of holding a Review in the morning. I have no doubt that some of the ladies were very unpopular when they opened their parasols.

On this occasion, many members of the Royal Household's had made their way to the ground independently, not by the accustomed line of carriages from Windsor Castle. Well before the King arrived, the best seats in the Royal Enclosure and Public Stands had been taken. The spectators included the Crown Prince and Princess of Sweden, Princess Patricia of Connaught, Princess Victoria of Schleswig-Holstein, Princess Alexander of Teck, and the Duke of Marlborough. In addition, there were two Marquesses, three Marchionesses, four Earls, three Viscounts, one Viscountess, five Countesses, two Duchesses, and many other distinguished persons, in the stands.

Shortly after 10 o'clock, a glittering column of blue, red and gold could be seen coming from the barracks across the Cavalry Exercise Ground as the Cavalry made their way to the parade-ground. When they arrived, they lined up with their bands (a band for each of the three regiments), who proceeded to play selection of music whilst waiting for the arrival of the King. At the Double Gates on The Long Walk, the King, wearing a Field-Marshal's uniform and riding his famous horse 'Delhi', was accompanied by the Duke of Connaught on horseback. Behind them was the Royal Carriage carrying the Queen and Princess Mary, as they proceeded to the Royal Enclosure. With perfect timing. an army airship arrived low over Queen Anne's Ride just as the King's arrival was being cheered by the thousands of spectators. The airship was watched with great interest as it circled the ground twice and then flew once round the Castle before heading back in the direction of Farnborough.

When the King drew up at the flagstaff, the massed bands broke into music, and the crowds of spectators in the stands rose as the Royal Salute was given. The King then proceeded to ride down the lines of the cavalry and back again to the saluting-base. The

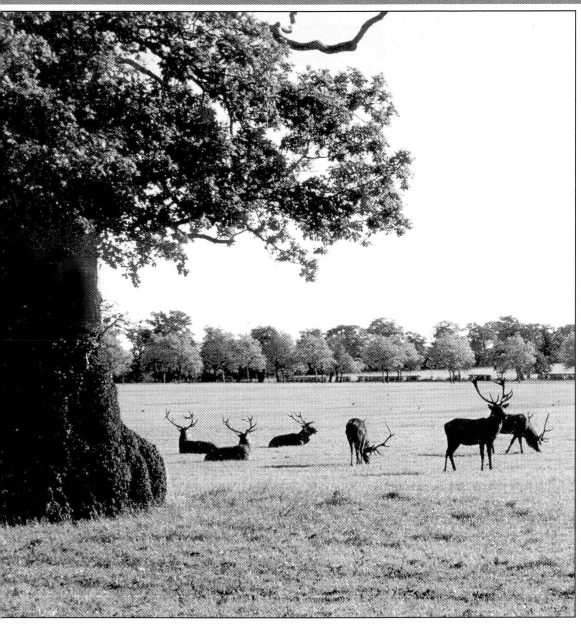

A group of red deer stags photographed in the Review Ground in October 1999 by the author. The Long Walk trees can be seen in the background and further back through the trees, is Newmeadow. The history of deer in the park and forest goes back to Norman times. They were introduced into the park for two purposes, hunting and for their meat (venison). Until the early part of 1941, the herds consisted of red deer and fallow deer. At that time it was found necessary to remove most of the deer to enable crops to be grown for much needed food during the Second World War. A small herd was rounded up and kept in the area west of Duke's Lane, presumably for re-stocking the park after the war. Alas this was not to be, as this herd was removed about 1948. It was not until 1979 that we saw the return of the deer.

Cavalry then put on a display of horsemanship, with a whole series of formation riding routines, which culminated with them lining up near The Long Walk. Then, at the sound of a bugle, they charged, line abreast, towards the stands, easing to a halt before lowering their lances in front of the stands. When the cheering had died down, the King and Queen departed to return to the Castle.

The Review was recorded as one of the best managed of all reviews, with particular praise being given to Mr. A J Forrest, the Crown Receiver and the park workforce. The St. John Ambulance Brigade, with Boy Scouts acting as orderlies, attended to at least sixty people who had fainted or had injuries. The Berkshire Police Force and a large force of Metropoliton Police, had their most difficult time controlling over 1,000 motor cars, hundreds of horse-drawn carriages and the mass of spectators, all trying to get through Queen Anne's Gate at the same time to go home.

Many of the spectators were unaware that a very sad

'Queen Elizabeth II at the Great Picnic 4th July 1981'

SATURDAY 5TH JULY

THE ROYAL PAGEANT OF THE HORSE

A Celebration of The Golden Wedding Anniversary of
Her Majesty The Queen
& His Royal Highness The Duke of Edinburgh
~ 1947 ~ 1997 ~

QUEEN VICTORIA REVIEW GROUND, WINDSOR GREAT PARK

Supported by

Asprey

LONDON

SOUVENIR BROCHURE

The main pavillion erected on the Review Ground for The Royal Pageant of the Horse for Saturday 5th July 1997. (Photo by Bill Cathcart).

Continuous rain in June 1997, whilst the Review Ground was being prepared for The Royal pageant of the Horse had turned the area into a field of mud. The conditions were so bad that the pageant had to be cancelled. (photo by Bill Cathcart).

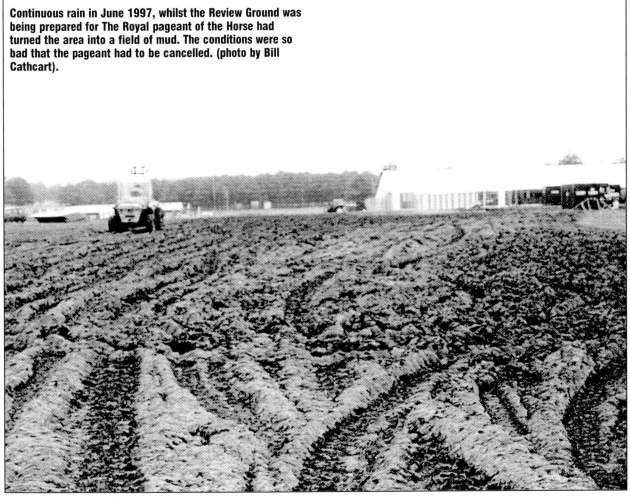

accident had occurred on the Saturday before, which happened during a full scale rehearsal by the Cavalry. The Cavalry were preparing for a charge, when a rider was thrown from his horse. The horse subsequently bolted, narrowly missing a policeman before running into a large cart bringing the horse to the ground. Before it could be caught, it galloped off towards the Double Gates on The Long Walk. It then hit a perambulator carrying a ten month old baby boy before the mother could pull it away. The baby was thrown to the ground and died soon afterwards from head injuries. The mother was treated, mainly for shock, at the King Edward VII Hospital before being allowed to go home. The horse was caught soon after the incident without incurring any serious injuries to itself.

Review of 2nd Life Guards, Coldstream Guards, Home Counties Reserves including the Surrey Infantry Brigade by King George V:

This was held on Thursday 8th April 1915 at 11.30 in the morning involving 850 troops. It was watched by several thousand spectators.

Although this Review was held in the spring, the weather on the occasion was very mild and sunny. However,

the event did not have the same festive atmosphere as had been experienced in the past, as we were now at war with Germany and the stark reality of modern warfare, with the high number of casualties being incurred, had a very sobering affect.

Well before the King was due to arrive, the troops, who were all reserves and who were dressed in khaki, had lined up on parade near Queen Anne's Ride. The Royal party arrived by way of The Long Walk from the Castle. The King was riding his black charger, escorted by a military escort and followed by four carriages. The first carriage was drawn by four greys and carried The Queen, Princess Mary, Prince Henry and Prince George. The following three carriages carried the King and Queen's guests. Arriving independently was a motor car which had driven from London with Queen Alexandra and Princess Victoria. On arrival, the King received a Royal Salute and then proceeded to ride down the lines of troops. With this completed, he was given three loud cheers. The troops then marched past the King, who had taken up a position at the saluting base near The Long Walk. They continued their march along The Long Walk and back to their quarters. The

Review was completed to everyone's satisfaction and without any mishaps. The one significant change from previous Reviews was the positioning of the saluting base, being near The Long Walk as opposed to the normal position near the Review Oak.

Review of the Life Guards by King Edward VIII:

This was held on Tuesday 7th July 1936 at 11.30 in the morning, involving 350 Life Guards and watched by several thousand spectators.

Although the weather was overcast, there was no rain to mar the occasion. All of the local schoolchildren, including those from the Royal School, were given a day's holiday to enable them to enjoy the event. It was the King's first official visit to Windsor since his accession. He drove to the Double Gates on The Long Walk in his car from Fort Belvedere at the south of Virginia Water Lake. He then mounted his black charger and, with the Earl of Athlone, Colonel of the Life Guards, at his side, he rode to the Guards lined up in front of the saluting base. Upon arrival, he was given a Royal Salute and the mounted band played the National Anthem. The King then passed down the lines before returning to the saluting base. The band took up a new position in the middle of the Review Ground to play 'Wheel may the Keel row', as the Guards trotted past the King in fours, followed by a series of formation movements. The finale was a charge to the music of 'The Campbells are Coming'.

At the end of the Review, the whole parade led by the King, moved off down The Long Walk to return to the barracks. The Long Walk and the streets of Windsor were crowded with people wishing to see the new King and to enjoy the ever popular military band and the spectacle of the Life Guards.

On a very cold night on Friday 2nd February at 10 pm, fifteen red deer hinds arrived on a transporter from the Balmoral Royal Estate in Scotland. They were unloaded in a prepared area at Bear's Rails. Almost two months later, a single red deer stag was introduced and by the autumn of 1980, forty calves had been born. Since that time a very large Deer Park has been created and the Review Ground is in the extreme north-western corner of that park. The Review Ground changed significantly during 1935-45 in the Second World War when the centre of the ground became the site for six anti-aircraft guns. The nearby fields were ploughed for much-needed food for the nation and the public were prohibited from the area. The full details how the park, forest and Windsor were affected during the Second World War are given in Chapter 18.

After the war, when the guns had been removed, the first post war event on the ground was the fiftieth anniversary celebrations of the first airmail flight, as already described, which took place on 9th September 1961.

A couple of years later, a horse-drawn ploughing match was held. Unfortunately, it was held during a dry spell and the ground had become rock hard. The event was a total disaster.

On Saturday and Sunday 4th and 5th July 1981, a Great Picnic was held by the Cancer Research Campaign to raise funds for the research. It was a huge success, raising thousands of pounds for this very worthy cause. Many fundraising groups and individuals had been sponsored to travel to the picnic, pushing beds, supermarket trolleys or by the more conventional method of cycling. The ground was the scene of many colourful shows and events, the most eye-catching being the hot-air balloons of all shapes and sizes. Many celebrities participated in the events. Dave Lee Travis (Radio Broadcaster) and Bob Champion with his Grand National winning horse Aldaniti, to mention two. (Bob Champion was an excellent steeplechase Jockey who, himself, was an ex-cancer victim).

Queen Elizabeth II, who was Patron of the Campaign, toured the ground on Saturday in an open-top car before being formally greeted by the Duke of Gloucester, President of the Campaign. The Queen then met the Picnic's organiser, Mr Michael Heyland before going on a 'walkabout'.

The summer of 1993 saw the return of the Scouts to the Review Ground. On this occasion they were accompanied by the Girl Guides when the WINGS (Windsor International Guide & Scout Camp) was held from Saturday 31st July to Saturday 7th August 1993. The opening ceremony started with a firework display, followed by the appearance of a rider on a brilliant white horse. He wore stag antlers on his head, depicting the legendary Herne the Hunter - a very appropriate theme for the park. The camp was attended by nearly 3,000 people representing twenty-four countries throughout the world. The weather could not have been kinder with glorious sunshine throughout. After a very enjoyable week, the closing ceremony was completed when everyone joined hands around an enormous camp fire and sang 'Heal the World', a song written by Michael Jackson the American popular singer. A lone scout from a Scottish troop played the pipes as the WINGS flag was lowered. The camp was a great success in spite of an

Windsor International Guide & Scout Camp 1998 Review Ground. From left to right:- Rosemary Dibben, S.W. Region Commissioner Guides. Bridget Towle, Chief Guide. Janet Russel, County Commissioner Guides (Berks). (Photo taken 6th August 1998 by the Author).

unplanned, and unwelcome, occurrence when three nude men were seen wandering close to the perimeter of the camp. When they were questioned by the police they said that they had drunk too much at a stag party. The police accepted their story.

The next large event was planned for 5th July 1997. This was The Royal Pageant of the Horse. Alas, the weather was so wet during the weeks leading up to the occasion that it had to be cancelled at the last moment. The Pageant was agreed to be the most suitable event to celebrate the Golden Wedding of Queen Elizabeth II and Prince Philip The Duke of Edinburgh, both being extremely interested in horses. It was originally planned to hold it on Ascot Racecourse, but it was felt that this venue was not large enough to cope with the extensive interest from the equestrian world. The Review Ground appeared to be the ideal location. Preparations for the event were carried out during June in continual rain and, with the need to bring heavy vehicles and equipment onto the site, the whole area was rapidly turned from a lush grass field into a quagmire of mud. The rainfall during the period was over three times greater than normally expected during June. Reluctantly, the organizers were left with no other option than to call the Pageant off, at considerable cost and to the great disappointment to everyone who was looking forward to the event.

The WINGS camp returned on 1st to the 8th August 1998 on much the same lines as the previous camp held in 1993. The security on the camp was of necessity well controlled, as I experienced first hand when I visited the camp on the Monday and the Thursday of the week. Even though I had been invited to the camp by Mr. R G Greenwood (Public Relations), I was scrutinized when I showed my pass at the entrance gate. It was well done.

On this occasion there were 1,350 scouts, 1,350 guides and 400 staff at the camp, consisting of representatives from the following countries:- Austria, Australia, Bahrain, British guides in Germany, Belgium, England, Finland, Ghana, Ireland, Italy, Japan, Maldives, Malta, Norway, Scotland, Sweden, USA and Wales. Themes provided at the camp were representative of many more countries and the centre of the camp was laid out as an enormous Union Jack. The week before the camp opened, an anxious time was experienced by the organizers when an outbreak of the killer disease, meningitis had affected a camp at nearby Chalfont St Peter. On Saturday 1st August the camp went ahead in torrential rain. Fortunately, the weather improved as the week went on, turning to glorious days of sunshine. The camp was superbly organised, with participation events for everyone's enjoyment. The on-site facilities included a post office, currency exchange, fuel centre, telephones, souvenir shop, tuck shop and an accident and emergency tent which was run by the South East Berks Emergency Volunteers. The younger generation in particular can

be a hungry lot and, during the week, 2,500 loaves of bread and 1,500 pounds of potatoes were consumed - just part of the total amount of food eaten

The camp was attended by the Chief Scout, George Purdy on Monday 3rd August and by the Chief Guide, Bridget Towle on Thursday 6th August. Other senior members of the Scout and Guides Association attended throughout the highly successful week.

The Windsor Horse Driving Trials were held on the Review Ground on the 3rd to the 5th of September 1999. The art of Carriage Driving, which is the general title used for this new and rapidly growing sport, was formulated in the 1960s and became fully established as an international event. In this country, its popularity was increased when Prince Philip, The Duke of Edinburgh became actively involved and competed in the sport. It followed that Windsor Great Park with its undulating and varied terrain would be the perfect location to stage these equestrian events. Since the early 1970s, the park has been the scene of many competitions held on a variety of courses.

The Trials was the last event to be held on the Review Ground before the world would unite to celebrate the start of the new millennium. The weather throughout the three days was ideal for equestrian eventing with the ground being in perfect condition. The first day on Friday 3rd September was for the Dressage Tests. The object of the tests is to test the freedom, regularity of paces, harmony, impulsion, suppleness, lightness and ease of movement. The horses must be correctly positioned, both on the move and at the halt, where all horses should stand attentive, straight and motionless. The driver is also judged on style, accuracy and control of the horses. Competing on the first day was Prince Philip, The Duke of Edinburgh.

On Saturday the Marathon Tests took place over a 21.3 kilometre (13.2 miles) course. The object is to test the fitness and stamina of the horses and the judgement of pace and horsemanship of the drivers.

The last day, Sunday, was for the Cone Driving Tests, designed to test the fitness, obedience and suppleness of the horses after the previous day's marathon.

The overall objective of the participants of the three day trials was to qualify for the 1999 National Championships to be held in Scotland later in the month. What was most impressive was the magnificent livery of the horses, carriages and drivers. At the conclusion of the trials, I reflected on the enormous history of events that had taken place on the Review Ground. When the field is empty but for the occasional deer, it is very hard indeed to imagine that it all took place. I wonder what the future has in store for this historical and fascinating part of the park.

The Long Walk

4

The Long Walk

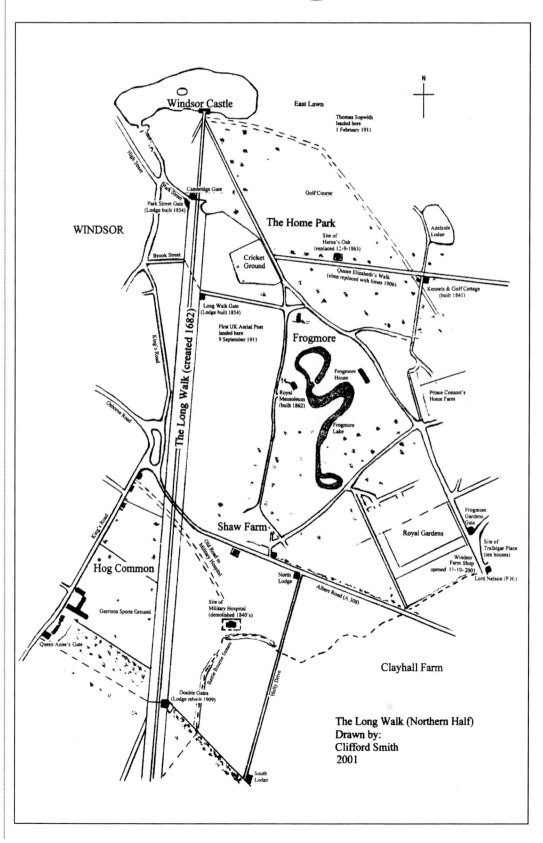

The Long Walk (Northern Half)
Drawn by:
Clifford Smith
2001

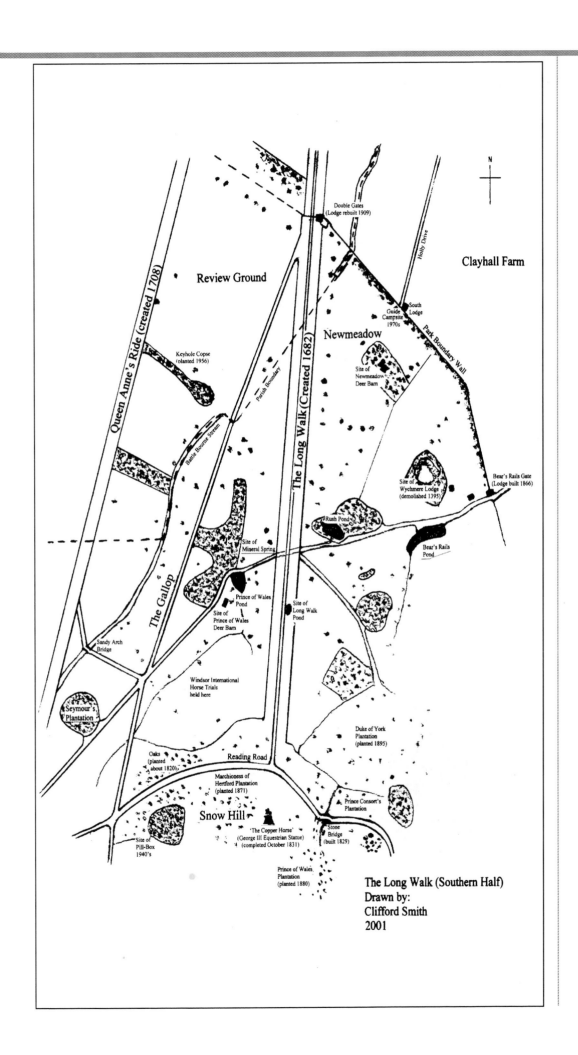

The Long Walk (Southern Half)
Drawn by:
Clifford Smith
2001

The Long Walk is a truly magnificent avenue of trees that stretches in a straight line from the Park Street Gate at Windsor Castle to Snow Hill, which is in a fairly central position in the Great Park. The King George III Equestrian Statue, or the 'Copper Horse' as it is more generally known, stands at the summit of the hill directly in line with The Long Walk. The walk is a perfect complement to the stately grandeur of Windsor Castle, and it is not surprising that it quite often receives as much interest from visitors as the castle itself. It has, as might be expected, an enormous amount of history associated with it, since its creation during 1682-5. However, before we go into some of the events that have taken place on or near the walk, it is important that we answer a question that is possibly asked more than any other. How long is it?. Looking down it from either end, you can see why it has often been said to be three miles (4.828 kilometres) long. In fact it is considerably shorter, being 2 miles 660 yards (3.822 kilometres) from the Park Street Gate to Reading Road, the road that runs in front of the Copper Horse. It is a further 255 yards (233 metres) from the road to the Copper Horse itself.

It would have been very convenient if the walk was lying directly in line with the north and south compass points. This was too much to ask for and far too convenient for cartographers. It lies in a direction of 5 degrees north-east and 185 degrees south-west. The walk consists of a metallised road running down the centre, with two rows of trees on each side. On each side of the road is a superbly maintained lawn. The first trees planted were elms, which looked extremely beautiful, particularly when viewed from a distance such as from the top of Snow Hill. The original number of trees planted was 1,652. They stretched right up to the top of Snow Hill to each side of where the the Copper Horse now stands. It is these trees that bring back the most nostalgic memories to the older generation. Over the years,

An Aerofilms photograph taken on 5th June 1947 from above Windsor Castle in an south-easterly direction. The old road to Staines and London can clearly be seen on the left heading through the Home Park and Frogmore. The newly planted trees along The Long Walk are barely visible, and the Copper Horse can just be made out at the far end of The Long Walk on Snow Hill. Smith's Lawn is shown as an L-shaped light clearing at the top right hand side of the picture.

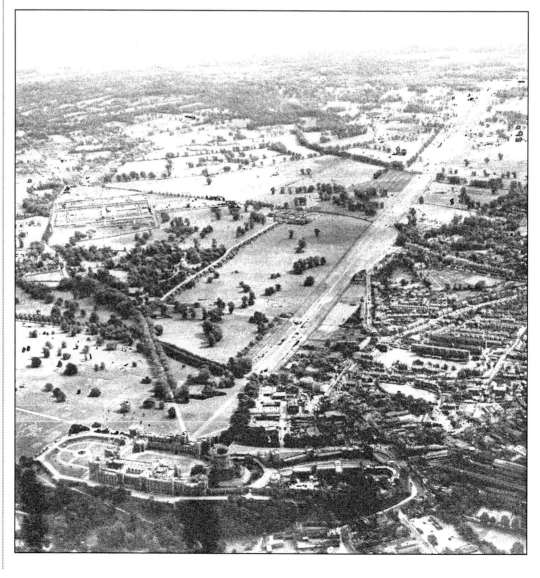

quite a few of the elms had to be replaced through storm damage and elm disease. Sadly, many of the young replacement trees were damaged by vandals, and in 1906 residents of Windsor were very upset when they saw the trees being destroyed as soon as they were planted (nothing has changed). During the 1800s, the trees on the grass slope of Snow Hill were cut down because they were restricting the panoramic view looking north from the hill. Each year the trees were becoming increasingly unsafe and there were a few incidents of people being injured by falling branches. In the 1920s, the first major step was made to replace them, and a stretch several hundred metres long, near the southern end of the walk, was replaced on both sides of the avenue. However, it was in the early 1930s that the complete removal of all of the elms began. Starting at the Reading Road, every tree was felled, including the ones planted during the 1920s, and replaced with horse chestnut and plane. In order to give the trees more breathing space as they matured, the outer rows were widened by 14.6 metres (48 feet), thus changing the overall width of the outer rows from 64.6 metres (212 feet) to 79.2 metres (260 feet). During 1980, every other tree was removed, changing the spacing along the row from 9.1 metres (30 feet) to 18.2 metres (60 feet). The trees are now maturing into something like the magnificence of days gone by, although we now have horse chestnut on the inner row and plane on the outer row. However, there will be a major problem to overcome sometime in the future as a horse chestnut tree is past its best when 140 years old, whilst a plane has a life span of 300 to 400 years.

The very fact that the northern end of The Long Walk is actually a very *short* walk from the main built up area of Windsor, and that it is grassed between the trees and is unlit at night, has for centuries made it a favourite trysting place for both licit and illicit lovers. The Windsor and Eton Express reported such an occasion in March 1865 as follows:-

'An elopement has taken place in this town which has caused great concern to the family of a young man closely related to a royal personage. The young man unfortunately became enamoured with a poor but, as far as we know, respectable girl who lived in the neighbourhood. This girl had all the graces of rustic charm and beauty.

The lovers used the hollow of a tree in The Long Walk to secrete their messages of love. The disparity of station made the match impossible but, before the young man's parents could act, the pair eloped and when they were eventually found in the North of England, they were married. The man's father took a generous course. He agreed to pay the passage of both parties to Australia.

We hardly need emphasise the disappointment and distress it has caused the parents, as the young man was due to enter a Military Academy and to

embark on the career of an officer.

Starting from the castle end of the walk and working down the whole length to the southern end at Snow Hill, the main features and historical events are as follows:-

The main public entrance is by way of Park Street which runs in front of the southern side of Windsor Castle. The main iron gate entering the walk is known as the Park Street Gate, with the Keeper's Lodge standing on the left and the Cambridge Lodge standing on the castle side. Upon entry, a magnificent view is seen looking down the walk to the south. Immediately towards the castle stands the Cambridge Gate, which is not open to the public. The original name of Park Street was Pound Street, and until 1851 it was a very popular public road which ran from Windsor across the top of The Long Walk, through Frogmore and coming out at the Frogmore Gardens Gate, near the Lord Nelson public house at Old Windsor. It then continued on to Staines and London.

On the western side of the walk, at a distance of 219 metres (240 yards) is the Brook Street footpath entrance. A tarmac surfaced footpath leads from this entrance at an angle to the gate that is the entrance to Frogmore. This gate is known as the Long Walk Gate, although, as with many other gates in the park, this gate was often known by the name of the gatekeeper who happened to be living in the gate lodge at the time. It is the stretch of the walk between the Park Street Gate and the Long Walk Gate that has been the scene of so many public occasions. Going back to King George III's reign during the 1700s, it was a common occurrence for military bands to entertain on public holidays and Sunday afternoons. It has also been the venue for firing miniature cannons on special occasions such as Royal birthdays. Sometimes pistol duels took place

The Long Walk looking south from the top of the Round Tower, Windsor Castle in 1955. The photograph clearly shows The Long Walk rising up where the Albert Road crosses and again at the far end at Snow Hill. (photo by the Author).

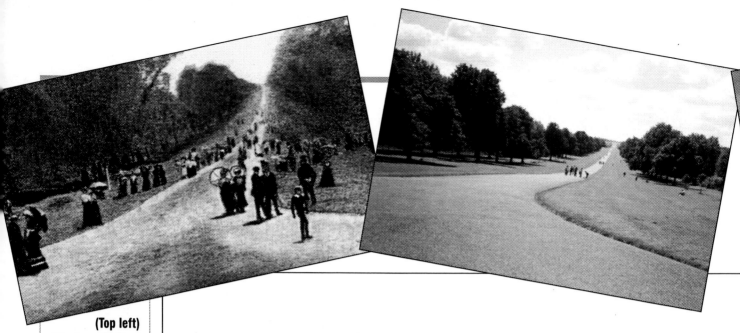

(Top left)
The Long Walk at
the extreme
northern end near
Park Street Gate
at the start of the
1900s. (Author's
collection).

(top right)
The Long Walk at
the extreme
northern end
nearly one
hundred years
later in July 1999
(photo by the
Author)

(Main picture)
The northern end
of The Long Walk
with sheep
grazing to keep
the grass short in
the 1930s.
(Author's
Collection).

SOUTH FRONT, WINDSOR CASTLE.

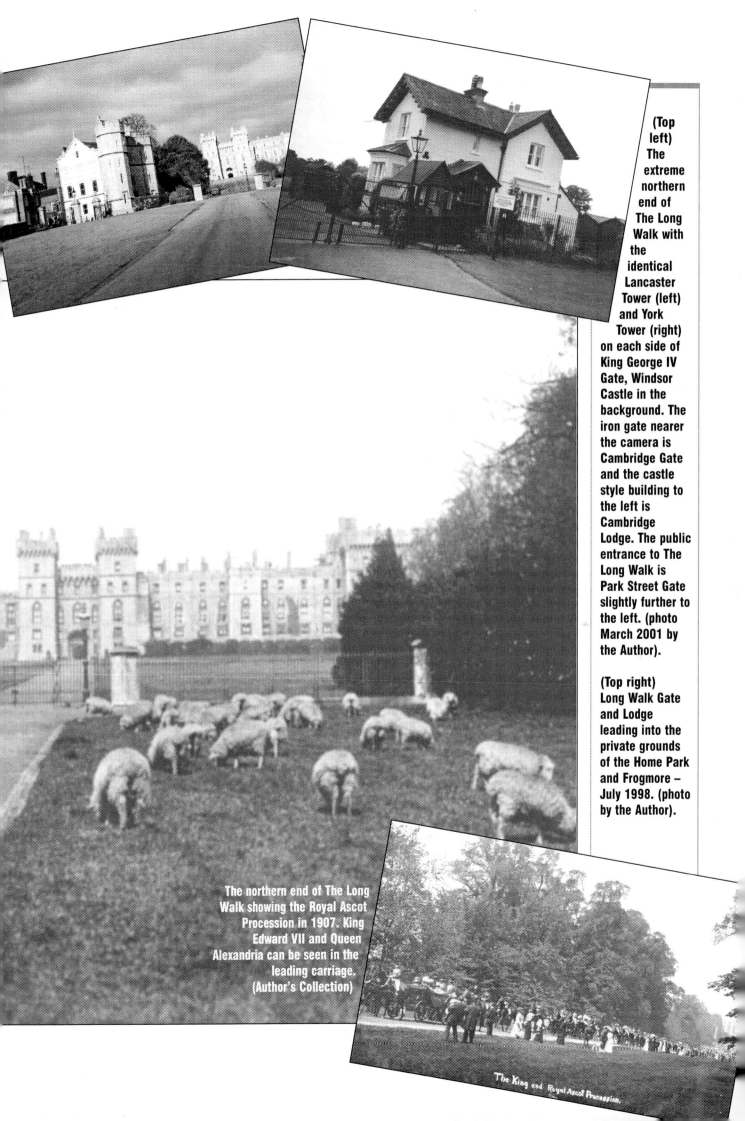

(Top left) The extreme northern end of The Long Walk with the identical Lancaster Tower (left) and York Tower (right) on each side of King George IV Gate, Windsor Castle in the background. The iron gate nearer the camera is Cambridge Gate and the castle style building to the left is Cambridge Lodge. The public entrance to The Long Walk is Park Street Gate slightly further to the left. (photo March 2001 by the Author).

(Top right) Long Walk Gate and Lodge leading into the private grounds of the Home Park and Frogmore – July 1998. (photo by the Author).

The northern end of The Long Walk showing the Royal Ascot Procession in 1907. King Edward VII and Queen Alexandria can be seen in the leading carriage. (Author's Collection)

The King and Royal Ascot Procession.

THE ROYAL ENTRANCE, WINDSOR CASTLE
FROM THE LONG WALK

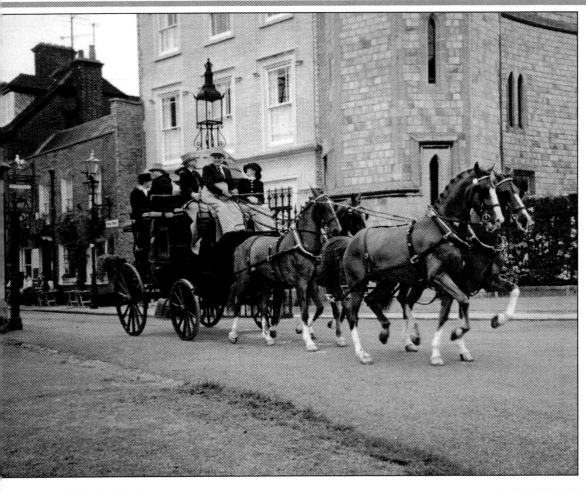

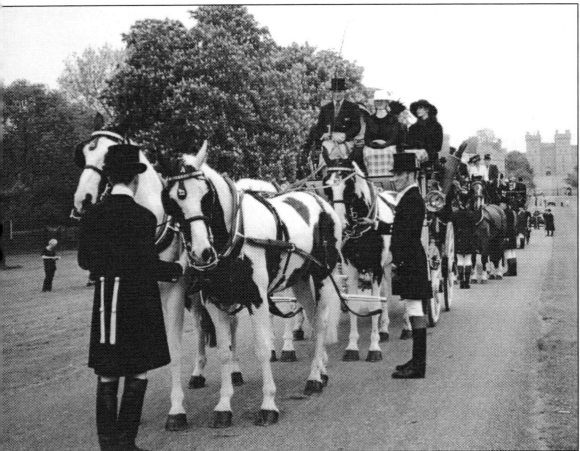

(top left) The northern end of The Long Walk looking towards Windsor Castle. The painting is by A.R. Quinton about 1880 when the road was made of gravel. (Author's Collection).

(bottom left) A twenty-one gun salute on The Long Walk as part of Queen Elizabeth the Queen Mother's 100th birthday celebrations on Friday 4th August 2000. Note how the cannon nearest the camera has been thrown on its back by the discharge. The tradition of firing cannons on The Long Walk for special occasions goes back centuries. (photo by the Author).

(top right) A stagecoach passing through Park Street Gate during the Royal Windsor Horse Show Coaching Marathon event on Friday 12th May 2000. (photo by the Author).

(bottom right) The stagecoaches being judged for presentation in The Long Walk during the Royal Windsor Horse Show Coaching Marathon event on Friday 12th May 2000. (photo by the Author).

King George V horse-riding with three of his sons at the east side of the Long Walk opposite Brook Street c.1926.

Left to Right: King George V. Born: 3rd June 1865. Acceded: 6th May 1910. Died: 20th January 1936; Prince Albert, the Duke of York. Born: 14th December 1895. Acceded: 11th December 1936 as King George VI. Died: 6th February 1952; Prince Edward, The Prince of Wales. Born: 23rd June 1894. Acceded: 20th January 1936 as King Edward VIII. Abdicated: 11th December 1936. Died: 28th May, 1972; Prince George, The Duke of Kent. Born: 20th December 1902. Died: 25th August 1942 in an aircrash.

there. One such event took place on Thursday 18th August 1826 at 11 o'clock in the evening. Two men drinking heavily in the New Inn in Park Street became embroiled in a heated argument. One of the men challenged the other to a pistol duel and he promptly took up the 'offer'. The duellists, assembled customers and the landlord went to The Long Walk. The challenger shouted that he would shoot a ball through his rival's body, and backed this statement up by taking on wagers of a guinea. When the men were lined up waiting for the signal to fire, the challenger ran for cover behind the portly form of his second. His opponent fired and missed both the second and the challenger. The opponent was declared the winner.

On 26th June 1830, King William IV became monarch, following the death of King George IV. The new king having decided to make Windsor Castle his home, an enormous event was held in the walk on Wednesday 18th August 1830 to celebrate his formal arrived at Windsor. Most of the shops in the town were closed for the day and, by midday, the walk was packed with people and rows of long tables stacked with food and drink. Over 3,000 plates and 4,000 glasses were used during the day. The King and Queen arrived at 2.30 in the afternoon to loud cheering. In the evening a giant firework display was laid on for the public in the castle grounds.

From the 1870s to the start of the First World War in 1914, this area of the walk became very much a social gathering place on Sunday afternoons, where people could put the world to rights and show off the latest fashions.

February 1911 was a month of extreme excitement for the Royal Family and the people of Windsor. Aviation history was being made by Tom Sopwith, when, on several occasions he flew his aircraft from Brooklands in Surrey to land on Datchet Golf Course, and on the East Lawn in the grounds of Windsor Castle. Although hot air balloons and airships had flown over the park before this time, it was the first recorded occasion involving an aircraft.

On Wednesday 1st February 1911, Tom Sopwith took off from Datchet Golf Course at 2.30 in the afternoon. A buzz of excitement was growing on the East Terrace of the castle where the Royal Household and servants had gathered. A similar excitement was being felt by the people who had gathered in The Long Walk. It must be remembered that many people at the time had never seen an aircraft before. First, the sound of the single E.N.V. engine could be heard as the biplane approached and, as it came clearly into view, it proceeded to fly around the castle and over The Long Walk about 100 metres (91 yards) south of Park Street before making a perfect landing on the East Lawn. The aviator was greeted by King George V, who was accompanied by Prince Henry, Prince George and Prince John. The King congratulated him on his success, not only for being the first person to fly round the castle, but also for his recent win of the £4,000 prize for the longest British flight in a British-designed and built machine.

Tom Sopwith, who was just 23 years old when he made this memorable flight, had landed on Datchet Golf Course two weeks before to visit his married sister, Mrs Raikes, who lived at Datchet. The aviator's full name was Thomas Octave Murdock Sopwith. Born on 18th January 1888 in London, he studied engineering at Seafield Engineering College. In November 1910, he first came into the public eye when he broke the British flight duration record with a time of 3 hours 13 minutes. This was attained at his operating base at Brooklands, the birthplace of British motorsport and aviation. In 1912, he founded the Sopwith Aviation Co. Ltd. at Kingston-upon-Thames. It was here that he designed the 'Sopwith Camel' biplane that was to attain so much recognition during the First World War. Later he became joint managing director of the H.G. Hawker Engineering Co. Ltd. at Kingston-upon-Thames. This company was to go from strength to strength with some outstanding aircraft designed by Sydney Camm from Windsor, culminating with the 'Hawker Hurricane' fighter aircraft, which became the mainstay of the Royal Air Force during the 1940 Battle of Britain in the Second World War. Tom Sopwith died on 27th January 1989 at the ripe old age of 101 years. What a man.

By a very strange chance in life, Tom Sopwith's granddaughter, Priscilla Sopwith, who became a district nurse, delivered her very first baby on 16th May 1958. That baby was the author's nephew, Martyn Smith.

Just seven months after the historical flight by Tom Sopwith, another milestone in aviation history was made. The day was Saturday 9th September 1911 when at 5.15 in the afternoon, a Bleriot monoplane landed in Shaw Farm Meadow to the south-east of Long Walk Gate. This was no ordinary event. The aircraft, flown by Gustav Hamel, of Scandinavian descent, had taken off from Hendon in London barely twelve minutes earlier. On board the aircraft was a mailbag carrying the very first aerial post delivery in Great Britain. It was also one of the very first services in the world. Speeds of up to 100 miles per hour were reached during the flight from Hendon to Windsor which was no mean feat considering the craft was only fitted with a 50 h.p. petrol engine.

The flight had been organised to commemorate the coronation of King George V. It was an extremely fitting event for such a Royal occasion. The mailbag weighed 10.66 kgs (23.9 lbs) and contained 1,100 letters and cards. The mail was addressed to the King and members of the various Royal Households. Many of the letters were addressed to the residents of Windsor and, by 7 o'clock in the evening, they had

The commemorative plaque of the first aerial post on 9th September 1911. It is fixed to the east fence of the Long Walk just south of Long Walk Gate. (photo 1998 by the Author).

ROYAL BOROUGH OF WINDSOR AND MAIDENHEAD

BEYOND THIS FENCE IN SHAW FARM MEADOW AT 5·13 P.M. ON SEPTEMBER 9TH 1911, AFTER A FLIGHT FROM HENDON, GUSTAV HAMEL LANDED WITH THE FIRST U.K. AERIAL POST TO COMMEMORATE THE CORONATION OF KING GEORGE V.

Priscilla Sopwith, granddaughter of Tom Sopwith, proudly holding Martyn Smith, who was the first baby she delivered after becoming a district nurse. Martyn, who was born on 16th May 1958, was the first born child of the Author's brother and sister-in-law, Denis and Shirley

Thomas Octave Murdoch Sopwith, generally known as Tom Sopwith, sitting in his bi-plane on Wednesday 1st February 1911 after landing on the East Lawn, following his historical flight around Windsor Castle. Tom Sopwith made his name in aviation history when he produced the highly successful 'Sopwith Camel' during the First World War.

all received their mail. Gustav Hamel took off with a return delivery of mail at 6.05 in the afternoon. There were no more flights that day. The next flights did not take place until Monday 11th September and these occurred at the northern end of the Review Ground. These are covered in Chapter 3.

Currently, we take it for granted that we can walk along The Long Walk any day that we wish.

However, this was not always so. In years gone by, the Great Park was closed to the public for one day every year as a measure to preserve the rights of the Crown. The following is an example of the wording of a notice displayed at the entrance to The Long Walk:-

'All gates in The Long Walk and the Home Park (Public) will be closed from 7.00 am on Thursday 6th to 7.00 am on Friday 7th January, except Queen Anne's Gate and Forest Gate. Holders of keys will be able to pass through as usual.

By order of: H.R.H. Prince Christian, Ranger, Cumberland Lodge, 30th December 1915.'

'On Tuesday afternoon 13th March 1928 Miss Connie Denham, of Bolton Road, Windsor, was walking in The Long Walk, when she found a bag full of silver articles in the ditch near Brook Street Gate. The Police were notified who confirmed that they were obviously the contents of a recent burglary as the items were still highly polished and consisted of table knives, forks, spoons, ornate teaspoons and silver match boxes etc. It would appear that the burglar had only just dropped them in panic.

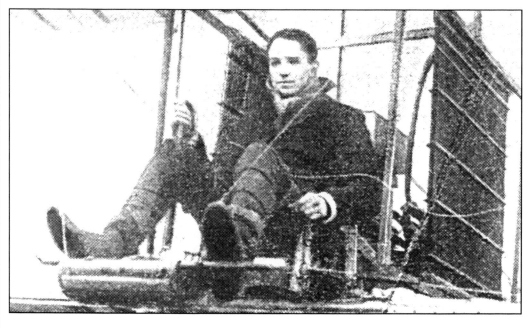

The very first official delivery of Aerial Post (Airmail) in the world. The photograph was taken on the East Lawn at Windsor Castle on Saturday 9th September 1911. The postman cyclist is Walter Kersley seen handing a postcard to Mr. A.A.T. A'Vard the Windsor Postmaster. Gustav Hamel, the pilot of the aircraft that landed at Shaw Farm Meadow, is the hatless person standing next to Walter Kersley. (The Royal Borough of Windsor and Maidenhead Museum Collection)

Looking to the east of the walk are the historical private grounds of Windsor Castle. The northern part is known as The Home Park. This includes the East Lawn, South Slopes, Queen Victoria Walk, Adelaide Lodge, The Golf Course, Cricket Ground, Queen Elizabeth's Walk, Kennel Cottage (since it was divided into two premises during 1900s, the other half is known as Golf Cottage), Royal Mausoleum and Frogmore House. Much has already been written about most of these features and it is not really necessary to comment further. However, the one exception is Kennel Cottage, which stands at the junction where Queen Victoria's Walk meets Queen Elizabeth's Walk. This cottage (it is really quite a substantial house) is very historical as far as the author's family is concerned. It was here that my great uncle Henry Smith and his sister, great aunt Ellen Maria Smith lived during the 1870s and 1880s. Henry had at one time been a Gamekeeper in the park. It was because of his love of dogs, that he was appointed as a Dogkeeper to look after the Royal dogs that were kept in the kennels on the east side of the cottage. The cottage was a short distance away from Herne's Oak, the site of the tree where the legendary 'Herne the Hunter' was said to have been hanged.

To his Most Gracious Majesty the King.

"May it please your Majesty. We, the undersigned Directors of the Grahame-White Aviation Company (Ltd.), and the undersigned Pilot Aviators of the First Aerial Post of the United Kingdom, conveying, this 9th day of September 1911, your Majesty's mails from the London Aerodrome, Hendon, to Windsor Castle, humbly and respectfully greet your Majesty, and offer sincere congratulations that the first official
Aeropost service of the world has been inaugurated in your Majesty's Dominions during the first year of your Majesty's reign.

We believe this important event will become historical, and its development will lead to a revolution of the present modes of conveying communication between the peoples of the world.
We are, your Majesty's most humble and obedient servants: (Signed) Herbert W. Mathews. Thomas Gates. L. Williamson (Directors).
Clement Gresswell. C. Hubert. E.F. Driver. G.W. Hamel (Pilot Aviators).

One of the several letters sent to the King George V in the first mailbag

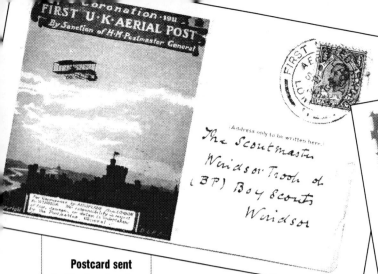

Henry never mentioned having seen Herne's ghost or hearing the baying of hounds that was so often reported by people over the years. Many theories have been put forward concerning Herne the Hunter, the most common one being that he was an outlaw who roamed The Great Park and Windsor Forest in the days of Henry VIII. His ghost, with horns on his head and riding ahead of a pack of hounds, haunted the park from the day he was hanged. In truth there was probably a man named Herne (Hern or Horn), who was an habitual poacher, and who was eventually caught and hung for his misdemeanours. From this the legend was founded. Incidentally, there is a French equivalent known as 'Grand Veneur of Fontainebleau'. The original Herne's Oak was cut down in 1796, when it was completely dead. Its name was transferred to another tree nearby which was subsequently blown down on 31st August 1863. In its place another tree was planted by Queen Victoria on 12th September 1863. When the elm trees of Queen Elizabeth's Walk were cut down in 1906, this latest tree was also cut down and the commemorative stone was placed next to an existing tree, standing nearby on the north side of the walk.

The author's great aunt Ellen Maria Smith, previously mentioned, was born on 6th May 1851 at Swinley Lodge, at the entrance to Swinley Park near Ascot. She was educated at the Royal School in the park and, being recognised for her excellent needlework, she went on to become a Royal Dressmaker. The Royal Household was very appreciative of her work, often giving her gifts for her efforts. She died on 9th June 1929 aged 78 years at the family home near The Thatched Tavern public house in Cheapside Road, Cheapside, near Ascot. A copy of a family letter in which part of a Royal Wedding and birthday cake given to Ellen had been wrapped is shown below.

Much has been written about Herne the Hunter, whose legend stems from the reign of King Henry VIII. For the author, there was a far more interesting and tangible character that lived as a hermit in the park during the late 1800s and early 1900s. He was 'Happy' Wootton, a person the author's father would talk to us about with amusing recollections. James Stanley Wootton was born in 1870 the son of a servant in Windsor Castle. He attended the Royal School in the park from 1877 to 1884, sometimes under the control of the author's great aunt Sophia Smith who was a teacher there. He was called 'Happy' by his class-mates because nothing appeared to upset him. When he left school, his father tried to teach him to be a locksmith. This was far too boring for Happy and, as soon as he was old enough, he enlisted in the Royal Berkshire Regiment, with whom he sailed to Bermuda. It was not long before his capers found him in trouble with the regiment and he was dismissed from the army. On return to England, he immediately made his way back to Windsor, where he began his outdoor life sleeping in the deer barns or in tree 'nests' which he made high up in the trees.

It was not long before he found himself before the magistrates in Windsor charged with poaching. Over a period of time the charges ranged from stealing eggs, catching pheasants, rabbits, young rooks, and pigeons which were particularly in high demand by the local tradesmen. His comments when being questioned in court were often highly amusing, as the following examples demonstrate:- When charged with poaching the Kings rabbits he replied, 'The rabbits ran into my

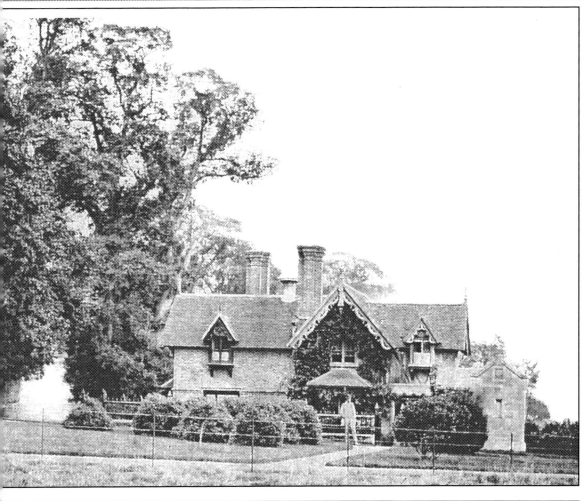

Kennel Cottage in the 1880s when the author's great uncle Henry Smith (Dog Keeper) and great aunt Ellen Smith (Dressmaker) lived there. The Royal Kennels were behind the cottage, and the old elm trees in Queen Elizabeth's Walk, seen on the left, were cut down in 1906. (Royal Borough of Windsor and Maidenhead Collection).

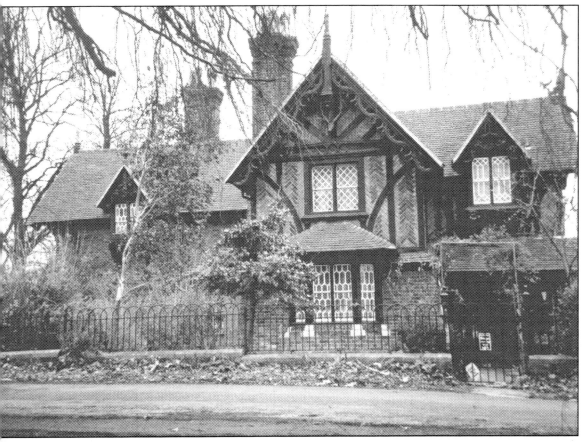

Kennel Cottage in February 1999. The branches in the top of the picture are from a large weeping beech tree that did not exist in the 1880s. (photo by the Author).

The Long Walk north of Albert Road on a breezy day in March 1955. The avenue of trees on each side had only been planted ten years before and Park Place, which was demolished in the 1960s, can be seen at the far left of the picture. (photo by the Author).

The Long Walk forty-six years later in March 2001. This unusual scene shows the results of the torrential and almost continuous rain that caused serious flooding throughout the country during the 2000 to 2001 winter. (photo by the Author).

The Royal Mausoleum built in 1862. It is the burial place of many members of the Royal Family. (photo 1955 by the Author).

pockets whilst I was asleep in the park and suffocated.' On another occasion he said, 'I made a trap and fell into it myself'. Another time, when he was accused of being late at the court, he said, 'I do not believe in running into trouble.' It must have been extremely difficult for the magistrates to keep a straight face during these episodes. The sentences for his poaching were anything up to two months' imprisonment. In an effort to make him mend his ways, he was sent to work on a farm in Wales. Happy was having none of this, he promptly walked off the farm and continued walking, all the way back to Windsor.

His tree climbing escapades were well known in the district, none more so than when he erected a Union Flag (Union Jack) on a pole at the top of the tallest elm tree in The Long Walk to celebrate Queen Victoria's Diamond Jubilee in 1897. On one occasion he built a 'nest' so high up an elm tree in The Long Walk, that the authorities had to use a large number of ladders strung together to enable them to pull it down.

Sadly, his tree climbing days and life came to an abrupt end in 1908. On Wednesday evening 29th April at about 10 pm. he was found groaning under a tree from which he had fallen in the park at Old Windsor. It appears to be an inhuman act that he was taken all the way to the Clewer Police Station at Windsor before a Doctor found that he had fractured his spine. The next day he was taken to the Old Windsor Infirmary (not far from where he had fallen). He died there the following day (Mayday) Friday 1st May 1908. On Tuesday 5th May 1908 he was buried near the park boundary wall at the Windsor (Spital) Cemetery. He was such a likeable character that over two hundred people, including his mother and two sisters, attended his funeral.

Moving down The Long Walk, the ground rises until it meets the Albert Road (A 308). This public

road was established in 1851 as a measure to take the public away from the existing road that ran through the Home Park to Old Windsor and Staines. The road is 1,170 metres (1,280 yards) from Park Street Gate. The very fact that Albert Road is the only public road to cut across The Long Walk causes its own problems. As it is a main route to and from Windsor town, vehicles carrying sightseers tend to slow down - and some even choose to stop - on the junction to get a better view of the castle, and to take photographs. Certainly, this location provides one of the most spectacular views of the castle as it proudly stands on the hill.

Heading towards Windsor, the Albert Road comes on to a large elongated roundabout junction. The first turning to the left is King's Road. This meets up with Sheet Street Road, which travels through the park to Ascot. The road on the other side of the roundabout is Osborne Road, whilst the road right around the roundabout, runs on a course almost parallel with The Long Walk past a public house until it meets the High Street. The public house is appropriately named the Windsor Castle, or by its long-time nickname, the 'First and Last', being the first and last public house on the road in and out of Windsor. Up until the 1960s, five houses which were the homes for Crown employees stood almost opposite the public house on the other side of the road. The houses were known as Park Place. It was sad to see those houses come down as everything looked so bare afterwards. It now looks perfectly natural to see no houses there and it has significantly improved the view. However, it was the building of the large roundabout in the 1960s that was to change the area so much. The roundabout replaced a much smaller one that was built in 1939. Originally, it was a cross-road junction simply known as 'The Fountain',

because of the drinking fountain and horse water trough standing at one side.

The stretch of The Long Walk between Albert Road and the Double Gates is a rather strange part of the walk, almost like being in no man's land. The land on both sides is steeped in history, very little of which has before been published. The large triangular shaped area of land on the western side is uninspiringly known as Hog Common. It was sometimes referred to as Queen Anne's Mead in the past. The three corner points of the area are the large roundabout at the north, Queen Anne's Gate at the south-west and the Double Gates on The Long Walk to the south.

At the northern end, there stands a character house facing King's Road called 'Bryn Brith' which, it is believed, was once used by the 'Bow Street Runners' as a gaol. To the south, there is a house called 'Queen Anne's Cottage', and further along, past the junction of Bolton Road, are two cottages known as 'Darvill's Cottages', which were completely rebuilt some years back. A small pond that once stood at the southern corner of the cottages was filled in at the time of the rebuilding. On the eastern side facing The Long Walk, two new houses were built for Crown employees in 1949. The houses are named 'Parkview' and 'New Lodge'. As it transpired, it was the garden of New Lodge that revealed an important part of local history. The first person to move into the house when it was new was Phil Greenaway and his family. At the time, he was employed as the cartographer at the Crown Estate Offices in the park. Phil, being a keen gardener, soon found that the making of the garden was not going to be as easy as he had anticipated. The prongs of his garden fork kept striking something very hard just below the surface. It was not until he had laboriously removed some of the topsoil that he realised that what he was actually standing on were the granite blocks of a very old road. A study of very old maps has confirmed that they were indeed part of an old road that ran between Bryn Brith and Queen Anne's Cottage, then through to the garden of New Lodge, across The Long Walk, curving in a south-easterly direction to a point where the Battle Bourne stream makes a sharp bend on Shaw Farm Estate. This was, in fact, an old military constructed road that led to the military hospital that once stood near the stream. It was known as the Hospital of St. Peter and dated back to c.1230. As its isolated situation suggests, it was used for patients with contagious diseases. During the 1830s it ceased to be a hospital, although, as the 1841 National Census records show, it was used for a period afterwards as living accommodation for several very poor families. By the end of the 1840s, the building had been demolished. For many years afterwards, the field was known as the Hospital Field.

In April 1859, the legacy of one of the hospital's unfortunate patients came to light. Under the instructions of the Prince Consort, the field, which was frequently waterlogged, had just undergone major drainage work. As part of the tidying up process, three boys were employed to collect up the large stones. One of them picked up what appeared to be a lump of lead. He was about to dispose of it, when he noticed that it was in fact a leaden case. When the boys opened it, they found to their amazement, that it contained 150 silver half-crown pieces. The coins carried the heads of, Elizabeth I, James I and Charles I. Most of the coins were in fine condition. The boys were in the process of sharing them out between themselves, when they were seen by the Consort's steward. The coins were duly handed in and given to Queen Victoria. The boys did receive a reward for the find.

On the next page is a photograph taken by Phil Greenaway showing the garden wall that he made in his garden from the road granite blocks.

The southern half of Hog Common, is more generally known as the Garrison Sports Field. As the name suggests, it is used for military sports, and has been used for this purpose for at least two centuries. The sporting activities started mainly as means to keep the troops occupied and fit when the field was used as a military camping ground.

In July 1865, the field was used for the Annual Encampment of the Berkshire Administrative Battalion of Rifle Volunteers. The camp lasted for a week and involved rifle shooting competitions at the park rifle ranges situated at the far southern end of Queen Anne's Ride. The sporting events were held on the camp site. At the time, the Berks Rifle Volunteers was still a relatively young organisation, consisting of about 400 members from branches at Abingdon, Faringdon, Wallingford, Wantage, Newbury, Reading, Sandhurst, Maidenhead and Windsor. Representatives from all of the above were camped in the field. The Windsor Great Park Rifle Volunteer Corps had 34 members present, which included the author's great grandfather George Smith (Gamekeeper) and great great uncle Charles Spencer Smith (Woodman). The camp was run on tight military lines with sentry huts with quaint thatched roofs at the entrances. Thatch was commonly used in those days by Crown employees to make shelters in the park. Reveille was at 5.0 in the morning, irrespective of whether anyone had a hangover from the previous night's drinking. A religious service was held at 8.0 every morning, with choirs from the Chapel Royal, Holy Trinity Church and St. John's Church, Windsor.

The daily routine would generally be sporting events in the morning, followed by a march down Queen Anne's Ride to compete on the rifle ranges. The evenings would be left to gatherings around the camp fires with mugs of beer to relax and chat about life in general. Quite often impromptu individual performances were carried out to entertain the

others, such as that given by William Menzies (Deputy Surveyor). Menzies, a Scotsman, was a highly accomplished highland dancer and violinist.

The sporting events were carried out in quite a competitive spirit. The £1 first prize for each event, a small fortune in those days, provided all the stimulus needed for the competitors. The titles of some of the events make highly amusing reading: The Running High Leap and the Running Long Leap to name just two.

Prizes for the rifle shooting competitions were even more substantial, with the value of the first prize being anything up to £20. The author's great grandfather and great great uncle were both accomplished marksmen, often taking home cash and other prizes after the regular shooting competitions. On one occasion, the author's great grandfather was narrowly beaten for the first prize.

The full history of the Windsor Great Park Rifle Volunteer Corps is given in Chapter 11.

Military athletic meetings reached their peak in the field during the 1940s, with competitors and spectators filling the ground to capacity. Many fine athletes of international standard competed there.

At the far south-western corner of the field, there are two groups of houses which are for retired Crown employees. The original six houses were built in the mid 1800s, and were known as Crown Cottages. During the 1960s a larger group of houses was added, known as Queen's Cottages. At the far southern end of the field, two Georgian houses once stood. These were demolished in the early 1800s.

On The Long Walk, stand the Double Gates, with the Gate Lodge on the eastern side. The Double Gates are a distance of 1.916 kilometres (1 mile 335 yards) from the Park Street Gate. The

gates mark the northern boundary of the Great Park with the old Park Pale (embankment) clearly seen today leading towards Spital in the west, and towards Old Windsor in the east. The original Gate Lodge was built during the 1720s. This was completely demolished and rebuilt in its current form in 1909. Looking south from the gates, the large open field on the right is the Review ground, the history of which, has been fully covered in the previous chapter. On the far western side can be seen the Queen Anne's Ride avenue of trees. Nearer The Long Walk is the start of the ride known as The Gallop. This runs in a south-westerly direction, meeting up with Duke's Lane, leading to Prince Consort's Gate. The field on the eastern side of the Long Walk, beyond the Battle Bourne Stream, is called Newmeadow. Until recent years, one of the old deer barns stood in the middle of the field. As you might expect, this was called Newmeadow Barn. This whole area of the park, to Old Windsor and Bishopsgate, along the southern side of Snow Hill through to Queen Anne's Ride and back to Queen Anne's Gate and the Double Gates, is now known as the Deer Park, so designated when the deer were returned to the park during February 1979. The Deer Park covers an area of approximately 405 hectares (1,000 acres), and it is surrounded by a 1.82 metre (6 foot) high wire fence, a necessary precaution bearing in mind the heights deer can leap when in full flight. The herd that was returned in 1979 was made up of red deer from the Balmoral Royal Estate in Scotland, consisting of 40 hinds and 2 stags. The deer have multiplied considerably since then.

At the entrance to the deer park, there is a very necessary warning notice as follows:-

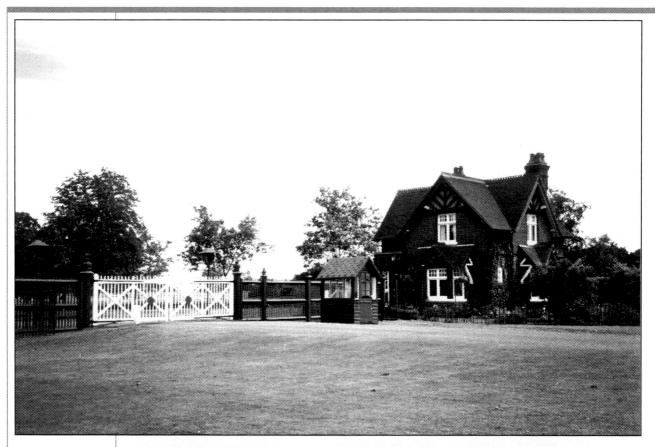

The Double Gates and Lodge situated where the northern boundary of the Great Park crosses The Long Walk – July 1998. (photo by the Author).

The Battle Bourne stream as it goes under the northern boundary wall of the park about 200 metres (219 yards) to the south-east of the Double Gates. This was once a favourite spot for the children of Windsor to go 'sticklebacking' – July 1998. (photo by the Author).

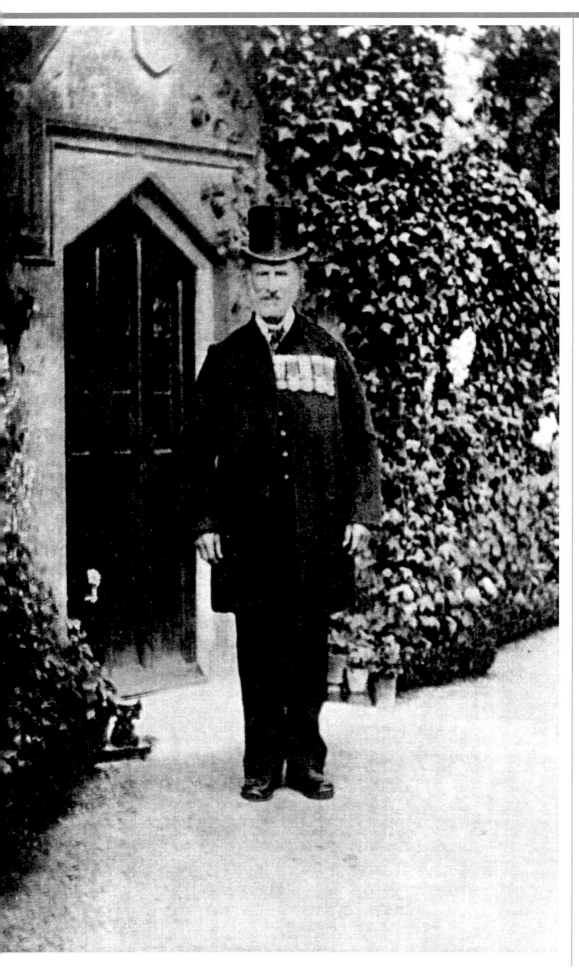

William Green Gatekeeper of the Double Gates on The Long Walk for over twenty years. Here he is seen standing outside the front door of the old lodge in about 1890, when he was 64 years old. Born in 1826 at Beckley near Oxford, he married late in life to Catherine Chapman (thirty years his junior) in 1886. They had one daughter, Bessie. He was noted for decorating the Double Gates with flags on all special occasions such as the Royal Reviews. (Royal Borough of Windsor and Maidenhead Collection).

DEER PARK WARNING
Always take care, as the deer are especially
dangerous during the calving period
May/June/July
and in the rutting season
September and October.

The Double Gates have for years been the starting and finishing point for various running races. On occasions, solo attempts have been made to run a distance to beat the clock for large wagers. One such occasion was held on 4th November 1826, when a seventeen-year-old German attempted to run from the gates to Bishops Gate and back in 36 minutes. To ensure that the runner did not cheat, he was accompanied the whole way by men on horseback. He ran for all his worth, collapsing to the ground on his arrival back at the gates. The judges announced that he had lost the wager by two minutes. However, the large crowd so admired his efforts, that they showered him with coins as he laid gasping for breath on the ground. The details of the many running events are described further on.

In 1906, another man of great character took over from William Green as Gatekeeper of the Double Gates. His name was Alexander Joseph McCarthy. Born in Ireland in 1865, he was a man of enormous physical strength and he served in the First Life Guards from 1884 to 1905, retiring as a Squadron-Corporal-Major. In 1901, he was honoured to be chosen as a pallbearer at Queen Victoria's funeral. Early in 1922, he was to receive the sad news that one of his sons had drowned in Canada. The shock was too much for him and he died suddenly a few weeks later on 15th February 1922.

About 300 metres (328 yards) from the Double Gates, the Battle Bourne stream passes through a culvert under The Long Walk. The open stream can be clearly seen leading away at an angle on each side of the walk. On the south-west side, it runs down from the park village and, at the other side, it travels in a north-easterly direction under the park boundary wall and across the Shaw Farm Estate into the Thames. Severe flooding has occurred here when the culvert has become blocked.

From this point, the ground gradually rises to where a ride crosses the walk. On the field on the right, just before the ride, stand two old horse chestnut trees. Until the 1970s, a scraggy walnut tree stood next to them. The walnut tree always had a very poor crop, whereas the horse chestnut trees had enormous crops. The trees were the main source for the local lads to obtain their 'conkers' to play the game by that name. The more important aspect of the trees is that they mark the location of once very popular mineral spring. In July 1825, King George IV had granite slabs and seats placed around it for use by the public. This was no ordinary spring, as the medicinal properties of the water were said to be equal to the nationally known Cheltenham and Leamington waters. The following is the report given when the water was analysed by the country's leading chemist, Professor Brande in June 1825.

The spring soon became very popular with members of the public and, at that time, the water was considered to be as good as any in the country. It is believed that the spring was popular for several decades, after which, for some unknown reason, it was no longer used.

The ride that crosses The Long Walk is at a point 3.127 kilometres (1 mile 1,660 yards) from Park Street Gate. On the left, it leads in a north-easterly direction connecting up with Bear's Rails Gate at Old Windsor. Barely 100 metres along the ride is Rush Pond. The pond is completely surrounded by trees and undergrowth and is fully enclosed within a high fence having no public access. It has an irregular shape and it is about 90 metres (98 yards) long and about 58 metres (63 yards) at the widest point. Because there is no stream leading into it, it suffers the affects of stagnation, and it is generally covered in various forms of weed. However, the very nature of the weeds and surrounding undergrowth, make it a perfect habitat for a wide variety of wildlife.

Prince of Wales Pond is situated on the opposite side of The Long Walk to Rush Pond. It is wedge-shaped and is about 82 metres (90 yards) long and about 58 metres (63 yards) wide at the head. Due to its shape, this pond was more generally known in the past as the 'Leg of Mutton'. The pond was drained during the summer of 1986 in order to enable the head to be completely rebuilt with some substantial

ANALYSIS OF THE STRONG SALINE WATER
FROM A SPRING IN
WINDSOR PARK.

This water is transparent and colourless, and affords
no indications of the presence of iron.
Its specific gravity is 1010.4, one pint (of 7000 grains)
left, after careful evaporation, 88 grains of
dry saline residue.
By the action of the tests the following
substances were detected in the water, and in the
annexed proportions in the pint.

	Grains
1.Sulphuric acid	33.00
2.Muriatic acid	21.00
3.Carbonic acid	00.98
4.Magnesia	21.25
5.Soda	10.52
6.Lime	1.25
Total contents	88.00

By the successive separation of the saline
substances during the evaporation of the water, it
is considered that the aforementioned substances
are arranged in the following combinations.

	Grains
1. Sulphate of Magnesia	38.00.
2. Muriate of Magnesia	24.50
3. Sulphate of Soda	10.80
4. Muriate of Soda	9.30
5. Sulphate of Lime	3.00
6. Carbonate of Soda	2.40
Total dry salts in the pint	88.00

A remarkable property of the water, not hitherto observed in any saline spring, is that when boiled it becomes turbid, and Carbonate of Magnesia is thrown down. This appears to depend upon the presence of the Carbonate of Soda, which, though compatible with the earthy salts in a cold and dilute solution, (such as is the water as it rises from the earth) decomposes them at a boiling heat, or when concentrated by evaporation.

and attractive brickwork. Because the pond is connected to the Battle Bourne stream, and the fact that the southern end is incorporated as a water feature for equestrian events, it seldom has a chance to stagnate.

Well into the 1960s, there was a very large deer barn standing just to the south-west of the pond. Before the Second World War the area was a natural and popular place for the deer to congregate.

At a distance of 165 metres (180.4 yards) south of the ride is the site of The Long Walk Pond. It was a natural 'dew-pond', which was semi-circular in shape and very shallow. The edge of the pond came to within half a metre of the eastern side of the road. Before it was filled in during the early 1930s, it was a very popular watering place for horse-drawn carriages.

From this point, The Long Walk levels off before sharply rising at the start of Snow Hill. To the east lays an open field that is not known to have any particular historical associations, just its natural

The two horse chestnut trees that mark the site of a once very popular mineral spring. Windsor Castle can just be seen to the left of the smallest tree – July 1998. (photo by the Author).

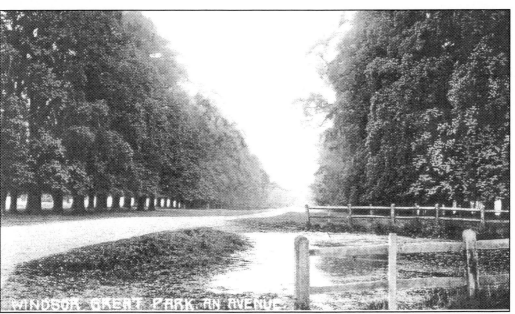

The Long Walk Pond looking north towards Windsor Castle in the early 1900s.
It was a favourite watering place for horse-drawn carriages before it was filled in during the 1930s. (Ruth Timbrell collection).

Rush Pond situated on the eastern side of The Long Walk near the ride that leads to Bear's Rails Gate – August 1999. (photo by the Author).

Prince of Wales Pond on the western side of The Long Walk near the ride that leads to the village -–June 1998. (photo by the Author).

A competitor seen clearing the jump in the lower end of the Prince of Wales Pond in the Windsor International Horse Trials, Saturday 22nd September 2001. (photo by the Author).

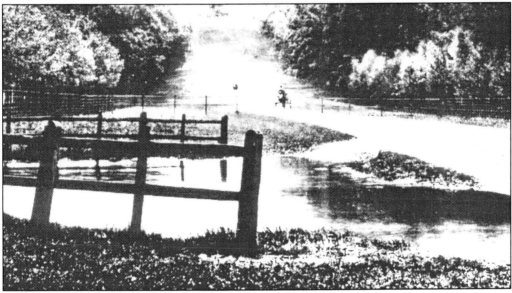

beauty - a place were time has stood still. To the west of the walk is a similar open field, standing in which are some truly magnificent old oak trees. In recent years, this field has become the venue for the Windsor International Horse Trials. Although the going here can be very hard underfoot for the horses in dry weather, this has become an extremely popular event for both competitors and spectators, attracting some of the best horses and riders from around the world.

The Long Walk finally meets up with Reading Road, which leads off to Bishops Gate in the east, and to Cranbourne Gate in the west. The junction of The Long Walk and Reading Road is 3.822 kilometres (2 miles 660 yards) from Park Street Gate. Reading Road is so named because it was once a popular high ground route between London and Reading. It fell out favour as the Windsor Forest Enclosure Act 1813 took effect.

The Reading Road as we see it today is not on the original route, which was higher up on Snow Hill. The old route can clearly be seen as a cut-out section that travels through the oak trees heading west. The current road came into being when the Stone Bridge, which passes over the deep ditch to the east, was completed in 1829. It should be pointed out, that Snow Hill was known as 'Snowdon Hill' in the 1600s.

The people who have walked, or run, up The Long Walk from Windsor, are usually relieved to see the Copper Horse statue standing just a short distance away at the top of Snow Hill. That short distance is very deceptive. To start with, the first part of the grass slope coming off the Reading Road is in the form of a steep embankment. During periods of wet weather, it becomes extremely slippery and hazardous. In these conditions, the wiser person will walk along the road to the left where the embankment is more gradual. One way or

95

The Long Walk at the extreme southern end at the Reading Road at the start of the 1900s. (Roy Whibley collection).

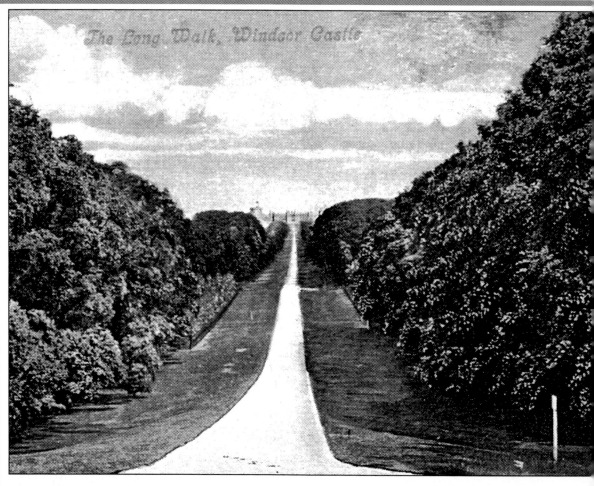

The Long Walk at the extreme southern end at the Reading Road nearly one hundred years later in July 1999. (photo by the Author).

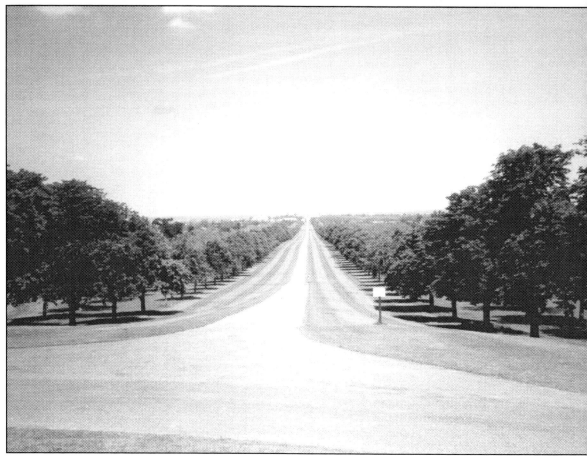

The Long Walk looking north from the southern end near Reading Road about 1935. The young trees in the foreground were planted about 1930 to replace the old elm trees, at the same time the outer row of trees on each side of The Long Walk were moved out by 24 feet (7.3 metres) as clearly seen in the photograph. The slightly larger trees at the end of the young ones were planted in 1921. By 1939, the widening and replacement planting had reached a point level with the southern end of the Review Ground.

Because of the affects of the Second World War, felling and replanting ceased during 1940-1941. After this short pause, the work continued and by 1944 the Double Gates were reached. An increased labour force accelerated the work, and by the end of 1945 the last old elm tree had been cut down. It was not until February 1946 that the replacement planting of Horse Chestnut and London Plane trees had been completed. It had taken a period of fifteen years to fell and replace every tree in The Long Walk. (Windsor Crown Estate Collection).

Cattle that originated from Scotland grazing on The Long Walk south of the Double Gates about 1942. (Windsor Crown Estate Collection).

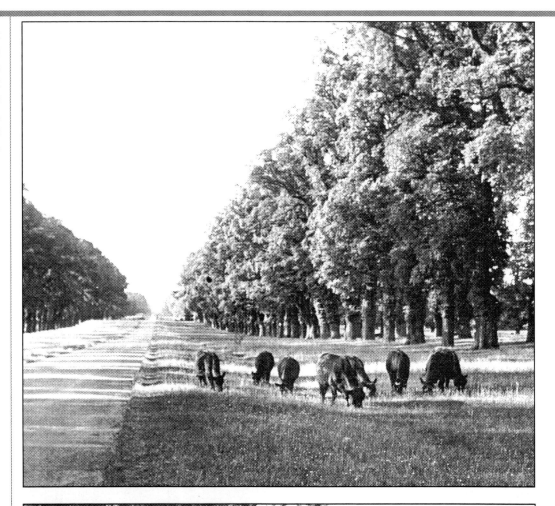

The Long Walk elm trees being felled south of the Double Gates about 1942. (Windsor Crown Estate Collection).

another, by the time you have reached the statue, you are generally in need of a rest.

Nothing quite replaces the experience of standing at the top of Snow Hill for the first time. Aside from the wonderment of seeing the statue at close quarters, the view to the north is stunning. The full beauty of The Long Walk, with the 'fairytale' castle at the far end and the fields and trees of the park to the east and west, is hard to describe and it has to be seen with your own eyes. It is well worthwhile to have a pair of binoculars or a telescope with you to obtain the full advantage of the view. Particularly fascinating is watching the airliners take off and land at London's Heathrow airport to the east. The height of the ground where the statue stands is 79 metres above sea level and it is a distance from Park Street Gate at the other end of The Long Walk of 4.055 kilometres (2 miles 915 yards) - just over two and a half miles.

The Copper Horse is the popular name for the King George III Equestrian Statue that stands on the top of Snow Hill. It is the most well-known landmark in the park and forest, mainly because it can be seen miles away from the north. It consists of two main features:- The horse and rider made of bronze (high copper alloy), and the pedestal made of granite. It was in 1822 that King George IV expressed his intention to have an equestrian statue of his late father, King George III, erected on the top of Snow Hill in his memory. It was seven years later that the first evidence of his wishes was more generally known.

The foundation stone was laid by King George IV to coincide with his sixty-seventh birthday on Wednesday 12th August 1829. The granite pedestal building work was carried out under the direction of Sir Geoffrey Wyatville and was not completed until two years later, in August 1831. The large single slab of granite, which is laid at the top of the pedestal, weighs four tons. The overall height of the granite pedestal is 9.144 metres (30 feet).

Half way up the north side of the pedestal, deeply cut into the granite blocks, are the words:-

GEORGIO TERTIO
PATRI OPTIMO
GEORGIUS REX

Translated from Latin, it reads:-

KING GEORGE III
BEST OF FATHERS
KING GEORGE IV

The transportation of the granite blocks to Snow Hill, without the use of modern roads and transport, was a major undertaking in its own right. The transportation of the horse and rider, having a total weight of twenty-five tons, from the foundry in London was no easy task. The wagon carrying the horse had a mishap at Staines and one of the horse's legs was considerably damaged. The leg was repaired using a makeshift forge. However, it was found that when the horse was erected on the pedestal, the repaired leg was badly out of position and had to be re-worked. It has always been a mystery to the author why the horse, which was constructed in sections, was transported by the sculptor Richard Westmacott in an assembled condition. Surely, it would have made more sense if it had been assembled on the site. The length of the horse from nose to tail is 6.270 metres (20 feet 6 inches). The girth of the horse is 6.4 metres (21 feet). The distance from the belly of the horse to the pedestal is 2.387 metres (7 feet 10 inches) and the overall height of the rider is 5.563 metres (18 feet 3 inches). To give you an indication of the size of the inside of the horse, sixteen persons

had their lunch inside it when it was lying on its side before it was erected. One of the persons who was inside the horse that day, was the author's great great grandfather, Joseph Smith who had planted many trees during the 1820s on Snow Hill.

The horse and rider were finally hoisted into position on Monday 24th October 1831. Although a number of people had gathered to watch the event, there appears to have been no formal unveiling ceremony. The overall height of the horse and rider is 7.772 metres (26 feet 6 inches) which gives it a perfect balance in size to the pedestal it stands on. King George IV did not live to see the finished work, having died the year before at Windsor on Thursday 26th June 1830 at the age of 67 years. It should be pointed out that the attire of the rider, King George III, was of classical Roman style and the wearing of the laurel wreath on his head is exactly how he appeared on our coins at the time. Over the years there have been several stories relating to the statue. The most common one is that the sculptor had forgotten to put stirrups on the horse and, upon realising his mistake, had hanged himself from a tree that stood in the direction in which the rider's finger is pointing. This is completely false on all counts, as the stirrups were never intended to be included and Westmacott did not hang himself.

By the end of the 1800s, the pedestal had taken on a different appearance, with bushes growing in considerable numbers from the crevices between the granite blocks. These, and new seedlings, have had to be removed from time to time. However, this is a minor problem when compared to the affects that time and the elements have had on the horse and rider. During the summer of 1956, it was found necessary to give the statue a thorough inspection followed by essential renovation work. To ensure that work was carried out in a satisfactory and safe manner, scaffolding was erected up to the head of the rider. After repair work and cleaning, the horse and rider were treated with a black protective coating. Unfortunately, this soon wore away and the statue has since undergone further inspections and maintenence work. A hazard has been created by combustible materials that are deposited inside the horse, creating a fire risk if hot repair work is found to be necessary. As long as the author can remember, jackdaws have entered the horse to make their nests by way of a small gap under the rider on the southern side. Anyone who has seen the amount of material jackdaws use to make their nests will appreciate the problem this causes. Birds were not the only ones to be attracted to the statue. Many young lads have found the temptation, and challenge, to climb the pedestal too much to resist. The author can clearly remember when he was twelve years old, climbing up the southern side of the pedestal and clambering onto the top to cling onto one of the horses legs. With legs

shaking through a mixture nervous tension and fear, the ground looked a miles away. The horrendous part was climbing down again. As this became more and more popular for boys, it was decided to erect an anti-climbing metal barrier on the southern side of the pedestal to prevent this very dangerous practice continuing. However, before this happened, a group of students on a moonlit night in the 1950s, festooned the horse and rider with strings of ladies' underwear as part of their rag week. No one could believe their eyes who saw it the next day.

For many years, The Copper Horse has been the focal point for celebrations of all kinds and, until the 1940s, it was a meeting point for hunts that took place in the park. The lighting of bonfires (beacons) in prominent positions throughout the British Isles to celebrate important events has been a long standing custom. Snow Hill, with its close proximity to Windsor Castle, has been a natural site for such events. Although it was used on lots of important occasions in Victorian times, it was during the celebrations for the Queen's Silver Jubilee in 1977 that the site really came into prominence. This memorable day was on Monday 6th June 1977. Although numerous events had already taken place during the preceding weeks throughout the country to celebrate the Jubilee, it was the 9.144 metre (30 foot) high bonfire that had been erected on the southern side of the statue that was to set celebrations going in full swing. Throughout the day, people were emerging from all directions to make their way to the Copper Horse. Refreshments had been laid on for early arrivals who had taken up the best vantage points. Aside from the bonfire, an ox-roast was ready in a position nearby, and a large bandstand had been erected to the west of the statue for the bands of The Life Guards and The Blues and Royals to provide the musical entertainment. The scene was set for an exciting evening.

For me, standing on Snow Hill in the early evening with a group of relations, it was an extraordinary sight to see the ever increasing numbers of people streaming up The Long Walk from Windsor. As the light of the day started to fade, an atmosphere of excitement was building up in the crowd which by now had grown in number to tens of thousands. When it was virtually dark, the first indication that the Royal Family was on its way from the castle was the sound of distant cheering from the crowd. In the Royal Party were The Queen, in emerald green, Prince Philip, Prince Charles, Princess Anne, Prince Andrew, Prince Edward, the Queen Mother, Princess Margaret and her children, Viscount Linley and Lady Sarah Armstrong-Jones. The Royal Land Rover was flanked by an escort of young torch bearers. Before them was a mammoth parade led with a blaze of colour by the Sussex Bonfire Carnival Society and their band. Upon

reaching the Reading Road, the parade turned left then right just before the Stone Bridge and, from there, the Royal Family made their way to the Copper Horse. To add to the colour of the celebrations, members of The Sealed Knot, dressed as Cavaliers and Roundheads, had congregated along the route and on Snow Hill. On the two days preceding, this organisation had carried out re-enactments of the English Civil War battles in the local area

At 10 o'clock, six-year-old Mark Richards from nearby Maidenhead had the honour of handing the Queen the silver torch to ignite the fuse which set off the bonfire. This gave the signal for the lighting of bonfires all over the British Isles. The full programme of events on Snow Hill was being seen by millions of people all over the world by satellite on television. This modern system helped to co-ordinate the lighting of the bonfires. From here the Royal Family made their way round to the Royal Box, which had been erected on the northern side of the Copper Horse, to watch a 15 minute firework display. The display was several hundred metres down The Long Walk and culminated with a giant set piece in green, red, blue and gold: 'ER II 1977', with a Royal portrait. The Royal Family watched the television link-up with the other bonfires being shown as they lit up on a map on a giant screen. They then made their way to the traditional ox roast to taste the ox, which had been roasted by the Army Catering Corps. The events were concluded at 11 o'clock when the Royal Family departed. The mass exit of spectators from the park created massive traffic jams when they started to leave in their cars, and it was well after 2 o'clock the following morning before the traffic was clear in Windsor. The only mishaps during the celebrations, were when the bonfire had been whipped up into a raging inferno by the wind causing sparks to fly and burn holes in people's clothes.

The next major event on Snow Hill was the celebrations on Tuesday 28th July 1981, the eve of the marriage of Prince Charles and Lady Diana Spencer. Although this was a joyous occasion, with the usual bonfire, fireworks, ox roast and band, it was not of the magnitude of the 1977 Jubilee. It was estimated that 20,000 persons had made their way onto Snow Hill to join in the festivities. The bonfire this time was erected on the northern slope towards the Stone Bridge and it was lit at just after 10 o'clock following the first bonfire which had been lit in Hyde Park in London. As before the bonfire was 9.144 metres (30 feet) tall.

Sadly the marriage was to flounder. After having two children, Prince William in 1982 and Prince Harry in 1984, very tragically, Princess Diana (Princess of Wales) lost her life through a car accident in Paris in the early hours of Sunday 31st August 1997.

Following the burning of the enormous bell-shaped bonfires of 1977 and 1981 the next event was held on Monday 8th May 1995 to celebrate the 50th

anniversary of V.E. Day (the formal ending of the Second World War in Europe). This 'bonfire' was lit in a more conventional iron cage mounted on top of a large pole. Although this did not have anything like the grandeur of the full-size bonfires, it was nonetheless quite spectacular, and it could be seen for miles away, particularly in its prominent position slightly to the front and to the west of the statue. Mainly because there was so much exciting national television coverage of the country's celebrations at the time, there were only a few hundred people there that night and these were mostly estate employees and relations.

As mentioned earlier, The Long Walk has been the central point of many running events. During Victorian times it became a popular place for the local garrison to keep fit and to compete in running races. In the 1900s, the running activities became more

The King George III Equestrian Statue, generally known as 'The Copper Horse' majestically standing at the top of Snow Hill at the southern end of The Long Walk. In 1900, the pedestal was covered with vegetation as the picture shows. It was erected by King George IV in memory of his father, King George III. Completed in August 1831, it bears the latin inscription on the pedestal which means:- 'King George III – Best of Fathers – King George IV' (Author's Collection).

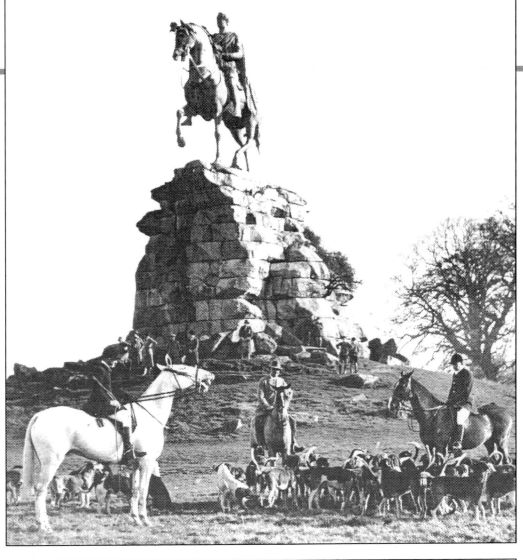

A hunt meeting at The Copper Horse in the 1930s at a time when hunts were still very popular in the park. At the time, The Copper Horse, Cumberland Lodge, Cranbourne Tower, Sandpit Gate and Stag Meadow were frequent meeting points. As a boy, the author clearly recalls that the Stag and Hounds public house at Spital in Windsor was a regular meeting point for the hunts, being so handy for the military officers who were stationed at the nearby Combermere Cavalry Barracks.

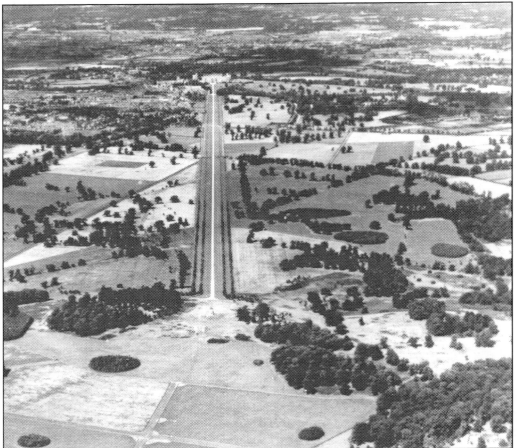

An Aerofilms photograph taken on 15th August 1951 from the south looking straight down The Long Walk towards Windsor Castle. The two lines of trees planted during the 1930s and 1940s on each side of The Long Walk are starting to mature. The Gallop Ride can clearly be seen as a straight line coming from the left and meeting The Long Walk near the double gates. The Royal Lodge and Ox Pond are at the bottom of the picture.

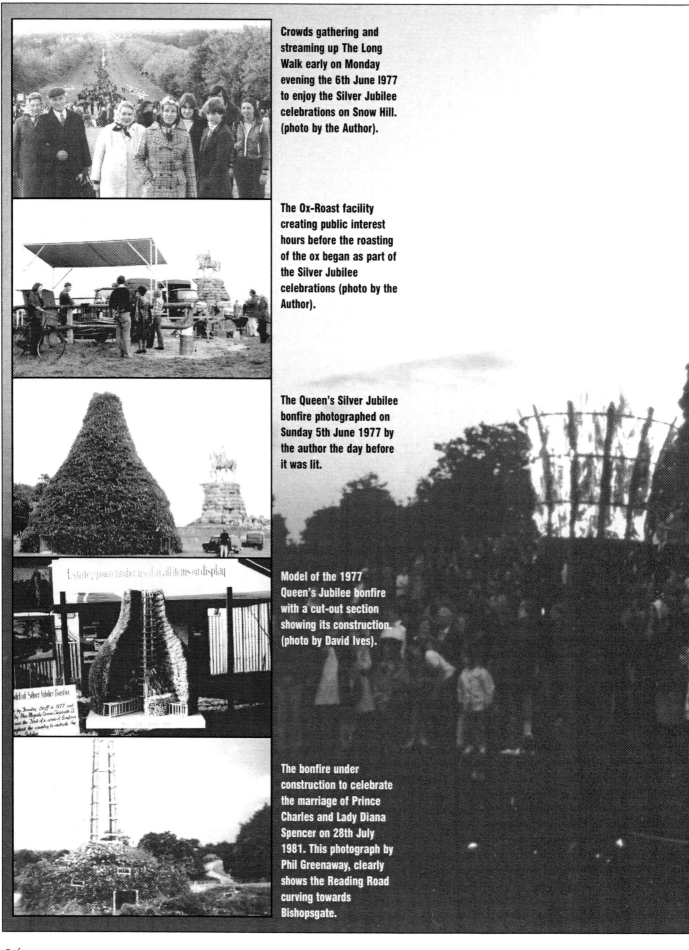

Crowds gathering and streaming up The Long Walk early on Monday evening the 6th June 1977 to enjoy the Silver Jubilee celebrations on Snow Hill. (photo by the Author).

The Ox-Roast facility creating public interest hours before the roasting of the ox began as part of the Silver Jubilee celebrations (photo by the Author).

The Queen's Silver Jubilee bonfire photographed on Sunday 5th June 1977 by the author the day before it was lit.

Model of the 1977 Queen's Jubilee bonfire with a cut-out section showing its construction. (photo by David Ives).

The bonfire under construction to celebrate the marriage of Prince Charles and Lady Diana Spencer on 28th July 1981. This photograph by Phil Greenaway, clearly shows the Reading Road curving towards Bishopsgate.

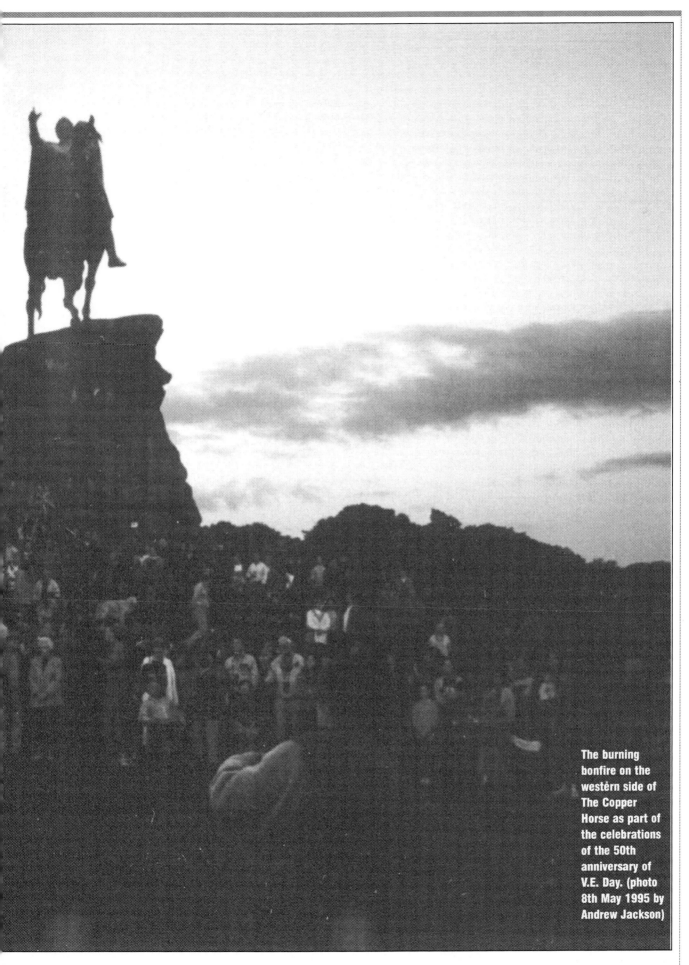

The burning
bonfire on the
western side of
The Copper
Horse as part of
the celebrations
of the 50th
anniversary of
V.E. Day. (photo
8th May 1995 by
Andrew Jackson)

common with the civilian population and it was regularly used by the Windsor Harriers for cross-country training and races. (The Windsor Harriers disbanded during the latter part of the 1940s. They were totally unconnected with the current Windsor Slough Eton and Hounslow Athletic Club which was formed in the 1949-1950 cross-country season.)

On Saturday 13th March 1920 the park was the venue for a major athletic event when the best of the country's runners arrived to compete in the National Cross-Country Championships. About 250 runners, representing 28 clubs, with the addition of many individuals competing on their own, was at the far northern end of Hog Common near the Albert Road. On a bitterly cold and wet afternoon, the race was started at 4 o'clock by the Earl of Athlone, in the presence of Princess Alice, Countess of Athlone, Colonel the Hon. Claude Willoughby (Deputy Ranger), Mr. A.J. Forrest (Deputy Surveyor) and many other dignitaries and spectators. The runners had only just started the ten mile (16 kilometre) course when, as they were climbing over the iron fence into the Review Ground, the fence collapsed. Fortunately, there were no serious injuries. They continued across the Cavalry Exercise ground and through the gate into Flemish Farm, then up the ploughed field towards Star Clump and then Ranger's Lodge, Prince Consort's Workshops, past The Battery to the Copper Horse, then down The Long Walk to the Double Gates. At the Double Gates, they turned left to continue on a second circuit of the course. Upon returning to the Double Gates, the final stretch of the race continued along The Long Walk and finished at Long Walk Gate. The winner was the French champion, C.A. Guillemot in a time of 1 hour 1 minute and 9 seconds. The second was Sergeant C.T. Clibbon, (Birchfield Harriers). Third was C. Vose (Warrington A.C.) and the fourth man home was James Wilson, who received the greatest cheer of all because he was actually born at Shaw Farm. A few weeks before, he had won the Scottish Cross-Country Championship.

On Saturday 26th April 1924, The Long Walk was part of the course of a more unusual sporting event. This was the National Road Walking Championship, held over a distance of twenty miles (32.18 kilometres). The start was at the junction of Frances Road and Osborne Road, and the route along Osborne Road to The Long Walk and up to Reading Road in front of the Copper Horse, turning left and around the Royal Lodge to Cumberland Lodge, Prince Consort's Workshops and along Sheet Street Road, Kings Road to The Long Walk. Then back up The Long Walk to cover the circular part of the course twice more with the last part of the race finishing opposite Brook Street in The Long Walk. Nearly one hundred competitors from all over the country set off starting at 3.15 pm on this gruelling event. After the first lap, F.E. Clark was well in the lead, only to be

overtaken during the second lap by the reigning champion, F. Poynton of Leicester Harriers. Poynton maintained his lead finishing a convincing winner in a time of 2 hours 47 minutes 17 seconds. Second was G. Goodwin of Surrey Walking Club in 2 hours 49 minutes 31 seconds. Third was T. Johnson of Leicester Harriers in 2 hours 54 minutes 17 seconds. The winning team was Belgrave Harriers.

The Windsor Harriers were the hosts of The South of the Thames Cross-Country Championships, which were held in bitterly cold snowy and icy conditions on Saturday 8th February 1947. The seven-and-a-half mile course started at Long Walk Gate, went up to The Copper Horse around the Royal Lodge and back again. In the race were 200 competitors from 20 athletic clubs and, as expected, the top clubs at the time won the team events as follows:- First: Aylesford Paper Mills. Second: Belgrave Harriers. Third: Hern Hill Harriers. After the event, the trophies and medal presentations were held at Combermere Barracks.

A larger and more significant cross-country event was held on Saturday 18th February 1956. This was the Southern Counties Cross-Country Championships and consisted of three races, Senior, Junior and Youth. The start was from the Double Gates and the course went up The Long Walk turning right before Reading Road, then back down The Gallop. The length of each race was governed by the number of circuits involved. In common with normal cross-country races, it was bitterly cold and the nervous waiting around to be called to the start did no-one any favours. In spite of the adverse weather, a large crowd had gathered to watch the runners endeavour to win or to do well. The first race of 4.827 kilometres (3 miles) was for the youths. The second race, and the most important, was for the seniors, and it had the distinction of being started by Prince Philip, the Duke of Edinburgh. At 3 o'clock in the afternoon the Duke set the runners on their way on the gruelling three-lap 14.481 kilometre (9 miles) race. By the start of the third lap, a small group of four runners had broken away from the main pack. The winner was Peter Driver of South London Harriers, second was Ken Norris of Thames Valley Harriers and third was Dennis O'Gorman of St. Albans City. Although O'Gorman was beaten into third place, he without doubt had put in the most outstanding performance because he was so short in stature compared to his two conquerors, he was taking almost two strides to their one.

The next and last race was the junior which started at 4 o'clock. The distance was 9.654 kilometres (6 miles) and the winner was S. Seal. of Ponders End, second was S. Langridge of South London Harriers and third was Stan Eldon, the local athlete of Windsor and Eton Athletic Club (the Slough Athletic Club was to amalgamate a few years later and Hounslow Athletic Club in 2001). It was Stan Eldon who had deposed

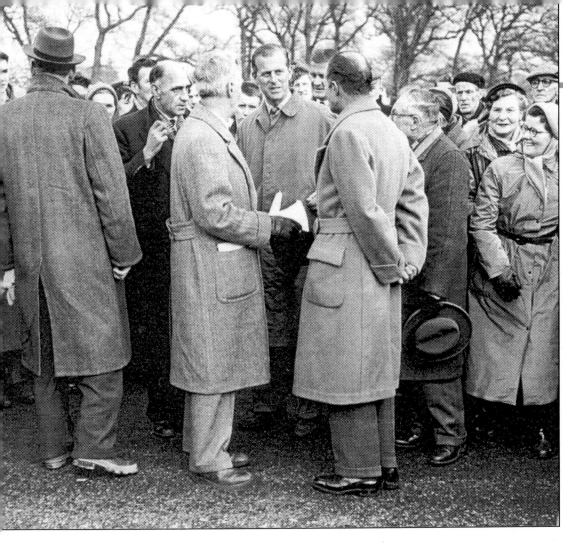

the author some years earlier as the club's cross-country champion. Stan was to go from strength to strength, becoming one of the county's top athletes winning the International Cross-Country event in Cardiff in 1958 and many other cross-country and track races at the time.

By 1960, the enthusiasm for cross-country was at its greatest, which was demonstrated by the large number of runners who turned out to compete in the South of the Thames Cross-Country Junior Championships on Saturday 12th November 1960. 500 runners started from the Double Gates on the 8.045 kilometre (5 miles) very wet and muddy course. It must be said that the local club did not perform to their full potential, with the first runner from the club coming home in 64th position.

In June 1976, The Long Walk was used for the first time for the start of the oldest and best known marathon in the country. Until that time, the 'Polytechnic Marathon' as it was known, had been run from Windsor Castle in a roundabout route to Chiswick in West London for many years. The ever-increasing volume of traffic had made it very difficult to manage, and it was found necessary to change the course to a more manageable and safer route, which took it down The Long Walk, through the park village to Sandpit Gate, across Smith's Lawn to Blacknest Gate. The route continued to Woodside and on to Warfield Church turning back across Winkfield Plain, the New Lodge, Oakley Green, along Dedworth Road and finishing at the Clubhouse in Vansittart Road in Windsor.

The difficulty in planning the route was to ensure that it covered a distance of 42.2 kilometres (26 miles 385 yards), being the recognised international distance for the marathon. This very popular annual race fell out of favour soon after the introduction of the London Marathon in 1981.

Since 1982, the main running event held annually in the park is the Windsor Half Marathon. This event has, since its beginning and until recently, been superbly managed by Mrs Alysia Hunt, Race Director, with many group and individual volunteers from different organisations. The race, under its full title of the Building Industry Windsor Half Marathon, has raised over £1,000,000 for worthy causes since it started. Recently the words 'Building Industry' have been dropped from the title of the race. In my opinion, it is events like these that bring out the best in society.

The Half Marathon is usually held on the first Sunday of October each year, and caters for everyone, from serious competitors to fun runners, whether old or young, both ladies and men, able and disabled; everyone has a go. The start is at a point where the Battle Bourne Stream runs under The Long Walk, with the changing and essential facilities in the field to the west. The original course was up to the Reading Road, around the park village, along Duke's Lane to Ascot Gate, Blacknest Gate, Smith's Lawn, around the village again, then back down The Long Walk, a total distance of 21.1 kilometres (13 miles 192 yards). The main part of the course is now run in a clockwise direction.

The start of the senior race of the Southern Counties Cross Country Championships on Saturday 18th February 1956. A point of interest is how young the trees were at the time in The Long Walk. (Len Runyard Collection).

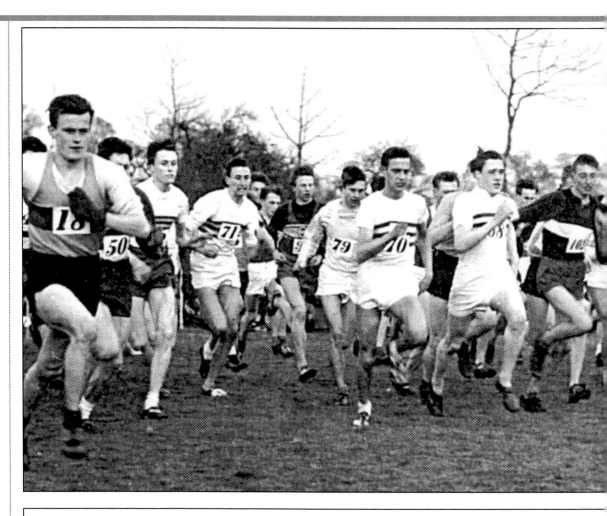

The start of the Building Industry Windsor Half Marathon Sunday 4th October 1998. Philip Everett, Deputy Ranger is silhouetted against the smoke from the starting cannon. (photo by the Author).

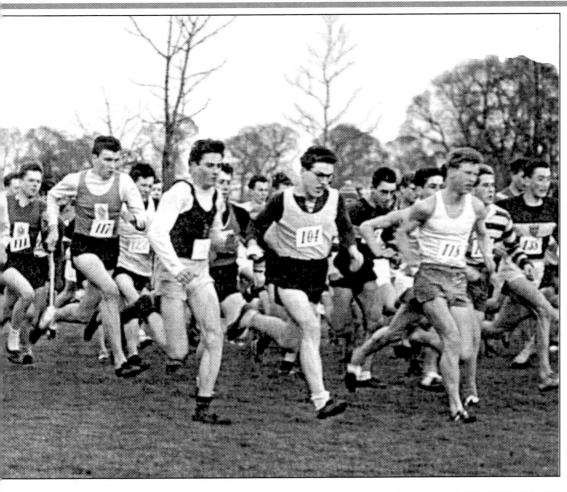

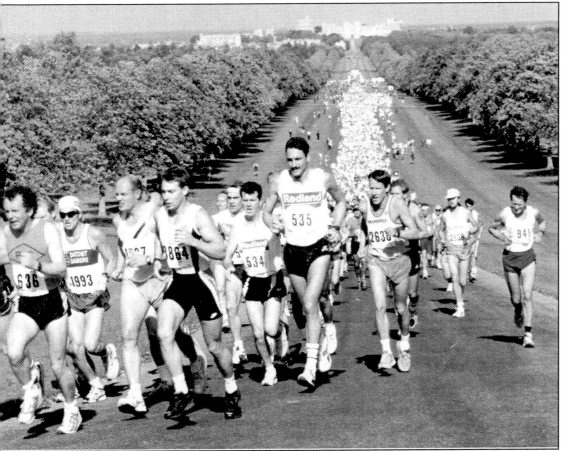

The Building Industry Windsor Half Marathon Sunday 1st October 1995. The runners are starting to turn right onto the Reading Road. (photo by Mike Nicholson Photography, Bracknell).

The runners streaming up The Long Walk shortly after the start of the Windsor Half Marathon on Sunday 30th September 2001. The wet and chilly conditions are clearly evident, with Windsor Castle barely visible on the horizon. (photo by the Author).

The two Kenyan athletes literally ran away with the race. The winner, wearing No 1, was Peter Edukan with a time of 1:07:50. Second was Julius Kibet 1:07:51. Tim Hyde from the Windsor Slough Eton and Hounslow Athletic Club was third 1:13:36. (photo by the Author).

Old Windsor

Old Windsor

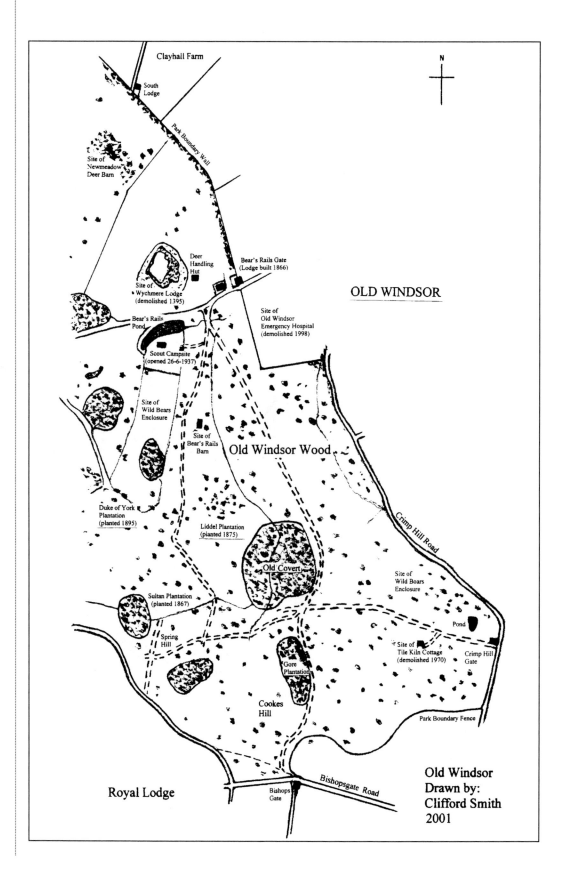

Clayhall Farm

South Lodge

Park Boundary Wall

Site of Newmeadow Deer Barn

Deer Handling Hut

Bear's Rails Gate (Lodge built 1866)

OLD WINDSOR

Site of Wychmere Lodge (demolished 1395)

Bear's Rails Pond

Site of Old Windsor Emergency Hospital (demolished 1998)

Scout Campsite (opened 26-6-1937)

Site of Wild Bears Enclosure

Site of Bear's Rails Barn

Old Windsor Wood

Duke of York Plantation (planted 1895)

Liddel Plantation (planted 1875)

Crimp Hill Road

Old Covert

Site of Wild Boars Enclosure

Sultan Plantation (planted 1867)

Spring Hill

Pond

Gore Plantation

Site of Tile Kiln Cottage (demolished 1970)

Crimp Hill Gate

Cookes Hill

Park Boundary Fence

Royal Lodge

Bishops Gate

Bishopsgate Road

Old Windsor
Drawn by:
Clifford Smith
2001

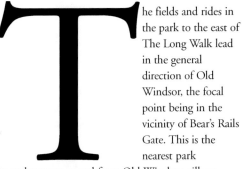

The fields and rides in the park to the east of The Long Walk lead in the general direction of Old Windsor, the focal point being in the vicinity of Bear's Rails Gate. This is the nearest park boundary gate to and from Old Windsor village. Unless visiting the Scout Camp, vehicles are not permitted to enter the park through the gate. The current Gate Lodge was erected in 1866 to replace a much older lodge that had stood on the opposite side of the drive.

Just inside the park on the right stand two semi-detached houses which were built in 1949 for park employees. The first one is named 'Rushmere', and the second one is 'Marion'. These are of typical 1940s building style. Beyond them, and some way in the field on the right, is one of the most historical sites in the park. Within a fenced and tree-packed enclosure is the site of Wychmere Lodge. It is known that the lodge was a substantial building surrounded by a double moat. For about thirty years before the lodge was demolished, near the end of the 1300s, it was used as a Royal hunting lodge. It is believed that King Edward III sometimes slept there. During September 1919 the site was partially excavated by a small team led by Captain Vaughan-Williams. At first it was thought that it was the site of Edward the Confessor's Palace. However, the items unearthed disproved this possibility. In the 1960s the site was listed as an Ancient Monument. It should be pointed out that there is no permitted access by the public to the site, either into its own protective enclosure or into the area of the deer park in which it stands. Since the reintroduction of deer to the park in 1979, a large deer-handling hut has been erected just to the north of the site.

In general, the return of the deer to the park caused a lot of excitement, in particular to the older generations who had so many memories of them before the Second World War. Unfortunately, the erection of the deer park fences between Bear's Rails Gate and the Double Gates on The Long Walk, excluded the public from the very popular walk within the boundary wall of the park. This direct route between the two gates has very strong memories for the author's family, mainly because we were petrified of the stags in the rutting season. Often we would climb on top of the high boundary wall on our way home from Old Windsor, walking on top as far as we could before having to climb down where the wall ended before South Gate Lodge, at the southern end of Holly Drive. Then we would climb up again when the wall re-started on the other side of the lodge, finally getting down where the Battle Bourne stream went under the wall. For many years, a large deer-barn stood in the middle of Newmeadow field to the south.

It was during the existence of Wychmere Lodge that a number of wild bears were kept, fenced in by high railings to the south of the Lodge. It is from this unusual part of the park's history that the name 'Bear's Rails' was derived. One very interesting feature of the area is Bear's Rails Pond. This is situated approximately 200 metres (219 yards) in from Bear's Rails Gate. It was created by damming up the existing stream, which continues on its way towards Old Windsor. It is crescent shaped, being about 165 metres (180 yards) long and 44 metres (48 yards) wide at the head. Although the pond is the home for some sizeable common carp, fishing for them is not permitted at any time. In recent years, the outgoing stream has been made more attractive by adding some miniature shallow waterfalls. Unfortunately, these can only be appreciated in wet periods. The pond has become more well known to the public since the Boy Scout Camp was set up on the south-eastern bank in 1937.

Bear's Rails Gate and Lodge as seen from inside the park – July 1998 (photo by the Author).

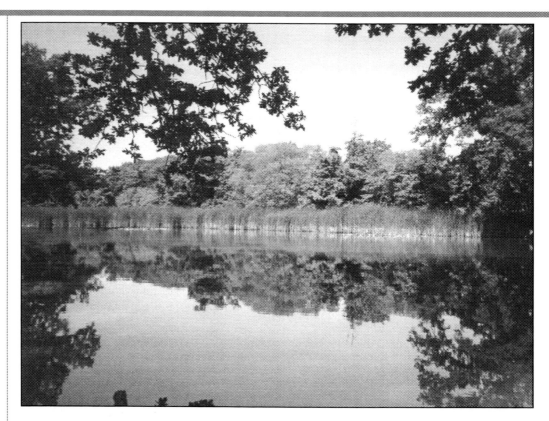

In 1935, the Windsor District Boy Scouts Association approached the Crown Authorities for a two acre campsite in the park. King Edward VIII, who later became the Duke of Windsor following his abdication, gave his consent for the campsite at Bear's Rails. However, because of the cost of the tenancy, the District Scouts could only afford to use three-quarters of an acre (0.303 hectares), even taking into account that the fencing and fresh water supply was a 'do-it-yourself' job on the part of the scouts.

This much loved and popular campsite was officially opened on Saturday evening 26th June 1937 by Mr Owen H. Morshead, librarian to King George VI. On the eventful weekend of the opening, which took place barely six weeks after the coronation of King George VI on 12th May, there were 200 scouts and cubs camped there. They were under the Command of District Commissioner, F. S. Soons, who lived in Windsor. Among those present at the opening ceremony were, Mr O. H. Morshead, Lieut-Colonel R. Pennell, Chairman of the Windsor Association, Admiral R. Collins the Assistant County Commissioner for Berkshire, and Mr E. H. Savill Deputy Ranger of the Park.

In the opening address, Mr Morshead spoke about the origins of the Scout Movement, started by Lord Baden-Powell in 1908, then at the mature age of 53 years. He went on to say that he hoped that their memories of the camp would be happy, and that, when the time came for them to look back on those years, they would be thankful for having had that beautiful spot with the King as their neighbour. He wished them good camping and good scouting.

Mr Morshead then broke the Union Flag, the National Anthem was played and the camp officially opened. Mr Morshead inspected the camp. Then followed various displays:- Parade Fire Lighting by all troops, Cubs' Grand Howl, Jungle Dance, Bridge Building by 2nd Windsor Troop, Cycle Ambulance in Action by 11th Windsor Troop, Pageant of the Flag by 3rd Windsor Troop, followed by various inter-troop activities. The camp fire was lit at half-past-eight, followed by the visitors and the scouts listening to a sing-song and a recorded broadcast by Lord Baden-Powell. The evening ended with prayers and the National Anthem.

On Sunday morning there was an inspection of the camp by the District Commissioner and District Scoutmaster, followed by flag-break and prayers, with a scouting game in the park afterwards. The weekend was concluded with the lowering of the Union Flag and the dismissal of the scouts in the afternoon.

Since the official opening, the camp has undergone many changes. Firstly, after fundraising and donations, a small hut was built by the scouts themselves and opened in October 1939. Because of the outbreak of the Second World War, there was no formal opening ceremony. It was because of the war that no overnight camping was permitted from 1939 to 1943. The original hut was of a practical design, built on concrete pillars. The timber structure had a veranda along the front and a shelter for bicycles at the rear. Alas, the hut did not have a long life, as it was burnt to the ground when it was hit by a flare in 1944 during army manoeuvres. The hut, known as the Dyson Memorial Hut, was rebuilt during 1954-

1956. Some extremely useful building expertise was given by William (Dickie) Grout, who not only was the Campsite Warden and Scout Master of the Park's 8th Windsor Troop, he also happened to be the Clerk of Works on the Estate. The hut was officially opened on Saturday 28th July 1956 by Sir Eric Savill, Deputy Ranger of the Park. Mrs Mitchell widow of the one time District Secretary, G.J.S. Mitchell Esq. unveiled the plaque which is still in the hut, and reads:-

> "This plaque is in memory of
> Sir Frederick Dyson JP
> (Chairman)
> and G J S Mitchell Esq.
> (Hon. Secretary)
> who gave many years of devoted service to scouting."

Sir Frederick Dyson, a former Mayor of Windsor, fully supported the local scouts. In November 1911 he donated a flag to the Scouts of Windsor which was presented every year to the winning patrol in the District Camping Competition. In 1922 he donated a second flag to be used for a competition among the Wolf Cubs. By 1971 the flags had become so fragile that it became necessary to replace them. The site has been considerably increased in size, and permanent toilets and washing facilities have been added since the early days. The author's own personal happiest memory of the camp was in 1947, winning the District Scouts Cross-Country Championship there as a member of the 2nd Windsor Troop.

A summary of the history of the Bear's Rails Campsite is as follows:

1936 — Agreement for campsite given by King Edward VIII.

1937 — Campsite officially opened by Mr Owen Morshead on 26th June.

1939 — The first Dyson Hut completed.

1944 — Dyson Hut destroyed by army flares during manoeuvres.

1956 — Second Dyson Hut officially opened by Sir Eric Savill on 25th July.

1958 — Campfire Circle completed.

1961 — The Michael Nodder Memorial Chapel erected.

1962 — Extra ground added at eastern side of the campsite.

1963 — Pioneer Rack and Shack constructed.

1966 — Woods Tavern (cooking shelter) opened in May.

1968 — Further ground added at eastern side of the campsite.

1978 — New ablution block completed and extra ground added to the south

1985 — The new enlarged Dyson Hut opened by Mr Rowland Wiseman.

1986 — Further ground added to southern side of the campsite.

1987 — Golden Jubilee Celebrations and George Cook Gate opened.

1989 — New water pipes laid.

1991 — New gate opened to Eddie Isley's Campfire Circle on 15th November.

1993 — Further ground added to southern side of the campsite.

1994 — Mains electricity connected to the campsite.

Mr Owen Morshead, who opened the campsite in 1937, was later to become Sir Owen Morshead, following many years service as the Windsor Castle Librarian. He had a major part to play in designing the Campsite Badge which shows the Round Tower of Windsor Castle on top of a crown and encircled by oak leaves.

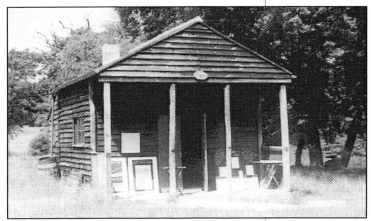

On the left hand side as you enter Bear's Rails Gate, there is a rectangular area of land just outside the park boundary fence which, for many people who were either poor, sick and/or childbearing, was a place of extreme human emotions.

In the 1800s a very large and imposing building was erected to house the poor who were desperate for a roof over their heads. The building was the called the Union Workhouse, though more generally known as the Old Windsor Workhouse. Although the building was used for this purpose for many years into the 1900s, it has recently been converted into

The second hut on the Bear's Rails Scout Campsite which lasted from 1956 to 1985. It replaced the original hut that was burnt down in 1944. It was in turn replaced by the current hut shown below. (Rupert Allison Collection).

The third and current hut on the Bear's Rails Scout Campsite. (photo taken in August 1999 by the Author).

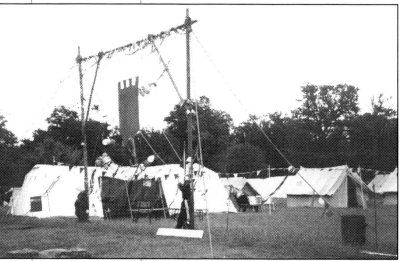

very desirable private apartments. Until recently, in the area between the building and the park fence, stood a series of large huts originally built as an emergency and overspill facility to the King Edward VII Hospital in Windsor. It was generally known as the Old Windsor Emergency Hospital and was mainly used as a maternity and children's hospital. Many park employees' children were born there. The park boundary fence had a single gate which provided easy access into the park. On summer days, it was quite common to see people from the workhouse and hospital chatting or snoozing under the trees in the park. In July 1928, an event which surely was not unique, took place at the workhouse. A man who had demanded a bath, meal and a bed at the workhouse when he arrived late in the evening, after having walked from the Hounslow workhouse, was told that it was not the Ritz Hotel by the master and that he would have to wait. The weary traveller immediately lost his temper and threw a chair through a window. The next day he appeared before the Windsor magistrates where he was sentenced to fourteen days

hard labour. As he left the dock, he shouted that prison would be better than Old Windsor Workhouse. Surely not!

The opening of the large Wrexham Park Hospital in Slough was the turning point in the hospital's life. It fell into disuse in the 1990s, and became a victim of the inevitable vandalism. It was finally demolished in 1998. Some high-quality detached houses now stand there, overlooking the park. The whole site is now known as 'Bear's Rails Park'.

As you go south from the Scouts' Campsite, the density of the trees progressively increases the further you head towards Bishopsgate. Until the 1960s, a large, L-shaped deer barn stood on the eastern slope of a ditch about 500 metres from Bear's Rails Pond. The large wood that runs along the eastern side of Crimp Hill Road, known as Old Windsor Wood, very seldom attracts any visitors. In fact, it can be very 'spooky' and not the place to be after nightfall. This area was at one time the family's favourite place for blackberrying. However, we would always leave for home well before the light started to fade. The ghost stories that our mother was fond of telling us did not help the matter.

In 1880, an enclosure was erected in an area just to the north of the Crimp Hill entrance to the park, to hold, of all things, a herd of wild boar (*sus scrofa*). They had been brought back from India by the Prince of Wales and presented to Queen Victoria. The boars were a particularly vicious breed, and the enclosure fence was very high, not so much to keep the boars in, but to keep the curious public out, for their own safety. The herd of boars also attracted some of the more sadistic members of the public, because there were several reported occasions when people were seen throwing dogs into the enclosure just to watch them being chased and gored by the boars. In February 1897, Queen Victoria had a new and more substantial shelter built to give them some

improved comfort. The boars were removed and the enclosure taken down sometime during the First World War. In 1999, a small pond was created where the enclosure stood near the gate lodge.

The Crimp Hill Gate and Lodge, because of its rather isolated situation was, and still is, one of the least used entrances into the park. Many people, even locals, have never used it or even been aware that this is an entrance. The drive through the gates is mainly made up from compacted gravel. In the woods on both sides of the gate can been seen large hollows in the ground where clay and gravel was once extracted.

The Gate Lodge in the past was mainly used as a Gamekeeper's residence. The Gamekeeper had the double role as Gatekeeper. It was on Friday 24th October 1862, that John Mortlock, who lived there at the time, was viciously attacked by three soldiers from Windsor. The injuries he received were so serious that word immediately spread that he had died. It was about 12 noon that the soldiers had been seen 'chestnutting' in the park near the lodge. For whatever reason, Mortlock asked them to leave the park and they reluctantly did so. About two and a half hours later, he heard some very loud howling noises coming from Old Windsor. Eventually five soldiers appeared, three of whom he recognised as the ones he had seen earlier. Mortlock, who was attending to the pheasants in the park at the time, was grabbed by one of the soldiers on his collar. He called his dog, which was still muzzled, to come to his aid. At this point the soldiers launched a brutal attack on Mortlock, hitting him with sticks and kicking him on the head when he fell to the ground. They were later seen walking through the park, returning to Windsor.

The ensuing investigation established that they had been seen earlier, drinking in the Fox and Hounds public house on the green at Old Windsor. They had become worse for drink, and witnesses heard them mutter that they were going to 'get' the keeper. The military turned the soldiers over to be dealt with by the civil judiciary and they were sentenced to a long period of hard labour.

The original Gate Lodge, which was a double-floored building, was pulled down in 1981 and replaced with a modern bungalow style building. At about 200 metres in from the gate and on the southern side of the ride is the site of an old tile works. For many years a house named Tile Kiln Cottage stood on the site. Like the Gate Lodge, this was the residence of Gamekeepers. Charles Beasley, a Gamekeeper in the park, lived there for many years during the mid 1900s. His son John Beasley, who currently lives nearby in Old Windsor, has childhood memories of deer coming right up to the garden fence. The house was demolished in 1970 and not rebuilt.

Throughout the area leading up to Bishopsgate and Reading Road there are several individually-named groups of trees. Sultan Plantation, planted 1867, Liddell Plantation 1875, Prince Consort's Plantation 1875, Gore Plantation 1864 and the Duke of York Plantation 1895.

Crimp Hill Gate and Lodge about 1955. It was demolished in 1981 and replaced with the bungalow shown below. (John Beasley Collection).

Crimp Hill Gate and Lodge built 1981-2 to replace the lodge shown above. (photo taken September 1999 by the Author).

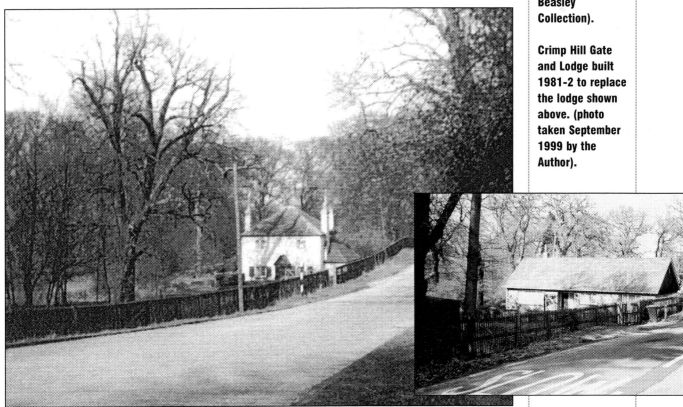

Tile Kiln Cottage about 1939. It was always used as a Gamekeeper's residence being in a quiet spot about 200 metres in from Crimp Hill Gate. Mr Luca was the last person to live there before it was demolished in 1970. Before him, Charles Beasley lived there from the 1930s to the early 1960s. (John Beasley Collection).

Crimp Hill Pond created in 1999 on the site of the Wild Boar Enclosure just inside Crimp Hill Gate. (photo by the Author).

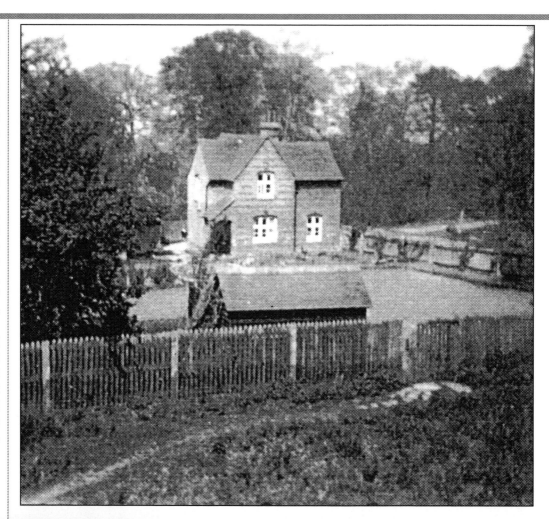

118

Royal Lodge

Royal Lodge

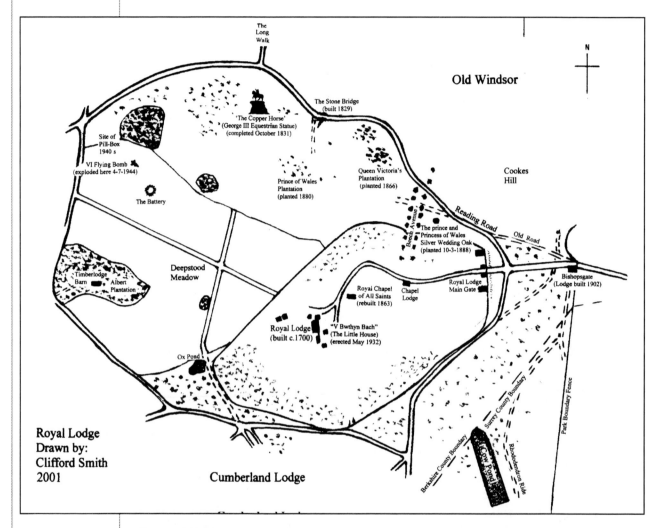

Royal Lodge
Drawn by:
Clifford Smith
2001

This mid-eastern area of the Great Park, is very popular with the public throughout the year, although there is a large prohibited area taken up by the Royal Lodge Enclosure. The direct and nearest entrance is Bishops Gate, which is the gate that confronts you in Bishopsgate Road, coming from Englefield Green. In the past, it was sometimes called Englefield Gate due to its close proximity to the green. The road through the gate in the park is Reading Road. The present Gate Lodge, which stands on the southern side of the gate, was built in 1902. It is of a lesser design and structure than the previous lodge that stood on the northern side of the gate. The old lodge was built in 1768 and was made mainly from sandstone, in keeping with the other gate-lodges in the park in that period.

During the 1800s, the keepers had dual roles, gatekeeper and gamekeeper. Of the keepers, Sanson Strickland comes readily to mind. Sanson was more generally known by his nickname 'Sampson' or 'Samson', even though he was slight of physique. He was born in Bryanston, Dorset in 1808 and he was appointed in his park role in 1839. He moved up in status to Deputy Head Gamekeeper and, for a short period Head Gamekeeper, before he retired in 1871. He was succeeded by George Wheeler, one of the Wheeler family from which Wheeler's Yard acquired its name. George died in the lodge shortly after Queen Victoria died in 1901. The first Gatekeeper to live in the new gate-lodge was Henry Austin.

Immediately to the left and at the end of the lodge garden is a gate that leads into the start of Rhododendron Ride. The ride was established about 1838, and it meanders a distance of 2.0 kilometres (1 mile 427 yards) having passed Cow Pond and The Savill Garden on the right, turning left before the Obelisk and finishing at the head of the Obelisk Pond. The ride itself is made up of compacted gravel and granite chippings. For most of its length, rhododendrons grow in a form of a dense and very high hedge on each side of the ride. Such is the vigour of the rhododendron that regular and severe cutting-back is necessary in order to prevent it encroaching over the ride.

At a distance of 58.5 metres (64 yards) from the start of the ride, at the end of the Bishop's Gate Lodge garden, stands a truly magnificent redwood (*sequoia sempervirens*). Although small by comparison with the giant specimens seen in North America, it is nonetheless well worth a pause in your travels to stop to have a good look at it. The circumference of the trunk, when measured 1.52 metres (5 feet) from the ground, was 7.0 metres (23.5 feet) in 2001. Just to the south of this tree you pass from the Parish of Old Windsor into the Parish of Egham. This is also the boundary between the counties of Berkshire and Surrey.

To the right of the Bishop's Gate entrance is the high fence of the deer park. At about 400 metres along the ride, in the direction of Old Windsor, stands the rather dense plantation named Gore Plantation. It was planted in 1864 in recognition of Charles Alexander Gore, Commissioner of Woods. It was in June 1918, that King George V gave his consent for a fully-equipped Red Cross Hospital to the built on the flat area of Cookes Hill between Bishop's Gate and Gore Plantation. The plans were drawn up for the hospital to accommodate up to 500 wounded American soldiers who had been injured during the First World War conflict. It had been intended to complete the hospital by the autumn of that year and for it to be given to the American Nation for their support during the war. Second thoughts concerning the project, prevented the hospital ever being built.

The road through the Bishop's Gate leads to a cross-road junction. The road to the left leads to Smith's Lawn and Cumberland Lodge. The road straight ahead passes through the main entrance gates into the private grounds of the Royal Lodge. The road to the right is Reading Road, which leads through one of the main gates into the deer park and then, after some sweeping curves, goes over the Stone Bridge, passes by the top of the Long Walk and heads west to meet up with Sheet Street Road. Retracing your steps, there is a large clump of sweet chestnut trees on the hill on the south-eastern side of the Stone Bridge. For some unknown reason, this group of trees doesn't have a formal plantation name or planting date, although it has always been known as the 'Chestnut

Clump' by locals. Close by, on the southern side of this clump, is Queen Victoria's Plantation, planted in 1866. This plantation is quite unique in that it is made up of copper beech trees. It is believed that the trees were used because the dark copper-coloured leaves would stand out to be easily recognised when viewed from Windsor Castle. Directly opposite, on the other side of the road, is the site of Prince Consort's Plantation. In 1856, the Prince Consort chose this site for a substantial plantation of conifers in the hope that they would stand out on the hill during the stark winter months. Alas, time has passed on, and the trees are no more. This hill where the conifers were planted is known as Spring Hill, a name that was used because of the number of natural small springs that once existed there.

Heading back towards Bishop's Gate, there is a 22 metre (72 feet) wide avenue of mature beech trees that comes out from the Royal Lodge enclosure, crosses the Reading Road at right angles and ends not far down the hill. In an open area between the road and the the Royal Lodge boundary fence stands a single oak tree planted on 10th March 1888 to commemorate the Silver Wedding Anniversary of the Prince and Princess of Wales.

In 1824, lamps were installed along the sides of the roads from Bishop's Gate to the Royal Lodge and to Cumberland Lodge, as measures to improve safety during darkness. Very little is known as to the nature of the type of lighting and how long it existed. The Royal Lodge is situated in a private enclosure of 41.7 hectares (103 acres). The entrance to the enclosure, for authorised persons only, is by way of the main gate that confronts you as you come along the road from Bishop's Gate. Immediately on each side of the gate stand the gate-lodges. Further out from these is a form of slanting dry moat, running along in front of them. The lodges are historic, in that they form part of the last major changes to the layout of the Royal Lodge area. From 1931, when the lodge was granted to the Duke and Duchess of York - later to become King George VI and the Queen, the lodge and road system were transformed, during the 1930s to more or less what exists today. The area immediately around the lodge was extensively landscaped, with lawns, ponds and shrubs. More significantly, the lodge enclosure, which had already been altered several times, along with the buildings from its origins back in the 1600s, was progressively extended. The last extension was in 1939 when a further 12.55 hectares (31 acres) was added to bring it up to the current size.

The Royal Lodge, or rather the original lodge, was known by many names from its beginning: Lower Lodge, Ranger's Lodge, Kings Cottage and simply as 'The Cottage'. The Lower Lodge name was used because it was at a lower level than the Great Lodge (the original name of Cumberland Lodge). The name Ranger's Lodge came from the fact that Thomas Sandby, Deputy Ranger of the park 1764-1798, lived

Bishopsgate entrance and lodge as seen looking into the park in 1900 before the Reading Road was re-routed and the original Gate Lodge, which was built in 1768, was pulled down.

Bishopsgate entrance and lodge as seen looking into the park in July 1999 showing the road layout change. The Gate Lodge, which was built in 1902, is shown on the left-hand-side. The old Gate Lodge, which stood on the right, has been pulled down.

there for forty-two years. Following the departure of Sandby, a Mr Frost lived there until the Prince of Wales became the Prince Regent in 1811. The Prince had always loved the park, and he soon decided to make the Royal Lodge or Cumberland Lodge his home. Both of the buildings were in a sorry state at the time, and extensive alterations started immediately. Although the Prince Regent originally intended to use the more grand Cumberland Lodge as his home, it was the Royal Lodge that became his favourite.

In June 1815, during Ascot Week, the Prince used the lodge for the first time, whilst his guests were put up at nearby Cumberland Lodge. From that time on he was to live there on a regular basis when there were pauses in the ongoing building work. The work was finally completed in 1818 and, in April, the Prince let his sister, Princess Elizabeth, use the lodge for her honeymoon. However, the 'dust was not allowed to settle' for, on 29th January 1820, he became King George IV, upon the death of his father, King George III, and the building work started all over again. Many alterations took place during the following years and in 1825, the King, who was not in particularly good health, started to complain that the thatched roof was making the lodge too hot. Subsequently, in June and July of that year, he moved to London for six weeks whilst the thatch was replaced with tiles. With the King's deterioration in health, very little further work was carried out. During the last few years before he died on Saturday 26th June 1830, he lived as a virtual recluse at the lodge and in Windsor Castle.

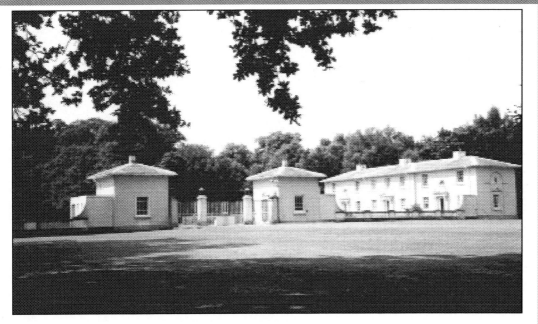

Royal Lodge Main Gate and Lodges – July 2000 (photo by the author)

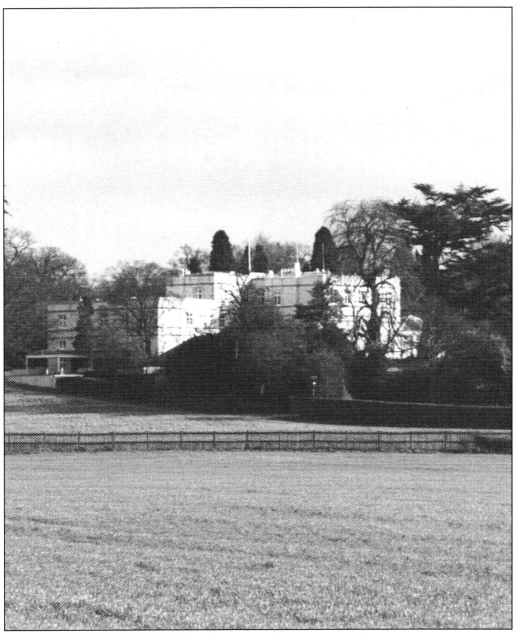

Royal Lodge, partly obscured by trees, as seen from the north-west – March 2000. (photo by the Author)

THIS TREE
WAS PLANTED BY
H.H. PRINCESS LOUISE OF SCHLESWIC HOLSTEIN
MARCH 10TH 1885,
IN COMMEMORATION OF THE MARRIAGE OF
THEIR ROYAL HIGHNESSES
THE PRINCE & PRINCESS OF WALES
MARCH 10TH 1863.

The Prince and
Princess of Wales
Silver Wedding Oak
– July 1998 (photo
by the Author)

125

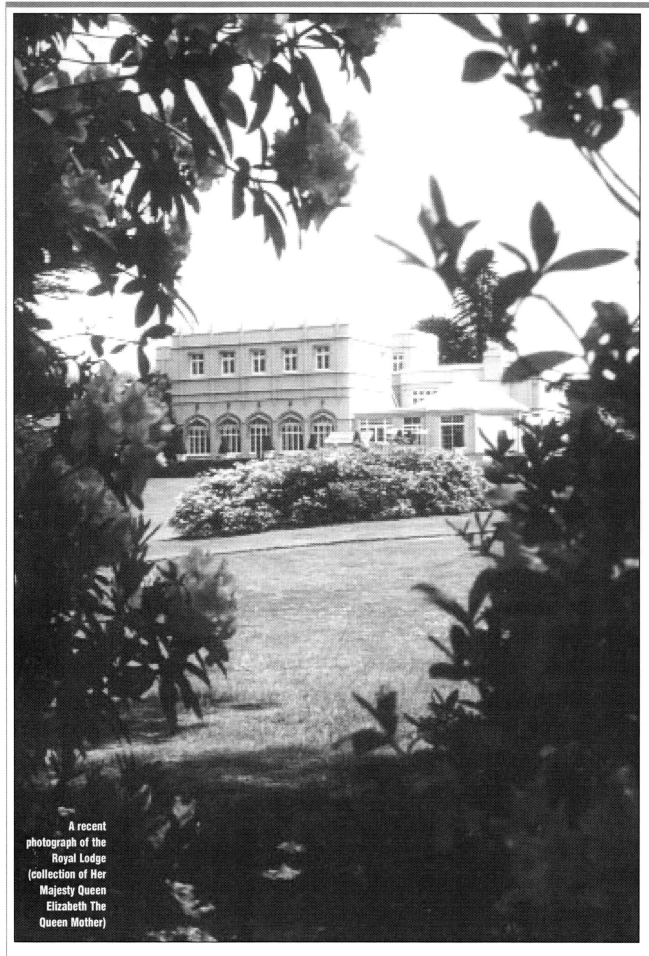

A recent
photograph of the
Royal Lodge
(collection of Her
Majesty Queen
Elizabeth The
Queen Mother)

Princess Elizabeth (now Queen Elizabeth II) standing in front of "Y Bwthyn Bach" (The Little House) in 1933, when she was seven years old. (Author's Collection)

'Y Bwthyn Bach' with two adults peering through a window giving an indication of the size. (Phil Greenaway Collection)

It is interesting to note some of the important historical events that took place during King George IV's short reign:-

1823 – Construction started of the British Museum, the first public museum in the world.

1825 – The Stockton to Darlington Railway was opened, the world's first railway service.

1829 – The Metropolitan Police Force was set up by Robert Peel.

From the time of the King's death, the lodge lost its popularity and the building suffered as a result. King William IV, who succeeded King George IV, showed very little interest in Windsor Great Park and the Royal Lodge, and immediately had a large part of the lodge pulled down. For the next one hundred years, it was used by farm bailiffs and as a grace and favour residence, mainly for retired senior army officers. The fortunes of the lodge suddenly took a dramatic turn for the better in 1931 when the Royal Lodge was granted to the Duke and Duchess of York, (later to become king George VI and Queen Elizabeth). The lodge was completely refurbished and the gardens landscaped, turning it into a place of grace and beauty much as we see it today. Princess Elizabeth (now Queen Elizabeth II) and Princess Margaret spent many years of their childhood enjoying the serenity of the lodge, the gardens and the park.

The first Royal Chapel was built 1824-1825 a short distance away to the north-east of the Royal

The Chapel of All Saints on a cold autumn day in the 1980s (photo by Alec Jacobs)

The Chapel of All Saints with the chapel choirboys beng proudly watched by their mothers and relations on a winter's day in the 1940s (John Beasley Collection)

The Windsor Great Park (8th Windsor) Scouts and Cubs outside the Royal Chapel in the summer of 1955. The persons in the photograph are, from left to right;-

Back Row
David Harlow Jim McGee Michael Cammel Tony Elliott Malcolm Bull
Alan Ashton John Gray Richard Gray

Middle Row
David Macdonald Peter Shefford William Grout (Scoutmaster) Rev. Peter Gillingham Phil Greenaway (Cubmaster) Ray Morrison Roy Stannett

Front Row
Unknown Edward Pusey David Wrixen Leslie Grout Philip Morgan John Cammell unknown
John Shefford Ian McDonald

Twenty-six years after this photograph was taken, Leslie Grout, son of William Grout
(Scout Master and Clerk of Works on the Estate) won the much coveted 'Mastermind' title.
The full details of this achievement are given in Chapter 11.
(Phil Greenaway collection)

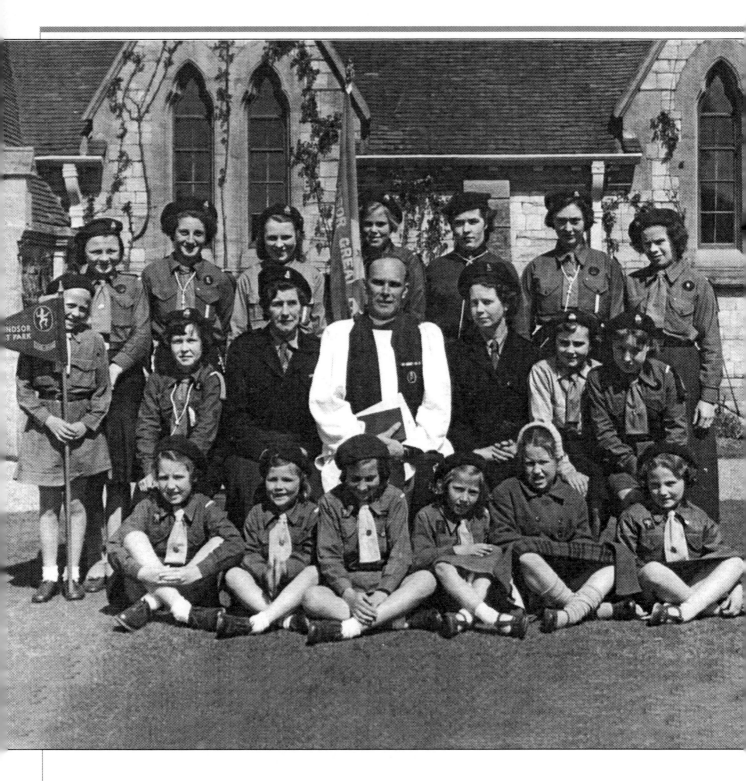

The First Windsor Great Park Guides and Brownies outside the Royal Chapel in the summer of 1955.
The persons in the photograph are, from left to right:-

Back row
Julie Stannett Josie Sheppard Cicelia Stannett Susan -
Anne Chamberlain (Sea Ranger) Pat Ponsford Sheila Gray

Middle Row
Susan Sheppard Diana Morgan Beatrice Moakes (Captain) Rev. Peter Gillingham
Joyce Braybrooke (Lieutenant) Mary-Rose Lindsay Valerie Patchet

Front Row
Morag Cocks Sarah Clark Christine Sheppard Wendy Greenaway Leslie Pashley Angela Harbard
(Phil Greenaway collection)

Lodge. It was built by Jeffrey Wyatville, the architect responsible for much of the rebuilding and modernisation of Windsor Castle at the time. The first formal use of the Chapel was on Palm Sunday, 27th March 1825, when King George VI attended a Divine Service while he was living at the Royal Lodge.

In the early 1860s, Queen Victoria decided to alter the Chapel. In November 1863, The Queen's eldest daughter, Princess Victoria, laid the foundation stone of the new chancel of the now named, Chapel of All Saints. The chancel was built to a design of Teulon and Salvin. It included an east window as a memorial to the Queen's mother, the Duchess of Kent. It was realised that the old nave was out of proportion and it was subsequently demolished and rebuilt during 1866-1867. The Bishop of Oxford, Dr Samuel Wilberforce, re-dedicated the Chapel in 1867. There is a stone above the west door commemorating the occasion.

Although many chaplains had conducted services there, the very first one to be given the title of 'Park Chaplain' was the Reverend St John Blunt who had been appointed to this position in 1852. He was also Vicar of Old Windsor. It was the Reverend Blunt who conducted the marriage ceremony of the author's grandparents at the Parish Church of St. Peter & St Andrews in Old Windsor on 24th April 1872. The Royal Chapel is primarily used by the Royal Family as a private place for worship. However, it is by kind consent of the Queen that estate employees and their families are permitted to use the chapel as a place of worship, baptism and for marriage ceremonies.

A further 200 metres from the Royal Chapel, and in the same direction from the Royal Lodge, is the

Windsor Great Park Chaplains
1852-2001

Reverend St John Blunt 1852-1876
Reverend E L Tuson 1876-1885
Archdeacon Joseph Baly 1885-1906
Reverend H O Moore 1906-1924
Reverend Francis J Stone 1924-1939
Reverend H G Barclay 1939-1946
Reverend R R Churchill 1946-1949
Reverend Peter L Gillingham 1949-1955
Reverend Edwin J G Ward 1955-1967
Reverend Anthony H H Harbottle 1968-1981
Reverend Canon John D Treadgold 1981–1989
Reverend Canon Michael A Moxon 1990 –1998
Reverend Canon John A Ovenden 1998-

Chapel Lodge. It was built and re-worked during the 1820s. Its main purpose appears to be as a form of a gatehouse when the Royal Lodge enclosure boundary came to this point. Its close proximity to the Royal

Chapel has made it ideal for its use as the residence for the Verger. The most notable Verger to live there was Mr Arthur Cripps. Born locally on 1st May 1879 he took up residence in the lodge in 1904 and served as Verger of the Royal Chapel until he died there on 14th January 1947, a period of forty-three years.

The quaintest addition to the enclosure must surely be what has always been known by many as the 'Doll's House'. Its correct name is 'Y Bwthyn Bach' (The Little House). It was given by the people of Wales to the then Princess Elizabeth on her sixth birthday. It was transported on a lorry from London on Thursday 19th May 1932. The lorry must have been on its 'last legs' by the time it entered the Royal enclosure because The Little House weighed a total of ten tons. The site for the house had been selected two weeks before by the Duke and Duchess of York. It proved to be very popular with Princess Elizabeth and her sister Princess Margaret during their childhood. Each room was fully furnished with the appropriately scaled furniture and fittings; even the garden is scaled accordingly. Over the years, it has been beautifully maintained. In July of the same year, the Duke and Duchess of York and their two children moved into the Royal Lodge.

The Main Gate Lodges were not completed until 1940, well after the start of the Second World War. It was on the night of 8th November 1940 that the most northerly of the four lodges received a direct hit from a German bomb, with tragic results. Joseph Pearce, the 19 year old son of Mr & Mrs Ernie Pearce, who was home on leave from the army at the time, was killed by the bomb. Major rebuilding work was carried out on the Gate Lodges during 1949-1950.

Just outside the south-western corner of the enclosure is a small pond, named Ox Pond. Always known by the author's family as 'Crown Pond', due to its shape, it was artificially created at about the same time as its bovine namesake 'Cow Pond' in the park during the 1750s. The average diameter of the pond is about 40 metres (43.7 yards). It was made by building up an embankment to form a type of deep basin near the lower slope on the northern side of the hill. For many years, a small wooden jetty existed for people to walk on. Fishing on this jetty during the Second World War brings back some of the author's happiest memories in the park. We would run home from the Royal Free School when it was at Bachelor's Acre in Windsor. We would gulp our tea and dash off up The Long Walk, run past The Copper Horse, then down the ride to the west of the Royal Lodge. All we had for fishing tackle was some basic line and a porcupine-quill float and hook wound round a stick. Fishing off the jetty, it was not necessary to have a rod, as the carp and perch could be clearly seen swimming underneath. It always seemed to be a lovely summer's evening when we were there. Being in the tight security of the war years, there were always several policemen

'The Battery' with The Copper Horse deliberately lined up behind to indicate its location – March 1999 (photo by the Author)

The Watch Oak situated just south of Reading Road and to the east of Queen Anne's Ride – May 1999 (photo by the author).

Ox Pond – July 1999 (photo by the Author)

continuously walking round the outside of the boundary fence of the Royal Lodge enclosure. Often they would stop to talk to us to break the boredom and, no doubt, to reflect on their own childhood memories. The jetty fell into disrepair during the 1950s.

Looking from the pond to the west of the ride that leads to The Copper Horse, an unusual feature can be seen on the furthest field. In the middle of this field is a distinctive round shaped mound, complete with a deep ditch and a scattering of trees growing on it. The mound is known as 'The Battery', a name which is normally associated with places where guns are fired from. In this instance it appears to be used in contradictory terms, as all evidence indicates that the mound was used as a target for cannon balls fired from guns mounted on the hill near Cumberland Lodge, probably during the 1700s. In 1979, two iron cannon balls were found on The Battery by Phil Greenaway when he was the cartographer of the estate. The balls were different sizes. The largest was a 'twelve pounder' (5.443 kgs), fired from a four-and-a-half-inch calibre cannon. The other ball was a 'six-pounder' (2.722 kgs), fired from a three-and-five-eighths calibre cannon. Towards the park village, further to the west, is an oak tree known as the 'Watch Oak'. There is every reason to believe that it is so named because this is where the military observers stood at a safe distance to monitor the accuracy of the gunners. The adjacent plantation is named Watchoak Plantation accordingly.

The Village and Queen Anne's Ride

Chapter 7

The Village and Queen Anne's Ride

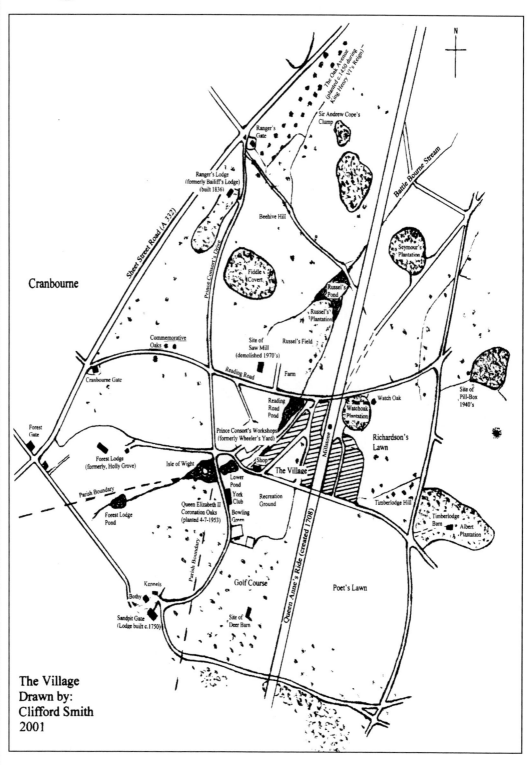

The Village
Drawn by:
Clifford Smith
2001

The Village in the park is a thriving community housing the park Crown employees and their families. The village has its own well-run shop, the York Club, a sports field consisting of cricket pitch, football pitch, bowling green, tennis court, children's play area, and a golf course. At the western side of the village stand the Estate Office and the Prince Consort's workshops. It is situated in a fairly central position in the park about 2.6 kilometres (1.6 miles) from the northern end of Queen Anne's Ride. The normal route by road to the village from Windsor is by way of Sheet Street Road, this being the main public road through the park between Windsor and Ascot. At Ranger's Gate, the non-public road called Prince Consort's Drive leads up the hill in a south-easterly direction to the village.

The Village itself is relatively new when compared with the more historical buildings, such as Cranbourne Tower, Forest Lodge, Sandpit Gate Lodge, Cumberland Lodge and the Royal Lodge. Looking at the extent of the village as it stands today, it is difficult to visualise that it evolved from a timber yard that stood there in the 1830s. During that decade, a cottage in the form of two semi-detached dwelling places was built on the western side of the Battle Bourne Stream. The first people to live there were Charles Morris, the yard carpenter, his wife Eliza and two children, Sarah and Charles. Sarah, who was born in 1838, was the very first person to be born in what was to become the Village. The other half of the house was lived in by George Perkins, who was a farmer, and John Clark and Ann Church. The 1841 National Census gave the name of the site as Carpenter's Yard and, by 1851, the name 'Wheeler's Yard' appears for the very first time. The name almost certainly came from the Wheeler family, who worked in the park at the time, particularly when you bear in mind that George Wheeler, who was employed at and lived in the park for many years as a Royal Fisherman, taught Queen Victoria's children the art of fishing. Although Wheeler's Yard is now known as Prince Consort's Workshops, it is still referred to by its original name by many of the older people in the area.

In the late 1850s and early 1860s, the yard was considerably improved, with many substantial buildings being added to accommodate an engine to drive the various machinery. The yard, under its new title of Prince Consort's Workshop, in recognition of the late Prince Albert, became a fully self-sufficient works including a sawmill, carpenter's shop, metalworking shop, blacksmith's shop, carter's yard and stables. The earliest date shown on the buildings is 1858. In 1862, the Farm Lodge was added. From 1859 to 1904, a building at the workshops was used by the Windsor Great Park Rifle Volunteer Corps to hold their meetings and annual dinners.

During the 1860s and 1870s, the largest family to live there was the Grays. William Gray worked as a Carter in the park, and many of his children were employed in different functions when they left school. His eldest daughter, Miriam, was employed as a Thistle Picker in the park. Her duties were to pick as much thistledown as possible during the summer months, ready to be used for the filling of pillows and cushions. Her main concern would be to collect the down before the goldfinches had become active, eating the thistle seed and dispersing the down. In 1890, a further dwelling house was built known as Wheeler's Lodge. In the year 1900, there were four families living on the site: W. Lightfoot, the works foreman, and the Boyd, Sparks and Warren families. 1905 saw the erection of the first two semi-detached houses on the eastern side of the Battle Bourne Stream.

Early in the morning of Saturday 1st December 1906 disaster struck. A foreman who was living in a house a short distance from the sawmills was awakened at about 4.45 in the morning by the sound of his dog barking. Looking out of his window he saw that the mills were on fire and, at about the same time, other residents were woken up by the sound of crackling timber as the fire, aggravated by a stiff breeze, took hold. The alarm was immediately given, and all available residents in the area worked furiously to put the fire out. Unfortunately, the fire was virtually out of control. Even the old fire-fighting pump that was kept in the engine house near the blacksmith's shop proved to be of little use. In such a hopeless situation they concentrated their efforts on getting the numerous valuable horses out of the stables which were near the burning building. From there they were led down to Russell's Field on the other side of Reading Road.

Meanwhile, Mr Lloyd (Clerk of Works) was busy trying to telephone the Windsor Fire Brigade. After repeated attempts he found that the wires had been damaged by the fire. At the same time, a message was sent to Cumberland Lodge for assistance, whereupon some confusion prevailed. The word 'confusion' is a polite way of saying that a state of chaos prevailed at Cumberland Lodge . An urgent request to send the fire-engine to the scene was turned down by the person in charge on the basis that his orders were only applicable to the lodge itself. In the end, a fire-fighting hose was sent without the fire engine. The reaction to this by the people desperately trying to contain the fire at the workshops must have been a feeling of utter despair. Almost as an act of desperation, a cyclist was sent to the Windsor Fire Station to get some much-needed help. He arrived at about the same time as the station received a telephone call from Cumberland Lodge, at a few minutes before six o'clock. The fire-

crew wasted no time, and were at the scene of the fire at ten minutes past six. It was fuelled by so much timber, even the fire crew were staggered by the intensity of the fire. The crew obtained the water supply from the Lower Isle of Wight Pond, which lay just south of the works and, after several hours strenuous work, they managed to get the fire under control. The saw-mills were completely destroyed, and most of the valuable machinery and craftsmen's tools were badly.damaged. The adjacent carpenters' shop and the clerk's office were also badly damaged. Not only had so much equipment been damaged, many of the priceless estate records were lost. The clerk's office and records had, only a few months before, been moved from the old records office at 'Parkside' just outside the park boundary at Englefield Green. A very unfortunate time, as it turned out, to move the office.

Before the fire brigade returned to Windsor, the sorry state of the site was inspected by Mr Hall, Chief Fire Officer of the Windsor Fire Brigade, Captain Walter Campbell (Deputy Ranger), Mr Halsey (Deputy Surveyor) Mr Lloyd (Clerk of Works) and Mr Bartlett (Park Foreman). After much discussion, the brigade left the site at about 10 o'clock in the morning. The cause of the fire was never established.

This disastrous fire came barely forty years after the damaging fire at Cumberland Lodge, and it was not exactly welcome news to Queen Alexandra, wife of King Edward VII, as the day of this latest fire, 1st December 1906, was in fact her sixty-second birthday.

In 1908, four more semi-detached houses were built, (two on each side of the houses built in 1905). The first residents to live in the six dwellings were the Harbards, Lovegroves, MacMillans, Mitchells, Whites and Wyes.

We had to wait forty years before any further building took place. It was still in the austere years following the end of the Second World War that the concept of a park village was born. During 1948-1949, a total of thirty-two houses and a village shop were built in a V-shaped layout on the land between the Battle Bourne Stream and Queen Anne's Ride, on the southern side of Reading Road. The land inside the 'V' was lawned for use as a village green. The layout and buildings were designed by architects, Sydney Tatchell, Son & Partners, and the building contractors were Y J Lovell & Sons Ltd. Following this, the York Hall, later to be known as the York Club, was erected in the direction of Sandpit Gate and to the east of Isle of Wight Pond. The metal framework of the York Club building had come from the Second World War buildings on Smith's Lawn. At the same time, the whole area in the front and to the east of the Hall was turned into a sports and recreation area. The current bowling green and tennis courts were added later. Later still, in 1978, a nine-hole golf course was built to the south of the sports field. The golf course was the brainchild of Keith Parkes, who

was groundsman in charge of the Sports Club in the park. What is quite extraordinary is that he managed to construct the course on a meagre budget of £200.

The York Club and Village Shop were formally opened by King George VI and the Queen in the afternoon of Saturday 7th July 1951 . They were accompanied by their two daughters, Princess Elizabeth and Princess Margaret. As a warm up to the opening ceremony, which was set for 4.45 pm, a total of fourteen sports events was staged on the newly created sports field, ranging from running races and tug-of-war for the more serious minded, to three-legged and egg-and-spoon races for the more light-hearted. The day's events, including the opening ceremony and an open-air tea, were held in fine weather, which helped the day to go off without a hitch. Sadly, King George VI died seven months later on 6th February 1952 at the relatively young age of 56 years.

On the other side of the Sandpit Road, opposite the entrance to the York Club, is a grove of oak trees which was planted by Queen Elizabeth II, The Duke of Edinburgh and representatives from the various countries in the British Commonwealth to commemorate the Coronation of the Queen on 4th July 1953. Forty-seven years later, the sixty-two trees are showing signs of serious overcrowding, and consequently are not being shown to their full glory.

The years 1954-1955 saw a further extension to the village when another eighteen semi-detached houses were built on the eastern side of Queen Anne's Ride. The architects were Clifford E Culpin and the building contractors were Laing. The author remembers this phase of the village so vividly, as he actually worked on the site on a temporary basis during the 1954-5 winter - and what a job that was, wading knee deep in squelching clay with a hod full of bricks on his shoulder, and then having to climb up to the bricklayers building the chimney stacks! It was no picnic. You would not have time to load up with more bricks before one of the bricklayers would be shouting for more 'muck' (bricklayer's slang for prepared cement). There was many an occasion when one of the bricklayers almost finished up having the muck supplied in a different place than on the mortar board. In spite of that, there was some good humour to be experienced with some of the workers, particularly during the rest-breaks in the canteen that stood near the road at the south where Lansing and Oak View now stand. On Christmas Eve, 1954, the author was encouraged to obtain some mistletoe from high in the lime trees in that section of Queen Anne's Ride for some of the workers. Climbing up was bad enough, climbing back down again was even worse. When he finally put his feet down on terra firma, every sprig of mistletoe that had been dropped down had 'disappeared'. Never again! Although there were a few more houses built in the village during the 1960s, it was the 1954-1955 phase that was the last major

residential building programme to take place.

With the ever-increasing popularity for visitors to the park and forest, and the associated heavier workload experienced in the estate office, it became necessary to update the offices. During the mid 1970s, a purpose built L-shaped office and stores building was erected on the south-west side of the workshops. The building was of brick and timber structure, designed by Rodney Tatchell, son of architect Sydney Tatchell who designed the 1948-9 buildings in the village. The contractor was William Hartley & Sons, Wexham Ltd. On the roof above the main entrance is an elegant timber constructed belltower, upon which stands a very appropriate bronze cock-pheasant weather-vane. The building is a credit to the designer in the way in which it blends in so pleasantly with the surrounding buildings. The stone inserted in the wall outside the main entrance has the following inscription:-

THIS STONE WAS LAID BY
HRH THE PRINCE PHILIP DUKE OF
EDINBURGH
RANGER OF WINDSOR GREAT PARK
30TH OCTOBER 1978

Under the direction of the Deputy Ranger, the offices are the administration centre for the control of the Windsor Crown Estate.

To the north and south of the workshops are a line of ponds which were created many years ago by damming up the Battle Bourne Stream. The pond immediately to the south is called the Lower Isle-of-Wight Pond, sometimes known as Shop Pond, due to its close proximity to the village shop. Its original name was the Battle Bourne Pond, for the obvious connection. The overall length of the pond is about 82.3 metres (90 yards), and the width at the head is about 54.9 metres (60 yards). The pond tapers, progressively, narrowing towards the next pond, which is the Isle-of-Wight Pond. This pond is about 137.2 metres (159 yards) long and about 64.0 metres (70 yards) wide at the head. In the centre of the pond is a round island. Although the island is fairly large, it is seldom shown on maps. The pond almost certainly derived its name from this island. For many years, access to the island was by way of a wooden walkway from the west bank. The pond is quite unique in that the Parish Boundary of Winkfield and that of Old Windsor runs right down the middle of the pond, Winkfield on the south-eastern side and Old Windsor on north-western side. Such are some of the quirks of our country's historical past. The road that leads up to Sandpit Gate runs between the two ponds. Another road that leads to Cumberland Lodge runs along the head of the Lower Isle-of-Wight Pond. Further south of the Isle-of-Wight Pond is another pond called Forest Lodge Pond. It is situated in the private grounds of Forest Lodge, quite a distance away, and it should not be considered as one of the village ponds. The pond is about 274.3 metres (100 yards) long and about 54.9 metres (60 yards) wide at the head.

To the north, virtually nestled in the village, is Reading Pond, so named from the Reading Road that runs along the head of the pond. This pond was, and still is, known as Perch Pond by the author's family, because of the fine specimens of perch that could be caught there. The pond is about 167.3 metres (183 yards) long and about 54.9 metres (60 yards) wide at the head.

Further north, we come to the largest of the four village ponds. This is called Russell's Pond. The pond with the plantation and field to the south all have the prefix 'Russell's' from when the area was operated as a farm by Mr Russell, well before the Windsor Forest Enclosure Act came into being. The pond is about 274.3 metres (100 yards) at the longest point and about 64 metres (70 yards) wide at the head. The pond has an unusual shape, very much like a tooth . Its water is supplied by the Battle Bourne Stream and a smaller stream coming down the hill from the south-west. This pond, along with the other three ponds mentioned previously, was drained and dredged in the mid 1980s to allow the brickwork at the heads of the ponds to be completely rebuilt. At the same time, the outflow penstocks and overflows were fully repaired. The work, which lasted several years was a very costly and time-consuming project, bearing in mind the large number of fish to be caught and transferred to other ponds to enable the work to be carried out. It is often quite surprising just how much silt collects in a few years at the bottom of a pond. Without regular dredging and cleaning, a pond will shrink in length, width and depth until eventually it will disappear altogether, if left unattended. The ponds are an integral part of the village and, without them, the village would lose much of its character. In recent years some trout have been added to the ponds and a pair of swans have made the Isle-of-Wight Pond their home.

At the southern end of Russell's Field, next to Reading Road, is the village farming and agricultural yard. An adjacent disused overgrown yard to the west is the site of the sawmill that was erected here some years after the disastrous fire of 1906, because of its safer position. For us lads, the most appealing part of the sawmill was the hot creosote pit. The smell of the hot creosote, as we leaned against the metal railings, was so pleasant that we found it difficult to move on. We would also be fascinated by the large number of pied wagtails and spotted flycatchers that were also partial to the smell, making their nests in the roof and in the stacks of timber. The sawmill and the creosote pit were removed in the 1970s, and no longer can we have a nostalgic sniff.

Queen Anne's Ride is a straight grass-covered ride with a single line of trees on each side, which starts near Queen Anne's Gate, cuts through the village and ends near Leiper Pond just north of Prince Consort's

The Village Shop
– July 1998 (photo
by the Author)

The Village
'stop me and buy
one' icecream
bicycle with the
sports field and the
York Club behind.
The seat in front of
the fence has been
made by cutting out
a tree trunk – July
2001. (photo by the
author).

The Village Shop
having just been
formally opened by
King George VI on
Saturday 7th July
The Queen, now
the late Queen
Elizabeth the Queen
Mother, is looking
on. The unveiling
flag is seen hanging
under the inscription
stone. (Cyril Woods
Collection).

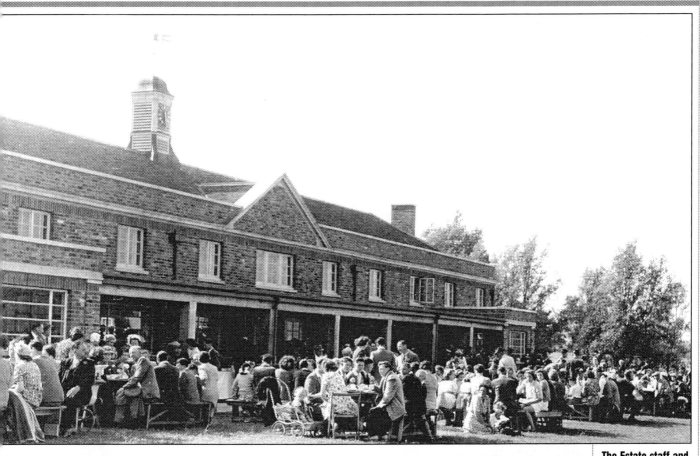

The Estate staff and their families enjoying the tea party outside the York Club after it was formally opened by King George VI on Saturday 7th July 1951. (Cyril Woods Collection).
The Crown Estate Office – June 1999 (photo by the Author)

Older buildings of the Prince Consort's Workshops – June 1999. The separate building with the chimney stack is the original engine room. It is now used as a store. (photo by the author).

The Prince Consort's Workshops Maintenance Department – July 1998. Mike Ashton on the left, Tony Elliott on the right (photo by the Author).

Russel's Field Sawmill c.1940. Lew Linneger (sawyer) and his assistant Bill Armsworth supporting the timber. The circular saw was made in 1932 by Robinsons of Rochdale. The sawmill was pulled down in the 1970s.

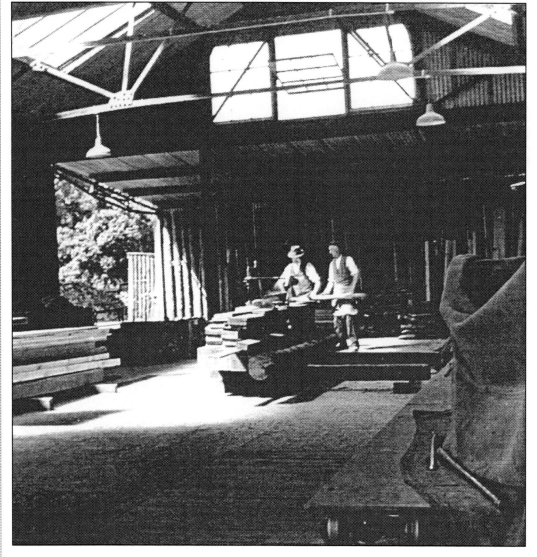

The York Club –
August 1999 (photo
by the author)

The York Club
Annual Flower Show
Trophies
(photographed at the
1998 Flower Show
by the Author)

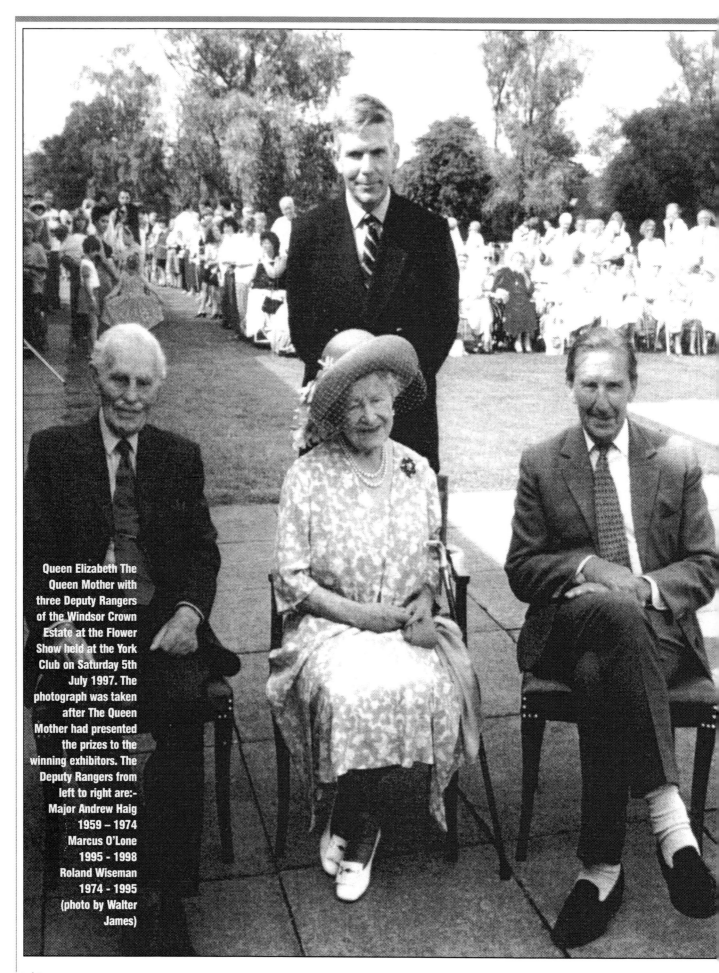

Queen Elizabeth The Queen Mother with three Deputy Rangers of the Windsor Crown Estate at the Flower Show held at the York Club on Saturday 5th July 1997. The photograph was taken after The Queen Mother had presented the prizes to the winning exhibitors. The Deputy Rangers from left to right are:-
Major Andrew Haig
1959 – 1974
Marcus O'Lone
1995 - 1998
Roland Wiseman
1974 - 1995
(photo by Walter James)

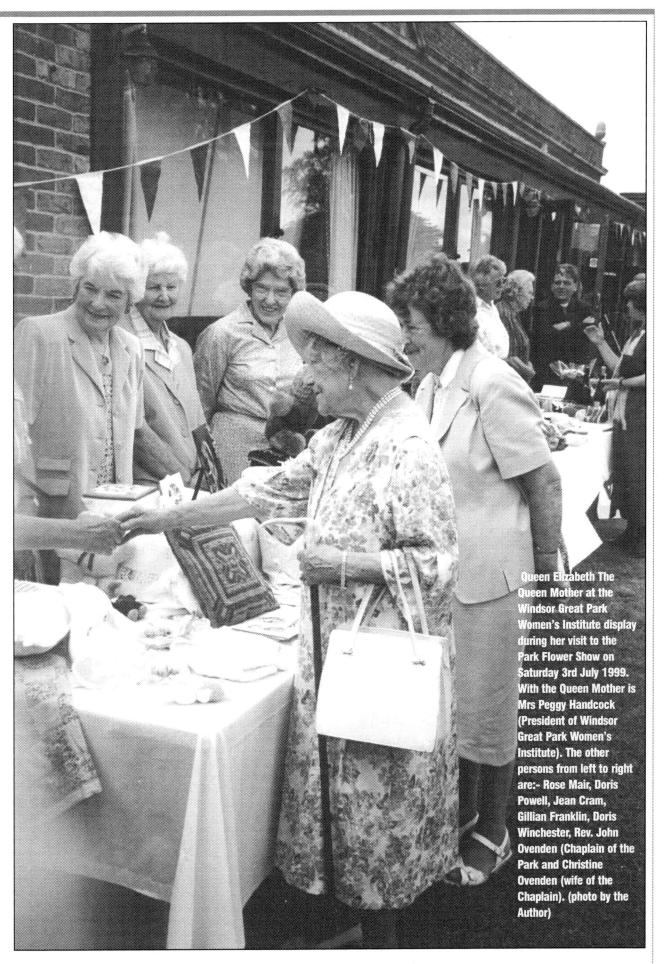

Queen Elizabeth The Queen Mother at the Windsor Great Park Women's Institute display during her visit to the Park Flower Show on Saturday 3rd July 1999. With the Queen Mother is Mrs Peggy Handcock (President of Windsor Great Park Women's Institute). The other persons from left to right are:- Rose Mair, Doris Powell, Jean Cram, Gillian Franklin, Doris Winchester, Rev. John Ovenden (Chaplain of the Park and Christine Ovenden (wife of the Chaplain). (photo by the Author)

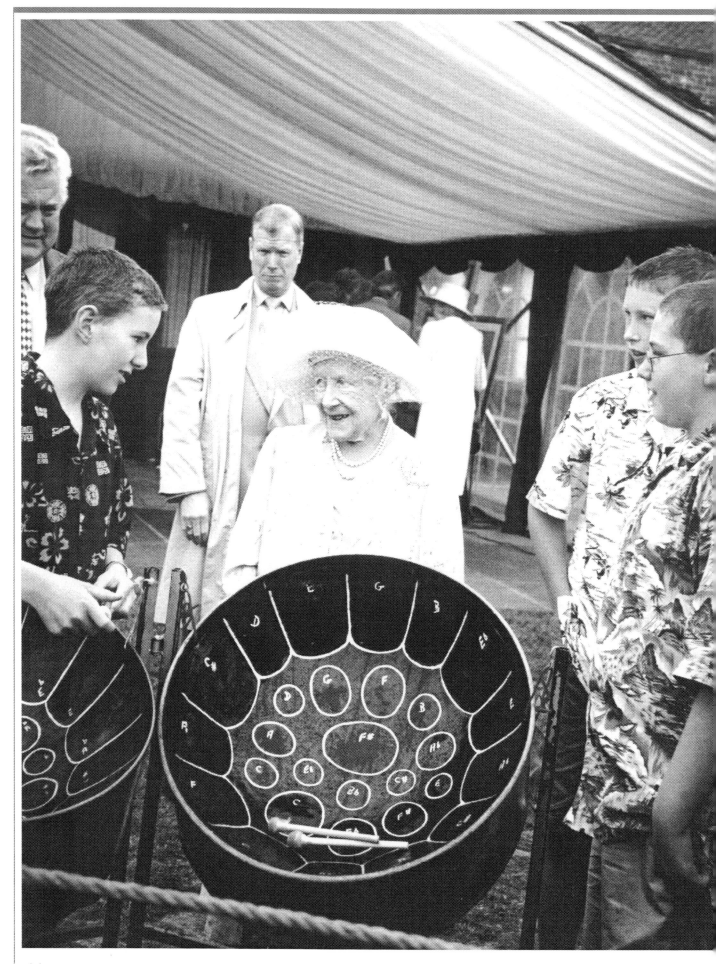

Queen Elizabeth at The Great Park Flower Show on Saturday 6th July 2002, part of the Golden Jubilee Celebrations. In the morning the Queen had opened The Golden Jubilee Garden in the Savill Garden. (photo by the Author).

(opposite) Queen Elizabeth the Queen Mother talking to members of The Windsor Boy's School Steel Band during her visit to the Park Flower Show on Saturday 7 July 2001. The Queen Mother is talking to Joseph Kimberley whilst at the extreme right are fellow band members, Jonathan Reddy and Craig Phillips (in the foreground). Behind Joseph Kimberley is Philip Everett the Deputy Ranger. The event was just four weeks before The Queen Mother's 101st birthday. (photo by the author)

Windsor Crown Estate Gamekeepers photographed by the author on Saturday 8th July 2000 after they had completed a Gun Safety Demonstration at the estate Flower Show at the York Club.
(left to right)
Andrew Stubbs, Peter Clayton, John Stubbs (Head Gamekeeper), Ian Watmore, James Earle, Raymond Morrison. Their jackets, waistcoats and trousers are made of Scottish 100% wool brown tweed.

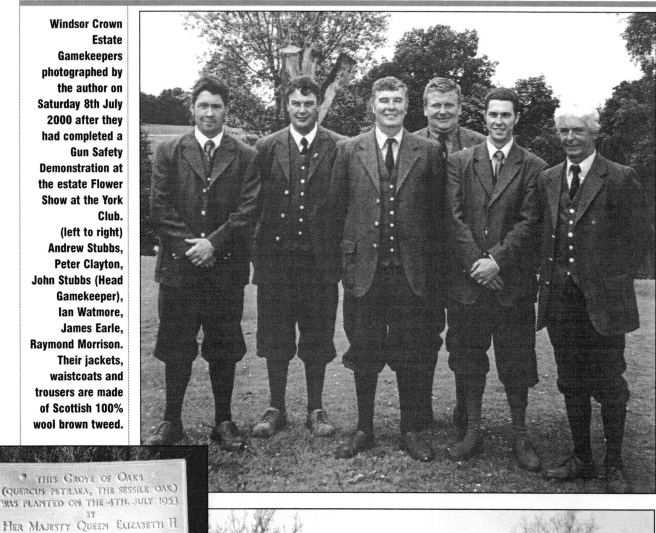

THIS GROVE OF OAKS (QUERCUS PETRAEA, THE SESSILE OAK) WAS PLANTED ON THE 4TH JULY 1953 BY HER MAJESTY QUEEN ELIZABETH II AND H.R.H. THE DUKE OF EDINBURGH AND REPRESENTATIVES OF THE COMMONWEALTH TO COMMEMORATE HER MAJESTY'S CORONATION 2ND JUNE 1953

The Oak Grove commemorating the Coronation of Queen Elizabeth II on 2nd June 1953. An enlargement of the commemorative plaque is shown above. (both photos by the author – March 1999)

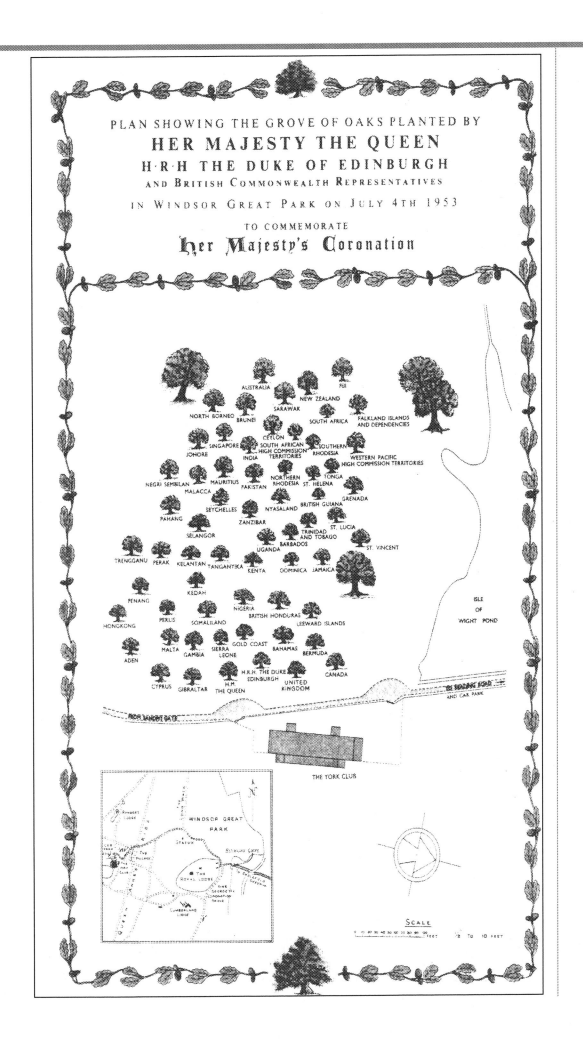

PLAN SHOWING THE GROVE OF OAKS PLANTED BY
HER MAJESTY THE QUEEN
H·R·H THE DUKE OF EDINBURGH
AND BRITISH COMMONWEALTH REPRESENTATIVES

IN WINDSOR GREAT PARK ON JULY 4TH 1953

TO COMMEMORATE
Her Majesty's Coronation

Isle-of-Wight Pond being refilled with water after the rebuilding of the head and island in 1986. (Photo by David Ives)

Isle-of-Wight Pond in August 1999 showing weeping willow trees on the island that were planted in 1986. The four-in-hand carriage (count the horses legs) is leading towards Sandpit Gate. (photo by the Author)

Gate. It is 4.67 kilometres (2.9 miles) long and the width of the avenue of trees 30.78 metres (101 feet). The trees are spaced 23.16 metres (76 feet) apart along the lines. The ride was originally created over the period 1708-20, starting in the reign of its namesake, Queen Anne. It formed a beautiful and direct route from Windsor to Ascot Heath at the time the racecourse was being established, and is a fitting memorial to Queen Anne, who was so keen on horse-riding and horse-racing.

Over the years, many of the trees were replaced, when they became diseased, damaged, or simply too old and dangerous. It was not until 1992 that it was agreed that a major replacement planting programme would be necessary in order to bring it back to its former glory. As soon as this became evident, as some of the trees started to be cut down, the public went wild or as Queen Victoria once said, they were not amused . The replacement work went on well into 1995, when over 2,000 people gathered in the ride to protest against the felling. It looked very bare when the work was completed, which was further emphasised by the fact that there is no road down the middle of the ride, thus making it not so acceptable as when The

Long Walk trees were replaced 1920-40s.

Starting from the northern end, near Queen Anne's Gate, the ride virtually touches Sheet Street Road (A332), which is the public road through the park from Windsor to Ascot. The road runs away at an angle to the ride as it travels southward. On the west of the road is the Cavalry Exercise Ground and, between the road and the ride is a large wedge shaped area of land which, from the 1970s, became a very popular picnic area. Access to the area by car is by way of the gravel drive that travels south, parallel with the ride, before it turns and meets up again with the road. The large open area on the eastern side of the ride is the Review Ground. Before the Second World War, when there were no fences surrounding the field, this was an extremely popular walk to The Copper Horse. A worn pathway went from Queen Anne's Gate straight towards the Prince of Wales Pond and onward. It now has a high fence as part of the deer park, and the direct route is not possible.

Moving south along the ride, there is a plantation further along the Review Ground which was planted in 1956. It is known appropriately as Keyhole Plantation, because it is shaped like a keyhole. The round shape of the keyhole is towards the The Long Walk. Almost directly opposite the plantation on the western side of the ride is the site of the Shaw Lane Deer Pen and Barn. The barn stood in the middle of the field where the oak trees have the greatest density. It was pulled down in the 1950s. Like all other barns in the park, it was black in colour as the result of years and years of treatment by thick creosote, with almost the consistency of tar.

Further on from the Keyhole Plantation is a long, rectangular plantation, planted in 1956. For some unknown reason, it has no name. At about 400 metres beyond the plantation the parish boundaries of New Windsor and Old Windsor cross the ride. In the large field to the west of the ride is the well-established Sir Andrew Cope's Clump planted about 1720.

At this point in the ride, the ground slopes down and then rises sharply, having passed over the culvert of the Battle Bourne Stream. The stream can clearly be seen on each side of the ride. On the Eastern side, it travels under a bridge named Sandy Arch, as it wends its way towards the River Thames. Why the bridge has that name is a complete mystery, as there is no sand in the area and it is certainly not made of sand. The plantation seen in the field to the south of the stream is known as Seymour's Plantation. It was named after Major-General Francis Seymour, who was the Deputy Ranger of the park between 1850 and 1870. As the ride starts to level out, Russell's Pond is laying in a shallow dip to the west. A trackway passes the head of the pond and continues up and over Beehive Hill (so named because of its shape), coming out at Ranger's Gate at the junction of Prince Consort's Ride and Sheet Street Road. The current gate lodge was built in 1949.

Within a short distance to the south of the gate stands Ranger's Lodge. It is set in an ideal position overlooking Flemish Farm to the north-west and, with its easy access to Prince Consort's Workshops and to Windsor or Ascot by way of Sheet Street Road, it is perfectly suited as the residence of the Deputy Ranger. The building has a rather unusual history, through its structural changes, which have been quite significant. The original building, known as Rutter's Lodge, was in a position slightly nearer Sheet Street Road. In the late 1700s the lodge was rebuilt as Rutter's New Lodge and, in 1837, it was virtually rebuilt again, which is indicated by the date plaque of that year on the wall. From the early days it was used as the residence of the park Bailiff and, in that connection, it soon became known as Bailiff's Lodge. This name remained until the next major changes to the lodge were made in 1932, the removal of the tower on the north-eastern corner of the building and the changes to the profile of the roof being the most significant. At the time of these changes, large ornate acorns were placed at the corners of the walls around the roof. For many people who did not know the formal name of the lodge, it became known as 'the acorn house' . It was about this time that Eric Savill, in his original capacity as Deputy Surveyor, took up residence at the lodge. In 1937, he was appointed Deputy Ranger and, at the same time, the title of Deputy Surveyor was discontinued. The name of the house then became Ranger's Lodge and it is now the official residence of the Deputy Ranger. The large enclosed garden, complete with tennis court, has been excellently maintained for many years by the current gardener, Ken Bailey.

There is a very important aspect regarding Ranger's Lodge which is often overlooked, in that it actually stands on the line of the oldest avenue of trees in the park and forest. The avenue of oak trees, which is also lined on each side by a 'park pale' (earth embankment), dates from about 1450, in the reign of King Henry VI. It is extremely likely that he personally instigated the creation of this avenue as a formal route through the forest, bearing in mind that he was born in Windsor Castle on 6th December 1421, spent a lot of his time at Windsor, and founded the nearby Eton College in 1440. It is likely that the avenue started near the castle and followed a route to the west of Queen Anne's Gate. From here it can still be seen today straddling the Sheet Street Road to a point where it leaves the road on Beech Hill at the southern end of the Cavalry Exercise Ground, then travels across the open field on the eastern side of the road, continuing on to Ranger's Lodge where, from here on, the park pale goes up the hill and over the Reading Road, finally coming to an end at the east of Forest Lodge (the large house on top of the hill). Unlike Queen Anne's Ride and The Long Walk, the avenue has a meandering course and a variable width, the average being 37 metres (121 feet).

At Reading Road, where the park pale passes over, there are three commemorative oak trees. The first one to be planted is near the north side of the road. This was planted on Friday 30th December 1887 by Princess Christian of Schleswig-Holstein (Princess Helena of Great Britain and Ireland) to commemorate Queen Victoria's Golden Jubilee. The tree is known as The Queen's Jubilee Oak and it had its first crop of acorns in 1893. The iron plaque under the tree has the following inscription:-

> THIS TREE
> was planted
> on the 30th December 1887 by
> H.R.H. Princess Christian of Schleswig Holstein
> (Princess Helena of Great Britain and Ireland)
> in commemoration of the 50th year of the
> reign of Her Majesty
> QUEEN VICTORIA

One of the first acorns from the above tree was raised for the next tree. The Queen's Diamond Jubilee Oak was planted several metres away to the east. This tree was planted at 12.30 pm on Thursday 9th December 1897 also by Princess Christian of Schleswig-Holstein who was the daughter of Queen Victoria. Present during the planting of the tree was Captain Walter Campbell (Deputy Ranger) and Frederick Simmonds (Deputy Surveyor). The iron plaque under this tree has the following inscription:-

> This Tree raised from an acorn of the
> Queen's Jubilee Oak 1887 was planted
> on the 9th December 1897
> by H.R.H. Princess Christian of Schleswig
> Holstein
> Princess Helena
> of Great Britain & Ireland
> in commemoration of the 60th year
> of the reign of Her Majesty Queen Victoria

The last of the three trees was planted on the southern side of the road. This tree, known as The Coronation Oak, was planted on Thursday 14th August 1902 by Mrs Walter Campbell, wife of the Deputy Ranger. It commemorates the coronation of King Edward VII, which had taken place six days before on Saturday 9th August 1902 at Westminster Abbey. Although this was the last tree planted, it is far larger and better shaped than the earlier trees. This fully illustrates how difficult it can be when working out the age of a tree. So much depends on genus, species, disease, soil, position, planting time, planting preparation, aftercare, weather, etc. All of these can have a marked effect on the growth of a tree.

A short distance to the west of the trees, the Reading Road comes to an end at Cranbourne Gate, at the junction with Sheet Street Road. The Gate Lodge is a smart bungalow-style building built in 1949. Eighty-four years before the lodge was built, a very sad event took place under the large oak tree that stands next to Sheet Street Road. A man who worked

Ranger's Gate with Ranger's Lodge further up the hill. Sheet Street Road is in the foreground. (photo by the author – July 1999)

Sheet Street Road looking south from Beech Hill at the southern end of the Cavalry Exercise Ground. The old oak tree avenue is seen in the field on the left. (photo by the author – May 1999)

Windsor Great Park Women's Institute 30th Anniversary Celebration Party held in Ranger's Lodge garden in the summer of 1952. The persons from left to right are:-
Back row (standing)
Mrs Lindsay, Mrs B Ashton, Mrs Phipps, Mrs J Russell, unknown, unknown, Mrs M Richardson, Mrs Nutley, Mrs Wright, Mrs P Cottrell, Mrs D Ashton, unknown, Mrs Goodchild, next twelve persons unknown, Mrs B Gray, unknown unknown, Ms Baker, unknown, unknown, Mrs Nicker, unknown, Mrs Searies, unknown, Mrs T Smith, Mrs M Puzey, Mrs El Puzey, Mrs W Cocks, Mrs S Finlayson.

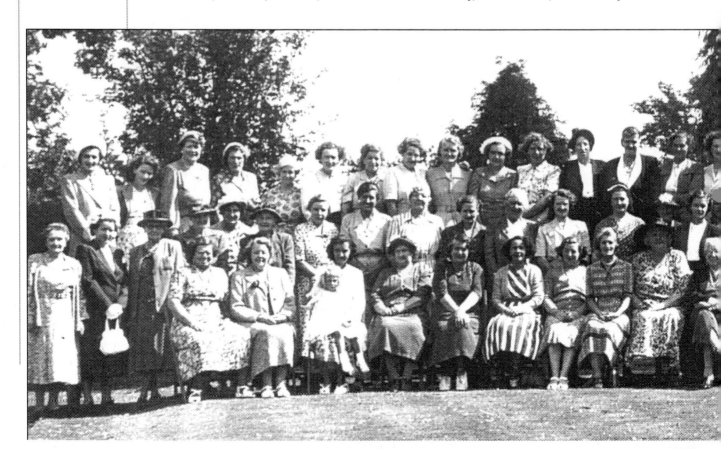

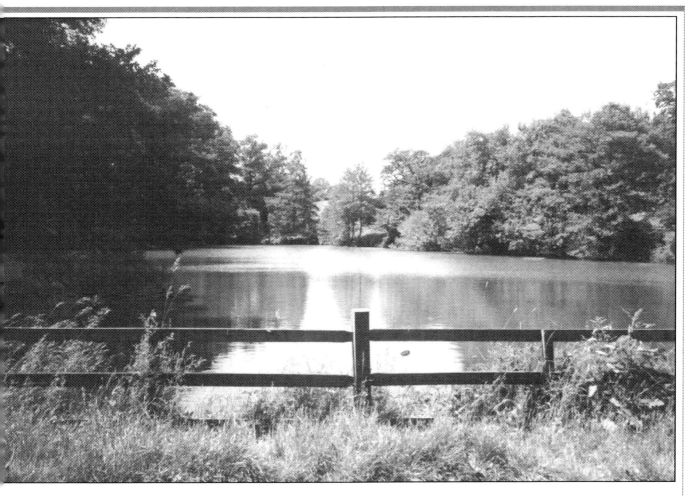

Middle row (standing)
Mrs Wye, Mrs Wilkins, Mrs Hobday, unknown, unknown, unknown, Mrs Kemble, Mrs Moakes, unknown, Mrs Hathaway, next ten persons unknown, Mrs McMillian, unknown, unknown, unknown, Mrs Clarke, all others unknown.
Front row (sitting)
Mrs L Cook, Mrs Thompson, Mrs J Greenaway with daughter Wendy, unknown, Mrs E Ashton, Mrs Morgan, Mrs M Mason, Mrs Twyman, unknown, Lady H Savill, Mrs K Shefford (with cake), Mrs J Gibbons, Mrs O Gillingham, unknown, unknown, Mrs Gurnett, unknown, unknown, Mrs Brant, Mrs R Woods, unknown, unknown, Mrs K Wrixen with son David.

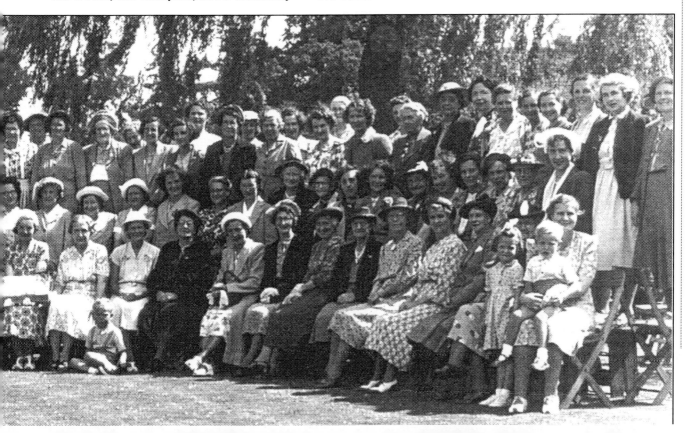

King Edward Vii Coronation Oak is the large tree in the foreground. The next two largest trees, from left to right, are the Queen's Jubilee Oak and the Queen's Diamond Jubilee Oak. (Photo taken in March 1999 by the Author) A photograph of the commemorative plaque under the King Edward's Coronation Oak (photo by the Author)

Cranbourne Gate and Lodge with Sheet Street Road in the foreground (photo April 1999 by the Author)

at a newsagent's in Windsor had been delivering newspapers all day on Saturday 28th January 1865. At 9.30 in the evening, already very cold and tired, he set out on foot to deliver newspapers to the houses in the park. It was a bitterly cold night and he was very tired, particularly as he had just walked up Goat Pen Hill, and it must have become too much for him. He sat down under the tree and fell asleep. The next morning he was found, frozen to death.

As already mentioned, Forest Lodge is the large house that stands on the hill at the far southern end of the old oak avenue. The views to the north from the Lodge are truly magnificent, with Windsor Castle being the focal point. It is obvious why it was used for so many years as the residence for the Deputy Rangers. Although it was built in the 1770s and has undergone many internal changes, the outside of the building has remained mainly the same.

The lodge has an imposing appearance and looking up at it from the northern side, it is easy to feel inferior

as a person. The house was built on the site of a much smaller house, which was simply known as 'Winkfield', almost certainly because it stood close to the boundary of the parish of the same name. At that time, it was within the confines of Cranbourne Park (Chase), a network of tree lined rides cutting through the forest, with Cranbourne House in a central position. The ride that ran from Fernhill to Sandpit Gate has been known as Holly Walk from at least 1750. This is not surprising as there were many holly trees (*Ilex Aquifolium*) growing in the area. The shorter habit and robustness of the holly allows it to thrive extremely well near and under the much larger oak trees. It is fairly certain that the lodge that replaced Winkfield was named 'Holly Grove' for that reason. In the early days, the Holly Grove Estate, as it was known, changed hands many times. It was not until 1842 that the occupancy stabilised when Sir William Fremantle (Deputy Ranger) took up residence there. The Deputy Rangers who followed him were Major-General Francis Seymour 1850-70. Colonel, The Honourable Augustus Liddell 1870-83. Captain Walter Douglas Samuel Campbell 1883-1916. Colonel, The Honourable Claude Willoughby 1916-29 and Lieut-Col. Sir Malcolm Murray 1929-37. During this period, the house was sometimes referred to as Ranger's Lodge. In 1937, the estate, consisting of 11.33 hectares (28 acres) of ground and three cottages, was let out to Sir John Aird, Equerry to King Edward VIII. At the same time, and after much debate, the name of the house was changed to 'Forest Lodge'. Currently, the estate is still held by Crown lease.

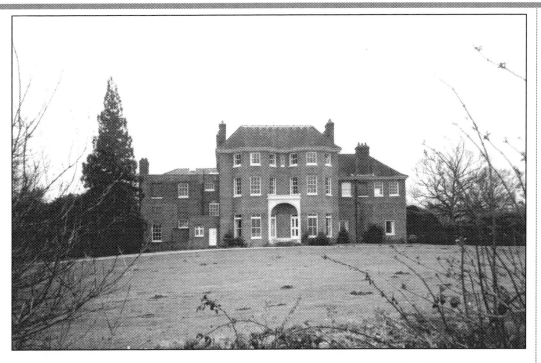

Retracing our footsteps back to the commemorative oaks at Reading Road, the road heads towards the village, passing over a cross-road junction. The road to the left is the start of Prince Consort's Drive. This leads down to Ranger's Gate and crosses over Sheet Street Road on its way to Flemish Farm. The road to the left leads to the southern area of the village. Continuing straight on down the Reading Road, a road branches off at an angle to the right, entering the Prince Consort's Workshops complex a short distance away. As the Reading Road slopes down towards the Battle Bourne Stream, the Russell's Field Farm buildings stand on the left. Just before the stream is a single residential building in the form of two semi-detached houses named 'South Lawn' and 'Devonia'. Almost immediately opposite is Reading Pond and from here we pass the northern end of the village and meet up again with Queen Anne's Ride. Russell's Pond is a short distance away to the left. Turning right into the ride, the enclosed Watchoak Plantation actually touches the semi-circular area of lime trees at the eastern side of the ride. Standing outside the plantation to the east is the Watch Oak. Access to the tree is by way of Reading Road.

A short distance along the ride to the south stands the Millstone Memorial commemorating the replanting of Queen's Anne's Ride and one thousand years of the Office of High Sheriff. The millstone is mounted on its edge on top of a stone pedestal. Looking north through the hole in the millstone is like looking from the wrong end of a telescope as Windsor Castle is seen in miniature. On the southern side, the badge of the High Sheriff is cut into the stone. The badge has an oval-shaped shield with crossed swords (symbolising Scotland). Two leeks (Wales) in a crossed position are shown on each side of the shield and at the top and bottom of the shield is a rose for England. A crown is set on the top rose. Below the centre of the millstone, a bronze rectangular inscription plate is set into the stone which is worded as follows:-

> Queen Anne's Ride
> Was replanted in 1992-93 to commemorate 1000 years of the Office of High Sheriff
> The first of 1000 was planted by
> HIS ROYAL HIGHNESS THE PRINCE PHILIP, DUKE OF EDINBURGH K.G. K.T.
> Ranger of Windsor Great Park.
> On November 23rd 1992.

Another bronze rectangular inscription plate is set into the wall of the pedestal worded as follows:-

> This millstone was quarried by hand on Stanage Edge, Derbyshire about 1825.
> It was not moved until 1992 when this memorial was created and the Sheriff's Badge carved by Brian Morley of Hope, Derbyshire.

155

Reading Road Pond – July 2000 (photo by the Author)

The Millstone Memorial commemorating the replanting of Queen Anne's Ride during the 1990s. (July 1998 – photo by the Author)

Timberlodge Deer Barn, one of the last remaining deer barns in the park – April 1999. (photo by the Author)

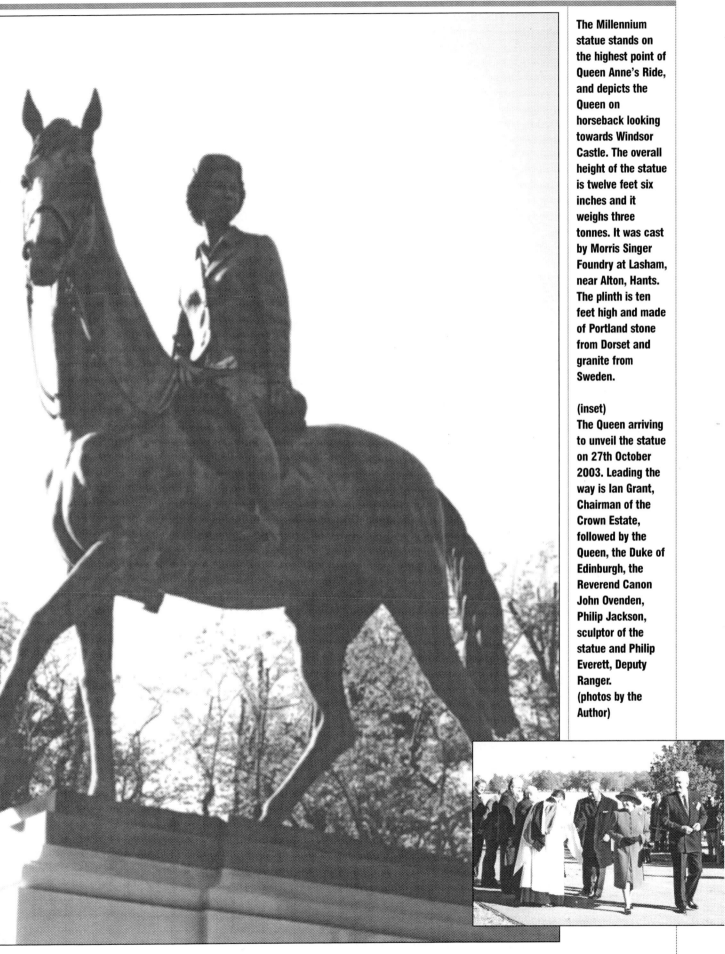

The Millennium statue stands on the highest point of Queen Anne's Ride, and depicts the Queen on horseback looking towards Windsor Castle. The overall height of the statue is twelve feet six inches and it weighs three tonnes. It was cast by Morris Singer Foundry at Lasham, near Alton, Hants. The plinth is ten feet high and made of Portland stone from Dorset and granite from Sweden.

(inset)
The Queen arriving to unveil the statue on 27th October 2003. Leading the way is Ian Grant, Chairman of the Crown Estate, followed by the Queen, the Duke of Edinburgh, the Reverend Canon John Ovenden, Philip Jackson, sculptor of the statue and Philip Everett, Deputy Ranger.
(photos by the Author)

To the south of the Millstone Memorial, the village houses on the right are those built during 1948-1949 and on the left the houses were built in 1954-5. At the end of the houses a road crosses the ride and heads towards Cumberland Lodge in the east. Not far along this road is a junction known as Timberlodge cross-road. At the far corner on the left is the Albert Plantation. In the middle of the plantation is one of the few remaining deer barns in the park. Not so many years after the Windsor Forest Enclosure Act 1813, and the subsequent Awards in 1817, a number of deer barns were built throughout the park. They were substantially built, mainly with well-seasoned and preserved oak and with a tiled rooves better than some houses would have had at that time. Although they varied in overall shape, they all shared a long Y-shaped slatted deer-feeding rack running down the centre of the barn, and a lockable food storage space at the end. Originally, every barn was built within the confines of a deer-pen. The demise of most of the deer at the start of the Second World War saw the start of the demise of the barns. Neglect and vandalism took their toll, and by the 1950s most of them were pulled down. The Timberlodge Barn has survived, mainly because it stands in a private area, and was renovated in 1981. For the older person, it is a reminder of times gone by.

Continuing the route southwards along Queen Anne's Ride, the village recreation field is on the left with the golf course going through the trees, rising up the hill known as Duncum Plantation. Until the 1950s, a deer-barn stood in the middle of this plantation. The open field on the left hand side of the ride is called Poets' Lawn. At the brow of the hill another road crosses the ride. To the left it leads to Cumberland Lodge, passing the start of Duke's Lane, Hollybush Cottages and the Royal School. The road to the right meanders up the hill to Sandpit Gate. Although Queen Anne's Ride continues to a point near Prince Consort's Gate, the public is not permitted to go beyond the southern side of the road. However, you can almost touch the semi-circle of lime trees on each side of the ride which stand there as part of the original layout of the ride.

Sandpit Gate is historic in that it stands on the boundary of the park, formally separating the park from the forest. It should be pointed out that it is all Crown Land and it is controlled as the same by the Windsor Crown Estate Office. It is not by chance that the gate is so named. The hill where the gate stands is almost entirely made up of sand. Sand was excavated there at least two-hundred and fifty years ago, leaving a series of sandpits in the area. One of the sandpits to the east of the gate was still being actively used as recently as 1942. The abundance of sand attracted badgers to the area and during the 1940s one of the largest badger setts in the park was active under some fir trees a short distance to the south. Sandpit Gate Lodge stands on the southeastern side of the gate and

was built about 1750. It is rectangular in shape, with castellations at the tops of the walls. Until the 1940s, the outside walls of the building had been left in the natural grey of the stone blocks giving a rather sombre appearance. It is now painted pink in keeping with the lodges at Queen Anne's Gate, Forest Gate and Blacknest Gate. The Lodge underwent much-needed refurbishment in 1970.

At least as early as the start of the 1600s, Sandpit Gate stood on a fairly busy track from Egham and beyond in the east to Forest Gate, Cranbourne and St Leonard's Hill in the west. Old maps show that the current group of buildings was not the first to be built there. From the early days it was soon established as a holding area for livestock, with horses and cows being the main animals. During the early 1800s, more unusual animals and birds were brought in, and by the 1820s it had developed into a well-run menagerie, stocked with two fine specimens of giraffe, and several antelopes, bears, wild boars and monkeys. By 1828, no fewer than twelve kangaroos could be seen in the yard. Some of the birds were quite exotic - storks, cranes, emus and cockatoos, to name just a few. The menagerie became very popular and received regular visits from King George IV and his guests. The public was allowed to visit at week-ends. During this period, Sandpit Gate and the Menagerie were controlled by Thomas Clark, Park Keeper.

Following the death of King George IV at Windsor on Saturday 26th June 1830, the future of the menagerie became bleak. The new King, William IV, showed no enthusiasm for the animals and birds, or for the park itself for that matter. By the end of the year the creatures were all settled in their new home at the Regent's Park Zoological Gardens in London.

Early in 1861, Sandpit Gate Lodge became the residence of the Head Gamekeeper for the first time. It is still the residence for that purpose today. The Head Gamekeepers who have lived there during that time are:—

1861 – 1874 John Cole
1874 – 1906 Goss Overton
1906 – 1915 George Weir
1915 – 1933 Edward R Dadley
1933 – 1946 Edward W West
1946 – 1964 George P Hallett
1964 – 1984 William Fenwick
1984 – 1985 David Mansfield
1985 – 1986 William Fenwick
1986 - John Stubbs

Of the Head Gamekeepers, it is Goss Overton who stands out for his character. Having already served six years as a Gamekeeper on the Royal Estate at Sandringham, he came to the park in 1874 to take up the post of Head Gamekeeper, a position he held until he retired in 1906. During his time in office he became well known, not only by Queen Victoria and King Edward VII, but by many European monarchs as well. He was decorated with the Queen Victoria

Edward Robinson Dadley, Head Gamekeeper leaning on the wall pillar with his wife Louisa Eliza Dadley nearest to him and two relations outside the front porch of Sandpit Gate Lodge c.1930. Edward was born at Bury St.Edmonds, Suffolk in 1866, and died at Windsor on 26th June 1933 aged 67 years. He was Head Gamekeeper of the estate for 18 years (1915-33). He would often be seen riding around the park on horseback. (Windsor Crown Estate Collection)

Jubilee Medal, Diamond Jubilee Medal with bars, Faithful Service Medal, King Edward VII Coronation Medal, and he was presented with seven other medals by European Monarchs. Goss was so proud of his medals that he always wore them when accompanying Royal shooting parties. In November 1905, King Edward VII was particularly grateful to him, when he came to his aid after the King tripped in a rabbit hole and injured himself. He was something of a gentle giant, well respected by people, and the deer would practically eat out of his hands.

Goss Overton was born on Wednesday 16th December 1835 at Burley in Rutland and died one day before his seventy-ninth birthday, on Tuesday 15th December 1914 at Gosford House, Longley Road, Tooting, London. He was buried next to his wife, Eliza at St. Peter's Church, Cranbourne on Saturday 19th December 1914. Eliza Overton died at Sandpit Gate Lodge on 14th October 1901 aged 67 years.

On 1st March 1936 the White Bus Services at North Street, Winkfield extended their bus routes to include Windsor Great Park for the very first time.

Sandpit Gate Lodge – September 2000 (photo by the Author)

Sandpit Gate Kennels – September 2000 (photo by the Author)

Sandpit Gate Bothy – September 2000 (photo by the Author)

This preserved White-tailed Eagle (Haliaetus albicilla) was 'winged' with shotgun pellets by John Cole, Head Gamekeeper in the Summer of 1865. He nursed it back to health and kept it at Sandpit Gate for 33 years when it finally died from a fit in 1898. Queen Victoria, who would have seen it many times, had it preserved and returned to Sandpit Gate for safe keeping by Goss Overton, Head Gamekeeper at that time. (photo by the Author - July 1999)

162

Starting at Windsor Castle, it entered the park through Queen Anne's Gate, then turned into the private roads of the park through Ranger's Gate, along Reading Road, past The Copper Horse and around the Royal Lodge, back past what is now the village, then through Cranbourne Gate, finishing at The Crispin public house at Woodside. Initially, the services operated on Tuesdays, Fridays and Saturdays only, and the 35 minute journey cost sixpence in old currency (two-and-a-half new pence) for a single journey and tenpence in old currency return. The service now operates every day except Sundays.

The Estate Offices, Prince Consort's Workshops and the village are the hub of the operating activities in the park and forest. Within the offices there is a coordinated management structure, with the Deputy Ranger overseeing all of the functions. Considering the area, and the extensive and varying staff roles necessary to control the estate, the workload and responsibilities are enormous. Most visitors to the park and forest, when they are out for a walk or maybe picnicking, are generally so absorbed with the beauty and relaxing nature of the place that the furthest thought from their minds is what is required behind the scenes to keep it the way it is. There are the Savill and Valley Gardens to be maintained, the forests and woods to be managed, farms to be looked after, lakes, ponds and streams to be kept clean and free from pollution, roads, lawns and fencing to be maintained. the list is endless.

During the past few decades, the park and forest has become an extremely popular venue for sports and charity fund raising events, all of which have to be controlled, not forgetting the public liability responsibilities placed on the estate. This has added enormously to the workload in the offices. At one stage the demand was so great that the use of the park and forest for such events was put under threat. However, it is possibly the danger of a major forest fire and, to a lesser extent, flooding that concentrates the minds of those in charge in the office. Controlled from the office is a network of Wardens, continually patrolling the estate with the aid of a radio communication system. In the main, their most common problem is dealing with someone who has decided to put up a tent, the main concern being that a camp fire could be lighted with possibly catastrophic results. And there is always the person who prefers to ignore a 'private' notice board.

Recreation for the estate employees, both current and retired, including their families, is available at the York Club and adjacent leisure and sports facilities. From 1953, with the opening of the York Club building and the establishment of the Recreation Ground, this became the centre point for most of the leisure and sporting activities in the park. Prior to this time, the main centre was in and around Cumberland Lodge. It follows therefore that some of the clubs and groups currently using the village facilities go back to

that time. The following pages give a brief summary, in chronological order, of the clubs and groups using the facilities today.

Windsor Great Park Cricket Club. Formally recognised as being founded in October 1861, although there are local newspaper reports covering matches played by the Windsor Great Park Cricket Club at Cumberland Lodge going back to 1817 (forty-four years earlier). The first matches were played at Cumberland Lodge and a few matches were played in the field in front of the Royal School. Following this, Smith's Lawn was utilised and the Recreation Ground is now used.

Windsor Great Park Women's Institute. Founded in 1932 at the suggestion of Mrs Ethel Tannar, wife of the Royal School Head Teacher Hubert Tannar. On Thursday 3rd November 1932 Mrs Tannar arranged a meeting in the Royal School where it was agreed to form a Windsor Great Park Women's Institute, under Berkshire Federation Rules. On Wednesday 14th December 1932 the inaugural meeting was held in the Reading Room in Cumberland Lodge and the Committee was elected as follows:- Lady Savill (President) Miss Vidal (Vice-President), Mrs Collins

The Windsor Great Park Women's Institute Banner lovingly crafted by hand of the members. The four squares in the shield show some features of the park. The Copper Horse, Windsor Castle, a Red Deer Stag near an Oak Tree and the Cumberland Obelisk.

(Secretary), Mrs Tannar (Treasurer), Mrs Cripps, Mrs Kew, Mrs MacMillan, Mrs Mansfield, Mrs White and Mrs Wye.

Windsor Great Park Football Club. Founded 1932 starting with two teams playing in the Windsor, Slough and District League. The pitches were at Cumberland Lodge, Russel's Field and currently on the Recreation Ground.

Windsor Great Park Scouts and Cubs Troop (8th Windsor). Founded 1937. Facilities used at Cumberland Lodge, Bear's Rails, and York Club.

Windsor Great Park Guides and Brownies. Founded 1937. Disbanded in the 1960s, and re-started from 1972 to 1975 by Mrs Bertha Moakes.

Windsor Great Park Annual Flower Show. First show held at York Club on Saturday 4th July 1953.

Windsor Great Park Bowls Club. Founded in 1954 when the bowling greens were created near the York Cub.

Windsor Great Park Tennis Club. Founded in 1954 when the tennis court was created next to the bowling greens.

Windsor Great Park Golf Club. Founded 1978 when the nine hole golf course was created at the south of the Recreation Ground.

In addition to the above, many social activities take place at the York Club throughout the year.

During the history of the clubs, there is one occasion that will probably never be forgotten. This was when the wrath of nature abruptly brought to an end a bowling match. On Wednesday evening 5th May 1982, a bowling match was in full swing between the Windsor Great Park Bowling Club and the British Airways 'Concorde' Bowling Club. The sky was overcast with cloud and becoming progressively darker. At about 7.10, the bowlers must have felt as if the world had come to an end, when lightning hit a nearby large oak tree. The power of the strike was so violent that many of the bowlers were lifted off the ground and they were left in a stunned and confused state. Fortunately there were no serious injuries. However, the material damage was considerable. The tree had been literally blown to pieces, with slivers of wood scattered up to 73 metres (80 yards) away. The bowling green looked like the back of a porcupine with wood embedded all over it, whilst the remains of the tree were merrily burning away. The blast had shattered most of the windows in the old pavilion that stood at the opposite side of the bowling green. It was the bowlers' cars in the nearby car park that incurred the costliest damage. Two cars were completely written off, and several others were badly damaged. It would appear that the heavens had finally responded to the repeated curses by the bowlers that the tree was a nuisance because of the shadows it created and the leaves that it shed on the green.

Cranbourne

8

Cranbourne

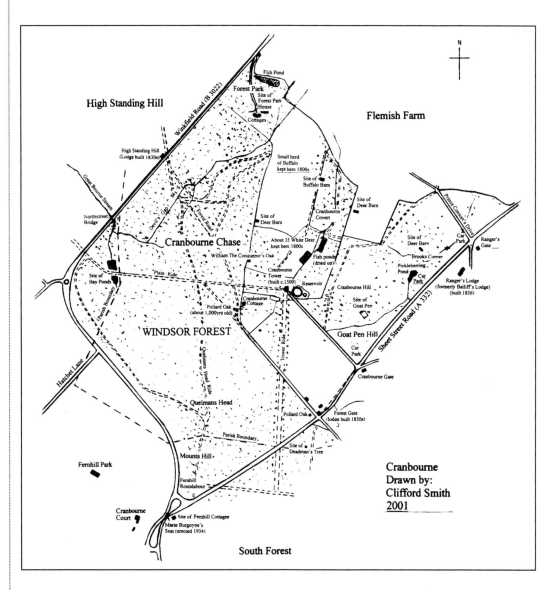

High Standing Hill

Forest Park

Flemish Farm

Cranbourne
Drawn by:
Clifford Smith
2001

WINDSOR FOREST

Cranbourne Chase

Fernhill Park

Cranbourne
Court

South Forest

Cranbourne is an area
in the park that is
generally recognised
by the local people as
the place that has the
Cranbourne Tower
standing at the top of
the hill. Although this
is the focal point of
the area, most of the
people who visit or drive through the park never see it
or are aware of its existence.

In addition to the history of the tower, there is an
air of mystique about the whole of the surrounding
area between Sheet Street Road in the east and
Winkfield Road in the west and from Flemish Farm in
the north to the Fernhill Roundabout in the south.
Whilst the whole area comes within the Windsor
Crown Estate, the northern half comes within the
boundary of the Great Park and the southern half is
part of Windsor Forest. Much of the area is densely
wooded and contains several very old specimens of
pollard oak trees.

Cranbourne Tower is the oldest building existing in
the park, and it could equally be said that it is the most
historical. Since its origins, which go back to the start
of the 1500s, it has undergone many changes to its
structure and it has seen many members of the Royal
Family and many well known persons pass through its
doors. The original lodge started as a very large
rectangular shaped country house (lodge) and it is
known that Anne Hyde, Duchess of York, who went

on to become the first wife of King James II, was born there in 1637 and spent the first twelve years of her life there, leaving in 1649 for her own safety, following the execution of King Charles I on 30th January 1649.

At one time or another, the lodge was visited by King Charles II, King George III, King George IV, Queen Victoria, The Prince Consort and many princes and princesses. In 1814, Princess Charlotte, daughter of the Prince Regent (later King George IV), was sent to live there as a kind of punishment by her father, who was opposed to her wishing to marry the love of her life, Prussian Prince Augustus. The Prince Regent even went so far as banning anyone from seeing her, and such was the public distaste over this action that it was even raised in parliament. It would appear that other members of the Royal Family would have none of this because, on New Year's Day 1815, she was visited by Queen Charlotte, Princesses Augusta, Elizabeth and Mary, accompanied by Dowager Lady Harcourt. Princess Charlotte finished up marrying Prince Leopold of Saxe-Coburg and, very sadly, died during childbirth the following year. Prince Leopold went on to become King of the Belgians.

In addition to the members of the Royal Family visiting and staying at the lodge, there were many notable persons who did likewise. The first to come to mind is the well-known diarist, Samuel Pepys. On 19th August 1665, while he was Secretary to the Navy Board, he visited the lodge to report to his 'boss', Sir George Carteret, Treasurer of the Navy Board, who was living there at the time, the destruction of the British Fleet by the Dutch off Bergen. Although Pepys visited the lodge on several occasions, he did not appear to be endeared to the area, describing the place as "melancholy, being little variety save trees." It was Sir George Carteret who had the original lodge, with the exception of the tower, pulled down and rebuilt (1663-6). The lodge once again went into a sad decline following the death of Princess Charlotte and was finally demolished in 1861, leaving the tower that was butted on the end of the lodge to survive to this day.

Not only has the original lodge long since gone, so has the spelling of Cranbourne, which was once written without the 'e' as Cranbourn. Furthermore, the area around the tower was known as Cranbourne Chase, a description no longer used.

Cranbourne Tower has an historical association with the equestrian world because it was here that the outstanding racehorse, 'Eclipse' was born. During the 1750-1760s, Prince William Augustus, The Duke of Cumberland was running a well-organised horse-breeding establishment next to the tower. His famous stallion, 'Marske' was mated with a mare named 'Spilette' and, as a result of the union, a handsome little chestnut colt was produced on 1st April 1764. Far from being an April Fool's Day trick, the colt which had a white blaze and one white sock, developed into one of the country's finest racehorses.

It was given its very appropriate name because it was born in the year of an eclipse of the sun. Within a year of the colt's birth, The Duke of Cumberland died and the horses at the establishment were put up for auction. Eclipse was sold for eighty guineas (eighty-four pounds sterling) to a loud-mouthed Yorkshire meat salesman named William Wildman. He soon realised that the horse not only had a exceptional physique but also had a vicious temper.

It was not until 3rd May 1769, when Eclipse was six years old, that he was first entered in a race at Epsom in four mile heats. Eclipse won his first heat easily and, in the final, left all of the other horses many distances behind. A very astute man named Dennis O'Kelly watched Eclipse's performance with awe. It was not long before O'Kelly persuaded Wildman to sell him a half-share in the horse for six-hundred-and-fifty guineas, for what he considered to be the perfect racing machine. On the day that the deal was struck, Eclipse won a Kings Plate at Winchester with such ease that, when he was racing two days later, all of the horses were scratched by their owners. O'Kelly then persuaded Wildman to sell him the other half-share for one-thousand-one-hundred guineas. The horse made his final racing appearance at Newmarket in October 1770 winning the four mile race by an enormous distance. Eclipse had become a legend in the racing world, not only for his own racing performances, but also for the other magnificent horses that he sired.

O'Kelly's investment in the horse paid handsome dividends, making well over twenty-five thousand pounds in stud fees alone. Eclipse's offspring won two Derbys and a total of three hundred and forty-four races. The great horse died from violent colic at Cannon's in Edgware, London on 25th February 1789. He was 25 years old.

Cranbourne Tower, even without the adjoining lodge, continued to be a focal point for the Royal Family and their guests. Queen Victoria in particular had a strong liking for the place and had the large central ground room set out as a private tea room. The room was mainly used for refreshments after the regular shooting parties that took place at nearby Flemish Farm. Following the death of The Prince Consort in 1861, Queen Victoria's visits to the tower during the remainder of her reign were of a much more sombre nature. The adjacent rooms to the tea room were for many years, used as a Gamekeeper's residence. One of the gamekeepers, William Wye, was well-known by my family. William was born at Thorpe, Egham, Surrey in 1830. He changed his name to William Bushnell-Wye when he re-married in the 1890s. In 1897 he moved from the tower to become the Gatekeeper at Cumberland Gate, Smith's Lawn. In spite of sustaining a bad leg injury when he was hit by a carriage, he continued to control the gate until he died there in 1910, aged 80 years. The tower

continues as a residence for estate employees, but no longer for Gamekeepers. During the 1960s it was found that the tower had a rat problem. It was whilst Peter Wagstaff was searching under the floor boards to get at the source, that he discovered a box of perfectly preserved Georgian long-stemmed smoking clay pipes, complete with wooden tobacco boxes. How they came to be there is anyone's guess. Although the building has undergone many repairs, its appearance is very much as it has always been. The most recent repair work was carried out in 1995 when it was found necessary to replace the lead on the flat roof. It is when you are on the roof that the tower really comes into its own, and you can soon see why it was used as an observer-post by the Home Guard during the Second World War. The finest aspect is looking due north in the direction of Flemish Farm and Windsor Castle. The Flemish Farm buildings from the height and distance of the tower look like a model of a farm yard with the Bromley Hill Clump standing in a dominant position to the east. In the foreground, between the tower and the farm, is a large rectangular field which, during the 1800s, was the home of a small herd of buffalo and white deer. The buffalo were kept at the far end of the field and they had their own very large barn known as 'Buffalo Barn'. Long after the buffalo had gone, the barn was pulled down in the 1950s. At the near end of the field known as White Hart Paddock (white hart being the name for a white deer stag), were kept about thirty-five white deer that had originated from Germany. On the eastern side of the field were two artificial fishponds. During the rutting season, the white harts were equally if not more aggressive than the more common red stag. On at least two occasions, once in 1897 and once in 1908, two were found dead in the fish ponds with their antlers locked together. The remainder of the white deer were taken from the park in the 1920s and the two ponds were allowed to dry up. Today all that is visible of the ponds are two hollow basins. A deer barn that stood on the western side of the field was pulled down in the 1960s. Turning eastwards, the scenery changes from open fields into a scene dominated by large oak trees with a scattering of large beech. A metal date-post, not far from Sheet Street Road near Ranger's Gate, is dated 1580 for the trees planted in the area. Many of the mature oak trees on Cranbourne Hill are almost certainly part of the tree planting that went on at that time to supply much needed timber for the British Navy. The historic sea battle between the British and Spanish Fleets that had taken place eight years previously was a stark reminder of the importance of having an adequate supply of timber to build and maintain the ships. Until the 1950s, a deer barn stood slightly up the hill as a reminder of the herds of deer that were kept in the area before the Second World War.

Moving up the hill, close to the western side of Sheet Street Road, two streams meet at right angles and merge into one. The immediate area where the streams meet, is appropriately known as Brooks Corner. The stream that travels up the hill and, close to the road, meets up with a spade shaped pond known as Pickleherring Pond. Like most of the ponds in the park, it was created many years ago by damming up the stream. It is about 64 metres (70 yards) long and about 32 metres (35 yards) wide at the head. On occasions some small fish can be seen, and sometimes a moorhen or two. The head of the pond has broken away several times and, as recently as 1998, the pond was dredged and the head repaired. As the stream goes up the hill towards Cranbourne Gate, an area on the west slope of the stream has a particular historic background, for it was here that a goat pen stood throughout the 1800s and up until 1940.

The Cashmere goats from Kashmir in the Himalayan Mountains were first introduced into the park in 1828, when Christopher Tower gave a pair of the goats to King George IV. Mr Tower of Weald Hall, Brentwood, Essex, had bred a herd from a pair he had purchased at a sale at Paris in 1823. They were purchased for the express purpose of using the fine wool that grows between the long hair of the goat to make cashmere shawls. The shawls were a much cherished garment and popularised by Queen Victoria, who would often be seen wearing one. Several shawls were made from the Cranbourne herd. The wool was painstakingly removed by hand from the goats, then sent to Darlington to be spun into yarn and then to Paisley in Scotland to be woven into shawls. The Cranbourne herd was rejuvenated by added new stock in 1874 and 1889. During the summer months, the herd was allowed to wander freely in the park, much to the delight of visitors who would often see them grazing on the Review Ground and the Cavalry Exercise Ground.

It was from the prize stock of about fifty white goats that was kept there that Queen Victoria presented the Royal Welsh Fusileers with a magnificent goat in 1844. From that time on, the various Welsh Regiments have used the goat as their official mascot. The Welsh Regiments have always cherished their mascots to such a degree that, when one was presented from the Cranbourne stock by King George V to the 7th Battalion Reserve Royal Welsh Fusileers in November 1914, two Fusileers travelled by train from Newtown, Montgomeryshire and escorted the goat all of the way back to their camp with fixed bayonets. The adjacent part of the hill on Sheet Street Road is known as Goat Pen Hill, or simply as Goat Hill in connection with the goats that were once kept there. When the goats were removed in 1940, one goat was kept as a kind of mascot for the small herd of deer that was retained in the private area west of Duke's Lane.

At the top of Goat Pen Hill there is a well made single track private road that starts from Sheet Street Road opposite Cranbourne Gate and sweeps directly

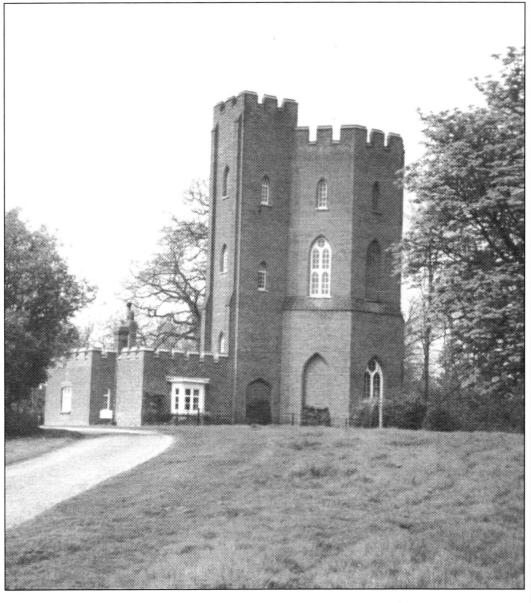

Cranbourne Tower from the east – May 1998 (photo by the Author)

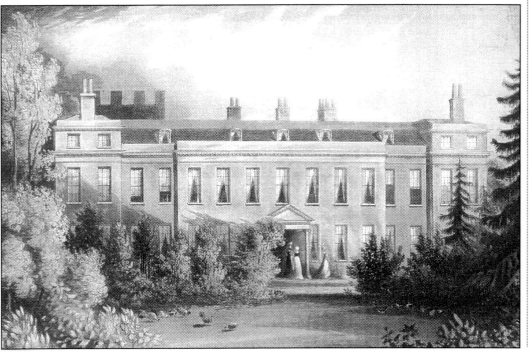

Cranbourne Lodge in a watercolour painting by an unknown artist about 1820. The lodge was erected about 1500 in the reign of King Henry VII. It started to fall into decay in the mid 1800s, and in 1861, the lodge was demolished with the exception of the tower which remains today. (The Royal Borough of Windsor and Maidenhead Museum Collection).

167

George Smith (Gamekeeper), great grandfather of the author, standing outside Cranbourne Tower in 1865 when he was 45 years old. His clothes were standard for a Royal Gamekeeper of the park. The trousers were made from green plaid, the jacket was dark green velvet with gold on the lapels and the top hat was green and black. His double-barrelled twelve bore shotgun had a pin-fire action. A triggered hammer would strike the cartridge firing-pin in a vertical position and not in the horizontal position as with a modern percussion firing shotgun. (Royal Collection – reproduced by kind permission of HM Queen Elizabeth II).

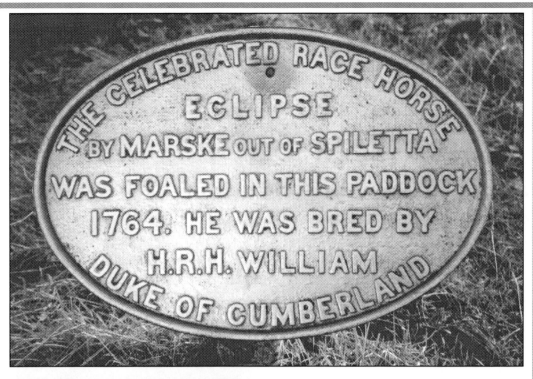

The commemorative plaque in the small field next to Cranbourne Tower. The Eclipse, was the most famous racehorse of the 1700s, and even today, the Eclipse Stakes, is held annually at Sandown Park Racecourse in the horse's honour.

The antlers of two white hart stags which were found drowned with their antlers locked together in one of the Cranbourne Ponds on 14th October 1908. An identical drowning in the same pond took place in 1897.

Looking south-east towards Sheet Street Road and Forest Lodge from the top of Cranbourne Tower. The road in the foreground comes in from Sheet Street Road opposite Cranbourne Gate – May 1998.

Looking north. The nearest part of the field in the foreground is known as White Hart Paddock, being where a rare breed of white deer were kept until the 1920s. At the rear of the field is where a herd of buffalo were once kept. The buildings further back to the right are part of Flemish Farm – May 1998.
(All photos by Author)

169

Pickleherring Pond situated at the bottom of Goat Pen Hill on the western side of Sheet Street Road - May 1998. (Photo by the Author).

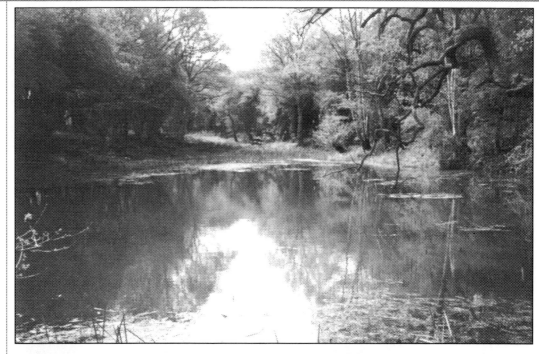

The Welsh Guards Band with their white goat mascot in Alma Road, Windsor on Saturday 28th May 1977 during the street carnival parade as part of the Septcentenary celebrations (700th anniversary of the grant of Windsor's first Royal Charter by King Edward I). The goat is from the Cranbourne stock. (photo by the Author).

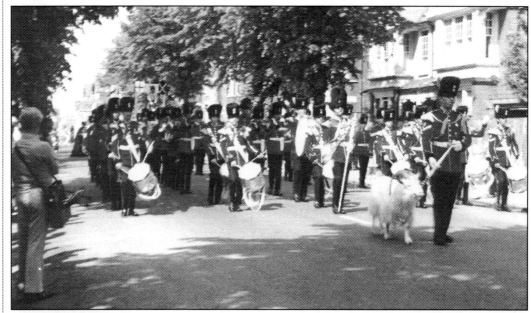

Sheet Street Road looking south towards Ascot. The elegant building is Forest Gate Lodge which, as the name suggests, stands where the boundary gate once stood between Windsor Forest and Windsor Great Park, the latter being nearest the camera – May 1999. (photo by the Author).

Cranbourne Cottage near the south-western side of Cranbourne Tower. It was built in 1893 replacing an old cottage known as Cranbourne Gardens. (photo taken in May 1999 by the Author).

The old pollard oak tree standing next to Forest Gate about 1939. It is believed to be about 950 years old. However, it is very difficult to estimate the age of a pollard tree even when it falls or is cut down. Invariably the centre of the trunk rots away which allows the tree to split open. In 1866, the circumference of this tree was 26 feet when measured five feet from the ground. In 1999, it was measured by the author and found to be 32 feet, proof that the girth of the tree is not linear with age. (Windsor Crown Estate Collection).

up to Cranbourne Tower. The large field on the southern side of this road is the last open space that can be seen from the top of the tower. About 366 metres (400 yards) south along Sheet Street Road is Forest Gate. This is the southern boundary of the Great Park and the start of Windsor Forest. The stretch of Sheet Street Road between Forest Gate and the previously mentioned Cranbourne Gate was a notorious accident spot for vehicles before the 1930s. Until that time, the road had a viciously sharp angle immediately on the northern side of Forest Gate. The problem was not helped by the fact that the road soon iced over in wet and cold weather, having very little protection from trees. On Sunday evening 24th May 1818, a very sad accident occurred there, which on this occasion had nothing to do with ice. Mr and Mrs Slan, whose family's name is given to Slan's Hill in Norfolk Farm in the park, were returning from Windsor in their gig (a light two-wheeled one-horse carriage) and, as they approached Forest Gate, their horse took fright and overturned the gig. Mrs Slan was thrown from her seat and died on the spot when she hit her head on the ground. Fortunately, this was a rare freak accident, whereas the number of motorised vehicle accidents in the 1930s was too high to disregard, and the road was changed to curve on the eastern side of its original course. The line of the original road can clearly be seen on the west side of the current curve.

In 1949, two modern style semi-detached houses were built close to the northern side of the Forest Gate Lodge. They are named Castle View and The Oaks. Before the Second World War, a large steel cattle-grid was set into the main road between the gate posts. The removal of the deer from the park made the grid obsolete and the steel rails, which were actually railway rails, were removed and the pit that stood under the rails was simply filled in. Although the original Gate lodge was built in the late 1790s, it was completely rebuilt in the 1820s in the form that we see it in today. The main outer walls are made with sandstone, which, over the years, has caused no end of cosmetic problems. The sandstone becomes dirty in appearance, with dark streaks running down the walls and early attempts to brighten it up with coloured wall paint resulted in making it even worse as the paint started to peel off. It was not until the 1960s that the problem was resolved with the introduction of improved wall-sealants and weather-resistant paints.

One of the lodge's first occupants was a Mrs Hardiman, and for many years the lodge and gate were known as Hardiman's Lodge and Gate. The next gatekeepers to live in the lodge were William and Mary Smith. When William died, Mary continued for many years after as the gatekeeper. During the 1920s, another William Smith and his family occupied the lodge. However, there appears to be no genealogical connection between the William Smiths that have lived in the lodge and the author's family.

Looking southwards from the lodge, which stands on the western side of the road, the road sweeps up to the Fernhill Roundabout road junction. Along this stretch of road, a deep ditch and a neat beech hedge is set on each side of the road. About 366 metres (400 yards) from Forest Gate, a wide ride, which was part of the original layout around Cranbourne Lodge, can be seen coming in at an angle from the south and continuing on the northern side of the road. The ride is known as Tower Ride. It provides a magnificent view of Cranbourne Tower at the northern end.

On the opposite side of the road at Forest Rate Lodge, there is a private road known as Lime Avenue. It leads in a south-westerly direction, passing through Sandpit Gate and on to Cumberland Lodge.

Close to the south-western side of Forest Gate Lodge stands a very old pollard oak tree. It would be more correct to say that it is hardly 'standing' as, without the props that have supported it for many years, it would almost certainly have fallen down by now. As a very rough guide, the girth of a tree is used to estimate its approximate age. In the case of an old pollard tree, this method should be completely disregarded. The records of this particular specimen confirm the point. In September 1866, the circumference was 7.92 metres (26 feet) when measured 1.52 metres (5 feet) from the ground. In September 1999, the circumference was 9.75 metres (32 feet). The trunk had so badly split open that the measurement of the girth has no age value. Based on the earliest available records, the tree is about 950 years old. Between the tree and Forest Gate Lodge, the old Forest Road travels in a north-westerly direction. A short distance along on the northern side of the road stand two houses named Nos. 1 and 2 Forest Gate Cottages. They were built in 1874, in the characteristic style at the time for the park.

A second, possibly even older, pollard oak tree stands along the old Forest Road not far to the south-west of Cranbourne Tower, near Cranbourne Cottage. As with the previously described pollard oak tree, it has been necessary to prop up the large branches to prevent it from falling down. Very old photographs of the tree show that it has been propped up for at least the last one-hundred-and-fifty years. Cranbourne Cottage was built in 1893 to replace the Gardener's Cottage that had stood for years about 46 metres (50.3 yards) to the east next to a small ornamental pond. Continuing in a north-westerly direction the old Forest Road crosses a long straight ride known as 'Plain Ride'. The ride derives its name from the fact that it was an old ride that led from Winkfield Plain in the west to Cranbourne Lodge in the east. Not far from Winkfield Road, on the line of the parish boundary, two fairly large ponds were situated on each side of the ride. They were known as Bay Ponds. After many years of neglect they dried up, and became non-existent by the end of the

1800s. The old Forest Road finally meets up with Winkfield Road opposite High Standing Hill Lodge.

On the eastern side of Winkfield Road, in the direction of Windsor, there is an area known as Forest Park. When the land was still in private ownership, a very large house was built there known as 'Forest Park House'. It was built in the 1820s, complete with stables, servants' quarters, gate lodge, icehouse, gardens and a large fish pond. The house, which would be more appropriately described as a mansion, had seventeen bedrooms. For much of the 1800s it was owned by the Weldon family from Ireland. In 1900 it was purchased by Mr Arthur Wigan, whose daughter, Mrs Beatrice Wigan, was still living there in 1947 when it was bought by the Commissioners of Crown Lands. Although it was in a poor state of repair, it was used for many years as a home for single mothers and their children. In June 1956 it was considered for conversion into an elderly care home. This was not a viable proposition, and a few years later the whole building was demolished - that is, with the exception of the garage buildings, which were converted into two residences for estate employees. The Gate Lodge, which stood at the start of the drive off Winkfield Road, was demolished in 1979.

A short distance in a south-easterly direction from Forest Park is the field where the buffalo and white deer were kept, as mentioned earlier. Following the west side of the field towards Cranbourne Tower, the ground progressively rises and continues to rise through the dense wood at the southern end of the field. Hidden in the wood, about 229 metres (250 yards) from Cranbourne Tower is the decaying trunk of an old pollard oak tree. The tree is known as the William The Conqueror's Oak. It is anything between 1,200 to 1,600 years old, and is probably the oldest tree in the park and forest. The name of the tree was derived from the fact that it was a favourite meeting point during William The Conqueror's hunting parties. Over the years, acorns from the tree have been planted throughout the world, mainly to commemorate a visit by a member of the Royal Family to the various countries. The old photograph shown below, which was taken in the 1890s, clearly illustrates how open it was in front of the tree. Note the use of wooded props to support the branches. The photograph on the next page, clearly illustrates how the tree and surrounding area have changed in one hundred years.

Forest Park House showing it in a run-down state in 1956 not long before it was demolished.

Forest Park Cottages being all that remains of the Forest Park buildings. The old garage doors are plainly evident and the position of a third can be seen from when the conversion took place. (photo in September 1999 by the Author).

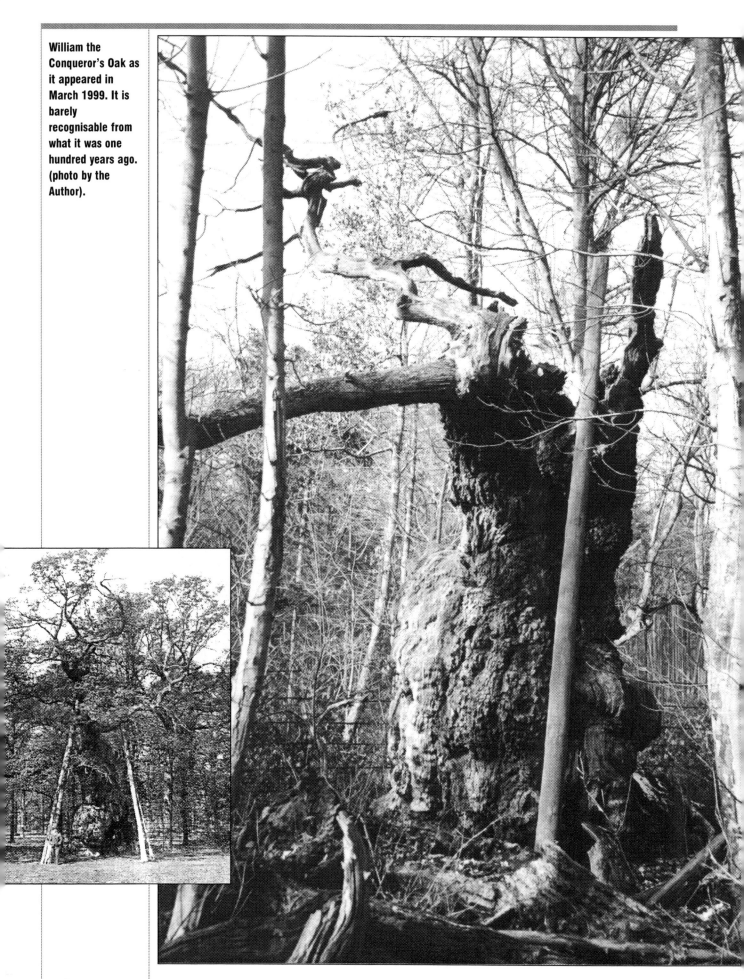

William the Conqueror's Oak as it appeared in March 1999. It is barely recognisable from what it was one hundred years ago. (photo by the Author).

Flemish Farm

Flemish Farm

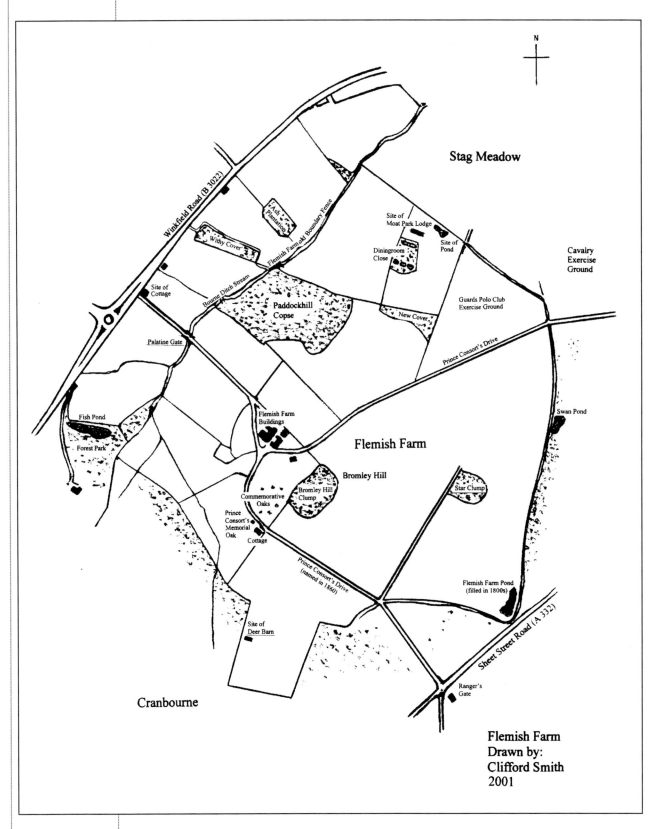

N

Stag Meadow

Winkfield Road (B 3022)

Ash Plantation

Withy Cover

Flemish Farm old Boundary Fence

Site of Moat Park Lodge

Site of Pond

Cavalry Exercise Ground

Diningroom Close

Site of Cottage

Bourne Ditch Stream

Paddockhill Copse

Guards Polo Club Exercise Ground

New Cover

Palatine Gate

Prince Consort's Drive

Fish Pond

Flemish Farm Buildings

Swan Pond

Forest Park

Flemish Farm

Bromley Hill

Commemorative Oaks

Bromley Hill Clump

Star Clump

Prince Consort's Memorial Oak

Cottage

Prince Consort's Drive (named in 1860)

Flemish Farm Pond (filled in 1800s)

Sheet Street Road (A 332)

Site of Deer Barn

Cranbourne

Ranger's Gate

Flemish Farm
Drawn by:
Clifford Smith
2001

lemish Farm covers an area between the Cavalry Exercise Ground in the east to the Winkfield Road (B 3022) in the west and from Cranbourne Hill in the south to Stag Meadow in the north. The whole area of the farm, consisting of 168 hectares (415 acres), comes within the parish of Windsor. Although it is part of the Windsor Crown Estate, it does not come within the boundary of Windsor Great Park and it has no public access. Originally it was part of Moat Park and, although it was in private ownership for much of its history, it was a very popular hunting and visiting area for the Royal Family. It was not until 1814 that it was finally purchased by the Crown.

Most of the Moat Park boundary can still be seen today in the form of the earth embankment pale that runs along the northern end and eastern side of the Cavalry Exercise Ground, then turns west near Ranger's Gate finishing at Forest Park near Winkfield Road. At one time the Moat Park was a grand estate with a large four-storey building known as Moat Park Lodge situated on the northern side of Diningroom Close. The lodge was surrounded by beautiful gardens with several artificial ponds as water features. Four of the ponds (or rather what is left of them, as they are badly silted up) can still be seen today in the dense undergrowth of Diningroom Close. The ponds consist of one long narrow pond at the northern end of the close and three small ponds in a line at the southern end. It was because of the closeness of the three ponds that the wood was known by the author's family as 'Three Pond Wood'. A further pond was situated at the northern side of the lodge. This was previously the habitat for moorhens, but was filled-in during the 1990s. Other ponds which were part of the Moat Park were Stag Meadow pond situated in the middle of Stag Meadow and a much larger pond that was situated at the far south-eastern corner of what is now Flemish Farm. This pond was filled-in during the early part of 1800s.

Although the Moat Park had for many years been used for livestock and agricultural purposes, it was King George III (affectionately known as 'Farmer George') who became the tenant farmer of the farm within the Moat Park in the 1790s, and developed the farm to something close to what we see today. In the main, the northern half of farm was used for livestock, and the southern half for crops such as oats, wheat, turnips, cabbages etc. It is understood that the name Flemish Farm originated from the use of the Flemish System in which the crops are grown on a rotation system between produce for human consumption and produce for livestock consumption. It was during the 1790s that a group of farm buildings were erected to

the west of Bromley Hill and at the same time the old Moat Park Lodge was demolished. The main farm buildings were themselves pulled down and completely rebuilt during the late 1850s, when The Prince Consort was actively involved in running the farm.

The dominant feature of the farm is the Bromley Hill Clump. This is an irregular circular-shaped plantation of trees that can be seen from almost any direction, proudly standing at the top of Bromley Hill. The most memorable view is from the direction of the Cavalry Exercise Ground in the park. Access to the farm, which is for authorised persons only, is by way of Prince Consort's Drive through the Cavalry Exercise Ground in the north-east.. The drive passes on the north side of Bromley Hill to the farm buildings. It then veers round to the east, meeting up with Sheet Street Road opposite Ranger's Gate. Retracing your footsteps along Prince Consort's Drive, a clump of trees can be seen in the middle of the field, in the direction of Windsor Castle in the north. The trees are known as 'Star Clump', simply because the original plantation was planted in the shape of a star. Until the 1930s, a small brick-built shelter stood in the middle of the plantation which was used by the farm workers and to get some respite when it rained during shoots. Continuing up the drive, the Bromley Hill Clump looms up on the right-hand side and a bungalow stands on the left as the drive comes to the top of the hill. Just beyond the bungalow, standing on the left-hand verge of the drive is a rather ungainly looking oak tree, standing on its own with an iron fence around it. The tree is the Prince Consort's Memorial Oak which was planted by Queen Victoria on Tuesday 25th November 1862 to mark the spot were the Queen's husband, The Prince Consort had spent his last day's shooting a year before. (The Prince Consort had died on Saturday 14th December 1861 at the early age of forty-two years, from typhoid). The assistants and attendants at the planting were:- Prince Leopold, Prince Louis of Hesse, Princess Louis of Hesse, Princess Alexandra of Denmark, Baroness Von Schenck, Princess Louise, Countess of Caledon, Count Gleichen, Major-General the Hon. A.N. Hood, Colonel the Hon. A. Liddell, Major-General F.H. Seymour (Deputy Ranger), William Menzies (Deputy Surveyor) and John Cole (Head Gamekeeper). The unappealing shape of the tree as seen today surely is a reflection of the sad circumstances for which it was planted.

On the other side of the drive on the slope of Bromley Hill, there are nine more oak trees which were planted by British and European monarchs during the early years of the 1900s. All of the trees were planted by the monarchs whilst they were with a shooting party on the farm. The King Carlos I of Portugal Oak which was planted by him on 18th November 1902 has a sad association, because he was assassinated six years later by a gunman in Madrid, on 1st February 1908. The last commemorative tree to be

A collection of spades used by members of British and European Royal Families when planting commemorative trees in the park and surrounding area. The chrome spades in the middle of the picture were used in recent times. The four-hand painted older spades were used when planting the grove of oaks on Bromley Hill in Flemish Farm. From left to right, the four spades are worded as follows:- Used by H.M. Gustavus V King of Sweden when planting Oak Tree – November 19th 1908. Used by H.M. King George V when planting Oak Tree on January 30th 1911. (Although not recorded on the spade, it was also used by Prince Edward The Prince of Wales to plant the nearby oak tree later in the year, on 14th November 1911. It was planted to commemorate the Coronation year of his father, King George V). Used by H.M. Manuel II King of Portugal when planting Oak Tree November 18th 1909. Used by the King of Norway when planting Oak Tree November 17th 1906. The position of the trees are shown on the plan

planted there was the Edward Prince of Wales Oak. This was planted on 14th November 1911 by Prince Edward to commemorate the Coronation year of his father, King George V.

Just before the farm buildings, another drive branches off to the east. The drive slopes down to a flat bridge that passes over the Maple Bourne Stream. This point is known as Palatine Gate. The Maple Bourne Stream continues north into Stag Meadow where it is simply known as the Bourne Ditch. At the Palatine Gate the drive carries up a gradient to meet up with Winkfield Road at a point almost opposite the entrance to St. Leonard's. For many years a gate lodge stood at the northern side of the drive, until it was demolished in 1983. The lodge, which was built with red bricks, was in the form of two semi-detached houses and was known as Flemish Farm Cottages. In August 1915, the cottages were the scene of one of several tragic accidents to have taken place on the Windsor Crown Estate. Richard John Bailey, the fourteen-year-old son of one of the farm workers, accidentally shot himself whilst playing with a shotgun on the premises.

On a lighter note, the farm was the scene of happier occasions, particularly when it was run by the Prince Consort. Every September during the 1840s to 1850s he provided a supper for all of the farm workers and their families.

Although the farm has produced an enormous quantity of crops over the years, it has been its prize-winning livestock that the farm has become more noted for. During the early 1860s an annual sale of the royal livestock took place on Flemish Farm, which continued well into the 1900s. Its reputation for quality livestock was recognised throughout the country, and a typical sale that took place on the farm on Wednesday 8th December 1897 is described below:

The auctioneers were Messrs. Buckland and Sons of

Windsor for the sale of thirty prime and heavy Devon bullocks at an asking price of £31-16s-8d each, three Devon heifers at £19 each, one Hereford prize steer at £39, two Hereford heifers at £20 each and one Shorthorn heifer at £24.

The large assembly of sheep consisted of one-hundred Hampshire Downs 70 to 90 shillings each, one hundred-and one Hampshire Down lambs at £3.-5s. each, two-hundred-and-thirty South Downs at 51 to 62 shillings each and one-hundred-and-forty-five Southdown lambs at 46 shillings each.

The prize selection of pigs were sixty-one Berkshire hogs at £5-14s-4d each, (the highest price achieved was £14-10s) and twenty-four of the smaller Windsor white breed of pig at £3-16s-7d each.

Seventy-two buyers from all over the country were actively bidding during the sale and it was interesting to note that Mr Shipman purchased three pigs for his meatpaste company in Chichester. In keeping with standard practice, a substantial luncheon had been laid on in the largest farm building.

Since 1856, when the Hereford cattle were introduced to Flemish Farm, they had become recognised as some of the finest specimens in the world, winning countless prizes at the various agricultural shows. It was not until January 1932 that much of the stock was dispersed. Fortunately, some of the best cattle were moved to Shaw Farm to retain the stock.

The most memorable recollection the family has of the farm is of the bulldog owned by Edwin Phillip Hornby (Farm Manager) during the 1940s. We only had to poke our heads over the farm boundary fence and invariably there was the bulldog menacingly staring us in the face.

For many older residents of Windsor, their lasting memories are 'bluebelling' in Paddockhill Copse on the hill south-west of Diningroom Close. The fact that the public was not officially allowed there added to the spirit of adventure. The masses of bluebells covering large areas of the wood were the nearest thing to paradise. For many years a large portable wooden cabin used by Gamekeepers was positioned near the north-eastern corner of the wood.

In 1980, there was a significant change in the function of the farm when the farm buildings were handed to the Guards Polo Club to stable their polo ponies. At the same time, the far north-eastern field on the farm was converted into an exercise and training ground for the ponies. It is now a common occurrence to see the polo ponies being walked to the Polo Grounds at Smith's Lawn and back to the farm.

Plan showing the grove of oaks planted by British and other European monarchs from 1862 to 1911 in Flemish Farm Windsor Great Park.

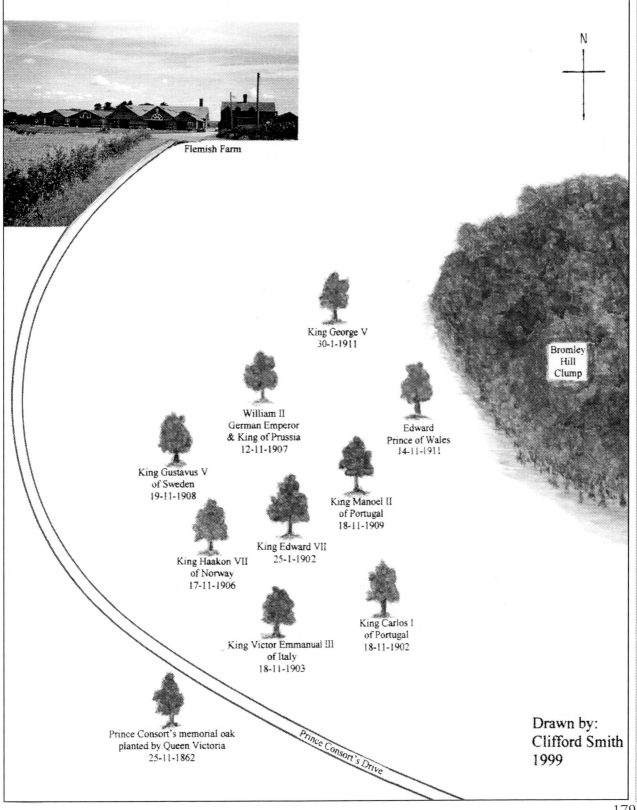

Flemish Farm

N

Bromley
Hill
Clump

King George V
30-1-1911

William II
German Emperor
& King of Prussia
12-11-1907

Edward
Prince of Wales
14-11-1911

King Gustavus V
of Sweden
19-11-1908

King Manoel II
of Portugal
18-11-1909

King Edward VII
25-1-1902

King Haakon VII
of Norway
17-11-1906

King Carlos I
of Portugal
18-11-1902

King Victor Emmanual III
of Italy
18-11-1903

Prince Consort's memorial oak
planted by Queen Victoria
25-11-1862

Prince Consort's Drive

Drawn by:
Clifford Smith
1999

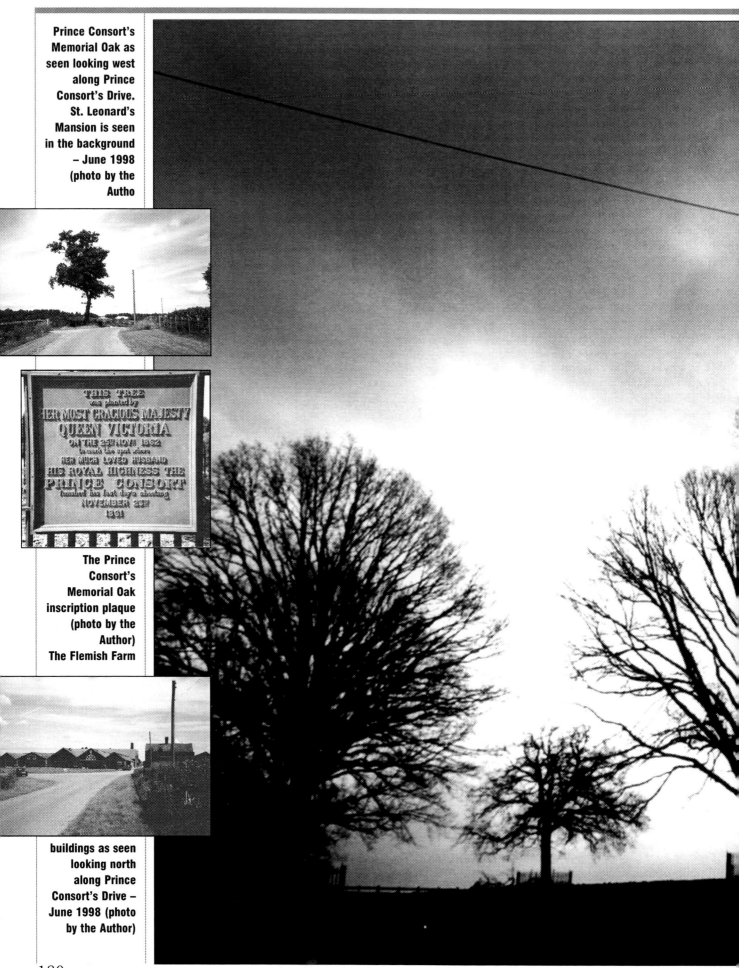

Prince Consort's Memorial Oak as seen looking west along Prince Consort's Drive. St. Leonard's Mansion is seen in the background – June 1998 (photo by the Autho

The Prince Consort's Memorial Oak inscription plaque (photo by the Author) The Flemish Farm

buildings as seen looking north along Prince Consort's Drive – June 1998 (photo by the Author)

A group of park Gamekeepers posing for the camera just east of Star Clump on Flemish Farm in 1865. The group are looking towards Windsor Castle and judging by the traces of snow on the ground, they were keen to get on with the shoot. Their 'bag', so far, was two cock pheasants and one rabbit. The Gamekeepers are from left to right:-

Henry Austin, standing with a black labrador retriever at his feet. Born: 1814 at Worcester, Worcestershire. Living at Virginia Lodge.

Thomas Foker, sitting on the donkey cart with two beagles at his side. Born: 1795 at Great Warley, Essex. Living at the "Clockcase".

George Smith, great grandfather of the Author, sitting on the ground. Born: 1820 at Brockenhurst, New Forest. Living at Hollybush Cottages.

Thomas Foster, standing with hand on donkey cart. Born: 1813 at Binfield, Berkshire. Living at Cranbourne Tower.

Sanson Strickland, Deputy Head Gamekeeper, standing with Irish Wolfhound. Born 1808 at Bryanston, Dorsetshire. Living at Bishopsgate Lodge.

John Orme, standing with shotgun resting on his shoulder. Born: 1806 at Ashby, Suffolk. Living at Bear's Rails Gate Lodge.

John Cole, Head Gamekeeper, kneeling with hand on labrador retriever. Born: 1815 at Chillingham, Northumberland. Living at Sandpit Gate Lodge. (Reproduced by kind permission of HM Queen Elizabeth II)

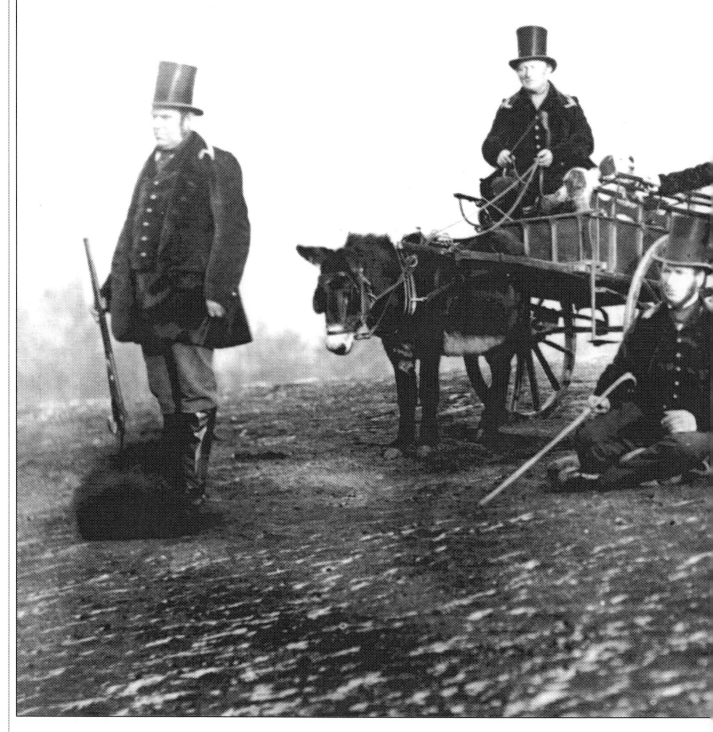

Flemish Farm as seen looking north from the extreme southern boundary fence on Cranbourne Hill. Bromley Hill Clump is on the left, Windsor Castle is in the distance in the centre and Star Clump is on the right. The field of wheat is almost ready for harvesting – August 1990 (photo by the Author)

Looking west into Flemish Farm along the northern end of Prince Consort's Drive from the Cavalry Exercise Ground – September 1999 (photo by the Author).

High Standing Hill

Chapter 10

High Standing Hill

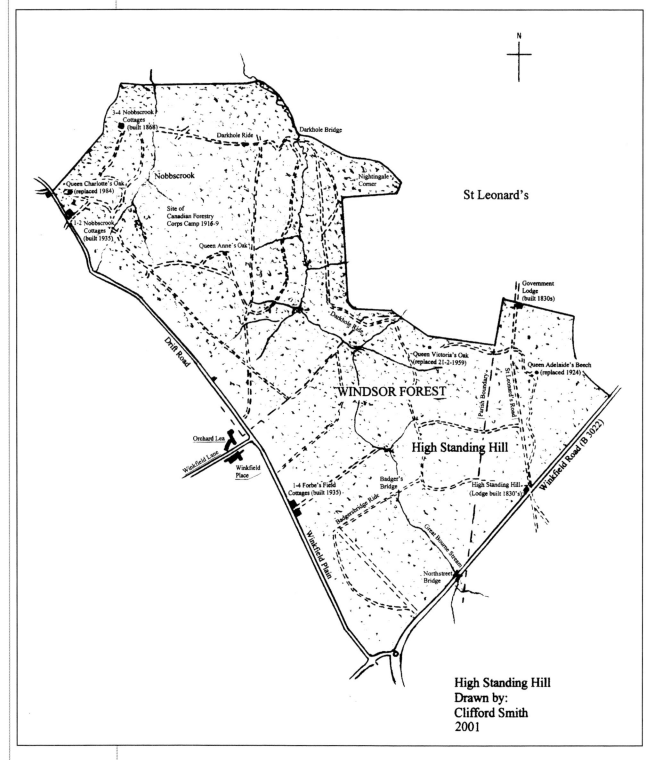

High Standing Hill
Drawn by:
Clifford Smith
2001

High Standing Hill is part of Windsor Forest and it is almost entirely an area of fairly dense woodland. Although this describes the features extending from Winkfield Road in the south-east to the extremity of the forest known as Nobbscrook in the north-west, it is the hill on the Winkfield Road itself that the local people have always referred to as 'High Standing Hill'. For many people travelling on this road from Ascot to Windsor, it is the first view that they will have of Windsor Castle. In the past, it was a very popular spot for artists to paint the view of the castle.

Other than those who use this road and Drift Road that runs along the edge of the forest at the south-west, very few people know anything at all about the area, which is mainly closed to the public. For this reason there is a level of mystery about the place. The main entrance, which is for authorised persons only, stands on the west side of Winkfield Road at a point where the old Forest Road ends. The entrance is the start of the old St Leonard's Road, which in fact is a continuation of the old Forest Road, running in a north to south direction. The lodge at the entrance is named High Standing Hill Lodge. Built in the 1830s, with an outer wall made from sandstone, it is said that King William IV once stayed there for a night or two. From its early days until quite recently, it has been the home for the estate gamekeepers, who quite often had an additional role as gatekeepers. The combination of the roles acted as an ideal deterrent to poachers.

Some distance along the old St Leonard's Road from the lodge there is a ride passing at right angles over the road, and a short distance along this ride to the east is a small clearing. Almost in the centre of the clearing stands Queen Adelaide's Beech. It was planted in 1924 by Queen Mary to replace a previous tree by the same name that had been blown down in high winds. However, it is not the tree that attracts attention so much as the truly magnificent view of Windsor Castle with the Legoland Attractions Centre in the foreground. The whole scene is very much of a fairy tale world.

Retracing your footsteps back to the old St Leonards Road, the continuation of the road brings you to the estate boundary gate. Just before the gate standing on the right is a house named 'Government Lodge'. It was built in the 1830s and for most of its life it has been the residence for the estate Woodman. The first woodman to occupy the house was Richard Rhodes, who was born in 1801 at Heckfield near Reading. It is interesting to note that in 1848 his wages were twelve shillings a week (sixty-pence current money). However, the woodmen lived on the estate rent-free in those days and twelve-shillings went a lot further at the time. Records show that Richard Rhodes was still living and still employed as a Woodman at the house in 1891 aged 90 years. His wife Jane was also living there at the time - less surprisingly as she was 27 years his junior. The house was always known as 'Woodman's Lodge' until about 1917 when it acquired its current name. Despite many years' research into the origin of the change of name, I have been unable to locate any written records as to why it came about. The only known and most likely reason that the house might have been given this unusual name is that the Canadian Forestry Corps, who were known to be using the house at that time, made the change in reference to Government House in Ottawa, Canada where the Duke of Connaught lived when he was the Governor-General of Canada.

Returning to the position where the ride crosses the road, the ride heads through the trees in a westerly direction. A short distance along it, close to the northern side of the ride is another named tree. This is Queen Victoria's Oak and it was planted by Queen Elizabeth II on Saturday 21st February 1959 to replace the original tree that had died the year before. The old tree was already very old when it was given its name by Queen Victoria.

The ride curves in a northerly direction close to the estate boundary fence. Several other rides intersect the ride which, it must be said, has a strange and remote presence about it in this part of the forest. Even the name of 'Darkhole Ride', as this part is known, adds to this foreboding feeling. The ride makes a sharp turn to the west over Darkhole Bridge into an area known as 'Nobbscrook' meeting up with two fairly remote cottages, called Nos. 3 and 4 Nobbscrook Cottages. Built in 1868, with outer walls of red brick and diamond-patterned dark grey bricks, they are unquestionably the most pleasing premises on the estate. For the nature-lover the site would be difficult to better. The old cottage that stood there previously was not always as peaceful as you would imagine, as it was here that a now long-forgotten ghost story originated. It transpired that the last but one family to live there was frequently disturbed by violent knocking on the doors and walls at all times of the day and night. When the authorities were informed of these unusual events, a policeman was sent to investigate, and stand on duty there as a means of eliminating the possibility of it being the work of a prankster. All was to no avail. The noises still continued until the family, consisting of a married couple and their daughter, could take it no more, and left the cottage never to return. The next - and last - persons to live there, were an old man and his wife. The cottage was by now in a very sorry state, having had floorboards taken up, doors taken down and the surrounding area dug up in an

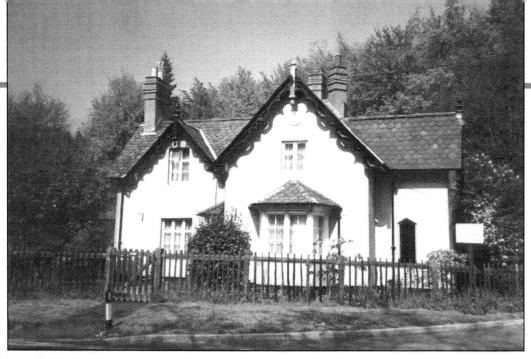

High Standing Hill Lodge situated where the old St.Leonards Road in Windsor Forest meets Winkfield Road (B 3022). Built in the 1830s during the reign of King William IV. (photo taken in June 1999 by the Author).

Government Lodge situated in the old S. Leonards Road at the extreme edge of Windsor Forest. Believed to be built in the 1830s, it was originally known as Woodmans Lodge simply because it was the residence for Crown Woodmen. (photo taken in August 1999 by the Author).

effort to find the 'ghost'. Accounts of seeing and experiencing a ghost in the area persisted for some time. Several years before the cottage was pulled down, it had been reported that the dog of a keeper that once lived in the cottage was seen running up and down between the cottage and the nearby Queen Charlotte's Oak. Suspicion aroused, a thorough search of the area found the Keeper's remains with his shotgun at his side not far from the tree. As to the cause of his death, it was said by some that he had been murdered by a beggar that frequented the area. Others said that he had committed suicide or had an accident. Whatever the cause, the forest workers tended the spot for many years after that.

The original Queen Charlotte's Oak was situated at the extreme north-western corner of the forest not far from Drift Road. It was a very old pollard oak

tree by the time the name was given to it in the 1800s. For many years it had a seat around it - a quaint custom that no longer continues. The tree finally 'gave up the ghost' when it fell down in 1983. It was replaced with the current tree in 1984. The ride finally comes out onto Drift Road at a point directly opposite the entrance to Nobbscrook Farm on the other side of the road. The two estate houses that stand here are Nos. 1 and 2 Nobbscrook Cottages and were built in 1935. From here the forest boundary fence follows the north-eastern side of Drift Road. This whole area of the forest was a hive of activity when it was a camp for the Canadian Forestry Corps during the First World War.

The Canadian Forestry Nobbscrook Corps, as they were known, was set up in 1918. It was the last satellite camp to be established in the park and forest. The Canadians, with the assistance of

No.4 Nobbscrook Cottage is situated at the far north-western part of Windsor Forest. Built in 1868 on the site of an old haunted cottage, it has a distinctive Victorian design with diamond patterned brickwork. The cottage stands in one of the most tranquil parts of the forest. (photo taken in May 1999 by the Author).

Nos. 1 and 2 Nobbscrook Cottages at the north-western end of Windsor Forest directly opposite the entrance to Nobbscrook Farm on the Drift Road (B 383). The cottages were built in 1935. (photo taken in May 1999 by the Author).

Portuguese labour, had become so proficient in their work that in a matter of six weeks they had installed an electrical power supply, fully operational saw mills, accomodation huts, and over 1.2 kilometres (three-quarters of a mile) of metal rails for hauling timber. In the areas where the ground was too soft for timber hauling horses to operate, Canadian 'Donkey' engines and hauling equipment were installed. Much of this part of Windsor Forest was made up of oak trees at the time, calling for robust equipment.

It was during 1918 that serious concerns were being expressed as to the extent that our woodlands were being depleted as result of the amount of timber that had been supplied for the war effort. On the Windsor Crown Estate alone it was estimated that 1,900 hectares (4,695 acres) of woodland had been

cleared of trees to produce about six million cubic feet of sawn timber during 1916-1918. Most of the timber had finished up at the fighting front line in Belgium and France for the shoring up of trenches and the making of shelters during the horrendous times of the First World war. Plans for re-afforestation in the country had become a major issue at government level, and the depletion of Windsor Forest was frequently mentioned.

In order to see first hand how the forest had been affected, a visit was arranged for the Berks, Bucks and Oxon members of the Royal English Arboricultural Society, the English Forestry Association, The Surveyors' Institute and The Land Agents' Society. The visit, which was carried out on Tuesday 29th October 1919, was conducted by the appropriately named Mr A.J. Forrest (Crown Receiver of The Great Park and

Anthony (Tony) Bish aged 12 years with his bow and arrow standing in front of the old Queen Charlotte's Oak in 1965. Tony, who was raised at Nobbscrook and is the son of Graham Bish, a retired forester, now works at Prince Consort's Workshop as a sign-writer. Many of the notices seen throughout the estate can be attributed to his excellent work. The Queen Charlotte's Oak fell down in 1983 and was replaced the following year. (Graham Bish Collection).

Forest). The party, consisting of about forty people included Major G U Courthope MP (President of the Royal English Arboricultural Association and the Royal English Forestry Association), Sir Herbert Matthews (Secretary of the Central Chamber of Agriculture) and Colonel S U Penhorwood (Commanding Officer of the Canadian Forestry Corps). At the Nobbscrook Camp they were shown first-hand the tree felling and the hauling, and they were most impressed at the speed and accuracy with which the oak trees were being cut in the saw mills. At midday they parted to see the tree nurseries in the Bagshot woods.

Although the Nobbscrook Camp had created a lot of activity in the area up until it disbanded in September 1919, it was the railway companies during the 1870s to 1890s who came closest to changing the

scene beyond recognition if they had had their way. For years they had tried to get plans approved to build a railway line between Windsor and Ascot, the main reason being for the prestige that would be gained by running racegoers to the Royal Ascot race meetings. If the plans had been approved, it would have entailed a tunnel being dug at a depth of 5.5 metres (19 feet) below the surface of the forest. For good or ill construction of the line never started.

In the centre of this part of the forest stands the Queen Anne's Oak. Like many of the named trees on the estate, its name was given to it when it was already an old tree. It is a maiden tree (a tree that has not been pollarded) and it has very little character.

190

Norfolk Farm
Duke's Lane and South Forest

11

Chapter 11

Norfolk Farm
Duke's Lane and South Forest

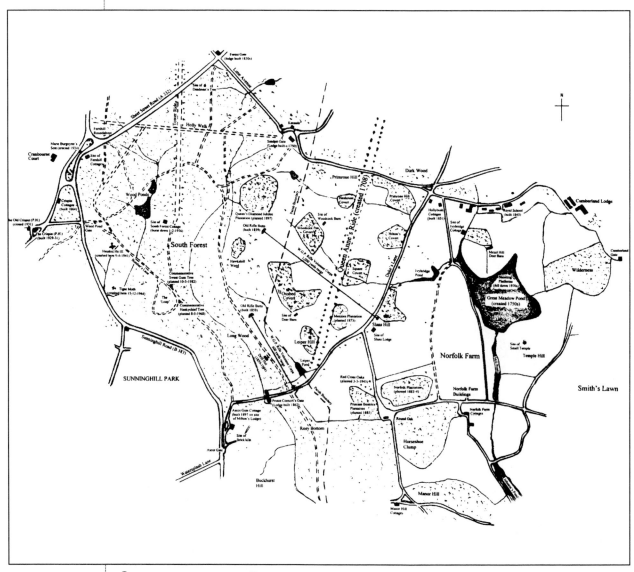

This area of the Windsor Crown Estate extends from Sandpit Gate at the north to Ascot Gate in the south, and from the western side of Smith's Lawn to the Fernhill Roundabout road junction in the west. With the exception of Duke's Lane, which has public access for pedestrians and cyclists only, it is a prohibited area of the estate to the public.

Norfolk Farm covers an area of about 544.3 hectares (1,345 acres) between Duke's Lane and Smith's Lawn. It was started in the 1790s during the reign of King George III, who was particularly keen on farming, so much so that he was generally known as 'Farmer George'. His enthusiasm for farming was so strong that there were many accounts of him walking from Windsor Castle to Norfolk Farm, just to see how it was progressing. The original farm spread over a much larger area and included what we now know as Smith's Lawn and The Savill Garden. Over the years its borders have changed, along with a varying emphasis on livestock, and type and quantity

192

of crops. In 1841, Prince Albert took charge of the running of the farm, this being barely one year after his marriage with Queen Victoria. He injected a renewed enthusiasm into the way the farm was run, until it declined once more following his premature death In 1861. By the early l880s, Queen Victoria had lost any remaining interest in it and the majority of the farm was made the responsibility of the Deputy Surveyor, who at that time was Mr Frederick Simmonds. The area on the southern side of Cumberland Lodge, including Mezel Hill, became the responsibility of Prince Christian, who was then living at the lodge. In 1937, the functions of the Deputy Surveyor and the Deputy Ranger merged into one and from that time the responsibility for running the farm was that of the Deputy Ranger. The 'hands on' running of the farm is carried out by the Farm Manager. The title of the manager has varied between bailiff, steward and even agent over the years since the farms in the park were created. From 1981, Queen Elizabeth II has farmed the Norfolk and Flemish Farms as the tenant of the Crown Estate Commissioners.

The northern entrance to the farm is just to the east of the northern end of Duke's Lane. At the entrance is a single building which was built in 1851 to house two estate families. In 1996, it was converted into four residences. The building is known as Hollybush Cottages, so named because of the holly bushes that once grew there. The cottages are embodied as part of the author's family history, being where his great grandparents lived for 38 years (1855-1893). Great grandfather, George Smith, worked as a Gamekeeper on the estate for 53 years, during which time he gained a reputation as an outstanding marksman with a single bore rifle whilst competing with the Windsor Great Park Rifle Volunteer Corps. When he died at No.1 Hollybush Cottages on Monday 10th April 1893, great grandmother, Sophia Smith moved with other members of the family to Cheapside, near Ascot where they lived for the rest of their lives. The next pages give more details about him and his responsibilities as a Gamekeeper.

On the eastern side of Hollybush Cottages, facing Duke's Lane, are two semi-detached houses which were built in 1949. They are named 'The Hollies' and 'Appletree Cottage'. Not surprisingly, this area of the park, which has a long association with holly trees and bushes, is known as Hollybush Corner.

George Smith was appointed Gamekeeper in Windsor Great Park on 9th November 1840, when he was twenty years old. He had lived at Milton's Lodge near Ascot Gate, where his father was both Head Woodman and Gatekeeper, since he was a 'babe in arms' . After he married at St Andrews Church, Windsor on 3rd April 1843, he lived at South Forest Cottage, Swinley Lodge and Hollybush Cottages respectively. All of his children were educated at the Royal School, and they all went on to

work for the Crown. William (warrener in the park and Gamekeeper at nearby Sunninghill Park), Joseph, the author's grandfather,(carpenter), George (nurseryman), Henry (dog keeper), Lydia (dressmaker), Ellen (dressmaker) and Sophia, who became a teacher at the Royal School.

The following is a detailed report on the death of George Smith that appeared in the *Windsor & Eton Express* newspaper on Saturday 22nd April 1893.

DEATH AND FUNERAL OF AN OLD CROWN SERVANT

On Monday week, the 10th inst., Mr George Smith, of Windsor Great Park, aged 73 years, after recovering from a long and painful illness, succumbed to pneumonia after six day's illness, the result of a chill. For over fifty-two years he served her Majesty faithfully as Gamekeeper and gained the respect of all who knew him for strict integrity and kindness of heart. Mr Smith joined the Windsor Park Rifle Volunteers when first formed and served in the company with credit for twenty-six years. He attained to the rank of sergeant, and was returned twenty times "marksman" and twelve times "best shot" of the Park Company., winning the Berks County Challenge Cup on one occasion, and many other prizes. The funeral took place at Sunninghill Church on Saturday last and was attended by most of the Park officials, Prince Christian (Ranger) being represented by Mr. Spangler, Captain Campbell (Deputy Ranger), Mr. G. Overton (Headkeeper), and nearly the whole staff of gamekeepers in their gold and green livery also attended, six keepers carrying the coffin from the church to the grave. Mr F.Simmonds (Deputy Surveyor), Mr. G. Street (Clerk of Works) Mr. Bartlett, Mr. G Wheeler, Mr. Lightfoot, Mr. Wells, Mr. R. Wye, Mr C. Smith, Mr. Higgs, Mr. Squires, Mr. Hoptroff, Mr. J. Wheeler, and many others from the Park testifying to the respect and esteem in which he was held. His sorrowing widow, four sons, and three daughters were also present. The coffin was of polished elm, with black fittings, and was covered by handsome wreaths and crosses, Mr. Overton and keepers sending a beautiful one of yellow and white immortelles, one of arum lillies, one from Archdeacon Baly, one from Mr. and Mrs. Janes, Mr. and Mrs. C. Smith, and others from his widow and sons and daughters. The officiating clergy were the Rev. J Snowdon of Sunninghill, and the Ven. Archdeacon Baly, Chaplain of Windsor Great Park. The funeral arrangements were excellently carried out by Mr. Janes, undertaker, of Egham. Mrs. Smith and family return heart-felt thanks to all for the kind sympathy shown.

Great Meadow Pond on Norfolk Farm as depicted in moonlight in an oil painting by the author's brother, Maurice Smith.

On the far left hand side of the field as you enter the farm stand some large storage and maintenance buildings. Developed from the 1950s under the control of the Parks Department, these form what is known as the Mezel Hill Depot. Before the structures were built, prize bulls were kept in a compound next to the stream at the corner of the field. On a visit to the farm in 1940, the author clearly recalls peering through the gaps in the railway sleepers that made up the compound and beholding the largest and most evil black bull he had seen in his life! It appeared to be emitting fire from its nostrils! . About half way along the stream that runs into Great Meadow Pond is the

site of Ivy Cottage. Built in the late 1700s, it was the residence of keepers and for many years in the mid 1800s it was the home of George Perkins (Foreman, then Bailiff). The cottage was, by the nature of its location, a very damp building. It was probably not a bad thing when it was demolished in the late 1800s.

Further along the stream and beyond the point were it runs into Great Meadow Pond there is a bridge appropriately called Ivybridge which was built to take the drive from Hollybush Cottages to the centre of the farm. To the west of the bridge a stream connects with Ivybridge Pond. The pond is shaped like a boomerang and, although it is not very large, it

is quite deep in places. It has long been one of the finest ponds in the park for tench and, for that reason, it is still known by the family as Tench Pond. A more unusual and inexplicable name for the pond which has been used in the past is 'Fourpenny Lawn Pond'.

To the east of the drive is the large expanse of water known as Great Meadow Pond. Shaped like a ray fish it is about 677 metres (740 yards) at the longest point and about 338 metres (370 yards) at the widest point. Due to the black mud that has formed at the bottom of the pond, it is not now particularly deep. It was created in the 1750s, about the same time that the Virginia Water Lake was formed. Not surprisingly, it is overlooked by Cumberland Lodge at the north-east, and another beautiful view of the pond is from the top of Mezel Hill due north. The deer-barn on the hill is the best vantage point to view the pond. Until the 1980s, there were several shooting platforms and hides around the pond with a further hide standing in the middle of the pond. This could only be reached using the dinghy that was kept in the boathouse on the northern bank. The platforms were mainly surrounded by a broad band of reeds that thrived around the pond. The very fact that the public is not permitted in the area and that there is so much vegetation growing in and around the pond makes it a wildlife paradise. The reeds are simply massed with reed warblers and sedge warblers. Virtually every type of water-loving bird, at one time or another, can be seen all over the pond. The dominant fish in the pond are pike and tench. When the pond was drained at the start of the Second World War, the fish were placed in Mill Pond and Johnson's Pond further down stream. They were returned when the pond was refilled in 1945. After years of neglect, the platform and hide posts rotted away, finally collapsing into the water during the late 1980s.

The field that slopes up to the plantation on the western side of Smith's Lawn is Temple Hill, so named from the small round and domed temple that was built there about 1750. It is believed that it was never built as a place of worship, more as a 'folly', such things being a popular feature of large estates at the time. It was pulled down in the mid 1800s.

Great Meadow Pond on Norfolk Farm looking north towards Mezel Hill when the numerous shooting platforms and thatch-walled hides had long since gone. (photo taken in July 1998 by the Author)

Mill Pond on Norfolk Farm as seen from the head of the pond. This pond, and Johnson's Pond lower down stream, are two of the oldest ponds in the park. (photo taken in July 1998 by the Author).

195

Not far down stream from Great Meadow Pond is a long and narrow pond called Mill Pond. The name was established when a water mill was built below the pondhead in 1794. The pond is well concealed by the alder trees that grow around the bank. At the pondhead a drive leads to the east coming out onto Smith's Lawn. The drive to the west passes the junction of the drive coming in from Hollybush Cottages and continues into the main Norfolk Farm buildings and cottages. The farmhouse, which was built in 1793, is the oldest surviving building. The other residential buildings are numbers 1, 2 and 3 Norfolk Farm Cottages, built in 1816 and numbers 4 and 5 built in 1954. In 1952, the spacious and excellent cow-sheds were built. Before continuing west, a drive branches off to the south, passing by the cottages and on to Johnson's Pond. The continuation of the drive to the west travels uphill through a thickly wooded area finally coming out onto a junction in a clearing at the top of the hill. Here is an old oak tree known as Round Oak. On the opposite side of the clearing stands a large dutch barn. The drive to the south leads to Manor Hill and the drive to the north passes Norfolk Plantation (planted 1883-4) on the right, and Princess Beatrice Plantation planted 1885) on the left. As you pass the plantations, there are nine oak trees in the clearing on the left named the Red Cross Oaks. The oaks were planted on Saturday 3rd March 1945. Unfortunately, being in a restricted area, they cannot be appreciated by the public. The words on the commemorative plaque under the trees are as follows:-

At the time the oak trees were being planted, the author was with two brothers walking along Duke's Lane from Windsor to see our great aunt and great uncle at Cheapside. We stopped as soon as we recognised the Royal Family planting the trees on the

upper slope of the hill. It was not until many years later that we became aware of the significance of the event. In addition to the four members of the Royal Family that are named on the plaque, the party included The Duke of Norfolk (President of the Royal Agricultural Fund), Lord Iliffe (Chairman of the Duke of Gloucester's Appeal), Mr R.W. Haddon (Chairman of the Red Cross Agricultural Fund), Mr Theo A. Stephens (Deputy Chairman of the Red Cross Agricultural Fund), the Duchess of Marlborough (Chairman of Rural Pennies) and Mr Eric H. Savill (Deputy Ranger).

The drive from the Red Cross Oaks sweeps down and up again as it meets Duke's Lane that comes along from Hollybush Corner. On the right is the site of Slan's Lodge, which was the residence of Richard and Daniel Slan during the 1600s. During the 1900s a deer-barn stood slightly to the north-east of the site. Directly opposite in the field on the other side of Duke's Lane is the Menzies Plantation. It was planted in 1873 on the instructions of William Menzies (Deputy Surveyor). For many years Duke's Lane,

The Royal party during the planting of the Red Cross Oaks on Saturday 3rd March 1945. The persons in the foreground are, from left to right:- Queen Elizabeth (the late Queen Mother), King George VI, Princess Elizabeth (now Queen Elizabeth II), Princess Margaret, The Duke of Norfolk and Mr Eric Savill (later Sir Eric Savill).

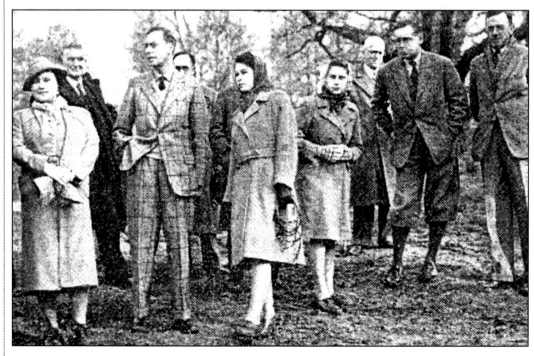

which is named after The Duke of Cumberland, was part of the route taken by the Royal Family during the Royal Ascot horse-racing week. Up until the 1960s, the Royal carriages travelled the complete route from Windsor Castle via The Long Walk, The Gallop and Duke's Lane. Since that time, the Royal party travel from the castle to Slan's Hill in limousines, then subject to reasonable weather, the party changes to horse-drawn open carriages for the rest of the journey.

Following Duke's Lane towards Ascot, the lane dips down to a bridge over a stream. The stream runs in a south-easterly direction passing an area known, rather cheekily, as Rosy Bottom, before finding its way into Virginia Water Lake. On the other side of the bridge is Leiper Pond, which is another example of a pond being created by damming up an existing stream. The pond is about 82 metres (90 yards) long and about 58 metres (63 yards) wide at the head. The line of the stream which passes down the centre of the pond, is the parish boundary between Old Windsor and Winkfield. Slightly to the north of the pond is the southern end of Queen Anne's Ride, with Leiper Hill rising up from the pond and the ride. The next few pages demonstrate that the area was not so quiet in the past.

Windsor Great Park Rifle Volunteer Corps were established in September 1859 with the full support of Prince Albert. They disbanded in 1904, after a period of forty-five years. During that time, they became one of the most respected and smartest Volunteer Corps, not only in Berkshire but throughout the Country.

The Rifle Volunteer origins go back well into the 1700s, however, it was not until 1859 that the Rifle Volunteers were formally structured on military lines, in accordance with an Act of Parliament. The prime purpose of the Rifle Volunteers was to provide a back-up to the Regular Army, particularly in the event of an invasion, the possibilities of such an event being very real at the time.

The Park Company expenses were generally borne by the Privy Purse. The Company was originally called the 'Windsor Foresters' and was made up entirely from the park and forest employees. In the beginning it consisted of thirty members as follows:-

One commander, Major-General F.H. Seymour, (Deputy Ranger); one ensign, William Menzies, (Deputy Surveyor); one sergeant, John Cole, (Head Gamekeeper) and twenty-seven privates. One of the privates was the author's great grandfather, George Smith, (Gamekeeper). Other known names were, William Lloyd, George Gavatt, George Orme and Charles Morris. An unknown private was the Company's bugler.

Initially, the Park Volunteers were listed as a Sub-Division, 12th Berks Volunteer Rifle Corps. In terms of numbers, they were small compared to the Town of Windsor (3rd Berks) who had two corps of 60

members each. The rifles used were Government issued muzzle-loading Westley Richards, as opposed to the more expensive breach-loading versions. The company had strict rules and training on how they must be used and maintained. Under an Act of Parliament, every Company had to have their rifle ranges, complete with a drill hut, designed and constructed strictly as approved. The park ranges were situated at the southern end of Queen Anne's Ride, in the area around Leiper Pond known as Western Sheep Walk (so named because of the sheep that were kept there). Two ranges were built, the first a 600 yard range to the south of Leiper Pond which started at Dukes Lane and ended with a U-shaped butt near the stream. The drill hut, which had a thatched roof, was positioned halfway along and to the south of the range on the edge of Long Wood. The second range was 1,000 yards long and started next to Duke's lane on Slan's Hill, where Slan's Lodge once stood. It ended with a round-shaped butt to the south of Sandpit Gate. The ranges were approved by a Government Inspector, Captain Gordon of the Scots Fusileer Guards, in 1859. The same Inspector had approved the Windsor Rifle Volunteer ranges at Clewer in the same year.

The ranges soon became a popular venue for shooting competitions, the largest being held there in September 1860, the very first full year of the Company's existence. The park was the host for the Berkshire Rifle Volunteer Shooting Championships, attracting a massive crowd. estimated at about 40,000. The event is described in detail later.

During the history of the Company there were many excellent shots, with George Smith (great grandfather) topping the list. He was a founder member and became a sergeant during his twenty-six year service. In that time he was acclaimed twenty times as 'marksman' and twelve times as 'best shot' in the Company. In 1861 he won the County's top prize, The Berkshire Challenge Cup and National Bronze Medal at the Vale of the White Horse. In 1872 he won the Sandhurst Cup and in 1882, the Prince Christian Cup. He won many other prizes along the way and represented Berkshire on many occasions at the National Championships.

Hot on the heels of George Smith was his younger brother, Charles Spencer Smith (great-great uncle), a woodman who was born a stone's throw away at Milton's Lodge in May 1823. Charles joined the Company in 1861 and formally resigned in 1886. In 1869, at the County Shooting Championships near Abingdon, he won the Berkshire Challenge Cup and the coveted National Bronze Medal. He went on to win many shooting prizes during his time with the Company. The two brothers were the only members to take the top prizes during the life of the Company. The following are the key events in the history of the park Volunteers:-

1859: Windsor Forest Rifle Volunteer Corps (12th Berks) established with Major-General F H Seymour (Deputy Ranger) as the Commanding Officer and William Menzies (Deputy Surveyor) as an Ensign. Rifle Ranges built and approved. Uniforms provided complete with cross-belt, ball pouch, waist belt and frog (total cost £4.45 each, old money).

1860: Hosts for the 1860 Berkshire Rifle Volunteer Shooting Championships. Annual General Meeting held at the sawmill, Prince Consort's Workshops. All AGM's held at the sawmill thereafter.

1861: Berkshire Challenge Cup, National Bronze Medal and £20. won by George Smith (Gamekeeper) at the Vale of the White Horse.

1866: Name of Company changed to 12th Berks Windsor Great Park Rifle Volunteer Corps. John Gale, William Lloyd and George Smith picked to represent Berkshire at National Championships held on Wimbledon Common.
Major-General Seymour resigned and William Menzies promoted to Lieutenant and made Commanding Officer. Frederick Simmonds and George Smith promoted to Corporals.

1868: Prize meeting held at the ranges attended by Prince and Princess Christian.

1869: Prince Christian made Honorary Colonel of the Berkshire Rifle Volunteer Association.
Berkshire Challenge Cup, National Bronze Medal and £20 won by Charles Spencer Smith (Woodman) at Radley near Abingdon.

1871: Frederick Simmonds and George Smith both promoted to Sergeant.
1872: Berkshire Annual Camp held at Cookham where the Volunteer were entertained by William Menzies, a talented violinist and highland dancer.
Sandhurst Cup won by George Smith at Reading.

1873: Berkshire Annual Camp held at Queen Anne's Mead (Hog Common) Windsor.
1874: Berkshire Annual Camp held at Streatley, the Company came second in the tug-of-war, the steeplechase was won by Charles Spencer Smith and the park played in a game of polo, riding donkeys.

1878: Lieutenant William Menzies died at 'Parkside' on Friday 3rd May

1881: The Company participated in the Royal Review of the Rifle Volunteers held on the Review Ground.

1882: Prince Christian Cup won by George Smith.

1884: Frederick Simmonds promoted to Captain.

1886: Berkshire Annual Camp held at Queen Anne's Mead (Hog Common).

1897: Frederick Simmonds promoted as Major.

1900: William Wye (Gamekeeper) promoted to Colonel-Sergeant.

1904: The Company disbanded.

From 1890 to 1904 the Company were credited as being the Best Shooting Company, the Best Turned out, and having Best Attendance of all of the Berkshire Rifle Volunteer Corps. It must have been a very sad day when they disbanded.

There is one event, both in size and in public interest, that stands out above all others in the history of the Company. It is the Volunteer Rifle Competitions and Sports Event that took place at the park rifle ranges on Thursday 13th September 1860. Even by modern day comparisons, the event was gigantic, attracting an estimated gathering of 40,000 people. All these years later, it really is difficult to imagine that this event took place in an area which is now so peaceful, and to some extent quite remote.

The weather throughout the day was beautiful and sunny, absolutely ideal for such an occasion. The ground occupied by the tents, the rifle ranges, games and review areas covered approximately 60 hectares (148 acres). The shooting competitions included Rifle Volunteers from Berkshire, Buckinghamshire, Middlesex and Surrey.

Queen Anne's Ride was opened up throughout its whole length, possibly for the first time, to provide an unimpeded straight route to the ground. From early in the morning, thousands of Rifle Volunteers and spectators were streaming to the ground from all directions, with Queen Anne's Ride being the most popular and picturesque route, by carriage, horseback and on foot. A charge of one pound was made to spectators wishing to have the best vantage points. Many large tents had been erected with chairs, tables and refreshments, in front of which was a long table displaying the prizes, the largest being the massive Berkshire Challenge Cup, to be presented for the first time. There were many other cups and prizes, including a breach-loading (Westley Richards) rifle complete with case.

The firing started at 9.30 in the morning and finished at 3.30 in the afternoon without a break. The herons at their nearby colony must have wondered what the devil was going on, and they were soon on their way to a quieter spot at the southern side of Virginia Water Lake. The competition for the Berkshire Challenge Cup, complete with the National Bronze Medal, was held on the 600 yard range with a standard target having 24" (61 centimetre) diameter bulls-eye. This looks huge when standing next to it; however, it looks somewhat smaller when looking down the sights of a rifle 600 yards (548 metres) away. The Cup was won by Jackson of Maidenhead. The Silver Cup given by the ladies of Berkshire for the best shot over 500 yards (457 metres) was won by R W Salter of Reading. The 300 yard (274 metres) was won by Bambrige senior of Windsor. Second was George Smith of the park. The breach-loading Westley Richards rifle, held over several distances, was won by Blatch of Newbury. Mr. Wheeler of the park won the 3rd prize.

Whilst the shooting was in full swing, the games and athletic events, which started at 11.00 in the morning, had created just as much interest. All these years later, it is rather amusing just to read the titles of some of the events, such as:- Running Long Leap for Civilians, Running Long Leap for Military, Climbing Smooth Poles, Putting a stone of 18lbs (8.2kgs) for Military, Running High Leap for Civilians, Running High Leap for Military,

Jockey Race, Boy's Bell Hunt, Single Stick Race (relay), Wrestling and Donkey Racing etc. Some of the games included Aunt Sally, Throwing Sticks and Quoits.

Throughout the day, the crowds were entertained by the band of the Scots Fusileer Guards, which included their Drums and Fifes. In addition, five of the Berkshire Companies had brought their own bands to play a variety of music. In a very large tent that had been erected on Leiper Hill a Dinner had been laid on for 670 people. At the head table sat Colonel Lloyd Lindsey, who was the Commanding Officer of the Berkshire Rifle Volunteer Corps, accompanied by Major-General Seymour and many other distinguished guests. Lord Overstone had met the cost of the food and drink, which had been supplied and served by the White Hart Hotel, Windsor. The rest being entertained were mainly made up from the Volunteers. A long session of 'toasting' followed.

The ground was overseen by fifty policemen of the Berks Constabulary, six London Horse Police, six plain-clothed Detectives from London and a hundred Coldstream Guards. Not surprisingly, only three watches went missing.

Continuing along Duke's Lane it now rises up a hill to Prince Consort's Gate. This is a boundary gate of Windsor Great Park. It is the least known and little used by the public. The Gate Lodge, which was built

Windsor Great Park Rifle Volunteer Corps in front of their drill hut in about 1877. Lieutenant William Menzies (Deputy Surveyor), who was Commanding Officer at the time, is wearing civilian clothes and is seated in the middle of the second row from the front. At the time he was a very sick man from typhoid and died the next year. (The Royal Borough of Windsor and Maidenhead Museum Collection).

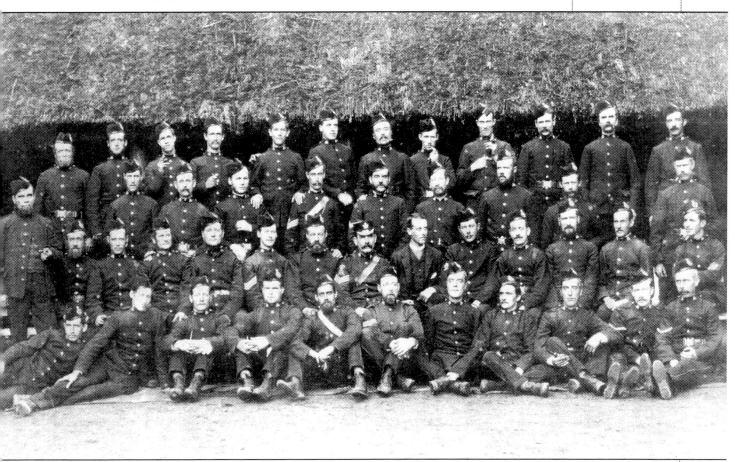

Windsor Great Park Rifle Volunteer Corps about 1882. Lieutenant Frederick Simmonds (Deputy Surveyor) is seated directly behind the bugle resting his hands on his cane. (The Royal Borough of Windsor and Maidenhead Museum Collection).

Coachmen waiting in Duke's Lane for the Royal Family to arrive by motor cars from Windsor Castle before continuing their journey by carriage to the Royal Ascot Meeting on Wednesday 21st June 2000. (photo by the author).

Queen Elizabeth II and Prince Philip The Duke of Edinburgh in Duke's Lane on their way to the Royal Ascot meeting on Wednesday 21st June 2000. There is a strong suspicion that they were laughing at the author's expense, as he had been running for some distance before taking this particular photograph. Norfolk Farm is shown in the background.

200

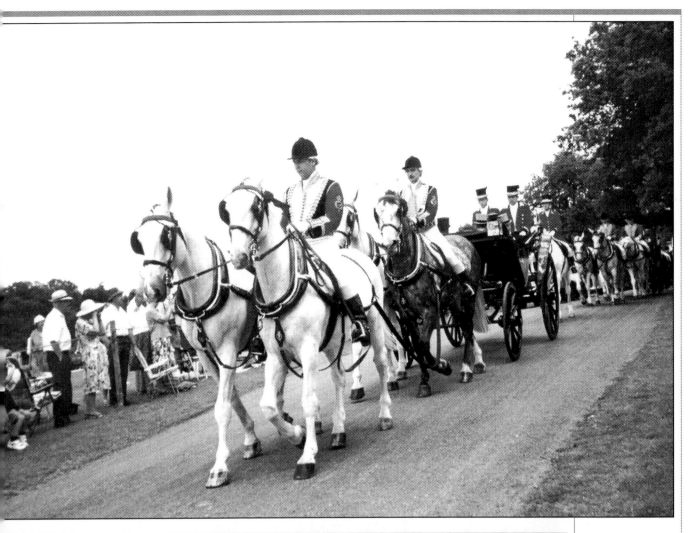

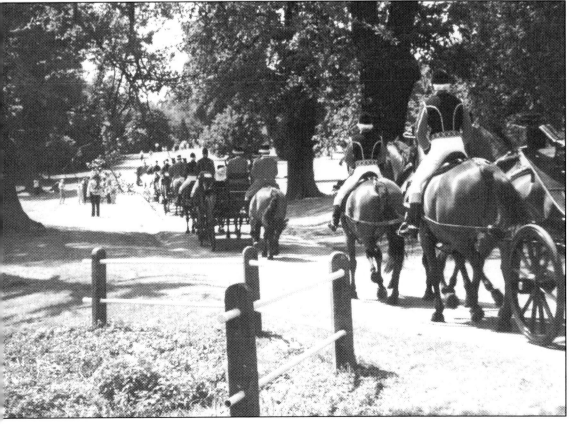

The Royal carriages on their way down Dukes Lane for Royal Ascot on Friday 18th June 1999. (photo by the Author)

The Royal carriages on Dukes Lane leading up to Prince Consorts Gate on their way to Royal Ascot on Friday 18th June 1999. (photo by the author's wife).

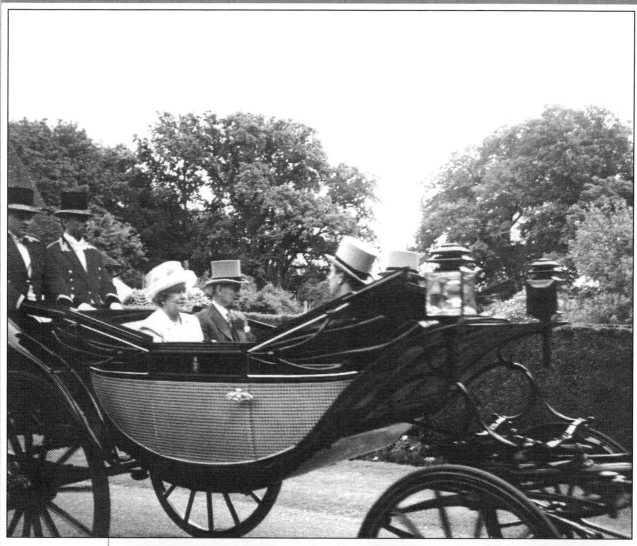

Queen Elizabeth II and Prince Philip, The Duke of Edinburgh having just passed through Prince Consort's Gate on their way to Royal Ascot on Thursday 17th June 1999. (photo by the Author).

School children dressed for the occasion of watching the Royal carriages go along Duke's Lane on their way to Royal Ascot on Thursday 17th June 1999. (photo by the Author).

Leiper Pond looking from the head of the pond near Duke's Lane. It is situated a short distance to the north of Prince Consort's Gate. (photo taken in April 1998 by the Author).

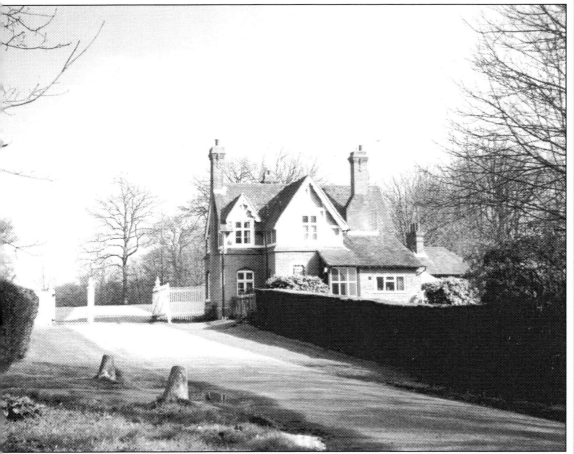

Prince Consort's Gate and Lodge looking north along Duke's Lane. The gate is on the true southern boundary of the park. The lodge was built in 1862 and for years it would have echoed to the sound of horses hooves and carriage wheels as the Royal Household made their way to the Ascot Race Course. (photo taken in March 1999 by the Author).

in 1862, stands on the south-eastern side. It has a quaint cottage appearance which is enhanced by the well-maintained park lawn at the front. For many years, one of the largest and oldest pollard beech trees in the park stood a short distance away on the lawn. On the opposite side of the lodge was a similar lodge, built at the same time. In 1941, when the O'Dare family lived there, it was badly damaged by an isolated German bomb. Fortunately, no one suffered any significant injuries and the building was repaired. Barely eight years later in 1949, it was pulled down and replaced with two semi-detached houses named 'Hilltop' and 'Beechcroft'.

From the gate, the lane takes a curving course through some fairly dense woodland passing a red-brick house on the left, and ends at another gate at the Sunninghill Road (B 383). This gate, known as Ascot Gate, was formerly known as Sawyer's Gate and before that as Milton's Gate, after the people that lived there in the past. It was here that the author's great-great grandfather, Joseph Smith lived (1820-60) when he was in charge of the gate and the planting and care of the trees in the park.

Born on 2nd June 1776 near Brockenhurst in the New Forest, Joseph left school when he was 13 years old to work for the Crown in the forest. In 1809 he was made the Keeper and Woodman in charge of the Stockley Enclosure, a truly magnificent part of the forest between Brockenhurst and Beaulieu. In 1820, he was promoted to take charge of the planting and care of the trees in Windsor Great Park. He was soon on his way by coach to Windsor with his wife and six young children, the youngest being George Smith (great grandfather), when he was only a few months old. He took up residence in Milton's Lodge, which had a one hectare (2.47 acres) tree nursery already established, laid out on the eastern side of the lodge. It is known that the lodge was owned by the Milton family in the 1600s. In 1613 the records show that Nicholas, Henry and Robert Milton were living there and had property and land at Buckhurst Hill to the east. In the 1700s, the Sawyer family took over. The last one to live there was William Sawyer. The Windsor Forest Enclosure Act of 1813 and the following Awards of 1817 affected the area. William Sawyer was an early 'casualty' of the Awards and was dismissed from his post in March 1820. William Maslin (Deputy Surveyor) intended to replace him with Robert Nurd, who lived at Sunninghill. However, the Commissioners were looking for a more experienced person to take charge of the massive tree-planting programme planned for the park. It would appear that Joseph Smith, who already had thirty years' experience in forestry work, and who came from a family who had centuries of working knowledge in the New Forest as farmers, landowners, blacksmiths and the like, was ideally suited for the role.

Throughout the park there are metal posts which have the following wording, "Planted about 1820." The posts are a legacy of his work. In his early years at the park, he had a further four children. Three of these grew up to work on the estate, two as Woodmen and one as a Gamekeeper. Whilst undertaking his other role as Gatekeeper, he would have been a familiar figure to the Royal Family as they passed through Ascot Gate during their visits to the forest and to the race meetings at Ascot.

During his time of duty, the name of the area of Cheapside closest to the park, became known as 'Smith's Green' and it was officially recorded on Ordnance Survey maps under that name. It is believed that it derived from the fact that Joseph Smith was the Gatekeeper there, and it was named after him, this being a common practice at the time. In a similar way, Milton's Lodge became more generally known as 'Keeper's Cottage' or 'Woodman's Cottage'. It would appear that the names of what we now know as Ascot Gate and Prince Consort's Gate had caused confusion, particularly at the Head office of the Estate in London. A request to clarify the situation in 1885 was made to Frederick Simonds (Deputy Surveyor), who in turn asked my great-great uncle Charles Spencer Smith, who was born there in May 1823, to provide an answer. The following is a printed version of Mr. Simmonds' reply to the Head Office:-

Parkside
Englefield Green
Surrey.

Feb.20th 1885

My Dear Sir,
Ascot Gate
 Charles Smith one of the Crown Woodmen was born at Woodman's Cottage near 'Ascot Gate'. He tells me that that gate was formerly known as 'Sawyer's Gate'.
 There was a gate too, at the gate now known as Prince Consort's Gate, but Smith cannot call to mind the name that gate was known by.
 I am dear Sir,
 Yours truly

 F.Simmonds

 J.F. Redgrave Esq.

In 1859, Joseph's beloved tree nursery was uprooted and turned into a brickworks. The clay was dug locally and fired in one large kiln. The bricks were cast with the letters V R (Victoria Rex) and W G P (Windsor Great Park) and were used during the construction of many buildings in the park. It ceased production in 1901. The construction of the

brickworks and the nearby rifle ranges, with the accompanying noise, in 1859, would surely have been hard for Joseph to take. He died the next year, on Friday 11th May 1860 aged 84 years having spent 71 years working for the Crown. He was buried at Sunninghill Church next to his wife, who had died some years earlier.

By the 1890s, the cottage was showing its age and it was pulled down to make way for the current building 'Ascot Gate Cottage', which was built in 1897. An interesting feature that stood on the grassed area in front of the cottage was a maiden oak tree,

known as the Parish Boundary Oak. Although not particularly old in terms of the life of an oak tree, it was sadly missed when it fell down in the 1970s.

To the north-west, the whole area consists of almost continuous forest, bordering along Sunninghill Road as far as the Fernhill Roundabout road junction. Just in from Ascot Gate, a private ride travels through the forest a short distance in from the road. About half way along, another ride crosses from the left and continues on the other side. On the first corner of this junction is a commemorative *davidia involucrata* (hankerchief tree). It was planted on Wednesday 8th May 1968 by C.V.

Ascot Gate Cottage built in 1897 on the site of Milton's Lodge. Milton's Lodge was steeped in history for the Author. Four of his great great uncles were born there during the 1820s when great great grandfather, Joseph Smith was in charge of the planting of the park and gatekeeper of Ascot Gate. It was a responsibility he held from 1820 to 1860. (photo taken in March 1999 by the Author).

Ascot Gate showing the start of Duke's Lane leading into the park. The public Sunninghill Road (B 383), on the extreme left of the picture, leads on to the Fernhill Roundabout passing Sunninghill Park on the left and South Forest on the right. (photo taken in August 1999 by the Author).

Joseph Smith c.1810 (great great grandfather of the Author). Joseph worked for the Crown as a keeper and forester 1789-1860, a total of 71 years. He was born at Brockenhurst in the New Forest of the Smith family of farmers and foresters on 2nd June1776. He was made Keeper of Stockley Enclosure in 1808, being the first person to hold this position. In 1820, he was promoted to take charge of the planting and care of the trees in Windsor Great Park, a position now titled, Chief Forestry Officer. He held the post for forty years living at 'Milton's Lodge', Ascot Gate until he died 11th May 1860. He was buried next to his wife Sophia at St Michael and All Angels Church, Sunninghill.

Venables OBE, President of the Royal Forestry Society of England, Wales and Northern Ireland, to commemorate the visit of the Society to this part of the forest known as South Forest. On the opposite corner is a commemorative *Liquidambar Styraciflua* (sweet gum tree). It was planted on Monday 10th May 1982 by Sir Marcus Worsley Bt, President of the Royal Forestry Society of England, Wales and Northern Ireland, to commemorate the visit of the Society to the estate. This visit was of particular significance, being the Society's centenary year. The visitors, some 250 strong, were the guests of the Crown Estate Commissioners, and were taken on coaches on a tour of the estate. At midday they were given a reception at The Savill Garden Restaurant, in the presence of Queen Elizabeth II and Prince Philip, The Duke of Edinburgh (Ranger of the Great Park), before continuing on a visit to The Valley Gardens and on to South Forest.

The ride carries on towards the Fernhill Roundabout, passing a ride that comes in from the left, being the other end of the ride from the hankerchief tree. This ride, which takes a circular route, is appropriately known as the 'Loop'. Just past where this ride comes out, there is a conifer plantation on the opposite side of the ride which was grown from seeds presented to Queen Elizabeth II in 1970 by the Governor of the State of Washington, USA. Further on, where the ride dips down, a Heinkel HE III German Bomber crashed into the top of beech tree on Wednesday 9th april 1941, killing two of the crew. Since that time the ride has been informally known as 'Bomber's Ride'. On Friday 15th December 1944, a De Havilland Tiger Moth biplane crashed into the trees near Sunninghill Road whilst on a training flight from Smith's Lawn. Although the two-man crew were shaken up, the worst injury was a badly cut nose sustained by the Australian pilot. The aeroplane was a write-off.

The ride goes uphill and turns to the left, coming out at Wood Pond Gate on the Sunninghill Road, not far from the Fernhill Roundabout road junction. The gate is so named after the two ponds situated to the east of the gate, known as Wood Ponds. After many years of neglect, they had almost completely silted up, when in 1998 they were dredged and once more were recognizable as ponds. Slightly to the south-east of the ponds is the Forestry Department's South Forest Depot, which utilizes the surviving outbuildings of South Forest Cottage, which last was destroyed by fire on Sunday 1st February 1976. Once again, the cottage was a part of the family's history, my great grandparents being the first family to live there and it being the home where great uncle William Thomas Smith was born in February 1845. William also grew up to become a gamekeeper, working for most of his life for the Crutchley family at nearby Sunninghill Park. It was one of the few residences on the estate that had always been the home of Gamekeepers.

Sir Marcus Worsley, President of the Royal Forestry Society of England (on the left), presenting Graham Bish (Forester) with the Society's Long Service Medal on Monday 10th May 1982. At the time, Graham had worked on the estate for 42 years. The occasion was incorporated with the planting of a Liquidambar Styraciflua (sweet gum tree) by the President, to commemorate the Company's centenary. The tree, which can be seen in front of Sir Marcus Worsley, is situated in South Forest at the junction of a circular ride commonly known as 'The Loop'. The next photograph shows how the tree has progressed. (Graham Bish collection).

The last area of trees facing the Fernhill Roundabout road junction consists of some mature pine trees. Between the trees and the roundabout is the site of the Fernhill Cottages. Built in 1864 as two semi-detached residences, they were part of the character of the forest. They had long gardens in the front and

The Liquidambar Styraciflua (sweet gum tree) as it appeared in July 1999, seventeen years after it was planted by Sir Marcus Worsley. The original commemorative plaque which can be seen at the base of the tree, is inscribed as follows:-
Liquidambar Styraciflua planted by SIR MARCUS WORSLEY Bt. President Royal Forestry Society To commemorate The visit of the Society 10th May 1982 Close by is another tree, a Davidia Involucrata (hankerchief tree) which was planted by C.J. Venables, President of the Royal Forestry Society of England on Wednesday 8th May 1968 to commemorate a previous visit to the forest by the Society.

South Forest looking south-east along 'Bombers Ride' near 'The Loop'. The name was informally given to the ride after a Heinkel HE III German Bomber crashed there during the Second World War. The full details of the crash are given in Chapter 18. (photo taken in July 1988 by the Author).

One of the two Wood Ponds in South Forest not far from Fernhill Roundabout. (photo taken in July 1998 by the Author).

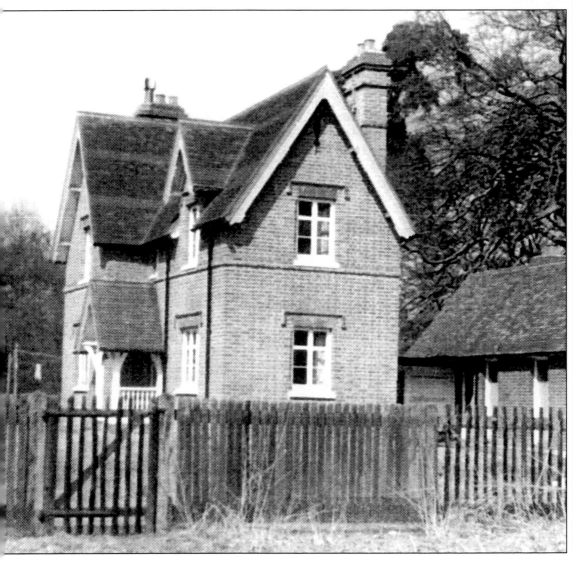

South Forest Cottage in 1968. Built in 1843, it is believed that the author's great grandfather, George Smith (gamekeeper) was the first person, with his wife, to live there. Their first child was born there in February 1845. It was finally destroyed by fire on Sunday 1st February 1976. (photo by John Lukawski, gamekeeper, who was the last person to live there).

The outbuildings of South Forest Cottage that survived the fire of 1976. The site is now used as an operating base by the Estate Forestry Department. (photo taken in July 1999 by the Author).

The gutted remains of South Forest Cottage following the fire on Sunday 1st February 1976. Fortunately, John Lukawski and his wife escaped with minor injuries from the fire that engulfed the cottage at about 2.0'clock in the morning. It must have been a horrendous experience for the Lukawskis, as on the bitterly cold night, they lost all of their personal possessions. To make matters worse, the remoteness and poor accessibility of the cottage, made it extremely difficult for the fire services to get there.

smaller gardens at the rear, where the disused deep-well was still intact when the cottages were demolished in 1985.

The Fernhill Roundabout road junction, was constructed in 1970 in the shape of kidney. Many people, not knowing its correct name, often refer to it as 'the kidney, or peanut shaped roundabout'. The roundabout replaced the notoriously dangerous crossroads of the main public roads that met there. The stone seat that stands in front of the oak tree where the roundabout narrows in the centre occupies the corner position where the roads from Sunninghill and Ascot came together at the crossroad. The stone seat is the 'Marie Burgoyne's Seat'. It was erected in 1934 in memory of Marie Henrietta Johanna Burgoyne by her son, Cuthbert John Burgoyne after she died on 7th January 1934 aged 84 years at 'The Woodlands', which overlooked Ascot Heath in Windsor Road. The inscription on the seat back makes interesting reading:-

> AD VIATOREM ET IN PIAM MEMORIAM
> MATRIS CARISSIMAE
> MHJB
> 1849 - 1934

'For the traveller and in pious memory of a very dear mother'.

When the junction was a crossroad, the seat was well used, and on occasion we used it to have a rest and to watch the traffic go by. Although the seat is now cracked and dirty from neglect and inaccessibility since the roundabout was constructed, the author cannot help having a fleeting glance at it as he drives past.

On the other side of the roundabout, although not part of the estate, there are several buildings in Fernhill Park, which ends at Hatchet Lane, that are of historical interest. The main Fernhill Park House originated in the time of Queen Anne as a Royal Hunting Lodge and has had some notable occupants since that time. In 1838, Charles Theophilus, first and last Lord Metcalfe (1785-1846), who had successively been Governor General of India, Jamaica, and Canada, took up residence there. He was created Baron Metcalfe of Fernhill in 1845. During the 1880s, the young Kenneth Grahame, author of 'The Wind in the Willows' lived there. Cranbourne Court, built in the 1700s, has been the home of the Victorian actress Edna May, film star and comedian Bob Hope, and pop singer Rod Stewart, who lived there from 1971 to 1976. He purchased the mansion for £90,000, spent £200,000 modernising it and sold it in November 1976 for £250,000.

Heading through the forest on the south-eastern side of Sheet Street Road towards Forest Gate, you pass over a ride called Holly Walk that leads in a straight line to Sandpit Gate. Further on we come to Tower Ride which starts at 'The Loop' in the south and ends in the north at Cranbourne Tower. About halfway between this ride and Forest Gate, situated well into the forest from the road, is the site of 'Deadman's Tree'. The explanation for the name is as simple as you would expect. A dead man was found under the tree many years ago. The edge of the forest takes a straight line from Forest Gate along Lime Avenue to Sandpit Gate. Although Lime Avenue is a private road on the estate, the public are actually encouraged to use it in December every year to purchase the Christmas Trees grown in the forest.

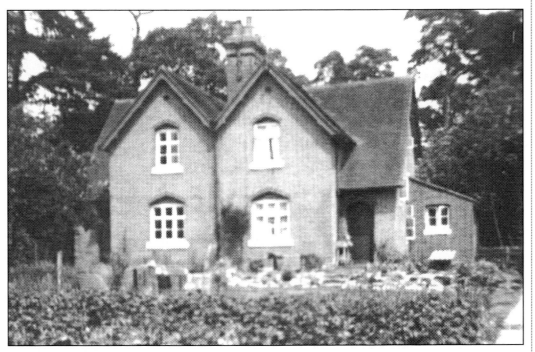

Fernhill Cottages in the 1950s. Erected in 1864 and demolished 1985. (photo by Peter Wagstaff when he was living there when employed in the park).

Marie Burgoyne's Seat on the Fernhill Roundabout. It was erected by her son in 1934 when the roundabout was a crossroad junction. (photo taken in July 2000 by the Author).

Graham H. Bish, Foreman (later Forester), on his right is John (Jack) Lewis, Head Forester (later Chief Forestry Officer) checking Christmas Trees near Sandpit Gate in 1957. (Graham Bish Collection).

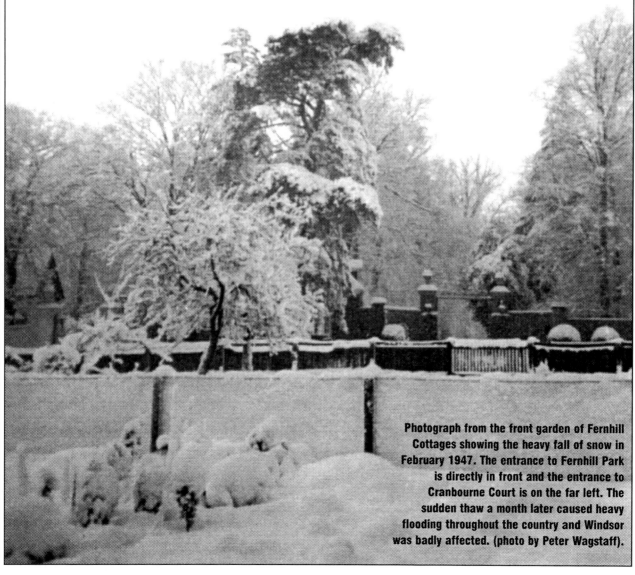

Photograph from the front garden of Fernhill Cottages showing the heavy fall of snow in February 1947. The entrance to Fernhill Park is directly in front and the entrance to Cranbourne Court is on the far left. The sudden thaw a month later caused heavy flooding throughout the country and Windsor was badly affected. (photo by Peter Wagstaff).

Cumberland Lodge

Cumberland Lodge

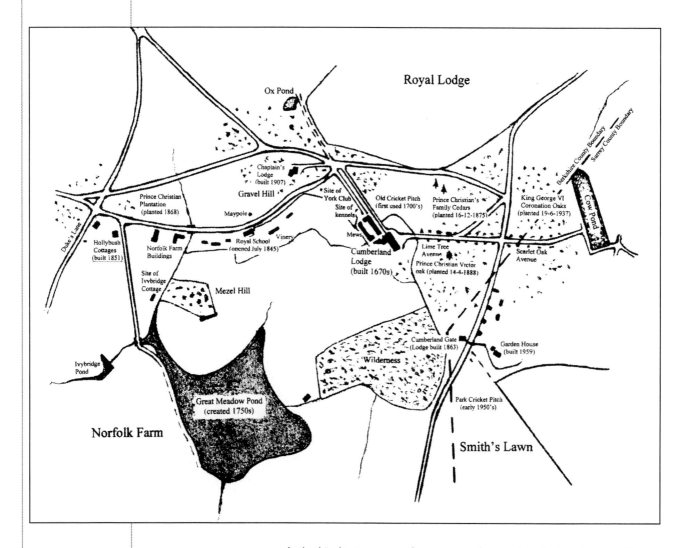

Royal Lodge

Ox Pond

Chaplain's
Lodge
(built 1907)

Gravel Hill

Prince Christian
Plantation
(planted 1868)

Maypole

Site of
York Club

Site of
kennels

Old Cricket Pitch
(first used 1700's)

Prince Christian's
Family Cedars
(planted 16-12-1875)

Berkshire County Boundary

Surrey County Boundary

King George VI
Coronation Oaks
(planted 19-6-1937)

Cow Pond

Duke's Lane

Hollybush
Cottages
(built 1851)

Norfolk Farm
Buildings

Royal School
(opened July 1845)

Vinery

Mews

Cumberland
Lodge
(built 1670s)

Lime Tree
Avenue

Prince Christian Victor
oak (planted 14-4-1888)

Scarlet Oak
Avenue

Site of
Ivybridge
Cottage

Mezel Hill

Cumberland Gate
(Lodge built 1863)

Garden House
(built 1959)

Ivybridge
Pond

'Wilderness'

Park Cricket Pitch
(early 1950's)

Great Meadow Pond
(created 1750s)

Norfolk Farm

Smith's Lawn

C umberland Lodge is situated about 1.2 kilometres (three quarters of a mile) almost due south of the Royal Lodge. It was built in the 1670s on the site of a previous building that had stood there since the 1500s. Rather ironically it was built by a Cromwellian Soldier, only to be taken over by King Charles II a few years later. It is built with red brick and, although it has had a rather chequered history, it has maintained its general appearance and character. During its early days it was more generally known as the 'Great Lodge', or more simply as 'The Lodge'. In 1828, about

thirty cannons that stood on the front lawn used for firing practice, were taken away to Fort Belvedere at Shrubs Hill.

From the start it was put to use as a residence for the Ranger of Windsor Great Park, a coveted position always granted to someone close to the sovereign. The first to use the lodge was a man with the unusual name of Baptist May, who was born in 1626, the sixth son of Sir Humphrey May. Baptist May held the position of Ranger from 1671 until he died 2nd March 1697 aged 71 years. The vacant position of Ranger was given one week later to William Bentinck, first Earl of Portland. He was still using the lodge as his main residence when his rangership finished in 1702. John and Sarah Churchill, Duke and Duchess of Marlborough, followed with the rangership of the park. The Duke was the Ranger until he died in 1722

and the Duchess continued until she died in 1744, aged 85 years. Although there were several other persons assuming the role during this period, it was the Duchess who dictated the terms of office. From 1744-1746, the Rangership and residence was taken over by John Spencer.

Dramatic changes came about during the next period from 1746-1765 when Prince William Augustus, first Duke of Cumberland, lived there as the Ranger. The Duke was born on 15th April 1721, the son of King George II and Queen Caroline. At the young age of five years he was created Duke of Cumberland. On his twenty-fifth birthday, 15th April 1746, he fought the decisive Battle of Culloden in Scotland. Many years later Queen Victoria referred to him (a great uncle) as the 'Butcher' from the unrelenting and brutal force he employed during the battle. On a more pleasant note, he had his soldiers create The Virginia Water Lake, Great Meadow Pond, the Obelisk Pond, and he also improved the landscape in the area. It was during his time at the lodge that the building became known as Cumberland Lodge. He died on Thursday 31st October 1765 at the relatively young age of 44 years. Shortly afterwards many of his magnificent horses that had been kept at the lodge and at Cranbourne, including a chestnut colt the famous racehorse named 'Eclipse', were sold. He was superseded by Prince Henry Frederick, second Duke of Cumberland, born on 26th October 1745, a younger brother of the future King George III. He became the Ranger of the park in 1766 at the young age of 21 years. It would appear that his time in office was very much taken up with interests other than the Rangership, as he spent more time away from Cumberland Lodge than actually living there. He entered the Royal Navy in 1768, rising to the rank of Admiral in 1778. He was also a member of numerous societies and one of the first members of the Royal Family to become a Freemason. He died in London on Sunday 18th September 1790 aged 45 years.

For the next seventy-seven years, Cumberland Lodge was not used as the residence for the Rangers of the park. It was used mainly by dignitaries and on occasion by several members of the Royal Household.

The running of the lodge was very much on the basis of that of a typical wealthy country estate. Aside from the heads of the household and the servants who lived in the lodge, there were numerous staff and tradespersons living on the site who worked in the stables, kennels, farriers and blacksmiths' shops, laundry and gardens. The number of people living on the site varied from sixty to eighty in total.

During the late 1830s and early 1840s, Henry Paget, Earl of Uxbridge and his second wife were the heads of the household. He was followed by William Wemyss and his wife Isabella. William was born in 1791 at Wemyss Castle on the family estate in Fifeshire, Scotland. During his tenure of the lodge, he was a Major General in the British Army. (It was at Wemyss Castle that Mary Queen of Scots first met the Earl of Darnley in 1565). William Wemyss died at Cumberland Lodge in 1852. From 1790-1841 the Rangership was taken on directly by the sovereign, starting with King George III, then King George IV, King William IV and Queen Victoria. Other than the occasional short stay, none of them took up residence there. The same applied when Prince Albert became the Ranger in 1841 which continued until his death on Saturday 14th December 1861. During 1861-1867 the role of Ranger reverted to the sovereign, Queen Victoria. In 1853, the household was taken over by Colonel Alexander Nelson Hood, who was born in London in 1815 and who, as his name suggests, came from the famous naval 'Hood' family. His second christian name relates to Lord Nelson, of Trafalgar fame, who was a junior officer when the Hood family were virtually in overall command of the British Navy. The Colonel appears to be the only member of the family to break away from the naval tradition. In 1858 he was appointed Equerry to Queen Victoria, and in 1868 he became Lord Bridport. He lived there with his wife, Mary Penelope Hood until a disastrous fire at the lodge on Sunday morning 14th November 1869 forced them to leave.

The fire, which started at about 9.30 in the morning, was first noticed by Lady Bridport's maid. As soon as he was notified, Lord Bridport ran outside to discover that the roof of the State Apartments was on fire. The apartments consisted of a central hall and pavilion, library, drawing room, billiard room etc. The rooms above were occupied by Mrs Thurston, a retired housekeeper from Windsor Castle. At the time of the alarm, Mrs Thurston was preparing to go to church. However, the fire was spreading so rapidly that she had to be hurried down for her own safety. Lord Bridport immediately put the lodge fire engine to work and sent messengers on horseback to the Cavalry Barracks, Infantry Barracks, the Volunteer Fire Brigade and the Castle Brigade at Windsor. All of the services responded to the emergency, arriving at the scene of the fire at about 11.00 a.m. Bearing in mind that there were no motorised fire engines in those days and the roads were far removed from what they are today, it was a very good response. It was fortunate that the wind was favourable that day for, although the main hall was still an inferno at midday, it was contained and finally brought under control. The fire had started when a wooden beam joined to the chimney stack caught alight. Queen Victoria rode over from Windsor Castle early in the afternoon to see first hand the extent of the damage. Suffice to say, a number of priceless artefacts, including scenery from the theatre in Windsor Castle that was being stored in the hall at the time, was destroyed. It took three years' work to restore the building.

In 1867, Prince Christian of Schleswig-Holstein-Sondenburg-Augustenburg became the Ranger of the park. His full name was Frederick Christian Charles Augustus, Prince of Schleswig-Holstein-Sonderburg-Augustenburg (normally referred to as Prince Christian). He was born on Saturday 22nd January 1831 at Augustenburg on the island of Alsen in the Baltic. As a great-grandson of Queen Caroline Matilda of Denmark he was his wife's third cousin. The Rangership was placed on him when he was naturalized a British subject and followed his marriage on 5th July 1866 to Princess Helena, daughter of Queen Victoria. At first they lived at Frogmore House near Windsor Castle before moving into Cumberland Lodge on Wednesday 17th July 1872 with the three children that they had in quick succession at Frogmore:-

Christian Victor Albert Louis Ernest Anthony, born 14th April 1867.
Albert John Charles Frederick Alfred George, born 26th February 1869.
Victoria Sophia Augusta Amelia Helena, born 3rd May 1870.

At Cumberland Lodge two more children were born and one stillborn:-

Franzisca Josepha Louise Augusta Marie Christina Helena, born 12th August 1872.
Frederic Christian Augustus Leopold Edward Harold, born 12th May 1876. (Known as Harold, he died eight days later)
A further son was stillborn on 7th May 1877.
From the beginning, Prince and Princess Christian

and their children soon became very popular, having shown a caring nature to the park employees and the residents in the surrounding area. At nearby Englefield Green they set up the Princess Christian Holiday Home for Boys and, in Windsor, the Princess Christian Hospital/Nursing Home. Prince Christian was actively involved in various capacities: High Steward of Windsor, Honorary Colonel of the 4th Battalion Royal Berkshire Regiment, Governor of Wellington College and President of King Edward VII Hospital, Windsor. In 1902 he became President of the Royal Agricultural Society, a position befitting his enthusiasm for agriculture, borne out by the prize winning Berkshire pigs that he raised at the lodge. Before this, he was actively involved with the army, becoming a General in 1877. He was a keen sportsman and horseman and, even at eighty years of age in 1915, he was still riding with the Garth Hounds, who often met at the lodge. In July 1891, the family had much to celebrate when the Prince and Princess had their twenty-fifth wedding anniversary and their daughter, Princess Louise was married to Prince Aribert of Anhalt. Starting with the arrival of the Emperor of Germany, Wilhelm II in Windsor on Saturday 4th July, the next four days were full of memorable events. The events are detailed in Chapter 3 in conjunction with the Musical Ride that took place on the Review Ground on Tuesday 7th July 1891. The next day, Cumberland Lodge became the focal point of the week's events, when a party was held to celebrate the Silver Wedding of Prince and Princess Christian. In the morning there was a cricket match between Prince Christian Victor's Team and the Brigade of Guards. As the game went on, the rain which had persisted all week became so heavy that the

The Windsor Corporate Address being given to the Emperor of Germany Wilhelm II outside Windsor Guildhall on Saturday 4th July 1891. The photograph was taken at 4.25 in the afternoon shortly after his arrival at the Southwestern Railway Station from London. The Emperor is on the left and the Prince of Wales (later King Edward VII) is on the right. (Household Cavalry Museum Collection).

match had to be stopped shortly after the Guards had taken their turn to bat. The party, which included the presence of Queen Victoria, went on for most of the day. However, my sympathy goes to the one hundred policemen who were on duty that day getting soaking wet as they stood outside in the pouring rain. The week had been a time of many happy events for the family.

In December, during the eventful year of 1891, a shooting accident occurred to take away that happiness. Most of the members of the Royal Family were spending Christmas with Queen Victoria at Osborne House on the Isle of Wight. On Boxing Day, 26th December 1891, the Royal Family were out on a shooting party when, late in the morning Prince Christian, who was standing nearby as an onlooker, was hit in the face by four pellets from a shotgun fired by his brother-in-law, Prince Arthur Duke of Connaught. One of the pellets entered his left eye so badly damaging it that his eye had to be removed. The pain and trauma caused would have been horrendous. Years later he would proudly show his box of spare glass eyes to his visitors.

Prince Christian soon adjusted to the loss of his left

The 'march past' of the guests at the front of Cumberland Lodge for the party held on Wednesday 8th July 1891. At the bottom right-hand corner of the picture is Queen Victoria with Prince Christian and Princess Christian standing each side of her. The blurring of the people walking past is a result of the slowness of the camera shutter speed, a common problem at the time when photographing moving objects. The appalling weather conditions are clearly evident. (Household Cavalry Museum Collection).

eye and continued with his love of sport by holding cricket matches on the sweeping lawn between the lodge and the boundary fence of the Royal Lodge. Cricket was first played on the lawn in the 1700s and, although it is generally thought that the Windsor Great Park Cricket Team was formed and started using it in 1861, records show that the park had a team playing on the lawn at least as early as 1817. Many first class cricketers have played there over the years, not least the world renowned Dr W. G. Grace (William Gilbert Grace), who played there on Saturday 10th June 1911. Prince Christian's sons, Christian Victor and Albert were themselves excellent cricketers and we can be sure that they played there on numerous occasions. In addition to the grand cricket matches held there, the lawn was used every year for the estate workers' athletic meeting. In 1924, the lawn ceased to be used for cricket when a new pitch was provided at the northern end of Smith's Lawn near Cumberland Gate. The old cricket pitch was used on a casual basis soon after, as a football pitch. In the 1930s, it was used by the newly founded Windsor Great Park Football Club, which suspended from 1939 to 1945 and recommenced until 1953, when it moved to the new recreation ground at the village. I have nostalgic memories of playing there during the early 1950s. It now has some fairly substantial young trees growing on it, making it very difficult to visualize it as the active sports field it was in the past.

By 1911, Cumberland Lodge was in much need of repair and parts had become unsafe. In February 1912, the removal of the masses of ivy that had regrown since the fire of 1869 revealed that parts of the structure were in an even worse state than expected. On the instructions of King George V, work started immediately. Prince and Princess Christian had moved to Frogmore House to allow the workmen to move in. It took two-hundred men working non-stop until the end of December to complete the work at a cost of £22,000. The repair work which was extensive, included the installation of a new heating system, electric lighting and a manually-operated lift for the benefit of the ageing Prince. The lift proved to be totally impracticable and it can still be seen today as a relic of the past. During the work, several fairly large underground passages were found leading in the direction of Great Meadow Pond which were almost certainly installed by the first Duke of Cumberland as an escape route.

During 1916, the health of Prince Christian started to deteriorate to the point where he was requiring the regular attention of a nurse. In 1917 he was moved to Schomberg House, Pall Mall, London where he died on Sunday 28th October 1917.

Barely three months before his death, which was a horrendous period during the First World War, the time had become ripe to sever the connection of the Royal Family's name with that of its German branches. The names Saxe-Coburg and Gotha were used at the time from Prince Albert's German ancestry. On

BY THE KING. A PROCLAMATION

Declaring that the Name of Windsor is to be Borne by His Royal House and Family and relinquishing the use of all German Titles and Dignities
GEORGE. R.I.

WHEREAS We, having taken into consideration the Name and Title of Our Royal House and Family, have determined that henceforth Our House and Family shall be styled and known as the House and Family of Windsor.

And whereas We have further determined for Ourselves and for and on behalf of Our descendants of Our Grandmother Queen Victoria of blessed and glorious memory to relinquish and discontinue the use of all German Titles and Dignities.

And whereas We have declared these Our determinations in Our Privy Council.

Now, therefore, We, out of Our Royal Will and Authority, do hereby declare and announce that as from the date of this Our Royal Proclamation Our House and Family shall be styled and known as the House and Family of Windsor, and that all the descendants in the male line of Our said Grandmother Queen Victoria who are subjects of these Realms, other female descendants who may marry or may have married, shall bear the said Name of Windsor.

And do hereby further declare and announce that We for Ourselves and for and on behalf of Our descendants and all other descendants of Our said Grandmother Queen Victoria who are subjects of these Realms, relinquish and enjoin the discontinuance of the use of the Degrees, Styles, Dignities, Titles, and Honours of Dukes and Duchesses of Saxony and Prince and Princesses of Saxe-Coburg and Gotha, and all other German Degrees, Styles, Dignities, Titles, Honours and Appellations to Us or to them heretofore belonging or appertaining.

Given to Our Court at Buckingham Palace, this Seventeenth day of July, in the year of our Lord One thousand nine hundred and seventeen, and in the Eighth year of Our Reign.

GOD save our KING

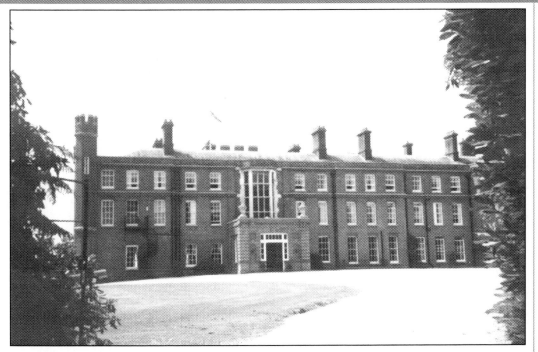

The front of Cumberland Lodge as seen from the main entrance gate at the end of Lime Tree Avenue in July 1998. (photo by the Author).

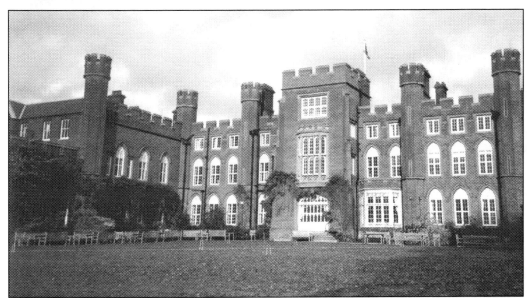

The rear of Cumberland Lodge in November 1999. (photo by the Author).

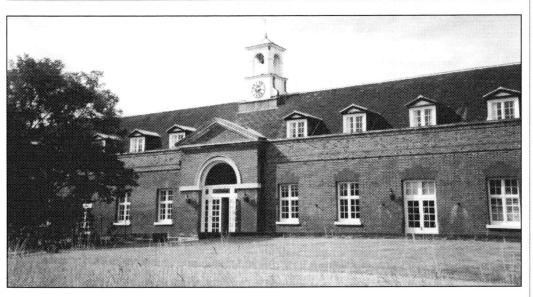

Cumberland Lodge mews which was fully converted from stabling and storage facilities into dwelling houses 1978-80. (photo July 1998 by the Author).

Cumberland Lodge mews inner area which at one time would have resounded to the clatter of horses' hooves. (photo July 1998 by the Author).

Cumberland Lodge main stairway. (photo October 1999 by the Author).

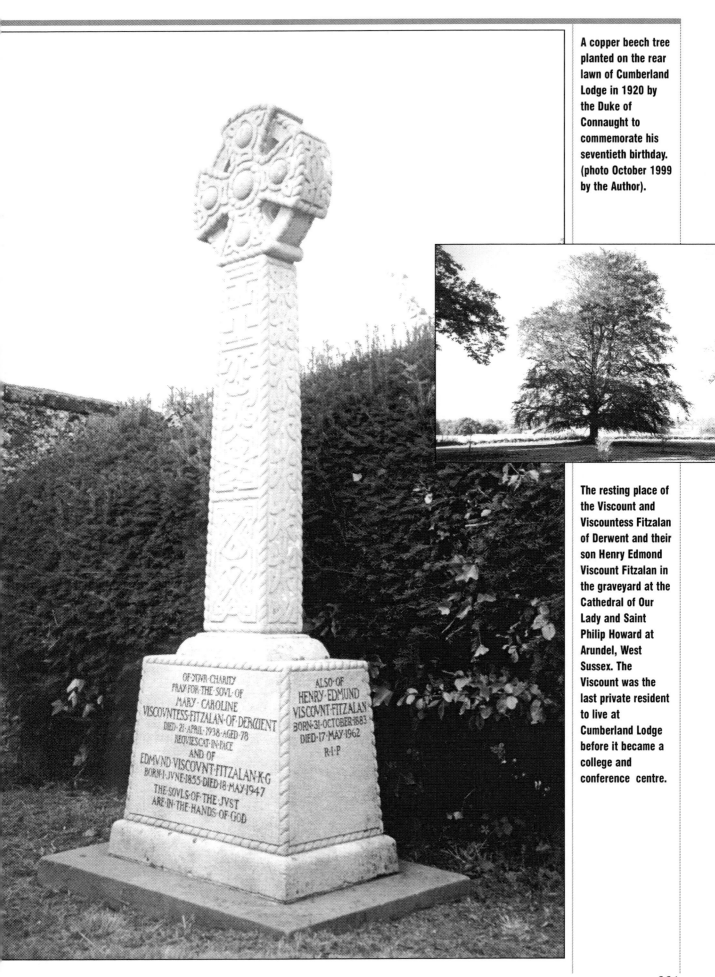

A copper beech tree planted on the rear lawn of Cumberland Lodge in 1920 by the Duke of Connaught to commemorate his seventieth birthday. (photo October 1999 by the Author).

The resting place of the Viscount and Viscountess Fitzalan of Derwent and their son Henry Edmond Viscount Fitzalan in the graveyard at the Cathedral of Our Lady and Saint Philip Howard at Arundel, West Sussex. The Viscount was the last private resident to live at Cumberland Lodge before it became a college and conference centre.

Tuesday 17th July 1917, King George V announced that he had chosen the local name of 'Windsor' for the Royal Family. The exact words of the announcement are shown below.

On Tuesday 18th December 1917 it was announced that King George V had become the Ranger of the park following the death of Prince Christian. Princess Christian continued to live at Cumberland Lodge until early 1923 when, due to failing health, she moved to Schomberg House, where she died on Saturday 9th June 1923 aged 67 years. She was buried at Frogmore alongside her husband Prince Christian.

As already mentioned, the family had committed themselves wholeheartedly to many good causes during their time at the lodge. However, full praise must be given to Princess Christian for an outstanding achievement which requires a special mention. Entirely on her own initiative she raised enough funds to buy a purpose-built hospital train to care for and transport the injured soldiers during the First World War. The train was built by the Birmingham Railway Carriage Company to accommodate 174 beds, spaces for 400 sitting-up patients, accommodation for 24 orderlies, four nurses, eight doctors and one chief medical officer. On Wednesday 7th April 1915, the train, named 'The Princess Christian Hospital Train' was inspected by King George V and Queen Mary at the Great Western Railway Station, Windsor, after which it was formally handed over to the War Office.

Following the death of Princess Christian in 1923 there was just over a year of waiting to know who the next occupants would be. All of the guessing came to an end when it was announced on 8th October 1924 that the lodge was to be loaned to Lord and Lady Fitzalan. Born on Friday 1st June 1855, the third son of the 14th Duke of Norfolk, his full name was Edmond Bernard Fitzalan-Howard. During his lifetime he had several variations of names and titles based on different circumstances:- Lord Edmond Talbot, Lord Fitzalan of Derwent and finally, Edmond 1st Viscount Fitzalan of Derwent K.G., P.C., G.C.V.O., D.S.O. He served several active years in the army, during which time he was awarded the D.S.O. However, his main interest was politics, and he served as the Conservative Chief Whip 1913-1921. He was created Viscount during the last year.

The Fitzalans loved to entertain and, from Friday to Monday the 16th to the 19th October 1936, the following prominent people were entertained at the lodge:- Stanley Baldwin (Prime Minister), Mrs. Baldwin, the Duke of Norfolk, Lord and Lady Salisbury, Mr. J.P. Herbert M.P. and Lady Mary Herbert. The entertaining drew to a close in 1938 when Mary Caroline Viscountess Fitzalan's health was failing, and she ultimately passed away late in the evening on Thursday 21st April 1938. It was whilst her body was being watched over by Sisters of Mercy

from Windsor, in the upstairs chapel in the lodge, that a burglar decided to carry out his dirty deeds, during the early hours of Monday morning 25th April 1938. As soon as it was realised that the lodge had been burgled, the police sergeant at Cumberland Gate alerted Ascot Police Station, who immediately threw a cordon round the park. With the assistance of bloodhounds and more policemen from the surrounding area, the burglar was finally found early in the afternoon hiding near Forest Gate. The next day, a 29 year old man was charged with breaking into Cumberland.Lodge and stealing jewellery and a pair of binoculars with a total value of £151.

The Second World War and the now ageing Viscount Fitzalan, saw a dramatic decline in the lodge and not the least to suffer were the once well-cared-for rear gardens, which were now virtually done away with. The Viscount continued to live there until his death on Sunday 18th May 1947, aged nearly 92 years. He was buried next to his wife in the graveyard at the Cathedral of Our Lady and Saint Philip Howard at Arundel, West Sussex. Their son, Henry Edmond, Viscount Fitzalan who often stayed at Cumberland Lodge, was buried at their side when he died on 17th May 1962. Arundel was the obvious chosen place of rest, being the seat of the Dukes of Norfolk. Fitzalan, sometimes written with a capital 'A' and/or with Howard after it, is the family name.

The name Fitzalan, Earl of Arundel goes back at least to the 1200s, when Arundel Castle first became the family home.

With Cumberland Lodge now in vacant possession, it was an extraordinary coincidence that at this moment in time Amy Buller, a lady of strong character and determination was looking for somewhere to set up a 'Christian College'. Many places had already been suggested and looked at which, for one reason or another, had not come to fruition. The assistance of Elizabeth Elphinstone, niece of the Queen (The Late Queen Elizabeth The Queen Mother) proved to be invaluable. On Sunday 6th July 1947, King George VI and the Queen visited the lodge to look at it for its suitability as a college. So it was that the King and Queen gave their consent for the lodge to be used for that purpose, and it was initially known as St Catharine's Foundation. On Wednesday and Thursday, the 1st and 2nd of October 1947, most of the priceless Elizabethan and Jacobean furniture of Viscount Fitzalan was auctioned at the lodge. Shortly afterwards, Amy Buller, Elizabeth Elphinstone and other helpers moved into the lodge and spent the rest of the year, and the whole of 1948, turning it into a workable college. At Christmas an international group of forty students was the first to stay there. Over the years, the college has improved in its scope of subjects and has developed into an extremely popular conference centre, accommodating 40-50 persons overnight from around the world throughout the year. In 1968, Queen

Elizabeth The Queen Mother became Patron, and the name of the college was changed to 'King George VI and Queen Elizabeth Foundation of St Catharine's'. Today, over 3,500 students and their teachers from London and other universities visit the lodge each year. The running of St Catharine's is overseen by a board of Trustees of the Charitable Trust.

The years 1978 to 1980 saw major changes to the Cumberland Lodge mews. For the previous 200 hundred years to 1939, the mews, which is built as two lines of buildings divided by a cobbled yard, was used for stabling of horses on the ground floor and accommodation for the trainers, grooms and coachmen on the first floor. At the outbreak of the Second World War in 1939, the existing horses were removed and the first floor was occupied by estate workers and pensioners. For a short spell during the war the cobbles once again felt the impact of horses hooves when a detachment of the Royal Horse Guards was stationed at the lodge. After the Horse Guards had left, the ground floor underwent structural changes to accommodate a drier and storage facilities for some of the grain being grown in the park to help the war effort. The major changes to the mews to convert it into modern residences started in March 1978 and were completed early in 1980. The changes necessitated the building of pile foundations to a depth of 11 .5 metres (33 feet) below ground level. The changes were total, with the old Armoury being converted into a Bedsitter. The old Post Office disappeared, though, thankfully, the letter box was saved and re-sited in the external wall of the Studio Cottage. Unfortunately, some of the character as I remember it was lost when the gardener's cottage, complete with the enormous brick built buttressed outer wall, was demolished. Possibly just as sad for some was when the old Bothy and Kennels were

pulled down and turned into a car parking area in 1980. The saddest event for most was when the old York Hall was pulled down during the same year. The original social facilities, such as they were, were in the old Reading Room in Cumberland Lodge. By the early 1930s, they had passed their 'sell by date' and new facilities were desperately needed. It was Sir Eric Savill (Deputy Ranger) who approached the Duke and Duchess of York (later King George VI and Queen Elizabeth) to suggest that an old detached stable-building could be put to use for the purpose. The Duke and Duchess readily agreed, and the building was converted during 1932 to have a stage, bar and basic catering facilities. The building became known as York Hall, after the Duke and Duchess and the club that evolved there was called the York Club. The hall soon became the focal point for the social life on the estate, with whist drives, Women's Institute meetings, Cricket Club and Football Club meetings, dances and concerts being regularly held there. Just before Christmas 1947, Tommy Trinder and Sydney Jerome, both well-known variety performers at the time, entertained King George VI, Queen Elizabeth and Princess Margaret in the hall.

Barely 250 metres (273 yards) away at the crossroads, north-west of the site of the old York Hall stands Chaplain's Lodge. Built in 1907 at the top of Gravel Hill, it has been the home of the Park Chaplain since that time. The first Chaplain to live there was The Reverend Herbert Octavius Moore, who was a close relation of John Moore, a past Archbishop of Canterbury. He was a man of considerable wealth and, when he died on 1st February 1931, he left everything to worthy causes. For many years the Chaplain's Lodge has been the venue for a Pensioners' Garden Party for retired estate employees and guests. Although the parties are not held every year, they are a significant event in the life of the park and they

Chaplain's Lodge situated at the top of Gravel Hill. It was built in 1907 as the residence for the Chaplain of the Park. (photo August 1999 by the Author).

Prince Charles The Prince of Wales signing the visitors book at the Pensioners' Garden party held at Chaplain's Lodge on Saturday 6th July 1985. Standing next to him is The Princess of Wales and the Park Chaplain the Reverend John Treadgold. On a glorious summers day, over 400 people attended the party. It was a very relaxed occasion with music provided throughout the afternoon by the Band of the Life Guards.
(John Treadgold Collection).

are often attended by members of the Royal Family.

Situated near the bottom of Gravel Hill on the road to Sandpit Gate is the Royal School. Queen Victoria and her Royal Consort, Prince Albert, recognising the need to have a school for the children of the Crown employees, chose this position because of its proximity to where a majority of the employees lived. At a total cost of £1,350, building started in 1843 and it was completed and opened in July 1845. A few of the school's early rules were as follows:-

None but the children of parents actually employed in the service of the Queen be eligible to go to the school, except by Her Majesty's commands.

That the school consist of 50 boys and 50 girls, clothed uniformly during school hours at the expense of H.M. The Queen.

That instruction be as follows:

All to have careful religious and moral training.

Boys: reading, writing, arithmetic, geography, history, grammar, etymology and gardening.

Girls: reading, writing, arithmetic, geography, history, grammar, needlework, knitting cooking, baking, washing and domestic economy.

From the start, the school has been well patronized

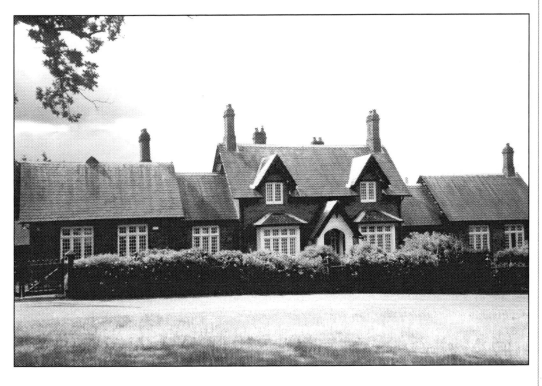

The Royal School built during 1843-1845 for the education of the children of the Windsor Crown Estate employees. The author's grandfather, Joseph Smith and many more of his relations were educated here. Great aunt Sophia Smith stayed on to become a teacher at the school for at least ten years in the 1880s-1890s. (photo taken in July 1998 by the Author).

by the Royal Family, a fact which may have had the subtle effect of keeping the teachers and pupils on their toes.

During Victorian times many members of my family attended the school, not the least of whom was my grandfather Joseph Smith who was born in the original Swinley Park Entrance Lodge on 28th February 1846. After leaving school he learnt his trade as joiner and moved on to become a master joiner, finishing up as the works manager of A.H. Reavell (Joinery Company) in Windsor. His youngest sister, Sophia Smith, who was born near the school at Hollybush Cottages on 14th May 1863, was a pupil-teacher and went on to teach as a qualified teacher at the school. The majority of the family worked on the estate after leaving the school.

The Royal School has always attained a high standard of education, with many of the pupils going on to greater things in life. One such person was Frederick William Camm, who also went on to become a master joiner at the Reavell works.

Although he was an excellent joiner, it was mainly through his two eldest sons, Sir Sydney and Frederick James Camm that he was more generally recognised. Both of the sons went to the Royal Free School in Windsor, a school with similarly high standards to the Royal School. It is my opinion that Sydney was one of the greatest aircraft designers of all time. At a very young age he became the Chief Designer with the Hawker Aircraft Company and designed more than 50 aircraft, of which the 'Battle of Britain' Hurricane was just one. Sydney's younger brother, Frederick was no slouch either. He designed and built a three-wheeled car called the 'Cambro', invented a device that automatically re-inflated a bicycle tyre if you had a puncture and, more importantly, became the editor of some extremely popular engineering reference books and magazines whilst working for George Newnes Ltd. *Practical Wireless,* which he edited, was first published in September 1932 and became a top seller.

There was one pupil who took up a more unusual style of life after leaving school - in fact he became a hermit living in the park. His name was James Stanley Wootton. His extraordinary life is described in Chapter 4.

It was not until 1938 that the energetic Welshman and keen rugby enthusiast, Hubert Tannar (Master) arranged a meeting to set up an Old Scholars' Association. The Inaugural Meeting attended by Old Scholars was held in the Royal School during the second week in May 1938. At this meeting the Royal School Old Scholars' Association was formed with Hubert Tannar becoming Chairman, and Charles West the Hon. Secretary and Treasurer. The very first reunion was held in July - two months later. However, it was not until the following year, during which rather more of the old scholars had been located that a full-scale reunion took place. The reunion was held at the school on Sunday 16th July 1939, and the old scholars assembled in glorious sunshine on the lawn to receive the address from the Dean of Windsor (Chairman of the Managers). The oldest scholars, who were eighty years old or over, were announced with their names and ages. Each announcement was met with a great cheer, with my great uncle, Henry Smith being the oldest at 86. However, the greatest cheer went to Mr and Mrs Liburn, who had travelled all of the way down from Glasgow in Scotland for the occasion. The more able old scholars took a nostalgic stroll along Rhododendron Ride afterwards.

The Royal School Foundation Centenary Celebrations held in July 1945 were a particularly joyous and memorable occasion. It was not only a time to celebrate the one hundredth year of the school, it was also a time of great relief now that the Second World War had come to an end. The celebrations were attended by King George VI, Queen Elizabeth, Princess Elizabeth (now Queen Elizabeth II) and Princess Margaret. The Master was Hubert Tannar who, as usual, had thrown his enthusiasm into the event to ensure its success. The happiest part of the day was 'Dancing around the Maypole' a traditional event which was normally performed on May Day only. Much to the delight of the Royal Family, the parents 'had a go' after the children had finished their turn. The Maypole still stands on the green opposite the school as a nostalgic reminder of the past.

Standing at the western front corner of the school is 'Park Farm House', which was built at the same time as the school for park employees. Just to the west of this house are numbers 1-8 Mezel Hill Cottages. Being so close to the school, they offered little chance for the children that lived there to 'play truant'. One boy who was born there clearly thrived in the environment achieving much in the academic field as follows:- Leslie Grout, a past pupil of the school, achieved the ultimate level of knowledge recognition when he won the much coveted BBC TV *Mastermind* award at the final on 16th December 1981. The next year he went on to win the International

The Royal Family watching maypole dancing on the green opposite the Royal School in July 1945. The Royal Family are sitting on the right of the maypole and the pupil wearing a school uniform from Victorian times. The late Queen Elizabeth the Queen Mother is wearing a light coloured dress and hat. King George VI is dressed in a suit. Princess Margaret is partly hidden behind the girl on the rope and Princess Elizabeth (now Queen Elizabeth II) is sitting with her arms folded on her lap. The look of happiness on all of the faces was mainly due to the fact that the Second World War had just ended. The two men in naval uniform, were no doubt happy to have survived and to be home on leave.

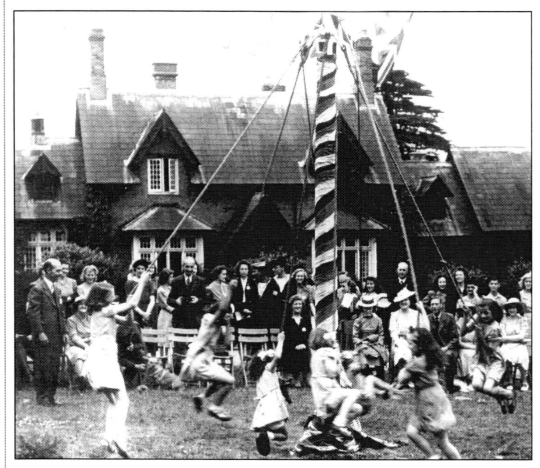

Mastermind title on 16th May 1982 at Christchurch, New Zealand. Although Leslie is very modest about his success, it was nevertheless a remarkable achievement. Leslie was born on 12th November 1946, the only son of William and Helen Grout when they were living at No.8 Mezel Hill Cottages. William started work in the park in 1928 where he learnt to be a wheelwright. As the requirement for this trade dwindled, William, or 'Dickie' as he was more generally known, took up the position of Clerk of Works of the Estate.

After seven years of trying, Leslie, who was then a teacher at the Ottershaw Middle School in Surrey, was finally accepted for the first round of *Mastermind*. That in its own right was some accomplishment when you consider that only 48 persons were accepted from over 4,000 applicants each year. In the British final, Leslie's chosen specialist subject was St. Georges Chapel in Windsor Castle. Competing against three contestants, he scored a total of 32, failing to answer only two questions.

In the final of the International Mastermind in New Zealand the next year, his chosen subject was Windsor Castle. The 'Mastermind' quiz was an extremely popular television programme which was started in 1971 and ended in 1997. It attracted well over 15 million viewers at a time who would watch spellbound as each contestant took their turn in the daunting black padded high chair, to be 'grilled' by Magnus Magnusson the questionmaster. The competition was not only a test of knowledge, it was also a test of nerves. The format has recently been revived by the BBC with John Humphries as the questionmaster.

It follows that the teachers at the Royal School were chosen with considerable care. An example of this was when Thomas Sydney Patchet was chosen as Headteacher in October 1948, from 200 applicants.

A short distance to the east of the Royal School is the 'Vinery'. It is a greenhouse which sadly no longer houses an enormous Black Hamburg grape vine that once grew there. The vine was planted in an old pine pit

Photograph of two pupils outside the Royal School in 1955.
Josephine Morrison is on the left wearing a perfectly preserved Royal School uniform from Victorian times. The dress is brown and cream check and the cape is red. The straw hat has a red ruffled band.
Joy Findlay is on the right wearing the Royal School standard uniform for the 1950s. The gymslip and beret are navy blue and the blouse is white.

Leslie Grout in Christchurch, New Zealand, with the much coveted International Mastermind Trophy which he won there on 16th May 1982. Leslie was born at No.8 Mezel Hill Cottages on Tuesday 12th November 1946 and attended the nearby Royal School as a boy. (Leslie Grout Collection).

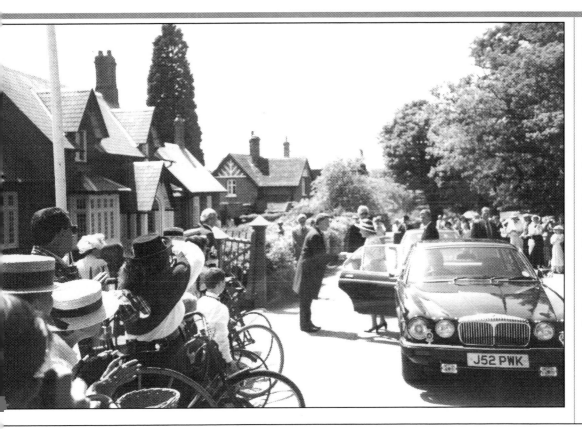

Queen Elizabeth II being greeted by Mr Peter Brock, Headmaster of the Royal School on Friday 30th June 1995 on the occasion of the one hundred and fiftieth anniversary of the school. Marcus O'Lone, Deputy Ranger is standing immediately behind the car.
(photo by Alison Mansfield, a member of the Veteran Cycle Club).

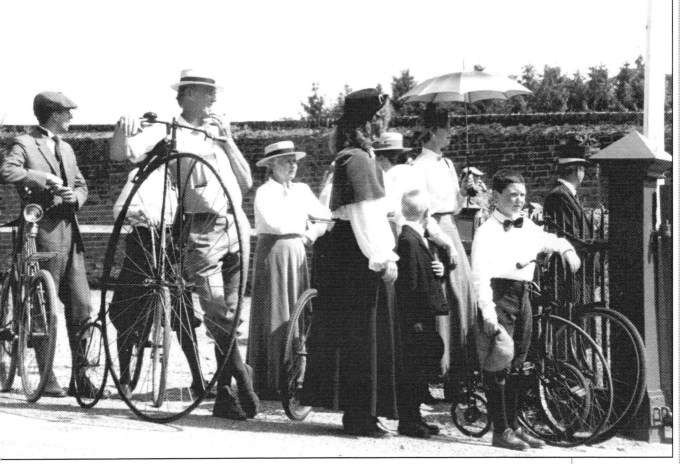

Veteran Cycle Club members appropriately dressed with their bicycles outside the Royal School at the one hundred and fiftieth anniversary of the school. The Club had been invited along to add more atmosphere to the occasion.
(Allison Mansfield photograph, a member of the Veteran Cycle Club).

The Grape Vine in the Vinery about 1939 a few years before it was cut down. The stump of the main stem (trunk), which was cut away a few years before, can be seen just above the base. (Margaret Findlay Collection).

230

in the 1770s and grew to an enormous size. By 1883, the greenhouse had already been enlarged three times to an overall length of 42.7 metres (140 feet), with a width of 6.7 metres (22 feet) as it stands today. In that year the dimensions of the vine and its produce were:

Length: 42 metres (138 feet).
Height: 6.1 metres (20 feet).
Trunk circumference: 112 centimetres (44.1 inches).
Crop: 2,000 bunches
Crop weight: 1,168.5 kilograms (2,576 lbs).

At the time it was the largest vine in Europe, being 1.158 metres (38 inches) longer than a vine of the same origin planted at the same time in Kew Gardens. The public was allowed to visit the vine by appointment with Mr. R. Wheatley who had looked after it from 1842 whilst living in the nearby Vinery Cottage. The large number of grapes produced could become an embarrassment, so the crop was sometimes deliberately kept down to 500 bunches a year. Over the years, large quantities of the grapes were distributed free to hospitals, institutions and schools, much to the delight of those that received them. During the 1930s, the main stem (trunk), which was suspended from the roof by heavy steel chains, was cut down. Alas, the whole life of the vine was soon to come to an abrupt end. In 1942, George Spong who had been the Vinekeeper for many years, was instructed to cut it down, along with the fig trees that had been planted against the vinery wall in 1932. At the time it was considered more important to grow tomato plants in the greenhouse as part of the war

effort. A few cuttings had been saved as the only consolation, one of which was planted by Hope Findlay at Lake Cottage, Bagshot. If only a cutting from this vine was started once again in the now empty Vinery!

In the close proximity of Cumberland Lodge there are several commemorative trees planted over the years. On the rear lawn of the lodge is a magnificent copper beech tree that was planted by the Duke of Connaught on his seventieth birthday, 1st May 1920. To the north-east of the lodge, near the boundary fence of the Royal Lodge, stand two cedar trees planted on 16th December 1875 and known as the Prince Christian's Family Cedars.

Lime Tree Avenue is a straight avenue of lime trees starting at the main gate of Cumberland Lodge and leading towards Cow Pond in the east. The avenue was originally laid out and planted about 1718. About halfway along the avenue, the Bishopsgate to Blacknest Road passes through at right angles. During 1877-1878, the lime trees from this junction towards Cow Pond were replaced with scarlet oak trees, The first few trees were planted by Prince and Princess Christian on Monday 22nd January 1877, being the forty-sixth birthday of the Prince. From that time this stretch of the avenue has been known as Scarlet Oak Avenue. At the far end of the avenue, a large ornate iron gate was erected at the entrance to Cow Pond. The gate was removed in 1998 to allow easy access for the estate vehicles.

Bordering the northern side of Scarlet Oak Avenue, there is a fairly large grove of different varieties of oak trees. Generally known as the Coronation Oaks, they were planted on Saturday

afternoon 19th June 1937 by King George VI and representatives from the British Commonwealth to commemorate the King and Queen's Coronation. As there were sixty trees to be planted that afternoon, the area had been fully prepared with the planting positions dug out and the trees placed ready for the planting process. The day, which had started with a heavy storm over the area, improved and it turned out to be a sunny afternoon. This was no ordinary tree planting occasion. Stands had been erected at the extreme northern end, where the first tree was to be planted. The Royal Family and their representatives departed from the Royal Lodge to be met by a Guard of Honour leading up to the stands of nurses from Windsor. At the stands the party was received by Mr Eric Savill (Deputy Ranger) and Major Ulick Alexander (Keeper of the Privy Purse). The first tree, to be known as the H M The King tree, was planted by King George VI. The second tree was planted by Sir Samuel Hoare representing the United Kingdom. The other trees were planted to represent the positions of the countries of the world, with the New Zealand oak being furthest away. As a boy, I was fascinated to see first-hand the extent to which oak trees could vary in form, particularly the shape and size of their leaves. Unfortunately, some of the trees have not fared too well, some replacements being necessary.

(See the plan of the grove).

Just south of Lime Tree Avenue is the Prince Christian Victor Oak, planted by the Prince on his twenty-first birthday - 14th April 1888. Until the 1970s,

a Parish Boundary Oak stood close to Wilderness Wood in line with Cumberland Gate. It fell down through old age. The latest addition to the trees in the area is the avenue of young limes planted on each side of the road leading from the north-eastern entrance of Cumberland Lodge. They were planted in 1999 to celebrate the centenary year of Queen Elizabeth The Queen Mother.

Cow Pond was created by dammimg up the stream in the 1670s, not long after Cumberland Lodge was built. It is about 270 metres (295 yards) long and about 75 metres (82 yards) wide throughout. Why it was given the unbecoming name remains a mystery. The name conjures up an image of a pond with cows wading in muddy water and having a drink. It is obvious from its shape and size that it was created as an ornamental pond. It is for this reason that the pond has always been known by my family as 'Ornamental Pond', a name much more appropriate for such a beautiful stretch of water, with a whole variety of water lilies to be seen and hundreds of common carp living in the water. The scene is further enhanced by groups of rhododendrons along the banks. Many visitors to the park only become aware of the pond when they have ventured along the rather secretive Rhododendron Ride that runs parallel to the eastern side of the pond. Because it is not very deep, it readily freezes over in the winter and at one time when there were not so many water lilies, it was not uncommon to see several hundred skaters at a time using the pond.

The grove of oaks planted between Cumberland Lodge and Cow Pond to commemorate the coronation of King George VI and Queen Elizabeth on Wednesday 12th May 1937. (Photograph by the author. Looking west – August 1998)
The commemorative plaque for the grove of oaks shown above. (photo by the Author)

THIS GROVE OF OAKS WAS PLANTED ON 19TH JUNE 1937 BY BRITISH COMMONWEALTH REPRESENTATIVES IN THE PRESENCE OF KING GEORGE VI AND QUEEN ELIZABETH TO COMMEMORATE THEIR MAJESTIES CORONATION 12TH MAY 1937

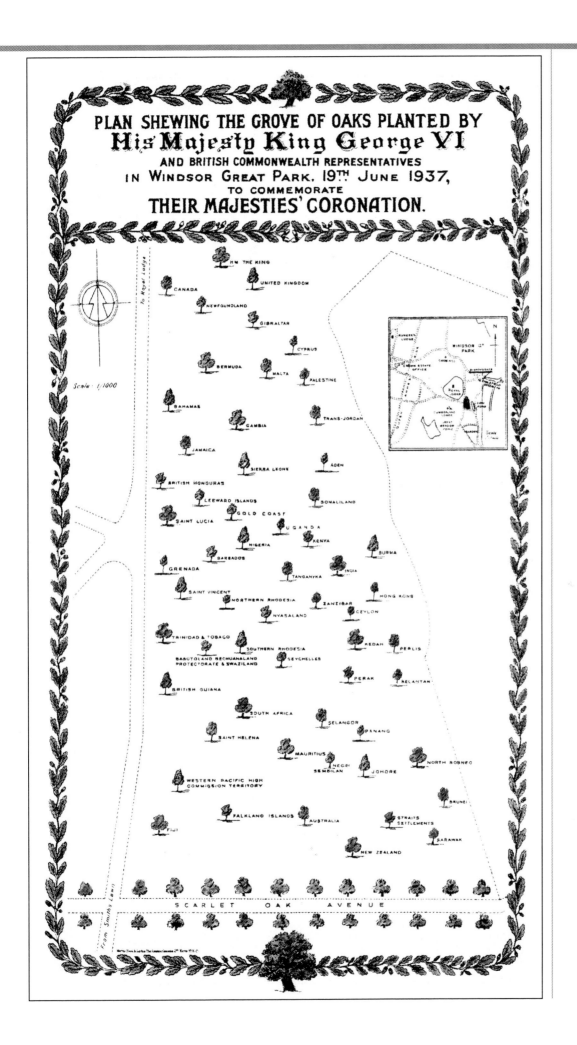

PLAN SHEWING THE GROVE OF OAKS PLANTED BY
His Majesty King George VI
AND BRITISH COMMONWEALTH REPRESENTATIVES
IN WINDSOR GREAT PARK, 19TH JUNE 1937,
TO COMMEMORATE
THEIR MAJESTIES' CORONATION.

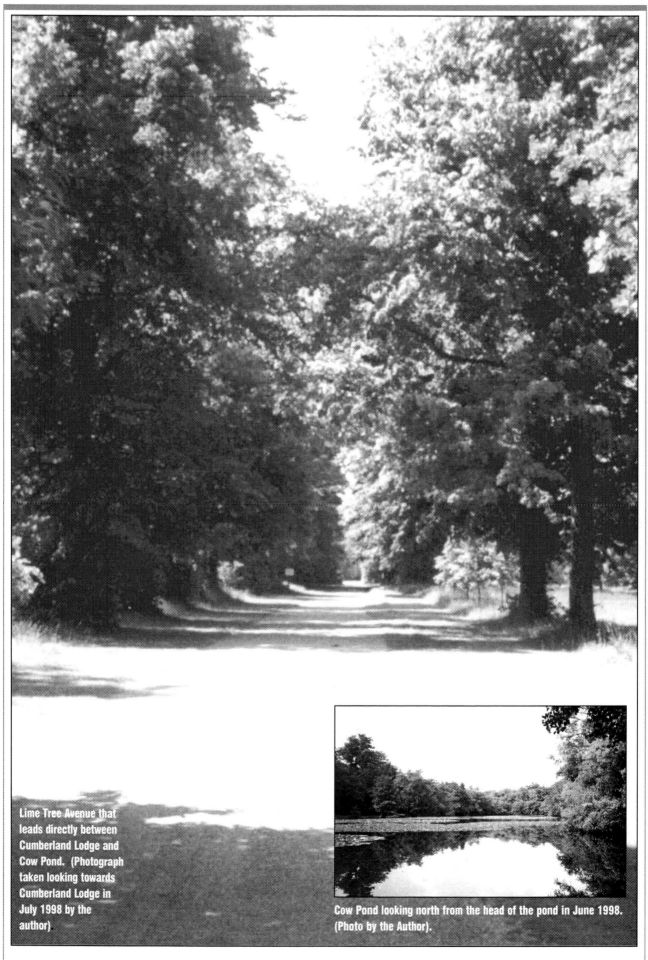

Lime Tree Avenue that leads directly between Cumberland Lodge and Cow Pond. (Photograph taken looking towards Cumberland Lodge in July 1998 by the author)

Cow Pond looking north from the head of the pond in June 1998. (Photo by the Author).

Smith's Lawn
and the Savill Garden

Smith's Lawn
and the Savill Garden

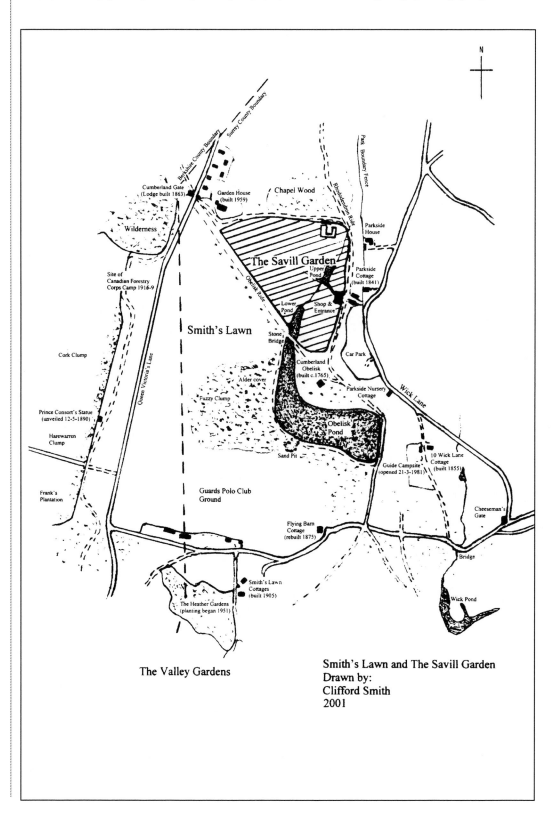

N

Surrey County Boundary

Berkshire County Boundary

Park Boundary Fence

Rhododendron Ride

Cumberland Gate
(Lodge built 1863)

Garden House
(built 1959)

Chapel Wood

Parkside
House

Wilderness

The Savill Garden

Upper
Pond

Parkside
Cottage
(built 1841)

Site of
Canadian Forestry
Corps Camp 1916-9

Obelisk Ride

Lower
Pond

Shop &
Entrance

Smith's Lawn

Stone
Bridge

Car Park

Cork Clump

Cumberland
Obelisk
(built c.1765)

Queen Victoria's Lane

Alder cover

Parkside Nursery
Cottage

Wick Lane

Fuzzy Clump

Prince Consort's Statue
(unveiled 12-5-1890)

Harewarren
Clump

**Obelisk
Pond**

10 Wick Lane
Cottage
(built 1855)

Sand Pit

Guide Campsite
(opened 21-3-1981)

Frank's
Plantation

Cheeseman's
Gate

Guards Polo Club
Ground

Flying Barn
Cottage
(rebuilt 1875)

Bridge

Smith's Lawn
Cottages
(built 1905)

Wick Pond

The Heather Gardens
(planting began 1951)

The Valley Gardens

Smith's Lawn and The Savill Garden
Drawn by:
Clifford Smith
2001

Smith's Lawn is an 'L' shaped flat plateau of grassland situated in the south-eastern area of the park. Geographically, it is unusual in that the western half of the lawn lays in the county of Berkshire and in the parish of Old Windsor, whereas the eastern half is in the county of Surrey and in the parish of Egham. It is bordered with tree plantations, The Savill Garden and Obelisk Pond on its northern boundary, Egham Wick to the east, the Valley Gardens to the south, and Norfolk Farm to the west. It is about 1,244 metres (1,360 yards) at the longest point (north to south) and about 914 metres (1,000 yards) wide. The total area is about 61 hectares (150 acres). A metalised road runs from Cumberland Gate on the northern border through to Breakheart Hill at the southern boundary. The road is known as Queen Victoria's Avenue, and continues on past Johnson's Pond through to Blacknest Gate. On Smith's Lawn it is met by another road that comes across the southern end of the lawn from Cheeseman's Gate in the east. Over the years, particularly during the First World War from 1914 to 1918, much work was carried out on the levelling of the ground. It is very possible that it was occasionally used as an airfield during the First World War. Certainly it was used on a regular basis as an airfield by members of the Royal Family during the 1930s. There is a house that stands at the eastern end of the lawn known as Flying Barn Cottage. This was built in 1875 on the site of a previous cottage of the same name, sometimes known as Obelisk Cottage. In Victorian times it was used as the home of the Royal Fisherman, who was employed to look after the fish in the park. However, the name of the cottage has nothing to do with aircraft flying.

It was simply the site of a portable (flying) barn on wheels. On the southern border stand two more houses built in 1905, known as Smith's Lawn Cottages. In 1949, a further two houses were built, known as 'Heatherside' and 'Heatherbelle'. Until 1963, a very old pollard beech tree stood at the far south-western corner of the lawn at the top of Breakheart Hill. Like most old pollard trees, the centre of the trunk had completely rotted away and, although every effort was made to preserve it with a protective iron fence, it finally succumbed to nature. On the far western side of the lawn stands the Prince Consort's Statue, the full details of which are given further on.

The origin of the name for this area of the park is steeped in mystery. Many names have been put forward and none have been substantiated. During the 1800s, it was commonly accepted that it was named after a Crown Gamekeeper who covered that area. Again this remains unproven. It would be nice to say that a member of the author's family is behind the name, which is very possible considering their enormous history of working for the Crown. However, after many years' research, I have not been able to find anything in writing indicating which 'Smith' relates to the name given to Smith's Lawn. I believe that this will always remain a mystery.

Smith's Lawn has an extraordinary history in its own right. It has been used for Royal gatherings, horse training, military camping and manoeuvres, vegetable growing, pig and poultry farming, timber cutting, athletic sports, cycle racing, cricket, football, baseball and equestrian events. Currently, polo is the sport it is best known for although, for many years during the 1930s and 1940s, the lawn was better known as an airfield. Prince Edward, The Prince of Wales (later King Edward VIII) often flew his own aircraft there before he abdicated. Its full use as an military airfield during 1940-5 in the Second World War is covered in Chapter 18.

The Prince Consort's Statue is situated on the western side of Smith's Lawn, about 900 metres (984

Cheeseman's Gate at the western end of Wick Road looking into the park. The gate is named after the Cheeseman family that lived there in the 1800s. (photo July 1998 by the Author).

Flying Barn Cottage at the eastern end of Smith's Lawn. It was built in 1875 on the site of a previous cottage by the same name. (photo June 1999 by the Author).

Cumberland Gate and Lodge as seen from Smith's Lawn in July 1998. The Lodge was built in 1863. (photo the Author).

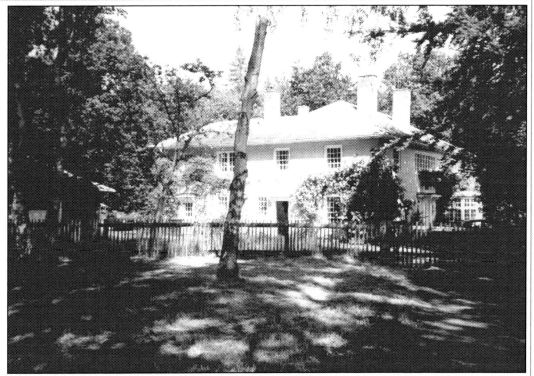

yards) south of Cumberland Gate. The statue is a memorial to the Prince Consort, the late husband of Queen Victoria. It appears to be quite out of keeping with its surroundings, but Queen Victoria chose the site because of her happy memories of the area as she rode to and from Virginia Water Lake, particularly with its close proximity to Norfolk Farm, where the Prince Consort had been so actively involved.

The foundation stone was officially laid by Queen Victoria on Thursday 14th July 1887 and, three years later, the statue was unveiled by Queen Victoria on Monday 12th May 1890. The base and pedestal were built by Messrs MacDonald, who had quarried and cut the large blocks of granite at Aberdeen. The total weight of the granite blocks is 90 tons. The length of the base is 6.86 metres (22.5 feet) and the width is 4.57 metres (15 feet). The height of the base and pedestal is 4.57 metres (15 feet). The height of the horse and figure is 3.11 metres (12.3 feet), making the total height of the base and figure 7.68 metres (27.3 feet).

The statue was modelled by Sir Edgar Boehm, an eminent sculptor, as a replica of one he had already designed and erected in Glasgow. The casting of the horse and figure in bronze was carried out by Mr James Moore at his works at Thames Ditton, near Kingston-upon-Thames. The difficult task of transporting it by road was successfully completed without any reported damage. The horse and figure is mounted on the rectangular pedestal looking towards the north. The figure is an image of the Prince Consort in field-marshall's uniform, bare headed, and with his plumed cocked-hat resting against his right knee. He is seated on a magnificent charger which has one foot raised as if in the act of pawing the ground. On each side

of the pedestal are fixed metal inscription plates, all of which were made by Warner's of London. The front plate facing the open expanse of Smith's Lawn has the following inscription:-

The inscription has been translated on the other plates as follows:-

> ALBERT
> PRINCE CONSORT
> Born August 26th 1819
> Died December 14th 1861
> This Statue was presented to
> VICTORIA
> QUEEN AND EMPRESS
> A token of love and loyalty
> From the Daughters of Her Empire
> In remembrance of Her Jubilee
> June 21st 1887
> And was unveiled here
> On Monday, May 12th 1890.

The plate on the southern side of the pedestal is in Sanskrit, an ancient language of India. It was translated from English by Professor F. Max Muller. The western facing plate is in Latin, translated by Professor R. Ellis of Oxford University. The last plate, which is facing north, is in Gaelic and was translated by Professor Mackinnon of Edinburgh University. The Gaelic plate, which was affixed in 1897, was placed over an original inscription that was cut into the granite in English. Part of the original inscription can still be clearly seen today.

Unfortunately, the inscription plates have discoloured over the years, and the lettering is not clearly legible.

The unveiling ceremony, which took place on Monday 12th May 1890 at 4.20 in the afternoon, was a grand occasion. Every member of the Royal Family was present, including the King of the Belgians. The unveiling ceremony was, without question, the most majestic that had ever been held in the park and forest. In addition to the thousands who were actually involved in the ceremony, more than seven thousand spectators travelled to Smith's Lawn by train, carriage and foot.

Preparation of the site was carried out by the park employees under the direction of Mr Frederick Simmonds, Deputy Surveyor of the park and forest. To the left of the statue was erected an enclosure for the Royal Household. On the right of the statue a stand was erected for the press and dignitaries. Placed in a dominant position in front of the statue was the Royal dais. Standing behind the dais was the Royal Pavilion and the flagstaff.

Well before the Royal Party was due to set out from Windsor Castle, Smith's Lawn was thronged with people who had converged from all of the entrances into the park. The military was well represented with detachments from the 11th Hussars, Grenadier Guards, Scots Guards, Somerset Light Infantry, Kings Rifles, Honourable Artillery Company and the Royal Horse Artillery. A large detachment was present from the Berkshire Volunteer Rifles, which included most of the members from the Windsor Great Park Company. Many of the local schools had been given a half day holiday to enable them to attend the ceremony. The pupils of the Royal Schools, under the charge of Mr. and Mrs. W.T. Warren - Headmaster and Mistress, looked very smart in their checked suits and scarlet cloaks.

In beautiful weather, the Royal Party left the Castle and proceeded down The Long Walk. With a full military mounted escort, the carriages made their way towards Smith's Lawn. In the first carriage was Queen Victoria, dressed in black silk and wearing a black bonnet with a white feather. On her left was seated the Princess of Wales, wearing a violet embroidered jacket with a matching dress and bonnet. Opposite them sat the King of the Belgians. The second carriage carried the Prince of Wales, Princess Christian and the Duke and Duchess of Edinburgh. The third carriage carried the Duchess of Albany, Princess Louise Marchioness of Lorne, Princess Beatrice and the Duke of Cambridge. The seven carriages that followed carried the rest of the members of the Royal Family. Accompanying the carriages on horseback were Prince Christian and the Duke of Connaught.

On their arrival at the Royal Pavilion, the National Anthem was played as the Royal Standard was raised. The Royal Party then took up their places to receive the address from the Duke of Westminster. The Queen then replied:- "I am much touched and gratified by this gift of my dear husband's beautiful statue. Nothing could give me greater pleasure, and I thank you all most heartily," Sir Edgar Boehm, the

sculptor, then placed a silken cord in the Queen's hand. When she pulled the cord, the canvas covers from the statue slipped to the ground to rapturous applause from the crowd.

The Canadian Forestry Corps came over to England in 1916 to help provide timber for the First World War involvement in Europe. They set up camps all over the country, the base camp being on Smith's Lawn. At the time, Smith's Lawn was already being used as a camp by a battalion of Coldstream Guards. The Duke of Connaught, who at that time was the Governor General of Canada, had chosen Smith's Lawn for the purpose. Much of the first few months was taken up building sawmills, railway lines and living accommodation. Smaller camps were set up at Wick Pond, Nobbscrook, Swinley Forest and at Bagshot near Rapley Lake. The very first timber to be sent from the park to the war front was sawn on 13th May 1916.

The Smith's Lawn Camp was very nearly self-sufficient. Having laid on their own electricity and water supply the foresters finished up having better facilities than many of the local people. By the end of 1917, they were using 14 hectares (35 acres) for home produce. Large areas of Smith's Lawn were used for pigs, poultry and vegetables. There were even several flower beds. The road leading from Cumberland Gate to Virginia Water Lake was reconstructed to take the heavy volume of traffic. The railway line ran along the western side of the road. Many of the huts were on a grand scale, with the Y.M.C.A. (Young Men's Christian Association) hut being the most luxurious. This was formally opened on Saturday 14th April 1917 by Princess Victoria of Schleswig-Holstein. The hut consisted of a large lounge, coffee room and a billiard room. With so many huts being built to house nearly three thousand troops, it soon became known as the 'Hut Town', or more formally as the Canadian Camp.

The camp commander was Colonel Penhorwood, who, rather surprisingly, was not Canadian. He was born in Wales in 1874, and moved out to Canada when he was only 11 years old. In fact, many members of the Corps were from other countries. The international flavour of the camp gave a different dimension to the park and forest, and the young ladies in the district were soon finding themselves attracted to this fine body of men. One such girl had found her way into the camp at Wick Pond. Whether or not she had been spurned by one of the men we do not really know, but on Friday night the 22nd March 1918, a fire was started on a pile of sawdust and, in a very short time, the sawmill and surrounding huts were ablaze. By the time the Egham Fire Brigade had arrived, the camp had all but been destroyed. The damage was estimated at about £10,000 - a considerable sum for those days. A young woman was found hiding in a sentry box after the fire. She was

Prince Consort's
Statue – July 1999
(photo by the
Author).

241

described as 18 years old, and she had come from London. The next day she was charged with being on military premises without a permit. She was kept at the Egham Police Station for further investigation.

During 1918, the Corps staged numerous events attracting large crowds of spectators. King George V, who had taken on the role of Ranger of the park and forest the previous year, was a regular visitor to the camp and attended many of these events. The first such event was the Corps Sports Day which took place on Saturday 25th May 1918. A crowd of about 3,000 spectators had made their way onto Smith's Lawn to cheer the competitors participating in the twenty-one events. Apart from the usual athletic races, there were some more unusual events, such as Log Chopping and catching the Greasy Pig. Competing that day was Quartermaster Sergeant Lukeman, one of Canada's finest athletes. He had represented Canada several years previously, coming second in the Pentathlon at the Olympic Games in Stockholm in 1912.

On Saturday 8th June 1918, an event more unusual to these shores took place at the camp. This was a Baseball Match, held between the Corps and the United States Army who had detachments posted in this country at the time. The teams were competing in the Anglo-American League, and it was not surprising that the Americans won the game, bearing in mind the history of the sport in their country.

A different sports event took place on Monday 5th August 1918. This was of an aquatic nature, and took place on and around the Obelisk Pond. Over 3,000 spectators had come to see this unique event. Twelve items were on the programme. Of these, several were displays or exhibitions of a fun-making rather than competitive nature, and were more suited to the large lakes of Canada. Canoeing, with the boat almost standing on its end and log burling, an event where a competitor standing upright revolves a huge floating log by the rapid motion of his feet, were virtually unknown this side of the Atlantic. Other events included swimming races, diving, barrel-racing and waterpolo. Among distinguished visitors were the Duke of Connaught, Princess Patricia Princess Christian of Schleswig-Holstein, Princess Alice Countess of Athlone, Princess Helena Victoria and Princess Marie Louise. Throughout the afternoon, the spectators were played music by the Corps pipers and brass band. Looking across the Obelisk Pond today, it is very difficult to imagine that this ever took place.

The last and largest event staged on Smith's Lawn by the Corps took place on Saturday 14th September 1918. This consisted of a Vegetable Show, and the Corps Sports Championships. The vegetable exhibits had come from the Canadian Camps as far away as Scotland. There was a total of 150 entries, with the Smith's Lawn Camp taking eight first prizes and five seconds. The Virginia Water Camp obtained two seconds and two third prizes. The top exhibit of the show was judged as being the King Edward potatoes that had been grown on Smith's Lawn.

The Sports Championships attracted competitors from all over England. The number of competitors was so great that preliminary heats were carried out

Members of the Canadian Forestry Corps outside the YMCA hut which was opened on Saturday 14 April 1917. The camp Commanding Officer, Lieutenant-Colonel Sydney L. Penhorwood can be seen here with a cane. Each side of him are lady guests. Penhorwood was born in Wales in 1874 and moved to Canada in 1885 (Author's Collection).

from early in the morning. The finals were held in the afternoon. In addition to the athletic events, a rifle shooting competition was held on the miniature range in the morning. The competition results in the athletic finals, although not comparing to present day standards, were still quite impressive.

Making use of modern transport, the King and Queen, with other members of the Royal Family, were driven from Windsor Castle by motorcar to Smith's Lawn. They were greeted at the camp by the playing of the National Anthem by the brass band of the Corps, after which they visited the vegetable show and watched the sports events.

Soon after the end of the First World War, the Canadian Forestry Corps left the park. Sadly, many of the soft-wood plantations which had been planted by the author's family had been decimated. However, there is a beech tree which, having survived the terrible storm of 1987, is still standing on the northern bank

lawn has become one of the country's busiest equestrian venues attracting many national and international sports stars and celebrities. The Royal Family have a long-standing association with horses and the current Royal Family is no exception. It was Prince Philip the Duke of Edinburgh, who introduced polo on Smith's Lawn on a permanent basis in 1955. The first games were played at the southern end of the lawn. Much has happened since those early years with games being played over most of the area. The permanent and temporary stands are always fully occupied at the main events. In 1955, the Household Brigade Polo Club was formed and was later renamed The Guards' Polo Club in 1969. The club organises all games played on the lawn. The game produces its fair share of injuries, and several members of the Royal Family have fallen victim to them during their playing years.

Although polo currently dominates the scene on the lawn, lots of other important equestrian events have

A group of Canadian Forestry Corps women with their vehicles. (Author's collection)

of Virginia Water Lake as a kind of memorial to the Corps. It clearly shows the head of a Canadian Indian Chief which had been carved into the bark by a member of the Corps.

During the latter part of the 1800s, Smith's Lawn became a focal point for various activities, mainly due to its close proximity to Cumberland Lodge and the popularity of Prince and Princess Christian, who lived in the lodge. The lawn was, at the time, being used on a regular basis for military exercises. A common practice was to get a message on foot to the barracks at Windsor in the shortest possible time and without being caught by the 'enemy'. This military connection with the lawn saw the occasional game of polo being played there in the 1800's, some time after the first games played on the Cavalry Exercise Ground.

The area just inside Cumberland Gate was a popular meeting place for fox and deer hunting. It is now many years since this event ceased. However, horse-related events have far from diminished, and the

taken place there. For three days from Wednesday to Friday 4th, 5th and 6th May 1955, the European Horse Championships were held in the park for the first time. The first two days were devoted to dressage on Smith's Lawn, whilst the Endurance Test was held on the Friday. The British team retained the championship title. The Queen, the Duke of Edinburgh, Prince Charles, Princess Anne, the Queen Mother and Princess Margaret were present each day along with an estimated 50,000 spectators who had come to watch the events. On the Saturday evening, the Royal Family attended a cocktail party given by the officers of the Berkshire Yeomanry in their marquee on Smith's Lawn. The Yeomanry were congratulated for the way in which they had organised the Endurance Test.

A large number of the events that have taken place in the park have combined sporting activities with fund raising. A very noteworthy instance of this is the Horse Ride organised by the Lions Club of Windsor. Inaugurated in 1973, much of the success of this very

popular annual event must be given to its organiser, Lions member, Peter Vaughan. Since he brought his idea into fruition, the event has raised over £1,000,000 for needy causes. The Ride is a two day event, starting and finishing on Smith's Lawn. It is an eight-mile obstacle-course, heading through Cumberland Gate, past Bishops Gate, turning at Bear's Rails, up to the Copper Horse, around the park Village and back to Smith's Lawn.

Presentation Cups are given for:

Best sponsored rider over 16.

Best sponsored rider 16 and under.

Best turned out horse and rider over 16 (on each day).

Best turned out horse and rider 16 and under (on each day).

Furthest travelled horse and rider.

In the 1930s and in 1945 to 1951, the northern area of Smith's Lawn near Cumberland Gate was used as the park's Cricket Pitch.

The 1948 Olympic Cycle Road Race was held in the Great Park on Friday 13th August. It was started on Smith's Lawn by Prince Philip, The Duke of Edinburgh at 11.00 in the morning, and the individual winner crossed the finishing-line shortly after 4.18 in the afternoon.

On a glorious summers day, a group of us from Windsor, who were enjoying our school holidays at the time, set off along The Long Walk early in the morning to ensure that we had secured a good vantage point at the Stone Bridge near The Copper Horse. In keeping with the sporting atmosphere of the day, the public was allowed to cycle up The Long Walk - the

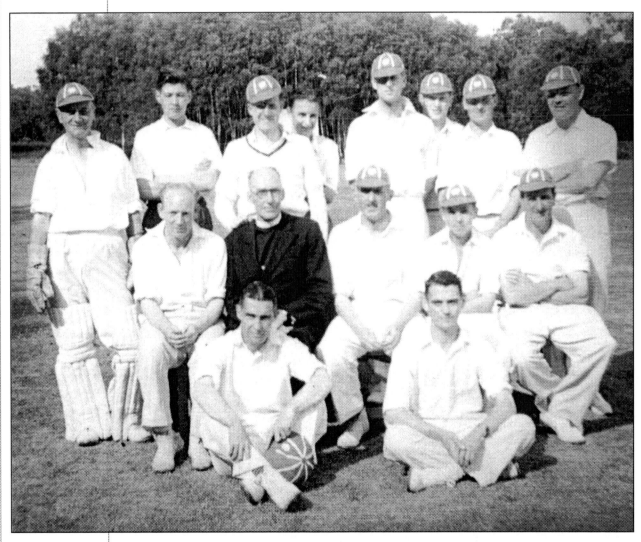

Windsor Great Park Cricket Team on Smith's Lawn in 1949. The persons in the photograph are, from left to right:-
Back Row:
Ernie Wye, Michael Phipps, Arthur Wilkins, Don Siddle, Prince Philip the Duke of Edinburgh, Maurice Cornelius, William Shefford, Reg Elliott.
Middle Row:
Charlie Elliott, Rev. R. Churchill (Park Chaplain), John (Jack) Lewis, Ken Richardson, Reg Ashton.
Front Row:
Sidney Patchet (Headteacher Royal School), Cyril Woods.

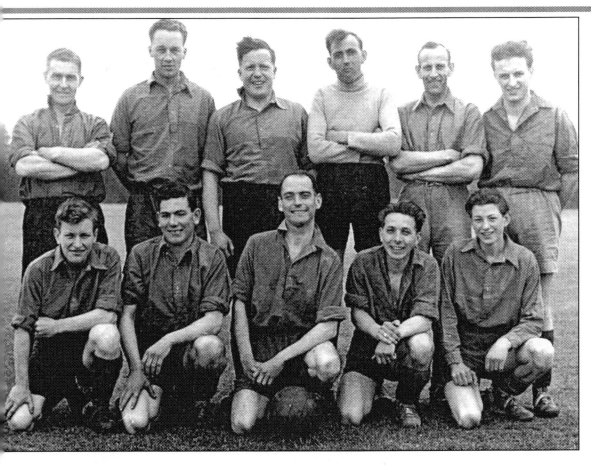

Windsor Great Park Football Team on Smith's Lawn during the 1954 – 1955 season. The persons in the photograph are, from left to right:-
Back Row:
Sydney Patchet, Alun Sunnick, Arthur Wilkins, Eddie Andrews, Phil Greenaway, Donald Siddle.
Front Row:
Ray Castle, Michael Ashton, Cyril Woods, Ken Richardson, Tony Jenkins.
Sydney Patchet was the Headmaster of the Royal School at the time the photograph was taken, and Arthur Wilkins' parents ran the Village Shop. (Phil Greenaway collection).

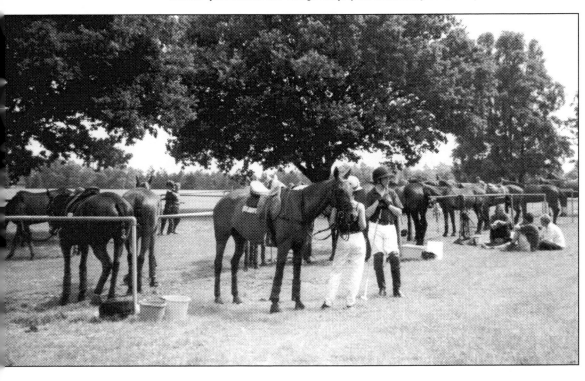

Polo ponies at rest on Smith's Lawn in June 1999. (photo by the Author).

Polo Players in action on Smith's Lawn in June 1999. (photo by the Author).

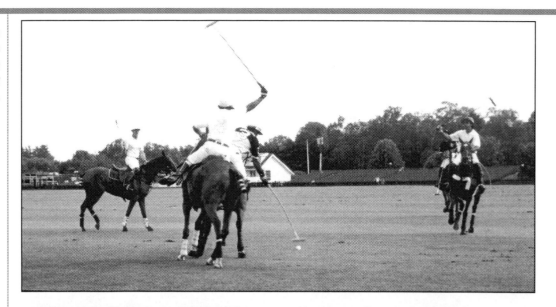

King Hussein of Jordan with his wife, Queen Noor and an adopted daughter taking a break during the 1995 Sponsored Horse Ride organised by the Lions Club of Windsor. The photograph was taken just outside Cumberland Gate. Sadly, King Hussein died four years later from cancer on Friday 5th February 1999 aged 63 years.

only occasion on which we could remember this permission being given. A cycle enclosure was provided on the right hand side of Snow Hill.

The crowd that had gathered in the park that day was full of excitement and anticipation about what was to come when the race started. You must remember that this was a time very much in the austere years that followed the Second World War. Most children did not even have a bicycle, let alone a racing model. Suddenly the race had begun. Never before had we seen such a mass of cyclists, heads down and dressed in so many different colours of their countries, as they came 'hell for leather' around the bend on the road leading to the Stone Bridge. (The bridge had been lined the day before with bales of straw to give the riders a measure of protection against hitting the bridge walls) Virtually all of the riders had at least one spare tyre with built-in tube, wrapped over their shoulders and back. As the race progressed, punctures and accidents were a common occurrence and some of the injuries were so bad that the riders were forced to retire from the race. Most injuries were deep grazes on the legs and arms caused by riders sliding along the road when they came off, mainly when negotiating the sharp bend coming through Blacknest Gate. We were most impressed by the toughness of the riders that day.

The race, which was over a distance of 194.63 kilometres (120.943 miles) and ridden anti-clockwise over the sixteen-lap course, appeared to go on forever.

It must have been a nightmare for the riders having to go up Breakheart Hill that many times - once is enough! In the course of the race the leading positions changed many times, and with one lap to go it was still anyone's race. With the excitement building up, we made our way to the finishing line on Smith's Lawn. The finish was spectacular, with a convincing winner followed by a desperate struggle for second place, and the second and third riders being given the same time. The first three places were as follows:—

First: Jose Bevaert of France, 5 hours 18 minutes 12.6 seconds.

Second: Gerardus Voorting of Holland, 5 hours 18 minutes 16.2 seconds.

Third: Lode Wouters of Belgium, 5 hours 18 minutes 16.2 seconds.

Winning Team: Belgium.

The Obelisk Pond is a crescent-shaped pond situated in a shallow valley between Smith's Lawn and the Savill Garden. It was created, by damming up an existing stream, by soldiers of the Duke of Cumberland's army about 1750. The overall centreline length of the pond is about 704 metres (770 yards and it is about 183 metres (200 yards) wide at the head. A single-width carriageway runs along the head embankment from Rhododendron Ride in the north. About halfway along the northern side of the pond, on the brow of Hurst Hill, stands the majestic stone Obelisk from which the pond gets

G.Rossi of Switzerland wearing number 114 seen desperately changing a punctured tyre at Blacknest Gate during the 1948 Olympic Cycle Road Race. The tyres used were designed without innertubes. The tyres were so lightweight that punctures were a common occurrence during the race. Behind Rossi can be seen the bales of straw placed against the garden fence of the gate lodge to help protect the riders. Blacknest Gate was the sharpest corner in the race to negotiate and collisions and 'pile ups' were a frequent occurrence at this point. (British Olympic Association Photograph Collection)

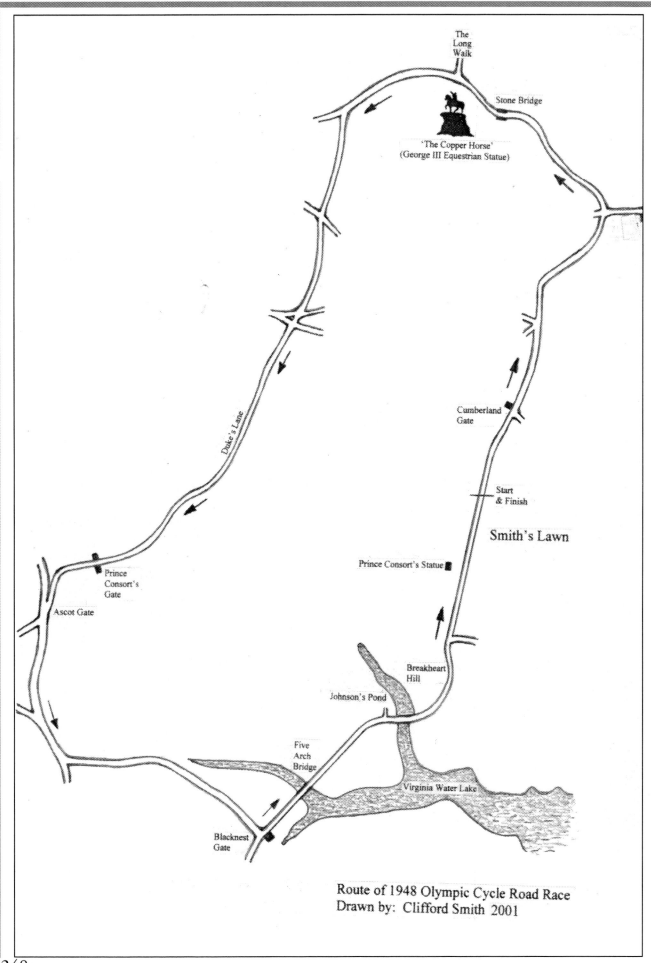

The Long Walk

Stone Bridge

'The Copper Horse'
(George III Equestrian Statue)

Duke's Lane

Cumberland Gate

Start & Finish

Smith's Lawn

Prince Consort's Statue

Prince Consort's Gate

Ascot Gate

Breakheart Hill

Johnson's Pond

Five Arch Bridge

Virginia Water Lake

Blacknest Gate

Route of 1948 Olympic Cycle Road Race
Drawn by: Clifford Smith 2001

its name. The Obelisk was erected about the same time as the pond was created. It was built by the command of King George II in recognition of the services of his son, William Duke of Cumberland. The inscription on the north-eastern side of the pedestal reads:-

This Obelisk
Raised by the command of
King George the Second
Commemorates
The services of his son
William Duke of Cumberland,
The success of his arms
And
The gratitude of his father.
This tablet was inscribed by
His Majesty
King William the Fourth.

The inscription tablet was clearly installed sometime during the reign of King William IV (1830-37). It is understood that the word 'Culloden' was removed from the original wording during Queen Victoria's reign, as she was not exactly enthusiastic about the actions of her great-great uncle the Duke of Cumberland, during that Battle. The decisive battle between the English Army and the Scottish Clans took place on 15th April 1746 on Culloden Moor, just east of Inverness in Scotland. It was due to the extent of the slaughter of the Clansmen, that the Duke was thereafter known as the 'Butcher'.

On the south-eastern and the south-western side, is a coat of arms and the words:-
Honi soit qui mal y pense
On the north-western side there is:-
W.A. Born April 1721
Died October 1765
The W.A. stands for William Augustus, the christian names of the Duke. He was born on 15th April 1721 and died on 31st October 1765

The Obelisk is constructed of square shaped stone blocks, tapering as the column goes up from the pedestal. On top of the column is mounted a sun-like sphere made of a copper alloy, which has a greenish patina formed all over. The height of the stone column is 26.2 metres (86 feet). The overall height, including the sphere is 28 metres (92 feet). From the Obelisk there is a ride that leads in a westerly direction, passing over a stone bridge and then onto Smith's Lawn. The ornate stone bridge of single arch design was built 1833-1834, replacing a bridge of a more simplistic construction. On the inner side of the balustrades are long stone-slab bench seats. These are commonly used to stand on by people to get a better view of The Savill Garden and pond on the north side. On the southern side, the same applies to get a view of the Obelisk Pond. Possibly this was the original purpose of the stone slabs and they were never intended as seats. Turning immediately left over the bridge, a footpath follows the southern bank of the pond until you come to a

The coat of arms on the south-western side of the Obelisk – May 1999 (photo by the Author).

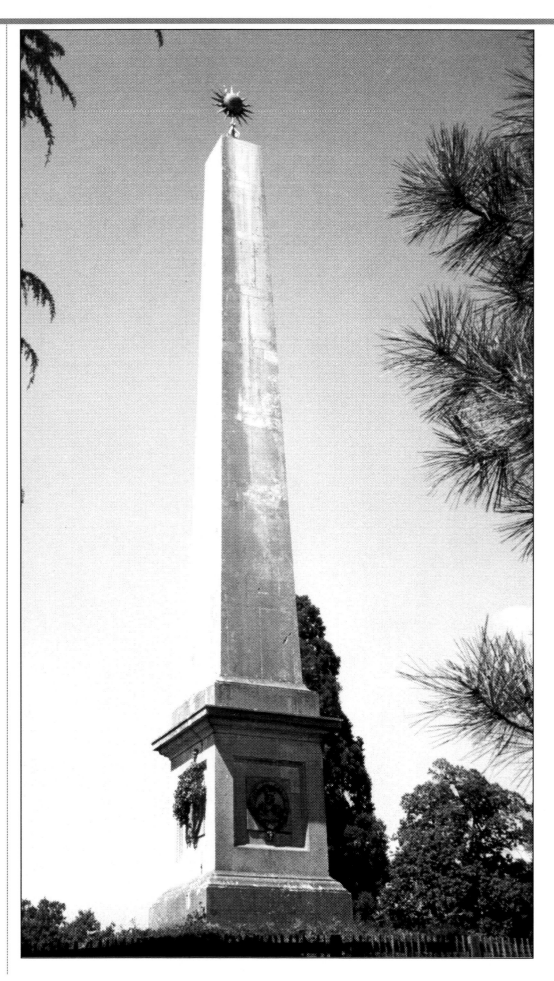

The Obelisk as seen from the east – July 1998 (photo by the Author).

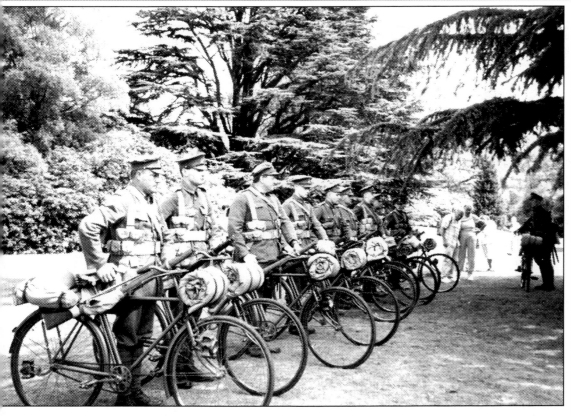

Members of the Association of Military Remembrance with army uniforms, bicycles and equipment exactly as used by a British Cycle Corps during the First World War 1914-1918. The photograph was taken near the Obelisk by the Author on Monday 3rd May 1999.

The Stone Bridge at the extreme northern end of the Obelisk Pond. A glimpse of Savill Garden can be seen under the arch. (photo taken in August 1999 by the Author).

251

The Obelisk Pond
as seen from the
head of the pond.
(photo taken in
July 1998 by the
Author).

disused sandpit. This is almost directly opposite the Obelisk on the other bank. The footpath then continues until it meets up with the carriageway at the head of the pond.

The Obelisk Pond creates mixed thoughts and memories for the author, particularly knowing that many of the older trees in this area of the park were planted and cared for by the family in the 1800s, firstly, by the author's great-great grandfather, Joseph Smith starting in 1820, followed by his son William Smith and, finally by another son Charles Spencer Smith. In addition to other duties, they were responsible for the planting and care of the trees and shrubs of the whole of the south-eastern area of the park, including the Clockcase and Fort Belvedere plantations. Charles Spencer Smith's responsibilities were increased to cover the control of the water levels of the Obelisk Pond and Virginia Water Lake. In addition, he was responsible for policing the area, reporting directly to Prince Christian. Having spent forty years in this position, working in all weathers, it is not surprising that he finally succumbed to pneumonia on 3rd March 1899 aged 75 years.

Many happy days have been spent by the family and friends fishing and swimming at the pond. From 1850 to 1950 the Obelisk Pond was extremely popular with bathers, reaching a peak when Smith's Lawn was used extensively as a military camp by the Canadian Forestry Corps during the First World War. The ladies' bathing area was on the northern bank just down from the Obelisk column. Several bathing huts were positioned under the trees, and a broad wooden platform ran parallel to the bank on stilts. The men used the sandpit opposite, making do with the bushes as 'changing rooms'. These are some of the author's happiest memories of the park. Having

walked from Windsor, we had a 'dip', then tucked into our sandwiches, washed down with cold tea (lemonade on a good day). We then trudged all the way back home. On a hot day, the pond would look very inviting, particularly with its sandy bottom and the calmness of the water. Sadly, the temptation was too much for some of the weaker swimmers, and several people have lost their lives in the pond. One young man drowned whilst swimming at seven o'clock in the morning in 1917, such was the lure of the pond. Swimming here has been prohibited since 1950.

On a much lighter note, fishing has always been a very popular pastime at the pond and has attracted anglers from a large area. There is an excellent variety of fish to be had, including pike, perch, tench, carp, roach and rudd. At one time there were some magnificent golden tench to be seen. Alas, these are no longer around. Up until the 1940s, you were able to fish in certain ponds in the park without a permit. As the demand grew, permits were issued (free of charge). Today, a charge is applied.

The Savill Garden is an extremely beautiful place, situated to the north of the Obelisk Pond at the far eastern boundary of the park. It is fully enclosed with a boundary fence surrounding an area of about 14 hectares (35 acres). The garden as we know it today, was developed by Sir Eric Savill, Deputy Ranger of the Park, from an existing tree and shrub nursery of about 2 hectares (5 acres), on the western slope near the Upper Pond. The original nursery was created in 1826 and known as the Chapel Wood Nursery. Later it became more generally known as Parkside Nursery. At the same time, the first pond was created by damming the stream further up from the existing Upper Pond. The large willow tree, which can be seen today at the extreme northern end of the garden,

stood on the bank of the now filled-in pond. The author's great-great grandfather, Joseph Smith, was involved in the creation of the nursery and, right up to 1899, several members of the family worked this and the nursery at Nursery Cottage (Verderers) south of Cheeseman's Gate. Many of the established trees that exist in the south-eastern area of the park were propagated at these nurseries.

It was not until Eric Savill took up his appointment in 1931 as Deputy Surveyor that the expansion of the nursery came about. He saw this area, which had a plentiful supply of natural water from the South Brook Stream and soil ideal for a variety of shrubs, as the perfect place to create the first garden in the park. With the full approval of the King, George V and Queen Mary, he set about the work early in 1932, making full use of the existing trees and environment. During the first visit by the King and Queen in 1934, they expressed their delight at what they saw. In those early days it was obvious that it had the makings of a beautiful garden. Initially, it was known as 'Bog Garden', because for most of the year you could feel the water squelching under your feet whenever you walked near the stream and ponds. During this period, the garden was known with affection by the author's family as 'The Garden of Giants' because we were staggered at the size of the *Gunnera* (Prickly Rhubarb) and the height of the *Heracleum Mantegazzianum* (Cow Parsnip) that were grown there. In July 1951, the area was given the name 'The Savill Garden', upon the express wishes of King George VI, in recognition of the man who had created it.

Up until the late 1950s, the entrance for the public was by way of huge wooden steps which were placed each side of the fence. These were situated at the southern and northern boundary fences of the garden. In 1953, a charge of two shillings was introduced for visitors. This was immediately lowered to one shilling following an outcry from the public. It even resulted in a 'slanging match' between the Egham Urban Council and the Windsor Borough Council as they begged to differ over the charge. Currently, visitors pay £5.00 and hardly bat an eyelid.

Over the years many improvements and features have been added to the garden. In 1974, a small area next to the entrance was provided to sell plants directly to the public for the first time. The popularity of this new venture evolved to the current well-established shop facilities, selling plants, books and various goods. On Friday 20th October 1978, Queen Elizabeth II formally opened the Jubilee Bridge and Garden, which had been built to commemorate the queen's Silver Jubilee held the year before. In 1993, The Chelsea Bridge was erected over the stream near the Temperate House. It was part of the Gold Medal-winning exhibit at the Chelsea Flower Show that year. During 1995, the Temperate House

(glasshouse), which had been built in 1964, was replaced with a much improved house. It was formally opened by Queen Elizabeth II on Tuesday 25th April 1995 at 3.0 in the afternoon. The Queen, accompanied The Duke of Edinburgh, was greeted by Lord Mansfield and Mr Marcus O'Lone, Deputy Ranger. It was stated that the house was to be named The Queen Elizabeth Temperate House in honour of Queen Elizabeth The Queen Mother, who was very fond of the old Temperate House and its contents.

On 16th October 1987, a violent storm swept across the country. It took a serious toll on the garden. In particular, most of the magnificent beech trees on the hill at the south-eastern corner were blown down. It was sickening to observe first-hand the devastation the next day.

The garden is now a world apart from what it was in the 1930s. It has a large shop and a licensed restaurant at the entrance area, which is situated on the eastern side of the garden. A whole range of plants, books and interesting articles can be purchased from these facilities. A large car and coach park is at the front of the entrance towards Wick Lane to accommodate the visitors who come from far and wide to see the garden. The average number of visitors during the past thirty years is 68,000 each year.

The Keepers of the Gardens since 1932, with some overlaps of office and with several titles, are:-

Sir Eric Humphrey Savill K.C.V.O., C.B.E., M.C.

Mr Savill, as he was then known, took up the appointment of Deputy Surveyor of the Crown Lands at Windsor on 1st January 1931, having spent the previous seven years as a partner in his family's firm, Alfred Savill & Sons Chartered Surveyors, in London. At the time, he was a Fellow of the Chartered Surveyor's Institution, and his father, Sir Edwin Savill was a past president of the Institution. Eric Savill was born in Chelsea, London, on Sunday 20th October 1895 and was educated at Malvern, and Cambridge University. He went on to serve in the Devonshire Regiment during the First World War and was injured during the heavy fighting at the Somme in northern France, where he was awarded the Military Cross. In 1937 he became the Deputy Ranger of the Windsor Estate when the roles of Deputy Surveyor and Deputy Ranger were merged into one. His role as Deputy Ranger ceased in 1958 when he was appointed Director of Forestry and Gardens. He relinquished the Forestry directorship in 1962, becoming Director of Gardens, a post which he held until he retired in 1970. Sir Eric Savill was an extremely active man being involved in several other functions in later years. He was a council member of the Royal Horticultural Society of England, Chairman of the Ministry of Transport Landscape Committee, a Governor of Great Ormond Street Children's Hospital in London and a member of the Management Committee of King

Edward VII Hospital, Windsor. He died at Windsor on Tuesday 15th April 1980 aged 84 years.

Mr Thomas Hope Findlay L.V.O., V.M.H.

Superintendent of the Park early in 1943, his title changed to Keeper of the Gardens in 1958. He played a major role in the development of The Savill Garden and the creation of The Valley Gardens. He retired in April 1975. His full history is given in Chapter 14 under the heading 'The Valley Gardens'.

Mr. John Bond L.V.O., V.M.H.

Mr Bond started on the estate as Assistant Keeper of the Gardens in 1963 and he was appointed Keeper of the Gardens in 1975 following the retirement of Mr Findlay. His father and grandfather were both head gardeners, and it came as no surprise when he started his career in a nursery at Cirencester. His extensive experience in the horticultural world was gained when he worked at Lord Aberconway's Garden at Bodnant, Leonardslee in West Sussex and at Hilliers nurseries. He retired in 1997 after 34 years on the estate.

Mr. Mark Flanagan.

Mr Flanagan took up his career as a professional horticulturist on leaving school, undertaking a four-year apprenticeship before completing the Diploma in Horticulture at the Royal Botanic Garden, Edinburgh. For over ten years he worked at the world-famous Royal Botanic Gardens, Kew. He was appointed Keeper of the Gardens in 1997 following the retirement of Mr. Bond.

There are several houses close to The Savill Garden that are steeped in history and have played a major part in the development and maintenance of the park in the past. The most important one is named 'Parkside'. It is a substantial house standing just outside the park boundary. From 1849 to 1931 it was the home and office of four successive Deputy Surveyors of the park and forest.

The first, and the most memorable, Deputy was William Menzies. William was born in 1828 at Kilcardine-on-Forth, Perthshire, Scotland. During 1842-1849 he studied the Art of Forestry at the University of Edinburgh. In the autumn of 1849, at the very young age of 21 years, he was appointed

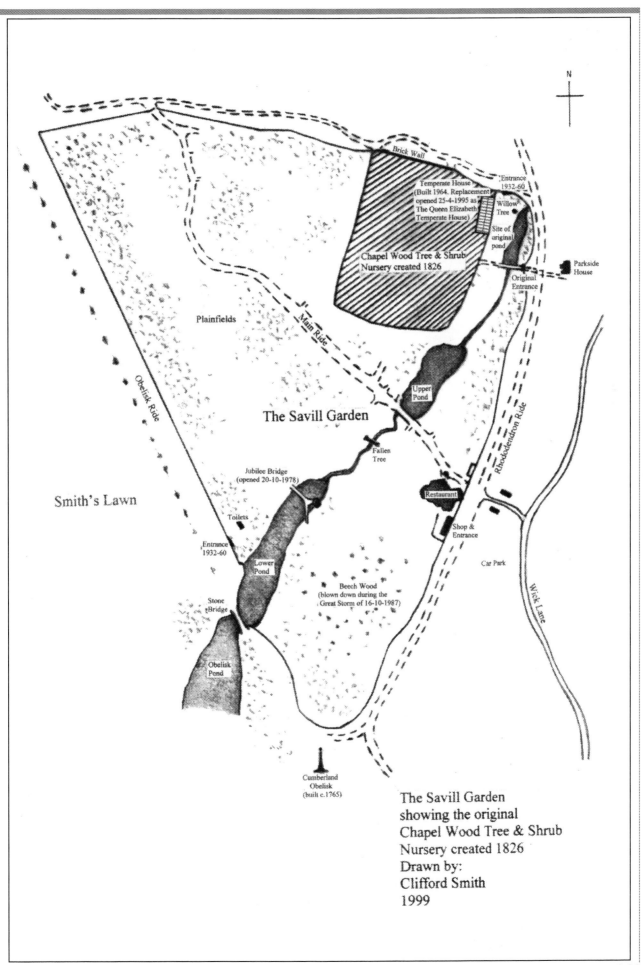

N

Brick Wall

Entrance 1932-60

Temperate House
(Built 1964. Replacement opened 25-4-1995 as The Queen Elizabeth Temperate House)

Willow Tree

Site of original pond

Chapel Wood Tree & Shrub Nursery created 1826

Original Entrance

Parkside House

Plainfields

Main Ride

Obelisk Ride

The Savill Garden

Upper Pond

Rhododendron Ride

Fallen Tree

Jubilee Bridge (opened 20-10-1978)

Smith's Lawn

Restaurant

Toilets

Shop & Entrance

Entrance 1932-60

Lower Pond

Car Park

Wick Lane

Stone Bridge

Beech Wood (blown down during the Great Storm of 16-10-1987)

Obelisk Pond

Cumberland Obelisk (built c.1765)

The Savill Garden showing the original Chapel Wood Tree & Shrub Nursery created 1826
Drawn by:
Clifford Smith
1999

The outside area behind the Gift and Plant Shop at Savill Garden. (photo taken in July 1999 by the Author).

Looking from the entrance of The Savill Garden on a glorious autumn day in November 2001. (Photo by the Author).

A plaque presented by the Friends of the Savill Gardens to commemorate the Millennium in 2001. (Photo by the Author).

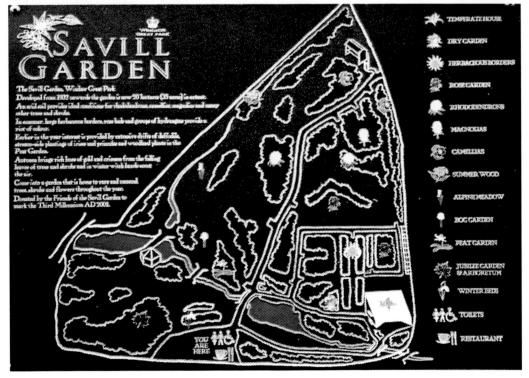

The Upper Pond in Savill Garden in the winter as photographed by the author in 1955. It is hard to believe that the next photo is of the same scene forty-four years later. The season in which it was taken does, of course, make a dramatic difference.

The Upper Pond in Savill Garden as seen in May 1999. (Photo by the Author).

257

The group of Podocarpus Salignus trees that stand in the centre of the position of the original Chapel Wood Tree and Shrub Nursery. This very attractive evergreen tree is a native of Chile and it was first introduced into this country in the late 1840s. The closeness of the base of the trees suggests that they grew there from a tray of discarded or forgotten seedlings. The trees are extremely slow growing and the seedlings may well have started in the mid 1800s. (photo taken in May 2000 by the Author).

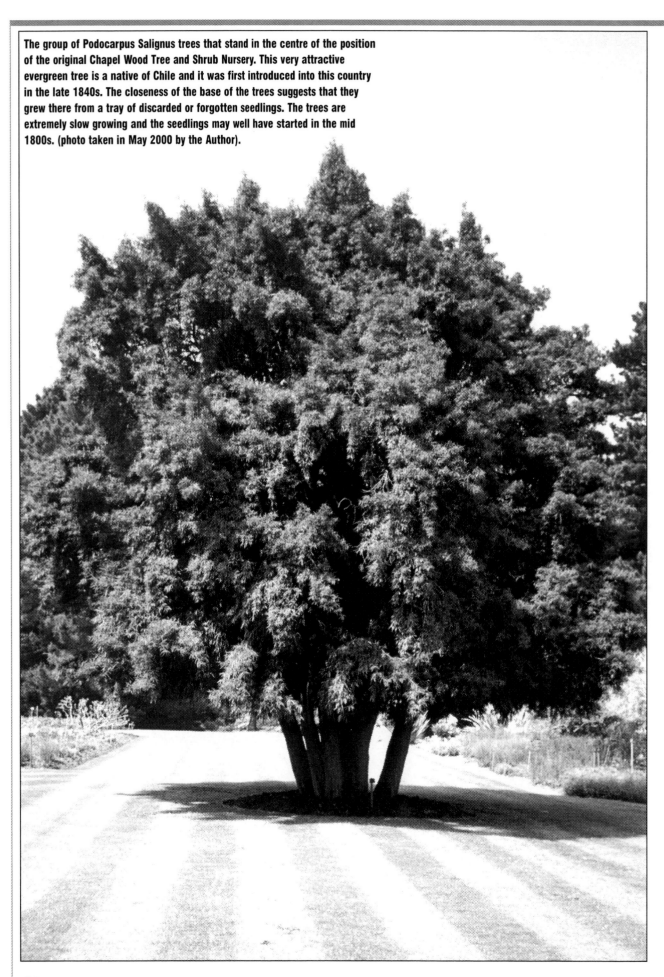

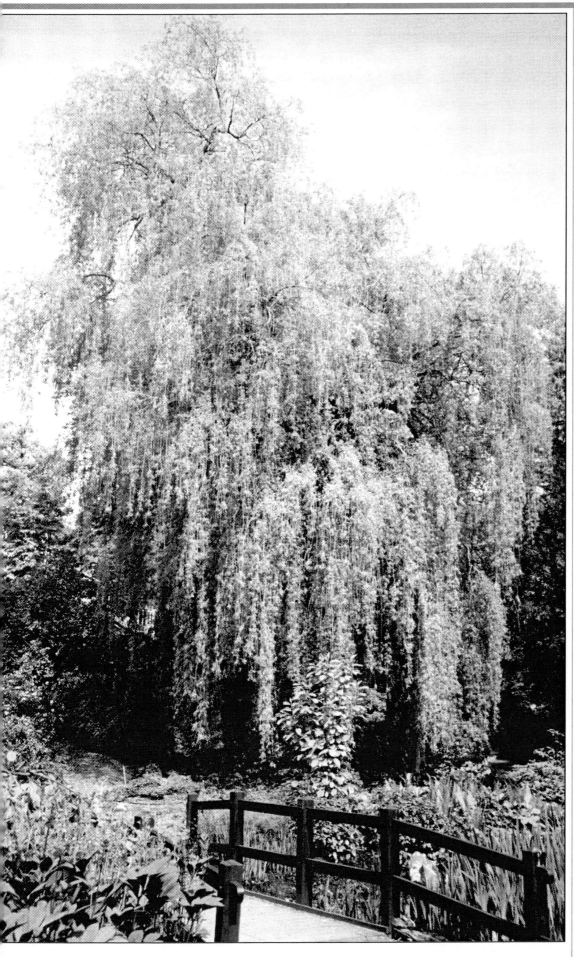

The willow tree whose branches once hung over the water of the original Upper Pond that was situated at the north-eastern corner of the Savill Garden. The wooden bridge in the foreground is part of the Windsor Great Park Gardens Department gold medal exhibit at the Chelsea Flower Show 1993. A glimpse of The Queen Elizabeth Temperate House can be seen in the background. (photo taken in May 2000 by the Author).

The Queen Elizabeth Temperate House situated at the north-eastern corner of Savill Garden. It was opened on 25th April 1995 by Queen Elizabeth II and named in honour of Queen Elizabeth The Queen Mother. (photo taken in May 2000 by the Author).

A beautiful border of primulas (polyanthus) situated behind the Queen Elizabeth Temperate House in Savill Garden. (photo taken in May 2000 by the Author).

Deputy Surveyor of Windsor Forest and Parks. He immediately took up office at Parkside, having brought with him his clerk, David Wishart, who was his cousin and then aged 15 years. He achieved much during his term in office, notably writing and having published two books. The first one, 'Windsor Forest and Parks', published in 1864, dealt almost entirely with the trees, using photographic prints to illustrate them. By any standards the book was an enormous width and height. Thank goodness it was not very thick. The second book was entitled 'Forest Trees and Woodland Scenery'. In 1866 he became the Commanding Officer of the Windsor Great Park Rifle Volunteer Corps. During camping time he would often entertain everyone using his excellent ability as a violinist and highland dancer. In 1856 he married Margaret Emmeline Simmonds, and they subsequently had two sons, William and Victor. Margaret was an elder sister of Frederick Simmonds, who was eventually taught the art of forestry by William.

A major problem to public health at the time derived from the prevailing methods of sewerage disposal. William spent much of his time studying and implementing methods of disposal. Whether or not as the result of this work, he fell very ill with typhoid fever in 1873. This left him a very weak man until he died at Parkside on Friday 3rd May 1878 aged 50 years. During the last few years of his life, his brother-in-law, Frederick Simmonds was appointed Deputy Surveyor to assist him with his duties. William Menzies was a very popular and respected person, being visited on many occasions during his illness by Queen Victoria and other members of the Royal Family. The scale of his funeral on Wednesday morning 8th May 1878, spoke volumes. The cortege was nearly half a mile long as it made its way from Parkside to St Jude's Church, Englefield Green. The author's great grandfather, George Smith and great-great uncle, Charles Spencer Smith were in the group of Rifle Volunteers that walked before the hearse.

Frederick Simmonds, as already mentioned, was made a Deputy Surveyor well before William Menzies died. This was a unique situation in that there were two persons with this title at the same time. Frederick Simmonds also became the Commanding Officer of the Windsor Great Park Rifle Volunteers, and he proved himself to be quite a good shot in the rifle shooting competitions. He was also a very keen cricketer, and an excellent batsman and bowler, during his forty years playing with the Windsor Great Park Cricket Club. During that time he was, at one time or another, the Club's Captain, Secretary and Treasurer.

Mr. Simmonds, who never married, was an extremely active person. In 1878, when his brother-in-law William Menzies died, he set up the Windsor Great Park Sick Fund, which remained in existence for twenty-six years. From 1878 to 1901, he was the Honorary Secretary of The Prince Consort's Association in Windsor. The

Association was disbanded soon after the death of Queen Victoria, which occurred on 22nd January 1901. Frederick was a steadfast and reliable Deputy Surveyor and, judging by the comments he made in letters concerning members of the author's family, he was a kindly person. During his retirement party at Cumberland Lodge in December 1905, Prince Christian presented him with the Fourth Class of the Victorian Order. He was also given a cheque for £500 from the residents on the estate, a rose bowl by the Cricket Club and a silver matchbox from the wives of the estate employees. Upon his retirement, he went to live at 97 Abingdon Road, Kensington, London, where he died on Thursday 14th July 1921, aged 75 years. He was buried in the nearby family vault at Kensal Green Cemetery, London. A photograph of him is shown in Chapter 11.

The last two Deputy Surveyors who resided at Parkside were Reginald Halsey and Arthur Forrest, neither of whom appears to have left the kind of lasting impression their predecessors achieved. The fact that the planting of the broad leaf plantations had virtually come to an end during their time in office doesn't seem to have helped bring them recognition. At the end of Arthur Forrest's term in office in 1924, the house ceased to be used as the residence and office of the Deputy Surveyor. In 1956, Parkside suddenly attracted the attention of the world's media when the famous American actress, Marylin Monroe, and her husband, playwright Arthur Miller, spent their honeymoon there during the first week in July.

Near the entrance to the The Savill Garden stand four relatively modern houses, built in 1963 and known as Nos. 1,2,3 & 4 Savill Garden Cottages. At the southern side of the large car park and facing Wick Lane stands a detached house known as Parkside Nursery Cottage. It was built in 1843, and the author's great-great uncle Charles Spencer Smith (District Woodman) lived there with his family from 1847 to 1855. Three of their children, Maria, Ann and Frederick, were born there. Further south along Wick Lane is a gate into the park. The drive through the gate is the route of a very old track that travelled across what is now Virginia Water Lake before the lake was created. A short distance along on the eastern side of the track stands a detached house which is simply known as No.10 Wick Lane. Charles Spencer Smith and his family moved in as soon as it was built in 1855 and a their son, Francis was born there in February 1858. On the other side of the track is the site of No.11 Wick Lane, which was formerly an inn. It was demolished in the early 1970s and later became the site of the Guides' Wickwood Campsite as described further on.

On the western side of The Savill Garden, near Cumberland Gate stands a substantial house named 'Garden House'. Built in 1958-1959, its first resident was Sir Eric Savill, who went to live there upon his retirement as Deputy Ranger.

The Guides' Wickwood Campsite is situated on the

Parkside House stands just outside the park boundary fence on the eastern side of Rhododendron Ride near The Savill Garden. From 1849 to 1924 it was the residence and office of the deputy Surveyor, sometimes known as Crown Receiver of the park. The house attracted the attention of the world media when the world famous American actress Marilyn Monroe and playwright Arthur Miller spent their honeymoon there after marrying on 29 June 1956 in London,. (photo taken April 1997 by the Author).

Parkside Nursery Cottage where the author's great great uncle Charles Spencer Smith (Woodman) lived with his family from 1847-1855. (photo taken August 1997 by the Author).

opposite side of No.10 Wick Lane. The Campsite is on the site of No.11 Wick Lane which was, at one time, an inn. The house was demolished about 1970 and the last people to live there were the Butler family. The campsite was opened by Princess Margaret on a gloomy and windy day on Saturday 21st March 1981. The cost to build the campsite was £7,000. The money had been raised over two years by the Windsor and Old Windsor district's Guides Association and donations by the Windsor Lions and Windsor Rotary clubs. Half of the £7,000 came from the borough lottery funds.

Note: No.10 Wick Lane was built in 1855 and the author's great great uncle Charles Spencer Smith, who was the Woodman for the area, was the first person to live there with his family.

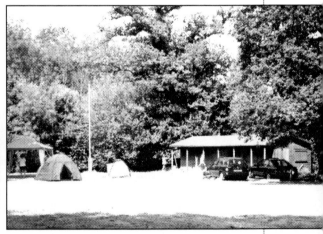

The Guides Wickwood Campsite when the 1st Kintbury Guides were camped there on Saturday 24th July 1999. (photo by the Author).

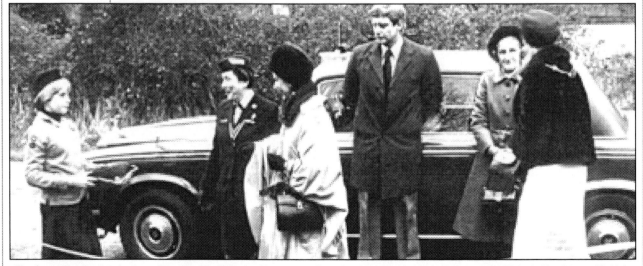

The Campsite about to be formally opened by Princess Margaret on Saturday 21st March 1981. (Left to right) Melanie Hutchinson (Guide), Mrs Jessica Blooman (Berkshire County Guides Commissioner), Princess Margaret (President of the Girl Guides Association), Chauffeur and Guard, Lady in Waiting, Miss Brigide Hellbronner (Deputy Mayor of Windsor and Maidenhead). Eleven year old Melanie Hutchinson, a member of the Third Old Windsor Guides, presented the scissors to Princess Margaret for cutting the entrance ribbon. She was chosen because she had thought of the name 'Wickwood' - very appropriate being so near Wick Lane and next to Egham Wick.

Virginia Water
and The Valley Gardens

14

Virginia Water
and The Valley Gardens

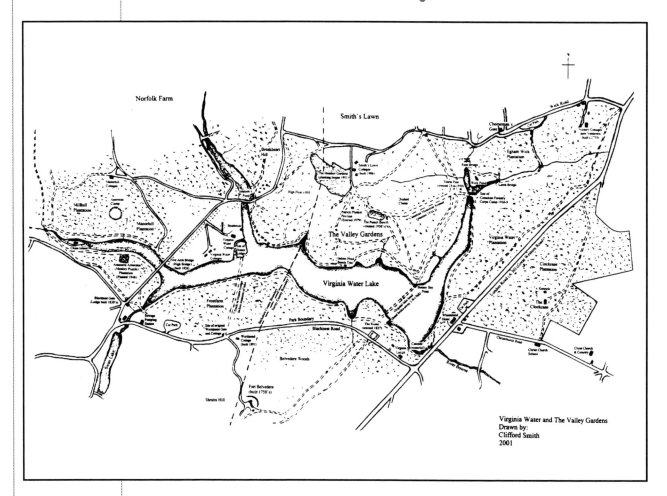

Virginia Water and The Valley Gardens
Drawn by:
Clifford Smith
2001

Virginia Water Lake and its surrounding area are situated at the south-eastern end of the park. The beauty of the lake, the trees and The Valley Gardens on the northern bank attracts tens of thousands of visitors every year. Additional interesting features are the Cascade, 'The Ruins' and the Totem Pole. The Clockcase Plantation and Belvedere Woods, both of which are prohibited to the public, are situated on the southern side of the London Road

and Blacknest Road respectively. Although they are outside the park boundary, they are still part of the Windsor Crown Estate.

The lake is the largest expanse of water on the estate and also has the most interesting history. It can be difficult to imagine that it was created by damming up an existing stream, the Virginia Brook. It is not generally recognised that there were three stages to its formation, first as a relatively small pond to the west of the existing Five Arch Bridge, secondly as a much larger extension as far as The Ruins and thirdly (and lastly), extending to cover the whole area as we see it today. The first pond was known to exist in the 1600s, and was probably created well before that. It was slightly crescent-shaped, starting near the existing China Island at the extreme western end and finishing

with the head situated where the Five Arch Bridge crosses the lake. During the period 1750-1753, the pond was extended and transformed into a lake, with the new head built along the line of an old thoroughfare. This old roadway passed through where The Ruins now stand on the southern side of the lake and continued to Botany Bay Point on the northern bank. The labour used for the construction were the now 'idle' soldiers of Prince William first Duke of Cumberland following the Battle of Culloden. Whose idea it was to create this large lake is not certain. The Duke, who was also the Ranger of the Park evidently gave his full support to the undertaking, as did Thomas Sandby (Deputy Ranger). However, it is most likely that the idea was that of Paul Sandby (brother of Thomas), who had a creative flair and was an excellent landscape painter. During 1753, a wooden high-arched bridge known as the Great Bridge, or High Bridge, was constructed where the stone Five Arch Bridge now stands, in order to provide a more direct southern route from Cumberland Lodge. Later in the same year, several fairly large boats were brought to the lake, the largest of which was a highly decorative Mandarin Yacht (also known as a Chinese Junk). The hull had been brought up the River Thames to the Bells of Ouseley Inn at Old Windsor and was hauled from there to the lake, where it was completed before being put to use. This was an early instance of the Chinese influence which marked Georgian tastes. Shortly after the arrival of this vessel, an appropriately Chinese style summer house was erected on the island at the far western end of the lake. The island itself soon became known as China Island.

On the night of 1st September 1768 a disastrous event occurred. Heavy rain swelled the lake to such an extent that the head embankment broke away on the northern side of the penstock (sluice). Bearing in mind that the embankment had been built using the local materials, gravel, sand and clay, it was inevitable that, sooner or later, such an event would take place. The water from the lake affected an enormous area and several people lost their lives. Livestock was also killed and a house was completely washed away. Aside from the loss of life, damage was estimated to be £9,000. A major rethink ensued and it was agreed that the pond head would have to be rebuilt on a more substantial basis. What was rather surprising was that it was decided to enlarge the lake even further when this was done, a brave undertaking in the circumstances. It should be pointed out that most of the plans and the overseeing of the work were carried out by Thomas Sandby (Deputy Ranger), who, by this time, was getting on in years. It was his brother, Paul Sandby who was responsible for much of the landscaping that followed.

Using large stones, gravel and clay, a wider and higher embankment was built on the eastern side of Southbrook Stream (also known as Sow Brooks or Wick Stream) from Wick Pond in the north-east to where the Cascade stands in the south. The construction of the embankmemt, including the Cascade and the bridge at Wick Pond was finally completed in 1790. This third and last stage of the creation of the Virginia Water Lake gave us the expanse of water as we see it today. Its size and capacity are as follows:-

Centreline length from beyond China Island to Wick Pond bridge:- 3.4 kilometres (2 miles 200 yards).
Widest point of lake:- 384 metres (420 yards).
Area of water:- 52.6 hectares (130 acres).
Volume of water:- 764.86 million litres (168.25 million gallons).
Length of ride round the lake:- 6.447 kilometres (5 and a quarter miles).

The most popular public entrance for those wishing to see the lake and surrounding area is at the side of the Wheatsheaf Hotel, which stands on the north-western side of London Road (A 30) just north-east of the Cascade. A large car park with toilets was established there in the 1960s. Over the years, the attraction of the Cascade (waterfall), particularly at times of high water, has caused many travellers using the road between Bagshot and Staines to pause there. Walking round the lake in a clockwise direction from the Wheatsheaf Hotel there are many interesting features and beautiful scenes to absorb. From the Wheatsheaf the ride dips down through an open wooded area which has a dominance of sweet chestnut and beech trees. At the bottom of the dip there is a stone bridge, with the picturesque River Bourne passing underneath as it makes its way to the River Thames at Chertsey. The bridge, which stands just below the cascade, was built in rustic style in the late 1780s with boulders from Bagshot Heath. Complementing the bridge is the Cascade itself, which was built at the same time using similar materials. The stones are positioned to give the best possible effect as the water falls 9.14 metres (30 feet) to the river below. No longer visible is the large Grotto (cave) that had been incorporated when the Cascade was built. Constructed with large boulders on the south-western side of the Cascade, it became more commonly known as The Robbers' Cave. Because it was wet and 'spooky', it was a favourite place for children to visit. During the 1950s it was blocked up because the floor had become unsafe. Needless to say, the Cascade is at its best after a period of heavy rain. However, the Cascade acts as a natural water level control. Mainly because of the flooding problems in the past, a large water pipe and penstock (sluice) was installed about 100 metres north-east from the Cascade when the embankment was built.

At the top of the Cascade there is a wide, shallow waterway which channels the water from the lake to the Cascade. It is at the start of this waterway that the unrestricted view of the lake is seen for the first time.

Immediately you enter the clearing, the Virginia Lodge is seen standing in a commanding position at the top of a slope to the south-west. Formerly known as Virginia Water Lodge, it was built in 1785 as a residence for the Head Gamekeeper of the park. The lodge has a stark appearance, with battlements on the roof and large chimney-stacks at each end of the building. The first Head Gamekeeper to live there was Mr Allport, whose position at the time also included that of Head Park Keeper. The last Head Gamekeeper to live there was James Turner who retired early in 1861, aged 69 years. At that time, he was living there with his wife Sarah and two daughters, Eliza and Elizabeth. From that time on, the Head Gamekeepers lived at Sandpit Gate Lodge. During February 1897, whilst Virginia lodge was occupied by Mr T. Wells, the park locksmith, an interesting discovery was made during the course of some alterations. Behind a frieze of one of the mantelpieces, seven printed cards were found having dates going back to 1791. The cards were elaborately printed and the oldest of them, which was dated 15th September 1791, was addressed to Mr. Allport, and carried the following message:-

"Mr. Webb, Mayor elect of Windsor, presents his compliments to Mr. Allport, and requests the favour of his company to dinner at the Town Hall, on Monday, the third day of October next at three o'clock. Windsor, 15 September 1791."

Two of the cards were finely-engraved with gaming scenes. Under a coat-of-arms, the following was printed on one of the cards:-

"A. Fisher, Gun and Pistol Maker, Furbisher to St. James and Hampton Court Palaces. No. 132 Long Acre, London. Makes, cleans and repairs all kinds of firearms in the neatest manner and on the most reasonable terms. Powder, Shot and Flints."

The cards were handed over to Mr Frederick Simmonds (Deputy Surveyor) for safe keeping. It is quite an extraordinary circumstance that the cards should have slipped behind the frieze after being placed there by Mr Allport a hundred years previously.

Adjacent to the lodge, the area to the north-eastern side was originally used for dog kennels. It was then converted into a pheasantry, and back again into kennels during the 1840s for Prince Albert's dogs. Two semi-detached houses now stand on the site.

Continuing along the ride, you come to a large open area. On the water's edge there is a very interesting stone landing-stage, which was once in regular use by boats, particularly during the 1800s. The strange figures built into the stage have lions heads and human faces. On the opposite bank of the

lake there is an open area, at the point where the lake turns towards Wick Pond. This is known as Botany Bay Point. From this clearing at the point to just west of the landing-stage is the line of the lake head which broke away on 1st September 1768.

The landing-stage was built in 1829, immediately following the construction of The Ruins, which stand at the south-western end of the clearing. The Ruins were often called the 'Temple of the Gods' and sometimes 'The Temple of Augustus' during the early years. Much has been written and said about them, some of which has been proven to be inaccurate and further distorted with the passage of time. What is known for certain is that all of the parts came from an old Roman temple and some nearby tombs from Lepcis Magna, situated on the coast a short distance to the east of Tripoli in Libya, a country in North Africa which was once part of the Roman Empire. The following is a historical sequence of events covering the ruins from 1816 to 2000:-

1816: Colonel Hanmer Warrington, the English Consul-General at Tripoli, persuaded the Bashaw (Governor) at Tripoli to let the Prince Regent (later King George IV) 'help himself' to the ruins of the temple. This, quite naturally, incensed the local people who vented their anger by breaking up as much of the ruins as they could.

1817: During October and November, H.M. Storeship Weymouth was loaded at the waterside at Lebida with 22 granite columns, 15 marble columns, 10 capitals, 25 pedestals, 7 loose slabs, 10 pieces of cornice, 5 inscribed slabs and various fragments of figure sculpture, some of which made of grey limestone.

1818: By March, all of the items were unloaded and transported to the courtyard of the British Museum in London. It was suggested that they could be put to good use for an extension planned for the museum. This did not materialize, and they were left untouched for eight years.

1826: Early in the year, it was agreed that King George IV's architect, Jeffry Wyatt (later Sir Jeffry Wyatville), was to take charge of the design of an artificial temple at Virginia Water. Jeffry Wyatt was already occupied in the massive work taking place at Windsor Castle, and the new Five Arch Bridge crossing Virginia Water Lake was halfway through construction. The Duke of Wellington (Master General of the Ordnance) was given instructions to have the parts transported to Virginia Water. Captain Charles Dansey of the Royal Artillery was placed in charge of the operation. On Monday 28th August 1826, at 5 o'clock in the morning, forty soldiers left Woolwich Barracks with large carriages (normally used for guns) to carry out the heavy transportation work. The route taken was along Tottenham Court Road and Oxford Street, through Hyde Park, along the Great West Road and through Hounslow and

The Wheatsheaf Hotel standing next to a popular entrance at the south-east end of Virginia Water Lake in July 2000. (photo by the Author).

Virginia Lodge which overlooks Virginia Water Lake from the south near the Cascade in August 1998. (photo by the Author).

The Cascade (waterfall) situated about 366 metres (400 yards) west of the Wheatsheaf Hotel. The photograph which was taken about 1900, clearly shows the entrance to the Grotto (cave) in the boulders on the left. The entrance was blocked up during the 1950s when it became unsafe.

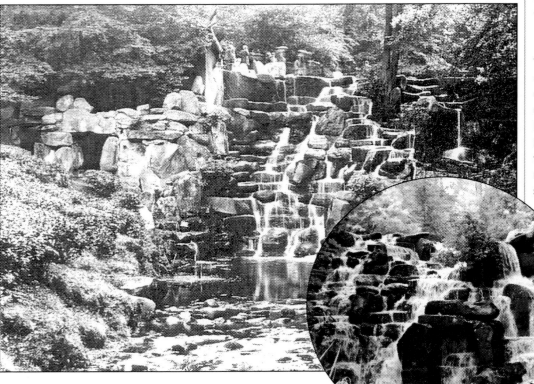

The Cascade in October 2001. Other than the Grotto on the left hand side being blocked up during the 1950s, it has remained the same since it was constructed in the 1780s. (photo by the Author).

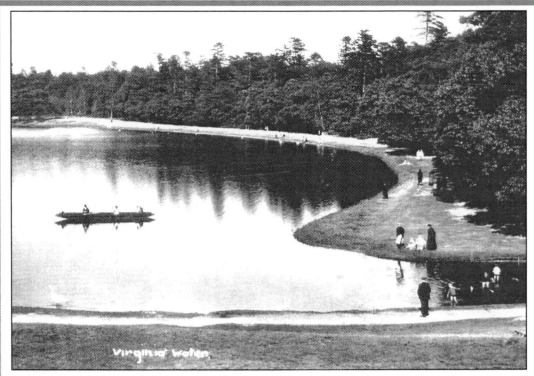

Virginia Water Lake as seen from the hill in front of Virginia Lodge c,1925. Boating on the lake was permitted at the time. (Author's Collection).

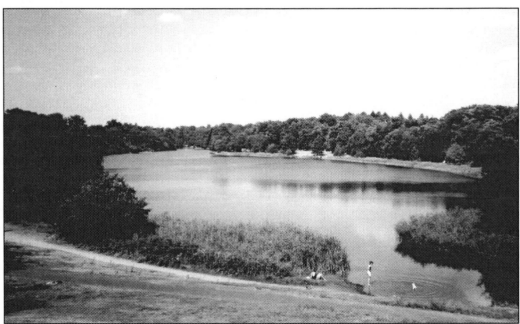

Virginia Water Lake as seen from the hill in front of Virginia Lodge in August 1999. Boating and bathing is no longer allowed. (photo by the Author).

Egham to Virginia Water. Egham Hill was the most strenuous part of the journey, with one column alone weighing eight imperial tons. Eight horses were required for each carriage. The first delivery arrived at the site the next day, Tuesday 29th August, and the last of the twelve deliveries was completed on Thursday 12th October that same year.

1827: Construction of the artificial temple was progressing as planned and a single-arched brick bridge was built at the site, to take the Blacknest Road over the ride that passed through the ruins into Belvedere Woods in the south. In June, King George IV visited the site to see for himself how the work was progressing.

1828: At the end of March, King George IV was shown around the site by Wyatville. By the end of the year, all but a few minor touches to the work had been completed. The ruins had been arranged with a central ride coming from the direction of the landing-stage at the lake, going under the arch of the bridge into the Belvedere Woods and on to Fort Belvedere. On the Belvedere side of the bridge, a semicircle 13.72 metres (45 feet) in diameter, consisting of 14 marble columns complete with architraves, had been erected with a circular wall at the rear. On the lake side of the bridge, parallel lines of columns with architraves had been erected on each side of the ride. Various fragments of stone had been scattered around

to provide a more authentic appearance to the ruins. The overall length of the ruins when completed was 68.58 metres (225 feet) and the maximum width was 30.48 metres (100 Feet).

1829: During the second half of the year, a few alterations were made to the ruins when the stone landing-stage at the lake had been completed.

1862: One of five inscribed stones was sent back to the British Museum for exhibition purposes.

1896: Following an Earthquake that affected the area on Thursday morning 17th December, two columns and architraves forming part of a large square shaped structure on the south-eastern side of the ruins were taken down in the interests of safety.

1924: Major repairs were carried out on the road bridge and its upkeep was transferred from the Crown to Surrey County Council.

1927: During the first week of July, a solid block of inscribed grey limestone, known as the Domitia Rogata Tombstone, was taken with King George V's agreement to Bagshot where it was used as a commemorative stone for the YMCA International Boys Camp held at Rapley Lake during the second week of the month. The tombstone is 61 centimetres (24 inches) square and stands 86 centimetres (33.86 inches) high. Its calculated weight is 821 kilograms (1,810 pounds). The four sides are countersunk giving the appearance of a picture frame. The Latin inscription on the front panel is written and translated as follows:-

> DOMITIAE ROGATAE VIXIT
> ANNIS XXIII
> M.IVLIVS
> CETHEGVS
> PHILYSSAM VXORI
> CARISSIMAE FECIT
> To Domitia Rogata.
> She lived twenty-three years.
> M. Iulius Cathegus Philyssam
> made this for his dearest wife.

1942: In September, large wooden struts were placed under the arch of the bridge to provide extra support for the heavy military vehicles using the bridge during the Second World War. They were removed a few years later.

1953: As a measure to provide greater preservation to the ruins, a metal fence was erected around the site in November. From that time on, the public has not been able to walk within the ruins.

1961: After years of standing virtually forgotten at Bagshot, the Domitia Rogata Tombstone was taken to the Classics Museum at Reading University in March of that year, by kind permission of H M Queen Elizabeth II. A metal inscription plate that had been fixed to the back of the stone to commemorate the

YMCA International Boys' Camp was removed and taken to Windsor Castle for storage purposes.

1971: An inspection of the ruins confirmed that considerable deterioration had taken place over the years. It was decided that it was best to leave the ruins undisturbed.

1973: In June, two further inscribed stones from the site were transported to the British Museum on an indefinite loan basis. A final inscribed stone remains half buried at the site today.

2000: Although time and the elements have taken their toll, the ruins are nonetheless a point of great interest, and the Virginia Water lakeside would not be the same without them.

Continuing in a westerly direction, the ride straightens out to run along the edge of the lake. A short distance along is a small stone landing-stage, which in the past was mainly used by the Royal Family when they used their boats between the Royal Fishing Temple on the opposite bank and Fort Belvedere to the south of Blacknest Road. Before the lake was created, this was the line of an old track that led from the Manor House (when it existed on the opposite bank) to Worldsend Gate at the junction of Blacknest Road and the entrance to Fort Belvedere beyond. Until 1890, an entrance lodge stood at the junction which was then a gateway into the park. In 1891, Worldsend Cottage was rebuilt on the southern side of Blacknest Road, just inside the entrance to Fort Belvedere. Looking across the water from the landing stage, it is hard to imagine that at least two brick buildings stood a short distance out, on what is now the bed of the lake before it was created. Up until the late 1940s, a clearing through the plantation

The Ruins on the southern side of Virginia Water Lake about 1895. On Thursday morning 17th December 1896 an earthquake affected the area and shortly afterwards, two columns and architraves forming part of the square shaped structure, seen at the right of the picture, were taken down in the interests of safety. (Author's collection).

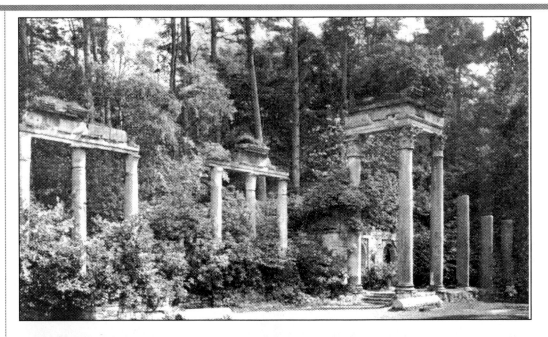

The Ruins in October 2000 showing just one remaining column from the original square shaped structure. (photo by the Author).

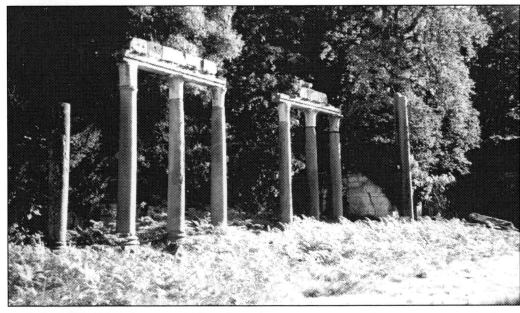

The Ruins as seen from the top of the bridge on the Blacknest Road – August 1999 (photo by the Author).

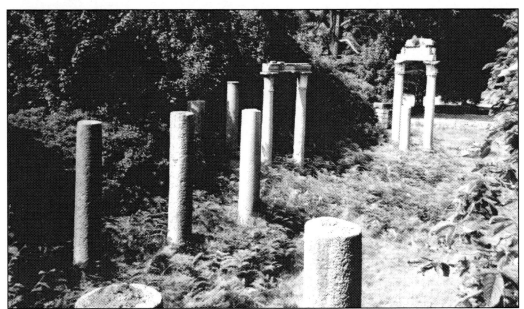

270

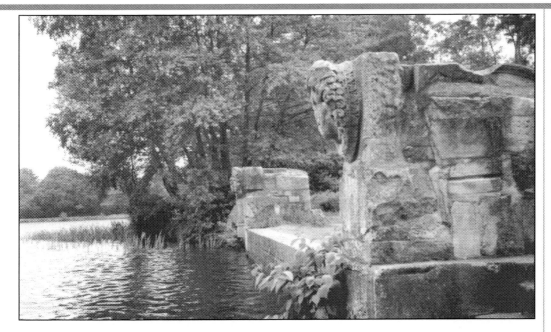

to the east of the old track was maintained, offering a view from Blacknest Road to the other side of the lake. The wood from the lake to the park boundary at Blacknest Road is known as Frostfarm Plantation. The name derives from a Mr Frost who farmed the nearby Shrubs Hill Farm during the early 1800s.

Heading towards Blacknest Gate, the Five Arch Bridge is clearly seen crossing the lake further on. Before reaching the bridge, a wide inlet of the lake heads in a south-westerly direction finishing up as a wide stream running under a rustic stone bridge. A short distance away are the park boundary fence and Blacknest Gate. Due south of the bridge there is small enclosed area of land, between the park boundary fence and Blacknest Road, that is no longer part of the estate. This is the site of the Blacknest Sewage Pumping Station. Not that I am particularly interested in sewage disposal, the station has, nonetheless, an important part to play in the history of the area. It now seems inconceivable that less than a hundred years ago disposal was normally via a cesspit or, quite commonly, in open streams and ditches, in this country. Nearby Sunningdale, Sunninghill, Cheapside and Ascot were no exception. Human health suffered from the effects of the less than sanitary conditions created. After much debate, it was finally agreed to install an enclosed piping system. The work started in late 1913 and came to a halt the very next year, soon after the start of the First World War. Work resumed in 1919 and was completed by January 1931, by which time 53 kilometres (33 miles) of piping had been laid. No fewer than 1,381 houses had been connected at a total cost of £200,000. The furthest house stood on the western side of Ascot Racecourse. It would appear that the residents at Cheapside had a raw deal, as they were not connected until the late 1930s. When the Blacknest Pumping Station was opened in 1925, it

must have been a nightmare for the local residents because the pump had a very noisy piston action. My earliest memories of this part of the park are of the constant 'thump-swoosh' noise of the pump, which could be heard about one kilometre (1,094 yards) away. Relief came to the residents early in the 1960s when it was replaced with a much quieter rotary pump. This was again updated in 2000. The sewage system is far more complex than you might imagine, in that most of the waste is gravity fed to the pumping-station. From there it is pumped back to the Whitmoor Bog Sewage Works, in Swinley Forest near Bracknell. A short distance to the east of the Blacknest Pumping Station, there is a large open car park entered from Blacknest Road. A pedestrian gate provides access to the park.

Blacknest Gate is an extremely popular southern entrance into the park, particularly over the past fifty years with the increased popularity of polo and the equestrian events held on Smith's Lawn. The original gate and lodge were built in about 1753 when the main part of the lake was created. They were completely rebuilt and completed in 1834. Of all the gate lodges in and around the estate, this lodge stands out as the quaintest. The upper section is built with four small castellated towers in the centre and a balustrade going between them and around the square-shaped roof. In the early 1960s the outer walls were painted pale lemon. Later on it was painted pink, in keeping with the other painted lodges. The public roads immediately outside the gate and park boundary fence can be somewhat confusing to a newcomer. However, the private road into the park could not have been better designed. It runs in a straight line in a north-easterly direction, over the Five Arch Bridge that crosses the lake and continues in a straight line before veering right just before Johnson's Pond. It then travels up Breakheart Hill to Smith's Lawn.

Needless to say, Five Arch Bridge is so named after its five arch style of construction. It is sometimes known as High Bridge possibly because it replaced a high wooden bridge that stood there before it. The wooden bridge had such a steep road surface that it was quite risky to ride or walk over it. In addition, it was constantly being repaired as the timber rotted away. The current stone bridge was designed and constructed by Wyatville, and completed in 1827. Other than a slight camber on the road surface for drainage purposes, it is level throughout its length of 63 metres (207 feet). In the centre of the outside of the eastern parapet is a large stone bearing the following inscription:

G IV R
MDCCCXXVII

Meaning:— GEORGE IV REX, 1827.

The lake to the west of the bridge is in the place of the original pond. It is surprising how many people say they have walked round the Virginia Water Lake having, deliberately or otherwise, missed this part of the lake. Thanks to its quietness, it has a charm of its own. A few hundred metres along the ride to the west of the bridge is a very unusual square-shaped plantation consisting of about one hundred *Araucaris Araucana* (monkey puzzle) trees. They were planted in 1946 under the instructions of Hope Findlay (Keeper of the Gardens). Unfortunately, they have become overcrowded and will never attain the natural formation we associate with the tree.

Nearing the end of the ride is China Island, so named after the Chinese style building that was built at its centre. The elongated island was built at the tail-end of the lake in about 1754 and the building was started soon after, and completed in 1758. It consisted of one central octagonally-shaped feature, having one large room and a kitchen and closet at the side. Connected to the building by way of two verandas to the east were two much smaller octagonal structures. Access to the island was by way of a bridge connected to the centre of the existing main bridge at the very end of the lake to the west. Two footbridges came in from the north and south banks of the lake. As a measure to prevent vandalism, and at the same time to provide accommodation for the park employees, facilities were included so that it could be lived in. One of the first persons to live there was William Page (Gamekeeper). He was followed by George Wheeler (Fisherman) and his wife Elizabeth. They went to live there when their two sons George and Edward were very young. It must have been a constant worry to them with the water all around the building. The Wheelers were part of the family associated with Wheeler's Yard. George junior grew up to become a park keeper and in the 1860s was living at Stag Meadow Cottage at the extreme other end of the park. Edward Chapman (Gamekeeper) and his wife Phoebe took over living on China Island, and the last person to live there before the building was demolished in the 1870s was James Benstead (Gamekeeper). The island is now so overgrown with trees and bushes, it is easy to pass by without realising that it is an island. It is not an exaggeration to say that it would be a perfect habitat for alligators if we had a temperate climate.

The stream at the end of the lake comes from the rather unusually shaped Mill Pond, situated outside the park boundary fence in the private grounds of Buckhurst Park.

The ride over the bridge branches off at a T-junction. The ride that continues straight ahead finally

Blacknest Gate & Lodge during the 1920s (the large tree in the foreground has long since gone).

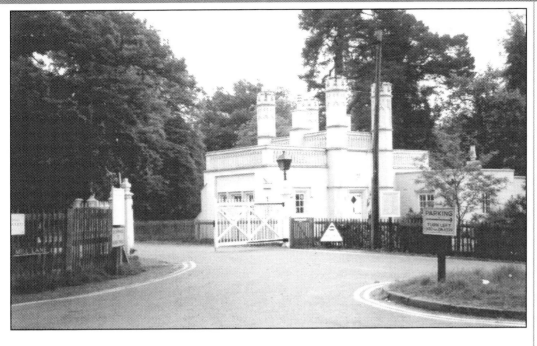

meets up with Duke's Lane near Leiper Pond, and the ride to the east travels along the northern bank of the lake. The whole length of the northern side of the ride from China Island to Five Arch Bridge is one continuous line of plantations. The first area, which slopes up Manor Hill, is known as Millhill Plantation. The next is American Clump. This is a circular plantation planted about 1795. Why it was given this name is subject to speculation as there appears to be no supporting documentation giving a name. The last area is appropriately known as Manorhill Plantation. It should be pointed out that many of the gaps in the plantations have been filled with conifers during the past fifty years. At the top of Manorhill are three attached premises. The first two were built in 1862 and the third was added in the 1930s.

At Five Arch Bridge, the ride continues within an avenue of trees along the eastern side of the road that leads to Johnson's Pond. There are several footpaths passing over the open area closer to the lake. At the start of the footpath nearest the lake there is a plantation with a metal record-post inscribed, 'Planted about 1820'. The trees consist of oak and sweet chestnut and are another record of the author's great-great grandfather Joseph Smith's work while he was in charge of the planting in the park. The footpath comes out in a clearing where four semi-detached houses stand. The first two houses were built in 1949 and named, 'Flinders Cottage' and 'Rowallan'. The next two houses were built in 1906 and named 'Brynwood' and 'Lakeside Cottage'. Beyond the houses there is an enclosed area prohibited to the public. This area is one of the most historical parts of the park, being the site of a very old manor lodge.

Manor Lodge was built in the 1240s, nearly 500 years before Virginia Water Lake was created. It was

The Five Arch Bridge (High Bridge) highlighted by the winter's sun. (photo by Alec Jacobs taken in the 1900s).

built for King Henry III as an alternative country home to Windsor Castle. Henry and many members of the Royal Family that followed actually preferred to stay there than in the castle, the solitude of the spot being the obvious main attraction.

The lodge was built with a moat around it forming a square shaped island. A bridge passed over the north-west corner of the moat and another bridge was at the south, connecting the track that came over the Virginia Brook. In the early days the lodge had strong religious associations, having had a chapel with accommodation for a Dean and up to twelve Chaplains. Over the years the lodge was subject to mixed fortunes as a result of varying interest and financial circumstances. Improvements and repair work continued throughout its life. By the late 1600s, the lodge was in a bad state of repair and it was found necessary to rebuild it during the 1710s. Before and

after this time, the lodge was being used as the residence for the Head Keeper of the park. In the 1740s, the keeper living in the lodge was Mr Johnson, and for a period of time it was known as Johnson's Lodge. The nearby Johnson's Pond was named after him. Before the lake was created in the early 1750s, a large area of fenced land known as Windsor Meadows straddled the stream coming down from Johnson's Pond and the southern side of Virginia Brook. Furthermore an even larger area was fenced to the west and south-west of the lodge. Situated to the north of the moat stood the dog kennels.

The creation of the lake saw a new interest in the lodge, with the roof being replaced and a dairy and cellar being erected nearby. As the century wore on, an increasing amount of repair work was required until the inevitable happened and the lodge was pulled down in the 1790s. For a period of time after

this the island was virtually devoid of buildings other than a boatman's house, boat house and landing-stage. Following the creation of the lake and its increasing use for waterborne activities, the moat island was established as the central boating area. The facilities were considerably improved during the 1820s, with the dockyard at the mouth of a channel to the west of the island being considerably extended. More noticeable was the erection during 1825-1926 of a very ornate Fishing Temple on the southern side of the island looking over the lake. It immediately became the venue for Royal parties and gatherings. In 1867, the original Chinese style fishing temple was replaced with a Swiss cabin-style building. At the same time a gallery was constructed all round the building and a platform-cum-landing-stage was built just above the surface of the lake. The new building was initially known as the Fishing Cottage but its name soon reverted to the 'Fishing Temple'. In 1906 it underwent work to replace some rotten timbers and survived a further thirty years before being demolished in September 1936.

During the life of the Fishing Temple many Royal events had taken place there. The following are just a few accounts of some of the events:-

On Saturday 26th August 1843 a grand fete was held at the site to celebrate the 24th birthday of Prince Albert (Francis Charles Augustus Albert Emmanuel of Saxe-Coburg-Gotha). A banquet was held in the fishing temple whilst the 'Queen Adelaide' and two other large sailing vessels sailed up and down the lake. The Coldstream Guards played the popular tunes of the day and at nightfall a grand firework display was held on the southern bank.

On Saturday evening, 14th June 1879, an aquatic fete was held at the site. The Royal party was headed by the Prince and Princess of Wales. After a picnic on the lawn, they sailed up and down the lake in a large vessel.

On Saturday 10th July 1882 the Prince and Princess of Wales held their annual picnic party to mark the end of the Royal Ascot Race Week. The Royal Family and their friends were rowed up and down the lake before returning to the fishing temple for a grand picnic followed by dancing by candlelight.

Most of the rowing was carried out by boatmen under the control of the Keeper of the Boats. The boat crew, normally consisting of six rowers, was always smartly dressed with blue and white striped jackets, white trousers and straw hats. It is interesting to note that the Keeper of the Boats in King George IV's time was William Cheeseman whose family's name was used for Cheeseman's Gate in Wick Road.

Many boats have sailed or been rowed on the lake. The following are a few of the larger Royal boats used there:- Prince Frederick's Barge, 'Mandarin'; *Queen Adelaide and King Edward VII.* Prince Frederick's Barge was the oldest and most ornate of the boats seen on the lake and had often been seen on the Thames before being brought to the lake. This magnificent barge was 19.8 metres (65 feet) long and was designed by William Kent, built by John Hall, carved by James Richard and gilded by Paul Petit using 24 carat gold leaf. It was built in the 1720s for Frederick Louis, Prince of Wales, eldest son of King George II. On its first day afloat, he was rowed, with his mother Queen Caroline and his five sisters, by the twenty-one oarsmen, from Chelsea to Somerset House to inspect the cleaning of the Royal Collection of Paintings. From that time on, it was often seen on the Thames on Royal occasions. Even after Prince Frederick's death on 20th March 1751 aged 44 years, it continued to be the principal royal barge on the Thames, making its last appearance in 1849 when Prince Albert was rowed to the opening of the Coal Exchange. Shortly afterwards it was transported to the lake where it was used until 1873. In that year a quite extraordinary event took place that would seal its fate as a floating vessel. It was cut into three and stored at Staines before being taken to the Painted Hall at the Royal Naval College (RNC), Greenwich, and displayed from 1892-1894. The barge was later put back together again and taken from the Victoria & Albert Museum to the National Maritime Museum, Greenwich, London in 1946 where it has been on display since that time.

The 'King Edward VII' was one of several 'brigs' that had been used on the lake. Brig is an abbreviation for brigantine, a ship so named because of it was popular with brigands and pirates. It is a two-masted, square rigged ship, with an additional lower fore-and-aft sail on the gaff and a boom to the mainmast. The King Edward VII was brought from Brentford during the summer of 1904 and was the last large vessel to be used on the lake. The peace of the lake was disrupted dramatically during the 1920s and 1930s when the Prince of Wales (later King Edward VIII) started using high-powered speed boats there.

During the latter part of the 1800s and the early part of the 1900s, members of the public were allowed to use their own sailing boats on the lake, or hire rowing boats that were kept not far from the Cascade. The use of these boats sometimes had dire consequences. The following are accounts of two different such events.

On Friday 30th August 1878, Seth Smith-Pocock, who lived at Virginia Water, was sailing on the lake with his two brothers when a solitary streak of lightning struck the mast of the boat and killed him instantly. His two brothers were fortunate to escape without any injuries.

A more well-known person was to lose his life on the lake in 1938. He was 71 year old Sir Malcolm Donald Murray K.C. V.O. C.B. C.I.E., who had been the Deputy Ranger of the Park from 1929 to 1937. He was also Comptroller to the Duke of Connaught, a position that he had held for the previous thirty-two years. On a very hot Tuesday afternoon, 2nd August

1938, after lunching with the Duke at Bagshot Park, he decided to take one of his regular sailing trips on the lake using the Duke's sailing boat which was kept at the old dockyard. Alexander Ure, who was walking along the side of the lake at the time, saw Sir Malcolm rowing the boat out from the dock and, when he was some way out, the sail fell down knocking him into the water. As he did not come up, Mr Ure swam to the upturned boat but he could not

find a trace of him. The police were immediately alerted and it was not until twenty-four hours later on the Wednesday afternoon, that his body was found in very deep water. Sir Malcolm Murray was born in 1867 the fourth son of Brigadier-General Alexander Murray and like his father served as an army officer for much of his life. The funeral service was held in the Royal Chapel in the park.

In 1878, the current Virginia Water Cottage was built within the enclosed area on the northern side of the moat replacing a much older building. By 1900, the layout of the area consisted of the Fishing Temple and an ornate fountain and fishpond in the centre of the lawn on the moated island. On an inlet to the west of the moat was the dockyard, and not far away northwards was a boatman's cottage, Virginia Water Cottage, as already described, and several boathouses not far from the cottage on the western bank of the lake inlet which heads towards Johnson's Pond.

Just to the north of the enclosure, near where the kennels once stood, an ice house was still in use. On the other side of the inlet, where the bank turns east on the lake, there was a small fishing cottage with a small boathouse further on. In 1902, the boathouses were replaced with a single boathouse, and a wooden footbridge over the moat at the north was replaced with a slightly arched iron bridge with criss-cross

railings. Both the boathouse and bridge exist today.

North of the enclosed area is the road from Blacknest Gate, which runs along the head of Johnson's Pond and up Breakheart Hill onto Smith's Lawn. A private road slightly to the west of Johnson's Pond leads into Norfolk Farm.

Johnson's Pond is about 457 metres (500 yards) long, and about 91 metres (100 yards) wide at the head. It has an elongated island about half way along it near the west bank. There is no walkway onto the Island. However, as a boy I found it was possible to get to the island by using a large oak tree that had fallen from the bank onto the island as a natural bridge. This was a favourite place to fish for the perch that gathered under the tree. The pond is relatively shallow and, when it was drained during the summer of 1990 to carry out repair work to the head, the original stream was revealed once again travelling down the centre of the pond bed. It was even possible to make out the traces of two former pond heads from the time when it had been three ponds in the 1700s. Even more unexpected and fascinating was the wide range of fossils I found on the pond bed - the best of which being an almost complete cast of a sea urchin. Needless to say, the fossils originated from millions of years before the pond had been created. The pond has always had a good range of fish and is the perfect habitat for the ducks that use it.

On the eastern side of the pond head, the ride continues along the northern bank of the Virginia Water Lake. From Johnson's Pond as far as Wick Pond, the complete slopes of the hill leading up to Smith's Lawn are appropriately known as 'The Valley Gardens'. The gardens are described in detail later in this chapter. Not far along the ride from Johnson's Pond, the boathouse, Virginia Water Cottage and the iron bridge are clearly seen on the other side of the inlet. Further on, the ride follows the contour of an inlet. The centre-line of this inlet, to the southern bank of the lake and beyond, marks the Berkshire County Boundary and the Surrey County Boundary. In 1979, two water pumps were installed at this point to supply water to the gardens. The area of the ride to the east was cleared of most of the large beech trees during the 1980s. There is one tree standing near the bank of the lake that thankfully has been preserved. This is the Indian Head Beech Tree, which has a North American Indian Chieftain's head cut into the bark. It was cut into the tree about 1918 by a Canadian Forestry Corps soldier.

Having already mentioned William Cheeseman as Keeper of the Boats who lived in the Boatmans Cottage, more generally known as the Royal Cottage, in the 1820s, we come to the appropriately-named John Whiting, who took over the boats, but apparently was never given the title of Keeper of the Boats. His wife, Ann Whiting, however, was made 'Keeper of His Majesty's Fishing Temple and Cottage, Virginia Water'. They jointly ran the boats and temple until 1861.

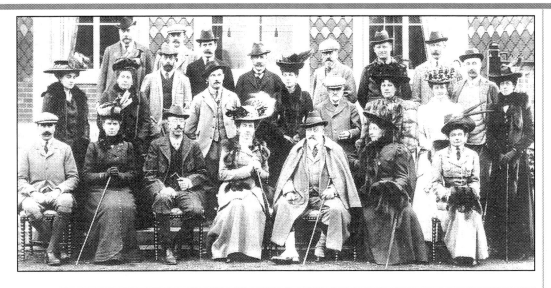

1. Captain Walter Campbell 67 years (Deputy Ranger).
2. Reginald Halsey (Deputy Surveyor).
3. Robert Crew-Milnes 50 years (Earl of Crewe).
4. Count Herman Wrangel 51 years (Swedish Foreign Minister).
5. Count Sage Shott.
6. George Granville 36 years (Third Earl of Granville).
7. Hon. Derek Keppel 45 years.
8. Princess Patricia of Connaught 22 years.
9. Princess Beatrice Henry of Battenberg 51 years.
10. Prince of Wales 43 years (later King George V).
11. Prince Arthur of Connaught 25 years.
12. Queen Alexandra 64 years.
13. Captain David Nairne Welch. R.N. 88 years (Keeper of the Boats).
14. Constance Grosvenor (Countess of Shaftsbury).
15. Lady Elsie Lansdowne.
16. Col. Hon. Harry Charles Legge 56 years (English Equerry).
17. Princess Victoria 40 years.
18. Prince Alexander of Teck 34 years (later First Earl of Athlone).
19. Princess of Wales 41 years (later Queen Mary).
20. King Gustavus (Gustaf) V of Sweden 50 years.
21. Queen Victoria of Sweden 46 years.
22. King Edward VII 67 years.
23. Princess Louise Duchess of Argyll 60 years.
24. Countess Charlotte Wrangel.

Captain Sir David Nairne Welch R.N. K.C.V.O. (Knight Commander of the Royal Victorian Order) was born at sea on 26th October 1820, the son of a Naval Lieutenant. He entered the Navy at the young age of seventeen in 1837 and became Navigating Sub-Lieutenant in 1843, Staff Commander in 1863 and Staff Captain in 1871, finally retiring in 1878 as a Captain. During his service in the Navy, he commanded the Royal Yacht 'Fairy' and, as soon as that became obsolete, he went on to command the Royal Yacht 'Alberta'. Before he retired from the Navy, he had taken up residence at the Royal Cottage on Virginia Water Lake in 1861, where he remained until his death.

The King Edward VII, formerly known as Prince Eddy's Brig in August 1908. The brig is being prepared for a trip round the lake. The portly figure of King Edward VII is seen near the stern. (Author's Collection).

Belvedere Fort, Sunningdale.

In 1850, he married Caroline Poole, daughter of Commander Poole R.N. On 3rd August 1871, their world fell apart when their youngest son, Henry Forrest Welsh, then only six years of age, drowned while playing near the boats. The inscription on the family grave at Sunningdale Church states: 'Drowned in Virginia Water'. Under his new title of Keeper of the Boats, Captain Welch was, as always, very popular with the Royal Family. He once said "King Edward was like a brother to me." The Royal children would like nothing better than playing with 'David' as he was affectionately called. On his ninetieth birthday, the King sent him a baton containing ninety sovereigns. At the time of his death, his drawing-room was covered with signed photographs of almost every member of the Royal Families of Europe.

He died on 1st February 1912 at 91 years of age, and was buried on 5th February 1912 at Holy Trinity Church, Sunningdale.

Captain George Alexander Broad R.N. M.V.O. was born on 15th November 1844 the eldest son of Captain William Henry Broad R.N. He entered the Navy in 1860, and served as Navigating Lieutenant of the 'Valorous' while attached to the Arctic Expedition of 1875. He was 'Staff-Commander Flagships' on the vessels, 'Triumph' and 'Pacific' 1885-1888, 'Northumberland' 1889-1890, and 'Camperdown' 1890-1892. He Commanded the Royal Yacht 'Elfin' 1892-1897, and the Royal Yacht 'Alberta' until his appointment as Keeper of the Boats at Virginia Water. Like Captain Welch, he was very popular with the Royal Family. He died on 17th December 1915 aged 71 years, and was buried at Holy Trinity Church, Sunningdale on 21st December 1915, next to Captain Welch.

When Colonel Sydney Penhorwood, Commanding Officer of the Canadian Forestry Corps, moved into Virginia Water Cottage in 1916,

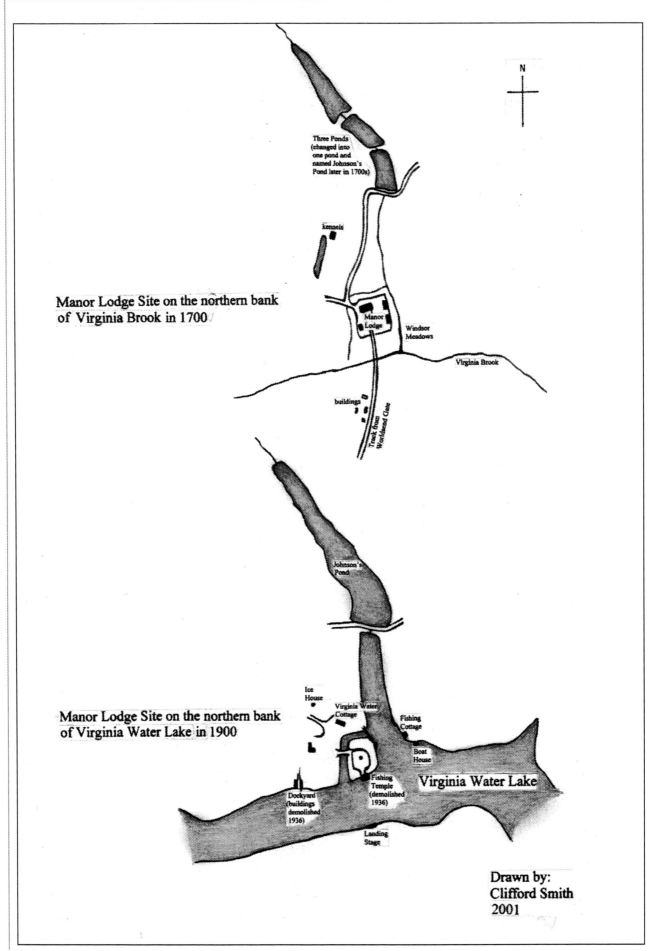

Manor Lodge Site on the northern bank of Virginia Brook in 1700

Three Ponds (changed into one pond and named Johnson's Pond later in 1700s)

kennels

Manor Lodge

Windsor Meadows

Virginia Brook

buildings

Track from Wordsend Gate

Johnson's Pond

Manor Lodge Site on the northern bank of Virginia Water Lake in 1900

Ice House

Virginia Water Cottage

Fishing Cottage

Boat House

Fishing Temple (demolished 1936)

Virginia Water Lake

Dockyard (buildings demolished 1936)

Landing Stage

Drawn by:
Clifford Smith
2001

Built in 1906, the semi-detached houses on the left are named 'Lakeside' and 'Brynwood'. The houses on the right were built in 1949 and are named 'Rowallan' and 'Flinder Cottage'. They are situated on the north bank of the lake near Virginia Water Cottage. (photo July 1999 by the Author).

Virginia Water Cottage showing the iron bridge that connects the island. The house was built in 1878 replacing a previous building. (photo by Alec Jacobs).

Johnson's Pond when it was drained for repair work during the summer of 1990. (photo by the Author).

281

Johnson's Pond as it normally looks – July 1998. (photo by the Author).

Photographs taken by the author of two trees standing close to the banks of Virginia Water Lake.

The first one is the Indian Head Beech Tree. The Indian Chieftain's head was cut into the bark about 1918 by a Canadian Forestry Corps soldier. Since that time, several other persons have added their marks to the tree. The second tree is of a sweet chestnut which stands on the southern bank of the lake. The photograph clearly shows where it was struck by lightning that tracked down the least line of resistance along the spiral of the bark and grain. It is common for a sweet chestnut to twist anti-clockwise as it grows, whilst in the southern hemisphere it will generally twist in the other direction.

the role of the Keeper of the Boats appears to have been made redundant. Subsequent residents of the cottage were Sir John Chapple 1919-25 and Paymaster, Rear Admiral Henry Horniman 1925-36, both of whom bore the new title of Keeper of Virginia Water.

The ride passes two small inlets before coming to the oldest and largest Monkey Puzzle tree in the park. Just beyond this is a clearing in the trees and shrubs that goes down to the lake. This is rather romantically known as Botany Bay Point. At the point, a clear view is provided of The Ruins on the other side of the lake,

with Virginia Lodge to the left. The ride continues in a north-easterly direction, coming out at the extreme eastern end of the Canadian Memorial Avenue, near the Totem Pole and Wick Pond. The Canadian association with the avenue and the Totem Pole stems from the fact that this particular area around Wick Pond was a satellite camp of the Canadian Forestry Corps during the First World War, as described in Chapter 13. The avenue is a memorial to the Canadians who lost their lives during that war. It was planted mainly with maple trees between 1931 and 1933, and runs up a gradual slope in a south-westerly direction from the Totem Pole. It is about 400 metres (437 yards) long and 19 metres (21 yards) wide. The Totem Pole which stands in a clearing on the western side of Wick Pond is described in detail further on.

Wick Pond, sometimes known as 'Little Virginia', is separated from the main lake by a rustic bridge made up with stone boulders. The pond is shaped like a boomerang, and is about 220 metres (240 yards) long, and about 44 metres (48 yards) wide. It was created about the same time as the lake and, until about 1916, a magnificently ornate large iron gate stood across the ride at the eastern side of the bridge. The footpath on the western side of the pond travels over a wooden footbridge known as Eton Bridge. The path continues around the back of the pond before going over another bridge, this one called Larch Bridge. Following the stream along, the path heads north over another bridge, coming out at the Cheeseman's Gate Car Park, having passed through the Egham Wick Plantation of pine trees.

A ride travels just inside the park boundary fence parallel to Wick Road in an easterly direction. Further along there are two sets of semi-detached park houses, 'Pinewood' and 'Woodside', built in 1965, and 'Weydon' and 'Silver Birches', built in 1949. At the end of the houses a made-up drive comes in from

Wick Pond looking towards Eton Bridge – July 1999. (photo by the Author).

'Verderers' cottage situated in the Egham Wick Plantations near Wick Road. It was formerly known as Nursery Cottage and for most of its life it was used as two dwellings for the district Gamekeeper and the district Woodman. The residence was the home of the author's great great uncle William Smith (Woodman) 1851-1859 and great great uncle Charles Spencer Smith (Woodman) 1859-1899. It is now the single residence for the Keeper of the Gardens. (photo July 1997 by the Author).

Virginia Water Lake looking east from the head of the lake near the Wheatsheaf Hotel – September 1999. (photo by the Author).

283

Wick Road heading south. A short distance along this drive are two more houses, 'Darfur' and 'Oakleaves', both built in 1965. Further along the ride is one of the older, and as far as my family is concerned, one of the most historical houses in the park. Named 'Verderers' by John Bond, a Keeper of the Gardens who lived there for many years before he retired in 1997, it was built about 1816 and used for most of its life as two residences, known as numbers 1 & 2 Nursery Cottages. In keeping with a standard practice in the past, they were used as residences for a gamekeeper and a woodman. A large area to the east of the building was used as a tree nursery by the woodman.

Charles Spencer Smith was one of my great-great uncles who lived there for forty years (1859-1899). He was born at 'Milton's Lodge' at Ascot Gate in the park in May 1823. Not only was he a great achiever, so were many of his children and grandchildren. At least three of his daughters became schoolteachers (one a headteacher), and one became Head Gardener for Lord Cobham. Charles's eldest son, who was born on the 25th April 1845, was also named Charles Spencer Smith after him. His life, and those of his four sons, were extraordinary, to say the least. For forty-six years (1874-1920), he was the Secretary and Receiver of the Westminster City School, Palace Street, near Buckingham Palace. It was a public school providing education for 850 boys. Charles's output of record-keeping and letter-writing was staggering, and over twenty bound volumes of his work are lovingly cared for in the City of Westminster Archives Centre in London. His four sons all attended the school, and excelled in the academic field, going on to Cambridge

and other universities. Three sons served as officers with the Queen's Westminster Rifles during the First World War. Sadly, two of them died during the conflict and the other was injured and spent time as a German prisoner-of-war. The fourth son pursued what he thought would a be a more peaceful life, but which, as it happened, turned out to be just the opposite. His full title was 'the Rev. Arnold Patrick Spencer-Smith' (by then the surname had become hyphenated).

Arnold was born on St Patrick's Day, 17th March 1883. After attending the Westminster City School and then Woodbridge School, Suffolk, where he excelled in cricket, football, fives and gymnastics, he went up to Queen's College Cambridge to read history. He was extremely industrious at college, and was the founder editor of the student magazine 'The Dial'. He was President of the St Bernard Society, the College Debating Society and Secretary of the Querists. In 1907, he was elected by his fellow students as 'Man of Mark', a tongue-in-cheek recognition for his academic and sporting ability. From college he became a schoolmaster at Merchiston Castle School in Edinburgh and he became a reverend, being ordained in post in 1910. In 1913, he was elected a Fellow of the Royal Historical Society, and the following year he applied, and was accepted, to join Sir Ernest Shackleton's Trans-Antarctic Expedition of 1914-17.

His position on the expedition was Chaplain and Photographer on the Ross Sea Party, whose role was to establish depots of food and fuel on the ice to the west of the South Pole, ready for Shackleton's Party coming in from the east. Unfortunately, the expedition turned into a disaster with Shackleton's

ship, the 'Endurance' being crushed and sunk in the ice-floes. At the same time, the Ross Sea Party's ship, 'Aurora' had broken away from its anchor and drifted miles away. In spite of all this, and great suffering and loss of life, the Ross Sea Party achieved their objective. Arnold endured ten days of blizzard in a tent on his own. He was then picked up and hauled for forty days across the barren ice before dying a short distance from the Safety Camp from the effects of the bitter cold and hunger, on 9th March 1916. He was buried in his sleeping bag he died in, and a bamboo cross placed on the cairn that marked his grave. One of his party wrote, "He never uttered a word of complaint," and the inscription on the cross was:-

"Sacred to the memory of of Rev. A.P. Spencer-Smith who died 9 March 1916. A brave man."

Since that time, a large cross has been erected near the spot as a memorial to Arnold, and to the two other members of the party who died, Captain Aeneas Mackintosh and Victor Hayward.

In 1999, an Antarctic party was inspecting the inside of Captain Scott's Discovery Hut when they found Arnold's wallet wedged in a bunk frame. The wallet had three photographs and some tram tickets of his inside it. It had been wedged there undiscovered for 84. years. There have been several books written describing his ordeal, and his handwritten diaries are used for educational purposes at Cambridge.

In 1859, Charles Spencer Smith, my great-great uncle, was appointed Woodman for the Virginia Water district, taking over from his brother William Smith, who had died at the early age of thirty from tuberculosis. The brothers were born at Milton's Lodge (Sawyer's Lodge) near Ascot Gate and were taught the art of forestry (arboriculture) by their father, Joseph Smith. Charles took over the occupancy of Nursery Cottages (since renamed 'Verderers') at Egham Wick from William at the time of his appointment in 1859, and lived there with his family until he died on Friday 3rd March 1899 from pneumonia. Responsibility for the Virginia Water district was no mean undertaking, as it not only covered the length and breadth of the lake, but also included the Clockcase Plantations, Belvedere Woods, Smith's Lawn and the woods and tree nurseries where Savill Garden now stands. Charles must have been a glutton for punishment because he took responsibility for controlling the water levels of the Virginia Water Lake and Obelisk pond, and was also a Park Warden at weekends and holiday times.

The following is a detailed report on the death of Charles Spencer Smith that appeared in the *Windsor & Eton Express* newspaper on Saturday 11th March 1899.

The ride continues on top of the embankment along the lake head to meet up with the ride near the Cascade. The whole area to the east of the embankment, as far as the park boundary fence running along the side of the London Road (A 30), is one large plantation, consisting of oak, sweet chestnut and conifers, known as the Virginia Water Plantation. The Windsor Crown Estate continues on the other

"DEATH OF AN OLD AND RESPECTED CROWN SERVANT

We regret to record the death, on Friday of last week, of Mr. Charles Spencer Smith, a well known and much esteemed Crown servant in Windsor Great Park. Born in May, 1823, at Sawyer's Lodge, Windsor Forest (about three years after his father took up his residence there on promotion from the New Forest, Hants, for the express purpose of organizing the planting of the Forest with oak). Mr Smith had spent all of his life on the Crown estate, and for the past forty years had charge of the Virginia Water district, first under the late Mr. William Menzies and latterly under Mr. Frederick Simmonds, Deputy Surveyors, by both of whom and also by H.R.H. Prince Christian the Ranger, he was held in high esteem. In practical knowledge of forestry he excelled, while his general intelligence was such that other duties were from time to time put upon him. For the space of twenty-five years he was a member of the Park corps of Rifle Volunteers, retiring from the corps in 1886 with certificate of good service and record of efficiency of a high order. As a rule he could be depended on to give a good account of himself as a marksman, several times achieving the coveted position of best shot of his company. A goodly number of prizes were won by him on the Park ranges and at the Berkshire County meetings, and great was the rejoicing of his comrades when, following the example of his brother on a previous occasion, he carried off the County Challenge Cup with bronze medal and purse of £20. Tradition depondeth that on the occasion his gallant and ever-revered commanding officer, Captain Menzies, toasted the hero in old Scotch whiskey, a plentiful supply of toddy being ladled out to the stalwarts of the Company from buckets, the camp affording no better vessels. The interment took place at Christ Church, Virginia Water, on Wednesday last, and was attended by Mr. Simmonds, Mr. Street, Mr. Bartlett, and the leading men of the Park. The funeral arrangements were ably carried out by Mr. P. Head, of Egham."

side of the London Road as another large plantation, stretching along the side of Christchurch Road to a point opposite Christ Church School. It should be pointed out that Christchurch Road starts from the Wheatsheaf Hotel and heads towards the Virginia Water Railway Station and Shopping Parade. The large plantation just described is known as Clockcase Plantation, a name taken from an unusual building of that name that stands in the plantation. The Clockcase Plantation was the responsibility of my great-great uncle, Charles Spencer Smith, for the period 1859-1899.

The Clockcase was built a short time after the Virginia Water Lake was created, as a vantage point over the lake. It stands on a high spot on the formerly rather sinisterly named, Hangmoor Hill (sometimes spelt Hangmore). The main part of the building is in the form of a red brick square tower, with four small columns on the corners of a flat roof connected by castellated walls. The tower contains four floors and has an overall height of 18 metres (59 feet), and a width of 4.57 metres (15 feet). The shapes of the windows and structure give it a churchlike appearance. The original purpose of the round brickwork on thee second floor, facing west, now a circular window, was for the installation of a clock. Although the clock was never fitted, the tower has a 'grandfather clock' appearance and the name Clockcase has been used ever since. Unfortunately, the view of the lake from the top of the tower is restricted by the tops of the sweet chestnut trees in the plantation. During the late 1800s, the public was permitted to go onto the roof of the tower to look at the lake and surrounding area. This privilege ceased in the early 1900s, and the Clockcase and plantation have been a prohibited area since that time.

Adjoined to the northern base of the tower is the residential building, which for much of the past two centuries was the home of the area Gamekeeper. One of the Gamekeepers known to my family who lived there, was Thomas Foker, a man of great character, who was often to be seen on his donkey cart with his two pet beagles. Thomas was born at Great Morley, Essex in 1795, and moved into The Clockcase as Gamekeeper with his wife Ann in 1847. Their first daughter, Emma, was born there in 1848, followed by three other daughters, Susan, Roseann and Charlotte. Thomas lived there as Gamekeeper for twenty-one years, dying there on 14th September 1868 aged 73 years. He was buried at the nearby Christ Church Graveyard. The kennels in which he and the other Gamekeepers kept the spaniels still exist today. However, it is now some time since they were used for that purpose. The Clockcase underwent a major refurbishment during 1999, but it is no longer used as a Gamekeeper's residence.

An area of historical importance on the estate is Fort Belvedere and the surrounding woods, situated outside the Great Park in a private enclosure on the southern side of Blacknest Road. Like Clockcase, the woods were looked after by Charles Spencer Smith during 1859-1899.

Fort Belvedere, was often spelt Belvidere in the past, being the way it is pronounced. The word 'belvedere' is the Italian word for 'viewpoint' and, as the fort stands in a dominant position on Shrubs Hill, it is a very apt name. It was built 1750-1753 in the form of a small triangularly-shaped fort with turrets on the three corners. Since that time it has been extended and modified with further castle-shaped structures, battlements and castellated walls, to give the appearance of a fairy tale castle. The most imposing addition to the original triangular structure, was a single high tower bearing a flag-pole positioned near the western turret. On a clear day with a pair of binoculars it is possible to see the dome of St. Paul's Cathedral in London from the top of the tower. During 1827-1828, a large semi-circular castellated battlement was built in front of the north-east side of the fort, upon which the brass cannons that had previously stood in front of Cumberland Lodge were mounted. The cannons used to be used to celebrate Royal occasions until the practice was stopped by King Edward VIII in 1907 because they risked being fractured when they were fired. Thirty-one of the cannons have survived until today, still lined up on the battlement.

Over the years it has been visited, and on occasion lived in, by members of the Royal Family. Starting with the Duke of Cumberland, it is known that King George IV, King William IV, Queen Victoria, King Edward VII and King George V had tea there, and finishing up with the Prince of Wales (later King Edward VIII) living there 1930-1936. In 1910, it was used as a 'grace and favour' residence by Sir Malcolm Donald Murray, Comptroller to the Duke of Connaught. When Sir Malcolm was appointed Deputy Ranger of the Great Park in 1929, he moved to Holly Grove (now Forest Lodge) in the park. During that same year, when it became vacant, the Prince of Wales asked his father King George V if he could take up residence there. After the usual debate between father and son, his request was granted. At the time, 'The Fort', as the Prince called it, was in a sorry state, and an enormous amount of work had to be done before the Duke could move in as planned in January 1930. He immediately had central heating installed, and new bathrooms, showers and toilets fitted throughout the fort. The yew trees that crowded the building were cut down to allow more light to enter the windows and to improve the views. Furthermore, he personally worked on clearing the 'jungle' that the grounds had become, with the assistance of his brother 'Bertie' (later King George VI). Even his guests were seconded to help with the work. Progressively, the area was cleared and a small pond that existed below the battlement at the western end was replaced with a swimming pool. The rest of the area below the battlement was turned into a croquet lawn, and a tennis court was built at the eastern end.

During 1936, the 'mood' at the fort changed dramatically following the death of King George V at Sandringham on Monday 20th January 1936. The next day, the Prince of Wales was proclaimed as King Edward VIII and suddenly acquired the added responsibilities as the Monarch. The problems for the new King increased as his love for American divorcee, Mrs Wallis Simpson grew. By the autumn, the situation had reached fever-

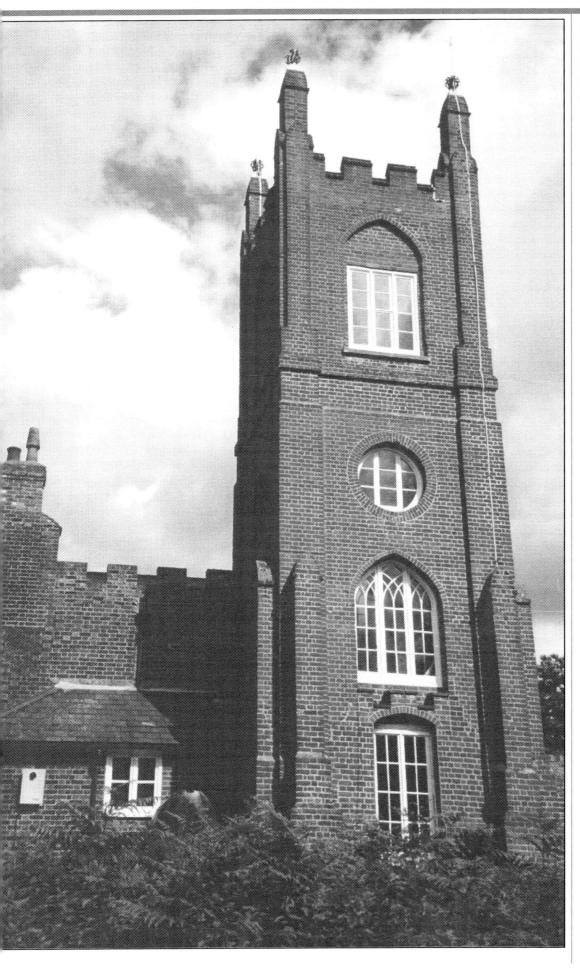

The Clockcase as seen from the west – July 1999 (photo by the Author).

The Clockcase Kennels – July 1999 (photo by the Author).

A view looking west from the roof of the Clockcase showing a glimpse of Virginia Water Lake through the gap in the sweet chestnut trees – July 1999 (photo by the Author).

pitch as it was not permitted for an English Monarch to marry a divorced person. Fort Belvedere became the focal point of the world's media and many reporters and photographers were caught actually getting into the grounds. Stanley Baldwin (Prime Minister), Winston Churchill, Maxwell Beaverbrook and many other well-known people were seen coming and going at the fort. By December an impasse had been reached. The King had two choices: to give up his love for Wallis Simpson and be formerly Crowned King, or abdicate to follow the call of his heart. He followed his heart.

The Instrument of Abdication was drawn up and signed by the King and by his three brothers, Albert, Henry and George as witnesses. The event took place at Fort Belvedere on Thursday 10th December 1936.

The Instrument of Abdication read:-

The next day he was to make his famous abdication speech on the BBC Radio from Windsor Castle. It was generally understood that Winston

Churchill had written the speech, but this was a misconception. The speech was in fact written by the King, but he invited Winston Churchill down to Fort

I, Edward the Eighth, of Great Britain, Ireland, and the British Dominions beyond the Seas, King, Emperor of India, do hereby declare My irrevocable determination to renounce the Throne for Myself and for My descendents, and My desire that affect should be given to this Instrument of Abdication immediately.
In token whereof I have hereunto set My hand this tenth day of December, nineteen hundred and thirty six, in the presence of the witnesses whose signatures are subscribed.

SIGNED AT FORT BELVEDERE IN THE PRESENCE OF

Belvedere on the Friday afternoon to check it over. After some of the wording had been modified in response to Churchill's suggestions it was ready for the broadcast. Later in the afternoon the King's younger brother Prince Albert - 'Bertie', who took over the throne as King George VI - arrived at the fort. The King was packing his personal belongings and it was during the brotherly chat that followed that Albert suggested to his older brother that his new title should be the Duke of Windsor.

It must have been a heart-wrenching moment when the King drove away from Fort Belvedere for the last time that evening. His route was through Blacknest Gate and across Smith's Lawn to the Royal Lodge, where the Royal Family had gathered to dine with him. After dining, he continued his journey down The Long Walk to Windsor Castle. At the Sovereign's Entrance he was met by Lord Wigram (Deputy Constable and Lieutenant-Governor of the castle). From there they went to the Augusta Tower where Sir John Reith, Director of the British Broadcasting Corporation (BBC) was waiting with the broadcasting team.

At 10 o'clock on that Friday evening, 11th December 1936, Sir John Reith made the following statement on the radio: "This is Windsor Castle. His Royal Highness Prince Edward." The Prince (no longer King) made his famous speech on the radio as follows:-

"At long last I am able to say a few words on my own.

"I have never wanted to withhold anything, but until now it has been not constitutionally possible for me to speak.

"A few hours ago I discharged my last duty as King and Emperor, and now that I have been succeeded by my brother, the Duke of York, my first words must be to declare my allegiance to him. This I do with all my heart.

"You all know the reasons which have impelled me to renounce the Throne. But I want you to understand that in making up my mind I did not forget the country or the Empire which as Prince of Wales, and lately as King, I have for twenty-five years tried to serve. But you must believe me when I tell you that I have found it impossible to carry the heavy burden of responsibility and to discharge my duties as King as I would wish to do without the help and support of the woman I love.

"And I want you to know that the decision I have made has been mine and mine alone. This was a thing I had to judge entirely for myself. The other person most nearly concerned has tried up to the last to persuade me to take a different course. I have made this, the most serious decision of my life, upon a single thought of what would in the end be best for all.

"This decision has been made less difficult to me by the sure knowledge that my brother, with his long training in the public affairs of this country and with his fine qualities, will be able to take my place forthwith, without interruption or injury to the life and progress of the Empire. And he has one matchless blessing, enjoyed by so many of you and not bestowed

on me, a happy home with his wife and children.

"During these hard days I have been comforted by my mother and by my family. The Ministers of the Crown, and in particular Mr. Baldwin, the Prime Minister, have always treated me with full consideration. There has never been any constitutional difference between me and them and between me and Parliament. Bred in the constitutional tradition by my father, I should never have allowed any such issue to arise.

"Ever since I was Prince of Wales, and later on when I occupied the Throne, I have been treated with the greatest kindness by all classes, wherever I have lived or journeyed throughout the Empire. For that I am very grateful.

"I now quit altogether public affairs, and I lay down my burden. It may be some time before I return to my native land, but I shall always follow the fortunes of the British race and Empire with profound interest, and if at any time in the future I can be found of service to His Majesty in a private station I shall not fail.

"And now we all have a new King. I wish him, and you, his people, happiness and prosperity with all my heart. God bless you all. God Save the King."

After his speech, he returned to the Royal Lodge for a final meeting with the other members of the Royal Family. In sombre mood, he left the lodge at midnight by car and, two hours later, he was on his way from Portsmouth on the destroyer H.M.S. Fury bound for France.

Following the departure of the Duke of Windsor, the future of the fort went through an uncertain period. It was, however, put to good use during the Second World War, when the Commissioners of Crown Lands (later to become Crown Estate Commissioners) used it as their Headquarters, safely removed from the bombing of London. When they moved back to London after the war, the fort really went through a bad time through neglect and vandalism. In 1953, King Farouk of Egypt, who had been forced to abdicate during the previous year, showed considerable interest in taking on the lease of the fort. This did not materialise, and it was not until 1955, when the fort narrowly escaped demolition, that salvation arrived when the Crown lease was granted to The Hon. Gerald Lascelles. The fort and gardens were significantly improved during his period of occupancy which ended in 1976. The improvements continued even further when Mr. Galen Weston, the current occupant, took over. The gardens surrounding the fort come to their full glory in May when the azaleas are at their best. At the same time a magnificent wisteria growing up the front wall of the fort enhances the beauty of the building. The tennis court and croquet lawn below the battlement have been done away with to create one large lawn. The only reminder of the King Edward VIII days is the swimming pool, and even that has been drained of its water and is no longer used. Within the unspoilt, mainly wooded 79 hectare (195 acre) grounds, a fairly large pond is situated about 200

metres away on the south-western side of the fort. However, the most glorious feature of the grounds are the old cedar trees that still survive along the drive that leads down to the ruins near the Virginia Water Lake. The trees have been used as a heronry since the birds deserted the Sandpit Gate location in 1860-1861.

Robert Turner was born at Hemingstone near Ipswich, Suffolk on 11th October 1820 and enlisted in the army on 25th November 1840. He joined the Royal Field Artillery at Woolwich, where he remained for a few years until the outbreak of the Smith O'Brian rebellion in County Tipperary in Ireland. After the suppression of the outbreak, he did five years service in Jamaica. Returning from there, he had another brief spell in Ireland. Then came the Crimean War, through which he served without injury, while nonetheless gaining the Crimean medal with clasps. He fought at Alma, the first battle of the campaign, in the terrible struggle on the morning of 5th November 1854 against overwhelming Russian forces at

Master Gunner Robert Turner in 1900 aged 79 years. He was appointed on 1st January 1867 in charge of the guns at Fort Belvedere on the death of his predecessor James Tait. He died on 20th June 1910 aged 89 years.

The burial of Robert Turner on 25 June 1910 at Holy Trinity Churchyard, Sunningdale. Here the carriages are near the Churchyard along Bedford Lane.

Inkerman, and finally in virtually the last battle at Sebastopol. It was at Inkerman that he earned his medal for distinguished conduct. During the fight, he suddenly discovered that the man who had been serving out ammunition had been killed. Recognising the desperate nature of the situation, he immediately got on his horse and continued to distribute the ammunition himself. Many times the boxes were hit by the hail of bullets but miraculously he escaped unhurt.

Under his full title of Acting Master Gunner, he was placed in charge of the guns at Fort Belvedere on 1st January 1867, upon the death of his predecessor, James Tait. For nearly forty-two years he looked after the guns while living in a cottage close to the Fort with his wife Elizabeth. On Royal Birthdays and on special occasions, at twelve o'clock he would fire a salute, until late in Victorian times, when some of the guns developed a tendency to explode, the practice was discontinued in the interests of safety. Many of the local children would gather on such occasions to watch the spectacle of the firing.

Queen Victoria and King Edward VII would often visit the Fort to have tea in a specially reserved tea room. On such occasions, Queen Victoria in particular would ask after his well being, as in later years his health started to decline. During his time at the Fort, he was awarded the Queen's Jubilee Medal, the King's Coronation Medal and the much coveted Meritorious Service medal. His wife Elizabeth died in December 1908 and Robert, too feeble to attend the funeral, stood to attention and saluted as the coffin left the Fort and made its way to the Holy Trinity Church, Sunningdale.

Robert Turner died on Monday 20th June 1910. The funeral took place on Saturday 25th June 1910. Although the time was fixed at the inconvenient hour of midday, hundreds lined Bedford Lane on the way to the churchyard, in anticipation of witnessing a military spectacle. By some misunderstanding the cortege was one hour late, and people, including many friends of the deceased, were kept waiting at the church in almost continuous rain. Eventually, the procession arrived with the coffin draped in a Union Jack and surmounted by the old soldier's shako (a cylindrical peaked military hat with a plume). It was borne on a gun carriage drawn by five horses, under the command of Sergeant Oddy. Many members of the military service and members of Windsor Park attended the service. Among those present was Sergeant Maguire, Keeper of Blacknest Gate, himself a Crimean veteran of distinction. Robert Turner was the oldest serving soldier in the British Army.

At the outbreak of the Second World War, in September 1939, the Virginia Water and Smith's Lawn area of the park was closed to the public and, at the same time, the Virginia Water Lake was drained of much of its water to disguise an otherwise perfect navigational feature for the German Airforce. Initially, Wick Pond was also drained, but was refilled shortly afterward. By the time the lake was refilled at the end of the war in 1945, much of the exposed bed of the lake had become overgrown

Fort Belvedere front view – May 1999 (photo by the Author).

Fort Belvedere rear view – May 1999 (photo by the Author).

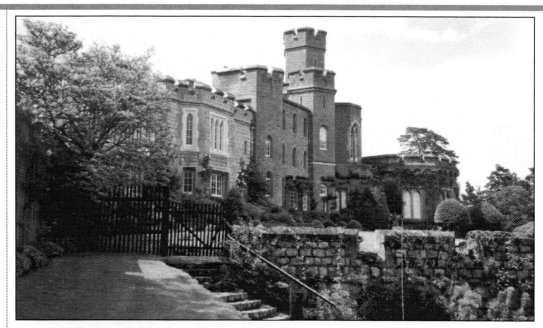

Fort Belvedere cannons – May 1999 (photo by the Author).

Fort Belvedere a distant rear view – May 1999 (photo by the Author).

Clearing the undergrowth at Fort Belvedere in 1930. Standing in the centre is Prince Edward Prince of Wales (later King Edward VIII). Standing on the left is Prince Albert Duke of York (later King George VI), known by his family as 'Bertie'.

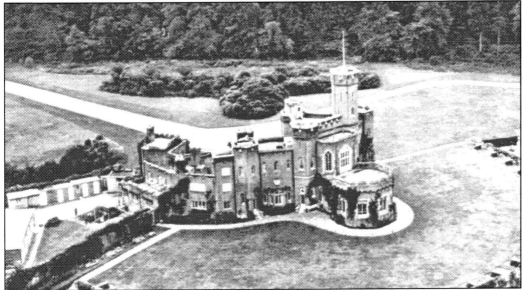

Aerial view of Fort Belvedere from the north-east c.1936.

with birch and alder saplings. These soon died when they became submerged by the returning water.

On 3rd September 1945, the fifth anniversary of the start of the war, King George VI gave his permission for the public to bathe in the lake. The following summer saw thousands of people taking a 'dip' and sunbathing along the east bank of the lake. Alas, this pleasure was interrupted when it was found that the long period during which the lake had been drained had dried out the clay and significantly affected the soundness of the Cascade structure. To enable the necessary repair work to be carried out, the lake was once again drained in 1947. Bathing restarted in 1949, although in a much more restricted form, now confined to a fenced-off area near the large cedar tree that grows on the eastern embankment. Fears of diseases contactable through bathing in the water having been expressed, the practice was discontinued in the early 1950s.

The Valley Gardens cover most of the northern slopes of Virginia Water Lake, from Breakheart Hill at the west to Wick Pond in the east, and from the bank of the lake to the southern side of Smith's Lawn. The creation of the gardens, which began in the winter of 1945-1946, was no mean task, as the whole area was a virtual jungle. So much so that it was known as 'Upper Burma' or 'Burma' by all of the estate employees when referring to the work going on there. It came as no surprise that it took nearly three years to find the body of a woman who went missing in the area from nearby Englefield Green. On Saturday evening 16th November 1918, the lady in question set off for a date with a soldier of the Canadian Forestry Corps at Smith's Lawn. It was only by chance that the dog of James Cooper, the Gamekeeper living at Smith's Lawn Cottages, found her skeleton under some undergrowth on Friday 15th July 1921.

The natural slopes and undulating valleys sweeping down to the lake and covered with an acidic topsoil formed ideal terrain for the landscape gardening planned. The abundance and variety of existing mature trees, such as beech, birch, pine, cedar, redwood, maple, sweet chestnut, oak and the like, was invaluable in providing a natural protection and backcloth to the enormous genus and species of plants to be cultivated there. It was extremely fortunate that a man of great knowledge and experience had joined the estate staff early in 1943. His name was Thomas Hope Finlay L.V.O. V.M.H. He was born on Thursday 21st April 1910, the second son of Robert Findlay, Head Gardener of the beautiful Logan Gardens at Port Logan on the west coast of Scotland. Under the direction of Sir Eric Savill (Deputy Ranger), he was extensively involved in the improvement of The Bog Garden (The Savill Garden) and the tree-felling and replanting on the northern half of The Long Walk during 1943-1945. It is this man who deserves recognition for the establishment of the magnificent Valley Gardens that we see today.

'Hope', as he was generally known, was a true plant enthusiast who had an excellent history in gardening before joining the park as Superintendent. He was trained at several famous gardens, including Luton Hoo and Bodnant in North Wales. He was a contemporary of Millar Gault (Regent's Park and later of the Rose Society), of Bill McKenzie (Chelsea Physic Gardens), Frank Knight (Wisley Gardens) and of Harry Hodson (Victoria & Garden Television Series). By the age of 21 years he had become a Head Gardener. During the development of the Valley Gardens he organised the moving of the famous collection of rhododendrons from Tower Court, Ascot between 1951-1953. In 1958 his title changed to Keeper of the Gardens and, under his organisation, the estate won many prizes at the Royal Horticultural Society shows and the Chelsea Flower shows in London. He personally raised many new species of plants and had the honour of having one of his new rhododendrons named 'Queen Elizabeth The Queen Mother'. His reputation in the horticultural world was fully recognised and he was often called upon to judge at Chelsea, Southport, Shrewsbury and Bristol, to name but a few. Aside from his gardening interests, he was actively involved in the community of the estate, being Chairman of the York Club in the park for many years and Chairman of the park Football Club for fifteen years. The highly successful estate flower show, which is held every year, was started by him in 1953. Hope retired in April 1975 when he was living at Lake Cottage next to Rapley Lake, Bagshot. Later he moved with his wife Margaret to Darville Cottages, King's Road, Windsor, still his residence when he died in October 1994 aged 84 years.

When the clearing of the undergrowth for the gardens was fully underway, I recall standing at the top of the main valley, near the centre of the slopes, and seeing for the first time a clear view of the lake which had previously been obscured - a view that most people take for granted today. As the planting progressed, it was fascinating to see the area being transformed from what was once a virtually impassable jungle into a series of landscaped hills and valleys. Utilising the natural structure of the ground, specific areas were laid out forming individual plant collections. Without question the most stunning and most popular feature is the Punch Bowl. In May and June this attracts thousands of visitors to see the masses of multi-coloured flowers of the Kurume azaleas. The Kurume azalea is so named from the city of Kurume on Japan's southern island of Kyushu, where the azaleas were developed. The plants in the Punch Bowl originated from stock supplied by Mr J.B. Stevenson of Tower Court, Ascot. The chosen area was at the top of a central valley which is shaped like an amphitheatre. Starting in 1946, the undergrowth was cleared and terraced paths were cut around the 'bowl' before the azaleas were planted in groups of 200 plants, each group being of an individual colour. From time to time, the plants are replaced, when they are past their best. The only 'downside' of the azaleas in the Punch Bowl, is that they have no fragrance to match their brilliant colours, unlike larger azaleas such as mollis which have an unforgettable fragrance and are yellow in colour.

Slightly to the north-west, close to the southern border of Smith's Lawn, is the Heather Garden. The garden comprises a collection of *calluna* (heather) and a collection of dwarf and slow-growing conifers. The undulations of the ground are the result of gravel extraction before, and to some extent during, the First World War (1914-1918). The idea for creating the garden came from nature. As the whole disused gravel pit had become covered in wild heather, it did not take much imagination to turn it into a recognisable garden. The work started in 1951 with the clearing and preparation, then the planting of the heather with a few strategically placed conifers, which was completed in 1953. In 1978, the dwarf and slow-growing conifers were added. The conifers have since been designated a National Collection by the National Council for the Conservation of Plants and Gardens.

An area of The Valley Gardens of particular importance and beauty is the Rhododendron Species Collection, situated at High Flyers Hill on the eastern side of Breakheart Hill. Planting started here in 1951, using a magnificent collection of rhododendrons purchased from the widow of Mr. John Barr Stevenson at Tower Court, Swinley Road, Ascot. The collection was the result of a lifetime's

work by Mr Stevenson, who had fully put to use the perfect soil for rhododendrons that existed in his garden. The transfer of the plants from Tower Court was completed in 1953. Since that time, further non-hybrids, similar to the original plants, have been added with a wide range of associated trees, shrubs and herbaceous plants, to provide colour and interest during the different seasons. The Rhododendron Species Collection has been designated a National Collection by the Nation Council for the Conservation of Plants and Gardens. Another area of interest is the holly trees near the bottom of Breakheart Hill. These include a whole range of hollies and were designated a National Holly Collection some years ago.

Before moving on from Breakheart Hill, we should be reminded that a potentially serious accident occurred there on the afternoon of Thursday the 26th August 1915. King George V, Queen Mary and Queen Alexandra were travelling in a motor car down the hill on their way to have tea at the Fishing Temple, when a pony pulling a cart in front of them trod on a large stone and crashed to the ground sending the cart flying. The driver of the cart, Mr Arthur Blake from Old Windsor, was thrown from the cart, and the three children he was carrying were seen screaming, trapped in the cart. Fortunately, the pony's hind legs were tangled in the harness restricting it from kicking the children. The King and Queen pulled up their car to find that, although everyone was bruised and badly shaken, there were no serious injuries incurred by anyone, including the pony. The King sent a chauffeur-driven car for Mr Blake and the children to be driven back to Old Windsor.

Although we can describe some of the important collections in the 93 hectares (230 acres) of The Valley Gardens, it should be pointed out that all parts of the gardens should be visited to really appreciate the extent and beauty of the plants growing there. Whilst the rhododendrons and their 'family offshoots', the azaleas, are the dominant species in the gardens, the magnificent range of camellias, magnolias, shrubs and trees seen everywhere are an unforgettable sight. The joint collection of the magnolias grown in The Valley Gardens and The Savill Garden is designated as the National Collection of Magnolias. Towards the eastern end of the gardens stand several large redwood trees. Unfortunately, the finest specimen was completely destroyed when it was struck by lightning in the early hours of Saturday morning 6th May 1972. The Great Storm of the night of 16th October 1987, which had a devastating affect on the country as a whole, took a serious toll on the trees and shrubs throughout the estate. The Valley Gardens and surrounding area were particularly badly hit. Of the trees stretching from the Cascade

to Wick Road and through The Valley Gardens to Breakheart Hill, the following is a list of the most common trees destroyed:-

442 Conifers (pine, larch and fir)
178 Birch
133 Beech
111 Oak
54 Sweet Chestnut
12 Cedars
11 Quercus (various)
A total of 941.

Add to this the numerous other different trees that were blown down that night, and the total was in excess of one thousand trees lost in this area alone.

Fortunately, the storm occurred when most people were at home, otherwise the human injuries would have been far greater than they were. In the area mentioned, the toilet block at the Wheatsheaf entrance was badly damaged, and the Patrick Plunket Memorial Pavilion was demolished when it received a direct hit by a falling sweet chestnut tree, and had to be rebuilt. The pavilion stands at the top of a valley to the west of the Punch Bowl, and was built in memory of Lord Plunket, who was a friend of Queen Elizabeth II. He was Assistant Master of the Royal Household and a great enthusiast of the gardens. The pavilion was erected during the early part of 1979, and was dedicated by the Queen on Monday 30th April the same year with the words, "in recognition of his service to the Royal Family 1948-1975". He died at the relatively young age of 52 years. The cleaning up operation after the storm was an enormous undertaking, with the roads and drives receiving first attention. Nature can be a great leveller in every sense of the word, it can also be a great restorer, as fifteen years later the gardens are as beautiful as ever.

Over the years, the gardens have attracted thousands of visitors, and it is not uncommon for people to walk from Windsor to see the gardens and the lake. For the less able or less energetic, a car park complete with toilets has been provided near Smith's Lawn Cottages. Entrance to this car park is by way of the Wick Road gate near Cheeseman's Gate, where a nominal charge is made at the automatic barrier. Even before the gardens were created, the area has been a popular spot for walkers, anglers, ornithologists and at one time ice-skaters. From the late 1800s well into the 1930s, it was not unusual to have up to six hundred skaters using the lake at any one time when it was frozen over.

The common fish found in the lake are pike, perch, tench and eels. Fishing in the lake is strictly by permit only, obtainable by application to the Crown Estate Office. During June 1918 the lake and many of the other ponds in the park were subjected to an enormous netting exercise as part of the First World War effort. The fish were taken to the High Street in Windsor where demonstrations were given in their

preparation and cooking, and were then sold direct to the public to raise funds for the Red Cross. For ornithologists, the range of birds seen on or around the lake is extensive. The most common birds are mandarin ducks, this being one of the largest habitats in Europe for these birds. Other ducks are mallard, widgeon, shoveller, tufted, teal and pochard. Also among water-loving birds are swan, goose (various), common grey heron, moorhen, coot, great crested grebe and little grebe. Numerous kingfishers live there with an enormous range of more land-loving birds:- Pigeon, dove, jackdaw, jay, magpie, crow, woodpecker, nuthatch, treecreeper, wagtail, swallow, swift, martin, long-tailed tit, blue tit, coal tit, great tit, chaffinch, greenfinch, goldcrest, wren, robin, blackbird and thrush. Birds of prey include kestrel, sparrowhawk and owl varieties.

Rarer birds occasionally to be seen are:- mistlethrush, redwing, fieldfare, siskin, redpole, bullfinch, nightingale, nightjar, woodcock, cuckoo, warbler (various), brambling, blue heron, bittern, buzzard, hen-harrier, hobby, merlin, white-tailed eagle and osprey. An osprey was actually caught near the bank of the lake in 1864. This was of some comfort to bird lovers, as it was more common in those days to shoot an unusual bird or animal, just to confirm

what it was. Thank goodness that bad practice is now a thing of the past.

Modern modes of transport and the presence of several large parking places near the lake have made the area an extremely popular place to visit, attracting many thousands of people all the year round. In recent years it has become a favoured location for fund raising walks and runs for worthy causes. Permission to hold these events must always be first obtained from the Crown Estate Office, The Great Park, Windsor.

The Totem Pole stands near Wick Pond, at the eastern end of the Canadian Memorial Avenue. The site has been associated with Canada since the First World War(1914-1918) when it was a satellite sawmill to the nearby Canadian Forestry Corps' main base camp on Smith's Lawn. The pole was a gift to Queen Elizabeth II to commemorate the centenary of British Columbia being so named by Queen Victoria in 1858.

The pole was erected on Wednesday 25th June 1958.

An amusing aspect of the pole's presence is to see the look of disbelief on the faces of visitors to the park when they come across the pole for the first time. It is also the most difficult thing to photograph. There must have been thousands of photographs taken with either the top or the bottom of the pole 'chopped off'.

A pair of mute swans on the southern bank of the Lake. (photo by the Author)

The Heather Garden information board. (photo by the Author).

The Heather Garden in The Valley Gardens in May 2000. It is situated near the southern side of Smith's Lawn and was developed from a disused gravel pit in 1951. (photo by the Author).

The Punch Bowl looking east in February 1947 being prepared for the planting of the Kurume azaleas.

297

The Heather Garden looking east in February 1953 showing the young heathers and a few conifers that had recently been planted. On the right in the trees at the rear stand the semi-detached dwellings of 'Heatherside' and 'Heatherbelle' built 1949

A sketch of the Canadian button by the Author. The actual diameter of the button is 24.0 millimetres (0.950 inch)

These items were dug-up in the Heather Garden by gardeners during April 1999. It confirms that it was used as a dumping ground when it was a disused gravel pit from 1914-1918. At the time Smith's Lawn was used as a Camp by the British Army and the Canadian Forestry Corps. The photograph, which was taken by the Author, shows part of a glazed earthenware pot with the wording, Army and Navy Stores Limited 'Junior', Farnboro' Hants. The broken glass bottle is Taylor, Staines. The 'fork', is a converted dessert spoon. Two of the buttons are British Army and the third button is Canadian, presumably worn by the Canadian Forestry Corps.

The Punch Bowl in The Valley Gardens in May 1970 which by now had become extremely popular with the public. (photo by the Author).

The Punch Bowl in The Valley Gardens thirty years later in May 2000. The photograph was taken by the author early in the morning and slightly closer up.

Patrick Plunket Memorial Pavilion in The Valley Gardens in May 2000. (photo by the Author).

The fascinating root structure of an old beech tree near the Patrick Plunket Memorial Pavilion in April 1999. Photo by the Author).

The Valley
Gardens – May
1998 (photo by
the Author)

The Valley
Gardens – May
1998 (photo by
the Author)

The Canadian
Memorial Avenue
on 23rd January
1999, sixty-six
years after the
planting that took
place as shown in
the following
photograph. The
Totem Pole that
was erected on
25th June 1958
can just be seen
at the far end of
the avenue.
(photo by the
Author).

The Canadian Memorial Avenue looking in the opposite direction with the maple trees in full leaf - July 1998. (photo by the Author).

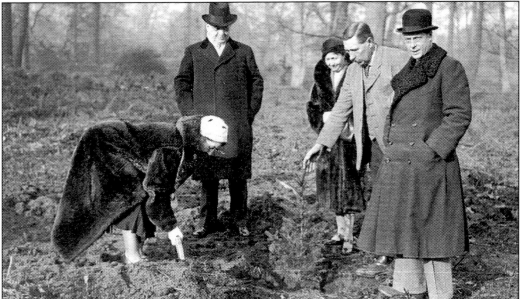

One of seven trees being planted in the Canadian Memorial Avenue on Monday 23d January 1933. The trees were presented to the Prince of Wales by the Canadian Forestry Association. From left to right:- Mrs Burden (with spade) wife of Agent-General for British Columbia. Hon. G.H. Ferguson, High Commissioner for Canada. Mrs Ferguson. Mr. Eric H. Savill, Deputy Surveyor. Prince Edward, Prince of Wales. (Windsor Crown Estate Collection).

After the planting was over on 23rd January 1933, from left to right:- Mrs Ferguson. Mrs Burden. Mr. A.S. Gaye, Commissioner of Crown Lands. Hon. G.H. Ferguson, High Commissioner for Canada. Mr. Eric H. Savill Deputy Surveyor. (Windsor Crown Estate Collection)

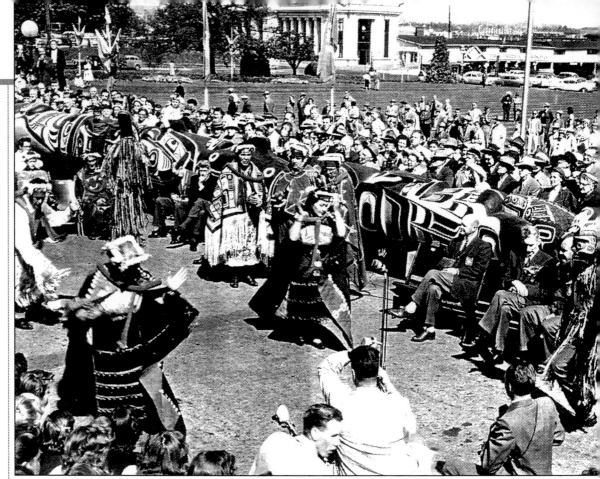

The 'Dance of Dedication' of the Totem Pole in Vancouver a few days before shipment to London. Chief Mungo Martin, the designer and carver of the pole, is facing the camera dressed in his chieftain's ceremonial dress with white tassels. He is standing in front of the totem pole, between where the two white circles are painted. His wife is not far in front of him with her arms raised whilst clapping. (The Royal Borough of Windsor and Maidenhead Museum Collection)

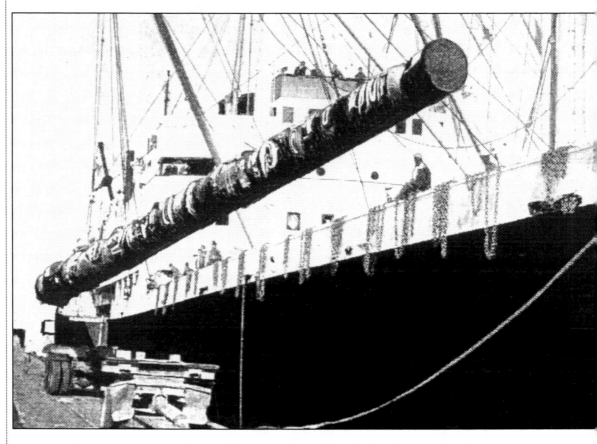

The Totem Pole being loaded onto the 'Pacific Unity' in Vancouver in May 1958 ready for sailing for London. This surely must have been the most unusual cargo the ship's crew would have handled, not forgetting the responsibility of handling it without causing damage. However, the most difficult part of the journey appears to have been getting it through Staines, up Egham Hill and then along Wick Road into the park. Because of the length and concern not to damage the pole, a two hour hold-up was experienced at Staines and it took a further hour to get it into the park.

The formal acceptance ceremony of the Totem Pole by Queen Elizabeth II on Saturday 19th July 1958. The pole had been erected almost a month before on Wednesday 25th June by forty engineers from the Third Field Squadron of the 22nd Field Engineer Regiment, Royal Engineers. It took the engineers over eight hours to erect the pole which entailed raising the pole into a vertical position, then lowering it into a hole six feet deep in a concrete base.

303

Queen Elizabeth II shaking hands with Mr Alec Jacobs (Building Surveyor of the Windsor Crown Estate). The occasion was to mark the completion of the repainting of the pole on Saturday 21 July 1985. The persons, most of which were Crown Estate staff, are, from left to right:- -Tony Chambers, Gary Johns, Gary Adams, Peter Rouse, Philip Hollister, Tony Jenkins, Richard Hunt, Tim Paul, Tony Jacobs, The Queen, Roland Wiseman – Deputy Ranger (in brown suit), Richard Caws – Crown Estate Commissioner (hands in jacket pocket). (Alec Jacobs Collection).

Tim Paul and Richard Hunt are Wood Carvers from British Columbia, the latter being a grandson of Chief Mungo Martin, the designer and carver of the pole.
During the preparation work before repainting, a Royal Engineer Cap Badge was found on the brim of the 'Old Man's Hat', presumably left there from one of the Engineers who had erected the pole in 1958. A record of the repainting of the pole was established by the placing of a 'time capsule' under the lead on top of the pole. The capsule contained the following:- a Windsor Great Park Residents List and Wages Slip, a Daily Mail newspaper and other articles including a list of names of those who had worked on the pole.

Historical and technical details of the Totem Pole that stands near Wick Pond at the eastern end of the Canadian Memorial Avenue in The Great Park.
Designed and Carved by:
Chief Mungo Martin of the Kwakiutl Federation, Vancouver Island, British Columbia.
Weight and Dimensions:
12.05 Imperial tons (27,000lbs). 100 feet high, six feet of which is set in the concrete base.
Material:
A single Western Red Cedar tree trunk, 600 hundred years old from one of the Queen Charlotte Islands.
Features:
The pole has ten different figures, each one represents the mythical ancestor of a clan. The figures from the top of the pole downwards are:- Man with Large Hat. Beaver. Old Man. Thunderbird. Sea Otter. The Raven. The Whale. Double-headed Snake. Halibut Man. Cedar Man. The 100 feet overall length of the pole represents the hundred years from when British Columbia was named by Queen Victoria and proclaimed a Crown Colony on 19th November 1858 to when the pole was erected in the park in 1958.

Transportation:
Shipped from Vancouver on the 'Pacific Unity' and arrived at the London Docks on Thursday 19th June 1958. Brought by barge on the Thames to Brentford, then by road along the A30 through Staines and down Wick Road on Sunday morning 22nd June 1958.
Erected:
On Wednesday 25th June 1958 by the Third Field Squadron of the Twenty-Second Field Engineer Regiment, Royal Engineers. The operation took over eight hours to complete and it had to be ensured, at the same time, that the figures on the pole were facing the Canadian Memorial Avenue.
Acceptance Ceremony:
The formal acceptance of the pole by Queen Elizabeth II took place on Saturday 19th July 1958.
Repair and Repainting:
During June and July 1985, the pole was repaired and completely repainted from top to bottom. Some of the intricate repainting work was carried out by Tony Paul and Richard Hunt who had been flown over from British Columbia to undertake the work. Richard Hunt is a grandson of Chief Mungo Martin the original designer and carver.
Queen Elizabeth II visited the site on Sunday 21st July 1985 to see the transformation of the pole.

Sunninghill Park

Sunninghill Park

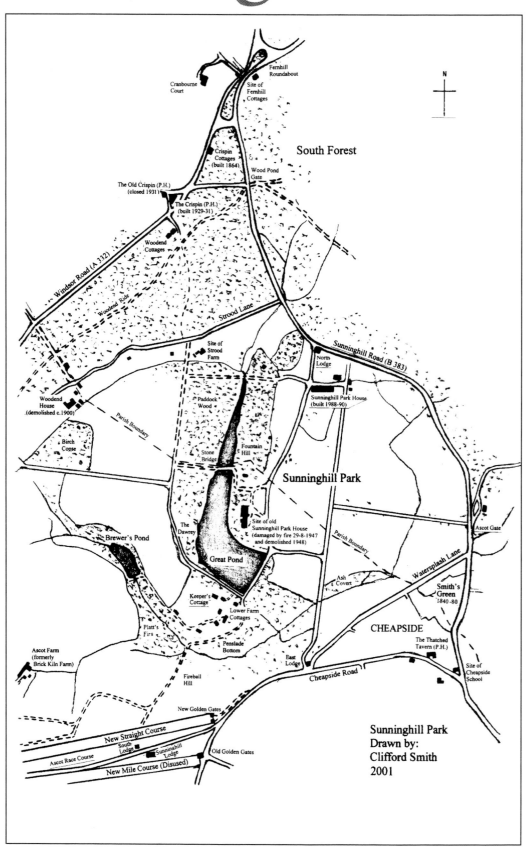

Sunninghill Park
Drawn by:
Clifford Smith
2001

S unninghill Park is situated outside the south-west boundary of The Great Park, with Strood Lane at the north-east and Watersplash Lane and Cheapside Road at the south-east. It extends as far as Winkfield Road, which runs along the side of Ascot Racecourse, making a total area of about 239 hectares (590 acres). Although it currently comes within the Windsor Crown Estate, it has had a checkered ownership history. Even its boundary has changed with the area increasing from 191 hectares (472 acres) when it was sold in 1630 to 270 hectares (668 acres) in 1936. It has since been reduced to its current size.

It was originally enclosed as a park within Windsor Forest in 1377 for King Edward III, mainly as a deer holding area for hunting purposes. It remained as Crown Land until 1630 when it was sold to its first private owner, Sir Thomas Carey. The private owners, and the years of their ownership, are as follows:-

1630-1654	Sir Thomas Carey
1654-1703	Sir Thomas Draper
1703-1765	Sir John Baber
1765-1769	Sir Thomas Draper Baber
1769-1805	Jeremiah Crutchley
1805-1868	George Henry Duffield Crutchley
1868-1878	Percy Henry Crutchley
1978-1898	General Sir Charles Crutchley
1898-1936	Percy Edward Crutchley
1936-1940	Philip Hill (later Sir Philip Hill)
1940-1945	Repurchased by the Crown

Fate played a heavy part for Philip Hill during his ownership. Having purchased the estate from Percy Edward Crutchley in 1936, he spent a considerable amount of money on improvements to the mansion. No sooner had he completed the work when the building was requisitioned by the War Office in 1940 for the duration of the Second World War. The use of Sunninghill Park as a military base is described in Chapter 18.

The Mansion was situated in a fairly central position in the park, standing a short distance away from the north-eastern bank of the Great Pond. During its lifetime, it has been almost completely rebuilt and altered, according to the tastes and financial position of its various owners. The 'death-knell' came to the mansion when it was extensively damaged by fire on the Friday night of the 29th August 1947. At that time it was undergoing an enormous amount of work by contractors, who were preparing it as a residence for Princess Elizabeth and Lieutenant Philip Mountbatten (later Queen Elizabeth II and Prince Philip, The Duke of Edinburgh) who were shortly to marry, on 20th November that year. There was much speculation as to how the fire had started. It has been confirmed since that it was an act of arson by some of the soon to be evicted residents of the huts scattered around the park to serve as wartime accommodation. It should be remembered that many of those people had just returned from the war and were desperate for somewhere to live, They were hard times indeed! An accidental fire in 1942 destroyed a large part of the roof and was repaired, whereas the damage caused by the 1947 fire was not. After several years of debate as to what to do with the mansion, it was decided that it should be demolished and the contract for the work was given to Bill Howlett, a specialist in demolition work. The work was started in 1952. My brother, Stanley Smith, who worked for Howlett on a casual basis, was staggered by the quality of the interior materials used in the house. Most of the timber was solid teak and the main toilet and bathroom was made of marble. The door knobs were made of cut glass. Such was the magnificence of the interior of the twenty-five room mansion that the process of pulling it down was soul-destroying. It was never rebuilt.

Altogether there have been four entrances to the park. 'North Lodge' and gate stands on the brow of a hill on the Sunninghill Road. 'East Lodge' and gate stands on Watersplash Lane at Cheapside. 'South Lodge' and gate ceased to be an entrance when the New Straight Mile on the racecourse was created (1954-1955). The fourth gate was at the junction of Windsor Road and Winkfield Road. The gate lodge was known as 'Shepherd's Corner Lodge' and has since been renamed 'Old Mile Lodge', after the road junction was changed in the 1950s placing the lodge within the confines of the racecourse. Contained within the park are three farms, complete with associated houses and farm buildings. At the south-western side of the park, near the racecourse, is Ascot Farm. It was formerly known as Kiln Farm having evolved from a small disused brick works. In a central position at the south of the park is Lower Farm and, in the north bordering Sunninghill Road is Home Farm. Until recent years, another farm stood to the west of this, known as Strood Farm. The site of Strood Farm lays in a lush green valley running in a south-westerly direction and bordering a wide strip of Windsor Forest appropriately known as Wood End. Travelling along the side of the forest is an old track known as Strood Lane and, although it is now devoid of buildings, it was not always so. In the 1800s, it was on the point of becoming a hamlet with at least ten buildings occupied along the valley. In a central position stood the farm buildings and, further down the valley, there is a ride that runs through the forest along the Sunninghill Parish and Winkfield Parish

boundary, coming out onto Windsor Road. It is where this ride starts in the valley that a substantial house stood until about 1900. It was named 'Woodend House', and it was second in size and in importance to Sunninghill Park Mansion. For many years, during the time that Sunninghill Park was owned by the Crutchley family, it was the home and office of the estate Comptroller (financial manager). In the 1860s the people living in the house were as follows:- two comptrollers, one footman, one coachman, one servant, one housemaid and one kitchenmaid. The only surviving house in this area is 'Cherry Orchard Cottage', on the eastern ridge of the valley.

Great Pond, which is situated on the south-west side of the site of the mansion, is the largest pond in Sunninghill Park. It was originally created as three smaller ponds by damming up the existing stream. About 1788, during the ownership of Jeremiah Crutchley, the head of the lower pond was considerably increased in height and girth, and completed with a substantial drive running along the top. After the work had been completed, the water level of the three ponds was encouraged to increase to form a single large crescent-shape. The overall length of the pond thus created is about 900 metres (984 yards) and the width at the head is 190 metres (208 yards). The water depth at the head is 9 metres (29.5 feet).

During the 1860s, a single arched stone bridge was built over the pond where the head of the top pond once stood. One of the stone blocks is inscribed 'PROPOSITI TENAX', meaning 'firm in purpose'. In 1989, the pond was drained of most of its water to allow the head to be rebuilt, to comply with an Act of 1974 which had been introduced in order to reduce the possibility of flash-flooding. As the water was drained, the fish in the pond, which mainly consisted of common carp, were netted and placed in a 'lagoon' that had formed to the north of the stone bridge. During a two day period, four tonnes of fish were netted, mainly by the efforts of the Crown Estate staff. The draining of the pond revealed some of its history, including, most interestingly, the head of the original middle pond, complete with a brick built culvert and timbers of the sluice. A small lead cannon ball was found, along with a more extraordinary and much larger item of more recent times - an almost complete American Army Jeep, which had obviously been dumped in the pond while the park was an American Military Base during the Second World War.

Across a field to the west of the Great Pond is Brewer's Pond. It was created centuries ago by damming up an existing stream. It is the last remaining counterpart of two similar ponds that were situated downstream nearly two hundred years ago. The old pond heads are still clearly visible in the undergrowth in the wood known as Platt's Firs. Brewer's Pond has three evenly-spaced circular islands built on it, making it a perfect habitat for wild ducks. The pond is about 130 metres (142 yards) long and about 65 metres (71 yards) at the head.

In a south-easterly direction, near the south-western side of the Great Pond, are the Lower Farm buildings and cottages. Close by is Keeper's Cottage, which is a bungalow built on the site of a much older building knocked down about 1980. The older building was more often known as Gamekeeper's Cottage and, as the name suggests, it was the home of the Sunninghill Park Gamekeeper. At the entrance to the cottage were the Gamekeeper's Dog Kennels which still exist today. The Pheasantry (for rearing young pheasants) that stood near the old building no longer exists. It was the old building that played an important part in my family's history. From 1873 to 1911 - a period of 38 years - my great uncle, William Thomas Smith, lived there as gamekeeper for the Crutchley family. During that time, William and his wife Esther's seven daughters and four sons were born and raised there. The family was struck a mortal blow in 1906 when their son, John Owen Smith, who was only 16 years 7 months old at the time, was killed in a shotgun accident. On a very cold Wednesday afternoon 21st February 1906, John, who was nearly six foot tall, set off to shoot pigeons with a single bore shotgun that his father had bought him. He was jumping over the stream in Platt's Firs Wood, below Brewer's Pond, when his gun went off. He died immediately from wounds to the head. The inquest was heard in The Thatched Tavern public house in Cheapside Road on Friday 23rd February 1906. The jury passed a verdict of accidental death. The shock of losing his son, so young and so tragically had a serious affect on my great uncle's health and he passed away five years later in a nursing home. One of the jurors at John's inquest was Mr. J.R. Toms, whose own family was to be involved in a tragic shooting accident in Sunninghill Park twenty-six years later.

The Gamekeeper who succeeded William Smith in Gamekeeper's Cottage was William James Benstead, who was born the son of a gamekeeper in Windsor Great Park. His world fell apart on Saturday 23rd July 1932 when he had been alerted just before noon that something was making the pheasants unsettled in the area. In the undergrowth nearby he saw what he thought was the movement of an animal. When he fired at it, a loud scream was heard. To his horror, he discovered it was Kenneth Toms, who had been in the habit of 'losing himself' in the park. Kenneth was a 15 year old pupil at the Windsor County Boys School and the only son of Benstead's best friend, Ernest William Toms, the carpenter on the estate. As soon as the extent of Kenneth's injuries was realised, he was rushed off to King Edward VII Hospital, Windsor. On 19th August, four weeks after the accident, he was discharged from the hospital when he appeared to be improving. On Sunday 4th September, he was attending a service at the Wesleyan Church in nearby Cheapside Road when he suddenly collapsed, and never regained consciousness. During the inquest, which was held at the Windsor Police Station on 8th September, it was stated that two pellets had entered the deceased's head causing cerebral haemorrhage.

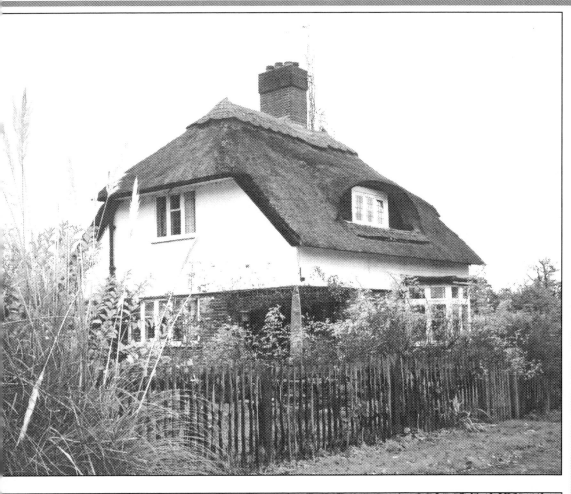

Sunninghill Park North Gate Lodge in Sunninghill Road. (photo taken in October 2000 by the Author).

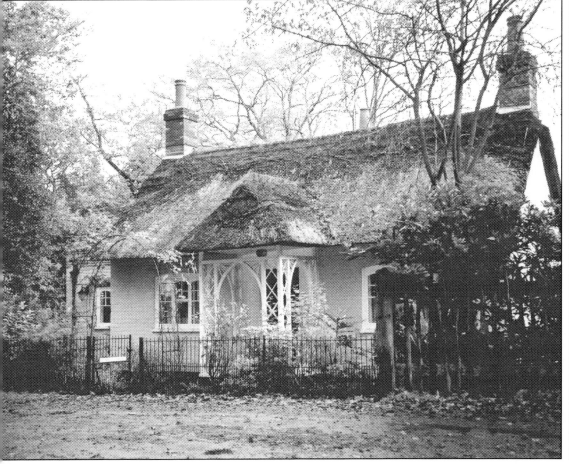

Sunninghill Park East Gate Lodge in Watersplash Lane. (photo taken in October 2000 by the Author).

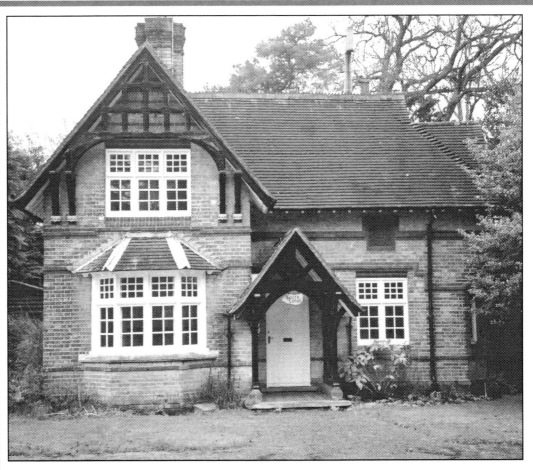

Sunninghill Park South Gate Lodge in New Mile Road. It became isolated in 1954 when the new straight mile course was created. (photo taken January 2001 by the Author).

Sunninghill Lodge situated on the northern side of the disused straight mile course. It was built by Percy Edward Crutchley of Sunninghill Park during 1890-1891. He died there on the 16th of October 1940. It is now under the control of the Ascot Authority. (photo taken January 2001 by the Author).

The Water Splash,
Cheapside, Ascot,
the road used for
centuries as the
royal route for the
Royal Ascot
Processions
c.1930.

Sunninghill Park
Mansion in 1769.

311

Sunninghill Park Mansion in the winter c.1930 as photographed from the far bank of the Great Pond.

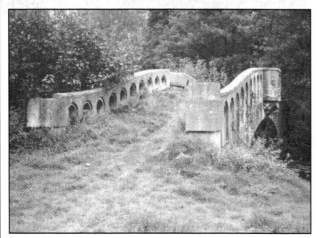

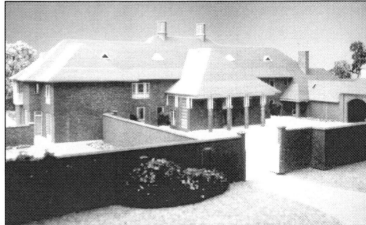

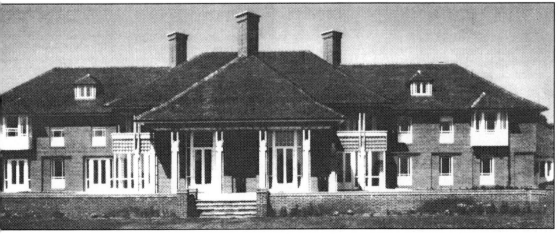

(Far left) The Stone Bridge which spans the Great Pond as seen in June 2000. Gone are the days when it was regularly kept free of vegetation and used for the purpose intended. (photo by the Author).

(Middle) An architect's model of the new Sunninghill Park House. (By kind permission of Prince Andrew, the Duke of York.)

(Left) The new Sunninghill Park House photographed soon after completion in 1990.

Doris Winchester standing above a culvert that was revealed when the Great Pond, Sunninghill Park was drained for major work to the pond head during 1987-1989. Quite extraordinarily this was possibly the first time that the culvert had been exposed since the pond had been made into one from three existing ponds, about 200 years ago.

Part of the new water level control system being built at the head of Great Pond, Sunninghill Park in 1988-1989. (both photos - collection of retired gamekeeper, Bert Winchester)

Brewer's Pond in Sunninghill Park – March 1999. The old tree trunk and its reflection gives the image of an alligator about to strike (photo by the Author).

Before we move on to the happier events that took place in Sunninghill Park, there is one more unimaginably sad event to report that occurred there in 1919. On Tuesday evening, 2nd September 1919, Edward William Sarney, an 18 year old from Woodside, and Emily Mason, an 18 year old from Ascot, who had recently started going out together, were seen walking together on one of the public footpaths that goes through the park. Early next morning, Charles Cordery, a young gardener working on the estate, noticed a hat and a cap near the bank of the Great Pond. Shortly afterwards the bodies of the couple were found in two metres of water. An examination of the spot found that a part of the bank had broken away and, as there was no evidence of any struggle, it appeared to have been a tragic accident.

Although there were four private owners of Sunninghill Park before 1769, it was not until the Crutchley family arrived in that year that the park became established as a place of benevolence more integrated with the activities of the local communities. The Crutchley family were land owners who treated their employees with great respect. It was a reputation that they brought with them from their main estate at Syston, near Grantham in Lincolnshire. When the first member of the family to own the estate, Jeremiah Crutchley, who was for some years a Member of Parliament for Horsham, died unmarried in 1805, it was passed on to his nephew George Henry Duffield, who took on the name of Crutchley in 1806. He became the Sheriff of Berkshire in 1807, as his uncle had done in 1773. By the 1850s, the staff who were living and working in the mansion were: one butler, two footman, one coachman, one groom, one housekeeper, one ladies' maid, two housemaids and one kitchen maid - who happened to be Mary Beesley, the sister of my grandmother. It was her first work after leaving school. In 1868, when George Henry Crutchley died, his eldest son, Percy Henry Crutchley, inherited the estate. He also served as the Sheriff of Berkshire and, when he died unmarried in 1878, the estate was passed on to his brother, General Sir Charles Crutchley, who had started his military service with the Royal Welsh Fusileers. He rose through the ranks progressively, eventually taking command of the army in Gibraltar, and becoming a General in 1877. During his travels whilst on military service, he married Eliza Mayfield in Canada in 1851 and their first child, Julia was born there. Their first son, and heir to the estate, Percy Edward Crutchley, was born in Kings County (now Offaly County), Eire in 1855. They had two other sons and two other daughters, all born in different places. Percy Edward Crutchley was educated at Harrow School and Trinity College, Cambridge. Upon leaving Cambridge, he dedicated his time to agriculture, arboriculture, law and, of course, running the estate - which by now included land and property

Great Pond in Sunninghill Park – March 1999. (photo by the Author).

outside the boundary of Sunninghill Park. The revenue from this land and property, which included farms that had been let out in the park, helped to maintain the estate in a sound manner. Percy Edward was a very busy person who sat on numerous committees, including the Royal Agricultural Show Committee which organised the show held in The Great Park in 1889. A photograph of him and the other officials taken at the show is shown in Chapter 2. The next year he married Frederica Louisa FitzRoy, who had been a lady-in-waiting to Queen Victoria, upon which he immediately had a house built at the southern border of his land at the side of the New Mile Course of Ascot Racecourse. The new house was named 'Sunninghill Lodge'. When his father, Sir Charles, died in 1898, the estate was passed on to him and he continued to live there, except for those few occasions when he stayed at the Sunninghill Park Mansion. The mansion was by now being let out on a regular basis to some of the country's prominent and wealthy people.

During the 1800s, the Crutchley family were extensively involved with, and regular visitors to, the local schools at Cheapside, Sunninghill and Ascot. A half day holiday was given to the schoolchildren in July every year to attend the Annual Forestry Fete that was held in the park. Each November, the children were also invited to the Annual Tea Party, held in the mansion. Not to be outdone, Joseph Savory, who lived at nearby Buckhurst Park, would invite the local children to see a Magic Lantern Show in his barn at Christmas. In the 1900s, while the mansion was being let out to its various residents, Sunninghill Park continued to be the focal point for many notable functions. A particular occasion of interest was the Grand Gala and Fete held there on Saturday afternoon 20th August 1921. It had been laid on by then residents, Mr and Mrs Benjamin Guinness, to raise funds for the Church Army Organisation, who ran nine homes for children who had lost their fathers during the First World War. The Duke of Connaught opened the event, which was attended by many senior ranking military

officers and members of the Royal Family:- Crown Prince of Sweden, Princess Helena Victoria, Princess Ingrid, Prince Gustaf Adolf, Prince Sigvard, Prince Bartil and Prince Carl Johan and the children of the Crown Prince of Sweden. Along the main drive, a guard of honour was formed by men of the Royal Berks Regiment and men of the Royal Air Force. Several thousand people from all walks of life turned up for the event, which included baby shows, military boxing matches and gymnastic displays. In addition, the Royal Air Force Depot at Ascot carried out their swimming and athletics championships during the day to add to the entertainment. The swimming events were held at the Great Pond, and the athletic events in a field to the north of the mansion. A five mile race was held for entrants from the public. Although the weather kept reasonably fine during the day, there was the inevitable shower when everyone was sitting down at the tea party. The day ended with a grand firework display.

Having sold the estate to Philip Hill in 1936, Percy Edward Crutchley, who by now was starting to feel his age, decided in the same year to resign his chairmanship of the Windsor Divisional Magistrates, a position he had held since 1882. He continued to serve on the Bench until he died, on Wednesday 16th October 1940 aged 85 years. His only son was Commodore Victor Crutchley, who was awarded the Victoria Cross for the gallant part he took in the blockade of Zeebrugge, Belgium on the night of 22nd April 1918 to prevent access to German submarines. The War Office took advantage of the fact that Victor was on active service at the time of his father's death to requisition the estate, and the one hundred and seventy-one years of ownership by the Crutchley family sadly came to an end.

During the short period of ownership by Philip Hill when he extensively improved the mansion, he had a walled garden complete with greenhouses and coldframes built at Home Farm. He also had a house built there for the gardener. Following the use of the estate by the military forces during the Second World War, it was repurchased back by the Crown from Sir Philip Hill's widow. Sir Philip Hill, as he was then known, had died in 1944. The affects of the use as a military base, as described in Chapter 18, had been dramatic. In short, it was a mess. The temporary huts left behind by the military were immediately occupied by people desperately looking for

a roof over their heads. The unrest in the area had a major part to play in the demise of the mansion described earlier in this chapter. An uneventful time followed the demolition, with the walled garden being let out to Blom's Nursery for a period of time. In the 1960s the Great Pond became a favourite place for water-skiing with Princess Margaret, The Princess Royal and her friends.

Sunninghill Park suddenly came back into the headlines in 1987, when Prince Andrew The Duke of York and The Duchess of York decided to make the northern area of the park their home. This required a new house to be built. Simple? Not so, for when the application was submitted for approval, Berkshire County Council refused permission on the grounds that it was Green Belt land. The local Bracknell District Council Planning Committee were not so uncompromising, and were prepared to waive some of the stringent Green Belt conditions. The whole issue became the subject of a somewhat embarrassing saga in the national newspapers and on television. Approval was finally granted in November 1987, much to the delight of the Duke and Duchess of York, and building work on the sixteen bedroom house started in the early part of 1988, on the site of the northern end of the walled garden, which by now, had become derelict and overgrown with brambles. The house completed in 1990 was designed by Law & Dunbar-Naismith Partnership of Edinburgh, and built using conventional 20th century materials by Simons of Ipswich.

Between the northeastern boundary of Sunninghill Park and Windsor Road is a pine plantation known as Wood End Plantation. It is part of Windsor Forest and Crown Estate and stretches from the Fernhill Roundabout to Winkfield Road at Ascot Racecourse. The Fernhill end is separated by a public road forming a wooded triangle. Facing the Winkfield Road, within the triangle, are two semi-detached houses built in 1864 and known as Crispin Cottages. On the other side of the dividing road in the main part of the plantation, almost opposite the Crispin Public House, are four semi-detached houses known as Woodend Cottages, built in 1936. Although The Crispin Public House is not part of the Windsor Crown Estate, it should be mentioned as it is a major part of the character of the area. More importantly, it has always been my favourite pub to have a 'jar' in, particularly on a beautiful evening, while watching the traffic go by. The current Crispin was built 1929-1931, in front of the old Crispin Inn, on what was the small triangular Woodside Green. In 1931, the old Crispin, which still stands, was converted into a private dwelling. Both Crispins have been the calling place of many Ascot racegoers over the years. Some to drown their sorrows, others to celebrate their success, depending on their fortunes at the races.

Ascot Heath

Chapter
16

Ascot Heath

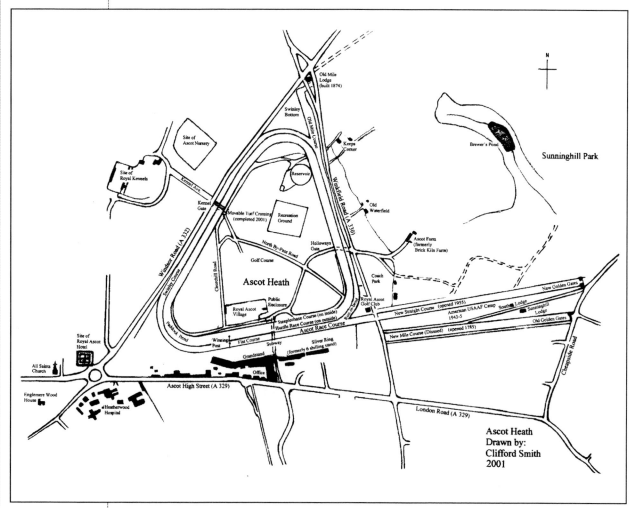

Ascot Heath
Drawn by:
Clifford Smith
2001

A scot Heath is a triangular area of heathland situated in a fairly central position on the Windsor crown Estate on the western side of Sunninghill Park. It was part of a much larger area in times gone by, known as Ascot Common. For one week every year it receives national and international attention, when it becomes the stage for an extraordinary equestrian event attended by the Royal Family, known as Ascot Week.

Although horse racing is what the heath has become most recognised for, it has been used for many other sporting and non-sporting activities, including golf, cricket, athletics, pugilism (barefist fighting) as well

as being the site of military camps. In recent years the heath and buildings have been the scene of conferences, wedding receptions, craft fairs, fundraising events and the like. This wide range of activities will be more fully described later in this chapter.

Horse racing was formally introduced to the heath during the reign of Queen Anne. It was through the Queen's love of horses that she became directly involved in the first races at Ascot. At the time there was a racecourse nearer to Windsor Castle, on Datchet Mead, which was patronised by the Royal Family. Though it was on her doorstep, it did not have the same attraction as Ascot Heath and the beautiful rides that she had established through the Great Park and forest to ride there. It was due to her love of this area of Windsor Forest that she had the kennels built there for the Royal Buckhounds during her reign 1702-1714.

The very first announcement that racing was to take place on the heath was printed in *The London Gazette* dated 12th July 1711. It appeared as a form of advertisement as follows:-

"Her Majesty's Plate of 100 guineas will be run for round the new heat on Ascot Common near Windsor, on Tuesday the 7th August next, by any horse, mare or gelding being no more than six years old the grass before, as must be certified under the Hand of the Breeder, carrying 12 stone, three heats, to be entered the last day of July at Mr. Hancock's at Fernhill, near the Starting Post".

Note:- In the early days of racing, a race consisted of three heats. The best horse in two of the heats was declared the winner of the race.

It was planned to hold a race the day before, on Monday 6th August, for fifty guineas. However, for some unknown reason these events were postponed until Saturday 11th and Monday 13th August. What is very significant about that very first advertisement is the location of the Starting Post near Fernhill. It follows that the start of the races was most probably where Woodend Cottages now stand in the pine plantation opposite The Crispin public house. It must be borne in mind that the Old Crispin, with the well on its small front green, was a popular meeting place for horse-riders, as well as a stop-off for carriages, at the time. Furthermore, the pine plantation that now leads up to Ascot Heath did not exist when the first races took place. Although the winner of the first race is not recorded, it is known that the race was watched by Queen Anne and her Court, and that seven horses competed for the fifty guineas prize. They were named:- Dimple, Doctor, Flint, Grey Jack, Grim, Have-it-all and Teague. The race on the Monday, which was also watched by the Queen, featured four horses only.

On Monday 17th and Tuesday 18th September that same year, two more races were held. The early race meetings at Ascot consisted of only one race (three heats) on any one day. The fact that Queen Anne attended virtually every meeting helped to lend more importance to the events and the prize money increased accordingly. The death of Queen Anne on 1st August 1714, at the relatively young age of 49 years, jolted the racing fraternity at Ascot, and a meeting fixed for two weeks later was cancelled. Since 1930, the first race of the Royal Meeting has been named 'the Queen Anne Stakes' in her honour.

For the next six years following the death of Queen Anne, there appears to be no racing at Ascot. In 1720 racing was resumed, initially only for horses that had hunted with the Royal Buckhounds. It should be pointed out that racing at Ascot was under the control of the Master of the Buckhounds from Queen Anne's time until the death of Queen Victoria in 1901. It was King Edward VII who abolished the Royal Buckhounds and from that time

on the Sovereign has appointed a Representative to look after the racecourse.

By the 1740s, the way some of the race meetings were being conducted in England, and the gambling and seedy characters being attracted, necessitated the introduction of an Act of Parliament to address the situation. The main wording described it as "an Act for the more effectual preventing of excessive and deceitful gaming," stating: "small prizes or sums of money had contributed very much to the encouragement of idleness, to the impoverishment of many of the meaner sort of subjects of this kingdom and the breed of strong and useful horses hath been prejudiced thereby." A further Act in 1745 was mostly devoted to controlling the playing of cards at race meetings. The Acts brought an end to many of the smaller racecourses in the country, and Ascot was very close to being one of them. In 1746 the racecourse was saved from extinction when Prince William Augustus, first Duke of Cumberland came to live at the Great Lodge (later named Cumberland Lodge) in the Great Park. He was an enthusiastic lover of horses and was responsible for the raising of the outstanding racehorse named 'Eclipse' at Cranbourne Tower. What was rather extraordinary about this saviour of the meetings, was that he had a reputation for brutality, and he was an impulsive and heavy gambler, which was rather ironic in view of the Acts that had been recently passed.

During the Duke's involvement prior to his death in 1765, the racecourse was improved and starting posts were erected at Shepherd's Corner (now known as Swinley Bottom) at the beginning of the mile curved course, and some basic wooden stands and stalls were built on the site of the current stands. At that time the meetings were getting longer, to almost a week in duration and the month of June became the most popular time of the year to hold races. Thus we saw the formation of what was to become known as Ascot Week. In 1772, the Gold Cup race at Ascot was inaugurated, the conditions of which were different from those of the prized Ascot Gold Cup established in 1807. Prince William Henry, Duke of Gloucester named the races the 'Windsor and Ascot Heath Races' in 1772. The next year, he modified the title to Windsor Races, Ascot Heath. Thankfully the titles did not stick. In 1785, the first Straight Mile Course was created and in 1793 the first permanent building, the Slingsby Stand was erected.

The 1800s saw the full establishment of the Ascot Races, which soon became increasingly popular not just with the Royal Family but also with the general public. From the beginning of the 1800s, the first day of racing was fixed on the Tuesday, and was attended by the Monarch or a senior member of the Royal Family.

Ascot Racecourse looking west from the stands in July 2000. (photo by the Author).

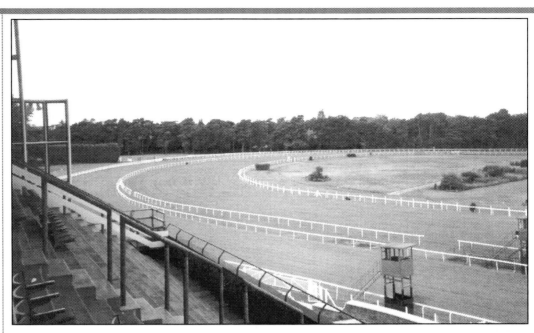

Ascot Racecourse looking east from the stands in July 2000 (photo by the Author).

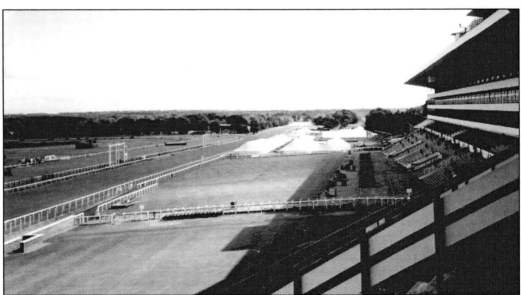

Ascot Racecourse looking over the heath from the stands in July 2000. (photo by the Author).

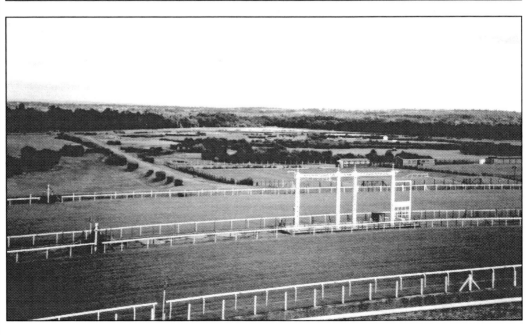

Ascot Racecourse stands in July 2000 (photo by the Author).

The Old Mile Lodge at Swinley Bottom. It was built in 1874 a a lodge at the western gate of Sunninghill Park. The lodge became isolated in the 1950s when the junction between the Winkfield Road and Windsor Road was changed to improve the safety of the crossroad junction. (Photo taken in March 2001 by the Author).

The original Golden Gates and Lodge. They were built during 1877-1888 and ceased to be used in 1955 when the New Mile Straight Course and the new Golden Gates were completed. (photo taken in June 2000 by the Author).

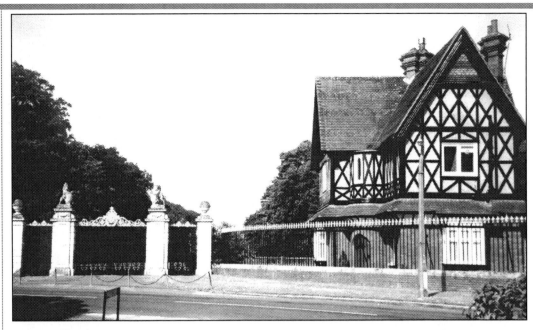

A modern day stretch limousine arriving with racegoers at Ascot Racecourse on Gold Cup (Ladies Day) Thursday 2lst June 2001. (photo by the Author).

A 1920s taxi in Ascot High Street on Gold Cup (Ladies Day) on Thursday 21st June 2001. (photo by the Author).

A group of happy racegoers outside the main entrance of Ascot Racecourse on Gold Cup (Ladies Day) Thursday 21st June 2001. (photo by the Author).

A group wearing more unusual hats and quenching their thirst in glorious weather in the Silver Ring on Gold Cup (Ladies Day) Thursday 21st June 2001. (photo by the Author).

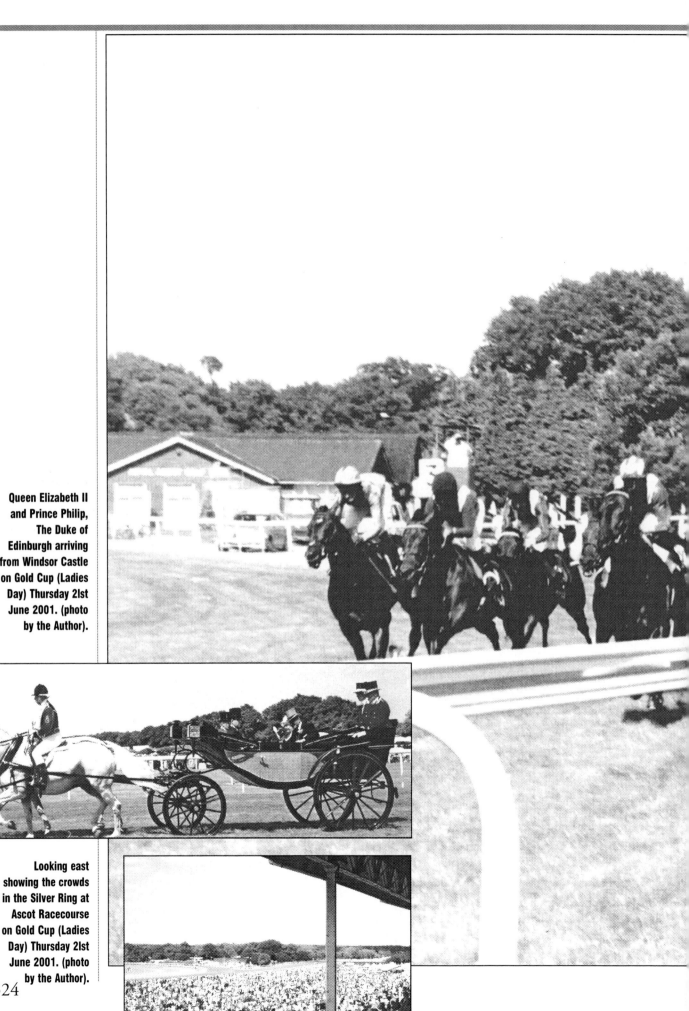

Queen Elizabeth II and Prince Philip, The Duke of Edinburgh arriving from Windsor Castle on Gold Cup (Ladies Day) Thursday 2lst June 2001. (photo by the Author).

Looking east showing the crowds in the Silver Ring at Ascot Racecourse on Gold Cup (Ladies Day) Thursday 2lst June 2001. (photo by the Author).

324

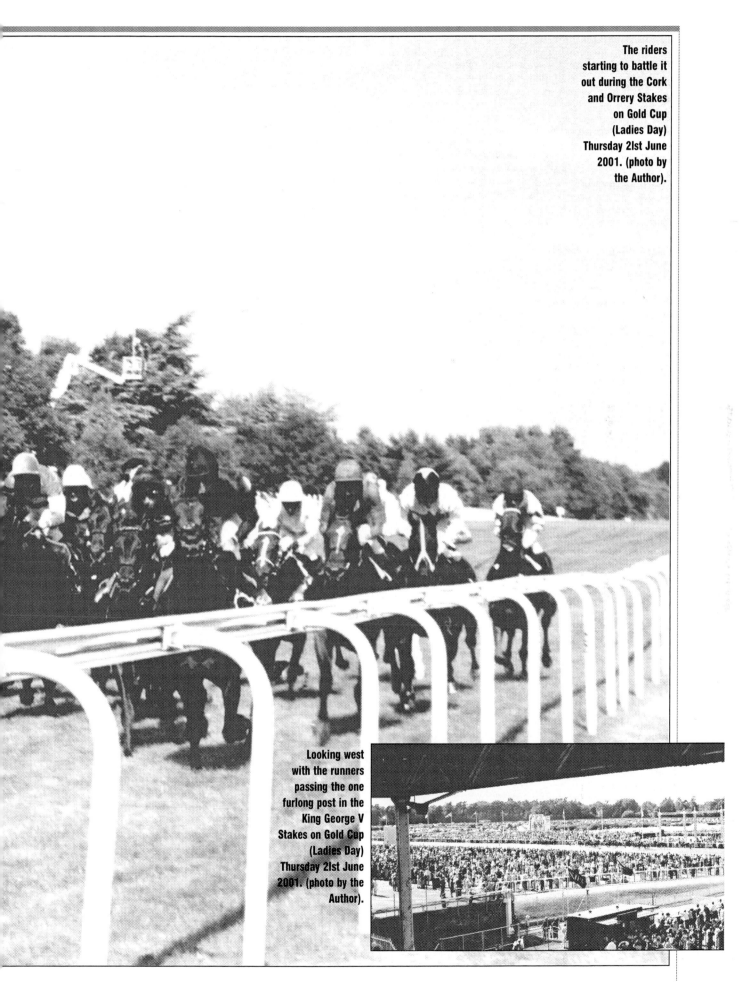

The riders starting to battle it out during the Cork and Orrery Stakes on Gold Cup (Ladies Day) Thursday 21st June 2001. (photo by the Author).

Looking west with the runners passing the one furlong post in the King George V Stakes on Gold Cup (Ladies Day) Thursday 21st June 2001. (photo by the Author).

325

Queen Elizabeth II waiting to present The Gold Cup in the 1990s. (The Ascot Authority Collection).

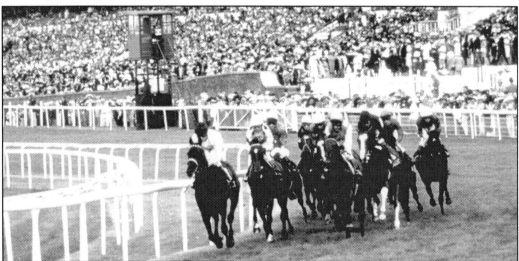

The rider coming round the Paddock Bend in The Ascot Stakes on Wednesday 16th June 1999. (The Ascot Authority Collection).

Queen Elizabeth (later The Queen Mother), Princess Elizabeth (later Queen Elizabeth II) and Princess Margaret entering the Old Golden Gates in 1951.

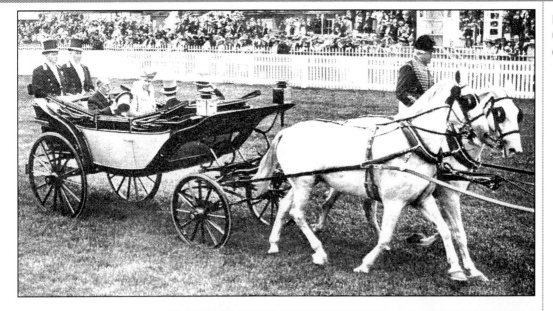

King George V and
Queen Mary
c.1933.

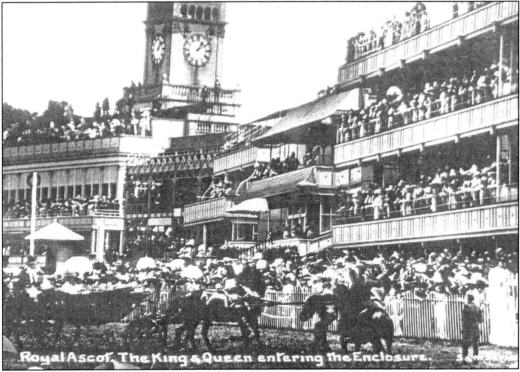

King George V and
Queen Mary
entering the Royal
Enclosure c.1911

Royal Ascot. The King & Queen entering the Enclosure.

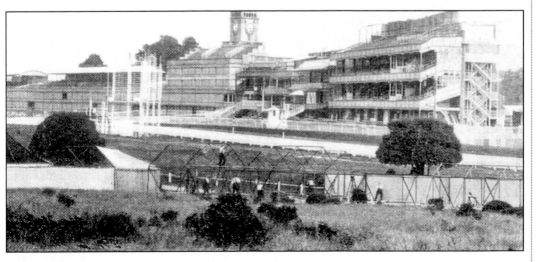

Royal Ascot being
prepared in 1935.

William (Willie) Hunter Fisher Carson OBE, well known as a top jockey and since his retirement in 1997, as a racing pundit with the BBC. Willie was born on 7th April 1942 in Scotland and rode his first winner in 1962. During his illustrious career he was the Champion Jockey in 1972, 1973, 1978, 1980 and 1983. He won many classic races including the Ascot Gold Cup on Little Wolf in 1983. In total, he rode 3,828 winners, of which 18 were Classics. Here he is seen in Ascot High Street on his way to the races on Gold Cup (Ladies Day) Thursday 2lst June 2001. (photo by the Author).

The Royal Ascot
Hotel – c.1900.

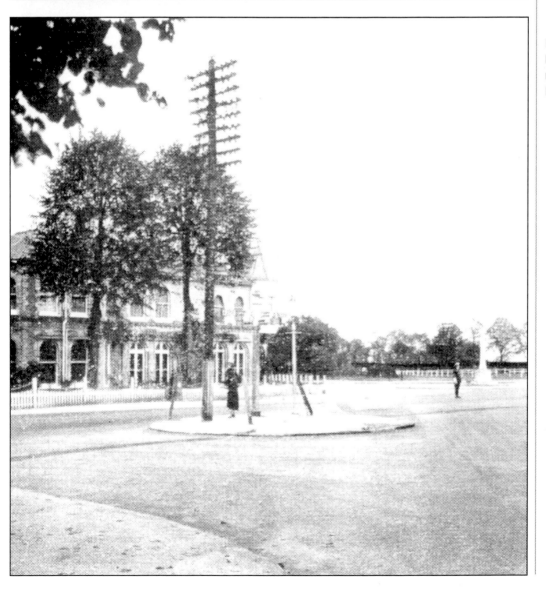

The Royal Ascot
Hotel in 1935
looking across the
roundabout from
King's Ride.

ASCOT HEATH — MEMORANDUM
ASCOT HEATH

Pursuant to a Resolution passed by the Sunninghill Parish Council in the year 1950 an examination has been carried out by the solicitor to that Council of the various Acts of Parliament and the other available evidence relating to the alleged rights of the Public to over or upon Ascot Heath.

An examination has been made of (a) the Acts passed on the 21st July 1813, 28th June 1815 and 11th July 1816, (b) an Enclosure Award made in 1817, (c) the evidence given at a meeting of Parochial Electors held at Sunninghill on the 20th November 1912, (d) the evidence given at a Public Enquiry held at Sunninghill by the Windsor Rural District Council on the 19th December 1912, (e) the Ascot Authority Act 1913, (f) the minutes of the Windsor Rural District Council, (g) the Rights of Way Act 1932 and (h) the General Law relating to the enclosing of open spaces and of the rights of the public to wander thereon. The clear and certain conclusions flowing from such examination are:

1. Ascot Heath is an enclosed space and the Public have no legal rights to over or upon it.

2. No rights of way can be claimed against the Crown as the owner of the land nor against the Ascot Authority as the Lessees of the Crown.

3. The only right of way which the Crown can and does admit is the footpath passing from Winkfield Road to the Golden Gates and running parallel with and on the South side of the New Mile.

With a view to resolving for all time the question of the alleged rights of the public to over and upon the Ascot Heath and to put an end to all such doubts in relation thereto, meetings have taken place between the Solicitor to the Parish Council—the Solicitors acting for the Ascot Authority—and the Commissioners of Crown Lands, and it has been decided:

(i) That notwithstanding the clear and certain conclusions referred to above, the Ascot Authority with the approval of the Commissioners of Crown Lands agrees that except on race days and on such days before and after race days and on such other days as the Ascot Authority may consider necessary the public shall be privileged to enjoy the amenities of Ascot Heath to the extent that they may walk thereon and use the pathways and may enjoy the advantages of playing fields and the like. Such privileges are in no way to constitute any legal rights whatsoever.

(ii) These privileges can be revoked at any time by the Commissioners of Crown Lands or the Ascot Authority but prior notice of any revocation will be given to the Parish Council.

(iii) In return for such privileges the public are expected to preserve the amenities afforded to them and to refrain from doing damage.

(iv) Without in any way being obliged to do so. the Ascot Authority intend as a matter of courtesy to give prior information to the Parish Council of any improvements or other alterations which they may intend from time to time to make to the Heath.

(v) The Ascot Authority with the approval of the Commissioners of Crown Lands confirm that the public shall continue in accordance with the Enclosure Award made in 1817 pursuant to the Windsor Forest Enclosure Act 1813 to have access on race days for the purpose of viewing the races to those parts of the Heath which are not then enclosed.

(vi) Whilst the legal position is as indicated in the above enactments no further claim that the public have any rights to over or upon Ascot Heath will at any time hereafter be put forward by the Parish Council.

A copy of this Memorandum shall be inserted in the minutes of the Parish Council and the contents thereof published in the local Newspapers.

(signed) WITHERS & CO.

Solicitors to the Ascot Authority.

6th March 1951

Wednesday was a quieter day until the introduction of the Royal Hunt Cup in 1843, which attracted an enormous amount of interest from the betting fraternity. The establishment of the Ascot Gold Cup in 1807 on the Thursday attracted the greatest crowds and the race rapidly became an occasion for the ladies to display the latest and grandest fashions. It very soon became known as 'Ladies' Day'. Friday was usually a quieter day, possibly as a result of the eating, drinking and entertaining that had taken place during the preceding three days.

During the reign of King George IV (1820-1830), the stands were significantly improved, and the Royal Procession onto the course became a recognised start to the day's racing when King George IV drove from Windsor Castle to the course in 1825. A side attraction to the official racing at the time was the exploits of

Captain Ramsey, who would hold wagers that he could ride a certain distance on his horse on the heath in under a set time. He was a superb horseman and he owned the best horses which, judging by his success, he could well afford to purchase. During the 1820s he won a small fortune on these wagers.

As the century moved on into the reign of Queen Victoria (1837-1901), the ever increasing popularity of Ascot Races which, incidentally, occupied four days of the week right up to 1939, was causing no end of problems as a result of its own success. Accommodation in the area was at a premium and just about every possible mode of transport was used to get people to and from the races. The transport situation was eased when the London & South Western Railway Company brought a line from London to Ascot and Reading in the 1840s. When the Ascot Railway Station was built, the Railway Hotel was built nearby, which eased some of the accommodation problems. Sadly, this very railway experienced a bad accident after the first day's racing in 1864. The accident occurred at 7.25 on Tuesday evening when two trains full to capacity with racegoers on their way home ran into each other. The scene was indescribable. Five people were killed instantly and many were seriously injured. The Railway Hotel was turned into a temporary hospital and the most serious casualties were rushed to London for emergency surgery. Not many years after this terrible accident, the Great Western Railway Company persistantly put forward plans to lay a railway line between Windsor and Ascot taking a route via Winkfield. The Company finally gave up in the 1880s when they realised that they were never going to be accepted.

In 1862-1863 the Royal Ascot Hotel was built on Crown Land adjacent to the junction of London Road and Windsor Road which at the time was a standard crossroad junction. It was an impressive square-plan building designed with an open courtyard in the centre and stables on the outside. During the late 1800s and early 1900s, the outer buildings were used as the Ascot Fire Station. In the 1920s the hotel, which was run by the Royal Ascot Hotel and Stable Co. Ltd., became a place of disrepute and in March 1931 the renewal of the drink licence was not granted. In December 1961, plans were put to the Ministry of Town and Country Planning for the demolition of the hotel and stables for replacement with a tower block of flats and a hotel. Shortly afterwards the Royal Ascot Hotel and stables were pulled down and the site remained empty until early 2001 when the Crown Estate Commissioners sold the 1.32 hectare (3.27 acres) site for housing development.

There were two other notable events that took place in the 1800s that have left their mark today. The most important one was the introduction of the Windsor Forest Enclosure Act 1813 and the subsequent Awards of 1817. As far as Ascot Heath was concerned it was already an established racecourse and although it was technically common ground, it never reached the land grabbing stage of the Awards, for as soon as the 1813 Act came into being, Ascot Heath was specially assigned to the Crown on the proviso that it 'should be kept and continued as a Race Course for public use at all times as it has usually been'. The second event was very much of an ornamental nature. In 1877-1878 the magnificent Golden Gates which incorporated the Prince of Wales Arms were erected at the start of the now disused New Mile Straight Course. The cast-iron black and guilded gates have been excellently maintained since they were erected and can be viewed close-up in Cheapside Road. It is hard to imagine how many people would have waited outside the gates to cheer the Royal Procession. In Victorian times in particular the crowds would have been boosted by the local school children who were allowed the afternoon off to attend the races. The school registers were simply marked 'School closed for the races'. For many of the children it was also a time to go 'Copper Sir-ing' after the races. Along all of the main roads as far away as Windsor and Staines, children would gather to shout, "Copper, Sir?" at the returning racegoers, particularly at the happier looking ones who had obviously done well during the day. At regular intervals handfuls of coins would come showering from the carriages onto the roads and pavements. Children would often risk life and limb to pick up the money. Sadly children were quite regularly injured, sometimes fatally, in their eagerness to get to the money first. It was not until 1948 that this very dangerous practice was banned. Note:- The term 'copper' was commonly used to describe a penny dating from times when they were made of copper.

The 1800s was also a time when pickpockets were rampant at the races with gentlemen's pocket watches being high on the list. Frequent skirmishes would break out in the crowds when a pickpocket was caught in the act. Penalties for the culprits was usually a spell in prison. However, the penalties that caught my imagination the most were imposed when the public took the law into their own hands by marching the culprits down to the nearby Englemere Pond and throwing them in. By the end of the 1800s trouble was so common at the Ascot Races, that a Government appointed Inspector of Nuisances was assigned to keep the order at Ascot. Yes, that title really did exist.

The 1900s saw many changes to Ascot. King Edward VII brought a breath of fresh air when he abolished the control of the races by the Master of the Buckhounds in 1901 and appointed a 'Representative' who reported directly to him. During his reign from 1901-1910, there was a more flamboyant atmosphere about the meetings and the clothing fashions changed to what is now referred to as 'Edwardian'. King Edward VII had proved to be extremely popular with the racegoers at Ascot and the first meeting after his death (on Tuesday 6th May 1910) held on Tuesday 14th June 1910, accordingly became known as 'Black Ascot'.

In 1913, during the reign of King George V, the Ascot Authority Act came into being. It was agreed that the Commissioners of Crown Lands (since renamed Crown Estate Commissioners) would lease the racecourse, stands and buildings on a long term basis to the Ascot Authority. The Ascot Authority is made up of three Trustees appointed by the Monarch. The Act gives them full powers to manage and superintend any lands in their hands as if they were absolute owners. It also gives powers to maintain, improve, add to or alter any of the enclosures, approaches, conveniences, fences, gates, or other property for the time being vested in them or to provide or erect buildings, stands, rooms, offices, enclosures, approaches, conveniences, gates, fences or other things deemed necessary or convenient. Generously, the very first objective and accomplishment of the Ascot Authority was to have the gas lights put back into full working order in Ascot High Street.

The continuation of racing during the First World War (1914-1918) caused great divides in the country. It was felt that it was obscene that the nation should be enjoying the pleasures of racing whilst so many were dying at the battlefront. The mood was such that Ascot Week in 1915 was cancelled and the grandstand was used as a hospital to look after fifty wounded soldiers later that year. Racing was not resumed until after the war in 1919. The rapid popularity of light aircraft following the war brought some unexpected problems and in 1923, pilots were instructed to fly at a higher altitude when watching the races.

The ever-increasing popularity of the motor car was never more evident during Ascot Week 1926. 8,750 cars were checked on to the heath against 8,000 the previous year and at the same time, charabancs and buses numbered nearly 3,000 against 1,900 the year before. The use of horse-drawn vehicles was on a rapid decline. The facilities at the course were also moving with the times and in May 1931, an enormous modern Totaliser was erected near the six-shilling stand at a cost of £250,000.

Dry seasons have created two problems on the heath. The first was the need to keep the course watered. The second was the threat of heath fires. In 1921 the heath was ravaged with fire on two occasions leaving a blackened smouldering landscape. 1933 was another bad year for fires on the heath. The water was pumped in from nearby Sunninghill to maintain the course and to fight fires at considerable cost. It was a prudent measure when the Authority built their own water reservoir near Swinley Bottom in 1936. In 1955 a pipeline and pump was connected up between the reservoir and the Great Pond in Sunninghill Park making the Authority completely independent for their watering and fire-fighting water supply.

The Second World War (1939-1945) came with similar problems as with the previous war. However, lessons had been learned and Ascot Week was cancelled in 1940 and later in the year serious consideration was given to ploughing up the heath for war produce. Fortunately, the nature of the sandy soil was not suitable for growing wheat as intended and ploughing never began. As the threat of invasion from the continent disappeared, it was felt necessary to bring some pleasure back into the country. The resumption of racing started on a low profile on Saturday 16th May 1943. Normal racing was not resumed until after the war with King George VI and the Queen attending Ascot Week in 1946. Soon after this meeting, major plans were put forward to improve the Ascot Racecourse. The changes starting in 1947 were considerable. First the bends on the round course were made less severe. Then in 1954-1955, when Sunninghill Park was back in Crown hands, a new straight mile course was created. Unlike the original straight mile course which was full of natural undulations and was actually only 7 furlongs 155 yards long (69 yards short of a mile), the new straight mile course was made much flatter by moving and bringing in tons of soil. It was also made a true mile in length. During the construction of the new course it was necessary to remove the old southern entrance drive into Sunninghill Park, and in doing so, the South Lodge became isolated. A new drive into Sunninghill Park was constructed north of the new course and at the same time a recreation ground was created between the new drive and new course primarily for use by Ascot United Football Club. The new straight mile course ran right through the site of the Second World War camp of the USAAF and I have often wondered how many of the Americans returned for a nostalgic visit to the site only to find the course running right through the very place where they had lived in 1943–1945.

In 1930, Ascot was hit by the most violent storm in the history of the racing there. The first day of Ascot Week the weather was pleasant with no indication as to what was to follow the next day. In the early hours of Wednesday 11th June 1930 a storm swept over the racecourse. The heavy rain on this Royal Hunt Cup Day was still pouring down as the thousands of racegoers started to arrive. At 1 o'clock King George V and Queen Mary arrived in closed cars during a lull in the rain. The break in the rain was short lived and by 2 o'clock the heavens opened up. People went into a blind panic cramming into the stands, tents and refreshment booths, any place to get some cover from the continuous rain, lightning and frightening sound of the thunder. What was so extraordinary was that the Royal Hunt Cup was run during the peak of the storm. Very few people actually saw the race and were staggered to hear that it had by the announcement that it had

been won by 'The Macnab'. The storm lasted for one-and-a-half hours, during which time the rain had been so heavy, the course was like a lake and the High Street was like a river with some of the local houses being flooded with up to 15 centimetres (nearly six inches) of water. It was utter chaos with people fainting and it seems hard to imagine that some of them were in danger of drowning when they fell into the water. Suffice to say that the remainder of the meeting was cancelled and as the storm passed over, the full extent of the affects of the storm were revealed. The worst of all was the tragic death of a bookmaker who was standing under his umbrella in the Tattersall's Ring. His umbrella had been hit by lightning killing him almost immediately. The unfortunate person was Walter Holbein a 43 year old from Stockport who had formally been an outstanding footballer having played for Sheffield Wednesday, Preston North End and Stockport. A very sad loss indeed.

Just as everyone was thinking that it was the end of the storm and they were making their way back to their transport, the rain started again as heavily as ever. People were using anything possible as stepping stones to get over the flooded areas and many were loosing their shoes in the squelching water and mud. Many of the people who had come by car had the ultimate frustration when they could not get their cars started. Fortunately, there was fine weather the next day and the mopping up operations were extensive with bagfuls of shoes and ladies hats being retrieved from all over the place. Miraculously, the course was cleaned up enough for the racing to go ahead. Three of the cancelled races from the disastrous day on Wednesday, namely the Churchill Stakes, Bessborough Stakes and the Fernhill Stakes were added to the day's racing making a total on ten races held on that Thursday.

Twenty-five years later another storm was to wreak havoc on the racecourse. The year was 1955. Almost as a bad omen, a railway strike prevented Ascot Week going ahead as planned for the 14th to the 17th June 1955. This was the first time this had happened at Ascot and the meeting was postponed to a month later on 12th to 15th July. On Thursday 14 July, a devastating thunderstorm came directly over the heath. Being Gold Cup day the stands and heath was packed with people. Just after four o'clock, when the King George VI Stakes had just been won by Prince Barle ridden by Manny Mercer, three violent flashes of lightning occurred in quick succession leaving a scene at the Number 2 enclosure like a battlefield. Tragically, Mrs Barbara Vera Batt from Reading who was only 28 years old and pregnant at the time, was killed instantly. Nearby, Mr Leonard Tingle from Sheffield who was 51 years old was badly injured. Sadly he died the next morning in King Edward VII Hospital in Windsor. The numerous others who were injured that

day included an AA Patrolman who was on duty outside the course. Six were retained in hospital for several days after the event before being allowed home. My brother-in-law who was nearby when the lightning struck said that many of the people were walking around in a dazed state long after it happened. After a pause in racing for about one hour, the Ribblesdale Stakes was run in an atmosphere of gloom. The rest of the meeting was cancelled.

Four years after the awful event of the thunderstorm, the very same jockey who had ridden the winner in the race before the lightning strike was himself killed on the course. It happened during a recently created September meeting. On Saturday, 26th September 1959, Manny Mercer was riding a filly named 'Priddy Fair' to the start when it slipped and fell in front of the stands. The fall appeared harmless enough, however as the horse struggled to his feet it kicked Manny on the head killing him instantly. As with life, happiness and tears are never far away from each other for earlier in the afternoon at the meeting, his brother Joe Mercer had ridden a double. Manny, born Emmanuel L. Mercer at Bradford, was an excellent jockey having ridden 125 winners the previous season. He was only 30 years old when he died. Out of respect, the rest of the meeting on the day of the accident was cancelled.

Since those sad events, there have been many happy times and further improvements to the course. The most majestic improvement was the renewal of the grandstand. The new grandstand was built by the Wimpey Organisation between July 1960 and May 1961 at a cost one million pounds. It was 170.69 metres (560 feet) long and 22.55.metres (74 feet) high. It incorporated 280 boxes each with a private luncheon room. The old clock from the former stand was built into the new tower which was 37.2 metres (122 feet) high. On top of the new tower was a weather-vane with a horse in the royal colours. The new stand had underfloor heating, lifts, escalators and space for 9,000 spectators in addition to those in the boxes.

Between the Ascot Weeks of 1963-1964, a new Royal Enclosure Stand was built by the Wimpey Corporation at a cost of one and a quarter million pounds. The Royal Box was rebuilt at a slightly higher level. Under the stand, a new weighing room was built complete with a sauna for jockeys who had a last minute panic to make the weight. The new stand was formally opened with a luncheon on the first day of Ascot Week, Tuesday 16th June 1964. All went well that week until Gold Cup Day, Thursday 18th June when the heavens opened up. . The rain was torrential, so bad that the entire day's racing was cancelled, it being the first time that this had happened at Ascot. Of course it had to be 'Ladies Day' when all of the ladies were in their best finery. There was one particular lady who would have been none too happy. Her name was Mrs Gertrude Shilling whose bizarre hats caused much amusement

Cumberland Lodge Stakes (1 mile 4 furlongs)
WALL STREET – odds 2-1, runners 8.
Racal Diadem Stakes (6 furlongs)
DIFFIDENT – odds 12-1, runners 13.
Queen Elizabeth II Stakes (1 mile)
MARK OF ESTEEM – odds 100-30, runners 7.
Tote Festival Handicap (7 furlongs)
DECORATED HERO – odds 7-1, runners 26.
Rosemary Rated Stakes (1 mile)
FATEFULLY – odds 7-4, runners 19.
Blue Seal Conditions Stakes (6 furlongs)
LOCHANGEL – odds 5-4, runners 5.
Gordon Carter Handicap (2 miles 45yards)
FUJIYAMA QUEST – odds 2-1, runners 18.

amongst the crowds. Her hats, which were made by her milliner son David, had to be seen to be believed. They were made to look like umbrellas, cartwheels, dartboards, steeples etc. Invariably there was a crowd of press photographers waiting in Ascot High Street to 'snap' the latest creation. Gertrude Shilling attended Ascot for more than thirty years and in the 1960s and again in the 1980s, she concealed her own physical and mental pain following surgery for cancer. In later years she became a favourite at charity events and entertained in hospitals and homes for the elderly. She died in October 1999 aged 89 years.

Another great character who would often be seen at Ascot until the early 1970s, was the racing tipster Ras Prince Honolulu who claimed that he had the same Abyssinian royal blood as Emperor Haile Selassie. He would take a customary fee for one of his cards which would give a 'hot stable tip' indicating which horse would win the next race. For many years, another name for giving a tip was known as giving an 'egg-flip'. Sadly, characters like these have disappeared.

The last major change to the racecourse was started during November 1962 when work commenced on the creation of a steeplechase course and a hurdle course on the inner side of the flat round course. The turf used on the two new courses came from Hurst Park Racecourse, East Molesey, London, which was being closed down for use as building land. The turf was cut and rolled at Hurst Park and transported by lorry to Ascot and laid the same day. The hurdles course consisted of six hurdles only, whereas, the steeplechase course consisted of seven hedges, two open ditches and one water jump. The courses were completed in the Spring of 1965 and the first race to be run at Ascot under National Hunt Rules took place on Friday 30th April 1965. The first hurdle race was the Inaugural Hurdle, won by the favourite Sir Giles, trained by Fulke Walwyn and ridden by Willie Robinson. The first steeplechase was the Kennel Gate Steeplechase, won by Another Scot ridden by Tim Norman.

Racing at Ascot is now far removed from the time when the racing consisted of just four days racing in Royal Ascot Week. In addition to Ascot Week, we now have a further ten days flat racing and ten days National Hunt racing during the year. It is hard to imagine how many racegoers have been to Ascot since the start of racing there in Queen Anne's time. Currently. over 200,000 people attend each day of the four days of Ascot Week and the people who watch it on television runs into millions. It is equally mind-boggling just thinking about the amount of money that would have changed hands on the course, not to forget the amount of food and drink consumed there. During Ascot Week there is currently around 3,700 catering staff working at the course to cater for the consumption of around 200,000 bottles of champagne, 70,000 bottles of wine, 11,000 bottles of Pimms, 2.5 tonnes of beef, 2.75 tonnes of fresh salmon, 2.2 tonnes of smoked salmon, 6,000 lobsters, four tonnes of strawberries and 520 gallons of cream.

In recent times, two modes of transport to and from the races different from the past, are helicopters and superstretch limousines. The helicopters can be seen landing and taking off on the disused straight mile course. Originally they were used by jockeys only but now they are being used to transport the public as well. The superstretched limousines which originate from America have dark tinted windows making it very difficult to see the eight passengers and, because they were a favourite vehicle of American gangsters in the past, they have a slightly sinister appearance.

The organisation required for Ascot Week is enormous, with one of the main problems being the control of traffic on and around the course. The Ascot Authority employs numerous staff to cover the various requirements necessary for organising and controlling the meeting. There is one particular duty that is quite unique and that is of the person who rings the silver bell which is fixed to the Runner's Board that stands opposite the Royal Box. When the horses reach the three furlong mark, the bell is rung to alert the Royal Family who may otherwise have been distracted.

There have been many outstanding races at Ascot over the years. However, we have to look at more recent times for the most oustanding of all. This occurred at the Ascot Festival Meeting on Saturday 28th September 1996. The racing world was staggered with the achievement of Lanfranco (Frankie) Dettori when he did the 'impossible' by riding all seven winners during the meeting. No jockey had achieved this before and the odds of 25,091 to 1, put some of the smaller bookmakers out of business. Frankie celebrated two of his wins dismounting by jumping from his horse in the Winner's Enclosure. Very spectacular but very risky.

As already explained, Ascot Heath from the first days of racing has first been under the control of the Master of the Buckhounds and now under the control of the Ascot Authority. The very first Monarch's Representative of the Authority was Victor Albert Francis Charles Spencer, Viscount Churchill. His time in office 1901-1934 (33

years), is the longest period before or since of any controller. In recognition of his work, Churchill Road which runs across the heath from the Kennel Gate to near the Winning Post is named after him. His coat of arms are set into the outer wall of the Grandstand Enclosure Entrance building facing Ascot High Street. On the same wall are displayed the coats of arms of thirteen Masters of the Buckhounds from the time that they were the controllers of Ascot Heath. Looking at the wall from Ascot High Street they are shown from left to right:-

Although much has been done to improve the layout of the facilities and course, the very fact that the triangular Swinley Course is bordered by the busy Windsor Road (A 332) at the north-east, the Winkfield Road (A 330) at the east and Ascot High Street (A 329) at the south, means that geographical expansion is restricted. Although a wide band of land on the opposite side of Windsor Road is Crown Land, any thoughts of expansion of the racecourse facilities in that area are completely ruled out, as it is extensively built upon with large residential houses, the oldest building being the 'Old Huntsman's House' standing at the end of Kennel Avenue. The adjacent Royal Kennels and the Ascot Nursery disappeared a long time ago.

In the pursuit of perfection within the existing space available, two major changes have been initiated. The first is the new moveable turf crossing that has been installed at Kennel Gate. Work was started at the end of the racing season year 2000 and completed before the start of the flat racing season 2001. The revolutionary new mechanically constructed system is the first of its type installed on any racecourse in the world. The new crossing allows vehicle access to and from Windsor Road and the heath without affecting the turf on the Flat and National Hunt courses. Such a system would not have been possible had it not been for the advantages of modern turf technology.

The next major alteration of the racecourse is planned to commence as soon as satisfactory results have been achieved from the turf trials currently being undertaken at Newmarket. The planned alteration is to realign the Straight Mile Course taking an angle from the Golden Gates to a position further away from the stands onto the heath. This will provide an area on the existing part of the racecourse to be used for the development of racecourse buildings, including the construction of a new grandstand when the existing one is demolished. Since the creation of the first Straight Mile Course in 1785 it will have been repositioned three times when the work is completed. Unfortunately, the intended changes will significantly affect the golf course and it has been agreed that the course will be re-constructed, complete with a new club house, on the eastern side of Winkfield Road.

Based on the history of the racecourse with its improvement to the racing and facilities, future changes are inevitable. Aside from the racing, the racecourse facilities are the venue for a wide variety of functions such as exhibitions, business conferences, seminars, product launches, craft

John Henry De La Poer-Beresford, 5th Marquess of Waterford, 1885-1886.

George William Coventry, 9th Earl of Coventry, 1886-1892 and 1895-1900.

Charles Philip Yorke, 5th Earl of Hardwicke, 1874-1879.

Lord Colville of Culross, 10th Baron, 1866-1868.

Richard Edmund St. Lawrence Boyle, 9th Earl of Cork and Orrery, 1866, 1868-1874, 1880-1885. (three times in office).

John George Brabazon Ponsonby, 5th Earl of Bessborough, 1848-1852, 1853-1858. 1859-1866. (Three times in office).

John William Montagu, 7th Earl of Sandwich, 1858-1859.

Granville George Leveson-Gower, 2nd Earl Granville, 1846-1848.

The Earl of Rosslyn, 1841-1846, 1852-1853.

George, 6th Earl of Chesterfield, 1834-1835.

Charles Harbord, 5th Baron Suffield. 1886.

Thomas Lister, 4th Baron Ribblesdale, 1892-1895.

Charles Crompton William Cavendish, 3rd Baron Chesham, 1900-1901.

Viscount Churchill's coat of arms are at the extreme right.

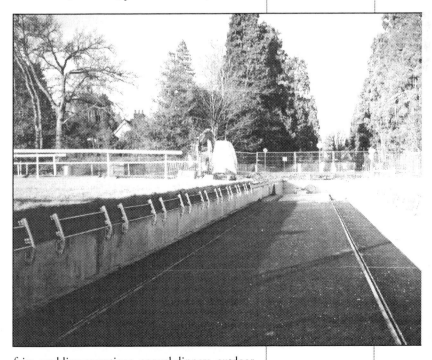

fairs, wedding receptions, annual dinners, outdoor fairs and charity fund raising events, all of which must be considered when planning any changes.

Royal Ascot Races (Ascot Week) which is held

TUESDAY

1. The Queen Anne Stakes, one mile on the straight course for three-year-olds and upwards. Named after the founder in 1930 from an existing race known as the Trial Stakes.

2. The King's Stand Stakes. Five furlongs for three-year-olds and upwards. First held in 1837 as the Stand Plate. Title changed several times until the current name in 1901.

3. The St James's Palace Stakes. One mile on the round course for three-year-old colts. First held 1834.

4. The Coventry Stakes. Six furlongs for two-year-olds. Named after George William Coventry, the 9th Earl of Coventry who was Master of the Buckhounds 1882-1892 and 1895-1900. First held 1890.

5. The Queen's Vase. Two miles for three-year-olds. Named after Queen Victoria. First held 1838.

6. The Duke of Edinburgh Stakes. One mile and a half for three-year-olds and upwards. Formerly known as The Bessborough Handicap after the 5th Earl of Bessborough, Master of the Buckhounds. First held 1914.

WEDNESDAY

1. The Jersey Stakes. Seven furlongs for three-year-olds, named after George Bussey, the 4th Earl of Jersey who was Master of the Buckhounds 1782-1783. First held 1919.

2. The Queen Mary Stakes. Five furlongs for two-year-old fillies. Named after Queen Mary the Consort of King George V. First held 1921.

3. The Prince of Wales Stakes. One mile and a quarter for four-year-olds and upwards. Named after the Prince of Wales (later King Edward VII). First held 1862.

4. The Royal Hunt Cup. One mile on the straight course for three-year-olds and upwards. Named after the Royal Buckhounds whose Masters controlled the racing on the heath 1711-1901. First held 1843.

5. The Chesham Stakes. Seven furlongs for two-year-olds. Named after Charles Crompton William Cavendish, the 3rd Baron Chesham who was the last Master of the Buckhounds to control Ascot Racecourse 1900-1901. First held 1919.

6. The Ascot Stakes. Two miles and a half for four-year-olds and upwards. First held 1839.

THURSDAY

1. The Ribblesdale Stakes. One mile and a half for three-year-old fillies. Named after Thomas Lister, the 4th Baron Ribblesdale who was Master of the Buckhounds 18992-5. First held 1919.

2. The Norfolk Stakes. Five furlongs for two-year-olds. It was first held in 1843 as the New Stakes. It was changed to the Norfolk Stakes in 1973 in honour of the Duke of Norfolk who was the Sovereign's Representative at Ascot 1945-1972.

3. The Gold Cup. Two and a half miles for four-year-old and upwards. Originally named The Emperor's Plate after Nicholas I (Czar of Russia) who gave the prize. First held 1807.

4. The Cork and Orrery Stakes. Six furlongs for three-year-olds and upwards. Named after Richard Edmund St Lawrence Boyle, the 9th Earl of Cork and Orrery who was Master of the Buckhounds 1866, 1868-1874 and 1880-1885. First held 1926 replacing the All-Aged Plate.

5. The King George V Stakes. One mile and a half for three-year-olds. Named after King George V. First held 1946.

6. The Britannia Stakes. One mile for three-year-old colts and geldings. First held 1928.

FRIDAY

1. The King Edward VII Stakes. One mile and a half for three-year-old colts and geldings. Formally started a the Ascot Derby Stakes in 1834. Renamed in 1926.

2. The Hardwicke stakes. One mile and a half for four-year-olds and upwards. Named after Charles Philip Yorke, the 5th Earl of Hardwicke who was Master of the Buckhounds 1874-1879. First held 1879.

3. The Coronation Stakes. One mile on the round course for three-year-old fillies. Named in commemoration of the Coronation (28th June 1838) of Queen Victoria. First held 1840.

4. The Wokingham Stakes. Six furlongs on the straight course for three-year-olds and upwards. Named after the Berkshire town First held 1813.

5. The Windsor Castle Stakes. Five furlongs for two-year-olds. Named after the nearby castle. First held 1839.

6. The Queen Alexandra Stakes. Two miles six furlongs and thirty-four yards for four-year-olds and upwards. Named after the consort of King Edward VII. Known as the Alexandra Plate when first held 1864.

HISTORICAL EVENTS OF ASCOT RACECOURSE

1711. Racecourse founded by Queen Anne. First race held Saturday 11th August 1711.

1785. The first Straight Mile Course created.

1793. The Slingsby Stand, the first permanent building was erected.

1807. The Gold Cup introduced.

1813. The Windsor Forest Enclosure Act introduced with Ascot Heath being one of the first allotted areas to be enclosed.

1822. The Royal Stand designed by John Nash was erected.

1839. Victorian Grandstand erected.

1859. Slingsby Stand demolished.

1864. Saddling Paddock created.

1878. The Alexandra Stand erected.

1883. Recreation Ground on the heath created.

1896. Grandstand Clock erected.

1902. Royal Enclosure with three new stands completed.

1906. First tunnel from the enclosures to the heath constructed.

1907. The Gold Cup stolen on Tuesday 18th June whilst on display.

1908. Five Shilling Stand constructed (later to become the Six Shilling Stand and now the Silver Ring Stand).

1913. Ascot Authority Act came into being.

1915. Ascot Week cancelled until the end of the First World War.

1930. A violent thunderstorm flooded the racecourse on Wednesday 11th June and a bookmaker was killed by lightning. The Reservoir was constructed north of the Recreation Ground.

1931. A huge Totaliser erected near the Six Shilling Stand.

1940. Ascot Week cancelled for the rest of the Second World War. Re-started 1946.

1955. New Straight Mile Course used for first time. On Thursday 14th July, two people were killed by lightning and several others were stunned on the heath during a thunderstorm. (Ascot Week had been put back a month through a railway strike).

1961. Old Grandstand replaced with the Queen Elizabeth II Grandstand.

1964. Royal Enclosure Stand constructed to replace three old stands.

1965. The first Steeplechase and Hurdle Courses completed and used.

1996. Frankie Dettori achieved the 'impossible' when he rode all seven winners at the Ascot Festival Meeting on Saturday 28th September.

2001. The moveable turf crossing at Kennel Gate completed and operated. Realignment of the Straight Mile Course planned for 2002-2003.

from Tuesday to Friday in June every year has remained very much the same for the past two centuries. A few of the races have changed titles and some have been switched to different days. The order of racing in 2001 was as follows:

Ascot Racecourse is the world's most famous racecourse brought about by its Royal pageantry, first class horse-racing and stunning fashions. Quite naturally the horse-racing events overshadow the other sporting activities that have in the past, and in many cases, still take place on the heath. The non-equestrian sport is as follows:-

Pugilism is the name for an old 'sport' where two opponents fought with their bare fists. For centuries village greens and meeting places in the country were the scene of many brutal fights with wagers being made on the outcome. It was not unusual for a contestant to die during or shortly after a fight. The race meetings where people had money to spend, were very popular places to hold the contests. Ascot Heath was no exception and many fights took place there during the period 1750 to 1870. One of the country's top prize-fighters Henry Sellers, was undefeated on the heath for four years 1777-1780. It is known that he beat Joe Hood during the 1777 racing week and Bill Stevens in 1778.

Cricket was occasionally played on the heath starting from the late 1700s. By the start of the 1800s matches were on a grander scale and on Thursday 20th July 1815, a grand cricket match was held on the heath between the Gentlemen of Berkshire and Gentlemen of Buckinghamshire for a wager of £2,000 a side. Matches continued on a casual basis until 1883 when a meeting was held in the Grandstand on Tuesday 24th July to form the Royal Ascot Cricket Club. The meeting was presided over by the Earl of Cork and Orrery in the absence of the Duke of Connaught who was indisposed at the time. It was confirmed during the meeting by Count Gleichen (a relative of Queen Victoria), that the Queen had given her permission for the club to use the heath for their cricket matches. The main objective of the club which was set out during the meeting was, 'To form a centre for cricket in the county of Berkshire, as there was no County XI, and it was desired to encourage young players, and to further the game of cricket which did so much to bring all classes together'.

The first appeal for funds raised £390 subscribed by, the Duke of Connaught (President), Prince Christian of Schleswig-Holstein and Lord Cork (Vice-Presidents), Mr Percy Crutchley, Mr H.F. de Paravicini, Sir Clive Bailey, Sir William Bruce, Mr C.C. Ferrard, Count Gleichen, Mr Edwin Lawrence, Mr Charles Murdock, Colonel Victor Van de Weyer and Mr Arthur Walter (Proprietor of the Times newspaper). On 22nd September 1883, a committee of management was appointed and the ground was laid out at a cost of £600. Some the early games were played against the Lords and Commons and other well-known clubs. In 1888, a group of lime trees were planted by Mr. Waterer of Bagshot at the southern end of the ground to provide some

shade for the spectators. During the First World War, the ground which by now was being used for sport other than cricket, was lent to the nearby Royal Air Force Depot. The ground was in a sorry state by the end of the war and it had to be extensively repaired. The most notable victory by the club, was during the 1920s when they dismissed a strong Windsor and Eton team for two runs by bowlers W. Parkinson and G. Bullock. On Friday evening 28th July 1933, the Royal Ascot Cricket Club celebrated their fiftieth anniversary with a dinner at the Royal Ascot Hotel. Mr Percy Crutchley, who was living at Sunninghill Lodge, was the only person present from the first meeting. The club still play on the heath on a regular basis.

Golf on Ascot Heath formally started in 1887, the year of Queen Victoria's Golden Jubilee. Although there was already a nine-hole golf course not far away in Swinley Forest which was a private course used by the Royal Family, the Royal Ascot Golf Club that was founded in that year was one of the first clubs to be set up in Berkshire.

The Royal Ascot Golf Club was founded by Frederick Joseph Patton. He was 37 years old at the time, a legal practitioner and above all an enthusiastic golfer. At the time he had just moved into a large detached new house situated on the other side of Windsor Road not far from the Royal Ascot Hotel. He very appropriately named it 'The Links'. Aside from his involvement with golf, he became a member of the Berkshire County Council, Chairman of the Sunninghill Parish Council and a Berkshire County Magistrate. In the latter years of his life his health suffered, no doubt exacerbated by playing golf in all conditions. He died at Eastbourne on Sunday 5th February 1922 aged 71 years whilst trying to recuperate.

During the early years of golf on the heath, there was a nine-hole course for the men and another nine-hole course for the ladies. In addition, another newly formed club, Ascot St. George's Golf Club had started to use the courses. In 1895, all activities were merged into one club and the courses were changed into a single eighteen-hole course designed by John Henry Taylor a golfer of high repute. Taylor was born at Northam, near Westward Ho, North Devon in 1871. He won the British Open Championship five times in 1894, 1895, 1900, 1909 and 1913. He wrote a book 'Taylor on Golf' in 1911. He died at his Devonshire home in February 1963 barely a month before his 92nd birthday. The new course was constructed under the supervision Joe G. Longhurst who played as a professional for the club for twenty-five years. For many years before the First World War, the Prince of Wales (later King Edward VII) and several other members of the Royal Family had lessons and played on the course. In 1901 King Edward VII became patron of the club.

By the start of the 1920s the proliferation of other golf clubs in the area and the affects of the war saw a decrease in the interest of the Ascot Club. In the spring of 1920, a local fifteen-year-old keen golfer T.H. South was practicing on the course with Major E.G. Fellows, the Hon. Secretary of the club, when he made the following comment, 'There is

to be a girl's championship, why not one for the boys?'. The idea was readily taken on board, and plans were immediately made to hold the first National Boys' Amateur Golf Championships the next year on the heath. The dates were fixed for six days starting Monday 5th September and ending with the finals on Saturday 10th September 1921. The maximum age was fixed for the forty-four competitors who came from all over the British Isles with at least one boy from France. The final was watched by the Duke of Connaught, the Crown Prince of Sweden and Princess Helena Victoria and several hundred spectators. The winner was Donald Mathieson a fifteen-year-old Scot from Edinburgh Academy. It took an extra hole of 37 to beat the runner-up, Guy H. Lintott a fifteen-year-old from Felstead, Essex. Third was C.D. Williams a Welsh boy from The Mumbles, South Wales. The Championship Cup was presented to the winner by the Duke of Connaught. Two of the competitors were the Cotton brothers both of whom were beaten in the first round, however, Henry who was fourteen at the time, 'picked himself up' and developed to become one of the country's finest players, winning the British Championship three times in 1934, 1937 and 1948. His contribution to golf was enormous and it was a sad day in December 1987, when just two days before his knighthood was to be announced, he died aged 80 years.

The second British Amateur Boy's Championship was held on the heath the following year in 1922 starting Monday 4th and ending Saturday 9th September The maximum age was raised to seventeen and most of the previous year's competitors had entered including the reigning champion and the runner- up. The standard of play was very high with the cup being won by Hugh Scot Mitchell a fifteen-year-old student from Sandwich in Kent. Hugh started playing golf when he was nine-years-old and he was totally self taught. He was an excellent all round sportsman representing his school at cricket, football, hockey and tennis. The runner-up was W. Greenfield from the Royal Grammar School, Newcastle. Third was the local boy T.H. South who had suggested the Championship two years earlier. The prizes were presented by Lady Henry in the absence of the Duke of Connaught.

The expected increase in the popularity of the club following the Boy's Championships did not materialise and the club disbanded soon after through lack of interest and funds. Certainly, the death of Frederick Patton the founder of the club in 1922 also had a affect on the club's decline. From then on golf was played on the heath on a casual basis until soon after the Second World War. By 1947 the club had re-formed and a new clubhouse was built and the course was re-designed. However the club had to wait until 1977 before it regained its Royal title when it was granted by Queen Elizabeth II during her Jubilee year. The club is currently an extremely popular and friendly club.

Bowls was played on the heath on a bowling green situated next to the northern end of the cricket pitch. Very few records have survived to clarify the structure of any club that played there. Certainly bowls was played there during the early part of the 1900s.

Tennis was first played on the heath using the cricket ground shortly after the First World War. The Royal Ascot Tennis Club started as a section of the Royal Ascot Cricket Club in 1920 and the disused bowling green was turned into two tennis courts for the club's use. By the end of the decade the club was on the point of floundering when it was decided to break away from the cricket club and in 1931 the tennis club became independent. Due to the close proximity of the courts to the cricket ground, tennis could not be played on a Saturday when cricket was being played. In 1933, this problem was overcome when three more courts were created on the northern side of the two existing courts. The affects of the Second World War brought an end to the Club.

Hockey was first played on the cricket ground, or recreation ground as it was becoming more commonly known, in the late 1920s. The Royal Ascot Hockey Club was formed in 1928 and for most of its existence it ran a first and second team. As with the tennis club, the affects of the Second World War brought the club to an end.

Athletics was held on the Heath on several occasions during the 1900s. The largest events were held on Whit-Monday 21st May 1917 and Whit-Monday 20th May 1918. The two occasions were the Royal Air Force's (RAE) Regional Sports Day organised by their No.6 Storage (Supply) Depot at nearby King's Ride, Ascot. On both occasions, over 5,000 spectators came to watch the athletes from RAF stations as far away as London, Oxford and Farnborough. The serious events were:- 75 yards (ladies), 100 yards, 120 yards hurdles, 440 yards, One mile, Two and a half miles, One mile relay, Six miles (Windsor to Ascot), High Jump. The non-standard events were:- Tug of War, Obstacle race, Three-legged race, Egg and Spoon race and finally a race between the various military bands who had been entertaining everyone during the afternoon. All of the events were highly competitive with personal and team pride at stake. The meetings were completed with a variety show in the six shilling stand. The local RAE camp always stole the show with some very entertaining performances given by their club called the Mascots. These large events came to an end soon after the end of the First World War.

On Saturday 26th February 1938, the Southern Counties Cross Country Championships were held on Ascot Racecourse. This was the first time that the Southern Counties Association had held the event on the racecourse. Four hundred and forty-two athletes from all of the major clubs in Southern England competed in the two races on a dull and bleak day. The senior race of ten miles was entered by 302 runners from twenty-nine clubs. The race consisted of four laps of two and a half miles distance starting near the Run-in-bend. The leading places were contested by some of the country's finest athletes with the final positions being:- First, S.O.A. Palmer (Mitcham A.C.). Second, A.E.J. Etheridge (South London Harriers). Third, F.Close (Surrey A.C.). The best team was Mitcham A.C. The junior race was held over five miles (two laps) with 140

runners competing and the result was:- First, J.J. Charlesworth (Aylesford Paper Mills). Second, M.W. Jenkins (Blackheath Harriers). Third, J. Hodges (Gravesend and District Harriers). The best team was Southgate Harriers.

Nine years later, on Saturday 22nd February 1947, Ascot Racecourse was once again the venue for the Southern Counties Cross Country Championships. 500 runners took part on a bitterly cold and snowy day with about 8 centimetres (3.15 inches) snow on the ground at the start. It was a scene far removed from the warm sunny days of the horseracing. Forty athletic clubs from all over the south of England had teams competing in the two races. The senior race was a distance of ten miles and some of the finest runners were there endeavouring to achieve individual and club glory. The first three places in the senior race were:- First, L.W. Herbert (Belgrave Harriers). Second, H.A. Olney (Thames Valley Harriers). Third, A. Belton (Surrey A.C.) The

best team was Aylesford Paper Mills. The person who came fifth was Sydney Wooderson who at the time one of the best 'milers' in the world. Immediately after the race he was fresh enough to sign the books of the many autograph enthusiasts. The results of junior race held over five miles were:- First, D.R. Burfitt (Belgrave Harriers). Second, D.C. Hawthorn (South London Harriers). Third, W.A. Robertson (Reading A.C.). The best team was South London Harriers.

Gymnastics were held as an annual event at Ascot Racecourse 1925-1939. The gymnastic displays and competitions were organised by the Ascot Gymnastic Club by permission of the Ascot Authority. At the time, gymnastics was an extremely popular activity with many prizes provided to the best individuals and teams. Surprisingly the best local boys clubs were from the villages nearby and not Ascot itself with the leading clubs being Chavey Down and Cranbourne. The events were highly competitive and well organised and

Frederick Joseph Patten Founder member of the Royal Ascot Golf Club.

Henry Cotton and brother in the National Boys' Amateur Golf Championships at Ascot.

typical of this, was the event held in the new stand on Tuesday evening 23rd March 1937. The senior judge was Mr Nicholson. (Hon. Secretary Metropolitan and Southern Counties Gymnastic Association) and the main competition results were:-

The Sir Homewood Crawford Shield for boys. First, Chavey Down Club. Second, Cranbourne Club.

The Iola Patterson Shield for girls. First, Ascot Club, Second, Sunninghill Club.

Military Camps were set up on a temporary basis on several occasions on Ascot Heath particularly during the 1800s. One of the largest camps and possibly the most interesting, was the one held by the Berkshire Rifle Volunteers during the week Sunday 27th July to Saturday 2nd August 1862. As already described in previous chapters, the Rifle Volunteers were made up of civilians trained on military lines. Their uniforms were typical of the time with grey being the colour of the Berkshire Volunteers. The purpose of the camp was to improve the efficiency of the volunteers by providing general training such as, marching, shooting, and manoeuvres, quaintly known at the time as 'sham-fights'. In addition to the volunteers, many groups of cavalry, artillery and infantry of the British regular army from around the country had joined the camp. In total, well over 8,000 men were camped in tents all over the heath.

The camp was ideally situated for the manoeuvres with Swinley Forest, The Great Park, Sunninghill Park (by permission of the Crutchleys) and Sunninghill Bog being a short distance away. At the time, Sunninghill Bog, an area to the south of Ascot was as its description suggests, an area of marshy ground with very few houses there. The shooting practices and competitions were carried out on the excellent rifle ranges next to Duke's Lane in the park, these being in easy marching distance from the heath. The knowledge of the local environment by the Windsor Great Park Rifle Volunteer Corps who were at the camp, gave them a superior advantage over the rest of the corps. This knowledge was put to full use during the week with the local corps ranking very highly in their performances.

During the week regular parades were held in front of the stands, heralded by the sound of many bugles. It really must have been an impressive sight with the rows of cavalry, artillery and infantry lined up for inspection.

The final day of the camp culminated with a grand parade addressed by the senior officers, with prizes presented to the best corps of the manoeuvres. The proudest man on parade was Private Hall of the Newbury Volunteer Corps who was presented with the Berkshire Challenge Cup, the top shooting prize. The parade finished with a 'march past' along the racecourse in front of the stands.

As already mentioned, Ascot Racecourse has been, and still is, the scene of many events other than horseracing. On Wednesday 18th April 1962, the paddock area of the racecourse was used to stage the Stallion and Colt Show run by the Ponies of Britain Club. The show which was first held in 1955, attracted some of the finest horses from around the country. On this particular occasion it was attended by Queen Elizabeth II who was escorted around the show by Mrs Glenda Spooner, secretary of the Ponies of Britain Club. The only element to dampen the show was the continuous drizzle that lasted all day.

In contrast, the glorious weather that existed on Sunday 22nd July 1984 during the Royal Ascot Spectacular held on the racecourse could not have been more different. The Prince Philip Trust Fund event was attended by The Prince Philip, Duke of Edinburgh and his youngest son Prince Edward. Well over 10,000 spectators (including myself and family) had come to see this unusual and exiting fund raising event. Prince Edward, on this his first public engagement, was extremely popular when he went out of his way to mingle and talk to the public. The Silver Ring and Stand was the central position of the event with excellent music provided by the military bands of 1st Battalion Grenadier Guards Corps of Drums, the Queen's Colour Squadron and the Central Band of the Royal Air Force. The nearby Tombola stall was run by the singer Dorothy Squires and the Donkey Derby as usual proved to be very popular. The highlight of the day was a fly-past by a Lancaster bomber and Spitfire and Hurricane fighters of Second World War fame followed by a Vulcan delta-shaped bomber which had played a prominent role in the Falkland War two years before. The day culminated with a spectacular display by the Army Red Devils parachuting team.

Over the years with the ever improving facilities, the racecourse has been the venue for many fund raising events and commercial craft fairs etc. In addition, the racecourse has some excellent halls and rooms to hold exhibitions, business conferences, seminars, product launches, wedding receptions and annual dinners. The facilities are far removed from those of the 1800s when the Ascot District Horticultural Society held their summer and autumn shows there with mud trampled all over the place.

Swinley Forest and Bagshot Park

Swinley Forest and Bagshot Park

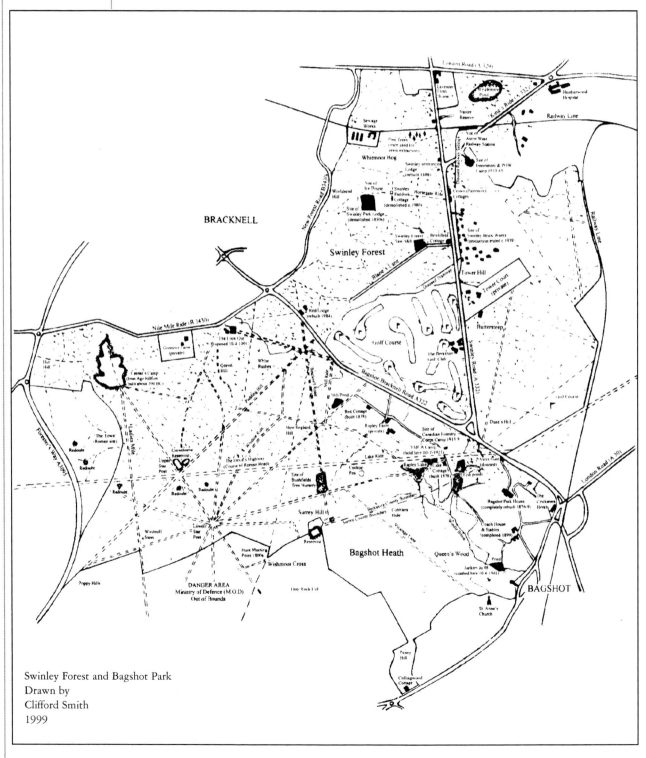

Swinley Forest and Bagshot Park
Drawn by
Clifford Smith
1999

S winley Forest and Bagshot Park currently covers an area of 2,000 hectares (4,942 acres) in the southern half of the Windsor Crown Estate. Over the years large areas have been sold, the last being two lots covering an area of 760 hectares (1,878 acres) at the south-western end known as Olddean Common, was sold to the War Office in March 1952. The northern boundary runs along the side of London Road (A329) between Ascot and Bracknell. The southern boundary touches the other London Road (A30) at Bagshot. The western boundary runs along part of Forester's Way (A3095) and the eastern boundary borders the Ascot to Aldershot railway line.

There are three very busy public roads cutting through the forest. They are King's Ride (A332) starting from the Ascot roundabout road junction and connecting up with Swinley Road (A332). Swinley Road starts at London Road in the north and goes in a straight line before joining the Bagshot Bracknell Road (A322) near Bagshot Park. As the name indicates, the Bagshot Bracknell Road connects the two towns. The Staines-Wokingham railway line runs from east to west across the northern area. Most of the northern area of the forest comes within the county of Berkshire, whereas the southern area comes within the county of Surrey. The route of The Devil's Highway, an old Roman Road that runs west to east is the boundary line of the two counties.

Englemere Pond is situated near the northern boundary, whilst Mill Pond is situated in a fairly central position. Further south near Bagshot Park is Rapley Lake. Of great historical interest is the Iron Age Fort known as Caesar's Camp situated near the eastern boundary. To the east of Caesar's Camp, a visitor's centre known as 'The Look Out', with parking and catering facilities was opened in 1991. There are two golf courses in the forest. In a central position is the Berkshire Golf Club Course, and at the south-eastern corner of the forest is the Swinley Forest Golf Club Course. Above all else, it is the endless pine plantations and the wildlife that exists there that provides this area of the estate with its greatest attraction.

Starting at the Ascot roundabout road junction, the estate widens out as it travels in a easterly direction within the line of London Road and King's Ride. The name 'Englemere' associated with the area, derives from 'Angles Mere' going back to Anglo Saxon times meaning 'English Lake'. Although there are several large houses in the area, Englemere Wood house is the oldest, being about 180 years old. On the other side of King's Ride, and outside the estate boundary, is a another large house originating from about the same time. Simply known as Engelmere, it

has had some very interesting and important residents over the years. The most notable was Field Marshal Lord Roberts V.C. K.G. K.P. G.C.B. O.M. G.C.S.I. G.C.I.E., who lived there for ten years (1904-1914). He was born at Cawnpore, India on 30th September 1832 and educated at Eton College and Sandhurst Military Academy. What he lacked in size and height he made up for with a lion-heart. His military achievements were outstanding and are well documented. At the age of 82 years, his fighting spirit was so strong that he made his way to France to visit the front line in the First World War in 1914. Whilst still in France he caught a chill that developed into pneumonia. He died at 52 rue Carnot, St Omer on Saturday 14th November 1914. Since 1972, Englemere has been the home of the Chartered Institute of Building.

The two aforementioned 'Englemere' houses stand at the top of a hill known as Englemere Hill. King's Ride sweeps down to a road bridge that goes over the Staines-Wokingham railway line that runs out of Waterloo Station, London and connects with Reading. Until the 1960s, the bridge was narrow and crossed the line at a right angle. This made the approach of the road on each side of the bridge extremely dangerous. Many accidents occurred there and it was not until a car with four occupants careered through the fence and landed on the railway line with tragic consequences that remedial action was taken. This accident happened in 1961, and the new bridge that followed was wider and aligned with the road to provide a clear view on the approaches.

In the 1860s, a small railway station was constructed just east of the bridge. Known as the Ascot West Station, it was introduced as a link to the nearby Swinley Brick Works that was established at the same time. A single railway line was constructed and curved south to the brick works south of King's Ride. During the First World War (1914-1918) the station became extremely busy when a Royal Air Force (formerly Royal Air Corps) camp was erected next to the station on each side of King's Ride. The camp was the known as the No.6 Storage Depot and consisted of the Headquarters, the Workshops group, the Aeroplane Group and the Motor Transport Group. An unknown number of aircraft were assembled there. By 1930, the now vacant buildings were being used by the Bertram Mills Touring Circus as their Winter Quarters. This continued until the outbreak of the Second World War in 1939 when it was turned into an internment camp. Several well-known people who were considered to be a risk to the nation were imprisoned there. The most notable was Sir Oswald Mosley who was interned at the camp from 1940 to 1943. He was born in London on 16th November 1896 and grew up to become a politician. He was the leader of the British Union of Fascists 1932-1940. The Fascists were known for supporting

the German Fascists and they created a lot of national unrest when they distributed anti-Semitic propaganda and conducted hostile demonstrations particularly in the Jewish sections of east London. The wearing of Nazi-style uniforms and insignia did not endear them to the general public. Oswald Mosley died on 3rd December 1980 at Orsay, near Paris. From 1943 to the end of the war, the site was used to hold Italian Prisoners-of-War. It was then used by 'Staravia' to store aircraft parts which the company were buying at aircraft surplus sales and selling to other countries. On Wednesday 11th June 1980 a huge fire swept through the buildings bringing an end their history. All of the old buildings have now gone, the southern side of King's Ride being replaced by the King's Ride Business Park and the northern side being replaced 1998-2000 by a modern business establishment.

Continuing along King's Ride the road meets Swinley Road. On the opposite side of Swinley Road is Swinley Lodge which was built in 1888 replacing a much older lodge. It was an entrance lodge of Swinley Park and mansion that existed there until the mid 1800s. The old entrance lodge was very much a part of the author's family history as explained in the caption to the picture. In a northern direction, the Swinley Road goes over the same railway line mentioned earlier. Just beyond on the eastern side are two semi-detached cottages known as Nos. 1 & 2 Whitmoor Bog Cottages. They were built in 1900.

A short way further along on the western side of Swinley Road is the entrance into the Englemere

Pond Nature Reserve which is an area listed as a Site of Special Scientific Interest (SSSI). A visitors' car park and marked walking routes have been provided for nature lovers. The focal point is, as you would expect, Englemere Pond. It is several centuries old and as its shape suggests, it was almost certainly created as a result of clay extraction for brickmaking. Over the years it has suffered from 'shrinking' through silting up and the natural progression of the reedbeds. It is currently about 370 metres (405 yards) at the longest point and about 200 metres (219 yards) at the widest point. In the 1800s it was an extremely popular pond for swimming, skating and fishing. Furthermore, it was often used to give pickpockets a drenching who had been caught whilst up to there tricks at the Ascot Race Meetings. The pond had a reputation for large pike. The reputation was expanded further when three local boys were swimming there on Wednesday afternoon, 19th June 1850. They were swimming in about 1.22 metres (4 feet) of water when a huge pike rose to the surface and snapped its jaws just below the elbow of one of the boys' arms. The boy screamed to his two friends and the fish released its grip. As the boy was making his way to the bank, it attacked him again even more viciously leaving him with a badly lacerated hand.

The northern side of Englemere Pond comes close to London Road and Englemere Sawmill. The sawmill was originally operated by the estate, but is now let to private concerns. A short distance west, bordering London Road, there are eight attached cottages laid

Swinley Lodge is situated on the west side of Swinley Road next to the junction with King's Ride. It was built in 1888 on the site of the original gate lodge that was then the entrance to Swinley House in Swinley Park. It is the original gate lodge that is so historical for the author, as this is where his great grandparents George and Sophia Smith lived 1845-1855 when George was the district gamekeeper. Five of their children were born there including the author's grandfather Joseph Smith who was born on Saturday 28th February 1846 All of the children grew up to work for the Crown. (photo July 1998 by the Author).

Crown Cottages (formerly Passmore Cottages) on the east side of Swinley Road just south of King's Ride junction – July 1999. (photo by the Author).

Lavender Farm House situated on the south-eastern corner of the cross-road junction of London Road and Swinley Road, Bracknell. Up until 1849, the house was the residence and office of the Maslin family, three of which, William, Charles and Wilby were Deputy Surveyors of Windsor Forest & Parks. The house and land is no longer owned by the Crown. (photo June 1998 by the Author).

Englemere Pond situated at the south of London Road about half way between Ascot and Bracknell. (photo June 1998 by the Author).

A dew pond in the Whitmoor Bog area of Swinley Forest – September 1998. (photo by the Author).

Pine trees at Whitmoor Bog showing the spiral scars where the trees were once used for resin extraction. The resin was mainly used to make varnish by mixing it with turpentine – September 1998. (photo by the Author).

out in a 'U' plan. They are known as Nos. 1 to 8 Forest Close and were built for the estate employees in 1954 by Laing building contractors. On the west side of the cottages, at the corner of the London Road and Swinley Road crossroad junction, is Lavender Farm House, set in a rectangular shaped piece of land of several acres. Although sold by the Crown some time ago, it had an historical part to play in the running of the Windsor Crown Estate. Shortly after the Windsor Forest Enclosure Act 1813 and the Awards of 1817, the house was used as the residence and office of the Deputy Surveyor of Windsor Forest & Parks (old title) until 1849. During that period all three Deputy Surveyors were from the same family. They were, William, Charles and Wilby Maslin. In recent years the land of the old farm has been converted into a golf range, appropriately named the Lavender Park Golf Centre. Rather interestingly, an old milestone at the London Road and Swinley Road crossroad junction indicates that it is 26 miles to London.

On the western side of Swinley Road, the estate continues to the boundary close to the residential part of Bracknell. Immediately south of the railway line is the Whitmoor Bog Sewage Works which takes the sewage all the way from the Blacknest Gate Pumping Station. South of the railway line, not far from Swinley Road, are a group of pine trees clearly showing the spiral scars where they were once used for resin extraction. The resin was used to make varnish by mixing it with turpentine.

From here on in a southerly direction there are many rides travelling in criss-cross pattern through the beautiful pine plantations.

On the eastern side of Swinley Road, just south of the junction of King's Ride, which is a private part of the forest, there are two lots of four terraced cottages facing the road. Built in 1935 for the estate staff, they were originally known as Nos. 1 to 8 Passmore's Cottages after the family of that name that managed that area of land before the Windsor Forest Enclosure Act came into being. The cottages are now known as Crown Cottages, Swinley Road. There were two older cottages built in 1878 that stood further south, but they were demolished in the 1980s.

Behind the cottages a large area was the site of the Swinley Brickworks. The brickworks was started on a lease basis by Thomas Lawrence of Bracknell in the 1860s and was run by the same company until closure in 1939. The bricks produced were rather misleadingly known as 'rubber bricks', simply

346

because they could easily be moulded to different shapes and sizes by rubbing them on a rough hard surface. It is known that many the bricks from the works were used to build Madame Tussaud's in Marylebone Road, London and some of the buildings at Harrow College.

At one stage there were eight kilns in operation. Each kiln had walls up to one metre thick and was fired from the bottom by coal. The process was to load each kiln with 120,000 bricks, then bake for three days on a low fire followed by seven days on full fire. The best bricks came from the centre of the stack. The bricks nearest the fire tended to be distorted. The unique nature of the bricks came from the type of clay and sand readily available in the area. The material consisted of 70% clay and 30% sand mixed together then left in settling pits during the winter. The bricks were made by hand in moulds of different sizes and the fastest brickmaker made up to 1,000 bricks a day. The work was thirsty and back-breaking for the workers, some of whom lived on the site and were partly 'paid' with beer. Even the transporting of the coal to the works and the finished bricks to the Ascot West railway station was arduous. Ten tons of coal was loaded on a truck and pulled by horse on a single railway line that went up a slope from the station to the site. The transportation of the finished bricks to the station was easier if not more hazardous. The loaded truck was allowed to freewheel down the slope controlled by one man using a hand brake. The most dangerous part was crossing King's Ride near the station. Peter Hoptroff, who is distantly related to the author, recalls having to stand with a red flag to stop any road traffic where the line passed over Kings Ride. The last works foreman in charge of the day to day running of the works in the 1930s was Bill Andrews who lived in Brickfield Cottage on the other side of Swinley Road.

During the last year that the brickworks were operating in 1939, the effects of modern brickmaking methods were taking their toll and production had been reduced to only two kilns. It is now hard to imagine what bricks were selling at in that year. Two inch thick bricks cost £2.00 per 1000 and three inch thick bricks were £3.00 per 1000.

All that remain of the works now are water filled clay pits, some bits of rusty equipment and the railway line embankment. In recent years several sika deer (cervus nippon) have found their way into the area. In 2000, a small herd of white goats was introduced to the site.

Directly opposite the existing Crown Cottages stood the second entrance to Swinley Park. The old ride to the site of Swinley Park Lodge (mansion) is

Photograph showing the comparison between a standard current brick and a ten-inch 'rubber' brick made at the Thomas Lawrence Brick Works, Swinley.

		Length	Width	Height	Weight
Top	A London Brick Company standard mass-produced brick, year 2000	21.0 cms (8.3 inches)	10.0 cms (3.9 inches)	6.2 cms (2.4 inches)	1.474 kgs (3.25 lbs)
Bottom	A Thomas Lawrence of Bracknell ten-inch 'rubber' brick, year 1900	25.6 cms (10.0 inches)	12.3 cms (4.8 inches)	7.5 cms (3.0 inches)	4.082 kgs (9.0 lbs)

Photograph by the author showing the comparison between a modern mass-produced brick and a handmade Thomas Lawrence of Bracknell, Swinley brick. The figure 2, after T L B, is the brick size reference.

347

A water filled clay pit on the disused Thomas Lawrence of Bracknell brickworks at Swinley – May 1999. (photo by the Author).

Parts of machinery last used in 1939 when the Thomas Lawrence of Bracknell brickworks at Swinley closed down – May 1999. (photo by the Author).

A well preserved 18th-century igloo shaped ice house of the type built and used at Icehouse Hill. Ice houses of this design were first used in the 1660s on the estates of large houses to keep a supply of ice available for the house throughout the year. The advent of electric refrigeration saw their demise. (photo taken in 2001 by the Author).

Swinley Paddock Cottage not long before it was demolished in 1980. (Ted Gardiner Collection).

Swinley Lodge, the residence of the Master of the Royal Staghounds. (engraving by Cook c.1800)

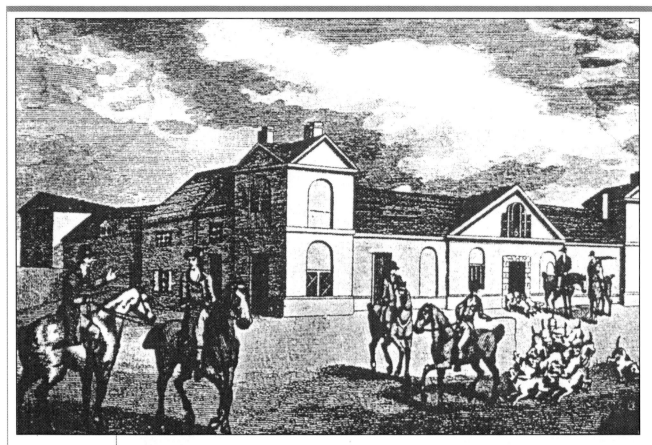

Swinley
Royal Kennels
(engraving by
Cook c.1800).

The Berkshire
Golf Course
Clubhouse. (photo
by the Author –
April 2001).

Swinley Forest
Golf Course
Clubhouse. (photo
by the Author –
April 2001).

known as Horsegate Ride. A distance along on the southern side of the ride is the site of 'Swinley Paddock Cottage'. It was built in the 1860s and was demolished 1980. For much of its life it was occupied by the Doel family, many of whom worked on the Windsor Crown Estate. The cottage was also known as 'Laundry Cottage' because the large Doel family always had washing hanging out on the line. Just beyond this on the northern side of the ride there is a circle of mature lime trees standing on what is known as Icehouse Hill. In the centre of the lime trees there was once an igloo shaped ice house that was used by the old Swinley Park Lodge. To the south of this is the site of the lodge. It was a considerable sized building originating in the 1500s and it was used for many years by the Master of the Royal Staghounds before being demolished in the 1850s. The adjacent Royal Kennels were pulled down shortly after. However the old deer pens were used for many years afterwards when the deer were rounded up.

To the south of Swinley Park, there is a drive named Blane's Lane. At one time it led to Blane's Farm which was last managed by William Blane in the 1850s - hence the name. The farm no longer exists having been replaced by the Windsor Forest Sawmill. Although the site had been used for many years for cutting and preparing timber, it was not until the old sawmill near Prince Consort's Workshops in the park was closed in 1979 that it was modernised with new buildings and equipment. The site was operated by eight men and produced broken up bark that was sold to the horticultural industry and equestrian centres. The wood chips were sold to manufacturers of chipboard. In recent years, much of the site has been let due to the arrival of private concerns in the timber product trade.

At the start of Blane's Lane at Swinley Road is the previously mentioned 'Brickfield Cottage'. It was built using bricks from the Swinley Brickworks in 1897 as a residence for the foreman of the works. The cottage was rebuilt in the early 1980s. At the far south-eastern end of Blane's Lane the lane meets up with the Bagshot-Bracknell Road. The original entrance lodge, known as 'Red Lodge', was built for the district Woodman in the 1870s. For many years the Woodman was Richard Bushnell-Wye who was a close friend of the author's family. The cottage was demolished in the 1980s and replaced with two modern detached houses.

During the 1920s, the forest north of Blane's Lane became an extremely popular picnic area on Sunday afternoons. Some of the local coach companies were quick to capitalise on this surge of interest by running coach trips from the local towns and villages. In 1985, the forest was used as a location for making a television version of the popular 'Dirty Dozen' films. The original Dirty Dozen film starring Lee Marvin, a rugged faced American actor, was made in 1967. This last version, which was a far cry from the original film, also starred Lee Marvin. Sadly, he was by now in poor health and was regularly being given oxygen in a caravan on the site. The film was called 'The Dirty Dozen: Next Mission' He made one more film after this before he died in 1987.

On Saturday 7th and Sunday 8th October 1995, Swinley Park was closed to the public as it was the venue of the very first (and possibly the last) motor rally to be held on the estate. The event was the Privilege Insurance London International Rally. The leading manufacturers and drivers competed in the two day event, amongst them Malcolm Wilson, the reigning British Rally Champion.

The triangular shaped area of the forest south of Blane's Lane is the eighteen hole golf course used and maintained by The Berkshire Golf Club. During 1841-1927, a nine hole private golf course existed on the site for use by the Royal Family and their guests. In 1927, a major transformation of the site took place when The Berkshire Golf Club was given permission to develop the course for its own use. Mr Herbert Fowler, a leading course designer of the time, was given the task of creating two eighteen hole courses to be known as the 'Red Course' and the 'Blue Course'. The construction of the courses and the clubhouse was enthusiastically watched over by the club's first Secretary, Major Sarel. The club and courses were opened in November 1928 and have continued to be popular with golfers ever since.

Slightly to the north of the entrance to The Berkshire Golf Club on the eastern side of Swinley Road, is the house and land of Tower Hill. It is a rectangular shaped piece of land in private ownership. It is unique in that it is the only property in the forest which is completely surrounded by Crown Land. Tower Hill has an important part to play in the history of The Valley Gardens on the northern slopes of Virginia Water Lake. Mr John Barr Stevenson, who lived at Tower Court during the 1930s – 1940s was the person who amassed a magnificent collection of rhododendrons and azaleas in his garden at Tower Hill that were used to establish much of The Valley Gardens including the Punch Bowl.

To the east of Tower Hill, the scots pine plantations stretch to the boundary of the estate at the Ascot to Aldershot railway line. To the south, the plantations decrease in density as they open out onto the Swinley Forest Golf Club Course. The southern side of the golf course marks the boundary of the estate which runs along the line of The Devil's Highway and the county boundaries of Berkshire and Surrey. The Swinley Forest Golf Club was founded in 1909 and was first opened for play three years later in 1912. The Clubhouse is situated near the entrance from Coronation Road being the road that runs between South Ascot and Windlesham. As with The Berkshire Golf Club Course, the setting of the Swinley Forest Golf Club Course is idyllic.

On the south-western side of the Bagshot Bracknell Road most of the area consists of some of the most beautiful scots pine plantations to be found in Southern England. Starting at the northern end, at the border of the residential part of Bracknell, a large car park, catering facilities and an information centre have been provided for visitors at an entrance on Nine Mile Road (B 3430), an old Roman Road. It was formally opened by Queen Elizabeth II on Wednesday 10th April 1991 in the blaze of brilliant sunshine. The Queen was accompanied by Prince Philip The Duke of Edinburgh and Lord Lieutenant of Berkshire, John Henderson C.V.O., O.B.E. Councillor Edwin Thompson, Mayor of Bracknell Forest Borough Council had the honour of escorting the Royal Party around the site then known as 'The Look Out, Heritage Centre', since re-named The Look Out Discovery Park. At the same time The Look Out was opened, access to the forest was granted to the public for the first time and, for obvious reasons, the role of the district Gamekeeper became redundant.

The Look Out centre is owned and managed by Bracknell Forest Borough Council, whilst the forest is owned and managed by The Crown Estate Commissioners. The centre consists of a large car park and picnic area. The buildings, which were designed by Andris Berzins Associates of London, feature a reception-cum-information hall, gift shop, coffee shop and exhibition area, and a 22 metre (72 feet) high Look Out Tower complete with a telescope for viewing the surrounding forest. Built into the inside wall of the coffee shop is an inscribed sandstone rectangular block which originated from Victoria Hall, Church Road, Bracknell where it had been installed to celebrate Queen Victoria's Golden Jubilee of 1887. The Look Out has become an ideal nature and history educational facility for children. It is the starting point for walks along clearly marked routes. Horse riding, cycling and mountain bike riding along planned routes is possible, strictly by permit only. A mountain bike hire facility is provided at The Look Out. Several charity fund raising events are allowed each year. Since 1991, a five-mile running race has been organised by the Bracknell Forest Runners. This extremely popular event which is held in the summer, attracts about 400 runners each year. During the year 2000, well over 600,000 people visited the centre and forest, of which, over 100,000 entered the recorded part of The Look Out.

Starting south from The Look Out, there are many rides laid out in a criss-cross pattern travelling in different directions through the seemingly endless scots pine plantations. The main rides are The Devil's Highway, Lake Ride, Bracknell Road (Ride) and Vicarage Lane.

From The Look Out, in an easterly direction, the estate boundary follows the line of the public road named Nine Mile Ride. It is interrupted by the privately owned rectangular plot of land known as Gormoor Farm. The farm originated from the 1870s and took its name from the pond that exists there.

Beyond the farm there is an Iron Age hillfort known as Caesar's Camp. As it dates from around 700 BC the name is very misleading. The earthwork defences of Caesar's Camp are made up of a double embankment having an overall cross-section width of about 40 metres (43.7 yards). From the air, the fort very much resembles the shape of an oak leaf. Listed as an Ancient Monument, it covers an area of about 6 hectares (15 acres). Although the fort has never been excavated, it has been established by evidence found at other similar hillforts in the south of England, that it was almost certainly built by the Atrebatic tribe whose capital was to the east at Calleva Atrebatum (Silchester) south of Reading. It was most likely used by the Romans during their occupation of the country. This is confirmed by the fact that a short distance away to the south of the fort, there was a small Roman site known as 'The Town'. A crude excavation of the site in the 1800s unearthed Roman pottery and coins. There are five entrances to the fort. It is not certain how many of these are from the original construction. Today they are known as:- Queen Anne's Gulley at the north, North-East Entrance, East Entrance, Southern Entrance, and Western Entrance.

In the 1840s a Woodman's cottage was erected inside the northern area of the fort. The cottage was appropriately named 'Caesar's Camp Cottage'. The first Woodman to take up residence there was George Slark, a local man who was born in 1820. He had five sons at the cottage with his wife Maria from Old Windsor. Sadly, Maria died there when she was quite young in the 1860s. George Slark continued to live there with his second wife Sarah until 1888. The next Woodman, who was well-known by the author's family, was James Wye. He moved in as Woodman shortly after his marriage to his wife Ada. They lived there for many years well into the 1900s. The cottage came to the end of its life when it was demolished in the 1960s.

Over a period of time several gravel pits were dug in and around the fort. During the 1950s, much of the fort's interior was planted with conifers. In 1990, trials began to establish how best to restore and preserve the site and at the same time provide clearer views for visitors. The major work was carried out by the Windsor Crown Estate Forestry Department in agreement with the Bracknell Forest Borough Council and Berkshire County Council during 1994. By the end of the year, over 800 large sweet chestnut trees and 700 tonnes of conifers had been removed from in and around the fort. For the first time for years, a clear view of the ramparts could be seen unrestricted from any direction. The main problem is how to keep it that way.

At the east of Caesar's Camp, the forest and estate boundary borders the Bracknell Forester's Way Road (A3095). In the centre is Hut Hill, which until the 1800s had a substantial house standing there named 'The Hut'. At one time as many as fifteen people, mainly servants, lived there.

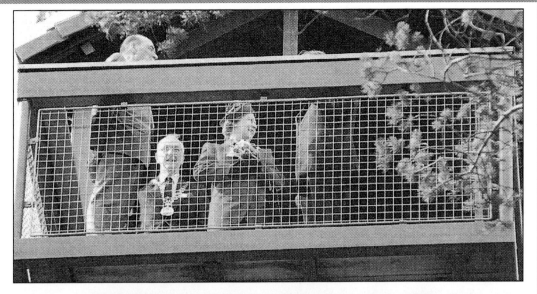

Queen Elizabeth II at the top of The Look Out when she opened the Heritage Centre (since re-named Discovery Park) on Wednesday 10th April 1991. (The Look Out Discovery Park Collection).

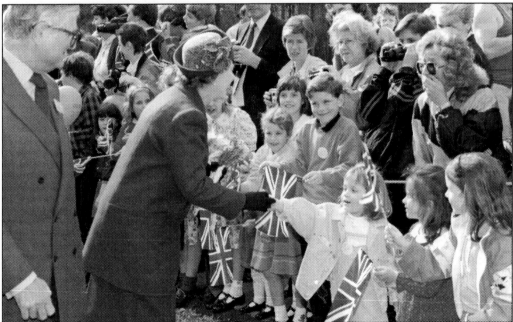

Queen Elizabeth II meeting a group of people who had come along to see the opening of the Heritage Centre. (The Look Out Discovery Park Collection).

The Look Out Discovery Park in Swinley Forest – June 1999 (photo by the Author).

Commemoration stone from the demolished Victoria Hall, Bracknell now mounted on the wall in the coffee shop at The Look Out. It is inscribed as follows:-
Public Subscription In commemoration of the fiftieth year of the reign of HER MOST GRACIOUS MAJESTY QUEEN VICTORIA
Scots pines, the main characteristic of Swinley Forest. (photo in July 1998 by the Author).

Scots pines - the main characteristic of Swinley Forest. (photo taken July 1998 by the Author)

THE CROWN ESTATE

SWINLEY FOREST

This forest forms part of the Windsor Crown Estate and is owned by the Crown Estate Commissioners as productive woodland.

The predominant species are Scots Pine, Birch, Sweet Chestnut and Oak. (There are over 60 species of trees in the forest) with a greater percentage of broadleaves now being planted.

The wildlife habitats are many and varied and it is our policy to conserve them, enhancing and increasing their diversity.

To this end, tracks and trails have been set up around the woodland and visitors are asked to stay on them and not walk through plantations.

DOGS MUST BE KEPT UNDER STRICT CONTROL

DO NOT START FIRES

FOR YOUR OWN SAFETY STAY CLEAR OF TREE CUTTING OPERATIONS

For further information contact :- The Forestry Dept, Crown Estate Office, The Great Park, Windsor 0753 860222

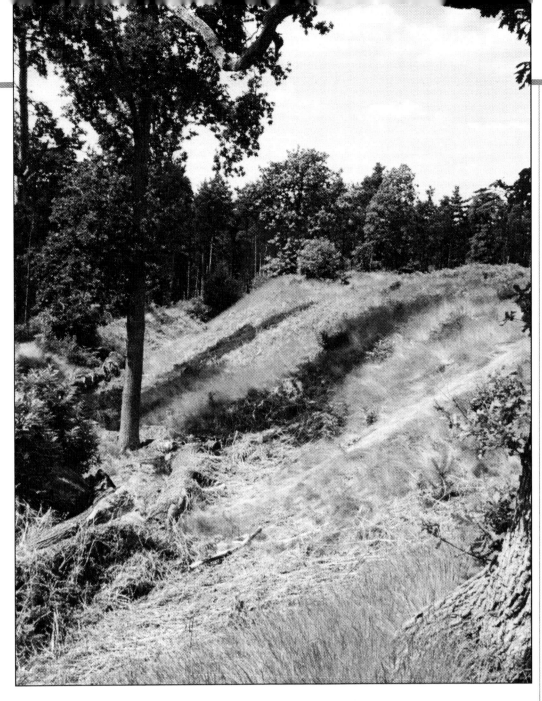

Part of the ramparts on the western side of Caesar's Camp in Swinley Forest. Caesar's Camp is an Iron Age hillfort and was probably built about 700BC. The name is quite misleading, as it would be easy to assume that it was built by the Romans, when in fact it is a name associated with their occupation of the country AD 43-410. (photo August 1999 by the Author).

From the southern entrance of Caesar's Camp, three rides branch out in a southerly direction. The central ride travels in a straight line through the pine forest and meets up with the junction with Pudding Hill ride which goes in a north-easterly to south-westerly direction. The Devil's Highway passes through in a west to east direction. At the northern edge of the junction is the Crowthorne Reservoir. The junction is known as Upper Star Post. Just south of The Devil's Highway there are several small earthwork mounds known as 'Redoubts' which were designed as outer defence posts in preparation for a possible Napoleonic invasion in the early 1800s.

Continuing in a straight line from the junction, the ride meets up with another junction known as Lower Star Post. The junction consists of the largest number of rides crossing each other than anywhere else in the Windsor Crown Estate. Standing in the centre of the junction, you can look along eleven rides going in different directions. Not far to the east is the site of a windmill now known as

Windmill Post. To the south Lower Star Post is the estate boundary line which zigzags from the west at a point known as Poppy Hills to the south-east at London Road (A30) in an area known as Collingwood. South of the boundary is Olddean Common being a large area of Bagshot Heath, It stretches as far as London Road and the Royal Military Academy, Sandhurst, in the south. This area was part of the Windsor Crown Estate until 1952 when it was sold to the War Office for military use. It is now marked as a danger area and the public is prohibited from entering the area.

At the boundary south-east of the Lower Star Post there is a place called Wishmoor Cross that is situated on the county boundaries of Berkshire and Surrey. For centuries it was a popular Royal Hunt meeting place. It was also the site of a gibbet, which was a large post with an arm at the top upon which criminals were executed and hung up as a potent warning to others. Persistent poachers were most likely to finish up here. Wishmoor Cross still has a foreboding feeling about the place.

Eastwards along the boundary is Surrey Hill, which at a height of 130 metres (427 feet) above mean sea level, is the highest point on the Windsor Crown Estate. For many years the hill was the site of an old lookout post. The lookout cabin was built at the top of four enormous pine tree trunks that soared above the surrounding Bagshot Woods, as the area was more generally known in the past. During dry seasons in particular, observers would spend hours looking for the dreaded signs of a forest fire. No time was more worrying than the drought that seriously affected the country in 1976. In that year, the natural water resources were depleted as never before. The situation was so serious that the Government introduced the emergency Drought Act 1976 as a measure to control the situation. Fires were breaking out on a daily basis, and a fire in July at Surrey Hill was in danger of destroying the Look Out itself. Later another fire destroyed about 40 hectares (99 acres) of forest next to the Bagshot Bracknell Road. With no let up in the drought, the month of August was even more worrying. The most vulnerable car parks and picnic areas on the estate were closed to the public. Thirty estate employees were taken off normal duties and placed on fire patrol. Fortunately, the forest survived the year without any further destructive fires.

In 1980-1981, the small reservoir that stood on the southern side of Surrey Hill was replaced with a much larger reservoir. The construction of the reservoir was a minor undertaking when compared to the work required to lay the 91.44 centimetres (36 inches) diameter mains pipe. It started at the River Thames near Egham and went via Bishopsgate, Ascot Gate and through the forest to the reservoir. Water is supplied from here to a residential area west of Bracknell by the Mid Southern Water Company.

From Surrey Hill, the Bracknell Road ride heads almost due north over the site of Bushfields (tree) Nursery. The nursery was used by the estate until the 1940s to propagate the tree stock for the local area. On Tuesday 29th October 1918, the nursery was visited by some of the country's leading people involved in the re-afforestation programme following the decimation of many of our forests during the First World War. The visiting party consisting of forty people included:- Major G.L. Courthope M.P.(President of the Royal English Arboricultural Association and the Royal English Forestry Association) and Sir Herbert Mathews (Secretary of the Central Chamber of Agriculture). The party were accompanied by Mr Arthur J. Forrest (Deputy Surveyor and Crown Receiver of the Windsor Crown Estate), Colonel S.L. Penhorwood (Commanding Officer of the Canadian Forestry Corps who were camped all over the estate) and Mr W.C. Squires (District Forester). At the time of the visit, the Bushfield Nursery was planted with seven million seedlings consisting of:- Scots pine, Corsican pine,

European larch, Japanese larch, Douglas fir, sita spruce, sycamore and beech. Most of the back-breaking work of planting the seedlings had been carried out by twenty-five women working on piecework.

Further north at a rise named New England Hill, a ride to the north-east leads to Mill Pond which has a ride running along the side known as Mill Ride. The pond is roughly triangular in shape being about 140 metres (153 yards) long and about 80 metres (87.5 yards) at the widest point. It was created as a result of clay extraction for brickmaking centuries ago.

To the south of Mill Pond, bordering the Bagshot Bracknell Road are the open fields of Rapley Farm. It is named after the family that worked the farm during the early part of the 1800s. On the northern half of the farm there is an isolated detached cottage named "Red Cottage". It was built in 1878 and has mainly been used as a Gamekeeper's cottage. The Farmhouse and yard stand in a central position on the farm. In 1984, the farm was the venue of The National Forest Machinery Exhibition. It is a biennial event held at different locations organised by the Association of Professional Foresters (APF's). The exhibition was opened by the Duke of Gloucester on Wednesday 12th September and it closed on Friday 14th September. No fewer than eighty companies from all over the UK were there to display and demonstrate their equipment in front of many visitors from home and abroad. Fortunately, the weather stayed dry helping to make the event very successful. There was also a welcome bonus for the estate for its involvement in helping to organise the event. Left behind on the site by the exhibitors from their demonstrations, was about 200 tonnes of pulpwood and sawlogs, free-of-charge, for the estate.

For centuries Windsor Forest has provided timber and by-products for an enormous range of end uses. The sand, gravel and clay-rich soil of Swinley Forest and Bagshot Woods made it ideal for conifer soft wood production. During the First World War, much of the timber was sent to the battlefronts for use as trench supports and shelters. Since that time many thousands of pine tree trunks have been sold to British Telecom (formerly the Post Office) for use as telegraph poles. Many other uses come from the pine trees:- agricultural fencing, rustic poles, wood for chipboard, pulpwood, bark chippings for equestrian and garden centres. Other uses in the past were resin extraction and bark used for the tanning of leather. It was not unknown for persons to be prosecuted if caught illegally taking bark from the forest for that purpose. Modern machinery has removed the back-breaking harvesting methods of past.

West of Rapley Farm we come back into the public access of Swinley Forest in an area locally known as Bagshot Woods. The two main features of the area are Lake Ride which is part of The Devil's

Highway and Rapley Lake. Lake Ride travels due east in a straight line through some truly magnificent pine plantations to Upper Star Post and beyond. On the southern side of the ride at the eastern end is Rapley Lake. It was created centuries ago by building an embankment and damming an existing stream. The lake is roughly shaped like a boomerang and it is about 340 metres (416.6 yards) long and about 90 metres (98.4 yards) at the widest point. A ride sweeps round the southern bank, over a quaint brick built bridge named Rapley Bridge. From the ride immediately past the bridge, the full beauty of the lake can be seen for the first time. The lake is well stocked with fish which over the years has attracted some of the country's rarer birds. During the 1860s, a white-tailed eagle was shot by a Gamekeeper next to the lake and in the 1990s an osprey was seen catching fish there. The ride comes to an end at some iron gates at a point where a track on the other side, known as Green Lane, passes at right angles. The lane and the rest of the estate stands in a private area.

The lane comes across an open field at the north-east from Rapley Farm. During 1916-1919, the field was used as a camp by the Canadian Forestry Corps. When the corps decamped in 1919, they left their main wooden hut that stood in the field in the corner nearest the lake. It was left there by special request of Princess Patricia the youngest daughter of the Duke of Connaught who lived nearby at Bagshot Park. The hut was thereafter known as 'Princess Patricia's Hut'. The hut

and surrounding area came into the public eye in 1927 when it was used by the YMCA for their International Boys Camp. The sight was the suggestion of the Duke of Connaught who was very familiar with the area. The camp, which started on Saturday 2nd July and ended on Monday 11th July, was attended by 150 boys and young men, aged between 14 and 19 years from America, Czecho-Slovakia, England, France, Germany. Japan, Poland, Russia, Scotland, Singapore and Sweden. The camp was under the direct control of Mr. Charles Heald, National Secretary of the English YMCA and Mr. Tracy Strong of the World's Committee of the YMCA. The focal point of the camp was a circular clearing in the rhododendron bushes next to the lake. The services were held around a fire in the centre of the circle. On the last Sunday, 10th July, in the evening, the service was ended with the Domitia Rogata Tombstone that had been brought from The Ruins at Virginia Water being placed on the ashes of the fire. It stayed there untouched until March 1961, when it was moved to the Classics Museum at Reading University. The full details of the tombstone are described in Chapter 14.

A short distance south of the iron gates along Green Lane stands 'Lake Cottage'. It was built in 1878 as a detached cottage in typical style of the estate buildings at the time. When Hope Findlay went to live there in the 1970s, he brought with him one of the last remaining grape vine cuttings from the gigantic vine once growing in the Vinery near Cumberland Lodge.

Telegraph poles being prepared for sale in Swinley Forest in 1968. The two Windsor Crown Estate Forestry Department staff are Jack Beard on the left and Graham Bish (Forester) on the right. (Graham Bish Collection).

Mill Pond in Swinley Forest – June 1999. (photo by the Author).

A wood ant's nest made almost entirely from pine needles. This nest, near Mill Pond, was photographed in June 1999 by the author when it was about one metre (39.37 inches) high. Similar nests can be found throughout the forest.

Lake Ride looking west towards Lower Star Post – June 1999. (photo by the Author).

358

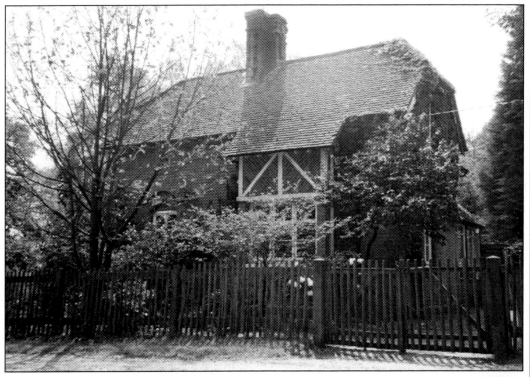

Lake Cottage built in 1878 stands near Rapley Lake – June 1999. (photo by the Author).

Rapley Lake – June 1999 (photo by the Author)

Rapley Bridge next to Rapley Lake – June 1999. (photo by the Author).

Further along the lane, a track branches off to the east between two concealed fish ponds, then over a small brick bridge named 'Dry Arch Bridge'. It is so named because it never has any water under it. The two ponds are elongated in shape and as with other ponds in the area, they were created as a result of clay extraction. Both ponds are about 145 metres (158.6 yards) long and about 70 metres (76.5 yards) wide. The county boundaries of Berkshire and Surrey cut through the top of the lower pond and continue in a north-easterly direction over the Bagshot Bracknell Road at a point where some majestic iron gates stand. The gates are known as the 'Ascot Gates' being once the northern entrance to Bagshot Park. Until the 1960s a red brick Gate Lodge stood high up in a dominant position on the southern side of the gate. The demise of the lodge came when the Bagshot Bracknell Road was widened into a dual carriageway at the same time the gates were permanently locked and barred to prevent access. Nearby within the confines of Bagshot Park is an area of the wood known as The Orangery. Not surprisingly an orangery once stood here. Situated south-east of here is a detached cottage called 'Laundry Cottage'. It was built in 1878 at the same time that the Bagshot Park Mansion was being constructed to provide accommodation and laundry facilities for the mansion.

The Bagshot Park Mansion was built on the site of the previous mansion that had stood there from the 1500s which was at the time in a fairly central position in Windsor Forest. It was the home of the nobility of the country and was often visited by members of the Royal Family particularly Queen Victoria who visited the park on many occasions. For several years the Duke and Duchess of Gloucester lived there during the 1820s. During the 1840s Bagshot Park had gone into decline and was rapidly revitalised in 1850 when Major General Francis Hugh Seymour, Deputy Ranger of the Park (1850-1870) went to live there with his wife Emily, three sons, Hugh, Albert, Eruesh and three daughters, Horatia, Florence and Georgina. By 1851, no fewer than fifty people were living in the mansion, surrounding stables, farm buildings and lodges. The adults were employed as servants, laundry workers, farm hands, gamekeepers, gardeners and gatekeepers etc. By the 1870s the mansion and outer buildings were falling into disrepair and the number living there was about twelve people, in particular Sir James Clark (Queen Victoria's Doctor) and John Graham (Queen Victoria's Farm Steward of Bagshot park).

In 1876, Queen Victoria thought that if the mansion and surrounding buildings were rebuilt, it would make an ideal residence for her third son Prince Arthur Duke of Connaught. On Monday 12th June 1876 a meeting was held at Bagshot Park between Mr Ferrey (architect), Mr William Menzies (Deputy Surveyor of the Park) and Sir Howard Elphinstone during which the plans were agreed for the clearing and rebuilding of all existing buildings. On Thursday 13th March 1879, the Duke of Connaught married Princess Louise Margaret of Prussia at St George's Chapel, Windsor Castle and on Monday 29th December that year, they moved into the mansion upon completion. In the very first year of being there the Duke allowed the Bagshot and Windlesham Horticultural Society to hold their shows in the park. In 1882 the Duke and Duchess had their first child there, Princess Margaret, followed by Prince Arthur in 1863 and Princess Patricia in 1866. The Duke and Duchess of Connaught were in favour of close links with the public and they helped to organise public functions in Bagshot Park. One of the grandest was a two day open-air bazaar and garden fete held on Tuesday 18th and Wednesday 19th July 1899. It was also an occasion to show off the new Coach House and Stables that had just been completed. The purpose of the event was to raise £1,600 to purchase a new organ for the nearby St Anne's Parish Church. The money raised far exceeded that figure. The event was brilliantly organised with special trains laid on to bring people from London and with horse-drawn carriages waiting at the flag covered Bagshot Railway Station. Many marquees, tents and stands had been erected and colourfully decorated with buntings in a large area of the park. Military bands of the Queen's Own Cameron Highlanders, Scots Guards and Royal Artillery added to the atmosphere by playing the popular tunes of the day. The extent of the Royal patronage and dignitaries attending the event was exceptional. Aside from the hosts the Duke and Duchess of Connaught, the following were just some of the many who attended:- Queen Victoria, Prince and Princess Christian, Princess Henry of Battenberg, Princess Victoria of Schleswig-Holstein, Princess Margaret and Princess Patricia of Connaught, Prince and Princess Adolphus of Teck, Princess Hatzfeldt, the Duchess of Somerset, the Viscountess Coke, the Earl and Countess of Dudley, the Earl of Kilmorey, and the Viscount and Viscountess Falmouth. There were many other Lords, Ladies and senior ranking military officers. An admission fee of a half-crown, which was a considerable sum in those days, allowed only the wealthier to attend.

In 1911, the Duke and Duchess moved to Canada to take up the Duke's appointment as Governor-General of Canada. At noon on 13th October 1911 he was sworn in to take up his new post. At the finish of his duties in Canada on 11th October 1916 he returned to Bagshot Park whereupon the Duchess's health deteriorated. Certainly the poor water supply and questionable sewage system at the mansion did nothing to assist her health. At the start of March 1917 the Duchess was diagnosed as having influenza and was put to bed at Clarence House in London. Sadly she never recovered and died on Wednesday 14 March aged 57 years. It was exactly one day after her thirty-seventh wedding anniversary. The

Duke returned to Bagshot Park shortly afterwards broken-hearted. Being a strong minded person he continued to make the most of his life and was often visited by other members of the Royal Family.

Come the start of the Second World War, it was not long before the Duke decided to take in about thirty very young evacuees from poor families in London. Further excitement came to Bagshot Park on 10th April 1941 when a German Junkers JU 88 bomber crashed on the farm. A full account of these events are given in Chapter 18.

During most of the 1900s until the Duke died at Bagshot Park on Friday 16th January 1942, a loyal coachman named Charles Ghost and his family lived there. Consequently it could be said that 'ghosts' were regularly seen in Bagshot Park. However, it is Prince Arthur William Patrick Albert, Duke of Connaught and Strathern, who was born on Wednesday 1st May 1850 at Buckingham Palace, for which Bagshot Park is most remembered.

Shortly after the death of the Duke in 1942, Bagshot Park was requisitioned by the Army for use by the Auxiliary Territorial Service (later to become the Women's Royal Army Corps. WRAC), as their Staff College. As the war drew to a close in 1945, this function came to an end and it was used for a few weeks as an RAC Officer Selection Centre.

In November 1946 King George VI offered the mansion to the Chaplain General of the Army to be used as a Church House and Chaplain's Depot. The offer was readily accepted and the mansion was leased to the Army for this purpose on a forty-year lease at a nominal rental. The Crown had the option to terminate the lease, should the house be required as a residence for any children of the Sovereign. The first intakes of Chaplains and Christian Information courses started in February 1947 and continued until 1996 when the lease expired. Due to financial defence cuts, no attempt was made to renew the lease.

In July 1998, Queen Elizabeth II agreed to let her youngest son Prince Edward use Bagshot Park for his television company Ardent Productions. The large coach house and stable building was used for that purpose, whilst the mansion was the subject of an enormous renovation programme. The main costs were to be borne by a company created by the project and the Crown Estates. On Saturday 19th June 1999, Prince Edward married Sophie Rhys-Jones at St George's Chapel, Windsor Castle. The ceremony was followed by a short tour in an open horse-drawn carriage from the castle, along the High Street in Windsor to The long Walk and from there back into the castle. Their new titles were, the Earl and Countess of Wessex. After a short honeymoon, they returned to Bagshot Park to embark on their married life and their businesses. In March 2000, Bagshot Park came back into the public eye when it was found that the renovation work had cost £2 million. Much of this cost was borne by the Ministry of Defence who under the terms of the old lease were responsible for the repair of the mansion which had been neglected. Bagshot Park, which covers an area of 35.6 hectares (88 acres), is currently covered by a fifty-year lease from the Crown Estate.

There are two entrances to Bagshot Park from London Road. Both have large ornate iron gates with adjacent lodges. The one at the south-east is near The Cricketers Hotel and the other is at the south facing Bagshot. The gates also mark the boundary of the Windsor Crown Esate. A large area of the park is mainly operated as a dairy farm under the direct control of a farm manager. In the lower half of the farm there is a triangular shaped pond with a bridge at the eastern end going over the Windle Brook. The pond is about 115 metres (126 yards) long and about 85 metres (93 yards) along the head and was created many years ago by damming the brook. During the 1800s some perfect specimens of Bronze Age axe heads were found in the proximity of the pond.

From the pond almost due south can be seen the spire of St Anne's Parish Church. From the church there is a straight track leading towards the old Bushfield Nursery. The track is appropriately known as Vicarage Lane. The plantation on the north-eastern side of the track is named Queen's Wood. To the west of Vicarage Lane, the estate continues across Bagshot Heath until it meets the boundary fence at the previously mentioned Olddean Common. This is the boundary fence that leads in a southerly direction until it eventually meets up with the London Road at Collingwood. A cottage that stands there is named 'Collingwood' and it is situated at the most southerly boundary of the whole of the Windsor Crown Estate. It was mainly used as a Woodman's residence and from the l860s to 1920 it was the home of Richard Bushnell-Wye and his family. The 'Bushnell' part of his surname was added in l898. Richard was born at Egham in 1838 and started work in the Egham Wick area of the estate as soon as he left school. After learning the art of forestry, he became a District Woodman, mainly in Swinley Forest. Richard married Mary Tanner from Egham and they had eleven children, a normal number for those days. He was a very good friend of the author's family and was a pallbearer at the author's great grandfather's funeral. Richard died at Collingwood on 26th April 1920

Having described the main features and events of Swinley Forest and Bagshot Park, the extent of the plants and wildlife to be seen there is almost infinite. For the true nature lover it is a dreamland. The trees and smell of the pines would be enough on their own, however, there is the added interest of the roe deer. muntjaks, sika deer, foxes, and badgers etc., plus an enormous range of birds, even on rare occasions Dartford warblers can be seen.

A photograph of Richard Bushnell-Wye and his family in the garden at Collingwood in 1901.
The family members portrayed are:- standing at the back, Frederick William his son, (1861-1912). Seated in front of him, Miss Annie Woods (Arthur's girlfriend), Richard Bushnell-Wye (1838-1920) and Mary his wife (1834-1906). In the front are Arthur, his son, born in 1879, Alice Marion his daughter, 1876-1962 and Jonathan Corbett, the husband of Alice Marion. 1876-1950.
(great grandson Richard Bushnell-Wye collection).

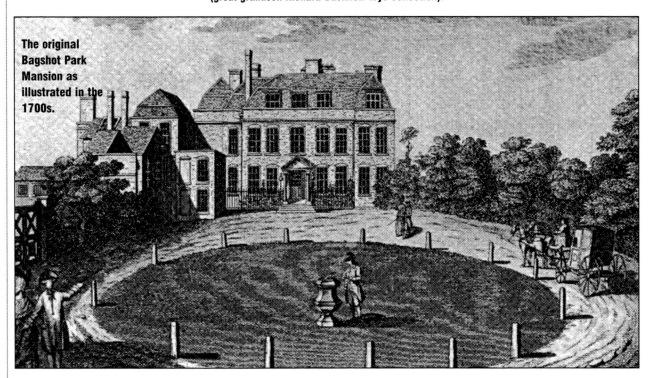

The original Bagshot Park Mansion as illustrated in the 1700s.

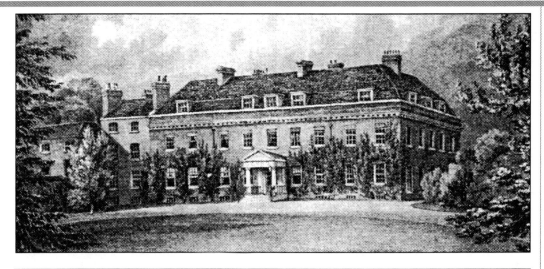

An illustration of Bagshot Park Mansion after it had been extensively enlarged and improved for the Duke and Duchess of Gloucester who lived there in the 1820s. It was demolished in 1876 and replaced with the current building.

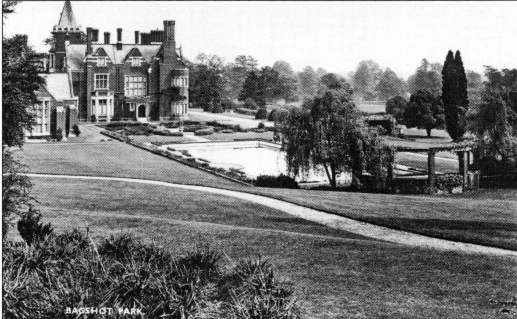

Bagshot Park Mansion in 1942 showing it in a well cared for condition.

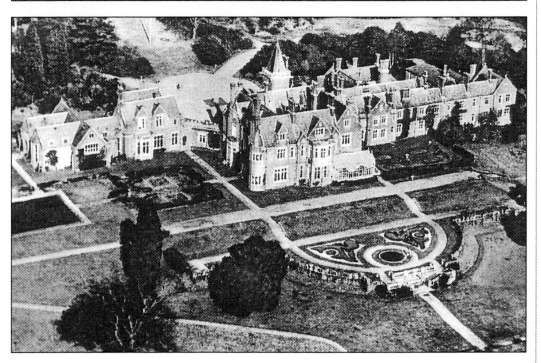

An aerial view of Bagshot Park Mansion in 1947. It was then being used by the Army as the Chaplain's Training Centre.

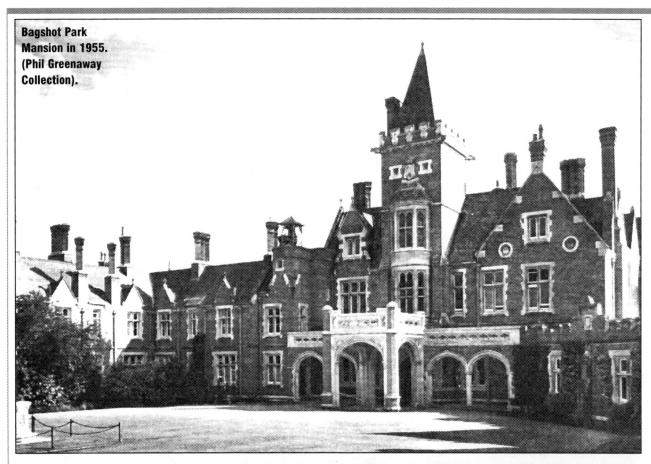

Bagshot Park
Mansion in 1955.
(Phil Greenaway
Collection).

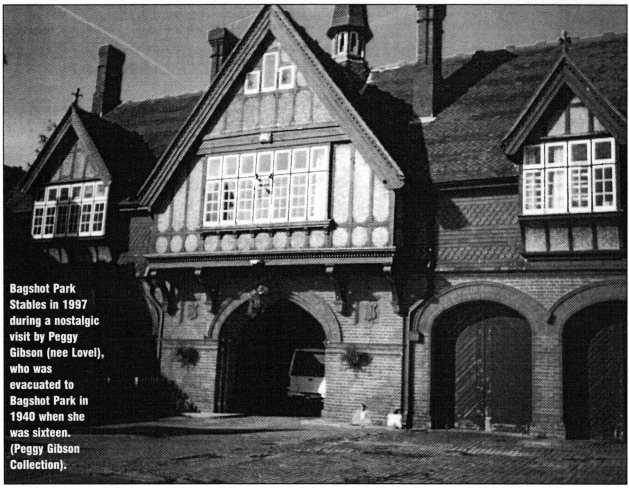

Bagshot Park
Stables in 1997
during a nostalgic
visit by Peggy
Gibson (nee Lovel),
who was
evacuated to
Bagshot Park in
1940 when she
was sixteen.
(Peggy Gibson
Collection).

Second World War

Chapter 18

Second World War

The Second World War, declared on 3rd September 1939, changed the park and forest from a place of peace and serenity to a hive of military activity that was to intensify as the war wore on. Before the war was over, three people were to lose their lives in the park and eleven people in Windsor and Eton. On the very first night of the war, air-raid sirens could be heard wailing away in the direction of Slough. This turned out to be a test exercise only. At the outset, strict blackout conditions were imposed and wardens patrolled the streets to ensure that not a glimmer of light could be seen through the curtains.

From the very start, the park and forest was placed in the hands of the military forces and an immediate measure was to lock the gates from sunset to sunrise. During 1940, three obvious landmarks from the air namely, Virginia Water Lake, Obelisk Pond and Great Meadow Pond were drained of most of the water. As a precaution to protect the young, evacuees, mainly from London started to arrive by the train load to be taken into the homes of the local people. One such person was Peggy Lovell, who 58 years on as Mrs Gibson, recalls her experiences of the time as follows:-

"It was June 1940. I had just reached my fifteenth birthday, when my mother deposited me at Bagshot Park, the home of the Duke of Connaught, I can remember waving goodbye to my mother from the long drive until she became a dot on the horizon. I was so sad as I did not know when, or if we would meet again. This was to be my home for the next two and half years. The Duke very kindly had the rooms above the stables converted into a nursery for the children from the London areas, most of whom had come from extremely poor homes, so it was wonderful for the very young children, about 30 in all to be looked after so well. Being only fifteen, I was too young to start my nursery training so I volunteered to help in the kitchen. Working from 7.00 in the morning to 7.00 in the evening was hard going and I must admit I found it tiring. However, the compensation of being there, the freedom of the grounds and produce in abundance from the Park Farms was real luxury. When we were out with the children, the Duke would often give us a lift back to the stables in the Royal Car which was very acceptable especially on cold days. On the Duke's ninetieth birthday he had a two tier cake and he gave the bottom tier to us and the children. The Duke was very fond of music and adored his social evenings. Often he would invite 'The Girls' as he would call us, to those wonderful events and we felt highly honoured. Queen Mary, I remember, was one of the guests on some of the occasions. We were so lucky to be part of the life in the Park".

Young evacuees from London at Bagshot Park during the darker days of the Second World War in 1940. The carers are from left to right: - Jean Sowerby, a student nursery nurse from Yorkshire, Daisy Brown, the Matron, who later married Charlie 'Pop' Ghost, the Duke of Connaught's Coachman and Peggy (Surname unknown), a student nurse from Darlington. (Peggy Gibson Collection).

The threat of an invasion by sea and air was very real indeed and the whole country was making defences for such an event. By June 1940, three concrete reinforced pill-boxes had been built in the park. One was positioned where Albert Road crosses The Long Walk at the south west corner of the junction. It was unique in that it had a wooden structure on top to make it look like a shed. Later in the war this became one of our favourite 'camps'. The second pill-box was just inside the park on the south eastern side of Queen Anne's Gate. The last one was at the far western end of Snow Hill, partially hidden under the trees.

In the centre of the Review Ground, reinforced concrete anti-aircraft gun emplacements were installed to take six 3.7 calibre guns. Later on, four were replaced with much heavier 4.5 calibre guns. The living quarter huts were erected under the old elm trees in Queen Anne's Ride, with the sergeants' mess on the southern side of the site entrance. This was at the end of the short drive that came in from Sheet Street Road at the Prince Consort's Drive junction. The gun site was enclosed with a substantial three coiled barbed wire fence. Within this area were the direction range finding units accessible by wooden slatted walkways. A mobile barrage balloon unit was installed on the site. Anti-invasion poles were erected all over the Cavalry Exercise Ground which was an obvious site for the enemy to stage an airborne landing. Approximately halfway between Sheet Street Road and Flemish Farm a searchlight station was installed on the northern side of Prince Consort's Drive. On the northern side of the gun site, a small airstrip in a east to west direction was marked out for use by a Westland Lysander light aircraft.

At eleven o'clock in the evening of 13th July 1940

the first enemy bombs were dropped in the area. They hit the High Duty Alloys factory in Slough killing six workers and injuring forty others. Slough with its war time production was an obvious target, and two days later, smoke screen producing burners were placed in the southern half of Slough. The smoke was one thing, the stench they created was another. During the night of 22nd August 1940 several bombs were dropped on Sunningdale and fortunately there were no casualties.

Parts of the anti-aircraft shells that were fired from the guns on the Review Ground. These parts were picked up by the author when the park was littered with fragments during the Second World War.

1. The nose cone. Several rooves in Windsor were damaged when they fell.

2. The timing adjusting collar.

3. Steel fragments from the shell casing which contained the explosive.

4. Parts of the copper base showing the deep rifling from the gun barrel.

A few minutes before midnight on 24th August 1940, the skies opened up. The anti-aircraft guns in the park and surrounding area were used for the very first time. What a din! Living barely half a mile away it was frightening. I was totally unprepared for it. Mixed in with the gunfire was the peculiar droning sound of the German aircraft and

then the deep 'crump' as the bombs exploded. That night, bombs dropped in Windsor Forest damaged Flemish Farm and no fewer than one-hundred-and-sixteen houses . The 'Victory Oak' planted by Queen Mary on High Standing Hill to commemorate the victory of the First World War was uprooted by a high explosive bomb (The crew of the aircraft would have been laughing all the way back to base had they known this).

Soon, air-raids were to become a regular occurrence and the siren situated on the cemetery side of Spital Gate could be heard over a wide area of the park and Windsor. A short interval sound was to warn of an air-raid and a continuous sound was the all clear. All school children were given the instructions that if they were more than half way to school, they must hurry to the school shelter, conversely, if they were less than half way, they should return home immediately. In practice, the siren would sometimes sound when we were about to enter the school gates, a quick glance round to see that no teachers had seen us, we would 'skidaddle' back home. Sometimes the sirens would be going all day and were never made it to school.

We were now in the period to became known as the 'Battle of Britain' and many lives were being lost both in the air and on the ground. On 14th September 1940 there was a disastrous air-raid on the Vickers-Armstrong aircraft factory at Weybridge and contingency plans were immediately put into action. Smith's Lawn, which had been used as an airstrip mainly by the Prince of Wales starting in the 1920s, was instantly developed for aircraft manufacture by the company. The site was referred to as VAX1 (Vickers-Armstrong Experimental 1) and was used for the assembly of special high-altitude Wellington Bombers. Two brick built hangers were erected known as 'Bottom Hangar' and 'Top Hangar' . The Bottom Hangar was situated on the western side of Southbrook Stream near the road that comes in from Cheesemans Gate. It was used for the assembly of fuselage centre sections and probably engines and undercarriages. The aircraft were then taken up the hill to the Top Hangar (known also as Flight Hangar) for completion.

The Wellington aircraft was designed by Barnes Wallis a remarkable British aeronautical engineer who designed other aircraft such as the 'Wellesley', 'Warwick' and Windsor etc. all of which are names linked to the Duke of Wellington. He was probably better known as the designer of the 'bouncing bomb' of dambusting fame. However, the high altitude version was the design of George Edwards and he would have made regular visits to the site. During the course of the war, 64 Wellington Mk VIs were assembled on the site. The main difference from the standard design was that they were fitted with a cylindrical pressure chamber which increased the flying ceiling from 23,500ft (7,165m) to 36,800ft

(11,215m), a much needed higher and safer flying level. It is also known that at least one Wellington Mk XI was also tested there, presumably following repair or modification. In addition, some Warwick aircraft were modified on the site for the carrying of the airborne lifeboat and at least one test dropping of a boat took place on Friday 21st May 1943. Although it is not certain, it was most likely to have taken place on Virginia Water Lake which still had a reasonable amount of water left in it. All completed aircraft were test flown by production test pilots and were then collected for service use by pilots of the Air Transport Auxiliary.

The general layout of the airfield was kept as natural as possible. The last thing we needed was to alert the enemy that it was being used as an airfield and part of these measures was to have some portable imitation hay stacks to give the impression that it was a hayfield. There were also some imitation canvas lorries scattered around, although personally I could not see the logic in this. The runway which ran in an east to west direction was never made up with concrete and/or tarmac and was unlit. However, there was a compass swinging base located near Smith's Lawn Cottages on the southern side of the field. Near the road at the top of Breakheart Hill was a single blister hangar and behind this was a large disused gravel/sand pit which was used to dispose of the airfield waste. For most of the war, this whole area, including Virginia Water was closed to the public. It took a lot of courage for us lads to 'sneak' through the surrounding woods to watch the activities going on. At one stage the air was swarming with De Havilland Tiger Moths being used for 'circuits and bumps' by the 18 Elementary Flying Training School from the Fairoaks Airfield near Chobham. Known as 'D' Flight it had netted dispersals and quite often the aircraft were left there overnight.

They first started flying there in March 1941. The year before the airfield had been used by Hawker Hurricane fighter aircraft. This aircraft is steeped in local history in that it was designed by Sydney Camm who was born on 5th August 1893 at 10 Alma Road, Windsor and was educated at the Royal Free School in Windsor. His father was Frederick William Camm who went to the park Royal School as a boy being the son of a Crown employee. The Camms, whose name was once spelt with one m, go back many generations in the area.. Sydney Camm designed well over fifty different aircraft in his lifetime. The most notable were, the Hurricane Hind, Hart, Fury, Tempest and Typhoon. However, it was the Hurricane that was the mainstay of the Royal Air Force and which did a magnificent job during the early years of the war, that he was most recognised for. After the war he had a knighthood conferred on him for his work.

At one time there were as many as ten Douglas Dakotas (DC3s) permanently stationed there. Later

on, the 27th Transport Group of the United States Army Air Force (USAAF) set up an operating base at the northern end of Smith's Lawn near Cumberland Gate. At least one wooden hut and several canvas structures were erected in concealed positions under the large trees next to the road. They used Stinson 'Sentinel' and Cessna 'Bobcat' aircraft well into 1944. On some occasions we saw a few Taylorcraft L2 'Grasshoppers', light liaison aircraft, parked there. The airfield was also used on some occasions to ferry military personnel to and from the nearby RAF and USAAF quarters at Sunninghill Park and another USAAF camp situated on the disused New Mile Course on Ascot Racecourse. There was also movement of staff to and from an underground complex next to Wentworth Golf Club. Strangely, my most lasting memories of the airfield were the effectiveness of the camouflage nets covering the hangars. From a distance the tops of the hangars looked like ploughed fields. Another memory was seeing the Prince Consort's Statue covered in barbed wire.

On Monday 30th September 1940 starting at 9 o'clock in the morning, the siren was sounded six times and nearly 300 enemy aircraft flew over England that day. Thanks to the bravery of our Air Force, the enemy had a bad day and were never allowed to reach their targets and some of their aircraft were brought down. At about 5 o'clock in the afternoon, I was in my back garden with some of my brothers, and with heads stretched back, we watched spellbound as an isolated air battle took place very high up in the broken cloud. After a short period, the muffled sound of machine-gun fire stopped, followed by a strange silence. The next thing we heard was our friend Leslie Fogg from the nearby Queen Anne' Mead House, shouting over to us that a German Heinkel Bomber had crashed in the Cavalry Exercise Ground. With our hearts pounding away, we clambered over the park fence to find not a Heinkel, but a German Messerschmitt ME 109 Fighter laying on its back. The aircraft was badly damaged and we assumed that the pilot had been killed, later we were told that the pilot Karl Fischer, amazingly came out of the aircraft with hardly a scratch and was in captivity. There is one thing about the aircraft that will stay with me forever. It was a very strong acrid smell that came from every part. It was so potent, that within a very short period even our clothes started to smell of it. It was created by a protective spray and paint applied during manufacture. For the rest of the war we knew it as the 'German Smell'. Whilst the crowds of sightseers and souvenir hunters gathered around, my brother Maurice and I went to examine the path of the crash landing. It had first made contact with the ground where it rises about 250 metres southeast of

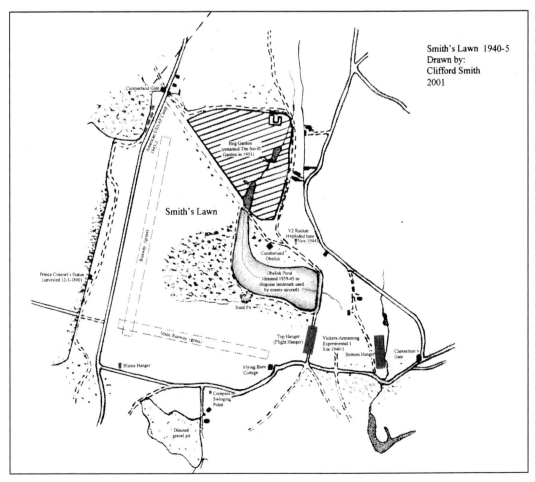

Smith's Lawn 1940-5
Drawn by:
Clifford Smith
2001

The Bottom Hangar near Southbrook Stream not far from Cheeseman's Gate where Vickers-Armstrong assembled sixty-four Wellington MK V1s special high altitude bombers during the Second World War. (Brooklands Museum Trust Limited, collection).

The fuselage frame of a Vickers-Armstrong Wellington MK V|I high altitude bomber. The photograph shows the cylindrical pressure chamber which allowed the aircraft to fly at 36,800 feet (11,215 metres), a considerable increase from the normal height of 23,500 feet (7,165 metres). (Brooklands Museum Trust Limited, collection).

A Wellington MK VI nearing completion. The circular window at the underside of the nose was for the bomb-aimer and the projection further back at the top of the fuselage was for the pilot. All of the crew sat in the pressure chamber. (Brooklands Museum Trust Limited, collection).

Looking from the front of fuselage frame of one of the Wellington MK Vis in the Bottom Hangar. The photograph clearly shows the special design to take the pressure chamber. (Brooklands Museum Trust Limited, collection).

Virginia Water Lake when it was drained during the Second World War. The photo was taken about 1940 looking towards the boat-house.
(Windsor Crown Estate Collection).

Virginia Water Lake about 1945 when vegetation had taken hold since the lake was drained. The old head of the lake, with the remains of original wooden damming posts and penstock (sluice) are clearly visible. The Ruins are in the background. (Windsor Crown Estate Collection).

[Virginia Water Lake showing the water level in 1941 drawn by Clifford Smith 2001.)

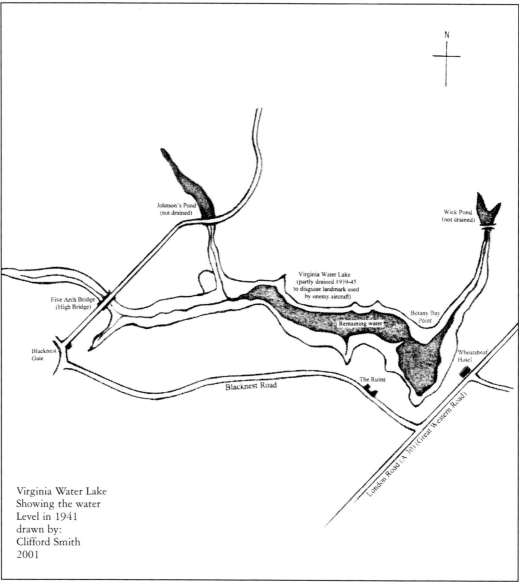

Virginia Water Lake
Showing the water
Level in 1941
drawn by:
Clifford Smith
2001

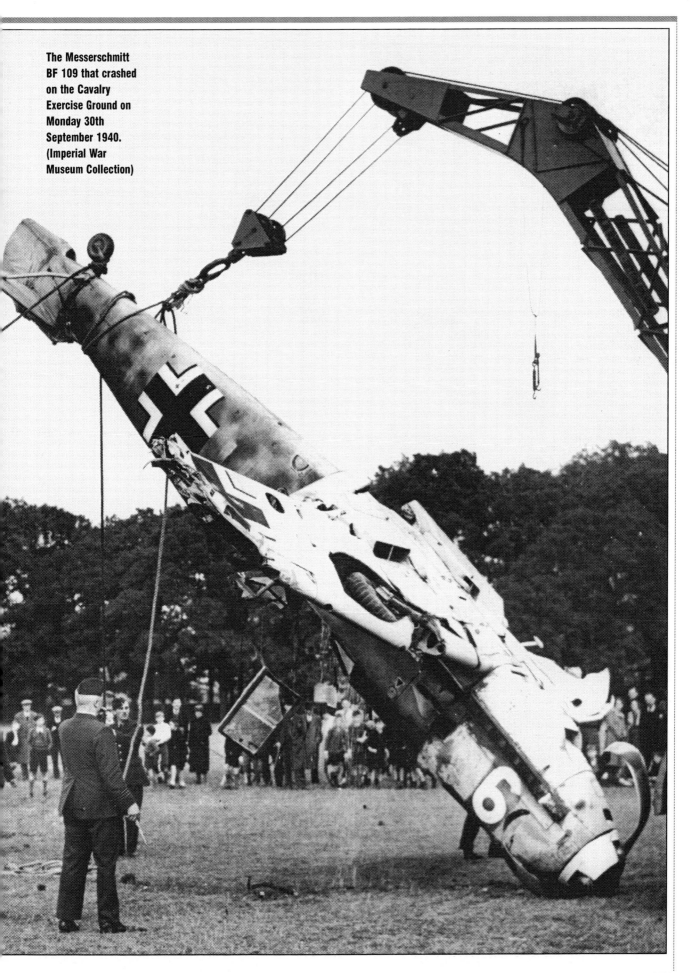

The Messerschmitt BF 109 that crashed on the Cavalry Exercise Ground on Monday 30th September 1940. (Imperial War Museum Collection)

Air combat 'dogfight' between Spitfires and Messerschmitts over Windsor on Monday afternoon 30th September 1940 as depicted in an oil painting by the author's brother, Maurice Smith. One of the Messerschmitts was flown by Karl Fischer and was forced to crash-land on the Cavalry Exercise Ground.

the Miniature Rifle Range. The point of impact had been deeply gouged out, with the turf thrown outwards by the speed of the propellers. It was obvious, judging by the length of the gouging, that the engine was still at high revolution when the aircraft made contact. The extent of the curling and burnishing of the blades bore this home. However, most of the damage had been caused to the wings, when it hit two anti-invasion poles.

The downing of this fighter aircraft created a great amount of local excitement and the site was visited by many people the next day. By that time an armed guard had been placed around it an no one was allowed to touch it as we had been able to the evening before. In the afternoon a Royal Air Force recovery team arrived and their first task was to disarm the two 20mm cannons and the two 12.7mm machine guns. A close examination confirmed that the aircraft had been hit by several bullets behind and beneath the cockpit. One bullet had entered the engine casing. It was later established that the bullets had come from a Spitfire flown by Pilot Officer P.G. Dexter of 603 Squadron, from Hornchurch. Sadly, he was to lose his life two months later during service.

Using a mobile crane, the aircraft was pulled upright and towed to a position near Queen Anne's Gate. Soon afterwards Princess Elizabeth (now Queen Elizabeth II) and Princess Margaret arrived and they were seen to be asking many questions about it. The next day it was taken into Windsor and placed outside the old Post Office at the western end of Park Street where it was used to raise money for Windsor's Spitfire Fund. The damage incurred when it crashed and the subsequent manhandling had left it in a very sorry state, and there was one thing certain, it was never going to fly again.

The wartime evacuees who had been moved out into the country were not finding it quite so peaceful as had been anticipated and by the autumn of 1940 air-raids had become a daily occurrence and much bomb damage was incurred in Windsor, Eton, Slough and the local area. Sadly, some people lost their lives and many others were injured at this time. Late in the evening of 22nd October 1940 Windsor Castle experienced some very near misses with bombs falling on the Royal golf course and on the Cricket and Bowls

Ground at Frogmore. Another bomb fell at the back of Thames Street narrowly missing W.H. Smith & Son.

The Great Park had more than its fair share of bombs. This was mainly due to the frightening effects of the Anti-Aircraft Guns with many aircrews dropping their bombs and making a run for it. On one night alone, over 400 incendiary bombs were dropped on Flemish Farm. The night of 8th November 1940 was a very sad time in the history of the park. A line of bombs, believed to be aimed at the gun site coming in from the south, were dropped from the Royal Lodge Entrance Gate across The Long Walk to a point just south of the Prince of Wales Pond. Tragically, the first bomb hit the rear of the most northern Gate Lodge and killed Joseph Pearce the 19 year old son of Mr & Mrs Ernie Pearce. Joseph was home on leave from the army at the time. Before joining the army he had worked for the Post Office in Windsor. The next day, my brothers and I saw the damage incurred on the Lodge and it was a very saddening to see affects of just one bomb. The last of that line of bombs had not exploded, and we soon found ourselves a grandstand view perched on the protective rails of a young tree as the Army Bomb Disposal Squad set about disarming the bomb. However, as the Squad came near the delicate part of defusing, we were told to 'scram' in no uncertain terms.

By now bomb craters were becoming a familiar sight all over the park and forest, the largest of which, was caused by a land mine that came down in the middle of the field on the east side of the Isle of Wight Pond (now planted with 1953 Coronation Oaks). The Estimated size of this mine was 725kgs (1,600lbs) and the chestnut pale fence towards Sandpit Gate had large gaping holes made in it by the blast. One of the horses in the field was killed. Had this parachute carrying mine drifted slightly to the north, the Prince Consort's Workshops would have 'disappeared'. The next largest bombs were dropped on Norfolk Farm and Flemish Farm, near Swan Pond, and one actually landed right in the middle of the gun site on the Review Ground. It was extremely fortunate that this bomb did not explode and we experienced two days of silence (and bliss) whilst the delicate task of disarming the bomb was carried out.

It is now hard to imagine, that we actually became quite excited by our experiences as the war progressed. On 17th February 1941 on my brother Denis's birthday, we actually cheered when a German Bomber crashed on Oakley Court Farm towards Bray. At the time we thought that it had been hit by anti-aircraft gun fire. It was later confirmed that it had been damaged by a night fighter. All four crew members of this Dornier 17 bomber survived by baling out before the burning aircraft crashed. The pilot Lieutenant Gunter Hubner broke his ankle when landing close to the crash and the navigator Lieutenant Rolf Dieskau, Unter Offizer Arnst Tiejen

and Gefreiter Walter Arnold were captured by the next morning.

During this period of the war, a bomb hit one of the Prince Consort's Gate Cottages and fortunately none of the occupants were injured. Some weeks after this event, a Heinkel HE III German Bomber was shot down on Wednesday 9th April 1941 at 2.30 in the morning and crashed in South Forest near Wood Pond Gate. Because of the isolation and density of the undergrowth it was not located until after daybreak by Frank Doel on his way to work in the park. The scene of the crash was quite horrific, as the plane had hit the top of a beech tree and it was badly broken up by the impact with the tree and ground. Of the crew of four, two died in the crash. They were Oberleutnant (Flying Officer) Jurgen Barthens and Oberfeldwebel (Warrant Officer) Franz Vonier. The two other crew members, Feldwebel (Flight Sergeant) Fritz Pons and Feldwebel Herman Kubur were injured and found sheltering under a bush. An examination of the aircraft found that it had been hit by at least fifty 0.303 bullets. It had G1+LS markings and a crest of three yellow fish on a shield on the starboard tail fin. Most unusual was to find two machine guns linked together in the mid-upper gun position. The port side engine was marked, DB 601 and numbered 102011, manufactured 18.10.1939..

An interrogation of the two surviving crew members found that they were from the 8/KGS5 Squadron and that they had taken off from Villacoublay airfield near Paris early the previous evening on an Armed Photographic Reconnaissance mission for Coventry. After a very eventful journey they were forced down when the port engine started to burn. The most probable aircraft to inflict the damage to the Heinkel, was a Boulton Paul Defiant night fighter from 151 Squadron based at RAF Wittering, Northants. It was flown by Flight Lieutenant D.A.P. McMullen DFC and the Air Gunner was Sergeant S.T. Fairweather. They were circling the airfield to land after an uneventful night patrol of Coventry, when they spotted a lone Heinkel III heading south at 0140 hours (1.40am) . At a range of about 70 metres (76.5 Yards), the gunner opened fire at the port side of the Heinkel and after two more bursts of the gun, it dived into the cloud with smoke coming from its Engines. The official Combat Report, made out the same day of the attack on 9th April 1941, states that the enemy aircraft was destroyed. Many years later, Fritz Pons returned to the scene of the crash with his family, and was heard to say 'what was that all about'. Quite!

At this stage in the war, the Country's anti-aircraft guns and in particular our night fighting aircraft were becoming more and more effective. So much so, that another German aircraft was shot down over Windsor Forest the very next night. This time it was a Junkers JU 88 that crashed into the top of a tree in an open

field next to Queens Wood in Bagshot Park in the early hours of the Thursday 10th April 1941. A study of the Combat Reports at the time, confirms that this was the aircraft shot down by Flight Lieutenant D.F.W. Darling and Pilot Officer J.S. Davidson and not the Heinkel that it has been said that they shot down in South Forest. The mistake is a very easy one to make, because Darling and Davidson were also flying a Defiant night fighter from 151 Squadron based at RAF Wittering and both the Heinkel and JU.88 crashed in Windsor Forest. Unfortunately, the detailed records of the JU.88 appear to have been lifted from the official records and the names of the crew members are not known. However, Mrs Peggy Gibson (nee Lovell) who was fifteen years old and worked and lived at Bagshot Park, clearly recalls one of the farm workers finding the pilot. The Duke of Connaught gave orders for him to be brought to the main house where he was given a full breakfast. Bert Wooders who was working at Bagshot Park at the time also remembers the JU.88 crashing into the tree (since cut down).

Early in 1941 it was obvious that if we were to survive the war it would be necessary to use every area of our land for food production. It was agreed by King George VI that the park would not be an exception, and arrangements for cultivation were set in motion. This was not expected to be an easy task, bearing in mind that most of the park had never been ploughed in its history. The term 'soil' could hardly be applied to such an enormous amount of clay in the area. Then there was the agricultural equipment to be made available for the task. However, before a single plough could be used, there was the problem of the

deer and the thousands of rabbits to contend with. The work was made easier by the assistance of 800 military personnel from the local barracks. Many deer were shot, which I found very upsetting as a boy. A small herd of about fifty deer were rounded up and driven into an enclosure on the west side of Duke's Lane. A white goat was put in with them as a companion. The removal of the rabbits however was not so easy but the persistent work by the gamekeepers with assistance from other Crown employees finally brought them under control.

In May 1941 the ploughing began and as expected it was not an easy task. The hardness of the ground and so many trees to negotiate meant that the tractors, ploughs (and drivers) were tested to the limit. A total of 435 hectares (1,075 acres) was ploughed three times that summer before it became more manageable. Another problem was the high acidity of the soil. Hydrate of lime was tried in the first instance without much success and it was the use

of ordinary ground chalk that finally achieved satisfactory results. The sowing was carried out in the very damp and foggy autumn of that year. By the end of the war, the area cultivated had produced 2,500 tons of wheat, 1,000 tons of other cereals, 700 tons of potatoes and many tons of swedes, white carrots and 'cow cabbage'. In the end it was very much worth the effort for the production of vital food. The fields of wheat had an added advantage as they were very much appreciated by courting couples. The one drawback as far as my family was concerned, was that we could no longer walk freely across the park.

The Windsor Great Park Woman's Institute was not slow in coming forward with some very useful ideas to help the war effort. One of these, was the purchase of a canning machine to preserve the local produce.

For the next three years in particular, the park and forest was to become the scene of intense military training in preparation for the day that the allies

A photograph of the Heinkel G1+LS taken from another German aircraft months before it crashed in South Forest. Although it is not known where the photograph was taken, it is possible that it could have been off the coast of Devon or Cornwall, judging by the low altitude to avoid radar detection. (Fritz Pons/Steve Hall Collection).

Franz Vonier (left) pilot, and Fritz Pons the wireless/gun operator of the ill-fated Heinkel G1+LS that crashed in the early hours of Wednesday morning 9th April 1941 in South Forest. (Fritz Pons/Steve Hall Collection).

378

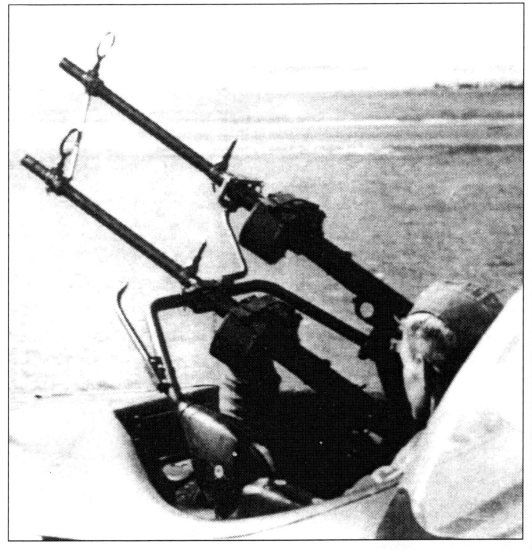

Fritz Pons seen sitting in the mid-upper gun position of the Heinkel G1+LS aircraft. The picture clearly shows how Fritz came up with the ingenious idea of linking two MG15 guns together which gave twice the fire power. He only had to use the sights on one gun when aiming at the target. Fortunately for Britain, his innovation did not appear to be used on other aircraft. (Fritz Pons/Steve Hall Collection).

The graves at Brookwood Military Cemetery, Surrey, of Franz Vonier (pilot) and Jurgen Bartens (observer) who died in the Heinkel G1+LS on 9th April 1941 in South Forest. (photo taken in August 1999 by the Author).

Two parts of the Heinkel G1 +LS that was picked up by Graham Bish, (retired Forester) when he was working at the site in South Forest many years after the crash. The piece of formed aluminium clearly shows where one of the bullets nicked the flange where it entered and left a large ragged hole where it come out. It is hard to imagine that these were parts of the aircraft that had played a major part in a series of low level attacks along the south coast of England the previous autumn. On Wednesday 8th October the aircraft set off with two other Heinkels on one such raid, shooting and bombing the towns of Worthing and Bognor Regis. As they passed over Ford Airfield near Littlehampton, Fritz Pons, with his 'twin' machine guns, was involved in the destruction of a Boston I on the ground. The aircraft being one of the RAF's latest purchases from America.

Ploughing the field between Queen Anne's Ride and The Gallop south of the Review Ground in 1941. (Windsor Crown Estate Collection).

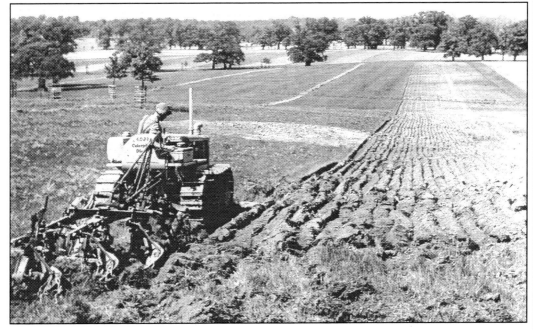

Ploughing the central part of the park for the first time in 1941. This photograph was taken from Reading Road looking north towards Windsor Castle.
(Windsor Crown Estate Collection).

An elevated conveyor machine being used to make a strawstack near The Gallop about 1945.
(John Beasley Collection).

A strawstack being made without the use of a conveyor machine near The Gallop about 1945.
(John Beasley Collection).

Straw thatch being made using a stitching machine near The Gallop about 1945. All other work in the park was 'paradise' compared to working this machine. (John Beasley Collection).

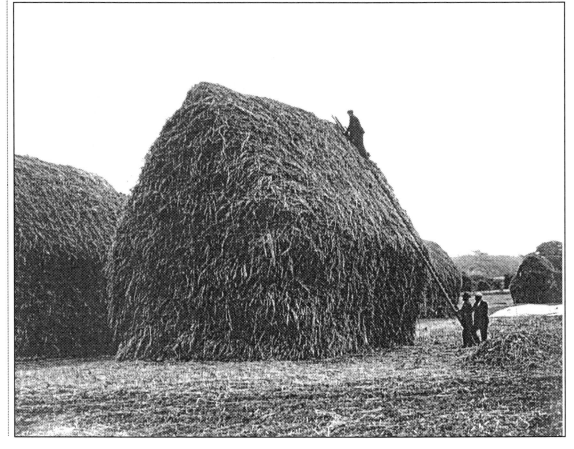

Preparing to put on the thatch near The Gallop about 1945. (John Beasley Collection).

would return to the mainland of Europe. Trenches were dug in many parts of the park, with Cranbourne Hill in particular being an area of great activity. Some trenches which were also dug to the west of Queen Anne's Gate and near the Bourne Ditch Gate can still be seen today. Invariably, the trenches were surrounded by rolls of barbed wire. In Queen Mary's Plantation, single twists of barbed wire were stretched about one foot high across the whole width of the plantation. At regular intervals along the wire was fixed an empty bean can containing several pebbles. The noise created if someone's leg was caught on one of the wires, would not only startle the hapless person making contact, it would disturb every living creature for miles around. Simple and very effective. A second rifle butt was built at the range at the southern end of the plantation and a single railway track was built for training purposes between the range and Prince Consort's Drive.

Most of the manoeuvres were held at night, and with the anti-aircraft guns going off at the Review Ground Site and the rifles, mortars (smoke and parachute flares) and thunderflashes, it was absolute bedlam. There was one night in particular that left scenes the next day very much like a battle front. Damaged vehicles were strewn along King's Road with one Bren gun carrier having lost its tracks. One soldier lost his life during that terrible night. Some months later, another soldier lost his life when a bullet deflected off the armoured plating of one of the vehicles and hit him in the chest. The park was no longer a safe place, with unexploded devices being left scattered everywhere. At the southern end of the park, the Leiper Pond area was particularly dangerous and the old rifle butts were once more put into use. Craters were formed in the bottom of the pond by the grenades thrown there while soldiers were made to clamber across wires suspended between two oak trees on the opposite bank. We treated each of the black plastic-coated grenades with the utmost respect – especially after my friend Jack Robinson's kneecap was damaged when a grenade he was moving exploded.

In order to accommodate the increasing numbers of our military personnel and those from abroad, several large houses were taken over. Castlemead, the garden of which backed onto the Cavalry Exercise Ground, was firstly used as a convalescent home for soldiers who had made their way to England when their countries had been overrun, and later on it was used by American USAAF Officers. Bagshot Park was requisitioned by the Army for use by the Auxiliary Territorial Service as their Staff College. Sunninghill Park was taken over for RAF Officers and then by the USAAF from 1942 as described below. This is when the children's request, 'Have you got any gum, chum?' became popular.

Sunninghill Park was requisitioned by the War Office in 1940 and it was immediately used as living quarters for Royal Airforce (RAF) Officers. Shortly after occupation, they acquired a Spitfire fighter aircraft which had been engaged in the Battle of Britain and was no longer airworthy. It was proudly displayed in front of the mansion until they moved out in 1942.

As soon as the RAF moved out of Sunninghill Park, the American Military moved in. During the next three years it operated as the Headquarters of the American USAAF, 9th Air Force, and the IX MF Service Command. Known as Station 472, it consisted of the mansion which was used as the offices and living accommodation for the Senior Officers. Immediately around the house were Nissen huts used as stores. To the south-east were numerous various sized wooden huts used for the accommodation of the military personnel. Close to Watersplash Lane was a fully kitted out Military Hospital. In addition, many tents were erected in 1944 to cope with the increase of personnel leading up to D Day. A satellite camp consisting mainly of tents was set up on what is now the course of the New Straight Mile. Although part of Station 472, it was known as the Ascot Camp. Many well known people passed through the main camp, not the least of which was Joe Louis, nicknamed 'the Brown Bomber' who was the world heavyweight boxing champion 1937-1949. The camp finally closed down in 1946.

At the north-western side of Sunninghill Park near Windsor Road and the site of Woodend House, a Searchlight Station existed for most of the war. It was operated by the Women's Royal Army Corps (WRAC) who lived in adjacent huts. They were privileged in that the generator had a starter motor fitted for easy starting. Normally, they were cranked by hand.

As the war progressed, the skies became more and more filled with our aircraft as they made their way to and from the bombing targets. Shortly after daybreak we would watch many Lancaster Bombers coming over the park making their way back to base. It was incredible how some of them were staying in the air, parts of the aircraft were missing and some had parts barely hanging on. Quite often several engines had completely stopped but still the aircraft carried on. For a period during the war the success of the raids and the survival rate of the crews had been improved by the introduction of 'window' - thousands of strips of silverfoil dropped from our aircraft to mislead the enemy radar operators into thinking that it was a formation of aircraft. This would confuse the enemy as to where they should concentrate their defences. Within a few weeks of this first being used, the park and forest was festooned with the strips giving the impression that Christmas had come early.

In the later part of 1944, when our armies were back in France fighting their way through to Germany, the enemy unleashed upon us the V.1 Flying Bomb and the V.2 Rocket. This flying bomb immediately became known as the 'Doodlebug' or the 'Buzz-bomb' because of the distinctive throbbing sound made by the impulse motor. This pilotless craft

had a war head containing 1,060 Kgs.(2,337lbs) of high explosive and caused a great loss of life and damage. On Thursday 15th June 1944 at 5.00 in the morning, one of the very first flying bombs launched against our country hit the rear of the Bells of Ouzeley Hotel at Old Windsor, causing the loss of two lives, many injuries and considerable damage to the hotel and surrounding property including Beaumont College some distance away. Two days later another one came down at Wraysbury on the northern side of the Thames killing two more people and again causing extensive damage.

With well over one hundred flying bombs being launched against us every day during the next month, it was inevitable others would come down in the district. At 2.45 on Saturday afternoon 1st July 1944, we were having a concrete garden path laid down by a builder from Croydon. He was obviously familiar with sound of a flying bomb, because he suddenly stopped what he was doing, listened for a moment, then shouted 'duck'. I remember laying on the ground and glancing up to see the horrific site of a flying bomb almost over our house, at which time the motor cut out, restarted and cut out again for a final time. After what seemed like an eternity, there was an enormous heavy explosion in the direction of Dedworth. I ran all of the way there and saw that it had hit the chimney of the Dust Destructor. Many people were injured but fortunately no one was killed. The bomb had exploded high up on the chimney causing an enormous amount of damage to property. Over 1,000 buildings were damaged and even the St. Agnes Church Steeple in Spital had not escaped the blast. I shall never forget seeing chickens running around in a garden in Kentons Lane with hardly a feather left on them.

The third and last flying bomb to come down in the immediate area was in the afternoon of Tuesday 4th July 1944. We were near the northern boundary of the park, when we heard the muffled sound of aircraft cannon fire coming from the direction of The Copper Horse. Moments later we heard and felt the ground vibrate with an enormous explosion. A large column of black smoke could be seen billowing up from the other side of Snow Hill. When we arrived at the scene, totally out of breath from running up Queen Anne's Ride, we saw about ten people already around the crater and we recognised the black Morris 10 saloon car used by King George VI parked nearby. The crater, which was about 80 metres west of 'The Battery' was still steaming and the surrounding area was littered with metal parts from the bomb. The King, not realising that we lived in Windsor, asked my brother Maurice whether we had suffered any broken windows as he had experienced at the Royal Lodge. Certainly, this had been a near thing for the Royal Family and had it come down sooner and slightly to the north it could have hit the Lodge with devastating results. We thought there was a strong possibility that the flying bomb had actually been brought down by the cannons of an RAF fighter as it was obvious that it had hit the ground at a steep angle. This had sometimes been known to happen when the motor stopped, but more generally they glided down. As soon as the excitement died down, we started collecting some the parts to take home as souvenirs. Within a week our garden shed was full of parts including the rudder support column, wing spars, and control units. All three flying bombs that came down in the Windsor area had been launched from ramps in Pas de Calais in Northern France.

Fortunately only one V.2 Rocket came down in the district. This was on a bitterly cold night in November 1944 and it came down at a point about 70 metres east of the Cumberland Obelisk. When we examined the crater the next morning it was very deep and formed a

USAAF taking the salute at Sunninghill Park c.1944

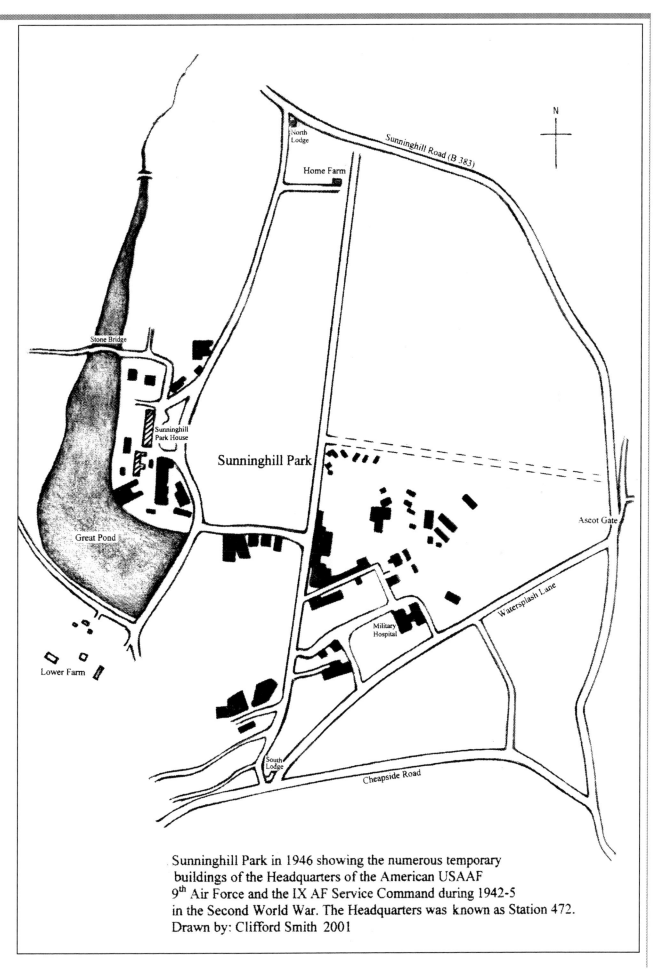

Sunninghill Park in 1946 showing the numerous temporary
buildings of the Headquarters of the American USAAF
9th Air Force and the IX AF Service Command during 1942-5
in the Second World War. The Headquarters was known as Station 472.
Drawn by: Clifford Smith 2001

Parts of the VI Flying Bomb that narrowly missed the Royal Lodge and exploded near The Battery on Snow Hill on 4th July 1944. A = One of the two hydraulic servos which either operated the rudder or the elevators. B = Part of the height control unit which contained two copper bellows. It was preset for the VI to fly at the correct height and it continually regulated the altitude through any change in pressure. C = Sparking Plug which was mounted on top of the engine combustion chamber. It was only used to ignite the fuel and heat up the combustion chamber prior to launching the VI from the launch ramp.

point at the bottom. Many of the trees in the area had been badly damaged and were embedded with parts of the rocket. Fifty five years later the crater can still be seen although it has mostly filled in with the passage of time. The nearby cedar tree (Cedrus Libani, park no.78935) still carries the scars of the explosion. The V.2 Rocket was a formidable weapon. It weighed 13.6 tons and carried a 907kgs (2000lbs) warhead, reaching a height between 50 and 60 miles with a maximum speed of 3,500 mph. It would come down, as launched, in a vertical position. I feared this weapon above all others, as there was nothing to stop it. You could not hear it and you certainly could not run out of the way.

On Friday 15th September 1944 the wartime lighting restrictions were lifted and we able to start playing marbles again under the light of the street lamps. However, the spate of flying bomb and rocket attacks was testing the resilience of the nation to the limit and it came as an enormous relief when the war in Europe came to an end on Monday 7th May 1945. There was hardly a street that did not hold a tea party to celebrate the victory. The children of Spital were privileged to be invited by Horace Dodge to a grand party and firework display at his St Leonards Mansion on St Leonards Hill. We had never experienced so much food or seen such a firework display in our lives. Horace Dodge owned the giant Dodge Corporation, American manufacturers of a wide range of motorised vehicles. Besides being very wealthy, he was a very caring person.

It was not until 25th May 1945 that Smith's Lawn and the Virginia Water area of the park was reopened to the public. The war had left its mark with sad loss of life and damaged property. In Windsor and the park 11 people had died and 111 had been injured. It could have been much worse, as a total of 2,303 bombs were dropped in the area damaging 1,643 houses and 3 churches. All of these years later it is hard to imagine that this actually happened.

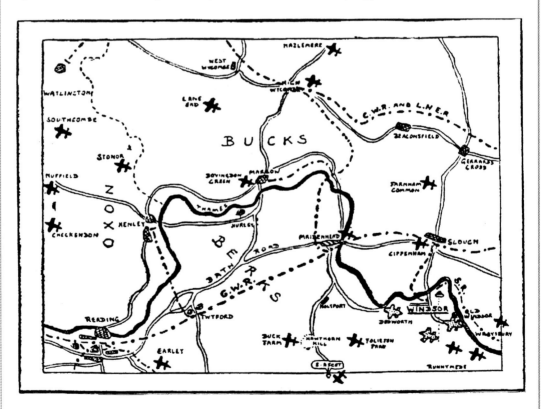

Very surprisingly this map appeared in the Windsor, Slough & Eton Express local newspaper on Friday 6th October 1944. It clearly shows where twenty-one VI Flying Bombs fell or passed over the Windsor area during the preceding months of June, July and August. With the exception of the one that fell at South Ascot, all of them had been launched from ramps in Pas de Calais in Northern France. It is believed that the one that fell at South Ascot was launched from a German aircraft over the North Sea.

Estate

Management

WINDSOR
PARKS AND WOODS.

By Authority of Colonel SIR NIGEL KINGSCOTE, K.C.B., Commissioner of Her Majesty's Woods, Forests, Land Revenues, &c.

RULES

TO BE OBSERVED BY THE LABOURERS IN THE APPROPRIATION OF DEAD WOOD, CHIPS, AND OTHER SIMILAR MATERIAL.

1. Previous Rules on this matter are hereby RE-CALLED and these Regulations to be in force instead.

2. The privilege granted is confined to the picking up of small dead Branches that have been blown down, and to the small Chips that are thrown off by the axe in cutting, and no Labourer is on any account to break boughs off the Trees.

3. No pieces of dead Wood or Chips so gathered by any Labourer are to exceed inches in thickness, or two feet in length, and they are to be carried by him during, and during his own hours, into a heap in some convenient place, where they must be inspected by the Woodman of the district before they are removed.

4. The Wood after being inspected is only to be removed upon Wednesday and day nights, and on no other night whatever, and the Wood so removed shall be string or wythe.

Estate
Management

he history of the Royal
Landlords can be traced
back to the Saxon Kings,
and the redistribution of
land following the
Norman Conquest. The
overall acreage under
their control changed at
various times by reason
of the gifts of land
bestowed by the Monarch on distinguished and
favoured subjects.

The Windsor Crown Estate is run by The Crown
Estate Commissioners. The Crown Lands were first
placed in the hands of the Commission in the reign of
George III, around 1760. The head of the Commission
was then the Surveyor General. In 1810, the Surveyor
General was replaced by a board of management with
the title of The Commissioners of Woods, Forests and
Land Revenues. The procedure by which the new board
was created and the form which it took were
characteristic of the time. During 1832, the
constitution of the board was altered, bringing in as an
official member the Surveyor General of Works and
Public Buildings, giving the First Commissioner the
Parliamentary Responsibility for Works as well as lands.
This arrangement lasted until 1851, when the two
departments were again divided. This time it was the
Works Department that was given the parliamentary

head (now DOE) and the Department of Wood and
Forests, as it once again became, was left in the charge
of two Commissioners.

In 1796, the Crown Lands Office, which had been
at Somerset House, moved to a new office known as
Whitehall Place, were it remained until 1909. The
building was replaced by a new building and the office
remained there until 1976, when a move was made to
its present home at 16 Carlton House Terrace.

The government decided to establish the Forestry
Commission in 1919. To this body was transferred
most of what remained of Crown Woods. Since then,
this office has been largely concerned with urban
property and farms.

The Crown Estate Commissioners consists of a
board of eight, headed up by the First Commissioner.
The Second Commissioner is the Chief Executive and
Deputy Chairman and is the only full time
Commissioner. The remaining six Commissioners work
on a part-time basis.

Windsor Crown Estate is headed up by the Ranger,
a position usually held by a Royal person, sometimes
the Sovereign. The current Ranger is Prince Philip, the
Duke of Edinburgh. The duty of the Deputy Ranger is
to ensure that the day to day running of the estate is
carried out to the Ranger's requirements. He also has
the managerial responsibilities for the Windsor Crown
Estate on behalf of the Crown Estate Commissioners.

The running of the Windsor Crown Estate is no

mean undertaking, with 6,070 hectares (15,000 acres) to be maintained, approximately half of which has public access. This entails the running of the following departments:- Forestry, Farming, Gardens, Administration, Gamekeepers, Parks Department, Fencing, Wardens, Animal Husbandry, Personnel, etc.

With the ever increasing number of visitors to the park and forest, the large number charity walks, running races and equestrian events and so on, there are ever more demands on management. Even the issuing of fishing and riding permits takes time, but the greatest concern of all must be the prevention of illegal fires. One lighted match in the wrong place could have grave consequences.

In the early 1800s, poaching was a serious problem. Groups of poachers roamed the park with as many as twenty persons at a time. Fully armed with guns and pikes, they would go to any lengths to get the deer, pheasants and rabbits. Sometimes full-scale battles would take place between the poachers and the gamekeepers, resulting in many serious injuries.

The following is an account of one such case that appeared in *Bell's Weekly Messenger.*

"On Monday the 15th February 1813, between eight and nine o'clock, a most daring attack was made on two of His Majesty's gamekeepers by five poachers, who were discovered in a plantation of Windsor Great Park in the act of shooting a pheasant. These men were all armed with fire-arms and bludgeons and some with long poles of peculiar construction, with which they are accustomed to discharge the spring guns which are set in their way. By this unequal force the gamekeepers were overpowered, although they manfully fought with pikes they usually carry when they expect a conflict, they inflicted many severe wounds on their opponents. One of the gamekeepers was so dreadfully beaten that his life is in the utmost danger from the severe blows he received on his head, with the butt-end of a gun, till it was shattered from the barrel, and the lock broken in pieces. One of the offenders is in custody, and a reward of £50 is offered for the apprehension of the two others who have escaped."

The setting of spring guns was a very delicate affair, and often led to the gamekeeper who had set it being its own victim. This led to the Mantraps & Spring Guns Act being brought in in 1827 forbidding their use.

The 1820s saw a massive tree-planting programme, on a scale never before seen. On the next page is a copy of a letter written by William Maslin, Deputy Surveyor, dated 7th October 1821, which gives the scale of the operation. The senior Woodman mentioned was the author's great-great grandfather, Joseph Smith. A copy

Bracknell 7th October 1821
Sir
I report further information of the Humble Board but subject to any alteration you think proper, and wait for orders and directions hereon.

Having surveyed the nursery plants in Windsor New Park, and the woodmans Cottage near Buckhurst Hill, in Windsor Forest, and have made a calculation I shall have Ten Hundred Thousand of Oak Seedlings for Bedding this Season into nursery rows, in the usual workmanlike manner. I have also calculated it will take up about 14 Acres of land to be trenched to receive the Oak Seedlings as above stated. And propose to trench up the grass field about 4 acres at the woodmans Cottage/Joseph Smith/ near Buckhurst Hill which I think it will do well for the growth of oak and fir plants, and the remainder of the trenching to be in certain plans most adapt for it

Sir the seedling scotch fir as sown last season in Windsor Forest have not done well upon a rough grass. I think we cannot plant out from the Seed Beds more than about 400000 Scotch fir seedlings which will take up about Three Acres of ground to be trenched to put the scotch fir seedlings in Nursery rows.

Sir the one and two year old transplanted Oak Seedlings in the several Nurserys in the Windsor New Park have taken very well in general. But none of them are of growth to plant out this Season.

The Scotch Fir Seedling plants bought of Mr..Hammond last Season go on very well indeed. The Hartfordshire Plants have not made any progress in growth, nor the Scotch and Larch from Chelsey.

Sir if you propose to plant any quantity of Scotch and Larch fir in Windsor Forest near Swinley this Season, it will be well to look out for Fir Trees from one foot to 18 inches high above ground when planted I think the best size for planting. And holes dug sometime before the trees are planted, as the turf soil is so tough it cannot be chopped fine enough to receive the plants without more Labour and Expence.

I am Sir
Your Very Obedient and Humble
Servant William Maslin

A.Milne Esq.

Bracknell 7th October 1821 —

Sir

I Report for the Information of the Honble Board
but subject to any alteration you think proper, And
wait for orders and directions hereon —

Having survey'd the Nursery plants in Windsor
New Park, and the woodmans Cottage near Buckhurst
Hill, in Windsor Forest — And have made a Calculation
I shall have Ten Hundred Thousand of Oak Seedlings
for Bedding this Season into Nursery rows, in
the usual workmanlike Manner — I have also
Calculated it will take up about 14 Acres of Land
to be Trenched to receive the Oak Seedlings as above Noted.
And propose to Trench up the grass Field about 4 Acres
at the woodmans Cottage (Joseph Smith) near Buckhurst
Hill, which I think it will do well for the growth of
Oak and fir plants, And the remainder of the
Trenching to be in certain places most Adapt for it,

Sir the Seedling Scotch fir as Sown last Season
in Windsor Forest have not done well (upon a Rough
guess) I think we cannot plant out from the Seed Beds
more then about 400000 — Scotch fir Seedlings which
will take up about Three Acres of Ground to be
Trenched to put the Scotch fir Seedlings in Nursery
rows —

Sir the one, and two year Old Transplanted
Oak Seedlings in the Severall Nurserys in the Windsor
new Park have taken very well in generall, But
none of them are of growth to plant out this Season,

The Scotch fir Seedling plants Bought of Mr Hammond
last Season go on very well indeed, The Hartfordshire plants
have not made any progress in growth, nor the Scotch and
Larch from Chelsey, —

Sir If you propose to plant any Quantity of
Scotch and Larch fir, in Windsor Forest near Sandhy
this Season, it will be well to look out

390

Report by the Commissioners dated 1848 giving Joseph Smith, great great grandfather of the author, as the highest paid Woodman in the Park. (Public Records Office ref. CRES 2/50).

Appendix No 33. Report of Commissioners on Woods and Works 1848 - Page 190.

Windsor Forest & Parks

Establishment under the Commissioners of Woods.

Name and Office or Employment	By whom Appointed & Date of Appointment	Duties	Salary, Allowances &c	Average annual...	The Amount of Consideration
Charles Maslen, Deputy Surveyor	The Commissioners of Woods in 1823	The care and management of the Forest Parks and adjoining Crown Lands; the Deputy Surveyor also superintends the falling and selling of timber in Whichwood & Waltham Forests	Salary £300. A House 1½ Acres of Land valued at £37. 10. 0 per Annum	Average of three years £977	1000
Philip Maslen, Assistant Deputy Surveyor	Commissioners of Woods in 1837	Assisting the Deputy Surveyor in the execution of his Duties	Salary £125 increasing after 5 Years to £150	Nil	Nil
Josiah Laver, Foreman	Do. in 1841	To attend Labourers in the Sundry Works in the New Park	18/ per Week and a Cottage £7.10 per Annum	Nil	Nil
Joseph Smith, Woodman	Do. in 1820	To attend Plantations in the New Park	20/ per week and a Cottage and two Acres of Land £7. 10 per Annum	Nil	Nil
Richard Rhodes, Woodman	Do. in 1831	To attend Plantations St Leonards and a New Lodge	12/ per week and a Cottage £7.10/ per Annum	Nil	Nil
Alexander Blake, Foreman	Do. in 1837	To attend to Labourers at Swinley	15/ per week, and a Cottage £7.10 per Annum	Nil	Nil
3 Woodmen	At various times	The care of the Plantations	Two at 12/ per Week & one at 12/6 per week; each Woodman occupies a Cottage, valued in two cases at £5 per Annum & the other at £6 per Annum	Nil	Nil

of the original letter follows. (Public Records Office ref. CRES 4/12).

The document below is known as a 'Deputation', specifying the responsibilities of George Smith, Gamekeeper, great grandfather of the author. It was introduced to comply with an Act of Parliament when the Estate Gamekeepers came under the jurisdiction of

To all to whom these Presents shall come I THE HONORABLE CHARLES ALEXANDER GORE the Commissioner of Her Majesty's Woods Forests and Land Revenues to whom have been assigned the management and direction of certain parts of the Crown including the Land Revenues in the Counties of Berks and Surrey SEND GREETING KNOW YE that in pursuance and exercise of the power and authority contained in an Act of Parliament passed in the Tenth Year of the Reign of His late Majesty King George the Fourth Cap. 50 and in another Act passed in the Fifteenth Year of the Reign of Her present Majesty Cap. 42 and of every other power enabling me in this behalf I DO hereby nominate constitute and appoint *George Smith* to be Gamekeeper during my pleasure of and within certain Lands and Estates belonging to Her Majesty being part of the Possessions and Land Revenues of the Crown situate in the Counties of Berks and Surrey hereinafter-mentioned that is to say Windsor Forest and Chase, Windsor Great Park, Bagshot Park, and also the Lands at Swinley and Rapley, the Manor of Egham, and all other Lands belonging to Her Majesty adjoining or near to the said Forest, Chace, Parks, and Manor or either of them and of and within the appurtenances to the same Lands and Estates belonging with full power license and authority for the said *George Smith* as such Gamekeeper to execute all usual and customary forestal Offices and to preserve the Beasts and Birds of Chase and Warren and other Game within or upon the said hereditaments and to preserve the Fish in any of the waters within the limits and precincts of the said hereditaments and on behalf and for the use of Her Majesty to take and kill any such Beasts or Birds of Chase or Warren and other Game and Fish within the limits or precincts aforesaid AND ALSO to take seize and destroy all Dogs, nets, guns, and engines used for the taking or destroying of the Beasts or Birds of Chase or Warren or other Game by any person or persons not lawfully authorized to use the same or to be found within the limits and precincts aforesaid AND FURTHER I do hereby authorize and empower him the said *George Smith* during my pleasure to do all other lawful acts and things within the limits and precincts aforesaid which in any way appertain to the office of a Gamekeeper and for so doing this shall be his sufficient Warrant IN WITNESS whereof I the said CHARLES ALEXANDER GORE have hereunto set my hand and seal the *twenty ninth* day of *October* One Thousand Eight Hundred and Fifty Eight.

Witness to the execution hereby

Horace Watson
Office of Woods

 Charles Gore

WINDSOR
PARKS AND WOODS.

By Authority of Colonel SIR NIGEL KINGSCOTE, K.C.B., Commissioner of Her Majesty's Woods, Forests, Land Revenues, &c.

RULES

TO BE OBSERVED BY THE LABOURERS IN THE APPROPRIATION OF DEAD WOOD, CHIPS, AND OTHER SIMILAR MATERIAL.

1. Previous Rules on this matter are hereby RE-CALLED and these Regulations are to be in force instead.

2. The privilege granted is confined to the picking up of small dead Branches that have been blown down, and to the small Chips that are thrown off by the axe in cutting Trees, and no Labourer is on any account to break boughs off the Trees.

3. No pieces of dead Wood or Chips so gathered by any Labourer are to exceed two inches in thickness, or two feet in length, and they are to be carried by him during the week, and during his own hours, into a heap in some convenient place, where they must be inspected by the Woodman of the district before they are removed.

4. The Wood after being inspected is only to be removed upon Wednesday and Saturday nights, and on no other night whatever, and the Wood so removed shall be carried in a string or wythe.

5. In taking down any old fencing or building, nothing is to be taken away by any one, except by special permission of the Deputy Surveyor.

6. No Labourer, except a Wood-cutter, is allowed to carry a hand-bill with him.

7. The Woodmen and Park Officers are at all times to be at liberty to stop any men, and examine their bundles, and the Woodmen will be held responsible to the Deputy Surveyor for any Wood improperly taken away.

8. Any Wood-cutter engaged in converting Fagot-wood, Stackwood, Charcoal-wood, or other similar material, who shall carry home any part of the same, or shall cut and splinter the same so as to make it into Chips, will be liable to be discharged immediately: and for the first offence under any of the other heads, the Labourer will be liable to have his Wages stopped for the week in which the offence happens, and for the second to be dismissed from the service.

F. SIMMONDS,

June, 1894 *Deputy Surveyor and Receiver.*

the Lord Steward's Department on 29th October 1858. Previously, it had been by the Prince Consort, Ranger of the Park. (Public Record Office Ref. CRES. 4/91).

During most of the 1900s, the park was split into five districts:- Windsor Great Park, New Park, Wick Nursery, Swinley and Wishmoor Cross. Each area was under the control of the District Woodman. The term 'Forester', as used today, was unheard of.

Rules to be observed by Labourers of the park in June 1894 for removal of dead wood or similar material. It should be noted that in those days, a Woodman was the most senior person working in the forest, reporting directly to the Deputy Surveyor and Receiver.

Acts and Regulations affecting The Great Park & Windsor Forest.

1813: Windsor Forest Enclosure (Inclosure) Act.

1817: Windsor Forest Enclosure (Inclosure) Awards.

1827: Mantraps & Spring Guns Act. (made illegal).

1828: Night Poaching Act.

1831 : Game Act.

1862: Poaching Prevention Act.

1872: Park Regulations Act.

1880: Ground Game Act.

1906: Ground Game Act.

1913: Ascot Authority Act.

1926: The Park Regulations (Amendment) Act.

1928: Protection of Lapwings Act.

1932: Rights of Way Act.

1937: Agricultural Act.

1951: The Windsor Great Park Regulations.

1956: The Crown Estate Act.

1960: Caravan Sites & Control of Development Act.

1961: The Crown Estate Act. Under the Act, the estate is managed by a Board of Commissioners who have a duty to 'maintain and enhance the value of the estate and the return the value obtained from it, but with due regard to the requirements of good management.'

1967: Criminal Justice Act

1976: Drought Act

1981: Wildlife & Countryside Act.

1989: Interpretation Act.

Rangers and Deputy Rangers of The Great Park & Windsor Forest

Rangers

Sir Henry Neville	1559-1607
Sir Henry Lovelace	1607-1647
Earl of Pembroke	1648-1662
Lord Maudaunt	1662-1668
Prince Rupert	1668-1671
Baptist May	1671-1697
William Earl of Portland	1697-1702
Sarah, The Duchess of Marlborough	1702-1744
John Spencer	1744-1746
William Augustus, Duke of Cumberland	1746-1766
Henry Frederick, Duke of Cumberland	1766-1791
King George III	1791-1815
King George IV (as Regent and King)	1815-1830
King William IV	1830-1837
Queen Victoria	1837-1841
Prince Albert The Prince Consort	1841-1861
Prince Christian of Schleswig-Holstein	1861-1917
King George V	1917-1936
King George VI	1936-1952
The Prince Philip Duke of Edinburgh	1952-

Deputy Rangers

Bulstrode Whitelocke	1646-1650
Thomas Sandby	1764-1798
General William, (later) 3rd Earl of Harcourt	1799-1830
Joint Keepers/Commissioners-	
Earl Harcourt, John Nash, Charles Bicknell, Francis Seymour	
(Viscount Yarmouth, later Marquis of Hertford.)	1815-1830
Sir William Freemantle	1830-1850
Major General Francis Seymour	1850-1870
Colonel The Hon Augustus Liddell	1870-1883
Captain Walter Campbell	1883-1916
Colonel The Hon Claude Willoughby	1916-1929
Lieut-Col Sir Malcolm Murray	1929-1937
Sir Eric Savill	1937-1958
Major Andrew Haig	1958-1974
Roland Wiseman	1974-1995
Marcus O'Lone	1995-1998
Philip Everett	1998-

Surveyors General and Deputy Surveyors of The Great Park and Windsor Forest

Surveyors General

Philip Riley	1687-1710
Edward Wilcox	1693-1715
Sir Thomas Hewett	1715-1716
Edward Younge	1716-1732
Francis Whitworth	1732-1742
Henry Legge	1742-1745
John Phillipson	1745-1756
John Pitt	1756-1763
Sir Edmund Thomas	1763-1767
John Pitt	1768-1786
John Robinson	1786-1802
Sylvester, Lord Glenbervie	1803-1806
Lord Robert Spencer	1806-1807
Sylvester, Lord Glenbervie	1808-1810

No records of Surveyors General after 1810.

Deputy Surveyors

No records of Deputy Surveyors before 1817.

William Maslin	1817-1828
Charles Maslin	1828-1848
Wilby Maslin	1848-1849
William Menzies	1849-1878
Frederick Simmonds	1878-1905
Reginald Halsey	1905-1909
Arthur Forrest	1909-1924
Christopher Lloyd	1924-1931
Eric Savill	1931-1937

In 1937 the role of the Deputy Surveyor was absorbed into the function of the Deputy Ranger.

Chapter 1 Stag Meadow

1911 Windsor and Eton Football Club
Ground created.
1921 Windsor & District Boy Scout
Association Jamboree.
1997 Girl Guides World Camp.
1962 Berkshire International Camp.
1972 Berkshire International Camp.
1996 Flood Control Embankment Built.

Chapter 2 Cavalry Exercise Ground.

c1650 Original Queen Anne's Gate Lodge
built.
1797 Queen Anne's Gate Lodge rebuilt.
1820 The Clump planted.
1840s Windsor Steeplechase meetings first
held.
1853 Queen Anne's Gate Lodge altered.
1860 Prince Consort's Drive named.
1872 First Polo Match held.
1874 Windsor Steeplechase Meetings ended.
1889 Royal Agricultural Society of England
held.
1914 Military camps set up.
1916 Tea Party held for 6,600 wounded
soldiers.
1924 Queen Mary's Plantation planted.
1939 Royal Agricultural Society of England
held.
1954 Royal Agricultural Society of England
held.
1968 Inter Counties Cross-Country
Championships held.
1972 Presentation of the Guidon by Queen
Elizabeth II.
1972-4 Rent Strike People's Festival held.
1998 Cycle Track opened.

Chapter 3 Review Ground

1818 1st Battalion Grenadier Guards review.
1822 1st & 2nd Coldstream Guards review.
1831 2nd Regiment of Life Guards review.
1844 5,000 Troops in honour of the Emperor
of Russia review.
1855 5,000 Troops in honour of Emperor and
Empress of France review.
1868 26,000 Rifle Volunteer Corps review.
1869 5,000 Guards in honour of the Prince
Ismail, Pasha of Egypt review.
1873 7,400 Troops in honour of the Shah of
Persia review.
1874 2,000 Troops who had returned from
Ashanti, Gold Coast review.
1877 14,771 Troops of all arms review.

1880 11,000 Troops of all arms review.
1881 55,000 Volunteers (Citizen-Soldiers)
review.
1891 40 2nd Life Guards review.
1893 350 St. John Ambulance Association
review.
1894 600 Yeomanry, (Berkshire and
Middlesex Regiments) review.
1895 3,692 South London Volunteer Brigade
review.
1897 3,679 Public Schools Volunteers review.
1899 600 Troops of The Honourable Artillery
Company review.
1911 17,987 Officers Training Corps review
35,200 Boy Scouts review.
First Airmail Flights
1912 15,000 St. John Ambulance Brigade
review.
1913 700 Household Cavalry review.
1915 850 2nd Life Guards, Coldstream
Guards and Surrey Infantry review.
1936 350 Life Guards review.
1961 Fiftieth Anniversary of first airmail
flights.
1981 Great Picnic held.
1993 Windsor International Guide & Scout
Camp held.
1997 Royal Horse Pageant cancelled.
1998 Windsor International Guide & Scout
Camp held.
1999 Windsor Horse Driving Trails held.

CHAPTER 4 The Long Walk

1540s The Legend of 'Herne the Hunter'
started.
1682 Long Walk created.
1720s Original Double Gates Lodge built.
1825 Mineral Spring made public.
1829 Stone Bridge completed.
1831 Copper Horse Equestrian Statue
completed.
1840s Military Hospital demolished.
1851 Albert Road to and from Old Windsor
built.
Long Walk Gate Lodge built
1859 Hoard of silver coins found on site of
Military Hospital.
1862 Royal Mausoleum built.
1865 Hog Common first used as camp by
Volunteer Rifles.
1890s James Stanley 'Happy' Wootton the
Hermit first mentioned.
1909 Double Gates Lodge rebuilt.
1911 Tom Sopwith landed on the East Lawn
in his aircraft.
Gastav Macel landed in Shaw Meadow with

first airmail.
1920 National Cross-Country
Championships held.
1921 Replanting of The Long Walk trees
began.
1924 National Road Walking Championships
held.
1947 South of the Thames Cross-Country
Championships held.
1956 Southern Counties Cross-Country
Championships held.
1977 Queen's Silver Jubilee bonfire lit.
1981 Prince Charles & Diana Spencer
Wedding bonfire lit.
1982 Windsor Half Marathon held for first
time.
1995 50th Anniversary V.E.Day bonfire lit.
2001 Windsor Farm Shop opened.

CHAPTER 5 Old Windsor

1395 Wychmere Lodge demolished.
1862 Gamekeeper John Mortlock viciously
attacked.
1856 Prince Consort's Plantation planted.
1864 Gore Plantation planted.
1866 Bear's Rails Gate Lodge built.
1867 Sultan Plantation planted.
1875 Liddell Plantation planted.
1880 Wild Boar Pen erected.
1895 Duke of York Plantation planted.
1919 Wychmere Lodge site partially excavated.
1937 Bear's Rails Scout Campsite built.
1970 Tile Kiln Cottage demolished.
1979 Deer Handling Hut erected.
1981 Crimp Hill Gate Lodge rebuilt with
bungalow.
1998 Old Windsor Emergency Hospital
demolished.
1999 Crimp Hill Pond created.

CHAPTER 6 Royal Lodge

c1700 Royal Lodge built.
1768 Original Bishops Gate Lodge built.
1811 Prince Regent used the Royal Lodge for
first time.
1838 Rhododendron Ride created.
1852 First Park Chaplain appointed.
1863 Royal Chapel of All Saints rebuilt.
1866 Queen Victoria's Plantation planted.
1880 Prince of Wales Plantation planted.
1888 Prince & Princess of Wales Silver
Wedding Oak planted.
1902 Bishops Gate Lodge built on other side
of road.
1918 Consent given for Red Cross Hospital,
but never built.

1931 Duke and Duchess moved into the Royal Lodge.

1932 'Y Bwthyn Bach' (The Little House) installed.

2002 Queen Elizabeth The Queen Mother continued to use the Royal Lodge as her home until her death

CHAPTER 7
The Village and Queen Anne's Ride.

c1450 Oak Avenue created.

1708 Queen Anne's Ride created.

c1720 Sir Andrew Cope's Clump planted.

c1750 Sandpit Gate Lodge built.

1770s Forest Lodge (formerly Holly Grove) built.

1830s First two houses of the Village built.

1836 Ranger's Lodge (formerly Bailiff's Lodge) built.

1861 Park Cricket Club founded.

1887 Queen Victoria's Golden Jubilee Oak planted.

1897 Queen Victoria's Diamond Jubilee Oak planted.

1902 King Edward VII Coronation Oak planted.

1906 Sawmills burnt down.

1932 Park Women's Institute founded.

Park Football Club founded.

1937 Park Scouts & Guides founded.

1948 Thirty-two houses and the village shop were built.

1951 King George VI formally open the shop and York Club.

1953 Queen Elizabeth II and the Duke of Edinburgh planted a grove of oak trees to commemorate the Queen's Coronation.

Park Annual Flower Show founded.

1954 A further eighteen houses built in the village.

Park Bowls and Tennis Clubs founded.

1970s Sawmills in Russel's Field demolished.

1978 New Estate Offices built.

Park Golf Club founded.

1986 Isle of Wight and the Lower Isle of Wight Ponds were drained to have major work done.

1992 Replanting started of Queen Anne's Ride.

The Millstone erected to commemorate the replanting.

CHAPTER 8 Cranbourne

c1200 William The Conqueror's Oak, oldest tree in the park.

c1500 Cranbourne Tower built.

1637 Anne Hyde, first wife of King James II,

was born in Cranbourne Tower.

1764 'Eclipse' the famous racehorse was foaled at Cranbourne paddock.

1797 Forest Gate Lodge built.

1800s Herd of Buffalo and White Deer kept at Cranbourne.

1820s Forest Park House built.

Forest Gate Lodge rebuilt.

1828 Herd of Kashmir Goats introduced and kept at Goat Pen Hill.

1832 Forest Gate Lodge rebuilt.

1861 Cranbourne Tower (with exception of the Tower) demolished.

1958 Forest Park Lodge demolished.

CHAPTER 9 Flemish Farm

1790s King George III became tenant of the farm.

First farm buildings erected.

1814 Flemish Farm purchased by the Crown.

1850s Farm Buildings rebuilt.

1856 Hereford cattle introduced.

1860s Annual livestock sales founded.

1862 Prince Consort's Memorial Oak planted.

1902 King Edward VII Oak planted.

King Carlos I of Portugal Oak planted

1903 King Victor Emmanuel III of Italy Oak planted.

1906 King Haakon VII of Norway Oak planted.

1907 William II German Emperor Oak planted.

1908 King Gustavus V of Sweden Oak planted.

1909 King Manuel II of Portugal Oak planted.

1911 King George V Oak planted.

Edward Prince of Wales Oak planted.

CHAPTER 10 High Standing Hill

1830s High Standing Hill Lodge built.

Government Lodge built.

1868 Nos 3 & 4 Nobbscrook Cottages built.

1916 Canadian Forestry Corps moved into Nobbscrook Forest.

1918 Large Re-afforestation Meeting held.

1924 Queen Adelaide's Beech replaced.

1935 Nos 1 & 2 Nobbscrook Cottages built.

Nos 1 to 4 Forbe's Field Cottages built

1959 Queen Elizabeth II planted a replacement for the dead Queen Victoria Oak.

1984 Queen Charlotte's Oak replaced.

CHAPTER 11
Norfolk Farm. Duke's Lane and South Forest

1750s Great Meadow Pond created.

1790s King George III founded Norfolk Farm.

1793 Norfolk Farm House built.

1816 Norfolk Farm cottages built.

1843 South Forest Cottage built.

1851 Hollybush Cottages built.

1859 Windsor Great Park Rifle Volunteers established.

1862 Prince Consort's Gate Lodge built.

1864 Fernhill Cottages built.

1873 Menzies Plantation planted.

1883 Norfolk Plantation planted.

1885 Princess Beatrice Plantation planted.

1897 Ascot Gate Cottage built on the site of Milton's Lodge.

1904 Windsor Great Park Rifle Volunteers disbanded.

1934 Marie Burgoyne's Seat erected.

1945 Red Cross Agricultural Fund Trees planted.

1968 *Davidia Involucrata* planted by C.V. Venables.

1976 South Forest Cottage burnt down.

1982 *Liquidambar Styraciflua* tree planted by Sir Marcus Worsley.

1985 Fernhill Cottages demolished.

CHAPTER 12 Cumberland Lodge

1670s Cumberland Lodge built.

1718s Lime Tree Avenue planted.

1746 Duke of Cumberland moves into Cumberland Lodge and the lodge has been known by that name ever since.

1770s Black Hamburg Grape vine planted in the "Winery".

1845 Royal School opened.

1863 Cumberland Gate Lodge built.

1868 Prince Christian Plantation planted.

1869 Cumberland Lodge badly burnt.

1872 Prince and Princess Christian move into Cumberland Lodge.

1875 Prince Christian's Family Cedars planted.

1877 Scarlet Oak Avenue planted.

1888 Prince Christian Victor Oak planted.

1891 The Christian's entertain William II of Germany.

1907 Chaplain's Lodge built.

1911 Dr W.G. Grace plays cricket at Cumberland Lodge.

1920 Beech Tree planted by Duke of Connaught on his 70th birthday.

1937 King George VI Coronation Oaks planted.

1945 King George VI attended the School's Centenary Celebrations.

1947 Last private resident of Cumberland Lodge, Viscount Fitzalan of Derwent dies.

1948 Cumberland Lodge converted into a

student college.
1995 Queen Elizabeth II visits the school on the one hundred and fiftieth anniversary.

CHAPTER 13 Smith's Lawn and The Savill Garden

c1765 Cumberland Obelisk erected.
1826 Chapel Wood Tree & Shrub Nursery created.
1833 The Stone Bridge built.
1841 Parkside Cottage built.
1855 10 Wich Lane Cottage built.
1875 Flying Barn Cottage rebuilt.
1890 Prince Consort's Statue unveiled.
1905 Smith's Lawn Cottages built.
1916 Canadian Forestry Corps set up their main base camp on Smith's Lawn.
1918 Canadian Forestry Corps hold large sports event.
1930s Cricket starts on Smith's Lawn.
1931 Development of The Savill Garden begins.
1940 Vickers Armstrong build an aircraft factory on Smith's Lawn.
1948 Olympic Cycle Road Race starts and finishes on Smith's Lawn.
1955 Polo held on Smith's Lawn for first time. European Horse Championships held.
1959 Garden House built.
1964 Temperate House built.
1973 Lions Club of Windsor holds the Horse Ride's for first time.
1978 Jubilee Bridge built.
1981 Guide's Campsite opened.
1987 Beach Wood blown down during great storm.
1995 Replacement to the Temperate House, The Queen Elizabeth Temperate House built.
2001 Plaque to commemorate the Third Millennium installed in The Savill Garden.

CHAPTER 14 Virginia Water and The Valley Gardens

1240s Manor Lodge was built for King Henry III.
1710s Manor Lodge completely rebuilt.
1750s Virginia Water Lake created.
'Verderems', formerly Nursery Cottages built.
Fort Belvedere built.
Johnson's Pond created.
The Clockcase built.
1753 Original Wooden High Bridge built.
Several large boats placed on the lake.
Blacknest Gate Lodge built.

1754 China Island created.
1758 China Island Cottage completed.
1768 Virginia Water Lake head breaks away.
1780s Rustic Stone Bridge below the Cascade built.
Virginia Water Lodge built.
1790 Construction of embankment from the Cascade to Wick Pond completed.
Construction of Cascade completed.
Construction of Stone Bridge at Wick Pond completed.
c1795 American Clump planted.
1826 Five Arch Bridge built replacing wooden high bridge.
Fishing Temple built.
1827 The Ruins erected.
1834 Blacknest Gate Lodge rebuilt.
1862 Manorhill Cottages built.
1870s China Island Cottage demolished.
1878 Current Virginia Water Cottage built.
1891 Worldsend Cottage rebuilt.
1904 King Edward VII brig launched on the lake.
1906 'Brynwood' and 'Lakeside' Cottages built.
1916 Canadian Forestry Corps set up camp.
1927 The Blacknest Sewage Pumping Station opened.
1930 Prince Edward (later King Edward VIII) moves into Fort Belvedere.
1931 Canadian Memorial Avenue planting started.
1936 King Edward VIII abdicated and left Fort Belvedere.
Fishing Temple demolished.
1938 Sir Malcolm Donald Murray, former Deputy Ranger of the Park, drowned in a boating accident on the lake.
1939 During Second World War Virginia Water closed to the public.
1946 *Araucaris Araucana* (Monkey Puzzle) Plantation planted.
1947 The creation of The Valley Gardens started.
1949 'Flinders' and 'Rowallan' Cottages built.
'Weydon' and 'Silver Birches' Cottages built.
'Heatherside' and 'Heatherbelle' Cottages built.
1950s 'Grotto' on the Cascade sealed up for safety reasons.
1958 Totem Pole erected.
1965 'Pinewood' 'Woodside' 'Darfur' and 'Oakleaves' Cottages built.
1979 The Patrick Plunket Memorial Pavilion erected.
1986 Totem Pole repaired and repainted.

CHAPTER 15 Sunninghill Park

1630 Sunninghill Park & Mansion purchased from the Crown by Sir Thomas Carey.
1790s The three ponds altered to make one large pond known as the Great Pond.
1860s Stone Bridge built over the Great Pond.
1864 Crispin Cottage built.
1890 Sunninghill Lodge built.
1900s Woodend house demolished.
1921 Grand Gala and Fete held.
1931 Crispin Public House built.
1936 Woodend Cottages built.
1940 Requisitioned by the War Office.
Becomes a station for Royal Air Force Officers.
1942 Royal Air Force moves out.
Becomes the Headquarters the USAAF 9th Air Force and the IX AF Service Command. Known as Station 472.
1945 Repurchased by the Crown.
1947 Whilst preparing the mansion as the home for Princess Elizabeth and Prince Philip, a damaging fire almost destroys the mansion.
1952 The mansion demolished.
1987 Approval given for a new Sunninghill Park House to be built for the Duke and Duchess of York.
The Great Pond drained for major work.

CHAPTER 16 Ascot Heath

1711 First horse race held on the heath.
1720 Racing resumed after a period of no racing following Queen Anne's death.
1740 Act of Parliament to prevent excessive gambling.
1745 Act of Parliament to control card playing.
1750s Champion boxing started on the heath.
1765 Starting Posts used for first time.
1772 Gold Cup inaugurated.
1785 The first Straight Mile Course created.
1793 Slingsby Stand erected.
1807 Gold Cup introduced on a permanent basis.
1813 Windsor Forest Enclosure Act comes into force.
1822 The Royal Stand erected.
1839 Victorian Grandstand erected.
1859 Slingsby Stand demolished.
1862 Military Camp held on the heath.
1864 Saddling Paddock created.
1874 Old Mile Lodge built.
1877 Original Golden Gates and Lodge built.
1878 Alexandra Stand erected.
1883 Royal Ascot Cricket Club founded.
Recreation Ground on the heath created.
1887 Royal Ascot Golf Club founded.
1896 Grandstand Clock erected.

1900s Bowls played on the heath.
1902 Royal Enclosure with three new stands created.
1906 First tunnel from the enclosures to the heath completed
1907 Gold Cup stolen.
1908 Five Shilling Stand erected, later called the Six Shilling Stand.
1913 Ascot Authority Act came into being.
1920 Royal Ascot Tennis Club founded.
1925 Gymnastics displays started.
1928 Royal Ascot Hockey Club founded.
1930 Violent thunderstorm - one bookmaker killed.
1931 Totaliser Board erected.
1936 Water Reservoir built.
1938 Southern Counties Cross Country Championships held.
1947 Southern Counties Cross-Country Championships held.
1955 New Straight Mile Course created.
Violent thunderstorm kills two people.
1961 Old Grandstand replaced with the Queen Elizabeth II Grandstand.
1964 Royal Enclosure Stand built replacing the old stands.
1965 Steeplechase and Hurdles Courses created.
1984 Royal Ascot Spectacular held on the heath in aid of The Prince Philip Trust Fund.
1996 Frankie Dettori rides all seven winners.
2001 Movable Turf Crossing completed.

CHAPTER 17 Swinley Forest and Bagshot Park

c700 BC Caesar's Camp created.
1850s Swinley Park Lodge demolished.
1878 Red Cottage built.
Lake Cottage built.
Laundry Cottage built.
1879 Bagshot Park House rebuilt.
1888 Swinley Entrance Lodge rebuilt.
1897 Brickfield Cottage built.
1899 Coach House and Stables in Bagshot Park built.
1900 Whitmoor Bog Cottages built.
1912 Swinley Forest Golf Course created.
1914 Royal Air Force No 6 Storage Depot built.
1916 Canadian Forestry Corps set up camp.
1927 YMCA Camp held.
1928 The Berkshire Golf Club Course created.
1935 Crown Cottages built.
1939 Swinley Brick Works ceases production.
Internment and POW Camp created. 1941 Junkers JU 88 crashes in the Bagshot Park.
1942 Bagshot Park requisitioned by the War Office.
1952 Olddean Common sold to War Office.

1954 Forest Close Houses built.
1960s Caesar's Camp Cottage demolished.
c1980 Swinley Paddock Cottage demolished.
1984 Red Lodge rebuilt.
The National Forest Machinery Exhibition held. 1985 Used for the location of the making of *The Dirty Dozen: Next Mission.*
1991 The Look Out opened.
1995 The Privilege Insurance London International Rally.
1998 Prince Edward moved into Bagshot Park House,

CHAPTER 18 Second World War

1939 Second World War declared on 3rd September.
The Virginia Water Lake, Great Meadow Pond and the Obelisk Pond drained of most of their water to disguise them from the air.
Smith's Lawn and Virginia Water areas closed to the public.
Internment and POW Camp created on site of Swinley Brick Works.
1940 Evacuees sent to Bagshot Park.
Pill boxes built.
Anti-aircraft Guns installed in the Review Ground.
searchlight Stations installed in the Cavalry Exercise Ground and at Woodend, Sunninghill Park.
First enemy bombs dropped on 13th July.
Anti-aircraft guns fired for the first time 24th August.
In September, Vickers Armstrong begin building a factory on Smith's Lawn.
Messerschmitt ME109 crashed in the Cavalry Exercise Ground on 30th September.
Bomb hits Royal Lodge entrance gate lodge on 8th November killing 19 year Joseph Pearce.
Royal Air Force officers take over Sunninghill Park.
1941 Dornier 17 brought down by night fighter and crashes on Oakley Court Farm, Bray on 17th February.
Heinkel HE III brought down in South Forest on 9th April.
Junkers JU 88 brought down in Bagshot Park on 10th April.
In May, a large proportion of the park ploughed up as part of the war effort.
1942 Bagshot Park requisitioned by the War Office.
Royal Air Force officers moved out of Sunninghill Park.
The USAAF set up camps in Sunninghill Park, Ascot Racecourse and Smith's Lawn.
1943 Most of the park producing good crops

of wheat, oats potatoes, etc.
1944 De Havilland Tiger Moth crashes in South Forest.
VI Flying Bomb hits the 'Bells Of Ouzeley' public house, Old Windsor on 15th June.
VI Flying Bomb hits the chimney of 'Dust Destructor', West Windsor on 1st July.
VI Flying Bomb narrowly misses the Royal Lodge on 4th July.
V2 Rocket comes down near the Obelisk Monument in November.
Wartime lighting restrictions lifted on 15th September.
1945 War ends on 7th May.
Smith's Lawn and Virginia Water area reopened to the public on 25th May.

CHAPTER 19 Estate Management

1760 In the reign King George III, the Crown Lands first placed in the hands of a Commission headed by the Surveyor General.
1810 The Surveyor General replaced by a board of management with the title of The Commissioners of Woods, Forests and Land Revenues.
1813 Windsor Forest Enclosure Act comes into force.
Violent attack on his Majesty's Gamekeepers.
1817 Windsor Forest Awards applied.
1820 Major tree planting started by Joseph Smith, great great grandfather of the author.
1827 Mantraps & Spring Guns Act.
1828 Night Poaching Act.
1831 Game Act.
1858 All Gamekeepers to adhere to a 'Deputation' under the Lord Steward's Department which clearly lays down their responsibilities.
1862 Poaching Prevention Act.
1872 Park Regulations Act.
1880 Ground Game Act.
1906 Ground Game Act amended.
1913 Ascot Authority Act.
1919 Forestry Commission set up.
1926 The Park Regulations (Amendment) Act.
1928 Protection of Lapwings Act.
1932 Rights of Way Act.
1937 Agricultural Act.
1951 The Windsor Great Park Regulations.
1956 The Crown Estate Act.
1960 Caravan Sites & Control of Development Act
1961 The Crown Estate Act clarified.
1967 Criminal Justice Act.
1976 Drought Act.
1981 Wildlife & Countryside Act.
1989 Interpretation Act.

ACKNOWLEDGEMENTS

Although much of the information and many of the photographs used for this book have come from my own family's knowledge and records, it would not have been possible to produce such a comprehensive scope of the Windsor Crown Estate, if it had not been for the assistance of the many organisations and individuals who have kindly allowed me to use their materials and photographs for this book. My special thanks go to Phil Greenaway (retired Cartographer of the estate) who I have known for most of my life, and who like myself, has a keen interest in the history of the estate. In particular, his working knowledge has been invaluable in defining the past and present boundaries of the estate.

THE ROYAL FAMILY

H.R.H. The Queen
H.R.H. The Prince Philip, Duke of Edinburgh
The late H.R.H. Queen Elizabeth The Queen Mother
H.R.H. Prince Andrew The Duke of York

BUCKINGHAM PALACE

Brigadier Miles Hunt-Davis, C.V.O., C.B.E., Private Secretary to H.R.H. The Duke of Edinburgh.
Charlotte Manley, O.B.E. Comptroller and Deputy Private Secretary to The Duke of York.

CLARENCE HOUSE

Alister Aird, Private Secretary to Queen Elizabeth The Queen Mother.

WINDSOR CASTLE

The Hon. Mrs Roberts, Curator of the Print Room, The Royal Library, The Royal Collection Trust.
Pamela Clark, Deputy Registrar, The Royal Collection Trust.
Helen Gray, Assistant Curator, Royal Photograph Collection, The Royal Collection Trust.

FORT BELVEDERE

The Weston family and Colonel (Ret'd) Robert ffrench Blake

ORGANISATIONS

Aerofilms Limited.
Air War Research: Mike Croft, Steve Hall, Nigel Parker and L Ritson-Smith. *Babtie Environmental:* Rob Bourn, Senior Archaeologist.
Berkshire Record Office: Elizabeth Hughes, Senior Archivist.
Bracknell Forest Borough Council.
British Olympic Association: Simon Clegg, Chief Executive.
Brooklands Aviation Museum: Julian Temple, Curator of Aviation.
Cheapside Publications: Christine Weightman.
Eton College Library: Provost and Fellows of Eton College.
Household Cavalry Museum Collection: Major Kersting.
Kingsley-Jones Photographic Studios: Stanley Kingsley-Jones.
Lions Club of Windsor: Peter Vaughan, Chairman Horse Ride Committee.
Lymington Historical Record Society: Peggy and Jude James.
Mike Nicholson Photography: Mike Nicholson.
National Maritime Museum: Sarah McCormick, Registrar.
Osborne House: Linda Smith, Deputy House Custodian.
Public Records Office: Tim Padfield, Copyright Officer.

Royal Agricultural Society of England: Phillip Sheppy M.B.E., Librarian.
Royal Ascot Golf Club: Norman Barker, Secretary.
Royal Borough of Windsor and Maidenhead Collection: Olivia Gooden, Heritage Development Officer and Dr Judith Hunter.
Slough and Windsor Express Newspapers: Sally Stevens and Michelle Wylie.
St John Ambulance Collections: Caroline Mulryne, Keeper.
Swinley Forest Golf Club: Ian Pearce, Secretary.
The Ascot Authority: D.V. Erskine Crum, C.B.E. Chief Executive.
The Berkshire Golf Club.
The Guide Association: Margaret Courtney, Archivist.
The Guide Association, Berkshire: Carole Snook, Archivist.
The Look Out, Discovery Park: Jacky Henderson, Manager.
The Rambler's Association, Berkshire Area: Dave Ramm.
The Scout Association: Pat Styles, Archives Assistant.
The University of Reading, Department of Classics: Peter Stewart.
UK Counties Athletic Union: Cliff Robinson, Hon. Secretary.
USA Department of the Air Force: Archie Difante, Archivist.
Veteran-Cycle Club: Geoff Paine and Alison Mansfield.
Windsor District Scout Archives: Rupert Allison.
Windsor Great Park Women's Institute: Peggy Handcock and Mrs O Cook.
Windsor Half Marathon: Alysia Hunt, Race Director.
Windsor International Guide & Scout Camp (WINGs 98): Bob Greenwood.
Windsor and Maidenhead Libraries: Pat Curtis.

GENERAL

The late Gordon Cullingham, Dennis Dance, Michael Dumbleton, Alister Gallaway, Peggy Gibson, Brian Hessey, Ron Hudson, Mary Hutchinson, Sharon & Ken Pritchard-Jones, Len Runyard, the late Freddie Shenston, Ruth Timbrell, Roy Whibley.

WINDSOR CROWN ESTATE, CURRENT, RETIRED STAFF AND RELATIVES

(in alphabetical order)
Ray Apperley, Ken Bailey, Daphne & John Beasley, Graham Bish (retired Forester), Reg Brind, Richard Bushnell-Wye, Bill Cathcart (Superintendent), Bill Chapman (Cartographer), Eric Critchlow (retired Assistant Keeper of the Gardens), Phil Elliott (Draughtsman), Anne Elliott, Philip Everett (Deputy Ranger), Nancy & William Fenwick (retired Head Gamekeeper), Peter Fielder (Forest Manager), Margaret Findlay, Mark Flanagan (Keeper of the Gardens), Ray Gardener, Ted Gardiner (retired Forest Foreman), Ted Green (Arboriculturist), Phil Greenaway (retired Cartographer), The late William Grout (retired Clerk of Works), Leslie Grout, Rod Haylor, Peter Hoptroff, Wendy Humphries, Dave Ives, Andrew Jackson (retired Parks Superintendent), Alec Jacobs (Surveyor of Works), Joycelyn & Walter James, John Lukawaski (retired Gamekeeper), Alec Mayor, Ray Morrison (Gamekeeper) Marcus O'lone (past Deputy Ranger), The Very Rev Canon John Ovenden (Park Chaplain), Betty Parrot, Gloria Ringrose (Headteacher, Royal School), Daisy & Jim Rutt, Steve Searle (Forest Manager), Derick Stickler (Head Forester), John Stubbs (Head Gamekeeper), Rev Canon John Treadgold (past Park Chaplain). Peter Wagstaff, Steve West, Doug Wilson (Bursar, Cumberland Lodge), Doris & Bert Winchester (retired Gamekeeper), Rowland Wiseman (past Deputy Ranger), Bert Wooders, Cyril Woods.